# CONTEMPORARY ART

# CONTEMPORARY ART WORLD CURRENTS

## TERRY SMITH

**PRENTICE HALL**

UPPER SADDLE RIVER   LONDON   SINGAPORE
TORONTO   TOKYO   SYDNEY   HONG KONG   MEXICO CITY

For Pearson Education, Inc.:
Editor-in-Chief: Sarah Touborg
Senior Editor: Helen Ronan
Editorial Assistant: Carla Worner
Managing Editor: Melissa Feimer
Senior Operations Supervisor: Brian K. Mackey
Director of Marketing: Brandy Dawson
Executive Marketing Manager: Kate Mitchell
Marketing Assistant: Lisa Kirlick

Credits and acknowledgments borrowed from
other sources and reproduced, with permission, in
this textbook appear on appropriate page within
text (or on page 347).

Published by Pearson Education, Inc., publishing
as Prentice Hall, One Lake Street, Upper Saddle
River, New Jersey.

Library of Congress Cataloging-in-Publication Data

Smith, Terry (Terry E.)
   Contemporary art : world currents / Terry Smith.
      p. cm.
   Includes bibliographical references and index.
   ISBN-13: 978-0-205-03440-6 (hardcover : alk. paper)
   ISBN-10: 0-205-03440-3 (hardcover : alk. paper)
   1. Art, Modern--20th century--Themes, motives. 2.
Art, Modern--21st century--Themes, motives.  I. Title.
   N6490.S568 2011
   709.04'5--dc22
                                        2011000219

10 9 8 7 6 5 4 3 2 1

This book was designed and
produced by Laurence King
Publishing Ltd

For Laurence King Publishing:
Commissioning Editor: Kara Hattersley-Smith
Senior Editor: Zoe Antoniou
Designer: Masumi Briozzo
Copy Editor: Robert Shore and
Angela Koo (endmatter)
Proofreader: Tessa Clark
Indexer: Vicki Robinson
Production: Simon Walsh

Printed in Hong Kong

Page 2: Wang Guangyi, *Great Criticism–Coca-Cola*,
1993 (detail of fig. 5.11).

**Prentice Hall**
is an imprint of

www.pearsonhighered.com

Hardback ISBN-10: 0-205-03440-3 | ISBN-13: 978-0-205-03440-6
Paperback ISBN-10: 0-205-78971-4 | ISBN-13: 978-0-205-78971-9

# CONTENTS

# ACKNOWLEDGMENTS

At Laurence King, I thank the publisher himself, and Lee Ripley, but above all Kara Hattersley-Smith for her shepherding the project through all of its stages. I also thank John Jervis, Julia Ruxton, Robert Shore, Zoe Antoniou, and everyone who worked on this book.

At Pearson/Prentice Hall, Sarah Touborg, Carla Worner, and everyone else involved. More than a dozen readers commissioned by both presses reviewed every stage of the manuscript, from proposal to final text—I thank them for their independent comments, detailed corrections, and useful practical advice. Among them were Micol Hebron, Chapman University; Matthew Jesse Jackson, University of Chicago; Evelyn Kain, Ripon College; Scott Koterbay, East Tennessee State University; Katie Kresser, Seattle Pacific University; Margaret Richardson, Marshall University; Joy Sperling, Denison University; and Timea Tihanyi, University of Washington.

Thanks to the artists who gave permission for their work to be reproduced, the gallery directors and archivists who facilitated this process, the photographers, and the collectors, all of whom are named in the captions and credits.

I am indebted to Larry Silver for the initial invitation to take such a broad view of modern and contemporary art, and to David Wilkins, textbook writer *extraordinaire*, for reviewing the entire text.

For expert help with specific chapters, I thank John Clark, Gao Minglu, Thomas Berghuis, Judith Farquhar; Boris Groys, Ales Erjavec, Marina Gržinić, Randall Halle, Nancy Condee; Mari Carmen Ramirez, Sônia Salzstein, Paulo Venancio Filho, Héctor Olea, Andrea Giunta, Rachel Weiss; Okwui Enwezor, Ulli Beier; Alexander Alberro and Hilary Robinson.

Many of the early chapters of this book were written while I was researching in the Schaeffer Library, Power Institute for Art and Visual Culture, University of Sydney: I thank particularly John Spencer and Peter Wright for their unstinting assistance. Most of the central chapters were written during 2007–08 while I was a GlaxoSmithKlein Senior Fellow at the National Humanities Center, Research Triangle, Raleigh-Durham, North Carolina. I thank particularly Geoffrey Harpham, Kent Mullikin, Liza Robertson, Jean Houston, Josiah Drewry, Lois Worthington, Marianne Wason, and Marie Brubaker.

At a crucial stage I benefited from comments received during a workshop on "Contemporaneity and Art" at the Sterling and Francine Clark Institute, Williamstown, convened jointly with the Getty Research Institute, Los Angeles. I thank Michael Ann Holly, Mark Ledbury, Thomas Gaehtgens, Andrew Perchuk, Alexander Alberro, Okwui Enwezor, Peter Galison, Andrea Giunta, Boris Groys, Wu Hung, Caroline Jones, Keith Moxey, Joshua Shannon, Anne Wagner, and Thierry de Duve.

At the University of Pittsburgh, I thank Dean John Cooper, Associate Dean James Knapp, and my colleagues in the Department of the History of Art and Architecture, led by Kirk Savage, for their generous and sustaining support. I had wonderful research assistance from Miguel Rojas-Sotelo, Cristina Albu, Jenny Lui, Izabel Galliera, Natalia Rentz, Nadav Hochman, and Nicole Scalissi. I thank students in my graduate seminar, and especially those in my undergraduate course, Introduction to Contemporary Art, for the clinical trials over the past few years. Teaching Assistants in the latter have been pivotal: these include Robert Bailey, Donald Simpson, and Alexandra Oliver. Leanne Gilbertson taught a strong version of the course while I was on leave in 2007–08. Department staff have been very helpful, especially Linda Hicks, Natalie Swabb, Veronica Gadzik, and Stephen D'Andrea, as have librarians in the Frick Fine Arts Library, led by Ray Anne Lockhard and Jim Cassoro. I particularly thank Isabelle Chartier for her sterling work on securing illustrations and permissions, and Jing Yuan Huang for help with those from China.

My family, Tina, Keir and Blake, Susan, Beck and Baxter, John and Lorna, are my homeplace.

To my mother, Gwen Smith.

# GENERAL INTRODUCTION
## CONTEMPORARY ART IN TRANSITION: FROM LATE MODERN ART TO NOW

At the beginning of the second decade of the twenty-first century, art seems markedly different from what it was during the modern era: it is now—above all, and before it is anything else—contemporary. What kind of change is this: illusory or actual, singular or multiple? Why did it happen? How deep does it go? Has it, yet, a history? This book offers answers to these questions by surveying the major changes in art since the 1980s. It will show that a worldwide shift from modern to contemporary was prefigured in some late modern art during the 1950s, that it took definitive shape in the 1980s, and that it continues to unfold through the present, thus shaping art's imaginable futures. It will also show that, while much is shared between artists wherever they reside, these changes occurred in different and distinctive ways in each cultural region, and in each art-producing locality. By the mid-twentieth century, modern art had become singular, even conformist, in its artistic orientations, and had concentrated its disseminative infrastructure (markets, museums, interpreters, publicists) in the great cultural centers of Europe and the United States. Now, however, diversity marks every aspect of the production and distribution of art, from the limitless range of materials used by artists, through the broad scope, specificity, and unpredictability of the questions their art raises, to the fact that they are active all over the world and interested in rapidly circulating their art everywhere else, across the planet and into cyberspace. Contemporary art is—perhaps for the first time in history—truly an art *of* the world. It comes *from* the whole world, and frequently tries to imagine the world *as a differentiated yet inevitably connected whole*. This is the definition of diversity: it is the key characteristic of contemporary art, as it is of contemporary life, in the world today.

These are broad claims, about large aspirations. Let us approach them through some commonsense responses to a plain question: what is "contemporary" about art today? A natural answer would be: its qualities of freshness, recentness, uniqueness, and surprise. At the same time, however, we accept that not all art being made today is contemporary: we can see that older, sometimes ancient, traditions continue to be revised—ink painting in China, for example—as deliberate responses to the present, just as many artists everywhere remain committed to exploring the more subtle nuances of the once shockingly new styles of the twentieth-century Modernist avant-gardes. We expect contemporary art to be—in technique, subject matter, meaning, or affect—noticeably different from any of the images that come to our minds when we think of the art on display in the "permanent" galleries of the museums that we might know, including that in the rooms devoted to "Modern Art," usually defined as the art of the modern era, a period stretching from the late eighteenth century to the 1950s. While we tend to see this period, and this art, as part of our history, we are attracted or repelled in a different way by the surprise of the open-ended potential, the clamorous buzz, of the art coming into being all around us now. It is contemporary with us in the most obvious sense, a vital part of our immediate experience of the present.

## MODERN ART AND MODERNISM

Genuinely modern art had these qualities, too—indeed, they were at its heart. Modernist Art might be defined as "the invention and the effective pursuit of artistic strategies that seek not just close but essential connections to the powerful forces of social modernity," with modernity in turn understood as "the cultural condition in which the seemingly absolute necessity of innovation becomes a primary fact of life, work and thought."[1] Such definitions go on to note that this epochal change originated in certain city-states in Italy and Holland during the sixteenth century, and became dominant in Europe during the nineteenth, with enormous consequences for colonized non-European countries, for residual cultural formations within Europe, and countries at its contested borders. The responses of modern artists—notably in mid-nineteenth-century France, then throughout the continent, in England, and in the United States—ranged from triumphal celebration to agonized condemnation and differed in mode from direct picturing of the impacts of the forces of modernization (for example, the rise of capitalism, industrialization, great cities, nation states, secularization, and commercial cultures) to extreme renovations of purely artistic assumptions and practices. Within these parameters, artistic strategies varied greatly, depending on many factors, not least the proximity of artists to the metropolitan centers where these changes were at their most intense. As modernity developed, however, disruptive transformation became less and less surprising in its forms, more organized, and subject to forces of standardization (although this effect was experienced more in the centers than on the peripheries, where modernization, many believe, is still unfolding). Modern art in general, and

Modernist Art in particular, moved in parallel directions, from the margins to the center of visual cultures, from reactive radicalism to institutionalized normality. Indeed, "Modernism" came into widespread usage only in the 1960s, principally as a name for the mainstream tendency in twentieth-century abstract art. It was applied to the American Abstract Expressionists and to contemporary hard-edge painting, colorfield painting, and abstract sculpture, most influentially by the critic Clement Greenberg.[2]

Certainly, these developments have a decidedly historical cast as we look back on them today. For some commentators, however, they are more properly seen as the earlier manifestations in art of what continues to be an underlying and ongoing modernity. From such a perspective, contemporary art is simply the latest manifestation of modern art. Others prefer to leave such questions undecided, feeling that it is too soon to know. Yet, if today's art is, as many are coming to suspect (and I am arguing), different in kind from modern art—if it is contemporary in and of itself, and in ways more fundamental than those in which previous art has been contemporary—then that would be worth knowing. We must look harder to find out how this might be the case.

## FROM MODERN TO CONTEMPORARY

Let us return to our own experience of these changes. As we become more acquainted with the art coming into being around us, we might begin to feel that—like other cultural phenomena such as the movies, fashion, design, architecture, new media, interactive technologies, and even, perhaps, celebrities and certain politicians—art can speak to us, in some special, direct way, about our own experience of living in the present time, of belonging to it, of being contemporary. Our reaction may be implicit: simply a sense that we are all—viewers, artworks, artists—coping, however individually, with the same set of circumstances. When a work of art provokes this feeling explicitly, however, it suggests that it is *of* our times in some special way, that it is immediately and convincingly recognizable as expressing the times in ways likely to be definitive. Such feelings of something significant being shared (of belonging to *our* times) can be vivid, even—perhaps especially —in cases where we recognize that the work we are looking at has been made by someone with a different perspective on the world today: he or she may be from another country or culture,

of a different gender or sexuality, or from an older or younger generation. Nevertheless, a sense of coexistence, or contemporaneousness, is present: we are all *in* these times together, however differently. We are, in a word, contemporaries.

Neither of these meanings of the word "contemporary"—being of the moment, and sharing presentness with others—is new. Both have long histories throughout human civilization—it remains relevant that the word "contemporary" was formed, in ancient Latin, from the words *con* and *tempus*, that is, "with" and "time"—and were, the definitions cited above tell us, at the core of what it was like to live in modern societies. However, it is definitive of contemporaneity (a contemporaneous condition or state) that they all occur to us, nowadays, at the same time, that we have become more intensely aware of this presence of difference all around us (and in us?), and that this quality of contemporary experience has come to override all other factors as the most central thing to be explained when we wish to characterize what it is to be alive today. Similarly, contemporary art is no longer one kind of art, nor does it have a limited set of shared qualities somewhat distinct from those of the art of past periods in the history of art yet fundamentally continuous with them. It does not presume inevitable historical development; it has no expectation that present confusion will eventually cohere into a style representative of this historical moment. Such art is multiple, internally differentiating, category-shifting, shape-changing, unpredictable (that is, diverse)—like contemporaneity itself.[3]

For me, the best start that we could make in understanding this condition, and the nature of art within it, is to ask how we arrived at it. To take, that is, a historical perspective—toward a phenomenon that, admittedly, challenges many of our assumptions about history, and about taking historical perspectives. Paradoxes such as these are typical of our times; they must be embraced. In this book, I will trace shifts from modern to contemporary art as they occurred in the later twentieth century, and will outline a pattern through which we might understand the multiple currents that course through art in the twenty-first century. The chapters are arranged in three parts, the first emphasizing artistic developments in EuroAmerica (the economic, political, and cultural zone created by mutual-interest exchanges between Europe and the United States, previously named, imprecisely, "the West"), the second those in much of the rest of the world, while the third treats the work of artists who, although obviously

products of particular cultures, see themselves and their work as participating in international artistic exchanges and global culture, and, most important, as contributing to the emerging sense of the world as a diverse yet connected whole, and to an awareness that the health of the planet itself is now our most urgent priority.

Organizing the book in this way is the result of some hard choices about how modern and contemporary art relate to recent geopolitical history, the volatility of which has led to incessant conflict between peoples with different world-pictures and distinct senses of their place in the world. Much of this conflict is traceable to a failure to understand the intricate connections between the local and the global in a planetary sense—that is, an inability to think regionally in the context of a vision of the needs of the planet and all who live upon it. No one pretends that this is easy to do. In their book *The Myth of Continents*, human geographers Martin W. Lewis and Kären E. Wigen point out: "Clearly, the world regional system has some serious flaws. In most presentations, it is contaminated by the myth of the nation-state and by geographical determinism. Similarly, although less Eurocentric than the standard continental scheme, it still bears the traces of its origin within a self-centered European geographical tradition. More fundamentally, a world regional framework continues to grossly flatten out the complexities of global geography. No less than the continental scheme, it implies that the map of the world is readily divisible into a small number of fundamentally comparable units."[4] They believe, nevertheless, that if one pays attention to historical processes rather than imagined civilizational traits, to assemblages of ideas, practices, and social institutions (that is, cultures) while acknowledging but not privileging political dominance and subordination, and to the interaction between peoples in each region as much as their internal relationships, a useful picture of regionality in the world can be drawn. A similar approach is adopted by the cartographic section of the United Nations in its conceptualization of the world's regions.[5] I have found these considerations helpful in arriving at the structure of this book, one that largely treats art as it is produced at localities within regions, and—following the impact of the forces of globalization, decolonization, and those within contemporaneity—between and across these regions. The order of chapters follows the chronology of the shift from modern to contemporary art as it occurred in each region.

The first part of this book is therefore entitled "Becoming Contemporary in EuroAmerica," not least because, in the post-World War II period, the major powers in Europe, in concert with the United States, developed the greatest concentrations of economic, political, and cultural capacity in the world. Many artists celebrated the forms taken by these developments, or retreated from any consideration of such matters—we might say that they matched their Modernism to this modernity. Some, however, were deeply concerned about the directions in which both modern society and modern art were tending. Their response was to open their art to the present, or to at least one of its striking qualities. Each of the now well-known art movements of the 1950s and 1960s—Situationism, Pop Art, Performance Art, Minimalism, Fluxus, Conceptual Art, Feminist Art, among others—did so in a distinctive way. I will argue in Chapter 1 that this opening up was essential to the innovations of each movement, and that the overall effect was to tip art in EuroAmerica toward contemporaneity.

## CURRENTS OF CONTEMPORARY ART

In the main body of this book, I will propose that contemporary art may best be understood by thinking of it as evolving within three closely related yet distinctive currents. They are different from each other in kind, in scale, and in scope. The first prevails in the great metropolitan centers of modernity in Europe and the United States (as well as in societies and subcultures closely related to them) and is a continuation of styles in the history of art, particularly Modernist ones. The second has arisen from movements toward political and economic independence that occurred in former colonies and on the edges of Europe, and is thus shaped above all by clashing ideologies and experiences. The result is that artists prioritize both local and global issues as the urgent content of their work. Meanwhile, artists working within the third current explore concerns that they feel personally yet share with others, particularly of their generation, throughout the world. Taken together, I suggest, these currents constitute the contemporary art of the late twentieth and early twenty-first centuries. Let me explicate these currents in more detail, as they undergird the three parts of this book.

*Contemporary Art (styles/practices).* A cluster of closely associated trends are contemporary in the sense that they are the

most evidently up-to-date, cutting-edge, fashionable forms of art today, hot topics in mass-media publicity, market leaders, and the core content of museums of contemporary art. They are the most celebrated, and controversial, forms of art of today, their manifestations instantly recognizable as identifiable by the brand name "Contemporary Art." Yet, for all their brand-newness, the priorities and practices of this art are extensions of those that defined modern art during the latter half of the nineteenth century and throughout the twentieth century. In this sense, they are Postmodern, a term used during the 1970s and 1980s when these changes first became evident to signal a questioning of the core assumptions of Modernist Art and the possibility of a different kind of art *after* Modernism.[6] In a deeper historical sense, however, these changes are better understood as "late modern," as manifestations of an art-historical trajectory that was reaching the end of its natural development—indeed, it may have already done so by those decades, yet persisted as a "belated" phenomenon. As this current has evolved since the 1980s, two tendencies have emerged that enable us to be more precise about the ways artists have revised key elements of Modernism: I call them Remodernism and Retro-Sensationalism. In the work of certain artists and architects they combine to become a kind of Spectacle Art and Architecture, an aesthetic of globalizing capital at its highpoint at the turn of the millennium. These tendencies will be discussed and defined in detail in Chapter 2. It will be shown that they are, in fact, art movements—that is, changes in the history of art and architecture akin to those that have become familiar since Realism, Impressionism, and the succeeding avant-gardes. They are the main elements of what might amount to an art-historical period style, one that may become known by its current brand name: "Contemporary Art."

*The Postcolonial Turn (ideologies / issues).* The second current is too diverse, uneven, contradictory, and oppositional to amount to an art movement in any of the usual senses. No style is widespread, no medium is ubiquitous—indeed, both are mixed in ways that often evoke traditional imagery but also register the new. While this current is international in its circulation, it originates in each of the many countries that have, since the mid-twentieth century, achieved (or are still struggling to achieve) degrees of independence from long periods of colonial rule by one or more of the European powers, and from the economic and cultural influence of the United States—a process

known as decolonization, the after-effects of which are known as postcolonialism.[7] Art emergent from these circumstances is, therefore, diverse to a degree unprecedented in the modern history of European art, and, because of its origins on the borders of and outside Europe, different in kind. Yet it also finds a strong resonance in the outlook of artists working in the centers of geopolitical power who are critical of their own governments' exercise of that power—they, too, are an important factor within this current. Overall, this is a content-driven art, aware of the influence of ideologies, and concerned above all with issues of nationality, identity, and rights. All of these are conceived as being in volatile states of transition, and requiring translation in order to be negotiated. From within these struggles, artists, like many others, are increasingly seeking modes of cosmopolitan connection and cooperation. These developments will be discussed in the seven chapters that constitute Part II.

*The Arts of Contemporaneity (concerns / strategies).* The third current is even more diverse internally and even more global, more particular yet more connected, than both of its predecessors. Many emerging artists sense that Modernism—no matter how often and subtly it is Remodernized—is past its use-by date. They regard "Postmodern" as an outmoded term, a temporary placeholder that is no longer adequate to describe conditions that, they believe, have changed fundamentally. Their youth means that they have inherited the successes and shortcomings of the political struggles of the 1960s and 1970s—from anti-colonialism to feminism—and now seek to relate these lessons to the even greater challenges of living in the conditions of contemporaneity. Emergent artists are focused on questions arising from this challenge: questions as to the shapes of time, place, media, and mood in the world today. In Part III, I will discuss their responses to living in times the parts of which seem out of sync yet remain vividly present to each other, their search for a sense of locality within situations of constant disruption, dispersal, and displacement, their resistant awareness of the pervasive power of mass and official media, their acute sensitivity as to how these pressures affect everyone's sense of selfhood, and, finally, their interest in acting in ways that will improve the situation.

These currents are manifestations in the visual arts of the great changes in the distribution of political, economic, and cultural power that have occurred throughout the world since the mid-twentieth century.

*Globalization.* The first current defined above flows strongest through the art centers of cities such as London, New York, and Paris: for centuries, they have been the engine rooms of modern art. These great modernizing cities were capitals of what became known, during the Cold War period, as the First World. Geopolitics was dominated by competition between free market-oriented, representative democracies led by the United States and Western Europe, and the centralized regimes led by the Communist governments of the Union of Soviet Socialist Republics and the Republic of China—the latter known as the Second World. Each of these groupings sought strategic influence throughout the rest of the world, built up huge, threatening arsenals of nuclear weapons, raced to dominate space exploration, and worked to attract the allegiance of intellectuals (including artists) to their belief systems or ideologies. The First World reached perhaps its most developed form during the 1980s, when artists working within the Remodernizing and Retro-Sensationalist current realized their definitive works.

With the collapse of the Communist governments in Europe around 1990, free-market capitalism gained untrammeled access not only to new sources of material and labor throughout the world, but also to new markets. American models of conspicuous consumption of goods and services were widely emulated. New technologies promoted the growth of networks of economic, political, and cultural power that reach everywhere in the world today. These processes are known as globalization.[8] Remodernist and Retro-Sensationalist artists have absorbed these energies into their art such that it now flourishes on a spectacular scale.

*Transnational Turnings.* In the years after World War II and since, it became increasingly apparent that the nation states that had come to define the modern geopolitical order were undergoing changes of radical kinds, both internally and in the nature of their relationships with others. The term "transnational" has come to mean more than the interactions—legal, political, sporting, or linguistic—between nations for which the term "international" better serves. It means something more than the management or delivery of services in more than one country, typically by a "multinational" corporation, or a multinational task force in the case of a military or a peacekeeping intervention. These usages tend to preserve the sense of nation states as relatively stable geopolitical, social, and cultural entities, which enter into relationships with their similarly structured partners. In the context of this book, by contrast, the word "transnational" is used to highlight the widespread sense that decolonizing forces, clashing with those of globalization, have obliged the modern nation state to understand itself as undergoing massive transformation, internally and in its external relationships. Some states, especially those formed by colonizers who set borders to divide existing tribal groups or ethnic concentrations, strain to remain within the nation-state framework, becoming what is known as "failed states." Provisionality can become evident in a nation's relationships to others, especially those with the power to invade it or regulate it in a less direct way. Transnationality is evident in the increasing role of what are called "nonstate actors," that is, international cooperative and quasi-regulatory organizations (for example, the United Nations, the World Trade Organization, the International Monetary Fund), transnational nongovernmental organizations (for example, Médecins San Frontiers [Doctors Without Borders], Oxfam, and Amnesty International), or terrorist organizations (of which Al-Qaeda is the best known). Such accelerating complexity means that each nation in the world is experiencing acute questioning of its sense of identity relative to others, and severe disruption to its internal, community-defining processes. Individual citizens, entire social formations, and international organizations have come to realize that we are all living in a condition of permanent transition, and moving toward uncertain, unpredictable futures. The sense that all societies, whatever the impediments, were moving toward a better, more comfortable and equitable future has, sadly, been lost. Our highly differentiated, multidirectional, and, at times, seemingly incommensurable contemporaneity within this shared uncertainty is what makes us no longer modern.

We can see these changes at work in the shift from modern to contemporary art—indeed, they are prominent among its underlying, driving forces. After the Russian Revolution, but especially post-1940, Soviet-style Socialist Realism was imposed throughout the Second World as the official aesthetic. Enforced by the state, it occupied a position of cultural prominence equivalent to that of institutionalized, popular "Modern Art" in the First World. During the 1970s and 1980s, as centralized control began to loosen, many artists adopted Western styles of painterly abstraction as a mode of unofficial or nonconformist practice. Others revived the innovations of early twentieth-century avant-garde artists from their region. Still others began to experiment with art "actions" that paralleled the happenings, environments, and

erformance Art of the West. These contributed notably to the collapse of the Soviet system. After 1990, artists from Eastern and Central Europe and in China interacted with art being made both elsewhere in their region and in the West, quickly developing distinctive kinds of contemporary art.

Many nonaligned countries in Asia, Oceania, Africa, the Caribbean, and South America were understood during the Cold War period as belonging to the Third World. Each of these regions had been subject to more than a century of colonization or at least semi-colonial dependence, but achieved independence from their European overlords at points throughout the nineteenth and twentieth centuries. Long-standing visual cultures such as those of Japan and China had undergone varying degrees of modernization during those times, yet developed artworld support systems (museums, schools, markets, collectors, interpreters) were rare, except in countries dominated by immigrants, such as Brazil and Argentina, and in settler colonies, the outposts of empire, such as South Africa, Canada, Australia, and New Zealand. Independence brought a widespread desire for national culture, including art, that would draw on local traditions but stand alongside modern art elsewhere, not least in the West. Some artists adopted a more confrontational approach to Western art, reflecting tensions in relationships between parts of the world that continue to be felt today.

"Fourth World" was the term applied to the cultures of peoples from Third World countries who had immigrated to the West for political, economic, or other reasons. They created culturally specific diasporas, and specific kinds of exilic art. At the same time, indigenous peoples throughout the world pursued traditional cultural forms while under duress of many kinds. For all of these peoples, diasporic and indigenous, art became an important means to perpetuate traditions and to register ethnic identity within the larger social formation. Some of this art took explicitly, and often surprisingly, contemporary form.

Transnational visual cultures show us what the world is like in all of its neocolonialist variety, manifesting the conflicted diversity of contemporary life. More productively than any other communicative medium, these arts and their institutional forms (for example, the ubiquitous art biennales held around the world, the plethora of websites) are reshaping our capacity to grasp the larger forces at work in the world today. Imagining the local within larger world-pictures is their main interest, their unique strength, and the basis of their likely persistence.

*Contemporaneity.* The era of the European and North American colonizers seems to be entering its final days, yet their influence persists, and is taking new forms. While some believe that the United States stands alone as the world's "last remaining superpower," as the only "hyperpower," others point to its failures in national and international policy during the years since 2001 as evidence that no nation retains the kind or extent of geopolitical influence once wielded by the advanced countries of the modern period. The economic rise of China and India is acknowledged, but it remains to be seen whether their efforts at global influence will be of the same kind.

In the twenty-first century, nation states no longer align themselves according to the four-tier system of First, Second, Third, and Fourth Worlds. Multinational corporations based in the EuroAmerican centers no longer control the world's economy, just significant parts of it. New global corporations are located in South, East, and North Asia. Manufacturing, distribution, and services are themselves dispersed around the globe, and linked to delivery points by new technologies and old-fashioned labor. Some would argue that, with globalization, capitalism has achieved its pure form. Certainly, the living standard of millions has been lifted, but only at enormous cost to social cohesion, peaceful cohabitation, and natural resources. Some national and local governments, as well as many international agencies, seek to regulate this flow and assuage its worst side effects—so far without conspicuous success. The institutions that drove modernity seem, to date, incapable of dealing with the most important unexpected outcome of their efforts: the massive disruptions to natural ecosystems that now seem to threaten the survival of the Earth itself. Awareness of this possibility has increased consciousness of our inescapably shared, mutually dependent existence on this fragile planet.

The most recent generation of contemporary artists has inherited this daunting complexity. Their responses have been cautious, devoted to displaying concrete aspects of this complexity to those who would see it, and to helping to reshape the human capacity to make worlds on small, local scales. For all its modesty, and pragmatism, theirs is a hope-filled enterprise. Their efforts allow us to hope that contemporary art is becoming—perhaps for the first time in history—truly an art *of* the world. Certainly, as I will show, it comes *from* the whole world, and it tries to imagine the world *as a whole.*

# BECOMING CONTEMPORARY
# IN EUROAMERICA

# 1. LATE MODERN ART BECOMES CONTEMPORARY

In the years around 1960, a clear set of presumptions about the visual arts prevailed in Europe and the United States—and in cultures elsewhere that fell within their spheres of influence. Works of art were understood to be the objects made by practitioners of the "high crafts," usually in studios, using appropriate tools, accumulated knowledge, and their fertile imaginations. Provocative actions—such as Marcel Duchamp's "readymades" (ordinary industrial manufactures, nominated by the artist as art objects)—were regarded as stimulating exceptions to mainstream developments. The *belle arti*—the "beautiful arts" of painting, sculpture, and design, including the graphic arts and architecture—had been defined in Renaissance Italy and in Protestant Northern Europe during the fifteenth and sixteenth centuries. Thereafter, they were refined into highly specialized practices during the Reformation and then even further by schools of artists in France, Spain, England, and elsewhere, working usually under aristocratic patronage. From the mid-nineteenth century forward, modern artists renovated each of the arts, in some cases toward greater internal refinement (as in abstract painting), in others toward integration with other, more popular elements of visual culture (as in collage). Stimulated by avant-garde activism, these renovations occurred in spurts, yet quickly spread from one art center to another, and out from the metropolitan centers to the cultural peripheries, to provincial towns and colonial outposts, where they challenged evolving local traditions and modernizations. Sustained by widening markets, critical scholarship, and a growing museum and gallery exhibition and educational system, modern art became an important element within the cultural life of liberal-democratic societies. During the post-World War II standoff between "the West" and those countries within the Soviet sphere of influence (where Socialist Realism served as the framework for modern art), official institutional acceptance or rejection of the respective versions of the avant-garde marked a significant ideological divide between the two sides. This cultural Cold War—a competition to determine which kind of political and economic system was most appropriate to the modern era—came to an abrupt end in 1989.

During the second half of the twentieth century, Pablo Picasso was indisputably the greatest modern artist. Although his reputation was based on the Cubist innovations of the years around 1910, his late works (he died in 1973) challenged younger artists, and were directly influential during the 1980s. *Three Figures* (Fig. 1.1), painted with his usual haste on September 6, 1971, is a large, drastically simplified version of a subject that preoccupied him throughout his career—the artist and his model in the studio—and had led to some of his greatest works. Typically, he infused this traditional subject with the sexual energy dormant in any encounter between a naked female and a male with authority. Here, he connects their lower body parts, concertinalike, across the bottom sections of the canvas. The artist's head becomes a doll-like manikin affixed atop a reclining nude. His face is boyish, recalling the self-portraits of ca. 1906, when Picasso first saw African and Iberian masks. The eyes of all three figures echo his "primitivizing" strategies of those years: they stare at us with the vacant, distanced intensity of the women in his famous painting *Les Demoiselles d'Avignon* (1907). At the center of *Three Figures* is the face that the artist is painting on the canvas, itself mounted on a barely suggested easel: it is a Late Cubist distortion of the visage of his then-wife, Jacqueline Roque. The unusual absence of color may be explained by the fact that Picasso was, at the time, modeling figures out of cardboard and painting them as maquettes for sculptures. Black and white also evokes graphic art, with which he was obsessed at the time, often making dozens of prints each day. *Three Figures* is exceptional in one other detail: the female model at the left, rather than the male artist, wields the brush. In this, the painting perhaps hints at the artist's concern about the impotence of old age, a frequent subject in his last works.

Jackson Pollock—widely regarded then and since as Picasso's most accomplished successor—had died in 1956. Yet Pollock's contemporaries, such as

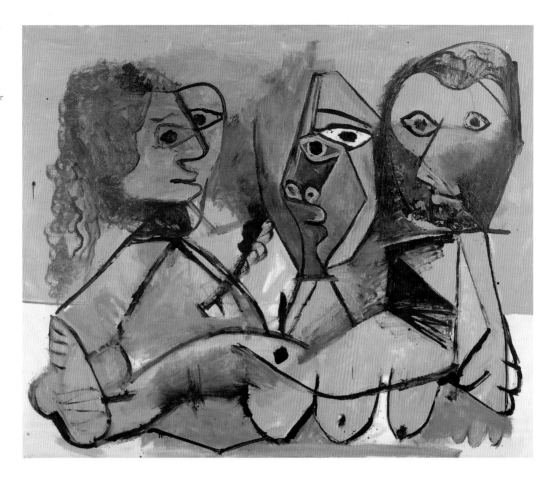

1.1 Pablo Picasso
*Three Figures*,
September 6, 1971.
Oil on canvas, 51⅛ x
63¾in (130 x 162cm).
Kunstmuseum Bern,
Legat Georges F. Keller
1981, Inv. Nr. G 84.015.

.2 Willem de Kooning
*Woman VI*, 1953.
il on canvas, 68½ x
8½in (176 x 148.6cm).
arnegie Museum of
rt, Pittsburgh. Gift of G.
avid Thompson (55.24.4).

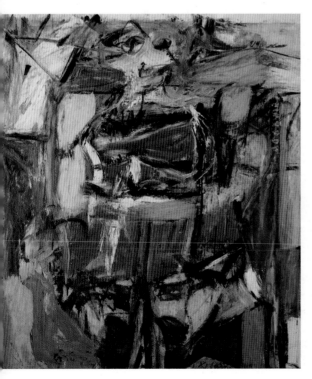

Willem de Kooning, were still producing major works. De Kooning's well-known *Woman* series, begun in 1950 and culminating in *Woman VI* (1953) **(Fig. 1.2)**, owes much to Picasso, not least in the aggressive, penetrative breaking apart of the figure, and the spaces around it, in their being stretched over an implied Cubist framework, which is in turn subject to the dispersive effect of disparate patches of hatched paint. Picasso's late works show signs that he, in turn, saw images of works by Pollock and de Kooning. *Woman VI* also hints at images from billboard advertisements, and of movie stars, as well as glimpses of landscapes, seen from a passing car—this is American-style abstraction first and foremost.

Expressionistic, gestural painting was, however, fading fast as the preferred approach among abstract artists during the 1960s. An influential school of formalist art critics, led by Clement Greenberg, argued that the torch for Modernist painting had passed to hard-edge, colorfield painters such as Morris Louis, Kenneth Noland, and Jules Olitski. Louis's *Alpha Pi* **(Fig. 1.3)** is part of the *Unfurled* series of 1960–61, regarded by the artist as his most ambitious works. Louis poured rivulets of pure color in scarcely touching, layered banks across the lower vectors of huge rectangular canvases, creating vast yet vibrant voids in their startlingly "empty" centers. No figures, however distended; no implied dimensional space, however irrational. No symbols, no associations. Just pure color, disposed across unmarked extension, via saturated acrylic seeping into lightly primed canvas. Critic Michael Fried was moved to comment: "In the unfurleds Louis made major art out of what might be called the firstness of marking as such… The banked

1.3 Morris Louis
*Alpha Pi*, 1960.
Acrylic on canvas,
102½ x 177in
(260.4 x 449.6cm).
Metropolitan Museum
of Art, New York. Arthur
Hoppock Hearn Fund,
1967 (67.232).

1.4 Anthony Caro
*Early One Morning*,
1962. Painted steel
and aluminum, 114 x
244 x 132in (289.6 x
619.8 x 335.3cm).
Tate Gallery, London.

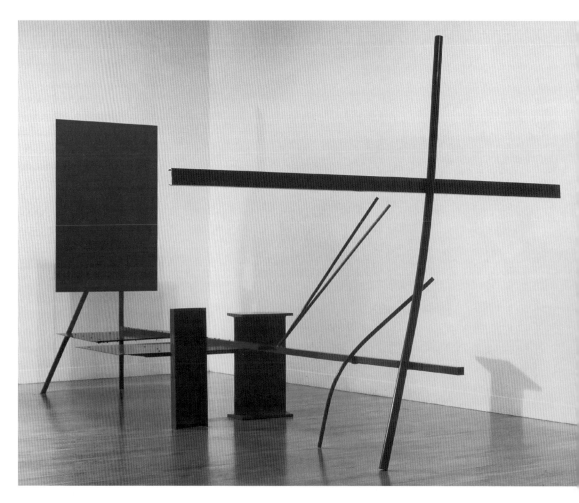

rivulets—here again their vibrant, biting color is crucial—open up the picture-plane more radically than ever before, as though seeing the first marking we are for the first time shown the void."[1]

Among sculptors, the late work of David Smith—inheritor of the line in sculpture that had been initiated by Picasso and Julio Gonzales and that was devoted to welded assemblage—was being matched by the open-form, painted metal abstractions of Anthony Caro. As we approach Caro's *Early One Morning* (1962) (Fig. 1.4), we see a variety of metal shapes disposed along, around, across, and above a long horizontal axis. It is as if the internal forms of a Constructivist painting have achieved three dimensions and are searching for the two-dimensional resolution that seeing them from one place might bring. This feeling is encouraged by their being painted in a uniform scarlet color. We might read them disposed against the floor or a wall, but they never quite form a still picture. This is because they are actual objects in space, some opaque, others transparent, some light, others heavy. They twist and turn like musical notation, suggesting a flowing from one compositional moment to another. Open in form, they encourage us to circle the sculpture, as if we were unannounced, perhaps early-morning visitors to an artist's studio, surprising his materials before they have had a chance to present themselves as finished works.

This sense of visceral excitement—and, more broadly, of artistic traditions stimulating themselves toward ever-greater heights of achievement—was deceptive. Everything that was essential to sculptures such as these, and to paintings such as those of Picasso, Pollock, de Kooning, and Louis, was already changing—and, it turns out, changing fundamentally.

## TRANSFORMATIONS IN LATE MODERN ART: ITS CONTEMPORARY ASPECTS

The story of art in the 1960s and 1970s is usually told in terms of an explosion of art movements that echoed and, it is widely believed, paralleled in significance the burst of avant-garde breakthroughs that occurred in the first decades of the twentieth century, the most experimental years of Modernist Art. No longer confined to one or two major tendencies—Abstract Expressionism and Geometric Abstraction—a plethora of new ways of making art appeared. They were quickly tagged with style names: Pop Art, Photorealism, Minimalism, Land Art, environments, happenings, Performance Art, Arte Povera (Poor Art), Conceptual Art, Political Art, Feminist Art, Postmodernism, the Pictures Generation, and so on. These are just a few of the terms used at the time and since; all capture essential qualities of at least some of the art they name, but they do so reductively, and they add up to a false picture. Their use implies that the same kind of art—Modernism, broadly conceived—continued to be made, only in more diverse forms.

From the 50-year retrospect available to us now, we can see that some deeper currents were in play.

During the post-World War II economic revival, many artists were excited by the vital energy and seductive promises of the burgeoning economies of consumption. Others viewed these new forces critically, and actively sought different options for art. Entranced engagement with the vital popular visual cultures of the period was accompanied by equally urgent efforts to engage spectators directly in artworks, events, environments, and processes. These were conceived as liberations from the limits of past art and as alternatives to the commercial and propaganda imperatives of mass media. Pop artists, for example, both celebrated and questioned the new age of consumerism. Their responses varied greatly according to their closeness or distance from the economic centers of mass production, marketing, and consumption: while Pop was central in the United States, it was marginal in most of Africa, and inconceivable in nonmarket economies such as those of Russia or China. At the same time, from a variety of political and especially feminist perspectives, artists and their supporters began to question the Modernist avant-garde's complicity with the institutions of modern art and those of societies organized according to the priorities of what U.S. president Dwight D. Eisenhower named the "military-industrial complex." This mood quickly led, in Conceptualism, to a profound interrogation of the nature of Art itself. Fundamental paradigms of what it was to make a work of art—residues of centuries-old practices as well as those inaugurated in the modern era—were suddenly shifted. This chapter will outline the transformations in art that occurred in EuroAmerica during the later 1950s, the 1960s, and the 1970s, laying the groundwork for the main body of the book. It will focus on these paradigm shifts as evidenced in the work of key artists or groups. Rather than repeat by-now orthodox descriptions of these broad changes, it will emphasize how a fresh engagement with contemporaneity was vital to the essential energies of each of them.

### Situationism, Gutai, Happenings: Art into Life/Life into Art

The Situationists were a volatile group of writers, intellectuals, artists, and anarchists active in Paris and across Europe during the 1950s and into the 1960s. Led by arch-polemicist Guy Debord, their films, statements, "actions," and "interventions" were inspired by two core principles. In order to release his or her inherent revolutionary potential—for fulfilled personal passion and for social effectiveness—each individual should live life to its fullest, treating every moment as a spontaneous, unpredictable event. Total utopia was, however, constantly threatened, in the West, by capitalism's "colonization of everyday life," its relentless conversion of free persons into desperate consumers, mere ciphers within "spectacle society." In the East, totalitarian regimes ruled by ideological intimidation and bureaucratic coercion. To precipitate a clash between revolutionary potential and spectacularity was to create

a "situation," a crisis for the system, an emergency. However small in scale, however momentary, each situation embodied a new spirit of freedom.[2]

These ideas married artistic avant-gardism to revolutionary politics in ways that had been prefigured in the early twentieth century—by the Dadaists, for example. By the 1950s, however, with both capitalist and Communist utopias turning dystopian, more extreme actions were required. In Debord's 1967 film *Society of the Spectacle*, extended scenes of bikini-clad models from American advertisements and long clips from Russian propaganda movies were broken up by critical texts analyzing the ideological strategies of both. Italian artist Giuseppe Pinot-Gallizio invented "Industrial Painting," a painting machine that enabled original abstractions to be created by anybody and distributed, cheaply, by the yard. To create his *Modifications* series of 1959–63, Danish artist Asger Jorn threw wildly gestural markings of thick paint over the sedate banalities of kitsch landscapes (Fig. 1.5). This process was dubbed *détournement*, that is, a turning of meaning in an open-ended direction. His statement for his May 1959 exhibition at the Rive Gauche gallery in Paris makes his provocation explicit:

> Be modern,
> collectors, museums.
> If you have old paintings,
> do not despair.
> Retain your memories
> but *détourn* them
> so that they correspond with your era.
> Why reject the old
> if one can modernize it
> with a few strokes of the brush?
> This casts a bit of contemporaneity
> on your old culture.
> Be up to date,
> and distinguished
> at the same time.
> Painting is over.
> You might as well finish it off.
> *Détourn.*
> Long live painting.[3]

The group itself released texts—pamphlets, essays, journals (such as *Internationale Situationiste* and *Potlatch*), statements, and mock manifestoes—that often included "détourned" comic strips, in which fashionable characters uttered anarchist slogans, or created disruptive situations.

*The Naked City* (Fig. 1.6), a map created by Debord and Jorn in 1957, is one of many images that demonstrate the Situationists' concern with the construction and perception of urban space. Subtitled *A Hypothetical Illustration of the Psychogeographic Battle between Places*, the map consists of 19 sections cut from a printed map of Paris, then connected with red arrows. This arrangement disrupts the well-known mental map of the city into *quartiers*, or cultural zones, shifts habitual orientations, and recasts its streets into areas of

blank, nonactualized space. The Situationists themselves would use such maps to (dis)orient their own wanderings around the city, enacting what they called *dérive*, or drifting, celebrating the pedestrian's more intimate, and chancy, experience of the city.

The impact of the Situationists on contemporary art has been incalculable, and continues to echo today. Their everyday anarchism was reflected in the work of the Nouveaux Réalistes (New Realists), a Paris-based group of European artists including Yves Klein, Jean Tinguely, Jacques Villeglé, César, Niki de Saint Phalle, and Martial Raysse. Founded in 1960, the group devoted themselves, in the words of their foremost champion, critic Pierre Restany, to the "poetic recycling of urban, industrial and advertising reality."[4] Debord's films also deeply influenced those of Jean-Luc Godard, arguably the most experimental filmmaker of recent decades. Jorn's *détournements* reappear in the 1980s, in the work of Julian Schnabel, for example. Situationism's spirit is pervasive among the many artists' collectives that continue to be formed in cities all over the world, such as the New York groups 16 Beaver and Bernadette Corporation.[5]

It was in Japan that this spirit first manifested itself as a fully fledged art movement. The Gutai movement is an example of the outbursts of experimentalism that occurred throughout the world during these decades, particularly in artworlds embedded in dynamic local cultures that were at the same time open to changes in art in EuroAmerica. These will be explored in detail in each chapter of Part II. The "Gutai Manifesto" of 1956 opens with an attack on the "fake" and "affected" nature of "the arts as we have known them up to now," on the proclivity of the fine arts to invest actual materials with "false significance." In contrast, "concrete" art (*gutai bijutsu*) "does not change the material: it brings it to life… the human spirit and the material reach out their hands to each other."[6] The Gutai Bijutsu Kyokai (Gutai Art Association) was formed in 1954 in Osaka by Yoshihara Jirō, Kanayma Akira, Murakami Saburo, Kazuo Shiraga, and Shimamoto Shozo. Its members took up a traditional concern within Japanese art—the embodiment of spirit—in very innovative ways. Inspired by Hans Namuth's 1951 film of Jackson Pollock painting, and by the example of European *art informel*—especially the much-publicized, performed "action paintings" of Georges Mathieu and Michel Tapié—they sought to bring a variety of materials to life. In a Tokyo hall in 1955, Murakami broke through many paper screens. At the same event, Kazuo painted a pool of mud, using his body as the painting implement (Fig. 1.7). Two years later, Atsuko Tanaka danced in a costume made of multiple colored, flashing electric light bulbs. These "actions" were contemporary in the sense that they aimed at making the essential qualities of materials spring to life in immediate ways, as events that banished the distinction between art objects and theatrical performances. They were also contemporary in that they sought not only to match the most innovative art of the U.S. and Europe, but also to go beyond that art into more

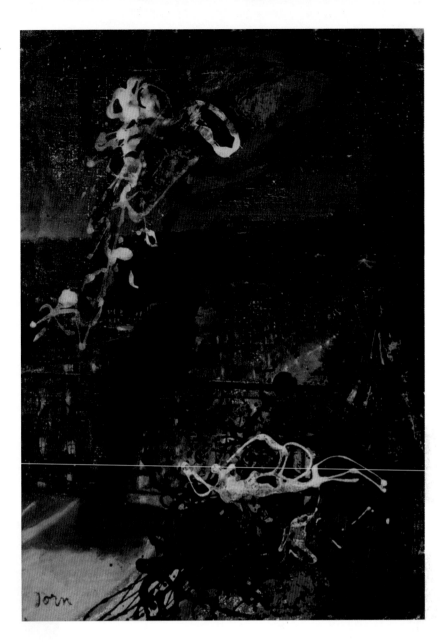

1.5 Asger Jorn
*Paris by Night*, ca. 1959,
from the *Modifications*
series. Oil on extant
painting, 20⅞ x 14⅝in
(53 x 37cm). Collection
of Pierre and Micky
Alechinsky, Bougival.

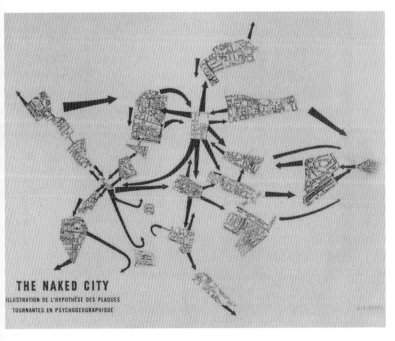

1.6 Guy Debord
and Asger Jorn
*The Naked City: A
Hypothetical Illustration
of the Psychogeographic
Battle between Places*,
1957. Collage, 13 x 19in
(33 x 48cm).

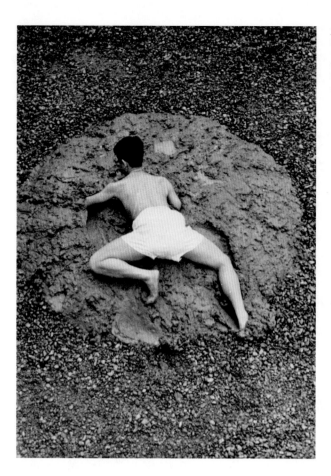

1.7 Kazuo Shiraga
*Challenging Mud*,
1955. Performance.
Courtesy of the Ashiya
City Museum of Art
& History.

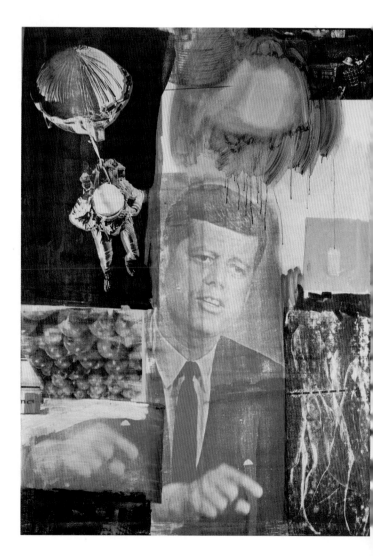

1.8 Robert
Rauschenberg
*Retroactive I*, 1964.
Oil and silkscreen
ink on canvas,
84 x 60in (213.4 x
152.4cm). Wadsworth
Atheneum, Hartford,
Connecticut. Licensed
by VAGA, New York, NY.

extreme formulations of what these artists took to be its as-yet-unrealized premises. Experimental art all over the world from the 1950s through to the 1970s was driven by these paired imperatives.

Experiments in the other arts had huge impacts on the visual arts. John Cage's composition *4'33"* (1952)—noteless, and shaped only by instructions to the performer to open the piano lid at the beginning of the piece, and to close or reopen the lid at designated times to indicate the three "movements"—is one of the most notorious and influential pieces of modern music. To Cage, it was "new music" in its purest form: "New music; new listening. Not an attempt to understand something being said, for, if something were being said, the sounds would be given the shape of words. Just attention to the activity of sounds."[7] First performed by David Tudor as part of a concert of contemporary music, *4'33"* is also contemporary in its formal distillation: it displaces the idea of music as special sounds generated by dedicated instruments and orchestrated through time by introducing everyday ambient sound as already existent, natural music. Its contextual shaping means that we do not hear silence—an impossibility anyway. We do not listen to four minutes and thirty-three seconds of silence; for the designated periods we listen to ourselves listening, we see those around us hearing. Unlike most classical and modern music, we cannot be transported to other realms of the imagination by the musical vision of the composer, the will of the conductor, the skills of the performers. Consciousness of being in a particular place at that moment of time is heightened. With no other piece of music are we, the audience, quite so contemporary.

Cage met the young visual artist Robert Rauschenberg at a summer school at Black Mountain College, North Carolina, in 1952. In a remarkable essay of 1961, Cage weaves a plethora of insights about Rauschenberg's art around comments made by the artist. Speaking of his screening of images from newspapers and magazines onto his canvases, Cage is led to observe: "Beauty is now underfoot wherever we take the trouble to look. (This is an American discovery.)" The most important remark by Rauschenberg that Cage quotes is this: "Painting relates to both art and life. Neither can be made. (I try to act in that gap between the two.)"[8] How does Rauschenberg make this "gap"—which may be nothing more than a conceptual distinction, a metaphorical space, an immaterial absence—visible in his work?

In Rauschenberg's *Retroactive I* (1964) [Fig. 1.8], the instantly familiar image of U.S. president John F. Kennedy anchors an array of images—above him, an astronaut descending, orange storage tanks, an engraving of workmen at an industrial site that is being violently erased; beside him, to the left, is some fruit in a case, upside down, while to the right an obscure object (a boiler in the corner of a loft studio?) sits above repeat profiles of a naked woman in motion, like a model on a catwalk, perhaps part of a photographic experiment by an enthusiast. In a general sense, this painting attests to the discovery that beauty is everywhere, in everyday

objects, common occurrences, even in the media images that constantly bombard us as if they were a phalanx of television monitors tuned differently. Yet this work, made shortly after the assassination of Kennedy, memorializes the passing of a dream: the anchoring of American destiny to the space race, the optimistic vision of social progress based on work and abundance. Retroaction, here, is not only an action contrary or reciprocal to a preceding action (essential to rocketry, for example, in launching), it is also retrospective, evoking the sense that a vividly present possibility of positive transformation has been lost to a society incapable of realizing it. History has suddenly turned away from itself, the present becomes a fast-frozen recent past, the future has evaporated. The artist's palette, here, is the social imaginary, the shared symbols and values of peoples belonging to a nation, or a culture. The social imaginary is a domain within which art will come increasingly to act, a medium in which it will perform with growing prominence, at times notoriety.

Of all the art forms emergent during this period, none would seem more evidently committed to contemporaneity than the happening. John Cage again provides a crucial link between artists alert to the potentialities of life as it is happening, and inspiration. Among the students in his experimental composition class at the New School for Social Research in New York, where he taught from 1956 to 1960, were key figures within the Fluxus movement—its slogan: "Overcome the gap between art and life!"—including George Brecht, Al Hansen, Dick Higgins, and LaMonte Young.[9] Allan Kaprow, chief initiator of happenings, and their most persistent (and consistent) innovator and theorist, was also a student of Cage. A 1958 essay by Kaprow described Jackson Pollock's drip technique as a kind of performance that opened the painter to the productivities of chance, the accidental, the improvised, and that, more broadly, enabled an expanded role for artists beyond the demands and limits of specific media: "Pollock, as I see him, left us at a point where we must become preoccupied with and even dazzled by the space and objects of our everyday life, either our bodies, clothes, rooms, or, if need be, the vastness of Forty-Second Street… [To the young painter of today] all of life will be open to him."[10] His career-long efforts to "blur the boundaries between art and life" were enormously influential on artists around the world.[11] Yet a close reading of Kaprow's instructions for each happening, and of his successive theorizations of the form, reveals an instinct for order that is as pronounced as his desire to generate openness. In his book *Assemblages, Environments, and Happenings* (written between 1959 and 1961, revised in 1966), he identified the evolution of "a number of rules-of-thumb" that could break down the great obstacle to genuine innovation: the gap between performance and audience.

· The line between art and life should be kept as fluid, and perhaps indistinct, as possible.

· Therefore, the source of themes, materials, actions and the relationships between them are to be derived from any place or period except from the arts, their derivatives, and their milieu.

· The performance of a Happening should take place over several widely spaced, sometimes moving and changing locales.

· Time, which follows closely on space considerations, should be variable and discontinuous.

· Happenings should be performed once only.

· It follows that audiences should be eliminated. All the elements—people, space, the particular materials and character of the environment, time—can in this way be integrated.

· The composition of a Happening proceeds exactly as in Assemblage and Environments, that is, it is evolved as a collage of events in certain spans of time and in certain spaces.[12]

In the original text, these rules-of-thumb are glossed with comments that make it clear that constraints are imposed precisely to generate the maximal possible openness to immediacy of experience on the part of all concerned. While many artists, and others (such as rock musicians), staged events that were randomizing in character and dispersive in their effects, each of Kaprow's happenings was carefully scripted through sets of rules made to be broken or, at least, exceeded.

Visitors to *18 Happenings in Six Parts* (Fig. 1.9), staged in 1959 at the Reuben Gallery, New York, were given programs and three stapled cards, which provided instructions for their participation: "The performance is divided into six parts… Each part contains three happenings which occur at once. The beginning and end of each will be signaled by a bell. At the end of the performance two strokes of the bell will be heard… There will be no applause after each set, but you may applaud after the sixth set if you wish."[13] Instructions also stipulated when audience members were required to change seats and move from room to room, each one distinctively decorated, and housing a different action or activity. In one, semi-transparent plastic sheets had been painted with references to Kaprow's earlier work; in another, words were being roughly painted by artists; while in a third, rows of plastic fruit served as spatial divides while a woman performer squeezed real oranges and an orchestra played on toy instruments. In effect, audiences were shifted, as if by ritual motion, from one staged scenario to another.

Subsequent happenings occurred out of doors, with attendees scripted to become active participants. Participants in *Household* (1964), enacted in a dump near Ithaca, New York, were divided into "men," "women," and "people," and assigned tasks—such as women building a nest, licking jam off a car, men building a towerlike totemic structure, destroying the nest, women tearing down the tower, people advancing from the forest beating drums—that obliged them to enact stereotypical roles and, presumably, become liberated from them by doing so.[14]

## Pop: The Social Mirror, Refracted

In Britain during the years following the devastation of World War II, the development of the local economy was closely tied to admiration for what was seen as a more advanced, and faster-growing, industrial culture in the United States. This spirit pervaded the thinking of the Independent Group, a loose association of artists, architects, and intellectuals, including the artists Eduardo Paolozzi and Richard Hamilton, the architects Peter and Alison Smithson, and the art critic Lawrence Alloway. In a series of exhibitions—*Parallel of Life and Art* (1953), *Man, Machine, and Motion* (1955), and *This Is Tomorrow* (1956)—at the Institute of Contemporary Art and the Whitechapel Art Gallery, both in London, the group displayed photographs, posters, advertisements, statistical and other official information, and, on occasion, architectural designs and works of art that highlighted the vitality of emergent popular, commercial, and industrial forms of life. In contrast to the constraints of traditional British life, and the attitudes that had led to the recent devastation of Europe, the group's members recommended contemporaneity with this brash culture of the new, and acceptance of its pop-up imagery, its in-your-face immediacy, its instinctive capacity to live entirely in its own present. Richard Hamilton's collage *What Is It That Makes Today's Homes So Different, So Appealing?*, used on the poster for the *This Is Tomorrow* exhibition (Fig. 1.10), is an inventory of its themes: from the Moon ceiling, through the movies, television, and comics filling the background, to the idealized male and female surrounded by the latest furniture and appliances. The lollipop held by the Charles Atlas bodybuilder implies the danger of infantilism, but the overall mood is one of acceptance of this "symbol-thick scene, criss-crossed with the tracks of human activity."[15] It also seems a prescient advertisement for an art movement—Pop—on the cusp of being named.[16]

The activities of the Independent Group were paralleled in the U.S. by the collage paintings and assembled "combines" of Robert Rauschenberg: both strove to act in the gap between late modern art and the newly spectacular forms of life. In the years around 1960, the U.S. Pop artists made art that held up a mirror to their image-saturated society, reflecting immediately recognizable images of itself as fast as it could produce them—absolutely up-to-date, pure contemporaneity, shown as it is happening, unmediated by overt artiness, accepted entirely on its own terms: America as it is, a land of material plenty, of mindless consumerism, laced with unacknowledged tensions of class, race, and belief, and thus prone to erupt into homicidal violence. No

1.9 Allan Kaprow
Preparing for
*18 Happenings in
Six Parts*, 1959.
Performance. Reuben
Gallery, New York.

1.10 Independent Group
Poster advertising
the exhibition *This
Is Tomorrow* at the
Whitechapel Art Gallery,
showing collage by
Richard Hamilton,
*Just What Is It That
Makes Today's Homes
So Different, So
Appealing?*, 1956.

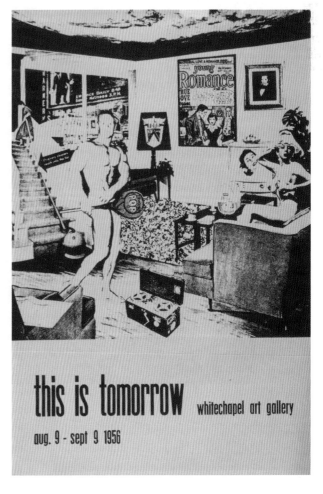

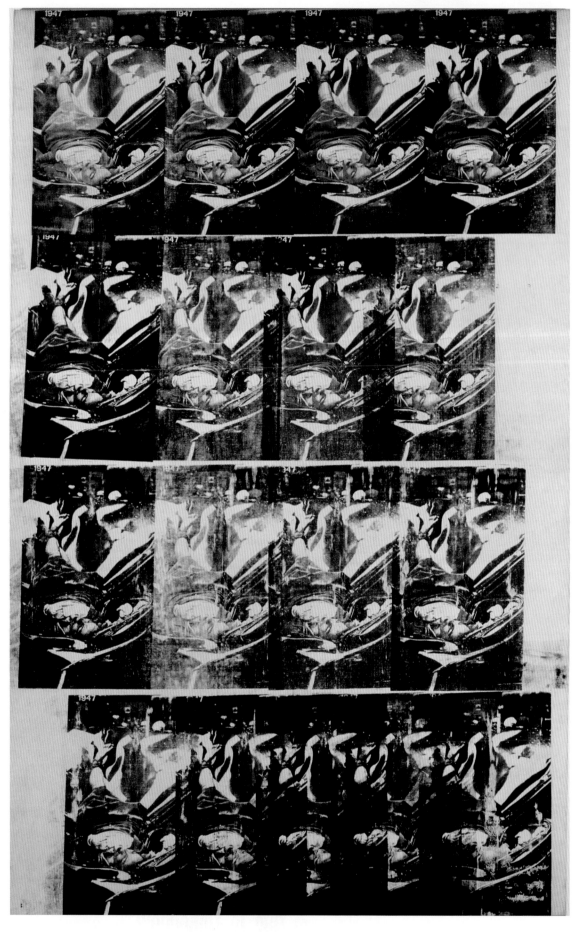

1.11 Andy Warhol
*1947 White*, 1963.
Silkscreen ink and
graphite on linen,
121 x 78in (307.3 x
198.1cm). The Andy
Warhol Museum,
Pittsburgh, Founding
Collection / Contribution
Dia Center for the Arts,
New York.

wonder some critics interpreted Pop Art as a contemporary form of Realism, while others insisted that its uncritical reproduction of the world as it was amounted to servile submission to popular culture, and was not art at all.[17] Yet a closer look at any of the major works of this movement shows that the artists were fascinated by the fact that their culture was composed of many, different kinds of time coincident with each other, and that this was visible in the fact that the objects all around them, even the newest, expressed contradictory values, and that they aged (fell out of fashion) at different rates. The artists sensed that these temporal coincidences gave rise to their culture's unprecedented innovatory energy, its ability—envied around the world—constantly to renew itself by bettering even its most recent manifestations. Some knew that this energy took a huge toll, not only on public figures but also on anonymous individuals.

Andy Warhol now seems the most representative artist of this moment in the history of the United States, the outstanding chronicler of what he called "Death in America."[18] Warhol's paintings of American icons—celebrities representative of deep currents in popular culture, such as Marilyn Monroe—have themselves become iconic. This has happened retrospectively, yet his choices at the time of their making were prescient. The iconic effect is not only the result of repetition: to become iconic, an image must first be deeply embedded in its moment, and be self-evidently representative of it. Monroe's public persona embodies her own aspirations and personal tragedy as much as it does the dreams and shortfalls of her fans. Her suicide in 1962 consecrated this relationship. Warhol was acutely sensitive to what philosopher Arthur Danto calls the tragedy of the commonplace—"beauty falls from air, queens have died young and fair"—and its potential for transfiguration.[19]

Warhol's depth of insight into his present is evident in paintings that do not use popular icons as their subjects, but show that something that could happen to anybody may have the same qualities as the acts of celebrities (who are, after all, only human too). *1947 White* (Fig. 1.11) uses a photograph from *Life* magazine, originally published by the popular photo-journal in 1947, then reprinted as one of its "classics" in 1963—the year Warhol made his painting. We see a black and white image speeding up as it repeats across and down the canvas, losing registration, like a film unspooling too fast. The top-left frame shows the supine body of an elegant young woman, as if asleep. Yet she is clothed, her stockings down over her oddly crossed ankles, her dress awry, as if she has been violated. We then see the men's faces and policemen's caps above what no longer looks like crumpled sheets but crushed metal: the woman has jumped to her death from the Empire State Building and landed on the hood of a parked United Nations limousine.[20] Warhol's accelerating repetitions reproduce the horror of her fall; they enact visually, at speed, what led to the stillness of the photograph. Yet we can also read back up to the instant when the camera recorded her death. We scan back and

forth between calm and horror, clarity and blur, life and oblivion. We are drawn into imagining what led the pictured woman to this act, however little we can know about her, and into asking why suicide is such a common response to modern life. We find ourselves pondering what occurred to make *this* photograph possible, and why death can look so beautiful.

## The Object Materialized: Minimalism

Similar qualities may be seen in much of the hard-edge, colorfield painting and Minimal sculpture produced during the 1960s, although, of course, they are apparent in quite different ways. For the painters, the viewer was invited to experience the work in a moment of intense optical exchange, while the sculptors addressed the spectator—understood as a physical body standing, then moving in the same actual space as the sculpture—through the most minimal of means.

Exasperated by questions about the content of his paintings—specifically, by the implication that they were pictures of something else—Frank Stella asserted: "All I want anyone to get out of my paintings, and all I ever get out of them, is the fact that you can see the whole idea without any confusion… What you see is what you see."[21] He began a lecture to students at the Pratt Institute, New York, with the flat statement: "There are two problems in painting. One is to find out what painting is and the other is to find out how to make a painting." He explained that he had learned quickly to make "other people's painting," but not yet his own. To do so, he realized, he faced two problems, one "spatial," the other "methodological."

> In the first case I had to do something about relational painting, i.e. the balancing of the various parts with and against each other. The obvious answer was symmetry—make it the same all over. The question still remained, though, of how to do this in depth. A symmetrical image or configuration placed on an open ground is not balanced out in the illusionistic space. The solution I arrived at—and there are probably quite a few, although I know of only one other, color density—forces illusionistic space out of the painting at a constant rate by using a regulated pattern. The remaining problem was simply to find a method of paint application that followed and complemented the design solution. This was done by using the house painter's techniques and tools.[22]

Art making, here, is clearly seen as a sequence of problems to be specified, then solved, as efficiently as possible. The artist's deliberately muted, unadorned, almost mechanical language reflects his commitment to finding a way for the work of art to seem to make itself, to issue from the fundamentals of the practice of painting as such, rather than from the artist's personality (as

1.12 Frank Stella
*Die Fahne Hoch!*, 1959.
Enamel paint on canvas,
121½ x 73in (308.6 x
185.4cm). Whitney
Museum of American
Art, New York. Gift of
Mr and Mrs Eugene M.
Schwartz and purchase,
with funds from the
John I.H. Baur Purchase
Fund; the Charles
and Anita Blatt Fund;
Peter M. Brant; B.H.
Friedman; the Gilman
Foundation, Inc; Susan
Morse Hilles; The
Lauder Foundation;
Frances and Sydney
Lewis; the Albert A.
List Fund; Philip Morris
Incorporated; Sandra
Payson; Mr and Mrs
Albrecht Saalfield;
Mrs Percy Uris; Warner
Communications
Inc. and the National
Endowment for the
Arts 75.22.

1.13 Donald Judd
*Untitled*, 1969.
Galvanized iron and
Plexiglas®, overall 120 x
27⅛ x 24in (304.8 x 68.8
x 60.96cm). 10 boxes,
each box: 6 x 27 ⅛ x
24in (15.24 x 68.8 x
60.96cm). Albright-Knox
Art Gallery, Buffalo,
NY. Edmund Hayes
Fund, 1972. Licensed by
VAGA, New York, NY.

1.14 Robert Morris
*Untitled*, 1965/71.
Mirror plate glass on
board, four pieces,
each 36 x 36 x 36in
(91.5 x 91.5 x 91.5cm).
Tate Modern, London.
(Grant-in Aid) 1972
T01532.

was the case with the Abstract Expressionists), or from the urge to reveal something about nature, history, or society (as Realist artists of all kinds attempt to do). A suite of works made in 1959 share large size, one color (black), simple structure, and straightforward paint application. *Die Fahne Hoch!* (Fig. 1.12) is achieved by dividing the rectangular canvas into quadrants, then marking out each section with regularly spaced lines, 3 inches apart, out to the edges. Black house paint is applied, flat and thick, between the lines, leaving them barely visible. Unpainted canvas is stretched around the sides, 3 inches in depth. A huge, black, weighty object looms over us. We stand dumbfounded, caught up in the mute echoes of this transparent visual labyrinth, pinned by its implacable cross structure. Stella's premeditated process of forcing out illusionistic space "at a steady rate" is felt by us as a slowing down of our experience of time, a stretching out of the present toward infinity.

Critics divide over whether the title—which quotes the opening line ("The flag up high!") from the anthem of the Nazi Party in Germany—is a pointer toward the continuing dark mood consequent upon the Holocaust, or the artist's provocative way of indicating that paintings such as this can be given any title at all: no relationships, no associations make special sense, each one is its own meaning. There is no dispute, however, about such works' overall impact. Compared to their predecessors, and to most of their contemporaries, their heraldic power and implacable force seem undeniable. These were conclusive arguments, in embodied visual form, about what art itself should be like today. To many young artists, and some critics, this seemed to be as far as Modernist painting could go. Art, from now on, must take some quite other form.

Implacable focus also characterized the "specific objects" that were coming to replace sculpture in its traditional and modern forms.[23] In his "Notes on Sculpture," the Minimalist artist Robert Morris best expressed what had changed: "The better new work takes relationships out of the work and makes them a function of space, light, and the viewer's field of vision… Every external relationship, whether it be set up by a structural division, a rich surface, or what have you, reduces the public, external quality of the object and tends to eliminate the viewer to the degree that these details pull him into an intimate relationship with the work and out of the space in which the object exists."[24] He could have been describing works such as Donald Judd's *Untitled* (1969) (Fig. 1.13). Yet immediate, literal, one-on-one address to the spectator as another body in actual space is only the most overt demand of Minimalism. Optical illusion, special effects, and external allusion are obvious in works such as Morris's *Untitled* (1965/71) (Fig. 1.14), which dissolves cubic form and activates the space around each piece by using mirrors as its surfaces. This taste for ambiguity becomes more evident to us as Minimalism recedes in time, making it more and more an art of its late modern moment.[25]

## Earthworks: Extending Sculpture's Field

Like the Minimalists, the artists who created "earthworks" during the 1960s were primarily motivated by issues internal to the evolution of Late Modernist Art, questioning its apparent impasse in formalist abstraction. Yet they also wished to match the tangible realities of everyday life, so they sought out working environments

1.15 Robert Smithson
*The Spiral Jetty*, 1970.
Long-term installation,
Rozel Point, Box Elder
County, Utah, 1,500ft
(457.2m) long, approx.
15ft (4.5m) wide; 6,650
tons of rock and soil,
plus salt crystal and
water (red algae).
Dia Art Foundation.
Licensed by VAGA,
New York, NY.

away from their studios (thus the "Post-Studio" tag that came to be associated with them) and places of display at a distance from commercial galleries and museums (thus descriptors such as "anti-Art"). Most artists who chose to work in natural settings like this had been trained as sculptors, so they brought along characteristic concerns with volume, mass, space, and scale, by their activities "expanding the field" of sculpture in a number of senses.[26] Allan Kaprow was among the first to articulate this broad shift of sensibility, writing in 1966: "looking broadly at the whole of recent modern art, the differences that were once so clear between graphic art and painting have practically been eliminated; similarly, the distinctions between painting and collage, between collage and construction, between construction and sculpture, and between some large constructions and a quasi architecture… Some interesting alternatives emerged, leading in different directions, but all of them involved *relinquishing the goal of picture making entirely* by accepting the possibilities that lay in using a broken surface and a nongeometric field… This principle may be named simply *extension*."[27]

This principle has proved more resilient than artists' desire to work in the materials traditional to sculpture (stone, wood, bronze, steel), and with its traditional techniques (carving, modeling, casting) as well as modern (assemblage) ones. In retrospect, we can see that the artists of this phase whose work is most suggestive for contemporary art were seeking ways of rethinking these fundamental elements of the craft-based arts from the inside out, as it were. Previous art in all media had prioritized the concentration of its constituent elements around internal intensities, thus creating an artwork that presented itself as an autonomous object to be pleasurably admired, although, for some, it was also a secret to be grasped by assiduous and ardent viewing. Formalism was the most developed version of this kind of spectatorship. In contrast, the artists who sought to prioritize the spectator's immediate experience of the work began to conceive the viewer as also possessing other senses, notably those of touch (tactility), of movement in space (vestibularity), and of passage through time (temporality)—in short, as inhabitants of an active body. Opening out the work of art became crucial; showing its parts to be extending in relation to each other became instinctive. Moving beyond the closed confines of the studio and the gallery became *de rigueur*.

Thus Robert Smithson, explaining in an essay written in 1972 the motivations that led to his definitive work, *The Spiral Jetty* (1970) [Fig. 1.15]: "The scale of the Spiral Jetty tends to fluctuate depending on where the viewer happens to be. Size determines an object, but scale determines art. A crack in the wall if viewed in terms of scale, not size, could be called the Grand Canyon. A room could be made to take on the immensity of the solar system."[28] These are generalities. Just how deeply the artist rethought them in this work is evident in his account of his exploratory visit to the site in 1968. With the vaguely formed intention of building an artificial island of barges on a lake reddish in color,

Smithson examined a number of sites around the Great Salt Lake, Utah, before coming upon Rozel Point. Attracted to the evidence of a number of failed attempts to drill for oil that littered its shore, he records the moment when the idea of the work came to him:

> About one mile north of the oil seeps I selected my site. Irregular beds of limestone dip gently eastward, massive deposits of black basalt are broken over the peninsula, giving the region a shattered appearance. It is one of the few places on the lake where the water comes right up to the mainland. Under shallow pinkish water is a network of mud cracks supporting the jigsaw puzzle that composes the salt-flats. As I looked at the site, it reverberated out to the horizons only to suggest an immobile cyclone while flickering light made the entire landscape appear to quake. A dormant earthquake spread into the fluttering stillness, into a spinning sensation without movement. This site was a rotary that enclosed itself in an immense roundness. From that gyrating space emerged the possibility of the Spiral Jetty. No idea, no concepts, no systems, no structures, no abstractions could hold themselves together in the actuality of that evidence. My dialectics of site and non-site whirled into an indeterminate state, where solid and liquid lost themselves in each other. It was as if the mainland oscillated with waves and pulsations, and the lake remained rock still. The shore of the lake became the edge of the sun, a boiling curve, an explosion rising into fiery prominence. Matter collapsing into the lake mirrored the shape of a spiral. No sense wondering about classifications and categories, there were none.[29]

This passage manifests the artist's erudition. It is full of allusions to travel writers who had visited the region before him, to Darwinian geologists, Edmund Burke's musings on the Sublime, and Aldous Huxley's mescaline-induced hallucinations in the New Mexico deserts. As art, *The Spiral Jetty* invites us to switch our perceptions of scale from the horizontal to the vertical, and from the Earth to the heavens: to imagine the spiral spinning out from the line of the lake shore as an explosion of superheated matter erupting from and then curling back to the surface of the Sun. We enter its fragile walkway moving counterclockwise, and exit moving as the clock does. But the journey has shifted our sense of time from being in the present to an awareness of the origins and then the end of the universe. We see what the artist saw: matter itself collapsing, spiralwise, creates the lake, and brings about its end. In between, there lies the still, mirrorlike surface of water, and the lens of our own eyes: onto these, anything may be projected. Everything is.

The volatility of the seemingly permanent is highlighted in a film made by Smithson of the project, also entitled *The Spiral Jetty* (1970), that tracks an imaginary natural history of the site, and culminates in a long zoom in to the artist walking the length of the spiral, deep in thought. In the 1972 essay quoted above, Smithson describes his experience of working with the film editor: "Like two cavemen we plotted how to get to the Spiral Jetty from New York City. A geopolitics of primal return ensued. How to get across the geography of Gondwanaland, the Austral Sea, and Atlantis became a problem. Consciousness of the distant past absorbed the time that went into the making of the movie. I needed a map that would show the prehistoric world as coextensive with the world I existed in."[30] The contemporaneousness of widely separated periods in time, and of radically distinct kinds of time, for an observer who sees truly into the natural world is a theme that occurs again and again in artworks of this kind.

These ideas stand in sharp contrast to the abstraction and generality that informs another famous example of Land Art, Michael Heizer's *Double Negative*. In 1969, Heizer had 240,000 tons of sandstone removed from the edge of the escarpment of Mormon Mesa, Nevada, to create two huge trenches.[31] The attraction toward transforming natural settings in ways as unconstrained as those pursued by the large-scale extractive industries has permeated American and some international art ever since, and has attracted the long-term support of a new class of patrons, such as the Dia Art Foundation.[32] Its temporal instinct is for the eternal, not for the immediacy or for the contemporaneousness of multiple, differential times that interest contemporary artists.

An equally bold, yet essentially noninterventionist aesthetic engagement with natural phenomena was imaginable at the time. *Wrapped Coast—One Million Square Feet, Little Bay, Sydney, Australia* (1968–69) [Fig. 1.16] remains the largest single "earthwork" ever realized— yet virtually no trace of it remains at the site. The first major environmental work by Christo Javacheff and Jeanne-Claude, *Wrapped Coast* stretched one mile along a rocky beach front of the Pacific coast just south of the port city, covering rocks and landforms from 150 to 800 feet inland, and ranging in height from 85 feet at the cliffs at its northern end down to sea level at the beach at its southern end. One million square feet of a woven polypropylene fabric in common agricultural use was tied down using 35 miles of rope and 25,000 fasteners. Fifteen professional mountaineers, 110 laborers, and unnumbered volunteers, mostly local artists and architecture students (including the author), expended 17,000 manpower hours in installing the project. It remained in place for ten weeks from October 28, 1969, after which all materials were removed. Local art patron John Kaldor initiated the visit by Christo and Jeanne-Claude, but the artists met all costs from sales of associated drawings and collages.

These bald figures convey something of the immensity but nothing of the poetry of the project. The artists convinced hundreds of people—ranging

from a skeptical press to the superintendent who offered access to a distant and underutilized part of some hospital grounds—to commit time, labor, and a receptive imagination to a project that claimed no purpose other than to be itself, for a short time, and at the artists' own expense. Potential objections evaporated quickly, willing cooperation ensued. Thousands visited the site, while many more followed the increasingly positive press and broadcast media coverage. Nothing of this kind had been seen in Australia before: it enchanted the general public, which understood *Wrapped Coast* as a symbolic celebration of their locality, and it inspired a number of local artists and critics, who responded to the conceptual leap entailed in the transformation, by the most literal of means, of an actual place into an imaginary landscape.

Christo commented: "When I first conceived the project, and even later when the site was found at Little Bay, I was planning to use a reinforced, but still transparent plastic. More and more, I moved from this semi-transparent material to the completely opaque material with which the project was finally done. Sculpturally, it was more powerful."[33] The entire work was visible only from the air, and its length could be grasped best from a boat out at sea. Its landscape character was most evident from these perspectives, whence the overall view could be framed, contrasts drawn with unwrapped areas, and the hidden shapes imagined by extrapolation. Born in Bulgaria in 1935, Christo moved to New York in 1964. Most of his works during this period entailed wrapping up everyday objects, partly to draw attention to them, in the manner of international Pop Art, but also to disguise what it was that was wrapped, rendering it an enigmatic package, in the manner of Surrealists such as Marcel Duchamp and Man Ray.

Both of these strategies—revelation via concealment and vice versa—were operative in *Wrapped Coast*. Walking around the land perimeter of the work, marveling at its size and its impact on visible natural phenomena such as sunlight reflections or the look of sea spray, one was drawn to compare it to sublime natural phenomena… and then to realize that was exactly what you were looking at. Within the work, as you made your way across it, the primary sensation was an uncanny sense of how appreciably different the familiar experience of clambering over rocks, crevasses, and ground became when everything was covered by this relatively strong plastic. Awareness of the larger-than-human scale of natural forces was inescapable.

A more subdued approach to working in natural situations is evident in the work of English artists such as Richard Long and Hamish Fulton. When asked in 1995 to which of the prevailing styles his art belonged, Long replied: "Nature is the source of my work. The medium of my work is walking (the element of time) and natural materials (sculpture). For me, the label 'Land Art' represents North American monumental earthworks, and my work has nothing to do with that. I could say that it perhaps has more in common with Italian Arte Povera (simple, modest means and procedures) or Conceptual Art (the importance of ideas)."[34]

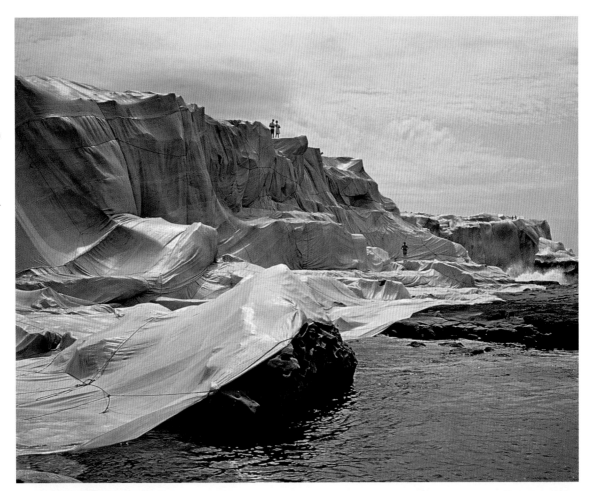

1.16 Christo and Jeanne-Claude
*Wrapped Coast—One Million Square Feet, Little Bay, Sydney, Australia,* 1968–69. Erosion control fabric and 35 miles (56.3km) of rope, 1 million sq feet (92,900sq m) of semi-transparent woven polypropylene fabric, 17,000 manpower hours, 110 laborers, 15 professional mountaineers, unnumbered volunteers. Length 1 mile (2.4km), 151–800½ft (46–244m) wide, 85⅓ft (26m) high at northern cliffs and at sea level at the southern beach.

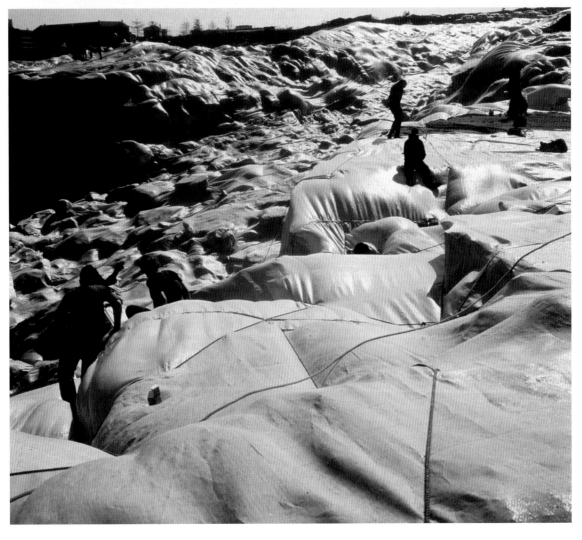

A LINE MADE BY WALKING

ENGLAND 1967

1.17 Richard Long
*A Line Made by Walking*,
1967. Photograph and
pencil on board, 14¾ x
12¾in (37.5 x 32.4cm).
Tate, London, purchased
1976. P07149.

Born in Bristol in 1945, Long was drawn in his work to natural settings, clarity of form, and ease of execution. Among early explorations of the idea of negative space was the removal of a layer of topsoil beneath turf, replacing the grass cover, to create a slight subsidence in a circular form, leaving a trace reminiscent of the structures of the early inhabitants of Britain that dot the countryside in this region. When he studied at St. Martin's School of Art, London, during the 1960s, the brightly colored, welded metal "New Sculpture" of his teachers Anthony Caro and Phillip King was being heralded by many as the most promising way forward for sculpture and even for Modernist Art itself.

Long looked for quite different principles. *A Line Made by Walking* (1967) (Fig. 1.17) is no more or less than what its title declares: the artist walked for a few yards (perhaps 50) forward and back across an unnamed, nondescript field in the west of England until the light falling on the flattened grass made a line visible. This was then photographed in a straightforward fashion, and the artist departed, leaving the grass to resume its normal form. The work exists in various forms: as an action of the artist occurring when it did; as a photograph of the site captioned plainly: "A LINE MADE BY WALKING ENGLAND 1967"; and in whatever imaginative re-creation of the action might occur to someone looking at the photograph. As the curator Rudi Fuchs observed, "because there was nothing left out and nothing included that wasn't there before, this sculpture became something of a prototype, or a matrix, a form so perfectly simple, open and resolved that it also became a clarification, even a revelation of how to make sculpture. Walking slipped into line, line slipped into form, form slipped into place, place slipped into image."[35]

Long has made site-specific works all over the world in a variety of settings, from rural landscapes to wilderness areas. These works usually entail the gathering of found materials—stones, wood, ash, vegetative matter, earth—and their placement in an implied geometric form: usually a circle or rectangle. The status of the other major current in Long's work—his gallery and museum installations—is ambiguous. These take essentially the same form as the exterior works: found natural materials arranged into a geometric configuration. Bringing them into an art space inevitably evokes Robert Smithson's pairing of "site" with "non-site," but there is less sense of the dramatic clash of geological temporalities in Long's work. Attention focuses on the inherent beauties of the materials, here isolated for contemplation, and on the artist's increasingly subtle placement of each element to generate deeply textured visual fields. From the mid-1980s, Long sought to bridge the nature/culture gap by creating mural-sized wall works and large floor-pieces through the application of mud collected from favorite rivers. His wild, seemingly random throwing of mud and water, and leaving of handprints, implies his debt to the painting practices of indigenous peoples. This was acknowledged at the pathfinding yet controversial exhibition *Magiciens de la Terre* (*Magicians of the Earth*), presented by the Centre Pompidou in Paris in 1989. In one room, a wall mural by Long using red clay mud to form a large circle was paired with a ground painting made of colored sands and other matter by Australian Aboriginal artists, elders of the Yuendumu peoples from the Central Desert. The complexity and the quasi-sacred character of the Yuendumu painting left Long's work looking like a thin, generalized, overblown gesture.

Asked in 1997 about his reaction to global warming and environmental devastation, Long replied:

> My work is just art, not "political" art… I first chose landscape so as to use the dimension of distance to make a work of art by walking. That was on Exmoor [a large area of moorland in England]. I was intuitively attracted to such relatively empty, non-urban landscapes partly because they were the best place to realize my ideas, but also because such places were a pleasure to be in. They had a spiritual dimension which was also important for the work. So my work comes from a desire to be in a dynamic, creative and engaged harmony with nature, and not actually from any political or ecological motives… Making art in the type of landscapes which still cover most of our planet gives me a quite optimistic and realistic view of the world. I think my work is almost nothing, it's just about being there—anywhere—being a witness from the point of view of an artist.[36]

As we shall see in the third part of this book, such optimism has become increasingly difficult to maintain in the face of the subsequent rapid acceleration in global warming. A corollary is that the ideal of making large artistic statements using the fewest possible materials has become widespread, if not all-pervasive.

## Conceptualism: Reconceiving Art

Of all the major developments in late modern art, Conceptualism would seem the least amenable to immediacy, instantaneity, presentness. Its appeal was to cognitive processes rather than emotional reactions, to mental operations, not intuitive responses to expressive signs. Conceptual works—especially those that were language-based—often required long periods of information ingestion and subsequent sustained reflection. Its major topic of inquiry—Art itself—was by definition a generality, however particular any given inquiry might be. There was no blurring of the boundaries between art and life here: "blurring" was anathema, and everyday life of little interest except as a setting for ordinary language use. Unlike Pop, few Conceptual works engaged with the images that were flooding consumer consciousness. To Conceptualists, Minimal Art seemed beholden to sculpture's limitations, and bound to the "thingness" of objects. Earthworks seemed too

embedded in actual materials and natural processes. Yet Conceptualism shared with these tendencies the definitive late modern repulsion against the reductive mindset and the constrictive loyalty to traditional art media that characterized formalism. It also shared—indeed, was to a large extent driven by—a sense that Modernist Art had reached a crisis point in its development, evidenced above all in the institutionalization of avant-garde art: for example, the ease with which museums seemed to be slotting the art of the recent past into their closed and comfortable narratives. To Conceptual artists, however, the way forward lay less in the production of art objects that manifested these concerns than in using any medium whatsoever (but preferably those, like language, that came closest to pure thought) to make propositions about the situation in which art found itself.

Exactly when the conceptual interrogation of late modern art became Conceptual Art is a matter still in dispute. The artists involved came to it via a variety of pathways, and after working in a number of existing styles, experiences that resonate in their subsequent work. Was Ad Reinhardt—who combined a resolute investigation of perceptual effects in his near-monochrome canvases with scatological cartoons lampooning the artworld—the first fully rounded Conceptualist? Or was it Fluxus artist Henry Flynt, who said in 1961: "'Concept Art' is first of all an art of which the material is concepts, as the material of e.g. music is sound. Since concepts are closely bound up with language, concept art is a kind of art of which the material is language"?[37] Or was it the Gutai artists (see Fig. 1.7), or the Neo-concrétismo artists such as Lygia Clark, Hélio Oiticica, and Lygia Pape (see Chapter 4), whose work prompted critic Ferreira Gullar to develop his concept of the "Nonobject" in 1960?[38] Was it Robert Morris when, in 1962, he made *Card File*, using standard office materials to record his process of making the file? Or Sol LeWitt, whose "Paragraphs on Conceptual Art," aimed mostly at elucidating the intuitive logics followed in generating his open cube works, drew the attention of a larger reading public to the term when it was published in *Artforum* in 1967?[39]

Some of the earliest works now cited as paradigms of the movement succeed in making cognitive processes visible to the spectator with a directness paralleled only by Pop Art. *One and Three Chairs* (Fig. 1.18), conceived by Joseph Kosuth in 1965, shows us the reality, the concept, and the word "chair" as they appear to us, simultaneously, in the three modes familiar from classic, Platonic philosophy: to our bodily senses (the actual chair), as a mental image (the photograph), and to our minds (the dictionary definition). At the same time, Kosuth was demonstrating a fundamental linguistic operation, the way a sign is made up of a relationship between signifier (word or image) and signified (actual chair). Any other object, or concept, could be substituted—and, in later works, was. Finally, he was offering us a proposition about what art might be, indeed, should be, now: a demonstration of its own propositional character. This latter, tautological aspect was more

evident in Kosuth's subsequent *Art as Idea as Idea* series, which presented enlarged photostats, in negative type, of dictionary definitions of words such as "art," "color," and "meaning," and of multiple subcategories such as "painting," "blue," and "word."

Art & Language, a group of British artists founded by Terry Atkinson, Michael Baldwin, David Bainbridge, and Harold Hurrell, took such inquiries a step further when they insisted during 1966 and 1967 that propositions about possible objects, ideas, or events could be regarded as works of art ("theoretical objects"). In 1969, in the editorial of the first issue of their journal *Art-Language*, they claimed that theoretical inquiry into whether inquiry itself counted as art—the very editorial itself, being read right then, with no visual qualities apart from the printed words on the page—could itself be understood as art. Their subsequent practice, as the group expanded to include members from the U.S. (including Kosuth), Australia (notably Ian Burn and Mel Ramsden), and other parts of Europe, made it clear that these artists believed that their inquiries were the most important kind of art that could be made at the time. *Index 01* (1972) (Fig. 1.19), shown at the influential Documenta 5 art exhibition, consists of eight file cabinets that contain 48 photocopies of essays written by members of the group, some published, others not. On the surrounding walls typed sheets of paper carry the results of an indexing operation carried out by the group on the texts: 350 citations are indexed according to their compatibility, incompatibility, or nonrelation to each other. The result is a conceptual map, formed in the minds of those willing to track the now-silent discourse of the group.[40] In 1974, the New York branch of Art & Language brought this process more immediately into the group's daily conversation by annotating each other's statements ("blurts"), and then indexing these in the manner of a thesaurus.[41]

## Political Interventions: Direct Democracy, Body, Self, Sexuality

"Only on a condition of a radical widening of definition will it be possible for art and activities related to art to provide evidence that art is now the only evolutionary-revolutionary power. Only art is capable of dismantling the repressive effects of a senile social system that continues to totter alongside the deathline: to dismantle in order to build A SOCIAL ORGANISM AS A WORK OF ART. This most modern art discipline—Social Sculpture/Social Architecture—will only reach fruition when every living person becomes a creator, a sculptor, or architect of the social organism."[42] This statement—by German sculptor and performance and installation artist Joseph Beuys—expresses in extreme form the belief that avant-garde artistic innovation could contribute significantly to much-needed social transformation. Declaring in 1964 "The silence of Marcel Duchamp is overrated," Beuys insisted that he could lead artists in extending the ideas left undeveloped

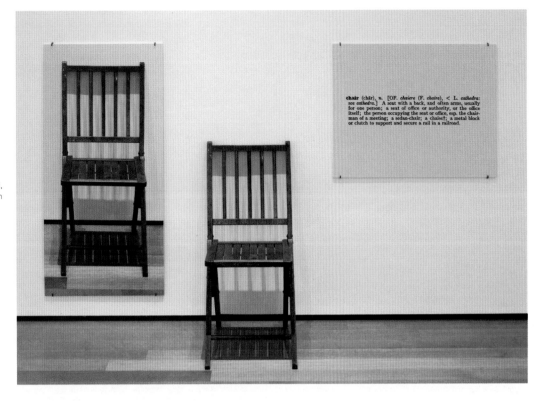

1.20 Joseph Beuys with Johannes Stüttgen *Blackboard from the Office for Direct Democracy (Unterrichtstafel aus dem Büro für Direkte Demokratie)*, 1971. Adolf-Luther-Foundation, Krefeld.

1.21 Hans Haacke *Shapolsky et al., Manhattan Real Estate Holdings, a Real-Time Social System, as of May 1, 1971*, 1971. Suite of panels with photographs and typed text. Musée National d'Art Moderne, Centre Georges Pompidou, Paris.

when the French artist announced in 1923 that he was giving up making art.[43] Like Duchamp, Beuys traded in ambiguity, ambivalence, and legend-building. Both devoted unflagging energy to fashioning a distinctive, deeply serious yet radically scandalous artistic personality. Beuys believed that certain artists could serve a role similar to that of shamans in earlier societies. For post-World War II Europe, he became that artist.[44]

Beuys was also committed to direct action, to "art actions" tied closely to the politics of the day. *Blackboard from the Office of Direct Democracy* (*Unterrichtstafel aus dem Büro für Direkte Demokratie*) (Fig. 1.20) was created by Beuys and Johannes Stüttgen in Düsseldorf in 1971. It hung on the office wall of the Organization of Direct Democracy by Referendum, a group founded by Beuys in 1970, precisely to bring about systemic change by binding representative social democracy to decision-making based on referenda. The encircled diagrams on the blackboard, drawn by Stüttgen, are derived from the ideas of the German Theosophist Rudolf Steiner to indicate the three social "fields" ("trias"): mind, law, economy. They also set out corresponding "steps on the road to the practical realization of referenda" via a petition, a draft bill, and a vote. The passages at lower left and right, drawn by Beuys, spell out the differences and linkages between representative- and referenda-based structures, and are colorcoded to indicate the leaflets to be distributed at each stage of the campaign. The *Blackboard*, then, represents the thinking of the group as it planned its specific actions. Invited to participate in Documenta 5 in 1972, Beuys transferred the office to the exhibition's home in Kassel, conducting its business there for the 100 days of the show, where he and followers generated hundreds of other, similar blackboards.

Art museums that were dependent on private philanthropy were then, as now, reluctant to exhibit works that might offend wealthy trustees. In 1971, the director of the Guggenheim Museum, New York, rejected key works by the young German-American artist Hans Haacke; a planned exhibition was canceled and its curator fired. Haacke had been making sculptural installations and environments since 1966 that demonstrated the laws of physics and revealed the operations of "real-time systems."[45] He soon oriented his practice toward social processes in works such as *Gallery-Goers' Birthplace and Residence Profile* (1969), which demonstrated the predominantly upper-class attendance at midtown galleries, and *MoMA-Poll* (1970), which asked visitors to cast ballots relating to current political issues. Haacke proposed to conduct similar polls at the Guggenheim, and to exhibit two displays that used public records to profile the extensive real-estate empires in the Lower East Side area of New York held by two companies. One of these displays was *Shapolsky et al., Manhattan Real Estate Holdings, a Real-Time Social System, as of May 1, 1971* (1971) (Fig. 1.21).

There were no direct connections between the museum and these companies, yet the implication that there might be was sufficient to threaten the still-widespread belief that art was autonomous, and museums were cathedrals of contemplation, separate from the conflicted, compromised flow of everyday life. Haacke's polls broke down this barrier by asking visitors direct, pointed questions about their everyday identities, behaviors, and beliefs. Works such as *Shapolsky et al.* imitated the techniques of sociological data-gathering—down to the snapshot quality of the profile "as of May 1, 1971"—and the objective, facts-only look of informational displays to show how certain specific structures of money and power were shaping everyday life, right there and then. As Haacke was to go on to show throughout his subsequent career, this disposition of power also shaped choices within the artworld. In his *Solomon R. Guggenheim Museum Board of Trustees* (1974), for example, he displayed the public-record interests of serving Guggenheim trustees, demonstrating among other things the role of certain directors' copper-mining interests in the overthrow of the Allende government in Chile in 1972 and the subsequent installation there of what would prove a long-serving dictatorship.[46]

During the 1960s and 1970s, a variety of political movements coalesced to protest what participants saw as their systemic exclusion—on the grounds of their minority racial, gender, religious, or ethnic status—from rapidly modernizing societies, particularly those that promoted values such as equality of opportunity and encouraged open access to material well-being. For artists, recognition of one's existence is the *sine qua non*, the necessary condition, for her or him to have any chance of participating in the flow of current art; a situation that is itself the entry point for the possibility of one's art having any sort of historical consequence. In a patriarchal society, women are systemically excluded from temporal comparison with their male contemporaries; just as, in racist condescension, they are presumed to be less developed, slower in practice, insufficiently far-seeing, and thus unlikely ever to catch up to the (male) artists who are advancing art now. Famous essays by Linda Nochlin and Germaine Greer, among others, pointed out the obstacles that had, historically, crippled women artists.[47] Rejecting the implication that the lesser visibility of women artists, and of artists of color, was rooted in their "natural" inferiority, artists joined forces to highlight their exclusion from collections and from major annual survey exhibitions. Surveys of U.S. museums around 1970 showed an average of 1 percent of works by women in collections, and 2 percent female representation in survey exhibitions during the previous decade.[48] In New York, a protest campaign at the Whitney Museum of American Art led to a 22 percent presence in 1971. In Britain, however, no women artists at all appeared in an important 1972 Tate Gallery survey entitled *New Art*.

Against this scenario of institutional exclusion, artists were active in creating alternative forms of mutual support and alternative spaces to show their work. Open for a month, from January 30 to February 28, 1972, in an abandoned mansion in Hollywood, a suburb of Los Angeles, *Womanhouse* was the first public exhibition of Feminist Art. Serving as a temporary home for the

Feminist Art program taught by artists Judy Chicago, Miriam Schapiro, and Mira Schor at the California Institute of the Arts, it was the suggestion of art historian Paula Harper. Treating the art class as a consciousness-raising group, the participants worked together to build an environment in which women's conventional social roles could be displayed, exaggerated, and subverted. Rooms included a sickly-pink kitchen, a sheets closet that trapped its user, a bride thrown against a wall, and a menstruation bathroom. Others, such as the "crocheted environment," a dollhouse room, and a "personal environment," imagined the interiorities of women's experience.[49] The project led to the idea of a center that would offer similar opportunities to women and men on a longer-term basis. The Woman's Building opened in Los Angeles in 1973 and remained active until 1991.

Reviewing, in 1976, the pathways taken by women artists during the preceding few years, the critic Lucy Lippard noted:

> Some feminist artists have chosen a fundamentally sexual or erotic imagery… Others have opted for a realist or conceptual celebration of female experience in which birth, motherhood, rape, maintenance, household imagery, windows, menstruation, autobiography, family background and portraits of friends figure prominently. Others feel that the only feminist art is one with a "right-on" political posterlike content. Others are involved in the materials and colors formerly designated as "feminine," or in a more symbolic or abstract parallel to their experiences: for example, images of veiling, confinement, enclosure, pressures, barriers, constrictions, as well as growth, unwinding, unfolding, and sensuous surfaces are common. Others are dealing with organic "life" images and others are starting with the self as subject, working from the inside outward. All of this work, at its best, exchanges stylistic derivation for a convincing insight into a potential female culture. Every artist trying to extricate her personal expressions and a universal feminism from the styles and prejudices of a male culture is undertaking a risky and courageous enterprise.[50]

*The Dinner Party* (Fig. 1.22), an installation created between 1974 and 1979 by a team of artists, needleworkers, ceramists, historians, and others led by Judy Chicago, was highly controversial when first exhibited, and has become the outstanding monument to this first phase of Feminist Art. All of the pathways listed by Lippard converge to create a place where we are invited to imagine a meeting—fiery, convivial, ultimately inspiring—between the most significant women in mythology, religion, history, and the arts. The large triangular table—tripling the attendance at the Last Supper, with 13 women on each side, echoing the number traditionally said to be present at a witches' coven—is draped in fine cloth elaborately embroidered with the imagery of each woman, whose place is marked by a painted china plate shaped for her. The names of hundreds of other women are inscribed into the porcelain "Heritage Floor" on which *The Dinner Party* sits. Chicago was clear about her goals: "to teach women's history through a work of art that can convey the long struggle for freedom and justice that women have waged since the advent of male-dominated societies, and to break the cycle of history that *The Dinner Party* describes."[51] Like all monuments, *The Dinner Party* seeks to embody, in materials that will outlast a human life, an idea deemed relevant to all who gaze upon it. Although broadly symbolic of the power inherent in women in general, it also images the possibility of a meeting of a set of extraordinarily powerful women—an event that would, the artist implies, change human history.

Similar impulses are evident in the work of other artists influenced by the women's movement. The major trajectory of Carolee Schneemann's work during the 1960s and 1970s—in celebrated "living theater"-style performances such as *Eye Body* (1963) and *Meat Joy* (1964), and in films such as *Fuses* (1964–67)—was an insistence that a woman's body can be a fountain of creative and artistic energy as well as being capable of fulfilling its more conventionally acknowledged roles as a vehicle of sexual attraction and procreation. Some later performances, however, had quite concrete points to make that were specific to their moment, and to the interplay of gender roles within the artworld. *Interior Scroll* (Fig. 1.23) was the second part of a performance by Schneemann at *Women Here and Now*, an exhibition of paintings accompanied by a series of performances, in East Hampton, New York, in August 1975. In the first part, the artist undressed, wrapped herself in a sheet, and climbed on the table. Dropping the sheet, she applied strokes of dark paint to her face and body and then read from her 1976 book, *Cézanne, She Was a Great Painter*, while adopting a series of "action poses" typically used by life models. In the second part, she slowly drew a narrow scroll of paper from her vagina, reading aloud from it. Taken from her 1973 super-8 film entitled *Kitsch's Last Meal*, the text recounts an angry conversation with "a structuralist film-maker" in which the artist pits intuition and bodily processes, with their traditionally "feminine" associations, against notions of order and rationality, usually regarded as "masculine."[52]

The difference of emphasis between Schneemann's early performances and *Interior Scroll* signals a broader evolutionary shift in the feminist movement in general. Influenced by Postmodern theory, essentialist understandings of feminism underwent an internal critique, not in order to reject femininity (the actual experience of women in the world), but to locate it more exactly as a psychic outcome of social forces, above all patriarchal expectations and regulations. These forces, once fully understood, could, it was believed, be resisted and revised, not only by direct, public, and political confrontation, but also subjectively, within each of us, by means of theoretical analysis.

1.22 Judy Chicago
*The Dinner Party*,
1974–79. Ceramic,
porcelain, textile, 576 x
576in (1,463 x 1,463cm).
Brooklyn Museum,
New York. Gift of the
Elizabeth A. Sackler
Foundation, 2002.10.

1.23 Carolee
Schneemann
*Interior Scroll*, 1975.
Performance. Courtesy
of the artist.

1.24 Mary Kelly
*Post-Partum Document:*
*Documentation VI;*
*Pre-writing Alphabet*
*Exergue and Diary*, 1978
(detail). Perspex unit,
white card, resin, slate.
One of the 15 units,
each 7¾ x 10in (20 x
25.5cm). Arts Council
of Great Britain.

While *Interior Scroll* stages the shifting emphasis within feminism as a confrontation, nowhere is the belief in theory more clearly articulated than in Mary Kelly's *Post-Partum Document* (Fig. 1.24), a documentation and presentation project undertaken between 1973 and 1979. In six broad sections and 135 smaller units—accompanied by a number of essays and footnotes—the work as a whole tracks in detail everything that Kelly's newborn male child ate and expelled, charts every act of caring, and maintains a diary of the artist's spontaneous thoughts as well as her more considered interpretations. By 1978, the project was documenting the child's learning to speak, starting school, his first questions about sexuality, and his beginning to write. By juxtaposing fragments of texts—the child's scrawl, records of his language-learning, the artist's diary for that day—Kelly shows these as signs of self making and of being constructed (she and her husband, artist Ray Barrie, named the child "Kelly Barrie"). Every recorded instance is unique to those involved and tied to exactly its own moment in time: we witness one lived instance of the everyday life *of those years* in all its quotidian *but nonetheless historically specific* detail. At the same time, however, the overall structure of the *Post-Partum Document*—and the monumentlike slabs of inscribed text that form the concluding Part VI—show that the fashioning of selfhood occurs in basically the same way for everyone. In a close reading of motherhood, *Post-Partum Document* finds that there is, in the artist's words, "no essential femininity."[53] In an equally bold gesture, *Post-Partum Document* deploys the deadpan, distanced, seemingly objective modes of Conceptualism to deal with a topic that Kelly's mostly male counterparts assiduously avoided: the formation of subjectivity. Small wonder that the work was met not only with public outrage but also anger within the artworld.

Works by Chicago, Schneemann, Kelly, and countless other artists suggest that Feminist Art did not simply arise in the 1960s, flourish in the 1970s, and then wither into some kind of "post-feminist" irrelevance. Rather, reflecting on this question during the mid-1990s, Kelly noted that feminism "did not generate a unified aesthetic," but instead overtly or indirectly influenced every other kind of art making, distinctly and irreversibly, "by transforming the phenomenological presence of the body into an image of sexual difference, extending the interrogation of the object to include the subjective conditions of its existence, turning political intent into personal accountability, and translating institutional critique into the question of authority."[54] In these ways, it contributed centrally to the shaping of late modern art, and to the fundamental transformations we have been following in this chapter. Feminism insisted, not only on equal opportunities for women artists, but also on the contemporaneity of women's concerns, above all on the inequities built into the social construction of sexuality in terms of gendered destinies.

Progress toward full contemporaneity for artists from minorities has been slow, embattled, often stalled, but nevertheless steady. The legacy of the struggles of the 1970s is evident in contemporary art-worlds in many countries: for example, women artists constitute a substantial number—sometimes a majority (for example, in the 2010 Whitney Biennale, New York)—of artists exhibiting, being shown in museums, and being collected and discussed in journals. In some centers—at this time, still only a few—this fact has become so normal as to go unremarked. Nevertheless, it remains necessary to recall the history hinted at here: feminism has been, and remains, a crucial element in the ongoing struggle of art to become contemporary with, and against, its own times.[55]

As with Feminist Art, so with the other tendencies discussed in this chapter. I have suggested that a heightened awareness of contemporaneity appears in each of the art movements that emerged in Euro America during the later 1950s, the 1960s, and the 1970s. Although only a few works by a small number of artists have been discussed, these are widely regarded as keys to the art of those decades. In each case, a distinct engagement with an aspect of contemporary life, or with the lives or the art of their contemporaries, was a vital inspiration, essential to the energies that made them so transformatory. This engagement expands in subsequent decades, forming the basis of what becomes "contemporary art" in EuroAmerica, a trajectory that I will trace in the next chapter.

# 2. THE CONTEMPORARY ART BOOM

A remarkable set of changes in the world picture became apparent during the 1980s. Advanced countries embraced economic rationalism and new technologies, shifting from manufacturing to service industries in order to generate high consumption and concentrate wealth. Leading companies consolidated their structures, diversified their products, exported manufacture, and expanded their markets—they became "multinational." Conservative political ideologies that advocated less government control achieved widespread electoral success, personified by President Ronald Reagan in the United States and Prime Minister Margaret Thatcher in Britain. Major cities such as New York, London, Paris, and Tokyo became the drivers of networks of economic, political, and cultural power that extended to all parts of the world, with profound effects on local communities. Nation states seemed less important, less certain of their direction, than globalizing companies and international organizations. Oppositional models retreated or evaporated.

Undergoing internal changes, the U.S.S.R. could no longer function as a counterweight to the United States and Europe, thus ending the Cold War that had dominated European politics since 1945. The Russian Empire collapsed, leading to internal chaos and uncertainty along its disappearing borders, symbolized by the tearing down of the wall between East and West Germany in 1989. In the same year in China, the Communist Party government resisted these changes violently, putting down a student-led uprising in Tiananmen Square, Beijing. It then introduced a number of policy changes—"the four modernizations"—that were to lay the basis for unparalleled economic growth in the "primitive capitalist" mode. Elsewhere in Asia, especially in the Southeast, many countries set out to emulate the Japanese example and became "tiger economies," assiduously serving the new global order. Right-wing ideologies and dictatorial regimes prevailed in South America, but were unstable and subject to the harsh economic rationalist requirements imposed by the World Bank and the International Monetary Fund. Together, these processes and changes became part of the new "globalization."

In Africa, the liberation of former European colonies, which had begun with the independence of Ghana in 1957, was now all but complete. In 1991, apartheid was abolished in South Africa, and Nelson Mandela was elected president three years later. The new nations, already embattled as a result of contradictions between traditional values and the demands of modernization, with many consumed by disputes over partitions and internal struggles for power, also faced international competition, obliging many to become dependent on external aid. In contrast, advanced Western countries—despite their dependence on fossil-fuel energy from the Middle East, and on cheap immigrant labor—celebrated unprecedented growth and what appeared to be universal envy of their way of life, now seemingly unchallenged by any other system of social organization. Some false prophets on Wall Street and in academia proposed that, in the current version of free-market society governed through democratically elected representatives, human history had reached its natural culmination.

The most influential thinkers of the period, and the most original artists, disagreed sharply that this ideal had been reached. Taking their cue from the instability and fragility evident throughout the world, including in the advanced countries, theorists drew attention to the proliferation of diversity and difference at all levels of experience. Universalizing theories—whether secular ones such as presumptions about human progress and historical succession, or religious ones about predestination—became, in the words of French philosopher Jean-François Lyotard, "master narratives" that seemed, suddenly, to lack legitimacy.[1] The dream of the Enlightenment encyclopedists, that scientific theories could account for the structure of all phenomena, natural and social, came to seem fantastical. A highly relativist form of critical interrogation (named "Deconstruction" by its leading exponent, Jacques Derrida) became the preferred mode of philosophy and sociology. The idea that one kind of social model could fit all circumstances, and that all human societies were converging toward it, flew in the face of evident experience.

Since the 1960s, visual artists and architects had been anticipating many of these social and cultural changes. Those active during the 1980s and later were strongly influenced by Poststructuralist and Postmodern theory. Many have also contributed original and powerful critical interpretations, or, as celebrities in the mode of Andy Warhol, have come to symbolize what it is to live fully, even sensationally, in the present. The growth of mass-communicative media, especially television and the movies, and of spectacle in commercial city centers and sports entertainment, led key commentators such as U.S. literary theorist Fredric Jameson to recognize that the work of artists such as Warhol displayed "the cultural logic of late capitalism."[2] Architects such as Robert Venturi were attracted to the complexities and contradictions of designing in settings where taste preferences tended toward comfortable novelty, commercial imagery, and retro styles rather than the austere geometries and programmatic regularities of the Modern Movement. Critics such as Charles Jencks popularized "Postmodernism" as a signifier of this change, a term that spread quickly through the arts and culture.[3] Taking these changes altogether, it appeared that advanced societies, and the world in general, was moving beyond the forces that had emerged in the mid-eighteenth century and cohered, dynamically during the next two centuries, as modernity. Now, modernity, it seemed to many, was itself fast becoming historical—an epoch that had become static—and was perhaps ending. But the shapes of what might follow remained unclear. This left the world in a state of suspension *after* modernity—that is, in "postmodernity."

By the 1990s, contemporary art had come to replace modern art as the dominant art movement. It was driven, mostly, by markets seeking to recover from the political and conceptual preoccupations of artists during the 1960s and 1970s, as well as by artists who personally rejected these preoccupations, and by institutions, especially museums of modern art, seeking to maintain their relevance and audiences. A specialized section of the market devoted to contemporary art appeared in the 1980s, buttressed by auction houses, whose focus expanded from secondary dealing (in Old Masters, Impressionism, and Modern Masters) to setting the agenda for the primary market. Collectors specializing in contemporary art appeared—most notably Charles Saatchi, a London advertising agent, who promoted works in his collection through publicity, museum gifting, and his own gallery. A small group of artists made spectacular works that sold for extraordinary prices to a small group of collectors, each willing to spend over $100 million annually. In 2007, Damien Hirst, the leading exponent of "Young British Art" in the preceding decade, deliberately created the most expensive work of art ever made. *For the Love of God* is a diamond-encrusted human skull that cost £9 million to make, and sold (to a consortium that included the artist) for £50 million (then approximately $100 million). By 2008, contemporary art had eclipsed all other sectors: works by Andy Warhol, the most visible symbol of the

category, outsold those of every other artist, including Picasso. The auction-house boom reached its apogee in September of that year, when Sotheby's in London sold 223 specially made works by Damien Hirst for $200.7 million. The next day, a collapse on the New York Stock Market exposed a worldwide recession. The vastly inflated market for contemporary art subsequently suffered a severe correction, especially in its middle tiers. For the top collectors and bestselling artists, however, something close to "business as usual" continues.[4]

The great museums of modern art have experienced a rougher ride in coping with the shift to contemporary art. Vast public interest in the phenomenon swelled visitor numbers already stimulated by the blockbuster exhibitions of the 1970s and early 1980s. Yet institutions such as the Museum of Modern Art, New York, had internalized a Modernist narrative of progressive avant-garde innovation within separated artistic media. As a result, while most were able to adapt to the enlarged size of artworks made during the 1980s, they struggled to change their layouts—usually a succession of "white cubes"—to accommodate the "black boxes" required by video and cinematic installations, and the open-sided spaces required by performance and participatory art. Some new galleries repurposed old structures—Tate Modern in London, a power plant, Dia:Beacon in New York State, a matchbox factory—while others renovated existing galleries, and adjusted their programming to include contemporary art to the degree that they could.[5] This struggle continues: no museum has succeeded fully in becoming a site for contemporary art, not even those, such as the New Museum, New York, that specialize in it. In general, markets and museums in the leading centers in Euro-America celebrate those artists who continue to work in traditional media (especially painting), who adapt existent media to Modernist taste (notably large-scale sculpture and color photography), and who perpetuate traditional subjects through calibrations of new media (including installation, video, and digital streaming).

These considerations take us to the heart of the late modern period, and to the core values of the first of the three currents treated in this book: Contemporary Art in its most obvious, controversial, and celebrated manifestations. But there is, I suggest, an important distinction to be made if we wish to understand fully the driving forces within this current. I will show that artists such as Jeff Koons, Damien Hirst, and Takashi Murakami developed practices that tackled questions arising from their experiences living in major art centers, and generated personal yet profound (if often sensational) works in fresh, often surprising mixtures of media: performances, environments, installations, processes and projects, videos and new-media arts. Through the last two decades of the twentieth century, these practices cohered into a style that we might call "Retro-Sensationalism." At the same time, certain other artists, such as Gerhard Richter, Richard Serra, and Jeff Wall, were able to find ways of transforming artistic media that had been brought to a high level of refinement during Modernism—especially

painting, sculpture, and photography—such that they could carry content as pertinent as that explored in more contemporary modes. This tendency we might call "Remodernism." While most late modern artists leant toward one or other of these tendencies, some—for example, Matthew Barney and Cai Guo-Qiang—were able successfully to combine the driving impulses of both, raising the specter of yet another style, one that might be dubbed "Spectacularism." Still others, notably Jenny Holzer, Barbara Kruger, and Cindy Sherman, made work that stood at a critical tangent to these tendencies. Let us track these changes in art during the 1980s and 1990s, beginning from a time *before* these distinctions became evident with the reaction by certain European and U.S. artists against both previous traditions of abstract painting and the transformations of art itself during the 1960s and 1970s that we discussed in the previous chapter.

## THE POSTMODERN RETURN TO FIGURATION

In the early 1980s, certain groups of artists and some important individual practitioners returned to traditional artistic media—above all, large-scale painting and photography, as well as (but to a much lesser degree) free-standing sculpture—in a defiant demonstration that these media could continue to be vehicles of substantive content. A striking difference from the recent past was that little of this work was abstract: figurative imagery of all kinds reappeared, or was appropriated from previous art or popular culture. The tendency emerged, first, in cities such as Berlin and Milan, then was seen to be happening in other previously provincial settings, such as Cologne and Los Angeles, before it became, late in the decade, the rage in the main centers, such as New York and London (it never took hold in Paris). The market for contemporary art—embattled during the previous decades owing to antipathy from many artists and critics, and to the fact that much Performance, Conceptual, and Political Art was impossible to sell due to its being ephemeral, too complex, or too radical—welcomed this development with enthusiasm and relief. Postmodern figuration was heavily promoted in a number of spectacular exhibitions at key museums and galleries—notably *A New Spirit in Painting* at the Royal Academy, London, in 1981, and *Zeitgeist* (*Spirit of the Times*) at the Martin Gropius Bau, Berlin, in 1982—becoming the contemporary complement to the Old Master and Impressionism blockbusters that were simultaneously building unprecedented audiences for art. The new painting and sculpture mixed Pop celebrity with a heavy dose of historical recall. In a revival of Romantic aesthetics, subjectivity was celebrated as the core of creative inspiration. Despite the radical positions of many of the artists involved, within the broader culture it became the conservative wing of Postmodernism—especially when contrasted with the use of more innovative media and more confrontational content by other artists. Sharp contrasts were drawn to the anonymous,

collective, and critical values of the previous decades. Coinciding with a period of economic growth in many countries, such immediate attractiveness secured its commercial and popular reception.

Nevertheless, the aesthetic power of this work resulted from the efforts of artists who had the courage to test whether traditional media could be pressured into sustaining the kind of interrogation that art had just undergone, and whether these media could meet the same kinds of demand as to content (or, at least, similarly taxing ones) that the new forms of Conceptual, Performance, Installation, and Process Art were successfully engaging. In short, the best artists of the 1980s strove to figure forth meaning, and to do so dramatically. For the painters, this meant above all that the visual field ceased to be primarily a picture or a surface, and became a site upon which randomly appropriated images met, often adventitiously, speedily, and with the implied energy of imminent departure. In the work of both painters and photographers, there was a shift from "perceptual" to "conceptual" seeing, from paying attention to the nuances of artisanal, material creativity to those of image movement within a quasi-virtual, extended, potentially infinite flow. For sculptors, the situation was both more and less complicated: those who continued to work with the idea of sculpture as a single object in actual space felt obliged to shift from the equipoise of abstract elements in abstract space (in the manner of British sculptor Anthony Caro) to exploring the possibilities of pitching the obduracy of raw materials against the subtleties of graphic or mental images. It was German painters and photographers who led these developments, while sculpture and installation were forged most strongly, and effectively, in Britain and then in the U.S.

### The Two Germanys

In the Federal Democratic Republic (F.D.R.; also known as West Germany) during the 1960s and 1970s, four tendencies dominated visual arts practice: international abstraction modeled on American Abstract Expressionism and French *art informel* (Informal Art) (in the work of, for example, Willi Baumeister and Ernst Wilhelm Nay); Pop Art (Konrad Klapheck, Wolf Vostel, Sigmar Polke); Op Art (the Zero Group in Düsseldorf); and Fluxus/Conceptual/Performance Art (Joseph Beuys). The German painters who came to prominence in the early 1980s set themselves apart from each of these. Many of them received their earliest training in the tenets of Socialist Realism in the German Democratic Republic (G.D.R.; East Germany), and were sympathetic to the socialist dream (but not to the failings of "actually existing socialism" in East Germany that obliged them to move to the West). From wherever in Germany they came, their work showed a deep knowledge of European figurative painting reaching back to Italian Mannerism, and was embedded in the graphic traditions of Northern European art, especially German

2.1 Bernhard Heisig
*The Unteachable Soldier's Christmas Dream*, 1974–75. Oil on canvas, 39⅓ x 42in (100 x 107cm). Kunstsammlung der Städtischen Museen Jena.

art, paying little heed to early twentieth-century avant-garde movements, especially French ones. Like contemporaries such as Günter Grass, author of the trenchant satirical novel *The Tin Drum* (1959), they disagreed strongly with the official viewpoint that Germany's turn to Nazism and its wartime defeat should be forgotten. The sanitized, consumerism-oriented consensus promoted by postwar governments did not, they believed, amount to an authentic national culture. The horrors of the past had to be confronted before Germany could recover its moral core as a nation. This approach, known as *Vergangenheitsbewältigung* ("coming to terms with the past"), became widespread —eventually achieving quasi-official status—and continued through into the twenty-first century, with pervasive influence on cultural production.

The situation inherited by artists who remained in East Germany was different. Beginning in 1949, the Communist Party had set out to build a society on socialist lines, following models provided by the U.S.S.R., including the belief that artists, supported by the state, should serve the people according to directives issued by the Party. On the winning side after World War II, its officials denied involvement with the Nazi past, including responsibility for its atrocities. The Berlin Wall was erected in August 1961, hemming in dissent and concretely dividing the city between two misleading public ideologies: historical anachronism and

historical amnesia. Socialist Realism predominated in East Germany, especially in the graphic arts, following the example of Käthe Kollwitz. Ten years later, however, East German leader Erich Honecker officially authorized artists to "explore the range and diversity of the creative possibilities."[6]

These changeable circumstances led East German artists to develop a unique form of contemporary history painting. It flowered particularly in Leipzig, in the work of the academy painters Werner Tübke, Bernhard Heisig, and Wolfgang Matthauer. Like many artists in the other cities (such as Walter Libuda, Willi Sitte, and Hubertus Giebe) who were committed to the principles of socialism but doubtful about the repressed form it was taking in East Germany, they tackled the complexities of "internal exile" through an allegorical realist style. Rejecting the orthodoxies of Soviet Socialist Realism, they staged scenes involving ordinary people and historical figures in actions of manic excess. In his 1964 painting *The Unteachable Soldier's Christmas Dream*, Bernhard Heisig portrayed his own fear-filled war service as a nightmare: the bombings and the battles are fought across his youthful, defenseless body. Ten years later, he revisited the same subject with greater effectiveness (Fig. 2.1). Here, historical forgetting is registered, but shown to be also a matter of personal trauma. Much honored by the state, if hounded by its officials at times, when the Wall fell in 1989 Heisig returned all his

medals and resigned his high offices. He continues to live in the former East Germany.

In West Berlin, some months after the erection of the Wall, Georg Baselitz and Eugen Schönebeck, both emigrants from the east, issued their *Pandämonia*, two manifestoes in defense of existential paranoia and apocalyptic fantasy as proper responses to the times.[7] Also in 1961, the groups Vision and Galerie Grossgörschen 35 were founded. These were loose collaborations between artists—notably K.H. Hödicke and Markus Lüpertz— determined to foreground both stereotypical and exceptional German motifs. In 1965, Baselitz developed a series known variously as *Helden* (*Heroes*), *Neue Typs* (*New Types*), and *Partisans*. Despite the National Socialist and Socialist Realist ring of these titles, his images were profound reversals of the prototypes of earlier propaganda. The "heroes" required by the new Germany would be poets who were also pilots, and partisan painters: disheveled antiheroes, victims still searching, ravaged but open to hope. Usually single figures isolated against monochrome grounds, the series culminates in *The Great Friends* (*Die Grossen Freunde*) (1965) (Fig. 2.2). A poignant echo of Lucas Cranach's paired panels of *Adam* and *Eve* (1528), these two figures rise like gentle giants from the ruins of war and disgraced ideologies— symbolized by the burning buildings, discarded cart, and flag at their feet—to step forward into uncertainty together, sustained by nothing but their timorous trust in themselves and, perhaps, each other.

During the subsequent decades, however, Baselitz's quest turned against itself. This appears in his art in quite literal terms. Beginning in 1969, he settled on one format—the inverted image—which he invariably adopted, irrespective of subject, for the subsequent four decades. Motifs narrowed to the objects and people in a painter's studio, and his handling became more and more schematic, reminiscent of the work of the earlier group of German artists Die Brücke ("The Bridge"). These reductions accompanied his spectacular success as the leader of the so-called New German Painting, and as the inspiration to a younger generation of Expressionists—including Rainer Fetting, Salomé, and Jirí Georg Dokoupil— known in Berlin as Die Neuen Wilden (The Young Wild Ones) and in Cologne as the Mülheimer Freiheit (Freedom in Mülheim, the name of the artists' studio in this suburb of Cologne). In 2007, Baselitz began his *Remix* series, quoting his early works and pairing them with references to his later upside-down works.[8]

Beginning in 1970 and continuing through a series of increasingly large works over the following decades, Anselm Kiefer took on the task of becoming a poet of the German spirit, seeking for small flickerings of humanity in the nation's darkest corners. He probed the harsh recesses of the Nazi mind: its myth making, its medievalizing, its penchant for self-aggrandizing memoria. In so doing, he resurrected the almost entirely discredited landscape form, but at the cost of showing his country to be a site of the grossest violations and the graveyard of hope—a scorched earth. True to his

training under Conceptual and Performance artist Joseph Beuys, he developed this imagery from situations, performances, and installations. These led to photographs that he scaled up and then painted over. Mixed in were techniques derived from the woodcut, long a favorite medium in German art, but here rendered at unprecedented scale. And to these surfaces he attached materials from the sites depicted: used earth, fresh straw, burnt remnants. This is contemporary history painting, reinvented in epic dimensions.

These qualities are evident in the huge size and expansive scale of his painting *Germany's Spiritual Heroes* (*Deutschlands Geisteshelden*) (1973), along with others that are less obvious at first (Fig. 2.3). We are invited to enter a large hall, roughly timbered yet immensely solid. Burning braziers light our path forward, as we move from relative darkness into increasing light. Above us the words of the painting's title are inscribed, as if by charcoal on the wooden beam— yet a closer look shows us that they seem to float in space, and are painted onto the surface, reminding us that this is a created image, not an unmediated pictorial illusion. We notice other words, similarly inscribed, as if written in acrid smoke. They seem to march down either side of the room, as if they were medieval knights taking their places in a ritual, or as though they were to be laid on the floor, like bodies in a hospice. The names range from the thirteenth-century Mechtild of Magdeburg, through painters such as Caspar David Friedrich and Arnold Böcklin, to poets such as Richard Dehmel, writers such as Robert Musil, and the Romantic composer Richard Wagner, beloved of the Nazis, Hitler in particular. Others, such as Joseph Beuys, are contemporaries of the artist and have a more ambivalent relationship to the idea that "great men" make history. At the back of the hall, space narrows suddenly and concentrates on a black door, modest in size. The room depicted here is, in fact, an old schoolhouse that Kiefer used as a studio. In this painting it seems to have been inflated, exploded awkwardly toward us, and to be haunted by the insistent, expanding presence of a past in which the genuine heroes of the nation have been much abused by the misuse of their memory. This type of interplay between epic national narrative and intensely personal experience is definitive of Kiefer's art, no matter how monumental— even grandiose—it may seem.

During the 1960s, Jörg Immendorff was a participant in Düsseldorf Fluxus actions led by Joseph Beuys, and the creator of a parallel anti-academy named "Lidl" (a nonsense word echoing Dada). Inspired by Renato Gattuso's paintings of Italian radicals passionately debating with each other, Immendorff's *Café Deutschland* series (1978–84) directly depicts the artist working through the dilemma of appealing to the evacuated memories of those who show few signs of listening. *Café Deutschland I* (1978) (Fig. 2.4) is set in a West German nightclub. In the background, patrons drink, smoke, and have sex, oblivious to the exploitation of others on which their pleasures depend (symbolized by the two totems on either side). Two men attempt to paint

2.4 Jörg Immendorff
*Café Deutschland I*, 1978.
Oil on canvas, 111 x
130in (282 x 330cm).
Courtesy of Galerie
Michael Werner Berlin,
Cologne and New York.

2.5 Neo Rauch
*Art*, 2002. Oil on canvas,
98⅖ x 82⅖in (250 x
210cm). Carnegie
Museum of Art,
Pittsburgh, The Henry
L. Hillman Fund 2003.1.
Courtesy of Galerie
EIGEN + ART Leipzig/
Berlin and David
Zwirner, New York.

a German flag, but it splits in half. At left, Immendorff, himself half in uniform, half in street dress, fights off the huge swastika-clutching eagle that is bringing down the superstructure. The artist also sits in the center foreground, stretching out a hand of friendship, and in so doing breaks a hole in the miniature Berlin Wall on the table before him. Presiding over the stagelike scene is the dramatist Bertolt Brecht, much admired by Immendorff.

Although great efforts have been made since 1989 to integrate the two Germanys at every level, including the cultural, major differences remain. Forced integration became itself a question for art, not least for a younger generation of painters from Leipzig, most subtly since the late 1990s in the work of Neo Rauch, whose paintings, such as *Art* (2002) (Fig. 2.5), recycle graphic styles, costumes, and signs from the 1940s and 1950s to create pseudo-allegorical landscapes peopled by alienated antiheroes, whose quests seem to be journeys that are going nowhere, and by artists faced with impossible choices between ideologically loaded formulas for making art.

The return of repressed figuration did not entirely dominate German painting in the last decades of the twentieth century. Gerhard Richter provided a powerful counterexample. Works by Pollock and Fontana seen in the 1958 Documenta exhibition led him to reject his Socialist Realist training. He defected to West Berlin in 1961 and, in 1963, with Konrad Leung, staged Germany's first Pop Art exhibit—*Live with Pop: A Demonstration for Capitalist Realism*—in a furniture store. Richter despised the tendency represented by Kiefer and Immendorff, seeing them as failed painters who "cover up their impotence, helplessness and sheer stupidity with stage-sets and fashionably nostalgic debris from the rubbish-bin of history. Nazis in disguise."9

For ten years from 1977, Richter created a plethora of works by enlarging sections of photographs, figurative studies, and digital images, rendering them in highly colored oils, across which he then dragged a squeegee to generate blurred but extremely attractive abstract surfaces. The tensions that underlay his earlier works here seemed sacrificed to a rather ready sense of beauty. Yet in 1988 Richter produced the series *October 18, 1977*, 15 oil paintings derived from newspaper photographs relating to the violent lives and deaths of members of the R.A.F. (Red Army Faction), known as the Baader-Meinhof Group. Returning to a gray palette, the sequence of images passed from photographs of leader Ulrike Meinhof as a young woman, the arrest of the gang members, the failed effort to secure the release of other members through kidnapping, the deaths of some by hanging in their cells (Fig. 2.6), and their crowded public funeral. These subjects become visible only after long and careful scrutiny, and even then remain elusive. This is contemporary history painting of the kind achieved by Jacques-Louis David and others before and during the French Revolution. During the nineteenth century, this genre became the official art of empire and of nation-building. But its role in contemporary conditions is much more complex, not least because it no longer serves official purposes. Richter's series is a resonant testimony to the power of post-Conceptual painting to register, vividly and through veiled indirection, the inevitability and finality of death. In this case, the capacity to kill is shown to be in the hands not only of terrorists but also the state. This series matches the symbolic epics of Kiefer and Immendorff in powerfully questioning the façade of a consensual national culture which is controlled by people who, the artists believe, cannot be trusted.

2.8 Francesco Clemente
*Teaching Emotions with Feelings (Con i sentimenti insegna alle emozioni)*, 1980. Fresco, three panels, 118¹/₁₀ x 236¼in (300 x 600cm) overall. Private collection. Courtesy of Galerie Bruno Bischofberger, Zurich.

## Trauma of the Victimized

Christian Boltanski grew up in Paris in a Jewish family traumatized by their wartime experience. His earliest works were evocations of imaginary childhoods —ideal family life distinguished only by its ordinariness— presented as if they were displays in archeological museums. In the mid-1980s, he began creating large-scale installations of photographs, illuminated from above and taken from obituaries published in newspapers and discarded albums found on his travels through Europe. Arrayed as wall-mounted displays, usually in considerable numbers, the images evoke lives cut short, thus belying the warm desire for communicative exchange expressed in the smiling faces of those pictured. "I never speak directly about the Holocaust in my work, but of course my work comes after the Holocaust… The Holocaust taught me that we are no better than we were in the past," the artist has said.[10]

For the series *Reserve: the Dead Swiss (Réserve: Les Suisse Morts)*, Boltanski selected over 3,000 photographed faces from obituaries in the newspaper *Le Nouvelliste du Valois*. These images, chosen by relatives of the deceased as souvenir portraits, were pasted onto one side of biscuit tins, often used by displaced people as receptacles for their possessions. In a 1995 installation at the Church of Santo Domingo de Bonaval, Santiago de Compostela, Spain, the tins were stacked in rows to form a gridded wall across the arched entrance to a chapel, blocking off the space behind. Elsewhere, they were piled up into towers, or formed two sides of a narrow passageway, and illuminated by arc lamps (Fig. 2.7). The artist commented: "Previously my works showed dead Jews, but 'Jew' and 'dead' just go together too well. Swiss people just look perfectly normal. There is really no reason why a Swiss should die. That's why all these dead people are so terrifying. They are us."[11] These tins are empty. We sense that just by looking, although we are not sure. Relics of moments when a particular human life was deeply valued persist with poignant anachronism into the present: a time when the value of each human life is shadowed by the memory of the twentieth-century genocides.

## The Italian Transavantgarde

In contrast to the treatment of such portentous matters by artists from Germany, France, and elsewhere, art critic Achille Bonito Oliva made bold claims that a loose grouping of Italian, mainly Neapolitan, artists best represented the "transavantgarde" spirit of the times. To him, this attitude entailed a Postmodern reversal of historical determinism and art-historical obligation in favor of "a continuous lateral movement whose path crosses every contradiction and every commonplace, including that of technical and operative originality."[12] Nomadic through time and place, eclectic in their use of imagery from anywhere, artists such as Sandro Chia, Francesco Clemente, Enzo Cucchi, Nicola de Maria, and Mimmo Paladino had created art in which the painted surface traced the perpetual free-spirited transit of personal and cultural imaginings. Contrasting their practice with German artists', Oliva said of them: "Working in fragments means preferring the vibrations of sensibility to monolithic ideological content… fragments are symptoms of an ecstasy of disassociation… signs of a desire for continuous mutation."[13]

No artist more thoroughly and consistently exemplifies this ideal than Francesco Clemente. In constant mobility between cultures, he paints in oil, pastel, watercolor, and fresco, and produces miniatures and sculptures, adopting styles and techniques ranging in source from ancient Rome to nineteenth-century Pondicherry. He is the central figure in his own iconography, appearing in nearly all of his works. Yet he initiates nothing: he is, always, someone to whom things happen. In the first of the three panels of the fresco *Teaching Emotions with Feelings (Con i sentimenti insegna alle emozioni)* (1980) (Fig. 2.8), his supine form floats in a yellow sea of ecstasy, every orifice touched gently. Alone in the central panel, he anxiously dances a desperate jig. These actions are lightly allegorized in the third panel: a leafy sprig yields schematic roses; a heart shape has been carved into the painted plaster.

2.9 Philip Guston
*Pit*, 1976. Oil on
canvas, 74½ x 116in
(189.2 x 294.8cm).
National Gallery of
Australia, Canberra.
Purchased 1980.

2.10 Julian Schnabel
*Circumnavigating the
Sea of Shit*, 1979.
Broken ceramics,
bondo and oil on
wood, 96½ x 96in
(245 x 244cm).
Courtesy of
Galerie Bruno
Bischofberger, Zurich.

2.11 Eric Fischl
*The Power of Rock
and Roll*, 1984.
Oil on linen, 120 x 80in
(304.8 x 203.2cm).
Courtesy of the artist.

## The American Scene Again

Philip Guston, perhaps the most subtle and reclusive of the first generation of the American Abstract Expressionists, surprised most—and set an extraordinary example to younger artists—when, in the late 1960s, he turned to large-scale, raw paintings of ordinary objects rendered in the style of cartoonists George Herriman (creator of Krazy Kat) and Robert Crumb. Here, a cast of hooded yet benign characters struggle through the travails of everyday existence, or fall subject to ciphers of authority. In *Pit* (1976) (Fig. 2.9), the artist joins the crowd of humanity, symbolized by horseshoe-clad feet, thrown into a yawning chasm, as a radio blares out its silent but oppressive message across a desert landscape.

While older-generation artists such as Guston—and others, notably Leon Golub—received renewed attention because of their return, after decades in which nonfigurative abstraction was dominant, to explicit statements of meaning, the use of images to make potent connections became a cliché in the work of the leading younger U.S. artists. In the case of the latter, however, the intimation yet avoidance of pointed meaning fitted closer to their mood: evoking a keen sense of the absence of meaning was their pursuit. Yet the fact that they pursued these concerns in paintings, however bizarrely, suited a market in search of commodities. Paintings remain the most salable form of art: their stocks rise with each economic boom, with the entry of new collectors into the market and the further enrichment of established collectors. Although artists from Europe led this revival, the art market in

New York recovered from the recession of the 1970s to become the major center for sales of modern and then contemporary art during the 1980s. This inevitably framed artistic practice, perpetuating the Warhol example of artist as celebrity. Foremost among Warhol's successors in this regard was Julian Schnabel, who energetically and successfully sought such fame, both directly and through the ambition of his art. Large works on big themes, in which random imagery collided on broken surfaces, became his signature style. *Circumnavigating the Sea of Shit* (1979) (Fig. 2.10) is typical: smashed plates, signifying a civilization at odds with itself, provide the ground, across which swing distorted shadows cast by furniture and trees, an inverted primeval landscape. Schnabel went on to direct some highly acclaimed films, beginning with *Basquiat* (1996).

The main contribution of U.S. artists of the 1980s was to take a step beyond 1960s Pop Art's use of mid-twentieth-century imagery such as that appearing on billboards, in magazine advertising, and as publicity photographs. Without forming a group, tendency, or style, a number of key artists found ways of evoking the long-term impact of Hollywood fantasy and consumerist desire on the imaginary life of millions. It is no accident that many of these artists came from, or were trained, in Los Angeles (notably at the Disney-funded California Institute of the Arts). In a loosely brushed manner paralleling the Neue Wilden, Eric Fischl pictured this hedonistic lifestyle in works such as *The Power of Rock and Roll* (1984) (Fig. 2.11) as if it were a culture seen from outside. Fischl often shows scenes from the viewpoint of a young boy. What might be going on in

2.12 David Salle
*What Is the Reason for Your Visit to Germany?*, 1984. Acrylic, lead, oil on canvas, wood, 96 x 191in (244 x 486cm). Courtesy of Mary Boone Gallery, New York. Licensed by VAGA, New York, NY.

such an observer's mind is seen in the work of David Salle. Of his colleague, Fischl observed that he "re-stated for his generation the whole thing about the meaning-fulness of meaninglessness… He puts the images out there as if he were only talking in nouns. The nouns call up things but they don't connect."[14] Salle became the master of double-panel painting: a format in which two, sometimes more, paintings are latched together, in apparent incongruity. Within each panel, images of many kinds appear in odd conjunctions. In *What Is the Reason for Your Visit to Germany?* (1984) (Fig. 2.12), a large, bent-over nude seen from between her legs, painted in grisaille on a red ground and suggesting a faded pornographic photograph, becomes background to two sketches of John F. Kennedy assassin Lee Harvey Oswald being shot, a stalactite of palette-knifed abstraction in the manner of Canadian painter Jean Riopelle, and the French word "FROMAGE" ("CHEESE")—what could link these "nouns"? The painting hints at a number of answers, all of which have to do with the pleasures and dangers of a curiosity that turns into obsessive, secretive looking, itself under surveillance.

The East Village of New York became the launching pad for a number of younger artists inspired by graffiti on streets and subways. Keith Haring drew his quasi-human graphic characters across any surface he could find, vividly projecting themes about the power of media such as television, the futility of the pursuit of money, the joys of homosexuality, and the threat of AIDS. Jean-Michel Basquiat graduated from the graffiti group SAMO© to confrontational paint-ings that combined a sophisticated response to sources ranging from Dubuffet, Rauschenberg, and Twombly, to Leonardo's sketchbooks and Gray's *Anatomy*. His *Untitled* (Skull) (1981) (Fig. 2.13) is a self-portrait, riven by the racial and social conflicts of the modern city, set against a field that is at once a painterly abstraction and a graffiti-covered wall; his head looks like a trophy on a stick. In 1984, Basquiat collaborated with Andy Warhol

and Francesco Clemente on a series of works. He died in 1990, aged 27, from drug overuse. Haring died three years later, aged 32, from AIDS.

## British Schools

Elsewhere in the world during the 1980s, figurative painting served as a powerful vehicle for emotion and observation, but occurred in more isolated instances and had less impact on the direction of local art. In London, for example, a number of older artists who had sustained the force of their earlier vision—Francis Bacon, Howard Hodgkin, Leon Kossoff, Frank Auerbach, and Lucian Freud—inspired younger painters, such as John Walker and Thérèse Oulton, with their combined achievement suggesting to some (not least the American-born painter R.B. Kitaj) a "School of London."

The rich tradition of quasi-figurative abstrac-tion in British sculpture, embodied in the twentieth century above all by Henry Moore, is echoed in a new generation of post-Conceptual sculptors led by Antony Gormley, Tony Cragg, and Anish Kapoor. Gormley's best-known work is his *Angel of the North* (1998), a monumental winged humanoid set in open fields at Gateshead that stands over the main axial motorway in Britain. A strong strain in Gormley's work is formed by his assemblies of small clay figurines, molded quickly by hand into schematic statues, each one slightly different, yet all with two large eye sockets staring from upturned heads. Installations such as *Field for the British Isles* (1993) (Fig. 2.14) gather 40,000 of these figurines into a teeming mass of miniaturized humanity, tiny but unstoppable, a crowd at once mute yet pleading, vulnerable yet open to an (unspecified) enlightenment.

Unconventional use of well-known materials can provoke insight into the sometimes strange, elusive relationships between our bodies and the inanimate matter that constitutes much of the material world.

2.13 Jean-Michel Basquiat
*Untitled*, 1981. Acrylic and mixed media on canvas, 81 x 69¼in (208.2 x 175.8cm). The Eli and Edythe L. Broad Collection, Los Angeles.

2.14 Antony Gormley
*Field for the British Isles*, 1993. Terracotta, dimensions variable, approx. 40,000 figures, each figure 3–10¼in (8–26cm) high. Installation view, Irish Museum of Modern Art, Dublin, Ireland Arts Council Collection, England. Arts Council Collection, England.

2.15 Anish Kapoor
*I*, 1987. Limestone
and pigment, 23¼ x
24¹⁄₁₀ x 37⅓in (59 x
63 x 95cm). Courtesy of
Lisson Gallery, London.

On a trip to his native India in 1979, Anish Kapoor was moved by the ritual power of raw pigment. Returning to London, he explored ways for viewers to contemplate the sublime, the unfathomable at the core of known universe. In *I* (1987) (Fig. 2.15), Kapoor hit on the quintessential sculptural formulation of this experience: a large block of rough-hewn limestone invites us to bend over and look into the black hole cut into its top surface, its seductive beauty yet ultimate invisibility secured by the precise tone of the powdered pigment within. There are parallels here to, as well as evocative differences from, the humanoid presences in Gormley's art, and to the tracery of natural processes in the work of Andy Goldsworthy (see Figs. 11.2 and 11.3).

## Critical Postmodernism

During the 1980s and 1990s, a number of artists used Postmodern ideas and theories to pursue a very direct, confrontational critique of commercial and official media. They took up the analyses of media rhetoric by philosophers such as Roland Barthes and devised ways of turning them into different kinds of critical counter-media. Prominent among these artists was Jenny Holzer. Having given up painting in 1977, U.S. artist Holzer spent the next two years writing *Truisms*, 200 statements various selections from which she published as posters, on T-shirts (Fig. 2.16), billboards, and the electronic news-boards in Times Square, New York, and Candlestick Park, San Francisco, and as installations in text, stone, and LED writing in galleries and museums. They mixed citations displaying both common sense and prejudice with sloganlike announcements that ape official com-munications and moralizing sayings, all addressing the themes of sex, death, and war: "Abuse of power comes as no surprise," "Any surplus is immoral," "Freedom is a luxury not a necessity," "Sex differences are here to stay." Other series continued these practices: from the *Survival* series (1983–85) comes the poignant "Protect me from what I want." Since 2004, Holzer has used classified documents relating to the U.S. war against Iraq as the basis for a series of "Redaction Paintings" aimed at exposing the facts covered up in the name of national security during the "War on Terror."

"All violence is the illustration of a pathetic stereotype" was the message staring out from one wall of U.S. artist Barbara Kruger's 1991 installation at the Mary Boone Gallery, New York (Fig. 2.17). Running through the banner with these words on it was another strip filled with the language of hate, while behind their convergence loomed photographic images of a young boy screaming. Ten years earlier, Kruger had adopted what became her characteristic mode of visual address: back and white images rephotographed from existing sources, especially mid-century photography annuals and manuals, cropped and enlarged to form backgrounds or surfaces for phrases of her own devising typeset in Futura Bold Italic and framed in red as pictures or posters. Years of work as a successful graphic designer lay behind these choices, as did the knowledge that both the artworld and the public media appreciated an instantly recognizable style.

Kruger was one of a generation of artists who used photographs to undertake a critique of representation as it was practiced both in commercial advertising and in Modernist "art photography." Sherrie Levine presented copies of key images by photographer Edward Weston and others, often in duplicate, as untitled works of her own. By recording—usually at unusual angles or from oblique and tangential perspectives—the instal-lation of exhibitions in museums and galleries, or the settings of artworks in private homes, Louise Lawler drew attention to the conditions in which works of art, including art photographs, created their aesthetic effects. Outstanding among this group, Cindy Sherman began

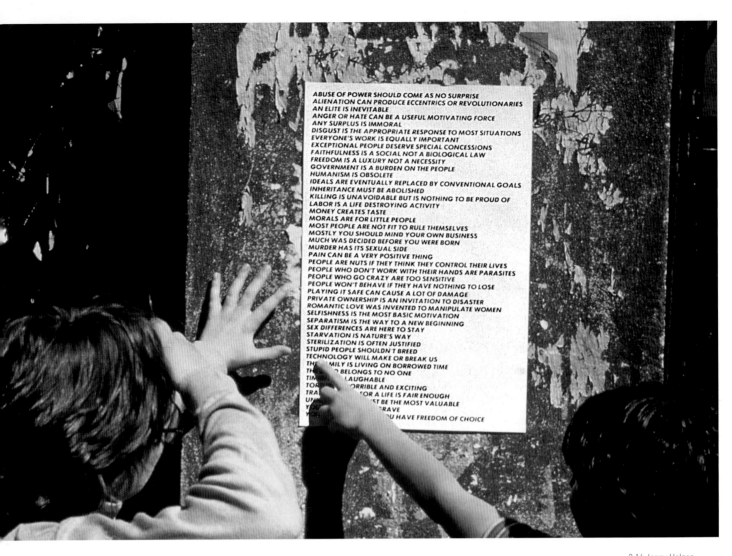

2.16 Jenny Holzer
From *Truisms*, 1977–79.
Installation, New York,
1977, offset poster,
36 x 24in (91.4 x 61cm).

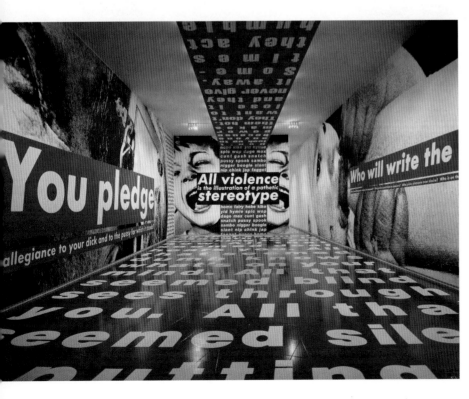

2.17 Barbara Kruger
*All Violence is the
Illustration of a Pathetic
Stereotype*, 1991.
Installation, the Mary
Boone Gallery, New
York, January 1991.
Courtesy of Mary Boone
Gallery, New York.

2.18 Cindy Sherman
*Untitled Film Still #6*,
1977. Black and white
photograph, 10 x 8in
(25.4 x 20.3cm).
Courtesy of the artist
and Metro Pictures,
New York.

2.19 Thomas Lawson
*Don't Hit Her Again*,
1981. Oil on canvas, 48 x
48in (121.9 x 121.9cm).
Collection of the artist.
Courtesy of the artist
and David Kordansky
Gallery, Los Angeles, CA.

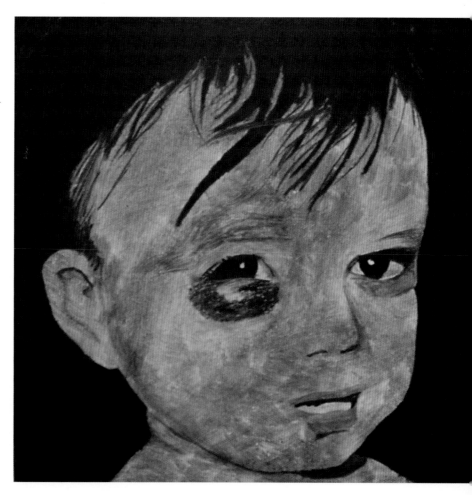

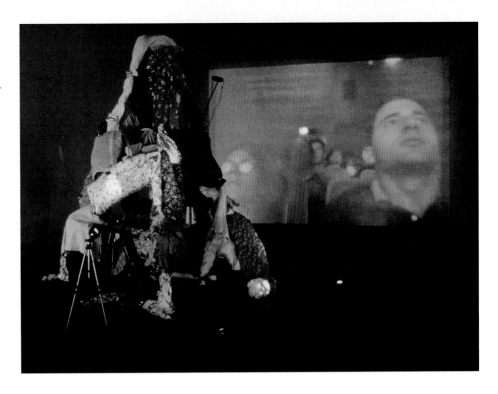

2.20 Tony Oursler
*System for Dramatic
Feedback*, 1994.
Rag dolls and
ten-channel video
and sound installation,
Portikus Gallery,
Frankfurt-am-Main.
Courtesy of Tony
Oursler and Metro
Pictures, New York.

her critique with the series *Untitled Film Stills* (1977–80) (Fig. 2.18), which consisted of black and white images of herself dressed and posed as an actress in imagined movies, the stills imitating the style of those issued by the studios distributing the films of directors such as Alfred Hitchcock and Michelangelo Antonioni. Since 1980, Sherman has worked in color, and at increasing size, while continuing to use herself as a model for images that examine women as subject to the ever more destructive gaze of the viewer. At times, the depicted figure seems the victim of monstrous abuse; at others, it adopts the defiant independence of a quasi-human monster. Through a trenchant use of the visual imagery of masquerade, Sherman has, for over 30 years, sustained an exploration of the psychology of the social positioning of women, and of women's self-positioning, that is unparalleled in contemporary art.

Photography was not the only medium in which Postmodernist critique found expression. Certain modes of painting were deployed, in consciously paradoxical ways, fully alert to the medium's supposed anachronism, by a group of artists allied with the New York gallery Metropictures, and subsequently known as the "Pictures Generation." Their approach was best theorized by Scottish artist Thomas Lawson in an influential *Artforum* essay of 1981 entitled "Last Exit: Painting." Lawson argued that, in a world saturated by systematically misleading commercial and official visual media, and in an artworld adept at marginalizing the most radical practices, using "the least suitable vehicle"—painting—was the only way to draw attention to the realities of contemporary life.[15] Lawson's own paintings—such as *Don't Hit Her Again* (1981) (Fig. 2.19)—an enlarged, burnished rendering of an abused child's face—most clearly exemplified his argument.

Lawson's last-ditch stand for painting was overridden by the increasing numbers of artists who tackled similar themes through video and film that they arranged into installations. Tony Oursler's *System for Dramatic Feedback* (1994) (Fig. 2.20) is a ten-channel video and sound installation in which nine small video projectors animate an elephantine pile of rag dolls of varying sizes, while a single large projection on the wall behind shows black and white film of a cinema audience, bathed in their unseen screen's silvery glow, who seem to stare into the room. As one enters the space, a nondescript piece of calico takes on a head shape, with wide eyes and an anxious expression, that screams "Oh, no! Oh, no! Oh, no!" For some, this is a child *in extremis*, witnessing some unspeakable horror, or imagining it about to happen. For others, it is an attention-seeking, or a warning, figure. As one approaches the pile of dolls, each appears to perform a distinct action due to the film projected onto parts of their bodies. At the top of the pile, one doll is repeatedly smacked on the backside by a projected hand; the slap resounds, while other figures murmur. From behind the mound, a naked female figure seems to lurch forward, straighten up, then fall down—over and over. Inside the mound, a male figure strives for a projected erection, which soon falls flaccid—again and again. At the base of the pile, a giant head made of white cloth has a face blurred with generalized anxiety. Emotions generated by this installation range from shock at its explicitness about base human desires to sympathy toward the therapeutic value of enacted repressions and amusement at its profiling of sexual fantasies. Some psychoanalysts locate the origin of fantasy at the point where the child realizes it is separate from its mother, others at the moment when the child realizes that its doll is in fact inanimate—fantasies rush in to fill the void. Each of the projected faces and actions in Oursler's work takes us back, as individuals, to this kind of formative moment. But the pile of bodies also recalls those victims of the inhumanity that social

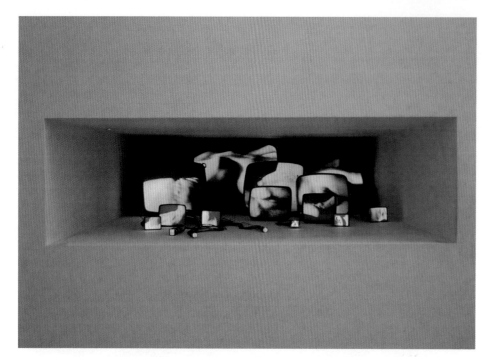

2.21 Gary Hill
*Inasmuch As It Is Always Already Taking Place*, 1990. Sixteen-channel video/sound installation. Sixteen modified ½-inch to 23-inch black and white video monitors (cathode ray tubes removed from chassis), two speakers, 16 DVD players and 16 DVDs (black and white; one with stereo sound). Dimensions of horizontal niche: 16 x 54 x 66in (41 x 137 x 167cm). Edition of two and one artist's proof. Courtesy of the artist and Donald Young Gallery, Chicago.

structures and organizations, such as fascism, engendered during the twentieth century. The audience sitting in absorbed silence on the back wall reminds us that many of our shared pleasures turn us into spectators, passive witnesses to the pain of others.

For *Inasmuch As It Is Always Already Taking Place* (1990) (Fig. 2.21), Gary Hill filmed a specific human body—his own—close up, from a large number of angles and at a consistent speed, creating 40 different video loops. The resulting installation consists of 16 of these loops, each playing on a separate raster (a monitor without its casing). The different-sized rasters are arrayed—as if in a shop selling electronic goods, or perhaps art jewelry—on a shelf recessed 5 feet into a wall, slightly below eye level. Naturally, the viewer seeks to compose these body parts into a single whole figure, or to discern in the camera's movement, over time, a purposeful narrative. Fragments may be made out: the largest screen shows a life-size view along a back. But soon we feel that we are seeing our own back, as if our head were hovering above our buttocks. Impossible-to-see body parts become uncannily familiar. Miniaturized ears, foot arches, armpits become mesmerizing still-life studies. A thumb plays with the corner of the page of a book. Soft sounds—a tongue clicking, rippling water, skin being scratched, and quietly spoken phrases—create an ambience of closeness and privacy. The disposition of the rasters, with their electrical wires snaking between them, implies a splayed-out body, quasi-mechanical but also spiderlike. Inside this "creature," we can see, lives a human, one whose parts we can discern but whose whole remains invisible—because it has, perhaps, somehow been displaced to the machineries of mediation in which it is immersed. A more pointed representation of the Postmodern idea of the decentered self in a fragmented, spectacularized society is hard to imagine.

Postmodern critical theory and the installation format have both been important tools for the growing number of African-American artists whose work explores public perceptions of racial identity. While sculptors such as Martin Puryear, and painters such as Glen Ligon and Lari Pittman, do so by subtle extensions of their media, artists such as Adrian Piper, Fred Wilson, Lorna Simpson, David Hammons, Carrie Mae Weems, Kara Walker, and Ayanah Moor mix media, and move between them, to challenging effect. *Corridor (Phone)* (2003) is a pair of photographs based on scenes from Lorna Simpson's video installation *Corridor* (2003) which follows, on matching screens, the daily lives of two women: one a household servant in the 1860s, the other a rich woman in the 1960s (Fig. 2.22). While the first does her chores and attends to her toilet in the dark corridors of a wood-paneled mansion, the second lives in the glare of a clean-lined, sun-filled Modernist house. Both women seem entirely alone, yet the servant seems to accept her lot, and be satisfied with internal reflection, while the modern woman constantly attempts to communicate with the world outside and prepares herself to be seen by someone unspecified. Both women, we slowly realize, are enacting stereotypes: they are trapped within them, but are also finding space to live, tolerably, within them.[16] The Kenya-born, Brooklyn-based artist Wangechi Mutu, whose work regularly and provocatively addresses the complex call of traditional roles and beliefs on contemporary African-American women, plays both parts.[17]

In her installations, films, wall texts, and drawings, Kara Walker uses imagery that seems, at first, old-fashioned and quite charming—thus the title of her *Slavery! Slavery! Presenting a GRAND and LIFE LIKE Panoramic Journey into Picturesque Southern Slavery or "Life at 'Ol' Virginny's Hole' (Sketches from Plantation Life)." See the Peculiar Institution as Never Before! All Cut from Black Paper by the Able Hand of Kara Elizabeth Walker, an Emancipated Negress and a Leader in Her Cause* (1997) (Fig. 2.23). Adapting vignettes of working life and leisure

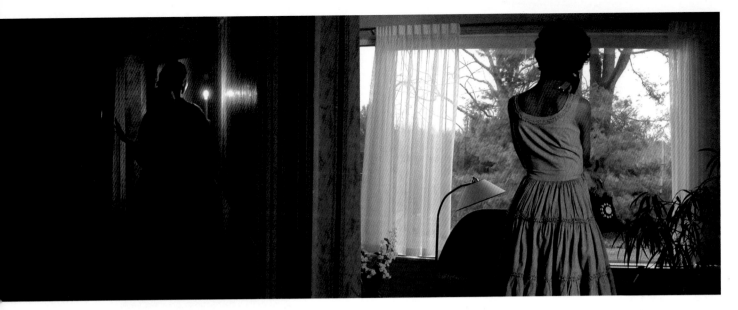

2.22 Lorna Simpson
*Corridor (Phone)*, 2003.
Photograph, 27 x 72in
(68.5 x 182.8cm), based
on *Corridor*, 2003,
double-projection video
installation. Courtesy of
Salon 94, New York.

2.23 Kara Walker
*Slavery! Slavery!*
*Presenting a GRAND*
*and LIFE LIKE Panoramic*
*Journey into Picturesque*
*Southern Slavery or "Life*
*at 'Ol' Virginny's Hole'*
*(Sketches from Plantation*
*Life)." See the Peculiar*
*Institution as Never*
*Before! All Cut from Black*
*Paper by the Able Hand*
*of Kara Elizabeth Walker,*
*an Emancipated Negress*
*and a Leader in Her*
*Cause*, 1997. Cut paper
on wall, 12 x 85ft (3.7
x 25.9m). Collection of
Peter Norton and Eileen
Norton, Santa Monica,
California. Courtesy of
the artist and Sikkema
Jenkins & Co., New York.

2.24 Jeff Koons
*Puppy*, 1992. Stainless
steel, soil, geotextile
fabric, internal irrigation
system, and live
flowering plants, 40½ x
40½ x 21⅓ft (12.3 x 12.3
x 6.5m). The Solomon R.
Guggenheim Foundation,
New York.

from Eastman Johnson's 1859 painting *Old Kentucky Home—Negro Life at the South*, this 85-foot-wide mural is laced with acts oppressive and erotic, showing the labor and sexual economies of the antebellum South to be two sides of the same human coin. Of her favorite technique, Walker says: "The silhouette says a lot with very little information, but that's also what the stereotype does. So I saw the silhouette and the stereotype as linked."[18] Her work is dedicated to a no-holds-barred attack upon stereotypes, including those that would constrain the aggressiveness of black Americans in the name of avoiding conformity to those very stereotypes. It has, as a result, been extremely controversial, not least among other African-American artists.[19]

Whatever the subject matter it carries, the installation format has become ubiquitous in contemporary art because it enables artists to deploy a number of media at once, to do so in spaces that, although delimited in practice, imply extension, and to present work with or without prescribed time limits to viewers who can choose their own time and length of engagement with the work, which they view either singly or with others. In all of these respects, installation is contemporary—indeed, it is the form that most completely embodies the multiple elements of the contemporary discussed above, in the General Introduction. And it does so as an open-ended setting, one that prescribes little but enables much. Small wonder, then, that its adoption has been so rapid, and variations on it have proliferated so quickly, as we shall see in the pages that follow.

## RETRO-SENSATIONALIST ART

If Picasso was the most prolific, stylistically promiscuous, and celebrated artist of the twentieth century, then Andy Warhol was the artist most immured in celebrity itself, eventually making it the main content and point of his art. In 1980, U.S. artist Jeff Koons set out to build on the lessons of both artists. Experienced as an interior decorator, artworld manager, and stock trader, he parlayed a Pop Art-like questioning of commodity culture into a celebration of it so excessive that it outsold most of the excesses of commodity culture itself. His 1980–82 series of Perspex-encased, store-fresh vacuum cleaners was entitled *New*. Of this kind of commodity he observed: "It's brand new, it's in a position to out-survive you, the viewer. It doesn't have feelings, but is better prepared to be eternal."[20] In subsequent series entitled *Luxury and Degradation*, *Statuary*, and *Banality*, Koons selected kitsch objects, from the mass-produced to the most expensive, and reproduced them in odd materials and on an exaggerated scale. The most popular example is *Puppy* (Fig. 2.24), a garden growing over the armature of a crouching dog, here 38 feet high but usually offered as a small house or garden ornament—which is what *Puppy* is, as each of the five versions in this limited edition is installed in front of castles (Schloss Arolsen, Germany) or museums (Guggenheim, Bilbao). Subsequently, Koons continued to elaborate imagery

appropriated from popular culture and kitsch ornament in inflated sculptures and in factory-produced paintings that recalled, in their application of paint, the billboard style of James Rosenquist, and, in their cheerful arrangements of imagery, David Salle's style but not his purpose.

Beginning with an exhibition in a disused building in the London Docklands in 1988 entitled *Freeze*, English artist Damien Hirst assiduously sought attention for his work and that of his fellow Goldsmiths College students. They formed the core of the "YBAs"—Young British Artists—as they became known when publicized by their first and most comprehensive collector, advertising man Charles Saatchi. Relentlessly promoted by Saatchi, their work achieved extraordinary market success and public notoriety. *Sensation*, a 1997 survey exhibition first mounted at the Royal Academy of Arts, London, lived up to its title, especially when it traveled subsequently to the Brooklyn Art Museum, New York. There, key works drew so many objections (the mayor of New York condemned Chris Ofili's 1996 painting *The Holy Virgin Mary* as blasphemous for depicting an African Madonna fixed in place by clumps of elephant dung and floating ethereally in an aura sprinkled with collages of naked female buttocks) that the exhibit was closed down.

After years of displaying his private collection, and cycling it successfully through the auction houses, Saatchi was able to establish a major public gallery in London in 2003. He promoted the YBAs as at once smart art and good advertising: "What is it about the life cycle of flies, someone's old bed, a portrait of a child killer made with children's handprints, mannequins with knobs on, someone sitting on a toilet holding a cistern, that makes British Art so different, so appealing? There's no clear link, just a very direct, almost infantile energy that gives the work here its full-on, check-this-out force."[21] This phrasing echoes the title of the 1956 collage by Richard Hamilton entitled *What Is It That Makes Today's Homes So Different, So Appealing?* (see Fig. 1.10). A generation later, Saatchi worked assiduously, and successfully, to promote key works in his collection as icons of the new British art. These artists were not the first to accept the priorities and techniques of effective advertising, but were perhaps the least inhibited in doing so. Works were designed to have direct impact on viewers, to be shockingly unexpected in either form or content or both, and to remain in the mind as a single image, one that could be reinforced by constant reproduction in the media. Sensational art with, it seems, just one aim: to be sensational. As one acute observer put it, in an allusion to the packaging of low-alcohol and low-calorie beer, this is "High Art Lite."[22]

Such an assessment does not, however, explain the power of at least some of this work, or the ability of certain of the artists to sustain their exploration of important issues over time. Unlike first-phase Pop Art, Retro-Sensationalist art of the 1990s did not confine itself to recycling existent popular imagery: at its best, it sought to have a brandlike effect, using imagery born of conjunctions of the unfamiliar and the unspoken to

bring to sight that which was usually out of mind. Hirst acknowledges: "You have to find universal triggers, everyone's frightened of glass, everyone's frightened of sharks, everyone loves butterflies."[23] And then present those triggers in a style consistent with mediated imagery: that of film, television, and advertising. Yet Hirst's main theme cuts deeper: the sense of decay, uncertainty, and closeness to death that pervades everyday life, even in the purported paradise of consumerism.

One of Hirst's best-known works captures this interplay between mediated image and psychic reality with unforgettable precision. *The Physical Impossibility of Death in the Mind of Someone Living* (1991) (Fig. 2.25) consists of a (12-foot 8-inch) man-eating tiger shark suspended in formaldehyde inside a glass and steel tank. At first, the work seems a novel way of presenting a shock image familiar from newspaper stories and Steven Spielberg's popular film *Jaws*. Yet its actuality changes the dead animal. Presenting it as if it were alive and in its habitat (a form of display favored by natural history museums) adds something more to the work's impact on viewers. The ensemble becomes a quintessential arrested image, evoking the fear of unexpected attack, of instant death coming from a great distance—indeed, from the nowhere that is all around us. Its title indicates the artist's acute awareness of unconscious processes, especially those involving trauma. The literal meaning of the title stands in stark contrast to the impact of the work itself as we stand before it, walk around it: as a proposition, it makes the plausible claim that a living being cannot imagine death in any specific way, yet shark attacks do happen, and are made into an imaginable possibility by the darting, open-jawed animal before us. More generally, psychic disturbance—fear of terrific effects that result from causes beyond our control, beyond our ability to prepare for, even to anticipate—is one of the great legacies of the twentieth century. Trauma became a central subject for artists during its last decades. Few dealt with it as consistently, or with as much media savvy, as Hirst.

The other works in Saatchi's list of "icons" seem more obviously possessed of that other quality in his description of them, having a "very direct, almost infantile energy." Their humor is broad: twentysome-thing regressions to adolescence aimed to shock publics accustomed to art as elevated indirection. But the most interesting work of this generation is, like Hirst's, tinged with trauma and intimations of abuse. Tracey Emin takes as her subject her own life as an abused child of immigrant parents who has fought her way to public notoriety and artworld stardom. Best known is *My Bed* (1998) (Fig. 2.26), a variable installation of her unkempt and human-stained bed, strewn about with personal memorabilia such as snapshots, toy, slippers, and suit-cases, as well as other items such as discarded bottles, cigarette butts, and condoms. In one version, a noose hangs above the bed. In all variations, the bed is sur-rounded by Emin's wall quilts, which feature crude cut-out statements that appeal for love, or express anger

at rejection or fear of violence. While on one level *My Bed* simply displays the physical traces of a confused life and seems the product of a terminal narcissism, on another it registers the struggle by members of the artist's generation to achieve personality in what they understand to be bland, corporatized, politically reactionary societies.

We have seen that the Conceptualist interroga-tion of the idea of art, its testing of art's boundaries, was often carried out via objects, performances, or events that were intended to ask the question "Is this art?" The Retro-Sensationalist artists thought that the best place to raise this issue was as a headline in a newspaper, or as a lead story on television. As such, the work could chal-lenge aesthetic norms as envisaged by both the artworld and the general public. The most energetic and skillful inheritor of this trajectory is Takashi Murakami, whose work we will discuss in Chapter 5.

## REMODERNISM IN SCULPTURE AND PHOTOGRAPHY

Many of the great experiments that had earlier dematerialized sculpture appeared in new forms in the monumental public art of the 1980s. U.S. artist Richard Serra had been a leading proponent of art that demonstrated an active process rather than sought to shape a finished object. Serra soon developed a pow-erful strategy for building this kind of dynamism into works that seem, at first, as reductive and self-contained as most Minimal sculpture, but which in fact draw the spectator into a much more engaged relationship. This energy flows from their size, their evident weight, the eccentricity of their angles, and the precariousness of their positioning—all qualities that are strongly felt by each observer's mobile eyes and body. Serra's sculptures require one to walk close to, around, or through them. In this sense, they share much with their immediate predecessors, happenings, and environments. The most controversial of his works, *Tilted Arc* (Fig. 2.27), was a 120-foot-long partial cylinder of raw Cor-Ten steel, 2½ inches thick and 12 feet high, installed in the Federal Plaza, New York, in 1981. Set against the banal geome-tries of the bare courtyard in front of the office building, and deliberately blocking a fountain, it stood astride the most direct access from the main street to the door, inviting people to measure themselves against it as they passed by. Judges working in the building and the courts opposite led a campaign for its removal. Since the work was designed specifically for that site, Serra objected that to remove it would be to destroy it. Nonetheless, it was removed in 1989. Despite many such battles, Serra's work has set the standard for Post-Minimal public sculpture, architecture, and memorials.

Yale University graduate student Maya Lin was inspired by Serra's work when coming up with what became the winning entry in the competition to design a Vietnam Veterans Memorial. Installed on the Mall in the national capital, Washington, D.C., in 1982, it attracted some controversy at first but has since become

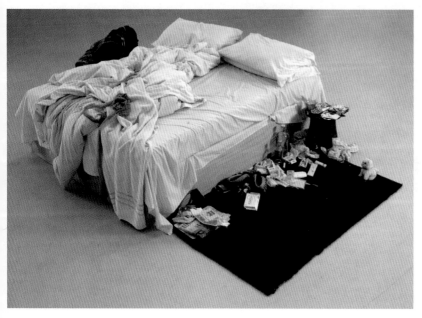

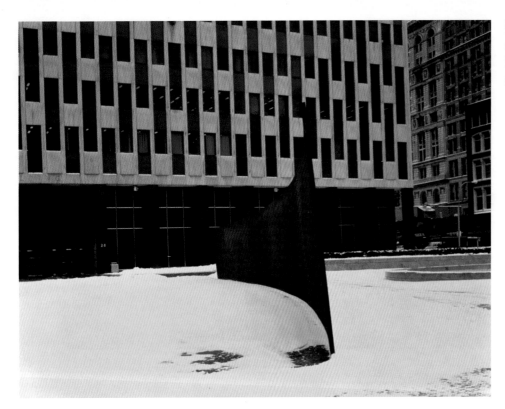

2.27 Richard Serra
*Tilted Arc*, 1981. Federal
Plaza, New York.
Cor-Ten steel, 120ft x
12ft x 2½in (36.5m x
3.66m x 6.3cm).

2.28 Maya Lin
*Vietnam Veterans
Memorial*, 1982.
The Mall, Washington,
D.C. Black granite, 493½
x 10¼ft (150.4 x 3.12m).

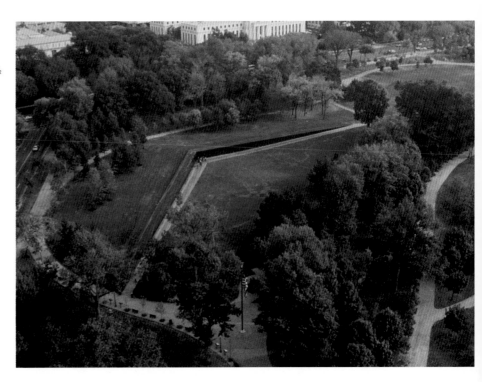

2.29 Richard Wilson
*20:50*, 1987. Used sump oil, steel, dimensions variable. Courtesy of the Saatchi Gallery, London.

much loved, attracting over 3 million visitors annually (Fig. 2.28). Experiencing Lin's marble wall requires us not to gaze at it from a distance, or close up from below, but to walk alongside it. As we descend the path beside it, noting the list of American casualties—all 58,161 of them—we face the fact of death, the irrevocability of specific human lives. The venal and arbitrary politics of that war quickly shifts to a more personal register. Even though it does not list the Vietnamese dead, Lin's design provides a protected place where anyone can perform a personal act of remembrance. As we walk up the ramps from the depths of the site, we exit toward views of the nation's most revered public icons: the Washington Monument and the Lincoln Memorial. In its formal design, Lin's memorial closes a gash in the earth, a slash in the parkland, a division in the national consciousness (and is thus a therapeutic memorial). War seems impossible from such a place: the anti-war sentiment at its core makes it an anti-monument.[24]

Later in this chapter we will see that contemporary architecture, using museum-building projects as its laboratory, reinvented itself in a series of variations on the spectacular. Meanwhile, sculptors reimagined architectural concerns in a fascinating variety of new ways. Environmental and Installation Art have led to a wide range of new approaches to space, its character as a human setting, and its social implications. Two English sculptors provide striking examples.

Richard Wilson reconceives the functions of standard architectural settings, transforming them into experiences of pure space. Since 1987, he has installed his work *20:50* (Fig. 2.29) in a number of different settings. One enters through a door that gives onto only one space in which a steel walkway, flanked by steel fences up to waist height, reaches into the center of the room. Once we have traveled to the middle, we realize that the ceiling and upper walls are reflected in the surface at our elbow, and that the room is filled to the walkway's brim with a huge quantity of sump oil. This sudden surprise creates an extraordinary sense of being at once in motion and stilled, of being weightlessly suspended and on the cusp of being immersed in dangerous heaviness. Such an in-between state allows our bodies to experience space with a rare purity, one untrammeled by conventions of either architecture or art.

Rachel Whiteread's early work explored the idea of social entropy in the form of wax casts of discarded beds and furniture, the survival items of the evicted and the homeless. These concerns took on a monumental, and highly controversial, aspect when she decided to draw attention to the impact of the development of inner-city neighborhoods by making a plaster

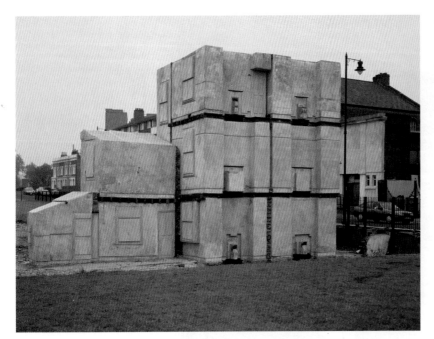

cast of the interior of the last remaining house of a
Victorian terrace in Grove Road, Bow, east London.
The result was *House* (Fig. 2.30), a poignant memorial to a
way of life now past, executed in gray concrete, as if in
negative. Completed in October 1993, it was designed
as a temporary installation, lasting one month before
being demolished. Since then, Whiteread has explored
the expressive potential of materialized architectural
space, especially casts of interiors marked by the faint
traces of specific human use. This reached a high point
in her 2005 Holocaust Memorial for the Judenplatz
in Vienna.

A more optimistic spirit is evident in the
glass installations of American artist Josiah McElheny.
By reaching back to the utopianism of the early
twentieth century, they show its fragility but also hint
that its promise may be recaptured. His installation
*Endlessly Repeating Twentieth Century Modernism*
(2007) (Fig. 2.31) invites us to stand before a mirrored
structure that has set into it, at eye level, a recess filled
with a seemingly infinite repetition of reflections of
Modernist design objects: decanters, vases, boxes, and
bottles based on designs from Scandinavia, Italy, the
former Czechoslovakia, and Austria, all made between
ca. 1910 and 1990. On the surface, this work appears
to show that anything can be remanufactured endlessly,
without regard to era, geography, or culture. The
mass-production technologies that drove modernity,
and Modernist Art's commitment to reflexivity, are on
show, inviting our delighted consumption. Yet all might
not be what it seems. What begins as a museumlike
display has a twist in that it seems to go on beyond
where the eye can see—indeed, beyond measurable
space—toward an ineffable fading away. The artist
has stated that his aim is to explore how "the act of
looking at a reflective object could be connected to
the mental act of reflecting on an idea."[25]

## Big Photography

During the 1980s art boom, photographs grew as large
as important painted portraits, landscapes, or genre scenes,
were cinematic in mode, and took human processes of
viewing as a favorite subject. Again, German artists took
the lead. A number of major artists—Thomas Ruff,
Axel Hütte, Andreas Gursky, Thomas Struth, and
Candida Höfer—were taught in Düsseldorf by Bernd
and Hilla Becher. Taking inspiration from the Neue
Sachlichkeit (New Objectivity) photography (August
Sander, Albert Renger-Patzsch) that flourished in Weimar
during the 1920s—and thus banishing the propaganda
work of the Nazi era and the tentative experimentality
and subjectivity of the postwar period (Otto Steinert)—
the Bechers pursued an encyclopedic approach to
subject matter and a dispassionate objectivity in their
treatments. They stated: "Our intention is not to make
aesthetically pleasing photographs but to make detailed
illustrations which, because of the lack of photographic
effects, become relatively objective. We do not intend
to make reliquaries out of old industrial buildings. What
we would like to do is produce a more or less perfect
chain of different forms and shapes."[26]

The new generation of German photographers
took this approach a step further: from black and white,
fixed-point images of specific but typical phenomena
presented in serial sequence, they moved to large single
images of such phenomena, evenly lit but intensely
colored, mostly close-ups or panoramas, favoring wide-
angled lenses and a sense of cinematic sweep. There
was the example of American photographers such as
William Eggleston and Joel Sternfeld, who made subtle
use of colors familiar from magazine reproduction
techniques in their images of city and suburban life, and
that of German artists such as Gerhard Richter, whose
Minimalist paintings were a fraught engagement with
both the fundamentals of photography and its predomi-
nant use as the medium of official record and folkish

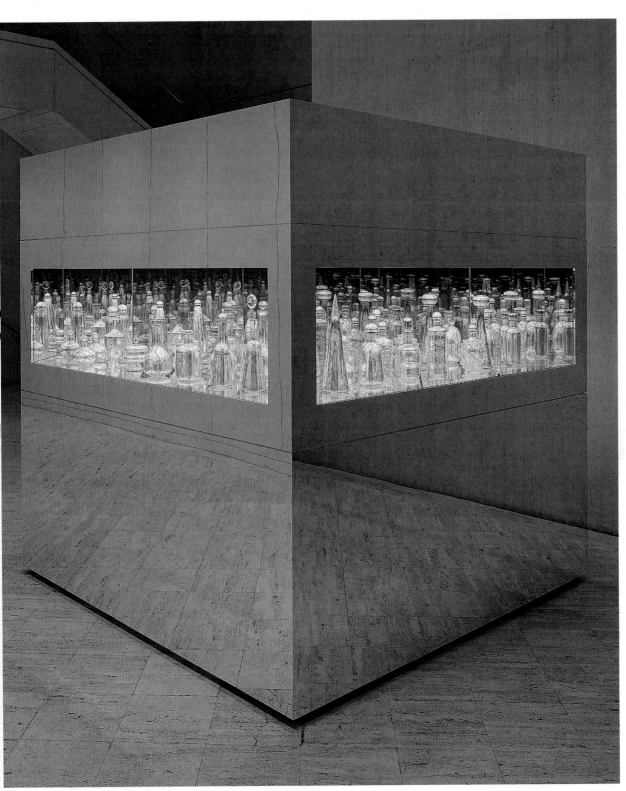

2.31 Josiah McElheny
*Endlessly Repeating
Twentieth Century
Modernism*, 2007.
Hand-blown mirror
and glass, low iron and
transparent mirror,
metal, wood, electrical
lighting, 94½ x 92¾
x 92¾in (240 x 235.5
x 235.5cm). Museum
of Fine Arts, Boston.
Museum purchase with
funds donated by the
Linde Family Foundation,
2007.600.

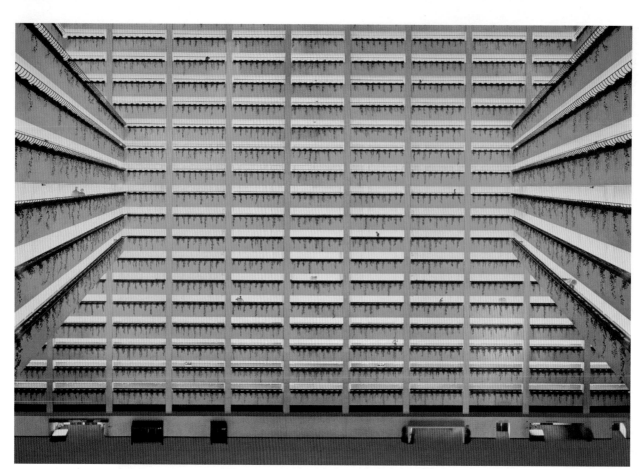

2.32 Andreas Gursky
*Times Square, NY, 1997*,
1997. C-print, 73 x 98in
(185 x 249cm).
Courtesy of Gallery
Sprueth/Magers.

2.33 Thomas Demand
*Poll*, 2001. C-print/
Diasec, 71 x 102⅓in
(180 x 260cm).

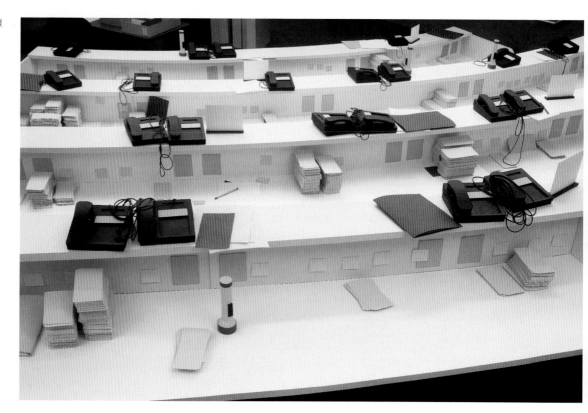

kitsch. These values were used to record the look of youthful Europeans (as in the photographs of Thomas Ruff and Rineke Dijsktra), heritage interiors (Thomas Struth and Candida Höfer), and the impact of globalization (Andreas Gursky).

As a witness to the processes of globalization, Gursky is paralleled, among artists who use photography, only by Jeff Wall, whose work we will discuss shortly, and Allan Sekula, whose work will be discussed in Chapter 10. Gursky's favored subjects are those of the much-heralded new world of capitalism triumphant: high-tech factories, shipping facilities, stock exchanges, international hotels, glittering city centers, luxury stores, supermarkets, mass sporting events, and raves. Huge size, depth of field, elevated viewpoints, broad lateral panoramas, glaring light, rich color—these formal qualities, added to instantly recognizable subjects, make him the undisputed and much-celebrated photo-poet of globalization. The works seem, at first, to replay globalization's self-image back to us in a whirlpool of new-age narcissism, exemplified also by Jeff Koons's later work. Yet a closer look at Gursky's images slowly reveals the implacable tensions grinding through these stunningly attractive surfaces. The glamorous world of international business and travel becomes a no-exit nightmare in *Times Square, NY, 1997* (1997) [Fig. 2.32]. To create this closed world, Gursky took four separate images of the atrium of the Marriott Hotel: one of each side of its six-level bridge, and one each of two of its room- and corridor-filled sides. To create the final composite image, he placed the bridges at either side of the frame, then merged the two sides into one continuous back wall. Never has the Modernist grid looked both so attractive and so unappealing.

Detachment, distancing: these effects of contemporary life have attracted the interest of many artists. Gursky's younger contemporary Thomas Demand builds cardboard replicas of settings made notorious by the events that occurred within them—the corridor outside the apartment of American serial killer Jeffrey Dahmer (*Corridor*, 1995); the prototype of an exhibition hall designed by Albert Speer for the Paris World's Fair of 1937 (*Model*, 2000); the Florida tally room in which the disputed voters' cards were assessed in the 2000 U.S. presidential elections (*Poll*, 2001 [Fig. 2.33])—then photographs them in the post-Becher style that fuses an exacting, deadpan gaze with luscious coloration and tonality. The images are precise assemblies of material objects in space (to the artist, they are sculptures) but contain no signs of humanity or stains of use: thus they become uncanny memorials, apparently familiar but weirdly generalized, as if they were exhibits of our culture in a museum for robots.

There are other, equally important aspects to "Big Photography" that also highlight its capacity to offer what might be called historical allegories of the present. Their range is nowhere better exemplified than in the work of Canadian artist Jeff Wall. Since the late 1970s, Wall has presented his large-scale, digitally enhanced photographic images—often pictures of elaborately orchestrated tableaux—as transparencies on light boxes, a format much used for advertisements in public places such as shopping malls, airports, and town centers. The artist comments:

> I think there's a basic fascination in technology which derives from the fact that there's always a hidden space—a control room, a projection booth, a source of light of some kind—from which the image comes. A painting on canvas, no matter how good it is, is to our eyes more or less flat, or at least flatter than the luminescent image of cinema, television, or the transparencies… To me, this experience of two places, two worlds, in one moment is a central form of the experience of modernity, it's an experience of disassociation, of alienation… The technological product, as we currently experience it from within capitalism, recapitulates this situation in its experiential structure, which gives us something very intensely and at the same time makes it remote."[27]

In a further layering, Wall usually orchestrates key elements in his pictures to suggest arrangements of figures, landscapes, and gestures used by earlier artists, particularly those now canonized for their contribution to Western painting, especially the French Romantics, Realists, and Modernists. The moment of the origin of Modernism has been, since the later 1970s, a subject of intense concern to art historians. At the same time that Wall reaffirms Modernism's concerns and techniques, he hints at a radical revision of its history. He asks us to imagine what Modernist Art would be like if it had unfolded differently. In 1992, Wall said: "I feel in general I have an experimental relation to traditional construction, and I have thought about my work as a kind of 'experimental traditionalism.' It is ironic that these new [digital] techniques make it possible to re-work and, I hope, re-invent aspects of older pictorial art which have been moved to the margins by the directly radical and experimental forms of modern art."[28]

Historical allegory on a grand scale attracted many artists as the end of the millennium approached. To Wall, the two great ideologies that contested the twentieth century—free-market capitalism and state socialism—had consumed themselves in different kinds of excessive overreach. *The Vampires' Picnic* (1991) [Fig. 2.34] shows denizens of North American suburbs at the construction site of a sewer system, apparently sated after indulging in sucking the blood of their neighbors. The orgiastic nature of their revelries is underlined by the fact that the figures are arranged in groupings that echo both traditional outdoor subjects such as the *fête champêtre* as well as elaborate Salon paintings such as French academician Thomas Couture's celebrated *The Romans of the Decadence* (1847). But the mood is darker, as the artist attests: "I wanted to make a complicated, intricate composition, full of sharp details, highlights

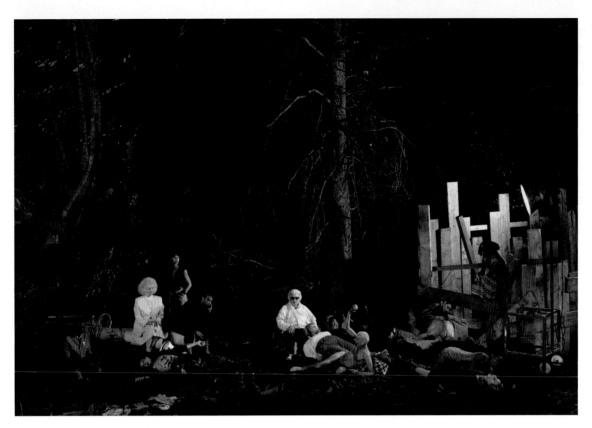

2.35 Jeff Wall
*Dead Troops Talk (A Vision
after an Ambush of a Red
Army Patrol near Moqor,
Afghanistan, Winter 1986)*,
1992. Transparency in
light box, 90¹⁄₁₀ x 164¹⁄₅in
(229 x 417cm).

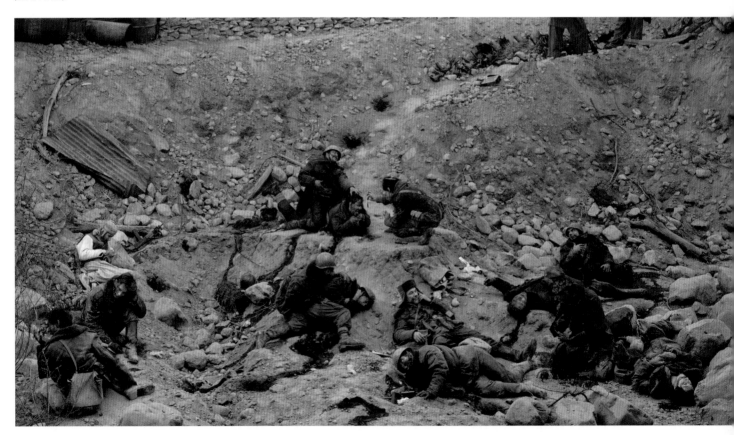

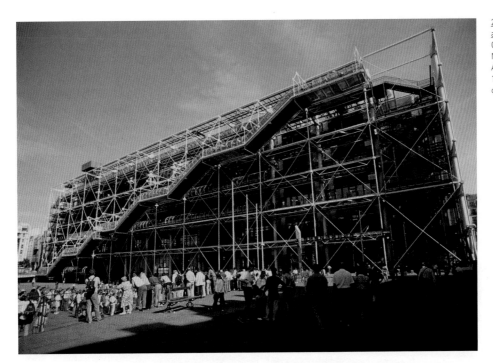

and shadows in the style of German and Flemish mannerist painting. This style, with its hard lighting and dissonant color, is also typical of horror films. I thought of the picture as a depiction of a large, troubled family. Vampires don't procreate sexually; they create new vampires by a peculiar act of vampirism… So a 'family' of vampires is a phantasmagoric construction of various and intersecting, competing desires… I thought of my vampire family as a grotesque parody of the group photos of the creepy and glamorous families on TV shows like 'Dynasty.'"[29]

The Vampires' Picnic may be paired with Wall's Dead Troops Talk (A Vision after an Ambush of a Red Army Patrol near Moqor, Afghanistan, Winter 1986) (1992) (Fig. 2.35). This even larger panorama evokes the painted battle scenes that were popular in many cultures throughout the eighteenth and nineteenth centuries. Specifically, it encapsulates the failure of the Soviet effort to subdue Afghanistan (which the U.S.S.R. invaded in 1979, retreating ten years later) by showing a bomb-marked ravine in which Soviet troops fiendishly turn into vampires who, it seems, will forever consume themselves in a vale of the dead, while their earthly remains are quietly looted by their mujahideen opponents. Wall felt himself to be on the side of the soldiers: "I also thought it could have a relationship to the Salon Machine paintings of the nineteenth century—but without Napoleon, without the hero… I feel that the literary, thematic core of it is: what would we say if we could speak about our death having died for a cause that we might not understand or even agree with but we would nevertheless accept as we accepted, acquiesced or submitted to being soldiers? The pictorial realization of the theme had to be hallucinatory, but the hallucination needed a foundation of almost documentary accuracy."[30] A vision, indeed—on the part of individuals, soldiers, fearing their own death, of the end of the Soviet Empire; but also of Europe's long-running imperialist ambitions

as they exhausted themselves in ghastly dissipation in the hostile environments of the rest of the world. The arrangement of the figures recalls Théodore Géricault's notorious The Raft of the "Medusa" (1819), which depicts desperate survivors of an actual shipwreck failing to attract rescuers, after which they resorted to cannibalism. In 1848, Karl Marx began The Communist Manifesto with the words: "A specter is haunting Europe. The specter of Communism." After 1989, this anticipation of man's perfectibility became a rapidly vanishing memory.[31]

## SPECTACLE ARCHITECTURE AS CONTEMPORARY ART

Remodernism appeared in architecture as well as the other arts, where it soon developed the highly refined yet physically engaging aesthetic that characterizes the sculpture of Richard Serra, the painting of Gerhard Richter, and the photography of Andreas Gursky. This transition is evident in the changes in architecture between the "spirit of the 1960s" embodied in the Centre Pompidou, Paris, and the Guggenheim Museum, Bilbao, which, a few decades later, instantly became the undisputed global icon of architecture's late modern moment and, many hoped, the harbinger of architecture's role in the new millennium.

The Centre Pompidou in Paris (Fig. 2.36), designed by Renzo Piano and Richard Rogers and erected between 1972 and 1978, is an interesting case of a cultural complex that was shaped in response to the cultural crisis of the late 1960s in advanced societies. The design was intended to shift dramatically the elitist image of museums in contemporary life toward maximum democratic access. Its open-handed contemporaneity was heralded in every aspect of its appearance and organization. The brightly painted elements on its exterior, its inside-out design, its frank celebration of its

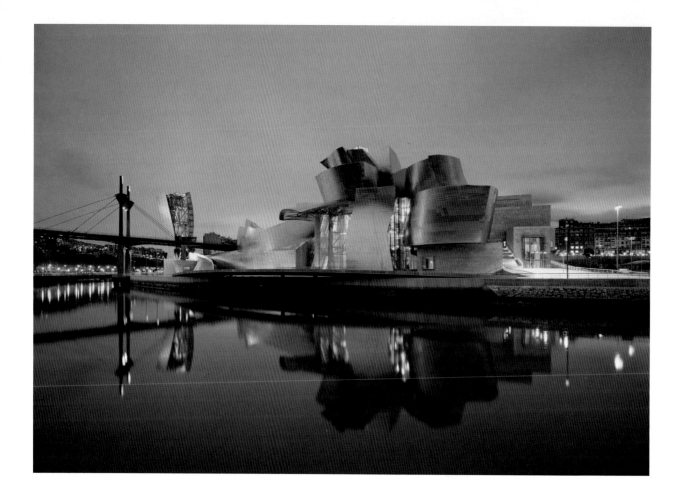

functions, the out-there quality of its circulation patterns, its transparency by day and night, add up to a structure that first and foremost exhibits itself. It is one of the first art museums to put itself on display by appearing to show its contents on its skin: like the Bilbao Guggenheim in the 1990s, its container displays itself as its content and as an eminently reproducible image. Architecture's engineering is foregrounded as itself an elaborate kind of sculpture, its effects emphasized by color contrast, dramatic shifts in size and scale, and an evocation of mechanic-organic metaphors.

While most read its chaotic exterior as signaling "art gallery," *le Beaubourg* (as the Centre Pompidou is also affectionately known) was designed to serve a diverse set of purposes simultaneously: the building actually houses a variety of functions, from the most accessible public library in Paris to the National Museum of Modern Art. In truth, the structure was more contemporary than its contents. Nevertheless, the Centre Pompidou led the way in encouraging mobility between cultural experiences, and in providing for the simultaneous satisfaction of related needs: for documentation, information, contemplation, and contact. Its best-known aspect is that it banished the formidable row of steps and imposing façade that, in most art museums, raises such a high rhetorical barrier against open access. Instead, it provided a spacious forecourt, a jazzy exterior, a transparent structure, and a welcoming attitude, thereby creating an urban environment that encourages interaction between those using it and its immediate setting. In this, it became a model for many subsequent

museums as urban-planning devices. It was the first step in what became—especially within the "new," "united" Europe—a lively competition between cities (rather than countries), conducted using cultural opportunities, rather than arms, as weapons.

A direct outcome of this competition, 20 years later, was the Guggenheim Museum in Bilbao, northern Spain (Fig. 2.37), designed by Los Angeles-based architect Frank Gehry between 1991 and 1997. As we noted above, outside the museum sits Jeff Koons's *Puppy* (see Fig. 2.24), a gigantic replica of a porcelain dog emblazoned with flowers, itself an oft-reproduced icon of Postmodern Art. Ubiquitous images of the museum's curving, titanium-clad surfaces have served as seductive invitations to a cultural pilgrimage. The museum is the symbol of the Basque government's effort to reinvent Bilbao as a high-tech cultural hub for the region. In world tourist imagery, the Bilbao Guggenheim signifies its city, registering it as an extremely desirable destination. An extraordinary economic success, the project amortized its initial construction costs within its first three years. The building's greatest impact has been its exemplary life as an icon of the attractiveness, and the power, of the contemporary culture industry itself.[32]

Many of the gallery spaces are conventional rectangular rooms, which work adequately for the showing of modern art. Curved walls in the galleries that circle the atrium house site-specific installations, such as an LED text piece by Jenny Holzer using English and Basque. The major space, the rolling ground-floor gallery that is about 430 feet long and 100

2.37 Frank Gehry
Guggenheim Museum,
Bilbao, 1991–97.
Exterior view (opposite)
and atrium view (left).

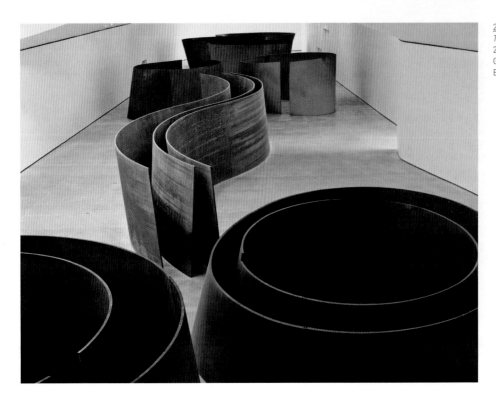

2.38 Richard Serra
*The Matter of Time*,
2005. Installation view,
Guggenheim Museum,
Bilbao, 1997.

2.39 Matthew Barney
*Cremaster 5: Her Giant*,
1997. Production still.
Courtesy of Gladstone
Gallery, New York.

wide, is a shell for works such as Richard Serra's *Snake* (1994–96). The latter was commissioned for the space, and conceived in parallel with the designing of the museum itself; its tall, weighty lengths of raw steel draw spectators through their tunnel-like folds. In 2005, Serra added a number of other major works to the space, notably *Torqued Ellipses* (1996–2004). Using engineering software to conceive shapes that turned the sweeping curves of steel against their own grain, the massive environment provides the awed but eventually enchanted spectator with a variety of complex and subtle experiences of moving through space. The entire ensemble, now a permanent fixture of the museum, is entitled *The Matter of Time* (Fig. 2.38). This treatment of time is the sculptor's response to a definitive aspect of contemporary life—a Remodernist one, in that it occurs entirely through the deployment of sculpture's given materials and their location in space.

## CONTEMPORARY ART BECOMES A STYLE

In this discussion of key tendencies in EuroAmerican art during the 1980s and 1990s, we have seen contemporary art become an aesthetic category and a cultural force as powerful as modern art had been in its own time. This occurred despite the difficulties experienced by some institutions and the ridicule heaped on much of the art by the popular press. Nothing attests to its success as much as the extraordinary resources that some artists are now able to command in order to realize their visions. Foundations such as Dia are dedicated to this ideal, as increasingly are many private collectors of contemporary art. Acceptance is apparent, too, in the scale, complexity, and expense of many exhibitions, not only blockbuster survey and theme shows, but showcases of individual artists.

Few, however, attain the baroque dimensions of the 2003 exhibit of Matthew Barney's *Cremaster Cycle* (Fig. 2.39) at the Guggenheim Museum, New York. This work epitomizes both the artistic and the institutional developments that we have been tracing. In stylistic terms, it merges, brilliantly, the imperatives of Retro-Sensationalism and Remodernism. *The Cremaster Cycle* takes the form of five feature-length 35mm films and a growing number of videos, drawings, collages, sculptures, and installations that relate directly to the films—demonstrating a mobility as to medium typical of all forms of contemporary art. Typical, too, is the esoteric portentousness of its central idea: the cremaster is the muscle that governs the chromosomal switch from female to male, and then controls testicular contraction. Despite its complex structure and Postmodern stylistics, the *Cycle* is essentially a quest narrative, a search for belonging through places that have their own imperatives, amidst physical and social processes that are strangely subject to incessant fusion and separation, isolation and metamorphosis. This—*The Cremaster Cycle* claims—is what it is to be, in the era of cultural division and genetic engineering. The same spirit of individuals battling against unfathomable odds to achieve community acceptance underlies the success of novels and films such as *The Lord of the Rings*, and the vast memberships, worldwide, of cults, organized religions, and civic organizations. Like them, this spirit makes *The Cremaster Cycle* at once extraordinary and banal.[33]

Since the 1980s, the Contemporary Art industry has been driven by the need to project its institutions as sites of dynamism, at the forefront of the kinds of change that characterize contemporary life. The latter face increased competition from the plethora of attractions that spectacle society makes available. Thus museums, artists, galleries, auction houses, and collectors have sought a brand image, an iconic form to distinguish themselves from competitors—others in the visual arts, in the culture industry in general, and within the broader spectrum of leisure and tourism. For museums, the stylishness of their architecture has become a primary element of identification. The next challenge has been to find ever-fresh ways to enable the viewer, once inside the galleries, to experience the specific qualities of the works on display as an exciting confrontation with contemporaneity.

We have seen that, during this period, artists were drawn into the whirlpool of competitive imagery: many became expert producers, while others evaded this kind of limelight, and still others became acute interrogators of it. A number of influential institutions, and many highly accomplished artists, continued to respond to the demands of contemporary life by refining, reusing, even remodeling the artistic imperatives of Modernism. Others sought to update the celebration of popular and commercial cultures that had first appeared in Pop Art, staging new kinds of ever more spectacular art. In these two senses, official Modern Art has become official Contemporary Art; only the name has changed. But this is just one part of the story of art since 1980. These tendencies were resisted by many artists, and were more and more strongly questioned, until, in the early decades of the twenty-first century, they were edged from dominance by art that originated away from the great EuroAmerican centers of promotion and marketing, by the open modes of inventiveness pursued by artists working in creative sites all over the world, and by those engaged in the constant traffic, actual and virtual, between these sites. These changes were global, in the sense that they happened all over the world, contemporaneously. But they occurred in different ways, and at different rates, in each region, each country, often in each city. The worldwide turn into transnationality—a global change that is still in process—is what makes art produced in any given location contemporary with art, however different, that is being made not only in the same place but everywhere else across the planet.

# THE TRANSNATIONAL TRANSITION

ubodh Gupta
ine of Control, 2008.
see fig. 6.9)

# PART II: THE TRANSNATIONAL TRANSITION
## INTRODUCTION

As was noted in the General Introduction to this book (see page 8), art made as part of the transnational turn that predominated in world geopolitics in the second half of the twentieth century is too diverse in its modes and too oppositional in its motivations to amount to an art "movement" of the kind that we saw in Chapters 1 and 2. No style is sufficiently widespread, no medium ubiquitous, no particular kind of content shared—indeed, all are mixed in ways that both evoke traditional imagery and register the new. This art is diverse to a degree unprecedented in the history of modern European art and, because of its origins on the borders of and outside Europe, different in kind. It is a content-driven art, aware of the influence of ideologies and problems of translation, intensely local but also mobile internationally, and concerned above all with issues of nationality, identity, and rights. All of these elements are in a state of constant transition. Transitionality has accelerated to the degree that it is definitive of the cultures of our times.

Decolonization occurred differently in each geopolitical region of the world, and in unique ways in each country—indeed, it often did so distinctively in specific areas of a country and in specific parts of its society. No single study can trace all of these variations in the detail that they deserve. But an outline is necessary, since otherwise the narrative of modern and contemporary art will remain one that is told from the cultural centers of modernity, with art from elsewhere appearing only in so far as it registers at those centers.

The following chapters, therefore, present an outline of the main developments in each of the major geopolitical and cultural regions of the world beyond Western Europe and the United States as they were constituted in the post-World War II, postcolonial period. In each region, one or two countries have been dominant, their art and its institutional structures deeply affecting those of other countries in their sphere of influence. Thus Soviet Russia played a major role in Eastern and Central Europe as a counterforce to local traditional cultures and "the West" (which includes, during the twentieth century, the United States along

with Western Europe, as well as a number of settler colonies, such as Canada and Australia). Japan and subsequently China are most prominent in East Asia, whereas India is influential throughout South Asia. No country predominates in Africa during this period, although in South Africa and Senegal art institutions were more fully developed than elsewhere on the continent. In South America, Brazil and Argentina—the largest states—led artistic growth, while Cuba was most active in the Caribbean. Australia and New Zealand remain prominent in Oceania. Yet artists from other countries in each of these regions often have much to show us, and their contribution is noted here as far as possible.

Overall, we might see these developments as representing the formation of modern art and culture in each region and country—formations that are parallel to, contingent on, but also distinct from those that arose in Europe, the United States, and former colonies such as Canada and Australia that remained closely tied to their founding nations. We might also equate the most recent phases of these developments, especially those occurring after the end of the Cold War period in Europe, with the emergence of a multipolar, regionalized, yet also intensely localized world, and see them as registering the global shift into conditions of contemporaneity. In the following chapters, we are, therefore, tracking how, in each of these regions and localities, modern art became contemporary.

Raša Dragoljub
Todosijević
*God Loves the Serbs
(Gott Liebt die Serben),*
1993. Mixed media,
dimensions variable.
Installation view,
Munchengladbach.
Musem G.A.M.E.S.
of art, 1997. Courtesy
of the artist.

# 3. RUSSIA AND (EAST OF) EUROPE

In geopolitics and in art, the very concepts of "Eastern" and "Central" Europe are as contentious as they are—for the present, at least—unavoidable. Widespread usage of these terms is recent, a product of the post-World War II division of global geopolitical power into areas of influence. During the Cold War (1945–89), Europe was seen as split between Western and Eastern parts, incorporating into its heart an intracontinental border between the First World, led by the United States, Britain, Germany, and France, and the Second World, led by the U.S.S.R. The infamous Berlin Wall—built in 1961 to separate the German Democratic Republic (East Germany) from the Federal Republic of Germany (West Germany)—was only the most literal embodiment of this divide. In a 1984 essay, Czech novelist Milan Kundera argued that "the tragedy of Central Europe" was that it was "a kidnapped Occident," a "piece of the Latin West which has fallen under Russian domination… [and] which lies geographically in the centre, culturally in the West and politically in the East."[1]

But the deeper reason why these terms are contentious has a longer history, and goes to the heart of the very idea of "Europe" itself. Centuries of warfare, as various regimes sought to dominate large tracts of the continent, incessant waves of attack, resistance, and retreat, left their mark. The areas now known as Eastern and Central Europe were precisely those in which such struggles were most often, and most bloodily, conducted. The history of these highly contested domains has less to do with geography and, until the nineteenth century, nationality, than with political expansionism from centers of concentrated power to east and west (Berlin, Moscow, Paris, St. Petersburg, Vienna). Some areas became highly industrial, others remained predominantly rural; large, ethnically homogeneous regions alternated with smaller ones of mixed ethnicity and religion; each related to the parts of Europe around them and to the Asian countries to their east in distinct, yet always contentious, ways.

In the visual arts, academies—above all, those established in Paris, London, Vienna, and St. Petersburg, but later and to a lesser degree in smaller centers such as Budapest and Bucharest—exerted decisive influence through their control over training, recognition, and commissions. Until the late nineteenth century, independent circles of artists and supporters were rare, as were private markets. At that time, secessionist groups sprung to prominence throughout Europe. In places without developed academic structures against which they could protest, artists formed associations to promote their work as distinctively modern—sometimes, as in the case of the Sztuka ("Art") group in the Polish territories, as definitively national too. Circumstances varied so greatly from place to place that generalizations about either politics or art have little value. This continued to be the case right through the modern period, although the Soviet system, including imposed Socialist Realism, dominated in much of Eastern and Central Europe from after World War I until its implosion between 1989 and 1992.

During the twentieth century, artists did not identify themselves as "Eastern" or "Central" European, except for purposes of irony or parody. Rather, they saw themselves as national citizens—however dissident—and as Europeans, but above all as artists, acutely aware of their forced isolation from artistic developments elsewhere. Many took leading roles in questioning the prevailing order, joining other intellectuals in public political debates, and were active in precipitating the mostly nonviolent "revolutions" that brought down Communist and dictatorial governments. Some became national leaders: playwright Václav Havel was elected president of the Czech Republic while author Árpád Göncz led Hungary.

Since the 1990s, however, fluidity of movement across national borders within the European Community has been accompanied by acrimonious debate as to which external countries might be eligible for membership of the European Union and by the erection of heavily policed perimeters aimed at excluding the African and Asiatic multitudes from "fortress Europe." The idea of Europe is still very much a work in progress.

3.1 IRWIN
*Frontispiece*, in IRWIN, ed., *East Art Map: Contemporary Art and Eastern Europe* (London: Afterall, 2006).

Just which countries belong to "Eastern Europe" as a whole, and which countries fit into its many subsections (Baltic, Central, and Southeastern—the latter previously known as "the Balkans"), remains fluid. The designation "(East of) Europe," coined by Slovenian critic/artist Marina Gržinić, brings out the provisionality of all such formulations.[2] By placing the idea of being east of Europe in parentheses, it implies a hope that, while the specters of the recent past will continue to hover for some time, they will eventually fade, and the idea of Europe will no longer need these kinds of exclusionary qualification.

This spirit has animated recent art practice and art scholarship in the region. As the frontispiece to their 2006 book *East Art Map* (Fig. 3.1) the Slovenian artists' group IRWIN reproduced a contour map of the European and Asian landmass, with all of the countries that came under Soviet control during the twentieth century shown as a vast, dark cloud—indeed, a black hole.[3] The book, compiled with the assistance of a team of art historians, artists, critics, and curators active in Eastern and Central Europe, tracks the development of avant-garde, nonconformist, alternative, and contemporary art in the countries of this region, reproducing examples of rarely seen works and profiling artistic developments in encyclopedia-style entries. The goal is to counteract the Western view of this region as a *terra incognita*. The book concludes with a map of "East Art" devised by the group. The names of artists from 23 countries, as well as important art events, are plotted as vectors in a matrix that moves through time from 1960 to 2005, and in space across the region. The sheer quantity of well-connected, innovative artists now active seems ready to fill up the black hole.

This chapter will trace the movements from modern to contemporary art in the region, drawing attention to the similarities and differences between the experiences of artists in each country. Early Modernist and later avant-garde movements as well as important individual artists will be discussed. The pervasive impact of Soviet-style Socialist Realism will be noted, as will the many kinds of resistance to it. Recent changes should not lead us to forget that Socialist Realism was the dominant form that modern art took within state socialism—itself a modernizing social, economic, and political system, paralleling, for much of the twentieth century, liberal-democratic capitalism elsewhere in the world.

## RUSSIA

Contemporary art in Russia is just beginning to find pathways beyond the legacies of its early twentieth-century avant-garde and Soviet Socialist Realism, two of the most powerful movements in modern art. From 1910 to the mid-1920s, experimental art and architecture in Moscow, St. Petersburg (named Petrograd 1914–24 and Leningrad 1924–91), and other cities such as Vitebsk matched, and at times outshone, avant-garde practice in France, Italy, Germany, and Holland. After 1917, artists such as Wassily Kandinsky, Kasimir Malevich, Vladimir Tatlin, Aleksandr Rodchenko, and El Lissitzky suddenly found themselves in positions of power in key cultural institutions, and therefore able to put into practice the utopianism that inspired avant-garde artists everywhere. This situation was exceptional in the history of Modernist Art. Although brief, and exaggerated in scope in hindsight, it became known as "The Great Experiment" and inspired subsequent generations of artists, especially in the 1960s and 1970s.[4]

These kinds of utopian aspiration also inspired the revolutionary Soviet state, and were imposed in the U.S.S.R. and soon in its satellites, at great and often deadly cost to large sections of citizenry.[5] By the mid-1920s, the political leadership under Vladimir Ilych Lenin and then Joseph Stalin moved beyond the revolutionary anarchism that accorded most closely with the views of the avant-garde artists and began to impose central control and new economic policies. Soviet Socialist Realism was officially codified in 1934 less as a style and more as an approach to literature and art that, in the words of cultural commissar Andrei Zhdanov, had as its purpose "to depict reality in its revolutionary development." In

practice, this meant showing recognizable experiences (*tipichnost'*), reflecting the spirit of the people (*narodnost'*), demonstrating the artist's class awareness (*klassovost'*), and highlighting the leading role of the Party (*partinost'*) as it introduced forward-thinking policies (*ideinost'*). Socialist Realism remained the prevailing official aesthetic until the 1980s. Abstract art, the use of erotic themes or religious symbols, and criticism of the Party, the state, or the system—all were prohibited. Artists' unions, the Russian Academy of Arts, and the ministries of culture controlled the production and distribution of art. To access studio space, to exhibit, accept commissions, or take teaching posts, artists were obliged to belong to a union, which restricted membership to those who conformed to Party ideals. Travel abroad was rare, and the circulation of information about art and culture from elsewhere was restricted.

## Art under Late Socialism

For a few years from the mid-1950s to the early 1960s, at the behest of premier Nikita Khrushchev, a political "thaw" permitted some degree of questioning of Stalinist rule and a brief opening up to art and literature from the West. During this period, artists such as the Expressionist sculptor Ernst Neizvestny received attention abroad. A small "unofficial art" community also began to emerge. In 1962, exhibitions of abstract painting by, for example, Oscar Rabin and other members of the Lianozovo Group provoked a resumption of restrictions; however, growing numbers of artists now started to circulate unofficial publications (*samizdat*) and stage modest exhibitions in their private apartments. Efforts to show art outside the official frameworks met with organized and violent opposition: in September 1974, the bulldozing and burning of an outdoor exhibition of paintings held on a vacant lot on the outskirts of Moscow, and the violence against artists participating in a follow-up exhibition, attracted international attention.[6] Most of the key participants were soon expelled from the Soviet Union, or took up voluntary exile in Europe or the United States.

Ilya Kabakov has highlighted his fellow artists' sense of isolation, their efforts to create a community, and to imagine how their art might seem when seen from outside or how it might figure in larger histories of art: "Such was the nature of Moscow Conceptualism, the basis of which is precisely a collection of observations of a cultural nature of various aspects of Soviet life, Soviet consciousness, and so-called art, including that unofficial art produced in this very community."[7]

Kabakov's own work exemplifies this tendency to make art from and about everyday life in the Soviet Union, focusing especially on its overcrowded cities, the massive and ever-watchful bureaucracy, and the increasingly unrealistic ruling ideology. Within this "Apartment Art" tendency, Kabakov belonged to a group known after their street of residence as the Sretensky Boulevard Group. Between 1971 and 1976, while making his

living as an illustrator who could be counted on to produce work in an entirely conformist manner, he created a series of albums, *Ten Persons*, consisting of whimsical stories about the lives of ten imaginary artists—including their dreams, their projects, comments by friends, critics, and other artists—all of which ended in ambiguity or failure. The first, *Primakov Sitting in the Closet*, follows the life of a young boy from his first glimpse of a black square (the world outside the bathroom in which he hides), through his exploration of a jumbled earth and sky (the actual world), until he reaches the white page of his own album (a metaphor for his disappearance). Between 1981 and 1988, Kabakov developed these albums into a series of installations, *Ten Characters*, each of which is a detailed, life-size reconstruction of a room in the character's apartment. *The Man Who Collects the Opinions of Others* evokes the world of a philologist who believes that all opinions are arranged in circles. A painter disappears into the vastness of an all-white canvas in *The Man Who Flew into His Picture*. An obsessive neatness characterizes the archives of *The Man Who Never Threw Anything Away*. *The Short Man* creates a labyrinth of minuscule images and texts. *The Man Who Flew into Space* (Fig. 3.2) shows what remains of the apartment of someone who so thoroughly believed in the romantic aspirations behind the Soviet space program—the poster images of which dominate the installation—that he built himself a catapult which has, it seems, projected him up and out through the ceiling. The accompanying text reads:

> The lonely inhabitant of the room, as becomes clear from the story his neighbour tells, was obsessed by a dream of a lonely flight into space, and in all probability he realized this dream of his, his "grand project."
>
> The entire cosmos, according to the thoughts of the inhabitant of this room, was permeated by streams of energy leading upward somewhere. His project was conceived in an effort to hook up with these streams and fly away with them. A catapult, hung from the corners of the room, would give this new "astronaut," who was sealed in a plastic sack, his initial velocity and further up at a height of 40–50 meters he would land in a stream of energy through which the Earth was passing at that moment as it moved through its orbit… Everything was in place late at night, when all the other inhabitants of the communal apartment were sound asleep. One can imagine their horror, fright and bewilderment. The local police are summoned, an investigation begins, and the tenants search everywhere—in the yard, on the street—but he is nowhere to be found. In all probability, the project, the general nature of which was known by the neighbour who told the investigator about it, was successfully realized.[8]

3.2 Ilya Kabakov
*The Man Who Flew
into Space from His
Apartment*, from the
*The Ten Characters*
series, 1981–88.
Installation, interior
view, wood, rubber, rope,
paper, electric lamp,
chinaware, paste-up,
rubble and plaster
powder, dimensions
variable. Produced
in Moscow. Musée
National d'Art Moderne,
Centre Georges
Pompidou, Paris.

3.3 Komar and Melamid
*The Origin of Socialist
Realism*, 1982–83.
Oil on canvas, 72 x
48in (183 x 135cm).
Courtesy of Ronald
Feldman Fine Arts,
New York.

3.4 Boris Mikhailov
*Case History*, 1999
(detail). Set of 400
photographs,
dimensions variable.

Others in the series are *The Untalented Artist, The Composer Who Combined Music with Things and Images, The Collector, The Person Who Describes His Life through Characters,* and *The Man Who Saves Nikolai Viktorovich.* These have become widely known since Kabakov's move to the West in 1988.

"Sots Art" combined the slang word for Socialist Realism—"Sotsrealism"—with Pop Art, the name of the mainly U.S. art movement. Driven largely by the artistic duo Vitaly Komar and Alexander Melamid, it sought to disrupt the visual codes of official Soviet imagery. Official imagery had the task of selling state policy and inspiring the masses forward in the task of socialist construction. Alert to Pop Art's ironic embrace of popular visual cultures, and Conceptualism's strategies of analysis and reversal, in the early 1970s Komar and Melamid made paintings that looked at a glance like Party propaganda posters but were in fact accumulations of meaningless blocks of red on white grounds, or vice versa. (There are parallels in China in the later use of familiar but actually meaningless Chinese characters by post-Cultural Revolution artists Wenda Gu and Xu Bing—see Chapter 5.) After moving to the U.S. in 1980, Komar and Melamid created a suite of paintings that mocked—by means of outrageous exaggeration concealed within a consummate application of hyper-academic Classicism—the glorification of Stalin in Soviet society. In *The Origin of Socialist Realism* (1982–83) (Fig. 3.3), they invoke the Neoclassical conceit that drawing (or Art more generally) originated when Dibutada (known also as the Corinthian Maid) outlined on a wall the profile of her sleeping lover. In Komar and Melamid's painting, both the political system and the style of art that serves it are shown, at a glance, to be cloyingly sentimental myths.[9]

During the 1980s, a performance group called Collective Actions, led by Andrei Monastyrsky, staged enigmatic events—usually out in the open, in quintessentially Russian settings—using a cocktail of forbidden elements drawn from Russian Orthodox and Eastern mysticism and early twentieth-century Russian avant-garde art. Today, Monastyrsky continues to plumb the spiritual connections between these non-Communist currencies in elaborate installations that evoke ceremonial spaces. In contrast, during the 1990s a conscious conservatism inspired St. Petersburg's Neo-Academicism group, led by the charismatic blind artist Timur Novikov, who sought to revive the aesthetics and techniques of the pre-Revolutionary era. This paralleled the political revivalism of the first post-Soviet, anti-Communist premier, Boris Yeltsin.

## Russian Art Becomes Contemporary

Beginning in 1985, Soviet president Mikhail Gorbachev attempted a restructuring (*perestroika*) of the centralized state by introducing degrees of autonomy into regional and local government, and a transformation of the economy, which by then had become demonstrably stagnant and dangerously inefficient, into a decentralized, market-based one. In 1989, the wall between East and West Berlin was torn down, as Germany ceased to be divided between a socialist state and a free-market regime. The Soviet empire collapsed from its borders inwards, as one satellite state after another declared its independence in (mostly) nonviolent, or "velvet," revolutions. By 1991, the Communist Party of the Soviet Union could no longer maintain control of the state apparatus, and a series of pro-free-market—and, in different degrees, pro-Western—governments assumed office. They could not, however, manage the implosive fallout from the sudden collapse of central organization. Chaos prevailed and gangsterism flourished, as the state sold off its assets and virtually every aspect of life was privatized.

The degradation of post-Soviet life was captured with graphic directness in Boris Mikhailov's series of photographs *Case History* (Fig. 3.4), begun in 1997. These record the abject lives of the newly prominent destitute, homeless, chronically alcoholic, and those expelled from asylums and prisons in his hometown of Kharkov.

> It is a disgraceful world, populated by some creatures that were once humans, but now these living beings are degraded, ghastly, appalling. This "fauna" is specific especially to the period of quasi-general diffidence, specific for most of the post-communist world. For as long as the USSR existed, there were no homeless people. Most of them sold their houses and "invested" the money they received in booze until they spent it to the last dime. I have personally met some of them, those from my hometown, Kharkov. I followed them in order to know how they lived, how they behaved, how they survived, how they fought for their lives. I chased some of them, paying them to pose… They show a living nature without any make up on. I am invited everywhere to show them, to confess.[10]

Other artists reacted to the new chaos by actions calculated to outrage public taste and to escape artworld incorporation—a deliberately self-marginalizing, retro-avant-garde strategy that critic Viktor Misiano names *tusovka* ("gang"). Moscow painter and performance artist Oleg Kulik is as representative of this tendency as he is unique as an artist. His curatorship promotes the actions of like-minded artists, such as those who used live animals in the exhibition *Animalistic Festival* (1992). His paintings are quickly made records of his extremely active daily life; his performances are calculated affronts. Kulik tackles the question of what to do after the evident failure of the great social systems with brutal directness, asking: "Why have I stood on all fours? Why have I become a dog?" In post-Soviet Russia, he showed his disintegrating society to itself: "In Moscow I became a dog, I growled there and demonstrated a dog's devotion to an artist's ambitions."[11] When performing outside of Russia, he came to feel that he was being seen as a

3.5 Oleg Kulik
*I Love Europe but Europe
Doesn't Love Me Back*,
1996. Performance.

3.6 AES+F
*Last Riot 2*, 2006–07.
Video projection.
Stills: *Panorama #1*
(left) and *The Cathedral*
(right). Digital collages,
digital prints on canvas.
Courtesy of the
artists and Triumph
Gallery, Moscow.

"mad dog," as an embodiment of the stereotypes of his country as a menacing but manacled wild animal. In Berlin in 1996, for his work *I Love Europe but Europe Doesn't Love Me Back* (Fig. 3.5), naked and with a collar fitted around his neck, he fought with a pack of guard dogs (restrained by dog-handlers in uniform). This was a deliberately provocative restaging of a legendary performance by the German Conceptualist Joseph Beuys, *I Like America and America Likes Me*, presented in New York in 1974, during which the artist spent a week in a New York gallery with a coyote.[12]

While alternative contemporary art spaces and a small number of commercial galleries were established in Moscow, Leningrad, and elsewhere during the 1980s, Russian artists and institutions did not connect with the international artworld in a thoroughgoing way until the later 1990s. Artists now travel abroad regularly—and make art out of the experience: in 1996, some Moscow artists joined members of IRWIN to cross the United States in recreational vehicles, documenting their discussions of art and culture.[13] The private market is nascent. The tastes of those who first profited from the sell-off of state assets tended toward traditional icons and nineteenth-century Realism, as well as a certain conservative revivalism among contemporary artists. Recently, some super-rich collectors with an interest in contemporary art have emerged, however, and the major auction houses are showing interest. The first Moscow Biennale in 2005 was a tentative step in this direction, organized by local and some overseas curators. The title of the second biennale, *Footnotes on Geopolitics, Markets, and Amnesia* (2007), neatly evoked the main themes of contemporary art. Some Russian artists appear regularly in international survey exhibitions, notably the group AES+F (Tatania Arzamasova, Lev Evzovitch, Evgeny Svyatsky, and Vladimir Fridkes), who specialize in brilliantly staged parodies of nouveau-riche fantasies through the use of videos, projections, and series of photographs (Fig. 3.6). Others, such as the group Chto Delat/What Is to Be Done?, are more directly political.[14] The main preoccupation of modern Russian art remains unchanged—the dream of general social deliverance from present shortfall—as does the tendency for artists to work together in focused groups or loose associations. Since 1989, however, they have not done so from positions of leadership within, or in internal opposition to, a large political—and therefore cultural—empire.

## LATE COLD WAR MODERN ART ELSEWHERE (EAST OF) EUROPE

Soviet-style state control over culture in most countries in the region from the 1950s to the 1980s meant that artistic expression was largely confined to official ideological frameworks. As in Russia, Socialist Realism was the dominant aesthetic. This was more the case in the "Eastern Bloc" countries (Poland, Czechoslovakia, and Hungary) and in the Baltic States (Estonia, Latvia, and Lithuania) than in the Balkans. Yugoslavia—a consolidation of the territories previously included in the post-World War I kingdom of Serbs, Croats, and Slovenes, along with Bosnia, Herzegovina, Macedonia, and Montenegro—declared its distance from the Soviet model in 1948 under the leadership of Josip Broz Tito.

Allegiance to the Yugoslavian ideal of a multinational state was expected but subscription to an official form of art was not required. Indeed, artistic innovation was supported, as was openness to the West. Avant-garde movements were active in these states throughout the twentieth century. In Serbia during the 1920s, Zenitism was announced through Ljubomir Mičić's magazine *Zenit* (*Zenith*), and Surrealist currents connected with those swirling through Europe. Constructivism thrived in Slovenia during the same decade, especially in territories then part of Italy. After Yugoslavia liberalized in the 1950s, it sought a new form of national Modernism, known as "third-way socialism," which meant that artists could adopt apolitical approaches, or what became known as "socialist aestheticism." During the 1960s and 1970s, a new phase of avant-gardism appeared in the work of such collectives as the Neoconstructivist New Tendencies movement, the Gorgona group—whose word/image Conceptualism was manifest both in its self-titled magazine, published between 1961 and 1966, and in the art of its members, such as the painter Julije Knifer and the Conceptual artist Mangelos—and OHO, whose members experimented with body, performance, and Conceptual practices.

Within the Eastern Bloc countries, state control of the arts varied according to local circumstances, becoming more repressive in response to outbreaks of revolt, as in Hungary in 1956 and Prague in 1968, whereas "thaws" were introduced during periods when the leadership felt the need for greater social and economic vitality. Some artists, such as the Polish painter Andrzej Wróblewski, found ways of implying social dissent while conforming to relatively conventional stylistic parameters. Throughout this area, as in Russia, there was a continuous production of nonconformist

3.7 Roman Opałka
*1965/1-∞, Detail 1-35327*,
1965. Tempera on
canvas, 77⅕ x 53¹⁄₁₀in
(196 x 135cm).
Museum Sztuki, Łódź.

3.8 Braco Dimitrijević
*Casual Passers-by I
Met at 1.15 PM, 4.23 PM,
6.11 PM, Zagreb, 1971.*
Museum Moderner
Kunst Stiftung
Ludwig, Vienna.

3.9 Krzysztof Wodiczko *Vehicle*, 1972. Mixed media, dimensions variable. Courtesy of Galerie Lelong, New York.

and unofficial art, sometimes in Western figurative and Abstract Expressionist styles, but more often in the abstract, geometric, and Surrealist modes that had been prominent in the region (although examples were rarely seen outside) during the 1930s and 1940s. Notable among the early and mid-twentieth-century innovators were the Lithuanian Symbolist Mikalojus Čiurlionis, the Czech Orphist František Kupka, the Czech Cubist architects Pavel Janák, Josef Gočár, Vlastislav Hofman and Joself Chochol, the Slovenian architect Jože Plečnik, the Romanian sculptor Constantin Brancusi, the Polish Concrete Abstractionists Władysław Strzemiński and Henryk Stażewski, the Czech Surrealists Jindřich Štyrský, Toyen (Marie Čermínová), Karel Teige, and Zdeněk Pešánek, the Hungarian Cubist Sándor Bortnyik, and the Romanian Surrealist Victor Brauner. Many of these artists worked in Paris—during this period the center of world art—yet all continued to draw inspiration from their cultural and artistic roots.

The endeavors of earlier avant-garde artists resonated strongly in their home countries. Young artists took up their examples, often giving their work new forms. Czech poet, writer, and painter Jiří Kolář turned to a distinctive kind of collage in the 1960s, pasting cut-outs from pages of dictionaries into molded configurations. Polish sculptor Magdelena Abakanowicz employed distorted imagery of the human body fused with unexpected uses of natural materials to convey the psychological pressures of living in a closed society. In 1965, her compatriot Roman Opałka began to paint numbers in sequence, an infinite series of patiently crafted, tempera-on-canvas paintings entitled *1965/1-∞* (Fig. 3.7). Each work, subtitled *Detail* followed by the numbers it bore from the top left to the bottom right,

is 77 by 53 inches in size, the dimensions of Opałka's studio door. Beginning with white numbers on a black background, he moved to a gray background in 1968, and in 1972 started adding more white to the ground each day. He also recorded each number aurally, and was photographed standing beside each work. "All my work is a single thing, the description from number one to infinity. A single thing, a single life."[15] At that time, Serbian curator Dimitrije Bašičević, in his persona as the artist Mangelos, created "noart" works in the form of globes or chalkboards illustrating the principle of radical negation: "to negate the picture by writing it with words, to negate the word by painting it."[16]

## Parodies of Official Imagery

Reacting to the widespread use of public monuments as expressions of state power and official ideology, parodies of official imagery began to appear throughout the region during the 1960s. They often took the form of anti-monuments, or absurdist exaggerations of monumentality. For his series *Casual Passers-by* (1971) (Fig. 3.8), Serbian artist Braco Dimitrijević took passport-style photographs of ordinary people on the streets of Zagreb, Paris, and New York, and had them blown up to the gigantic proportions typical of images of political leaders in order to hang them in prominent positions in public places in those cities.

In 1972, Warsaw artist Krzysztof Wodiczko created *Vehicle* (Fig. 3.9), a conveyor-belt-driven quasi-machine that was set in motion by walking back and forth on its tilting top surface. In contrast to the techno-socialist utopianism of the Constructivists,

3.10 Krzysztof Wodiczko
*Lenin Monument*, 1990.
Public projection at the
Lenin Monument, Berlin.
Courtesy of Galerie
Lelong, New York.

*Vehicle* gently mocked the official rhetoric of progress and the intellectual's incessant pacing, showing both to be ways of going nowhere. Wodiczko subsequently designed a number of other interactive communicative devices and vehicles, notably the *Homeless Vehicle Project* in New York in 1988–89 (with David Lurie). Based in New York since the early 1980s, he has projected images onto public monuments and governmental buildings that contradict and counteract the edifices' official messages—his intention being, in his own words, "to reveal and expose to the public the contemporary deadly life of the memorial."[17] For instance, he projected images of a supermarket consumer onto the Lenin Monument in Leninplatz, East Berlin, in 1990 (Fig. 3.10); of U.S. and U.S.S.R. missiles chained together onto the Triumphal Arch in the Grand Army Plaza, Brooklyn, in 1995; and of local Polish women speaking of their abuse at the hands of males onto the City Hall Tower, Central Market Place, Kraków, in 1996.[18]

In *Hammer and Sickle* (1973) (Fig. 3.11), Sándor Pinczehelyi—an artist from Pécs, a provincial town in southern Hungary—combined the hammer and sickle, a Communist Party symbol of unity between rural and industrial workers, with an image of himself in the manner of Andy Warhol's deadpan celebrations of celebrity. As with the adaptations of Western rock and roll music by Iron Curtain musicians such as the Czech group Plastic People of the Universe, the critique here lies in the implication that a younger generation is creating a culture that is ambivalent toward official ideologies. To regimes uncertain of their hold on power, these mild manifestations proved intolerable. Repression of the Czech band was one of the triggers leading to the nationwide protest known as Charter 77, which in turn fueled a dissident movement that in 1991 became the "Velvet Revolution."

Between 1984 and 1990, Croatian artist Mladen Stilinović created, in a concentrated Constructivist style, 400 small relics in which images of Communist atheist mourning rituals were combined with similar images from religious cultures. He entitled the series *Exploitation of the Dead* (Fig. 3.12), describing it as referring "first, to the exploitation of the dead poetics of painting—Suprematism, Socialist Realism, and geometric abstraction. Second, to the exploitation of dead signs: for me, these signs are dead because they have

3.11 Sándor Pinczehelyi
*Hammer and Sickle*,
1973. Acrylic on canvas,
55¹⁄₁₀ x 39¹⁄₃in (140 x
100cm). Courtesy of
the artist and Museum
Moderner Kunst Stiftung
Ludwig, Vienna.

3.12 Mladen Stilinović
*Exploitation of the
Dead*, 1984–90. Mixed-
media installation,
dimensions variable.
Detail of exhibition view,
*Whatever Happened
to Social Democracy*,
Roseum Center
for Contemporary
Art, Malmö. Van
Abbemuseum, Eindhoven.

3.13 Zofia Kulik
*May-Day Mass*, 1990.
Photographs, 95½ x 60in
(243 x 152cm). Muzeum
Narodowe, Wrocław.

3.14 Sanja Iveković
*Triangle*, 1979. Four black
and white photographs
documenting performance,
Zagreb, May 19, 1979, each
12 x 15⅞in (30.5 x 40.5cm).
The Art Collection of the
Erste Group, Vienna.
Courtesy of Kontakt.

lost their meaning or their meaning is so transparent that it is in fact dead. For other people, of course, these signs are not dead. Third, the signs of the cross and star initially represented man and were later used by religion and ideology for their purposes; today, and this is a personal interpretation, they have turned into signs in ceremonies, not dead signs, but signs of death."[19] Miniaturization and repetition became Stilinović's way of responding to the deadly ambiguities hidden within the apparent simplicities of official rhetoric. He mourned the utopian dreams that drove international socialism during the twentieth century, along with expressing a realization that traditional religious beliefs would, most likely, not return as an adequate substitute. From a similar perspective, Polish artist Zofia Kulik (Fig. 3.13) collects the huge flood of images that constituted the symbolic inventory of totalitarianism, mixing them with the plethora that make up contemporary media worlds, and then employs a male model to enact poses of subjection, rephotographing each image in high-contrast black and white. "By accepting 'subjection' as my own problem and theme, full of fear and, simultaneously, full of hate towards the situation in which the constraint of yielding to subjection dominates, I commit an artistic revenge, grasping all weapons (symbolic and formal) used against me."[20] She then collages them into photographic displays that recall traditional formats, such as altars. The result is a snap-frozen scene from an uncanny archive.

## Performance Art Tests the Limits

Within these countries, performance artists often worked at the edges of permissibility. In Zagreb on May 19, 1979, Sanja Iveković staged *Triangle* (Fig. 3.14):

> The story takes place on the day President Tito visited the city, and develops out of the communication between three persons: 1. A person on the roof of a high-rise on the opposite side of the street from my apartment; 2. me on my balcony; 3. a policeman on the street in front of my house. Because of the concrete structure of my balcony, only the person on the roof opposite can see me and follow my actions. I presume this person is equipped with binoculars and a walkie-talkie. I notice that the policeman on the street also has a walkie-talkie. The action begins when I go out on to my balcony and sit down on a chair. I sip some whiskey, read a book, lift my skirt and make gestures as if I am masturbating. After a time the policeman rings my doorbell and commands that "persons and objects be removed from the balcony".[21]

Provocatively, the artist was wearing a top with the word "America" on it, and reading an English-language book, *Elites and Society*, by sociologist T.B. Bottomore.

3.15 Marina Abramović
*Rhythm 5*, 1974,
published 1994.
Gelatin silver print
with inset letterpress
panel. Artist's print
1 of 3, edition of 16.
Photograph: 22⅞ x
31⅞in (58.1 x 80.4cm).
Text panel: 9¾ x
6¾in (24.9 x 17.3cm).
Solomon R. Guggenheim
Museum, New York. Gift,
Willem Peppler 98.5214.

A more oblique, and in the event dangerous, performance was *Rhythm 5* (1974) (Fig. 3.15) by Marina Abramović, whose works of that time and since have been based on subjecting her body to tests of endurance that raise larger questions about personal and social power. On this occasion, the artist laid out strips of wood in the shape of a five-pointed star, symbol of the regime, to which she then set fire. Throwing her cut hair and nails into the flames, she stepped inside them and lay down, intending to endure the heat for as long as possible. The fire sucked out the oxygen, causing her to faint. Spectators came to her rescue.

During the early 1980s in Ljubljana, the capital of Slovenia, then still part of Yugoslavia, lively intellectual ferment—exemplified by a spate of publications about the historical avant-gardes of the early twentieth century, and by the work of philosopher-psychoanalyst Slavoy Žižek—led to an outburst of countercultural activity that resonates to this day. Laibach, a musical group formed in 1980, whose performances featured fanatical overidentification with totalitarian symbols and rituals, believed that "All art is subject to political manipulation (indirectly—consciousness; directly), except for that which speaks the language of this same manipulation." They identified their materials as "Taylorism, bruitism, Nazi Kunst, disco" and proclaimed: "Art and totalitarianism are not mutually exclusive. Totalitarian regimes abolish the illusion of revolutionary artistic freedom. LAIBACH KUNST is the principle of conscious rejection of personal tastes, judgments, convictions… free depersonalization, voluntary acceptance of the role of ideology, demasking and recapitulation of regime, 'ultramodernist'."[22] "Laibach," Ljubljana's name in German, was last officially used during World War II. Lead singer Tomaš Hostnik performed in a style reminiscent of Mussolini before stage settings filled with exaggerated Nazi-era props (Fig. 3.16). Laibach Kunst—*Kunst* is the German word for "art"—challenged the official ideology by embodying its precepts to such a degree that they became ludicrous overstatements. Hostile to anything but negative references to the Nazi past, the

Communist authorities banned their performances. In response, the group performed under other names, continuing to play the same music: industrial rock, derived from hard, local experience (members came from the coalmining town of Trbovlje).

By 1983, three other groups had formed in the city. IRWIN, the visual arts group mentioned at the beginning of this chapter (see Fig. 3.1), created installations that incorporated fascist and Communist imagery within the techniques derived from those of the early twentieth-century avant-gardes, especially the Russian Constructivists and Suprematists. With the irony typical of the time, the group announced the centrality of the "Retro-principle," a project of "reviving the trauma of the avant-garde movements by identifying with them in their moment of assimilation into a system of totalitarian states."[23] Scipion Nasice Sisters, a theater group, performed exorcisms of religion and ideology, while New Collectivism, a design group, became famous for winning a Yugoslavia-wide poster competition in 1987 for the "Day of Youth" with a recycled Nazi painting. In 1984, these groups joined together to form Neue Slowenische Kunst (NSK; New Slovenian Art), with the aim of creating a virtual but apparently real "institution" that had, in palpably exaggerated form, all the features of the state systems that, the artists wanted to show, were fragile fictions. The State of NSK was created, with ultra-totalitarian uniforms, Suprematist insignia, and a labyrinth of fictive bureaucratic departments. During the 1980s, the group staged its operations as theatrical or street performances. With the fragmentation of Yugoslavia into warring states during the 1990s and the eventual declaration of Slovenian independence, the group morphed into NSK State in Time, a traveling "state" that issued passports and sought to establish embassies in other countries around the world. Its first embassy, in Moscow in 1992, took the form of an exhibition and a meeting of artists in an apartment.

Other important art made at this time traces the transition to a post-Soviet condition on a more personal level. Nedko Solakov's *Top Secret* (Fig. 3.17), made

between December 1989 and February 1990, is a box file filled with random materials—drawings, notes, statements, clippings, and other texts—*residua* of the daily life of the artist as a young man. Among them is a series of cards that record the artist's collaboration with the Bulgarian secret police, his coming to self-consciousness about what he was doing, his refusal—in 1983—to continue to cooperate, and the consequences thereof. Whimsical in style, these materials suggest a poignant narrative of a jejune believer in a system, who is drawn into informing on his friends and colleagues, first in the art academy, then in the army. "But the man had made up his mind that this revelation should see the light of day as well. So he made a new card index in a chest. There he drew and described, using Pop art means, everything shameful and depressing which was still creeping around his ever more hurting heart… The man exhibited in public this card-index chest… and accepted internally once and for all that only he or she who can overcome his or her fears can be a true artist… Many of his younger colleagues (and some of the older ones as well) understood and shook his hand."[24] The work was exhibited in Sofia in 1990 at the height of the changes from Communist rule, and caused much controversy. In the explanatory statement cited above, Solakov goes on to warn young artists against cooperating with the authorities in the future if they are asked "whether some Communists, anarchists, etc. are having meetings." In Bulgaria even today, a shameful consensus means that most secret police and other state files remain closed: only the records pertaining to the pasts of elected representatives may be opened. Solakov's exceptional bravery is that he outed himself.

## Czechoslovakia

Founded in 1918, Czechoslovakia became the most prosperous country in the region. This led to major developments in Functionalist architecture, Surrealist art, and Cubist sculpture in the years before World War II, when the country came under German control. From 1948, now under Communist Party rule, Socialist Realism became the official style. Yet, in the late 1950s and 1960s, links to Western Europe resumed, leading many artists to work in the emergent avant-garde modes. In 1966, Stano Filko, Alex Mlynárčik, and Zita Kostrova wrote the *Happsoc* ("happenings" plus "society") manifestoes, one of which declared the Slovakian city of Bratislava, and everything in it, an artwork.

Czech artist, poet, and musician Milan Knížák became known in the West when Allan Kaprow included photographs of the 25-year-old artist's "actions" in his widely read book *Assemblage, Environments, and Happenings*. Knížák's *A Walk into the New World* series of 1963–68 included quixotic configurations of found materials made in the Prague street where he lived. His Aktual Group enacted nonviolent "war games," walks through the city staged as happenings, and gave public lectures on banned topics. Knížák is best known for

his playful collations of popular cultural imagery, crude mixtures of the kitsch and the sublime, such as *Czech Landscape No. 1* (1990), in which a mossy ooze flows from a bust of newly elected president Václav Havel only to sprout iridescent mushrooms. Works such as this are in the spirit of actions by sculptor David Černý and the collective the Neo-Stunners, who in 1991 sprayed pink a Russian tank that had been monumentalized as a memorial in the center of Prague. After the country was divided into the Czech Republic and Slovakia in 1993, Knížák became director of the Academy of Fine Art, which had previously expelled him as a student; he is currently minister of culture of the Czech Republic. Černý caused enormous controversy when invited to install a sculpture in the European Union headquarters to mark the Czech presidency. His *Entropa: Europe, as Seen by Artists from the 27 Member States* (Fig. 3.18) proved to be a mosaic compilation of toylike images, shaped like each country's geographic borders and filled with crude—and in some cases scatological—images evoking stereotypical prejudices about each nation.

## Hungary

For much of the twentieth century, innovative modern art in Hungary was curbed by conservative and, during the 1930s and 1940s, fascist governments. Members of avant-garde groups such as The Eight and MA, along with major independent Modernists such as László Moholy-Nagy, were driven into exile in 1919. In 1945, the country came under Soviet control, leading to the imposition of Socialist Realism. Hungary was a People's Republic for 40 years, from 1949 to 1989. Experimental art practice burgeoned during the 1970s and 1980s, however, notably in the "textual actions" of Conceptualist Miklós Erdély, an early member of Fluxus. In 1956, Erdély and a group of friends placed boxes in the streets of Budapest to collect money for the families of those killed during the suppression of the popular political uprising of the same year. He later referred to this as a "happening," entitling it *Unguarded Money*. He taught for many years, forming the Indigo Group with his students.[25]

For his work *Intelligent Landscape* (1993) (Fig. 3.19), Hungarian sculptor Imre Bukta shaped husked corncobs into 600 scarecrow figurines, which he then arrayed across a gallery wall at evenly spaced points on an implied grid. Shown in the Hungarian Pavilion of the 48th Venice Biennale in 1999, the figurines evoked the stereotypical image of Hungary as a primarily agricultural country, while their arrangement deployed the basic armature of Modernist, especially Minimalist, painting. The installation combined the ingenuity and practicality typical of objects (children's toys, in this case) made by peasant artists with the grid, the most refined and taxing format yet developed in Western aesthetic practice. This simultaneity is shocking. Was the artist subjecting the folkloric imagery of his native country to the stylistic imperatives of international art? Was he merely presenting imagery that Biennale visitors

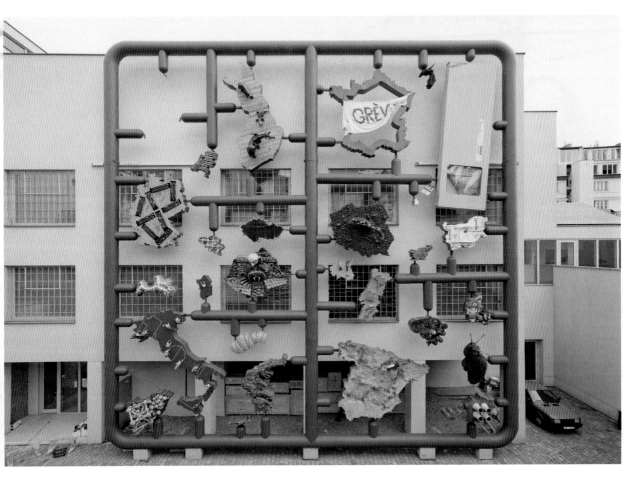

3.19 Imre Bukta
*Intelligent Landscape*, 1993. Corncobs, wire, shelled maize, plastic bags, 165⅓ x 393¾ x 6in (420 x 1,000 x 15cm). Hungarian Pavilion, 48th Venice Biennale, Venice, 1999.

3.20 Kai Kaljo
*Loser*, 1997.
Single-channel video,
1 min. 24 secs. Courtesy
of Anthony Reynolds
Gallery, London.

3.21 Leonards
Laganovskis
From the *Fossils* series,
1988–89. Amber, carved
and backed with resin,
and military pin, ½ x
2½ x 1½in (1.2 x 6 x
4.2cm). Jane Voorhees
Zimmerli Art Museum,
Rutgers, The State
University of New Jersey.
The Norton and Nancy
Dodge Collection of
Nonconformist Art from
the Soviet Union D01389.

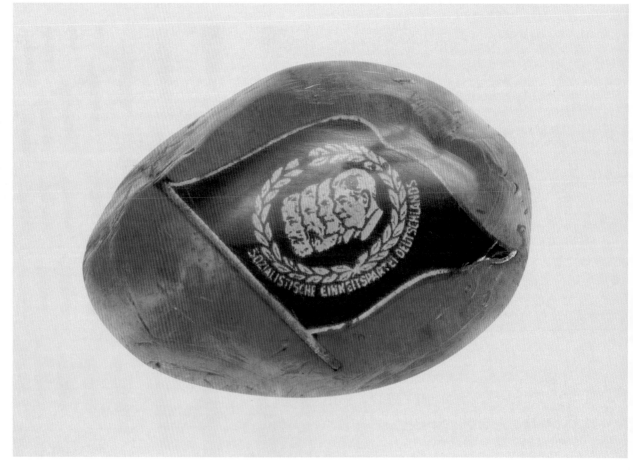

would identify as Hungarian, but in a manner that they could recognize? In fact, Bukta had been carving Expressionist sculptures, making paintings and prints, and staging performances using corn, stumps, tree branches, and agricultural implements to explore relationships between humans and the natural world for decades. For the artist, *Intelligent Landscape* had an intensely personal purpose. The corn was gathered from the fields worked by his recently deceased father. Each "doll," posed like a praying supplicant, offered up a plastic bag filled with maize seeds—that is, their own essence, their growth potential. In mourning, the artist reverts to a child-like state and, through the meditative making of these figurines, works toward a public acknowledgment of his experience. By displaying them in such numbers, he drew viewers into this simplicity of feeling, and reminded them of the actuality, and the vulnerability, of peasant culture. *Intelligent Landscape* also hints that the visual codes of High Modernism and peasant artisanship, seemingly so contradictory, share a dependence upon convention and repetition that may be, at base, the same. This quest for the "universals" of human experience is widespread in the region, and is a natural response to centuries of divisiveness.

## The Baltic Nations

A province within the Romanovs' Russian domains, although with close ties to the neighboring Scandinavian countries, Estonia was absorbed into the Union of Soviet Socialist Republics in 1940, along with the other Baltic states. Throughout the nineteenth and twentieth centuries, Estonian artists were involved in nascent nationalist movements but at the same time tended to view St. Petersburg, Moscow, and then Paris as their metropolitan centers. Post-Impressionist Konrad Mägi and Cubo-Futurist Ado Vabbe stand out in this group. From 1940, art production in Estonia was "Sovietized," that is, brought into the same artists' union system as prevailed in the central Soviet states. Nevertheless, independent artists' groups formed, especially in Tartu, including ANK, Visarid, and Soup '69. In the 1970s, as information about the earlier European avant-gardes and current art in the U.S. became known, art historian Sirje Helme described local experiments in these modes as "repro-avant-gardism."[26] Surrealist painter Ülo Sooster was a participant in and conduit to Soviet underground art during the 1960s; printmaking boomed, attracting many outstanding practitioners, such as Raul Meel and Tõnis Vint; Leonhard Lapin developed a Neofunctionalist architecture, evoking earlier Estonian achievements in this field in the 1920s, and a distinctive form of semiotic sign painting. Jüri Okas staged performances in isolated places in the later 1970s, and has since documented buildings and sites throughout the country, including unremarkable structures, for his *Concise Dictionary of Modern Architecture*. During the 1990s, he constructed elegant installations based on landscape photographs and imposed graphic signs.[27]

Independence in 1991 led to increased connections with international art. The Soros Center for Contemporary Arts opened in Tallinn in 1992, establishing an information center, an annual exhibition of work by young artists, and conferences on hot topics (known as *Interstandings*). Video artist Jaan Toomik's *Way to São Paulo* (1994) tracks a mirror cube as it swims peacefully through the rivers of three cities. In her 1997 video *Loser* (Fig. 3.20), Kai Kaljo stands in a spartan studio and introduces herself in spare English sentences: "Hi, my name is Kai Kaljo. I am an Estonian artist. My weight is 92 kg. I am 37 years of age, but still living with my mother. I am working at the Estonian Academy of Art for $80 per month. I think the most important thing about art is freedom. I am very happy."[28] Each sentence is followed by a loud burst of laughter in the manner of U.S. television comedies. The work is an elegant and moving evocation of Estonian realities and Western presumptions about career rewards. Kaljo's deadpan ironies parallel the use of the fixed smile in the paintings of Chinese "Cynical Realist" Yue Minjun (see Fig. 5.12). Both kinds of self-portrait explore the problem of how to represent selfhood in conditions of threat and constraint, especially when the official expectation is to maintain a happy face.

Smallest of the Baltic nations, Latvia was subject to Soviet cultural control throughout the twentieth century. Evaluating the work of artists in the Riga Museum of Latvian and Russian Art in 1948, writer Meinhards Rudzītis stated: "One may still paint an apple, but it must be a Soviet apple."[29] Latvia's best-known artist, Gustav Klucis, became an outstanding Constructivist photomontagist in Moscow in the 1920s, and a leading designer of graphic propaganda during the 1930s. In the 1970s, a group of environmentalist artists—including Māris Argalis, Valdis Celms, and Anda Argāle—attempted to realize Klucis's projects as architectural models and in drawings. Argalis had his career terminated by the K.G.B. This atmosphere led Leonards Laganovskis to create his *Fossils* series (1988–89) (Fig. 3.21), in which Soviet-era items such as military pins, Party membership badges, microphones, and bullets are cast in amber, a popular souvenir medium.

Since independence, Latvian artists have worked in a variety of contemporary media and styles. Notable works include the machine-versus-nature installations of Oļegs Tillbergs, Ojārs Pētersons's architectural installations exploring unexpected color combinations, and Kristap Ģelzis's installation series *Sēta* (*Yards*) as well as his psychologically resonant assemblages Lithuania, a province of Russia, then Poland, with strong Byelorussian and Jewish cultural strains, was an independent republic from 1918 until it, too, was absorbed into the U.S.S.R. in 1940. The fusion of folk-art themes with international Symbolism by Mikalojus Čiurlionis around the turn of the twentieth century paralleled similar work by František Kupka, Mikhail Vrubel, and Wassily Kandinsky. The Modernist group ARS was active in the 1920s. After 1940, aspirations toward nationalist forms of abstraction and expressive figuration were constrained, sometimes through direct repression, and Socialist Realism was promoted, although

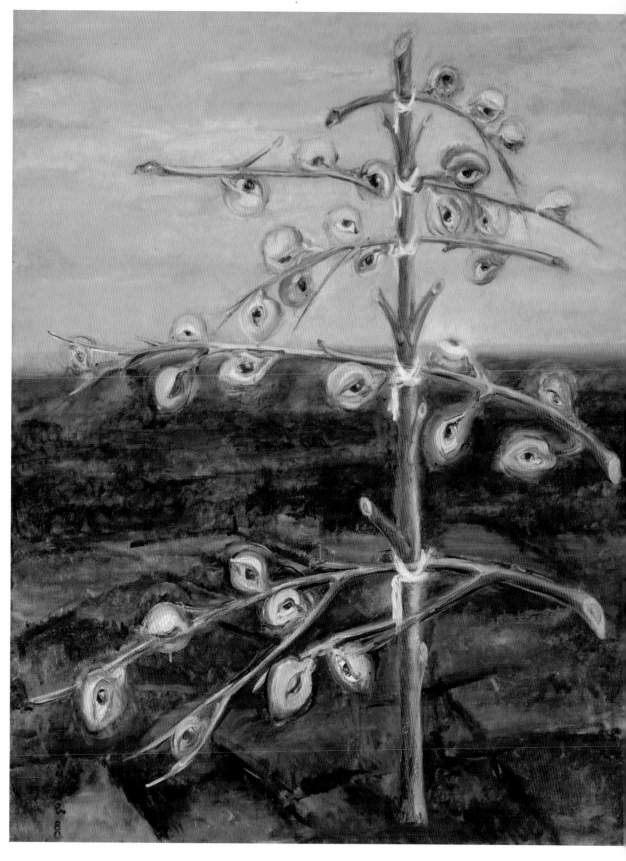

not widely adopted. As elsewhere, artists painted "with two easels" (one style for public exhibition, the other for private and communal sharing) or retreated into silent exile ("inner emigration"). Drawing on the fantastic imagery of Hieronymus Bosch and Pieter Brueghel, Henrikas Natalevičius evoked scenes of individual and collective metamorphosis (Fig. 3.22). The Photorealist paintings of Romanas Vilkauskas contain oblique expressions of dissent from dominant ideologies. His *Interior X* (1981) (Fig. 3.23) displays the effects of sunlight on a wall covered with yellowing newspapers: a cross has been removed, as has a collection of family photographs. All that remains is a news photo of Joseph Stalin, whose memory, the painting implies, will also fade when the paper turns to dust. The artist's purpose was recognized by Lionginas Šepetys, secretary of the Central Committee of the Lithuanian Communist Party, who wrote that "this superfashionable 'hyperrealism' is dangerous in that it works its way[,] insidiously undermining the foundations of realism... A realist form, when very meticulously executed, is by itself devoid of ideology."[30] These works were not exhibited publicly until well into the *perestroika* period.

After Lithuania's declaration of independence in 1990 and international recognition of its status the following year, the country's artworld underwent revolutionary change. In 1992, the Contemporary Art Center and a Soros Center for Contemporary Art were founded in Vilnius, commercial galleries opened, art magazines were published, and exiled artists who had been invited back from the West began teaching in local art schools. The Post Ars group, formed in 1989, served

as a link between the Communist and post-Communist periods through their continuing use of the traditional avant-garde method of challenging audience suppositions. Their 1990 exhibition at the Kaunas Artists' House displayed the Red Star in outrageous materials—floppy canvas *à la* Claes Oldenburg and raw pigs' heads—managing to offend both artists and officials. In a similar spirit, sculptor Mindaugas Navakas has led a questioning of the nature and limits of sculpture, an inquiry that continues to preoccupy most leading Lithuanian artists today, including Artūras Raila, Gediminas Urbonas, and Deimantas Narkevičius.

## AFTER THE FALL: POST-COMMUNIST ART?

1989 was the year in which major shifts in the great forces shaping the world—decolonization of the Third World, the implosion of the Second World, and globalization spreading out from the First World—were manifested in both political and cultural spheres, often in closely related ways. On the borders of Europe, transformatory events occurred in cascading fashion throughout the year. In May, Slobodan Milošević was elected president of Serbia in the first multiparty elections in the area since World War II. In June, the Polish trade union federation Solidarnosć won limited parliamentary elections. In August, Hungary removed border restrictions with Austria, followed by Czechoslovakia and Poland, thus opening the "Iron Curtain" to the West. Artists gained direct access to Vienna, for decades a leading center of radical experimentation, notably by

groups such as the Vienna Actionists. In November, East German border police unexpectedly opened the Berlin Wall, leading to the structure's demolition by thousands of visitors over the following days, and to the unification of Germany 11 months later. At the same time, six weeks of demonstrations in Prague led to the bloodless overthrow of the Communist regime (known as the "Velvet Revolution"). In December, the Romanian dictator Nicolae Ceaușescu was deposed, quickly tried, and executed. Capitalizing on these events, U.S. president George Bush and Soviet president Mikhail Gorbachev met to declare the Cold War over. During the next two years, most of the former Soviet republics declared their independence. In February 1992, the 12 members of the European Community signed the so-called "Maastricht Treaty" and established the European Union, which has since swelled in size so that it now counts 27 states as members. In response, Russia, Belarus, and Ukraine established the Commonwealth of Independent States in December 1992. This quickly grew to include 12 of the former Soviet republics. While a counterforce to the European Union, it was and remains much smaller in economic and political strength, and in social and cultural cohesion.

The evaporation of the Soviet Union as the dominant political and cultural force in the region, and the emergence of a major European federation—the European Union—dedicated to the avoidance of war among its members, led to a number of effects that were shared in different ways by all the countries in the region. Most prominent was a desire to join, or rejoin, Europe in economic and perhaps cultural confederation. In many places, not least Russia itself, this was accompanied by an instant, and widespread, amnesia regarding the period of Communist rule, and by efforts to re-create a historical memory of pre-Communist times as positive and free, providing national foundation myths on which new social structures could be built. IRWIN's assemblage *Retroavantgarda* (1996) **(Fig. 3.24)** ironizes this process by exaggerating its ahistorical amnesia. It is a collage of images of works by artists from the former Yugoslavia, arranged as if it were an art-historical chart of stylistic progression, yet its temporality is random: for instance, it makes Kasimir Malevich, reappearing symbolically in Belgrade in 1986, the most contemporary of artists.

These broad ideological tendencies varied from place to place, and met different kinds and degrees of resistance in each country. We have already noted the centrality to contemporary art in Germany of "coming to terms with the [Nazi] past." In the former East Germany after unification, a parallel effort of self-accountability undertaken by many artists, writers, playwrights, and others was accompanied by resistance to the total embrace of Western consumerism and neoliberal economics. Within the region as a whole, there was a marked increase in communication between artists, as they struggled to make sense of their shared post-Communist experience. At the same time, artists eagerly sought to participate in international art institutions. These changes

in outlook inspired a major effort to recover the complex history of twentieth-century Modernism in these regions, highlighting the overlooked originality of many artists—a project that is ongoing. Fresh scholarship and engaged theorization inspired a number of important survey exhibitions, notably *Europe, Europe: The Centenary of the Avant-Garde in Central and Eastern Europe* (Bonn, 1994), *After the Wall: Art and Culture in Post-Communist Europe* (Stockholm, 1999), and *Aspects/Positions: 50 Years of Art in Central Europe 1949–1999* (Vienna, 1999).

Art administrators sought ways to exhibit the transformations occurring in current art, and to reflect these changes in new exhibition formats. Since its first iteration in Rotterdam in 1996, Manifesta has been a "nomadic biennale," staged every two years in a different European city, by teams of curators from outside that city who have never worked together before. Curators spend the intervening years combing the continent for new art, ultimately presenting it in whatever ways suggest themselves. After Rotterdam, it was staged in Luxembourg, Ljubljana, Frankfurt, and Donista-San Sebastián, deploying an innovative range of formats, from traditional museum exhibitions to Internet sites.[31] The Manifesta planned for Nicosia in 2006, which was to take the form of an artists' school that would conduct classes in both parts of the only divided city remaining in Europe, fell foul of local regulations and political tensions. After a hiatus, Manifesta resumed in 2010 in the Spanish cities of Murcia and Cartagena, focusing its gaze on the divide between Europe and its southern neighbors.

Contemporary art in the region also received significant support from external agencies, such as the German chocolate baron and collector Peter Ludwig, who established major contemporary art museums in St. Petersburg in 1995 (a part of the Russian Museum), Vienna in 2001, and Budapest in 2003. More influentially, the Hungarian-born U.S. financier George Soros funded a string of Centers for Contemporary Art in 20 countries in the region in order to promote the anti-totalitarian goals of his Open Society Foundation. The Soros Centers encouraged local experimental art in internationally recognized Conceptual, installation, and performance modes, and supported the travel of young artists, curators, and researchers. In 2000, Soros withdrew funding. Some centers closed, but others, such as that in Sarajevo, continue to play an important role in their local communities.

## Romania

After becoming an independent kingdom in 1881, Romania reached a peak of economic and cultural development between the two world wars. Romanian artists Tristan Tzara and Marcel Janco were major instigators of the Dada movement in Trieste and Zurich, while Constantin Brancusi and later Victor Brauner exercised great influence in Paris. In 1945, Romania came under Communist control and was subject to the dictatorship of Nicolae Ceaușescu from 1965 until

# Retroavantgarde

- 2000
- 1990    *Malevich*    *Irwin*
-          *Belgrade 1986*    *Ljubljana*
- 1980
- 1970
- 1960    *Stilinović*    *Dimitrijević*
-          *Zagreb*    *Sarajevo*
- 1950
- 1940    *Mangelos*
- 1930
- 1920    *Laibach Kunst*
-          *Trbovlje 1981*
- 1910    *Zenitism*
- 1900

3.24 IRWIN
*Retroavantgarda*, 1996.
Mixed media, 47¼ x
78¾in (120 x 200cm).
Courtesy of Galerija
Gregor Podnar,
Ljubljana.

3.25 Lia Perjovschi
*Endless Collection*, 1990–
today. Installation view,
Generali Foundation,
2005, display of approx.
1,000 objects. Courtesy
of the artist and Generali
Foundation, Vienna.

1989. Nonconformist art was rare in a society dominated by surveillance and fear. Exceptions include the performance works of Ana Lupas, Geta Bratescu, Ian Grigorescu, and Lia Perjovschi. In Perjovschi's *I'm Fighting For My Right to Be Different* (1993), the artist treated a life-size doll as her "double," dressing it, talking with it, covering it with black paint before throwing it against walls and into crowds of spectators, then sitting beside it, adopting its postures. These actions made visible the traumatized, imaginary, other "self" generated inside each citizen by oppressive regimes. A related work was Dan Perjovschi's *Romania* (1993), in which he had the name of his nation tattooed on his body, signifying his protest against the continuation of oppression even after the fall of Ceauşescu. Ten years later, he performed *Erased Romania*, having the tattoo removed, indicating his belief that a greater degree of freedom had been achieved.

Both artists, a married couple, are deeply committed to archival practices. Lia Perjovschi established as archival and art projects the Contemporary Art Archive Center for Art Analysis in 1990 and the Knowledge Museum in 2006. Her installation *Endless Collection* (Fig. 3.25), begun 1990, is an open-ended accumulation of more than 1,000 objects all shaped as or containing an image of the world as a globe, symbols of liberation to those whose travel had been severely restricted. Dan Perjovschi began drawing cartoons for the liberal newspaper *Revista 22* in 1991. Since then, he has extended his use of satirical images to the drawing of elaborate murals that connect artworld currents to contemporary world political events, creating "interior graffiti" installations such as, in 2007, the amusing *The V Drawing* in the entranceways to the main exhibition halls at the Venice Biennale, and the 110-foot-high wall drawing *What Happened to US?* (Fig. 3.26) in the atrium of the Museum of Modern Art, New York. Within the latter, Perjovschi sketched an image of three men standing together as if to swear an oath of allegiance. The two outer figures wear the insignia of the United States and the European Union respectively, while the central figure is labeled "East Europe." He attempts to shake the hands of the

3.26 Dan Perjovschi
*What Happened to US?*,
2007. Installation view,
*Projects 85: Dan Perjovschi*,
May 2, 2007–August 27,
2007. The Museum of
Modern Art, New York.

3.27 subREAL
*Draculaland 2* (room
#2), 1993. Mixed media,
dimensions variable.
Installation at Art
Museum Bistritza.

other figures but in the process manages only to tie himself in knots (lower right in illustration).

In the immediate aftermath of the end of the Ceauşescu regime, the group subREAL was formed in Bucharest, by Călin Dan, Dan Mihalţianu, and Iosif Király. Their installations evoke everyday life and the plight of the intellectual in the new times. Beginning in 1993, the installation series *Draculaland* (Fig. 3.27) uses exaggerated images from the Bram Stoker novel, many movies, and folk art from Transylvania as well as allusions to internationally known Romanians (a vaulting horse evokes star gymnast Nadia Comineci) in order to mock stereotypes of Romanian nationalism. In 1994–95, an installation based on the black market during the Communist dictatorship took the form of a re-creation of the infamous House of the People—a gigantic palace built by Ceauşescu—made from contraband cigarette packets (Fig. 3.28). Above it hovered a chair, its long legs honed to sharp points, making it a kind of Sword of Damocles. In a series entitled *Art History Archive Lessons*, subREAL installed materials from the archives of *Arta*, the journal they had edited before the political revolution. The contents included mocking letters written to the Securitate (state security service) pointing out how subversive the artists' aims were and how ineffective they were being. SubREAL, they say, is "first of all, a certain way to react towards an environment. Which just happened to be Romania. Then, it became a concept covering the ambiguous faces of that reality. Then again, the fact that Romania is just a piece in a huge subREAL context became obvious. But what is subREAL remains a question potentially addressed to everybody and everything. For the moment, let's say that subREAL is all the information coming from the territory where stupidity and cynicism become one."[32]

This is the territory of post-socialism, the period that succeeded a political system that had been failing for decades, and that did so in a protracted—and, to many of its inhabitants, a dangerous and debilitating—way. In the current void, a number of interest groups compete for power: old Communist elites, nouveau-riche oligarchs, historical institutions such as the Church, and those seeking to create civil societies. Just which will set the agenda for the future remains an open question.

## The Breakup of Yugoslavia

Against the grain of the mostly nonviolent political changes in Eastern and Central Europe during the 1990s, civil war broke out in Yugoslavia in June 1991, with Croatia and Slovenia soon declaring independence from the multistate, followed by Macedonia, then Bosnia and Herzegovina. Serb minorities fought to keep Yugoslavia intact, then to remove Muslim populations, leading to bloody conflict. In April 1992, the calamitous Siege of Sarajevo began, lasting until February 1996, when NATO forces intervened against the Serbian besiegers. Ethnic cleansing occurred throughout the area, most shockingly at Kosovo.

Despite close official surveillance, some artists were critical of the nationalist regime led by Slobodan Milošević between 1989 and 2000. Raša Dragoljub Todosijevič's *God Loves the Serbs* series consists of wall installations of bureaucratic office furniture arranged in a visual dialogue with a raking red swastika. One of these (Fig. 3.29) uses two sets of three chairs, evoking Joseph Kosuth's famous Conceptual work of 1965 *One and Three Chairs* (see Fig. 1.18). Each chair precariously supports a bucket of water, and a Titoist pioneer song blasts out from six cassette players. The text below is a poignant short story written by the artist describing the sufferings of his mother, a down-to-earth nonbeliever and dissident, under an unforgiving God and a failed socialism. The ideological confusion of the post-Communist state is thus made clear, as is the persistence of totalitarian elements within it. Meanwhile, the Tudjman dictatorship obliged Croatian artists to produce celebratory nationalist works. Similar pressures were brought to

3.28 subREAL
*The Castle*, 1994. Mixed
media, dimensions
variable. Installation
detail, Center for
Contemporary Arts
(Ujazdowski Castle),
Warsaw, December
1994–January 1995.

3.29 Raša Dragoljub
Todosijevič
*God Loves the Serbs
(Gott Liebt die Serben)*,
1993. Mixed media,
dimensions variable.
Installation view,
Stadtmuseum,
Graz, during the
exhibition *Europeans*,
1993. Courtesy of
the artist.

3.30 Mladen Stilinović
*An Artist Who Cannot*
*Speak English Is*
*No Artist*, 1992.
Artificial silk, 54¾ x
78in (139 x 198cm).
Van Abbemuseum,
Eindhoven.

3.31 Zbigniew Libera
*Lego 6772* and
*Lego 6773*, 1996. Lego®,
19 x 11 x 3¹/₁₆in (48 x
28 x 8cm). Courtesy of
Faurschnou CPH.

bear in Belarus, Ukraine, Turkmenistan, and elsewhere. These were, however, exceptions to the general tendency toward liberalization throughout the region.

## BEYOND "EASTERN" AND "CENTRAL" VERSUS "WESTERN" EUROPE

In 1995, Hungarian curator László Beke reported on a widespread mood: "the artists, critics, curators, and art historians of East Central Europe are in a transitional (or acute) identity crisis. We don't really know why we do what we do, what the dominant characteristic of our art is, what the rest of the world expects of us, or what art's purpose is anyway." It seemed to him that "the change in the political system brought to an end the viability of avant-gardism," not least because the "enemy" had vanished, but also because Postmodernism, arriving fresh from the West, devalued overtly political art as out of date: "before 1989 progressive art had an oppositional image, while today's art doesn't. The recognizable characteristic of today's art is that it has no recognizable characteristic."[33] A year later, at a conference in Budapest devoted to these questions, Beke's colleague János Sturcz vigorously objected to regional comparisons as "tunnel vision": "According to my experience, I would say that for the 'Central European' artists of my generation or younger, the identification point is by no means Western Europe but much rather North America, as well as the context we have referred to here as global art, in which the most diverse cultures take their place on equal terms."[34]

This desire for a level playing field on which artists from everywhere could freely and openly compete—expressed as a wish for a "normal" life as an artist—led Austrian curator Robert Fleck to declare in 1998 that art from the region had finally achieved a "Post-Communist" state, and that there were "no fundamental aesthetic differences" between the work of

the current generation of artists in "the various parts of Europe." Not only had the East/West division disappeared, he believed, so, too, had the need to insist on national distinctiveness. European artists, he felt, were now in "a decentralized situation not experienced since the 1920s."[35]

Other artists, critics, and curators have not always expressed such confidence that these sweeping changes were entirely beneficial. In 1992, Mladen Stilinović bitterly protested the inequalities of power and resource distribution by producing a silk banner—in the style of those held up at protest rallies—on which the words "An Artist Who Cannot Speak English Is No Artist" were painted in English (Fig. 3.30). Ekaterina Dyogot succinctly expressed the paradoxical position in which many artists in the region still find themselves: "In Russia… being a contemporary artist means to represent Western culture" whereas "in the West… a Russian artist must inevitably represent Russia."[36] Much of the art produced in the region at this time was obliged to face both ways, to be legible from both sides of an ideological curtain that had, it was too quickly and mistakenly assumed, been torn down. Curator Igor Zabel astutely observed: "Since 1989 in the West and East, [young] artists have reacted to basically the same mass cultural products, making their art appear quite similar. But there are, nevertheless, important, if not very obvious, differences in understanding and appreciating such mass culture that affect the character of the art."[37] One example is *Lego* (1996) (Fig. 3.31) by Polish artist Zbigniew Libera. The work's seven constituent boxes at first look like ordinary Lego® products, but on closer examination each turns out to be part of a toy concentration camp, complete with grounds, buildings, torture areas, and gas ovens. Amidst the storm of controversy that arose, the artist drew attention to the need to remember the German imposition of these camps on his country's soil, and drew parallels to current practices of child-rearing, pressures toward social conformity, and "the

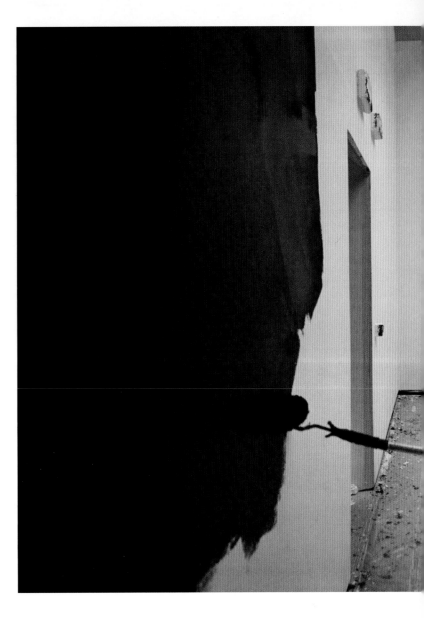

3.32 Nedko Solakov
*A Life (Black and White)*,
1998. Black and white
paint; two workers/
painters constantly
repainting the walls of
the exhibition space in
black and white for the
entire duration of the
exhibition, day after
day (following each
other); dimensions
variable. Edition of 5
and 1 artist's print.
Collections of Peter
Kogler, Vienna; Susan
and Lewis Manilow,
Chicago; Sammlung
Hauser und Wirth,
St. Gallen; Museum
für Moderne Kunst,
Frankfurt am Main,
Tate Modern, London.
Courtesy of Nedko
Solakov. *Plateau of
Humankind*, 49th Venice
Biennale, Venice, June
9–November 4, 2001.

cultural cacophony that the free market has brought to formerly Communist Eastern Europe."[38]

Astutely aware of the continuing contradictions of the post-Communist situation, since 1998 Nedko Solakov has repeatedly staged a performance in which two roller-wielding painters, with their backs turned to each other, continually cover the walls of a room, one in black, the other in white, one color contesting the other (Fig. 3.32). The work's title, *A Life (Black and White)*, brings out the symbolic resonance of this apparently futile activity. It is a metaphor for living between two worlds—locked together in a mutually obliterating incompatibility—seemingly unable to allow a fuller range of colors to flourish or figuration to develop. Nevertheless, in his drawings—whimsical sketches of absurdist situations, of hopeful dreams and wistful longings—Solakov hints at the persistence of hope against all the odds.

## TRANSLATING THE EUROPEAN IDEAL

In 2005, one country after another, beginning with France and Holland, voted against a proposed "Constitution" for the European Union, leading others to quickly cancel proposed polls. Despite their persistence, a modified version of the constitution was ratified by all member states and came into force in 2009. While it is impossible to summarize the motives of millions, most commentators attributed the negative mood to two quite distinct causes: a reluctance on the part of voters to subject themselves to yet more governance by political and bureaucratic elites, and a fear on the part of many that the borders of Europe had been opened too widely. In these reasons we see, again, the contradictory forces that have been at work shaping culture on the continent for centuries.

Our consideration of the shifts from modern to contemporary art in the region, in the context of broad social and political changes, has led us to see that Europe is less a fixed geographic area, more a "borderland"—that is, an idea of unity that mediates constant negotiations between heterogeneous peoples with much to share but also with many valued differences to maintain. Luchezar Boyadjiev has given a name to this phenomenon, "Deep Europe," believing that "Europe is at its deepest when there are a lot of overlapping identities."[39] Awareness of this state of affairs is perhaps less evident among artists and political commentators in

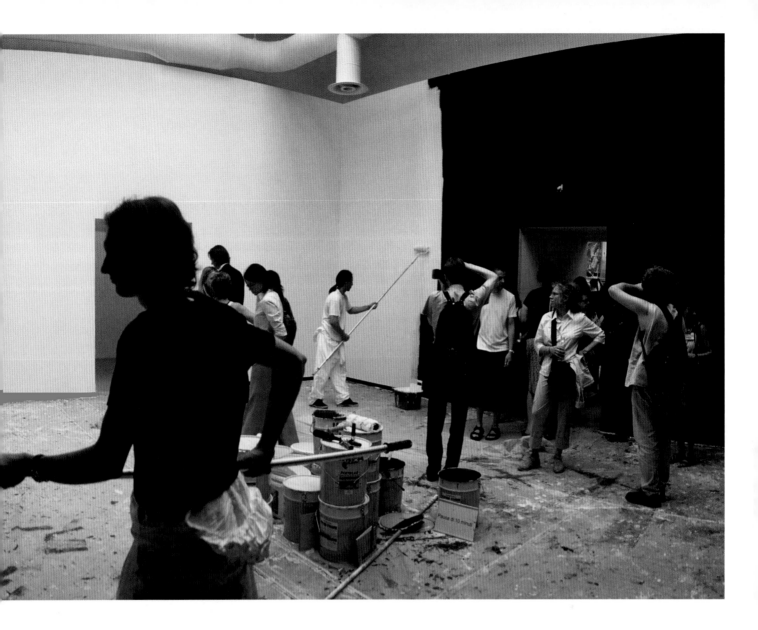

France, Germany, and Great Britain—in recent centuries the dominant nations in Western Europe—than it is in Central and Eastern Europe, including Russia and its allied states. A large division remains in the consciousness of many between *Kern Europa* (Europe's core) and the peripheral states, those on either side of the much-contested borders of "Europe." Yet we have seen that the European "interior" has also, for centuries, been a site of contestation—although armed conflict seems unlikely to break out again in the foreseeable future.

French theorist Étienne Balibar has observed that these circumstances—both long-term and more recent—have created an important opportunity for artists and thinkers. "Europe is not the only region in the world where translations are made, where technologies, professional instructions, literary works and sacred texts continuously pass from one idiom to another. But nowhere—not even India and China—was it necessary to organize to the same degree the political and pedagogical conditions of linguistic exchanges."[40] Balibar goes on to suggest that this history—to which must be added the efforts required to interpret global expansion on the part of, and competition between, imperialist powers, followed by the "striking back"

of the colonies during the recent phase of decolonization—gives European intellectuals an "exceptional" opportunity to draw on their hard-won inherited strengths as translators, and to act as mediators within these conflicted situations—to become "interpreters of the world" to itself, starting with an expansion of the scope of European translation to include the Arabic, Turkic, Urdu, and other languages now widely spoken on its soil. Balibar points to the value of a broader idea of *translation*: the showing of that which is shared, that which is different, and that which is untranslatable in all spheres of life. In this chapter, we have seen that this is exactly what artists in the region have been doing for some time, especially during the recent turmoil. Alertness to multiplicity and difference has been, and continues to be, at the core of their contemporaneity.

# 4. SOUTH AND CENTRAL AMERICA, THE CARIBBEAN

Contemporary art in this part of the world is permeated with vital, often contradictory, energies: even the most basic terms for self-description are intensely debated, as they have been for centuries. Prior to the appearance of Europeans here in 1492, the Indian, Aztec, Inca, and Mayan inhabitants of the western hemisphere did not see themselves as "Indians" living in "America," but rather as members of their own cultures living in regions contingent to each other. It was the Spanish and then Portuguese conquerors who regarded them as "barbarians" and who now added to their maps of the world—which until then had consisted of Europe, Asia, and Africa—a fourth region, consisting of two continents linked by a narrow isthmus. Initially named "Indias Occidentales," owing to a belief that it was an extension of southern Asia, it was renamed "America" in the sixteenth century for the merchant, explorer, and cartographer Amerigo Vespucci, who realized, as he gazed at the night sky in southern Brazil, that he was actually standing in a "New World" from a European perspective. During this period, Spanish and Portuguese forces colonized much of both continents, employing indigenous peoples as laborers, and then importing slaves from Africa, for the export of local materials to Europe. In subsequent centuries, British, French, and Dutch colonists did the same in the northern continent and on the islands of the Caribbean. The phrase "Latin America" emerged on the southern continent in the mid- and later nineteenth century to emphasize the Latin-based languages spoken in the Spanish and Portuguese colonies within the independence movements led by *mestizo* (mixed-race) intellectuals, as a way of linking the goals of their struggle to the Enlightenment ideals widespread across Europe since the eighteenth century, many of which were based on Roman (thus Latinate) models. After the 1898 Spanish-American War, the phrase came to underline the continent's difference from the "Anglo-American" northern nations (the United States and Canada). In recent years, an Afro-Caribbean consciousness has been asserted by many, and throughout South America an "after-coloniality" identity is being imagined by many indigenous peoples, using a term from the precolonial period: "Abya-Yala." Meanwhile, the words "Latinos" and "Latinas" designate an emergent phenomenon: the millions of people from South America and the Caribbean who work in or travel to and from economic centers in both American continents. In all their diversity, they are the majority population of these continents in the early twenty-first century.[1]

## SOUTH AMERICA

Battles for independence, and the heroes who fought in them or governed thereafter, were the main subjects of official and academic art throughout the nineteenth century. Landscapes and genre scenes were produced in number by traveling artists such as Franz Post and Albert Eckhout, and by explorer-scientists such as Alexander von Humboldt. In the late nineteenth century, these topics and treatments converge in the panoramic landscapes of Mexican painter José María Velasco. Graphic arts were popular in many countries, not least Mexico, where the prodigious output of José Guadalupe Posada inspired generations of printmakers, notably the Taller de Gráfica Popular (People's Graphic Workshop), founded in Mexico City in 1937. During the early twentieth century, artists from all over the region studied and worked in Europe. Some remained abroad, creating their own innovative Modernisms—for example, the "Vibrationism" of Uruguayan painter Rafael Barradas. Others, such as Mexican painter Diego Rivera, contributed significantly to major European movements before returning to their home countries to found tendencies responsive to local needs: Rivera was a significant Cubist before helping to launch the Mexican Mural Movement (within which his achievement was at times matched by other artists, including David Alfaro Siqueiros and José Clemente Orozco). *Modernista* artists in Brazil traveled extensively between their country and Europe, evolving a "cannibalistic" ethos expressed in Oswald de Andrade's 1928 "Anthropophagite Manifesto": based on intimate

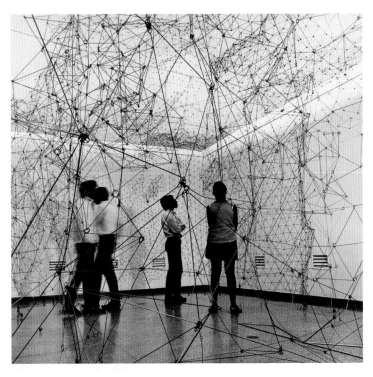

4.1 Gego
*Reticulárea (Atmosphere)*
*(Reticulárea,*
*Ambientación)*,
1969. Stainless-steel
wires, and aluminum,
dimensions variable.
Museo de Bellas
Artes, Caracas.
Courtesy of Fundación
Gego, Caracas.

knowledge of the aesthetics of the colonizer, studied at their source, they selectively consumed the tastiest morsels in order to create a local art, one that acknowledges both its indigenous roots and its contemporary dependence.[2]

Other significant artists took independent pathways, notable examples being Paul Figari's studies of the black population of Uruguay, Argentine Xul Solar's mythic imagery, and Venezuelan Amando Reverón's light-blinded paintings of self-exile. After his return from Paris to Uruguay in 1933, Joaquín Torres-García founded a Constructivist school, magazine, and circle of artists. His famous 1935 diagram *The North Is the South* expressed his view that "we shouldn't have a north, except to contrast with our South. So let us turn the map upside down, and there, that is our real position, not how the rest of the world sees it. The tip of America, from here on, extending upwards, insistently indicates the South, our north. At the same time, our compass points relentlessly to the South, to our pole… That correction was necessary. So, now we know where we are."[3] Arguing that the geometric sign prevalent in European modern art had its deep sources in Pre-Columbian art, Torres-García developed a powerful fusion of abstract imagery from multiple cultures, anticipating a major tendency in mid-century art throughout the world, not least in the United States, and the first phase of Abstract Expressionism in the paintings of Mark Rothko, Adolf Gottlieb, Jackson Pollock, and others.

Surrealism was attractive to artists living on a continent where, in the words of novelist Gabriel García Márquez, "Everyday life… proves that reality is full of the most extraordinary things."[4] All significant artists of the mid-century were drawn to it, some going on to create distinctive forms that continue to resonate today. These include Mexican artist Frida Kahlo's votive self-portraits, Chilean Roberto Matta Echaurren's "inscapes," and Cuban-African painter Wifredo Lam's reverse

"primitivizing" of Picasso. Each deployed Surrealist devices to display the impact of social inequity and political conflict on the everyday lives of individuals.[5] Artists in the region were also drawn to geometric abstraction and the example of such Dutch and Swiss artists as Piet Mondrian, Theo van Doesburg, Hans Arp, and Max Bill. Inspired by Bill's 1936 formulation "We call concrete art the works of art created according to a technique and laws entirely their own… without intervention of any process of abstraction," the Arte-Concreto Invención (Concrete Art Invention) association was formed in Buenos Aires in 1945.[6] In the following year, certain members broke away to create the Madí group. Their innovations readily match those of better-known artists active in Europe.[7]

Artists throughout the region came up with far-reaching transformations, particularly those, such as the Argentine Lucio Fontana, who lived for long periods in Europe. In Venezuela during the later 1950s and early 1960s, artists such as Alejandro Otero, Jesus Raphael Soto, and Carlos Cruz-Diez led the world in the experimental development of geometric abstraction and kinetic art. A responsive city government invited them and others to create architectural decorations and public sculptures in these styles, notably at the Central University, Caracas. In Paris in 1960, Julio Le Parc formed the Groupe de Recherche d'Art Visuel (GRAV; Group for Research in the Visual Arts) with fellow Argentine Hugo García-Rossi, Spaniard Francisco Sobrino, and the French artists Yvaral (Jean-Pierre Vasarely), François Morrellet, and Joël Stein. These artists were the foremost Op Art and kinetic artists in Europe. Working at oblique angles to the flat abstraction and colorfield work of her Venezuelan colleagues, Gego (Gertrudis Goldschmidt) sought to capture fragile, hidden geometries in her *Reticuláreas* (*Nets*). Her 1969 installation at the Museo de Bellas Artes, Caracas [Fig. 4.1] was an intricate,

4.2 Antonio Dias
*Note on the Unforeseen Death (Nota sobre a Morte Imprevista)*, 1965. Acrylic on wood, fabric, Plexiglas®, agglomerate (Duratex), 76¾ x 69¼ x 23¾in (195 x 176 x 63cm). Courtesy of Antonio Dias and Cristiane Olivieri.

*He practiced every day.*

*He feared thirst.*

*The weight drove his pulse into the wall.*

4.3 Luis Camnitzer
*Uruguayan Torture Series*, 1983–84. Photo etchings, 35 parts, each 29½ x 21½in (75 x 55cm). Edition of 15. Courtesy of the artist and Alexander Gray Associates, New York, NY.

enveloping environment of thin wires hooked together, like a potentially infinite yet irregular spider-web, yet also evocative of the tensions within a modernizing city and the proliferating chaos of the *favelas* (shanty towns) around it. Dawn Ades sums up the key dynamic at work throughout the continent during this transitional period: "So a fertile tension arises between a geometric order, with its values of lucidity and modernity, and an invitation to chaos, disorder, flux, organicity, the random, the void—which begins to create a new kind of space."[8]

Political themes became insistent during the 1950s and 1960s, as the hemisphere reeled from the shock of the revolution in Cuba in 1959, in which a government closely tied to the United States was overthrown. While this event inspired similar uprisings elsewhere, it also precipitated reactions in major countries such as Brazil and Argentina. Political and military leaders feared that insurrection would threaten the modernization programs on which they were embarked: for example, the creation of Brasília, an ideal capital consisting of High Modernist structures designed by Oscar Niemeyer and located in the center of Brazil. Dictatorships were instituted, some lasting for decades: Paraguay 1954–89, Brazil 1964–85, Argentina, intermittently then 1976–83, Uruguay 1972–85, and Chile 1973–90. Civil wars in Colombia, Guatemala, and Venezuela frequently led to the imposition of dictatorial policies and the use of paramilitary violence.

The initial impulses toward rapid and widescale modernization in the early 1960s had inspired artists and accelerated their connections with avant-garde art elsewhere, precipitating unique kinds of experimentation that, in many centers, matched for quality and innovation Late Modernist Art anywhere in the world. Soon, however, the dictatorships came to exercise such ideological control, involving both psychological threat and physical coercion, that artists were forced into exile or to have recourse to more indirect imagery. This is the situation evoked in Antonio Dias's *Note on the Unforeseen Death* (*Nota sobre a Morte Imprevista*) (1965) (Fig. 4.2), in which Pop-style scenes of the deadly effects of chemical spills, atomic radiation, and natural disaster hover, like altar panels, above a buoylike shape that frames, as if it were a reliquary, a bleeding body part. From it, a black, viscous substance flows to the floor. Artists in exile had the option of addressing such issues more directly, but often found that subtlety led to greater affect. Although he has lived in the United States since 1964, Luis Camnitzer's Conceptualist works have consistently explored issues relevant to South America in general or Uruguay in particular. He uses subtle, often oblique, relationships between words and images in order to convey the slippages between human intentions and actions in highly political circumstances. His major work is the *Uruguayan Torture Series* (1983–84) (Fig. 4.3), a suite of 35 color photo etchings in which an image of an object or an action is paired with a short, handwritten notation. A photograph of pins pushed into the nails of spread fingers is captioned: "He practiced every day." For a close-up of a man's hip and hand the caption is "Time thickened in his veins." Beside a simple glass of water are the words "He feared thirst," while a finger tied so that no blood will circulate is accompanied by the words "Her fragrance lingered on"—an apparent allusion to the one known female torturer in Uruguay's prisons at that time. There are no full figures, no recognizable settings, no complete statements, only the interplay of emotions when humans are visiting inhumanity on each other.

Taking the South American region as a whole, we can now see that a variety of avant-garde initiatives—so inventive that many innovations preceded similar moves by artists in Europe and the United States, and so extreme that they prefigure later shifts from modern to contemporary art—were quickly blunted, or banished into cultural limbos, by reactionary regimes. In recent years, however, artworlds have begun to be rebuilt, and artists from this region—often in exile and as frequent travelers—have come to influence contemporary art around the world. In this chapter, these developments will be reviewed as they have unfolded in the major art centers of the region.[9]

**4.4 León Ferrari**
*Western and Christian
Civilization (La Civilización
Occidental y Cristiana)*,
1965. Polyester, wood,
cardboard, 78¾ x 47¼
x 236¼in (200 x 120 x
600cm). Alicia and León
Ferrari Collection.
Courtesy of the artist.

## Argentina

After the long and popular rule of Juan Domingo Perón (1943–55), Argentine leaders sought stronger economic ties to North America and Europe. In agenda-setting art after Perón, innovative energy and market attention swung from Paris to New York. Historian Andrea Giunta demonstrates the finely tuned relationships between national ideals and artistic ambition in Argentina by tracking how artists, critics, curators, and cultural officials variously understood the idea of "internationalization": "whereas in 1956 internationalization meant, above all, breaking out of isolation, in 1958 it implied joining an international artistic front; in 1960 it meant elevating Argentine art to a level of quality that would enable it to challenge international spaces; in 1962 attracting European and North American artists to Argentine competitions; in 1964 it brought the 'new Argentine art' to international centers; in 1965 it brandished the 'worldwide' success of Argentine art before the local public; and, finally, after 1966, internationalism became increasingly synonymous with 'imperialism' and 'dependence,' upsetting its previous positivity."[10] Internationalization did not, however, mean slavish imitation of northern hemisphere models; on the contrary. Collagist Antonio Berni chose to focus on the victims of modernization, such as dispossessed and migrant workers, whose travails he depicted using discarded or "poor" materials. Luis Felipe Noé's paintings of protesting crowds showed them holding banners that extended above the picture frame, symbolizing a direct connection between radical art and political action. In León Ferrari's 1965 sculpture *Western and Christian Civilization* (*La Civilización Occidental y Cristiana*) (Fig. 4.4), a U.S. jet hurtles downward, bearing a wooden figure of the crucified Christ. While opposition to the war in Vietnam was the immediate inspiration for this work, on a more general level it displays not only the destructive power of mechanized modernity (the jet plane) but also the use of visual imagery by the Catholic Church—and by extension the military juntas in South America—to induce fear and obedience.

In Buenos Aires in 1961, a group of artists led by Kenneth Kemble staged the exhibition *Arte Destructivo* (*Destructive Art*). They were inspired by the use of everyday materials by U.S. artists such as Robert Rauschenberg and Allan Kaprow, the furniture-destroying actions of Puerto Rican artist Rafael Montañez Ortiz (then in New York), and the ideas of "auto-destructive" art proclaimed in 1959 by German artist Gustav Metzger. In Paris in 1962, Argentine artists Marta Minujín and Alberto Greco, inspired by the "art into life" experiments of the Nouveaux Réalistes, staged an exhibition in which Minujín publicly burned her paintings, while Greco began his long-running series of *Vivos Ditos* (*Living Jests*), actions which consisted of him signing living beings or existing things, thereby designating them works of art. At the same time, the Di Tella Institute in Buenos Aires was promoting experimental work, including *La Menesunda* (*The Challenge*) (1965), a labyrinthine environment aimed at engaging the viewer in an experience of uninhibited everyday life. One of the contributors was Rubén Sanantonin, who sought to create objects—raw, shapeless, tied in knots, perforated, colorless, camouflaged, crudely material yet quasi-organic—that seemed to be highly tactile, yet mute, barely existent "things" (Fig. 4.5). Against the craft basis of painting and sculpture, he proclaimed: "No more 'lines' or 'planes' or volumes. I want 'the thing' to include *directions, intentions, 'contacts,' connections, bulk, wrinkles*. I have withdrawn the old expired canons from my soul."[11]

The Centro de Arte y Comunicación (CAYC; Center of Art and Communications) was founded in Buenos Aires in 1969 "to promote the development of projects and shows in which art, technology and community concerns are combined in an effective

4.6 Victor Grippo
*Life, Death, Resurrection (Vida, Muerte, Resurrección)*, 1980. Five hollow geometrical lead bodies with black and red beans, painted wood base, and glass vitrine, 62¾ x 47¼ x 31½in (159.4 x 120 x 80cm). Courtesy of Alexander and Bonin, New York.

4.7 León Ferrari
*Letter to a General (Carta a un General)*, 1963. India ink on paper, 5¾ x 8½in (14.5 x 21.5cm), on cover of the artist's first solo exhibition catalogue, *Writings, Wires, and Hands*. Alicia and León Ferrari Collection.

4.8 Marta Minujín
*The Parthenon of Banned Books (Homage to Democracy)*, 1983. Installation, books wrapped in plastic on steel frame, Buenos Aires. Courtesy of the artist and Alejandra von Hartz Gallery, Miami.

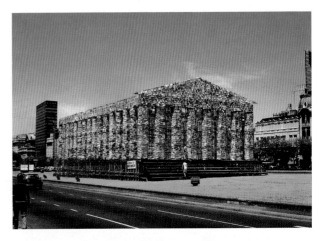

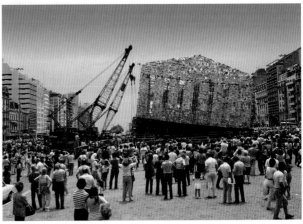

interchange that highlights the new unity of art, science and the social environment in which we live."[12] During the following decade, CAYC mounted over 100 exhibitions of contemporary art on these themes in Buenos Aires, 50 in the provinces, and more than 80 elsewhere in South America, the United States, and Europe. In this context, Conceptualists such as Victor Grippo created works such as *Life, Death, Resurrection (Vida, Muerte, Resurrección)* (1980) (Fig. 4.6), which deftly juxtaposes a set of geometric figures—cube, cone, and sphere—in a science museum vitrine. But this apparently straightforward celebration of rationality literally disintegrates before our eyes: we see the shapes as whole, ideal, Platonic forms only in the mirror glass at the back of the vitrine. Directly in front, the leaden shapes split open, spilling red beans, a staple food throughout South America. Alongside this vitrine there are two others (not illustrated): in one, a piece of redwood has been attacked by worms so that it has become quasi-reptilian in character; in the other, a violin with its case cracked open, spilling corn. The artist leaves open the question of which vitrine most closely illustrates each of the portentous ideas contained in the title. We realize, slowly, that there is no simple match-up, but rather that the three vitrines invite a poetic rumination on the differences between secular and religious understandings of these concepts.

In Argentina during these years of oppression, then dictatorship, activist artists were increasingly obliged to address their deepest concerns indirectly or risk their lives. Sculptor León Ferrari turned to "written paintings" (Fig. 4.7): highly personal, virulent tracts attacking political and military leaders and the complicity of the institutionalized Catholic Church, executed using a compressed, agitated calligraphic style. Direct political action was taken by the Tucumán Arde (Tucumán Is Burning) group of artists who, in concert with local trade unionists, staged a "Mass-Mediatic" event in Rosario in November 1968 to draw attention to the exploitative conditions of local sugar-cane workers. Such overt actions became rare as repression increased: ultimately, 30,000 people were imprisoned, tortured, and killed without trial. Victims became known as *los desaparecidos* ("the disappeared"). Throughout this period, mothers and grandmothers would gather in the main square of Buenos Aires (the Plaza de Mayo) in silent protest, wearing headscarves embroidered with the names of their missing children and grandchildren. Returning to the city in 1983, Marta Minujín created a public artwork that celebrated the first open elections in decades. Erected in a major thoroughfare near the centers of power, *The Parthenon of Banned Books (Homage to Democracy)* (Fig. 4.8) was a templelike structure built from books banned between 1976 and 1983 by the dictators, which had been held secretly by Argentines. Real democracy, the installation implied, consisted of the ideas in these books. After three weeks, people were then invited to take back their books, thus symbolically putting the tools for rebuilding a free society back in their hands.

During the 1990s, memories of these years continued to haunt Argentine art the innovative extremities of which were set, on the one hand, by the

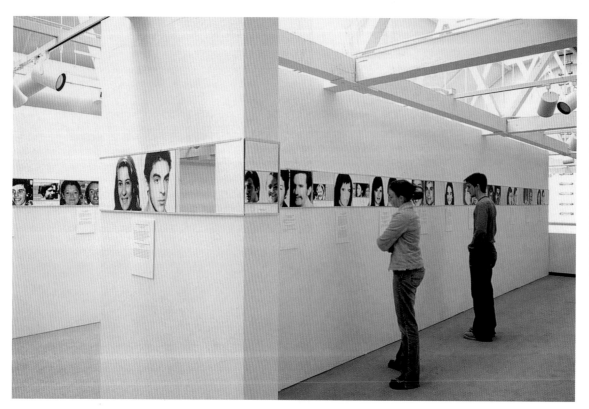

4.9 Carlos Alonso, Nora Aslan, Mireya Baglietto, Remo Bianchedi, Diana Dowek, León Ferrari, Rosana Fuertes, Carlos Gorrarena, Adolfo Nigro, Luís Felipe Noe, Daniel Ontiveros, Juan Carlos Romero, and Marcia Schvartz *Identity (Identidad)*, 1998. Twenty-four wall texts, 132 mirrors, 224 photographs, each 12 x 12in (30.5 x 30.5cm). Installation view, *The Disappeared*, North Dakota Museum of Art. Collection of the Association of the Grandmothers of the Plaza del Mayo.

4.10 Jorge Macchi *Speakers' Corner*, 2002. Cut paper and pins on board, 51⅛ x 71in (130 x 180cm). Courtesy of Jorge Macchi.

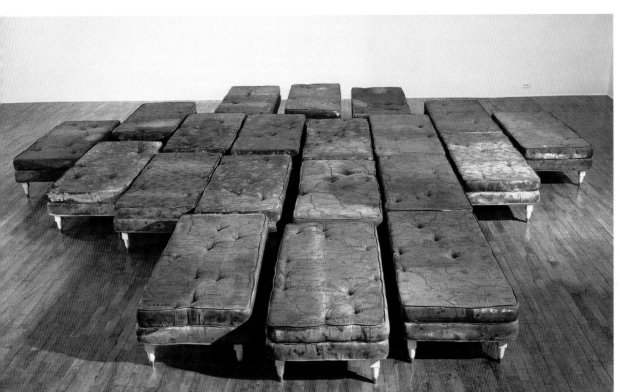

4.11 Guillermo Kuitca
*Untitled*, 1992. Acrylic
on mattress with wood
and bronze legs. Twenty
beds, each 15¾ x 23⅝ x
47¼in (40 x 60 x 120cm).
Tate, London, purchased
with assistance from
the Latin American
Acquisitions Committee
and the Estate of Tom
Bendhem 2004.

political Conceptualism of the CAYC artists and, on the other, the large-scale Expressionist paintings of Guillermo Kuitca. In 1998, a group of artists conceived a work entitled *Identity* (*Identidad*) (Fig. 4.9) for the Association of the Grandmothers of the Plaza de Mayo. Drawing on some of the key tropes of Conceptualist Art, they created an environment consisting of a mazelike series of rooms in which horizontal strips of photographs and mirrors were arranged at eye level, above wall texts. Each pair of photographs showed a married couple who had disappeared under the dictatorship. It was common practice for the state to have the children of the disappeared adopted. By placing a mirror alongside the dead couple, a viewer might be able to recognize a family resemblance. A number of individuals have been able to identify their natural parents in this way.

The Argentine writer Jorge Luis Borges is the best known of the many novelists and poets from the region who have explored imagery associated with memory and loss. Many visual artists have followed their lead. The title of Jorge Macchi's *Speakers' Corner* (2002) (Fig. 4.10) evokes the practice of people giving vent to personal opinions in public, but the work's use of statements taken from newspapers and magazines, and then further cut to leave only an empty space between quotation marks, shows free speech to be a dangerous activity; even so, although words might become invisible, the flow of language itself, even in silence, seems unstoppable.

The expanding city, site of a constant struggle between lawlessness and coercion, is a key motif in contemporary art in Argentina as elsewhere in the region. León Ferrari has recently explored this theme in a series of prints that show multitudes of humanoids flowing through intricate, mazelike structures, as if trapped within the irrational master plans of a future dystopia. Since the late 1980s, Guillermo Kuitca has accompanied his paintings with installations of beds, stripped to their mattresses and charred as if they were the result of an inmates' rampage in a prison or orphanage. Across their surfaces, maps of real cities and imaginary places, and random mixtures of the two, are painted, suggesting dreams of escape, and of unrestricted travel (Fig. 4.11). Such quiet yet uncanny evocations of persistence in the aftermath of unspeakable horror seem to suit the mood of living with the memory of traumatic times.

## Brazil

By the 1950s, as Brazilian society committed to rapid modernization, the Constructivist legacy of Max Bill was brought to high degrees of refinement by the likes of sculptor Luis Sacilotto, painter Waldemar Cordeiro, and Willys de Castro, creator of "active objects" that combined the optics of painting with the materiality of sculpture. Seeking to give expression to more subjective experience and to use more organic forms, Lygia Clark, Hélio Oiticica, and Lygia Pape broke away from this legacy in 1959 to form the Neoconcrétismo (Neo-Concrete) group. In response, critic Ferreira Gullar proposed his "Theory of the Nonobject" in 1960, perhaps the first statement anywhere of what became an important strand of Conceptual Art.[13] Clark had already moved from paintings in which stark black and white contrasts generated dramatic figure-ground reversals toward painted wooden wall-mounted reliefs in which the optical exchanges between similar parts could be seen to occur in highly confined, shallow, but nonetheless actual space. In 1960, she began her series

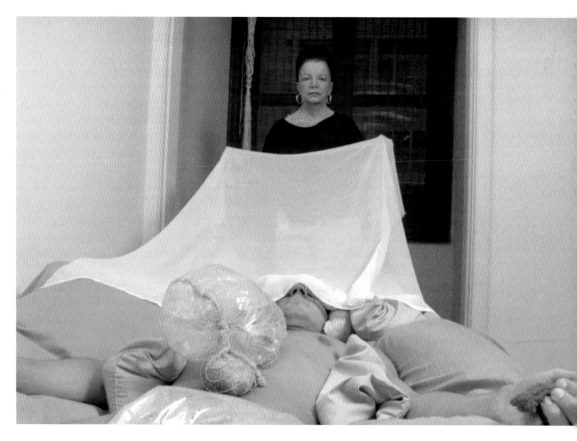

4.14 Hélio Oiticica *Parangolé P4 Cape I*, 1964. Worn by Nildo da Mangueira. Mixed media. Courtesy of Galerie Lelong, New York.

*Critters* (*Bichos*) (Fig. 4.12), in which a set of geometric planes are hinged so as to take on a variety of shapes depending on the mood and taste of the viewer, who is invited by the logic of the work itself to manipulate it, learn its potentialities and limits, and thus become, in a sense, its companion. Clark comments: "The *Bicho* has no wrong side… He is alive, and an essentially active work. A total, existential interaction can be established between you and him… The *Bicho* has his own and well-defined cluster of movements which react to the promptings of the spectator."[14]

Clark then sought to give form to the spatial movements implied by these manipulations, creating one series of works after another that increasingly drew the spectator into the work as a full participant in a process of liberation and self-realization. The *Bichos* were followed by the *Trepantes* (*Creepers*) (1964), cut shapes of metal or rubber that could be arranged to respond to any given environment; shapes that pairs of people could manipulate together; devices for pairs or groups to share the experience of textures or odors; or environments in which to do so, as in *A casa é o corpo* (*The Body Is an Abode*), her installation at the 1968 Venice Biennale. Her sustained, step-by-step expansion of art practice toward therapeutic adjustment of the individual

to the world's currents as they exist in the immediacy of the present culminated in works such as *The Structuring of the Self* (*Estructuração do self*), carried out in Rio de Janeiro and in Paris from 1978 to 1980 (Fig. 4.13).

An equally radical and compelling rethinking of mid-century Modernism occurred in the art of Clark's colleague Hélio Oiticica. He, too, was a committed Concrétist who sought ways to mobilize the derived geometries and flat planes of his brightly colored paintings and graphic works by presenting them for viewing from both sides (*Bilaterals* and *Spatial Reliefs*, 1959), opening them out for viewing via mirrors from below and then as built environments (*Nuclei* and *Penetrables*, 1960), and then adding to them found materials, powders, and other natural elements so that direct, tactile perception of these colors, textures, densities, and odors might occur (*Bolides* [*Boxes*], 1963). His break from artworks as discrete objects occurred when, inspired by the vitality of samba dancing in his home city, and the proliferation of *favelas* in his neighborhood, he created a number of brilliantly colorful, eccentrically cut capes (*Parangolé*, 1964), which consisted of a variety of materials, objects, and sensory stimulants, and which could be worn to give rise to a sense of festive abandon. One of them carries the slogan: "We live from adversity!" (Fig. 4.14). (*Parangolé*

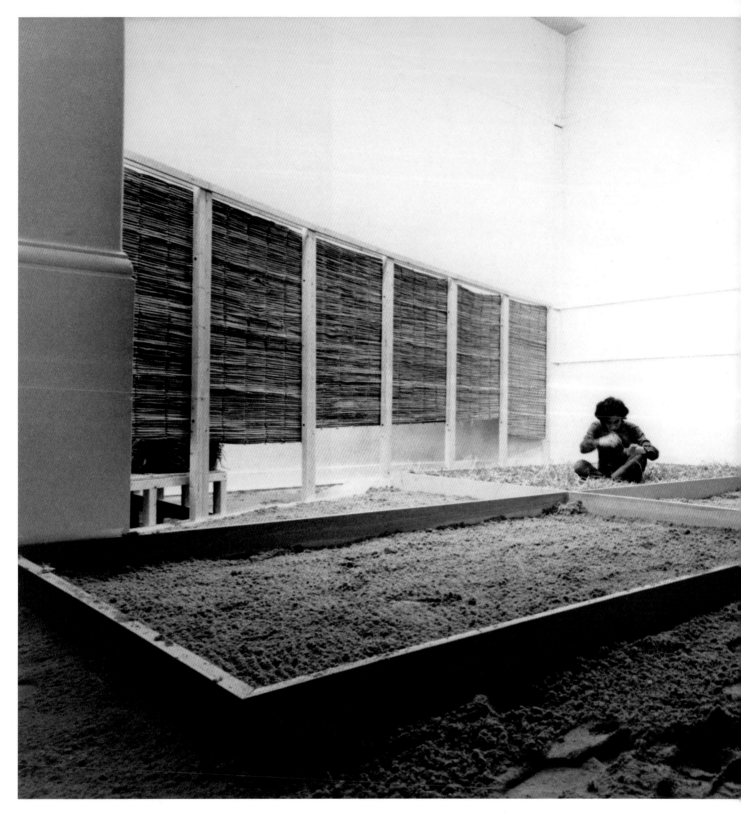

4.15 Hélio Oiticica
*Eden*, 1969. Mixed
media, dimensions
variable. Installation
view, Whitechapel Art
Gallery, London.

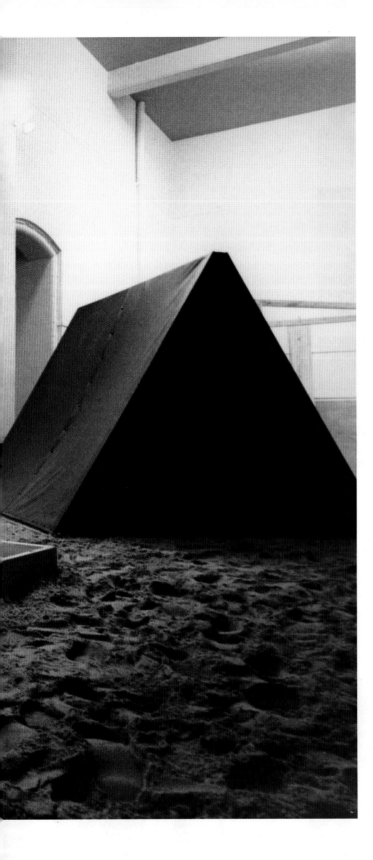

is Brazilian slang for a situation of sudden confusion or excitement among people.) In 1966, Oiticica began to combine these innovations into elaborate environments, camplike settings of roughly assembled structures on sand, straw, gravel, stone, and carpeted surfaces. Participants were invited to enter tents, perform using the capes, examine the natural materials, experience a variety of enclosures and open areas, and contemplate their responses, either individually or with others. The first of these works, *Tropicália* (*Tropicalism*), was shown at the *Brazilian New Objectivity* exhibition at the Museum of Modern Art, Rio de Janeiro, in 1967. Oiticica added local signifiers such as tropical plants and a macaw, as well as a tent in which one could watch a television monitor tuned to a local entertainment channel. Such deliberate, ironic exaggeration of national stereotypes was directed against the inflated yet narrow patriotism promoted by the country's dictatorship. This mood among visual artists was shared with a powerful tendency in Brazilian popular music and experimental theater, which itself took on the name "Tropicália" when singer Caetano Veloso entitled one of his satirical songs after Oiticica's installation.[15]

Oiticica understood his work to be "the very first conscious, objective attempt to impose an obviously 'Brazilian' image on the current context of the avant-garde and of national art in general."[16] Such ambitions were curtailed by the promulgation in 1968 of the Fifth Institutional Act, which suspended all legislative bodies indefinitely, authorized the executive to rule by decree, and provided the legal basis for a new purge of political critics, including those in the arts. Oiticica then began to elaborate his experiential environments overseas, notably in the *Eden* project at the Whitechapel Art Gallery, London, in 1969 (Fig. 4.15).

Clark and Oiticica were two among an extraordinary cohort of innovative Brazilian artists, including filmmakers such as Glauber Roca, experimental theater directors, and many practitioners of "concrete poetry." Mira Schendel sought ways of drawing with the most minimal yet highly suggestive marks on paper, including word fragments created using Letraset. In 1964–65, she knotted handmade Japanese paper into randomlooking assemblages that she entitled *Droguinhas* (*Nothings*); at the Venice Biennale in 1968, she presented an installation of hanging sheets of rice paper which gave the impression that the words displayed on them were floating free on currents of air. Lygia Pape imagined the space implied by a sheet of white paper and conceived of it as a vital connector of people who might choose to act in public together. Her *O Divisor* (*Or Divider*) was a square piece of white cloth, 98 by 98 feet, cut with equally spaced, head-sized holes into which people inserted themselves to create a shared cape—dazzling to the eyes, and potentially limitless in scope. It was used for a political demonstration in Rio de Janeiro in 1968.

The legacy of Marcel Duchamp—particularly his aesthetic appropriations of objects in everyday use

4.16 Artur Barrio
*Unleashing Confusion
on the Streets: Situation
(Situação...DEFL...+s+...
ruas...Abril)*, 1970.
Mixed media,
dimensions variable.

4.17 Cildo Meireles
*The Sermon on the
Mount: Fiat Lux*, 1973.
Installation, dimensions
variable. Courtesy of
Cildo Meireles.

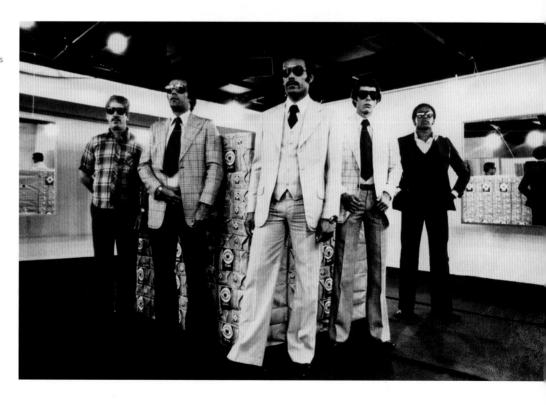

("readymades") and his eye for the economies of power and sexuality hidden within everyday life—resonates strongly through art in South America, as it does elsewhere. During the years of dictatorship, indirect strategies were essential, and irony—both bitter and sardonic—became a prevailing mood. Artur Barrio provoked awareness of the violence of state repression by staging "situations" aimed at unleashing confusion in public places. For *Unleashing Confusion on the Streets: Situation* (*Situação…DEFL..+s+…ruas…Abril*) (1970) [Fig. 4.16], Barrio and his assistants placed 500 plastic bags filled with blood, dung, nails, excreta, and other debris at various locations on the streets of downtown Rio de Janeiro. Cildo Meireles's 1970–75 series *Inserázes em Ciruitos Ideologicos* (*Insertions into Ideological Circuits*) is another example of indirect intervention. In one case, the *Cedula Project* (*Identity Project*), he stamped banknotes with slogans that were critical of the regime, or replaced the images of national "heroes" with photographs of anonymous indigenous people. In another, the *Coca-Cola Project*, the slogans were stenciled in white paint onto empty bottles, their message only becoming visible when

the bottles were filled again and recirculated. His 1973 installation *The Sermon on the Mount: Fiat Lux* [Fig. 4.17] centered on a cube-shaped mass of 126,000 matchboxes. The walls of the room in which they were placed were lined with mirrors, above which were printed the Beatitudes—biblical prayers for divine intercession especially popular with the poor. This was a risky gesture, as any expression of concern for the plight of the needy was seen as sedition by the authorities. Evoking this danger for the spectator, every step on the sandpaper-covered floor risked setting the room alight—a fear exaggerated by amplification of the sounds of movement. The matchboxes, themselves useful contraband, were guarded by five men dressed as gangsters. On every level, this work hovered on the edge of being incendiary.

Women artists have become prominent again in Brazilian contemporary art. During the years of hyperinflation (1987–97), Jac Leirner arranged vast amounts of nearly worthless money into configurations suggestive of a Minimalist aesthetic that had been loosened, become fragile [Fig. 4.18]. Adriana Varejão conjures the atrocities of colonization in her sculptural reliefs in which the grid

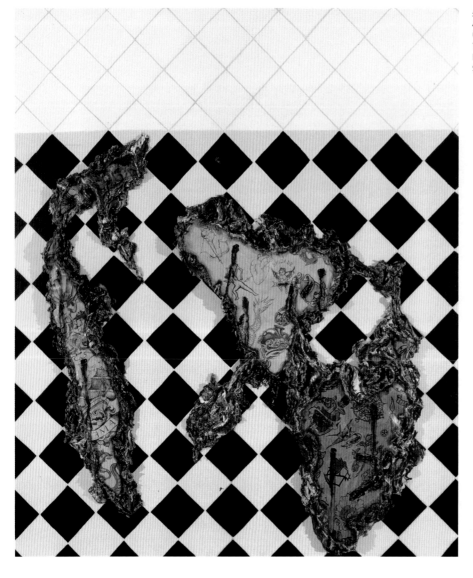

4.19 Adriana Varejão
*America*, 1996.
Oil on canvas and linen,
76¾ x 65in (195 x 165cm).
Private collection,
São Paulo.

4.20 Iole de Freitas
*Untitled*, 2007.
Installation piece
for Documenta 12,
Kassel. Stainless steel
and polycarbonate,
dimensions variable.

4.22 Mestre Didi
(Deosocoredes
Maximiliano dos Santos)
*Iwin Igi—Ancestral Spirit
of the Tree (Espírito
Ancestral da Árvore)*,
1999. Bundled palm
ribs, leather, beads,
and cowrie shells, 75 x
23½in (190 x 60cm).
Collection of the artist.

4.23 Rubem Valentim
*Totem*, ca. 1974. Painted
wood, 50⅜ x 30 x 30in
(128 x 76 x 76cm).
Courtesy of Museu
Nacional de Belas Artes,
Rio de Janeiro.

structure of decorative tiles imported by Portuguese and
Spanish conquerors erupts from within, spurting out
the intestines of the enslaved peoples upon whose labor
the New World was constructed (Fig. 4.19). In her large-
scale sculptural environments, Iole de Freitas revisits the
complex spatialities of Concrétismo, reinterpreting them
as invitingly open to the mobile spectator, who is drawn
into these semi-transparent settings to experience them
as at once enveloping and infinite (Fig. 4.20). Artists con-
tinue to tackle issues central to life in the teeming cities:
in his *Aftermath (Angélica)* (1998) (Fig. 4.21), photographer
Vik Muniz arranges detritus left over from the Rio
Carnival—a festival in which people from all classes and
areas enthusiastically participate—to create a portrait,
appropriately in negative, of a young girl who has fallen
victim to a violent confrontation between inhabitants of
illegal *favelas* and those sent in by officialdom to enforce
the rule of law.

Elsewhere in Brazil, certain indigenous artists are
drawing on elements of modern and contemporary art to
reassert imagery and content that highlights the ancient
identity of their peoples. Mestre Didi makes sculptures
that use both traditional materials and abstract schemat-
ics, as in his *Iwin Igi—Ancestral Spirit (Espírito
Ancestral da Árvore)* (1999) (Fig. 4.22). Sculptor Rubem
Valentin cuts metal and wood into shapes that suggest
cult symbols from the Bahia region, then skillfully repeats
and varies them to create powerful totems (Fig. 4.23).

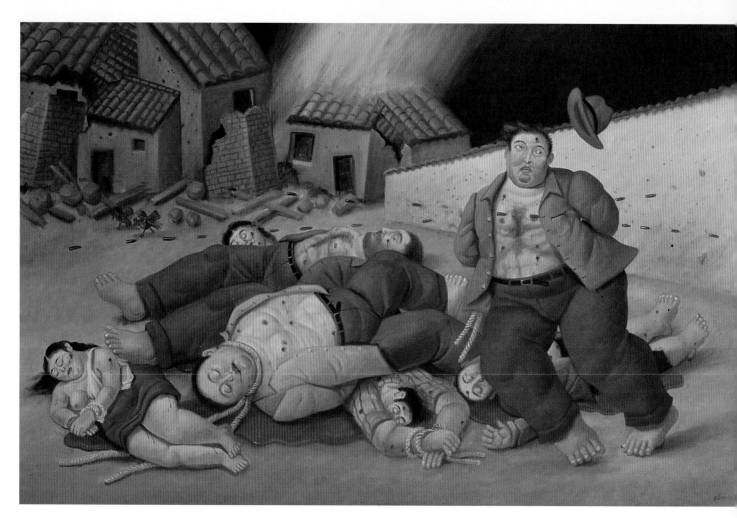

4.24 Fernando Botero
*Massacre in Colombia*,
1999. Oil on canvas,
50¾ x 75¾in (129 x
192cm). Courtesy of
Marlborough Gallery,
New York.

4.25 Fernando Botero
*Abu Ghraib 57*, 2005.
Oil on canvas, 55¹/₁₀
x 76in (140 x 193cm).
University of California,
Berkeley Art Museum
and Pacific Film Archive.
Gift of the artist.

## Colombia

Painting against the grain of Modernist avant-gardism, Fernando Botero has, since the 1950s, constantly recast masterpieces from the history of art in contemporary terms and, at the same time, presented current events in a consciously anachronistic style. All of his subjects—models, family members, figures from famous paintings, self-portraits, still-life elements, groups of priests or military officers—face outward yet remain introspective. All are subject to a gentle inflation, to a compacted yet exploded corporeality, which the artist describes as "formal fullness, abundance." Botero is frank about the seductions of painterly practice: "You start to paint the head of a dictator. You begin to caress him, he appeals to you, and, touched, you give him a kiss."[17] Yet in every work tiny details undermine this apparently all-inclusive humanism: abundance is rotten at its core, an affront to the actual poverty experienced by people who nonetheless live in settings of natural plenitude. These people are also subject to the vicissitudes of an ongoing civil war which Botero chronicles in paintings such as *Massacre in Colombia* (1999) (Fig. 4.24). After many years of painting subjects drawn from the everyday life of his country, in 2004 he began a series based on images that had recently become internationally infamous: photographs of the humiliation and torture of Iraqi prisoners taken by the perpetrators in the U.S. military prison at Abu Ghraib, Baghdad (Fig. 4.25). Botero said: "I was shocked because the Americans were supposed to be the model of compassion."[18] Whereas the soldiers involved took the photographs in order to threaten the prisoners they were interrogating with shameful exposure, and because they were in the habit of taking snapshots for their own amusement of every-thing they did, through his works the painter sought to restore dignity and bodily self-possession to the abused prisoners. That he did so by employing his unique, "for-mal fullness" style provoked considerable controversy.

Contemporary artists in Colombia cannot avoid the realities of social and political division arising from the state of civil war that has gripped the country since the 1970s. "*La violencia*" pervades their art, most subtly in the work of Doris Salcedo. Trained in Bogotá and New York, Salcedo returned to Bogotá in 1985 and has worked there ever since. She has sought to identify with the experience of the victims of political violence, and to attest to their suffering by displaying familiar, usually personal or domestic, objects as if they were reliquaries. Asked about the ethics of remembering in her work, she responded:

My work deals with the fact that the beloved— the object of violence—always leaves his or her trace imprinted on us. Simultaneously, the art works to continue the life of the bereaved, a life disfigured by the other's death... My works are for the victims of vio-lence. I try to be a witness of the witness... I do not speak of the violence in Colombia from a nationalist perspective. I focus on the individual and not the acts of violence that define the State. I am not interested in

4.26 Doris Salcedo
*Atrabiliarios*, 1993
(detail). Timber, gyproc,
cow bladder, shoes and
surgical thread, wall
niches, animal fibre,
dimensions variable.
Art Gallery of New
South Wales, Sydney.
Mervyn Horton Bequest
Fund 1997.

4.28 Eugenio Dittborn
*All Its Second Life,
Airmail Painting No. 77,*
1990. Paint, stitching,
and photosilkscreen
on two sections of
nonwoven fabric, 78 x
110¼in (198.5 x 280cm).
Courtesy of Alexander
and Bonin, New York.

4.27 Oscar Muñoz
*Project for a
Memorial (Proyecto
por un monumento)*,
2005 (detail).
Video installation,
five projections
synchronized, 7 mins.
30 secs. e/o. No sound.
Courtesy of the artist
and Iturralde Gallery,
Los Angeles.

denouncing before an international audience what is happening in my country here and now. Moreover, violence is present in the whole world and in all of us… I try to keep in mind the famous line from Dostoyevsky's *The Brothers Karamazov* that is also close to what Levinas writes and which seems to me a good model to emulate, a proposition that we all should make our own: "We are all responsible for everyone else—but I am more responsible than others."[19]

Her series *Atrabiliarios* (1991–97) (Fig. 4.26), the title of which derives from the Latin expression for mourning, *atra bilis* (*atratus* = clothed in black; *bilis* = bile or rage), consists of items such as shoes—acquired from the families of those who had disappeared, in the course of sharing with the family their mourning—placed in niches in gallery walls as *memoria*. Across the apertures, semi-transparent animal membranes are sewn, like stitched wounds that seem unlikely to heal, at least not quickly.

How might those who are lost in such circumstances be best remembered? How can those who grieve resist the inevitable process of forgetting? Oscar Muñoz addresses these questions in works such as his *Project for a Memorial* (*Proyecto por un monumento*) (2005) (Fig. 4.27):

a room in which video monitors set into the walls at viewing height show endless loops of his deft portraits of dead individuals, painted quickly with water onto viscous surfaces (a wall, a pavement) and fading just as fast.

## Chile

During the dictatorship of General Augusto Pinochet that followed the assassination of Chilean president Salvador Allende in 1973, artists critical of the regime came under surveillance, were imprisoned and tortured, or driven into exile. As elsewhere, artists sought indirect means to make their views known. Outstanding among these practitioners was Eugenio Dittborn, particularly in his *Airmail Paintings* (Fig. 4.28), beginning in 1983. On large sheets of brown wrapping paper Dittborn silk-screened a variety of images, including photographs of the missing, scenes of state violence, children's drawings, bits of poetry or philosophical statements, newspaper clippings and the like, none of which directly illustrated the public violence under which he lived; nonetheless, when the work was unfolded and exhibited abroad, an unmistakable sense of the fragility of ordinary life in these circumstances was conveyed. Lotty Rosenfeld risked imprisonment by carrying out a series of public actions, usually involving making an alteration to official

4.30 ASCO
*Instant Mural*, 1974.
Patssi Valdez taped
to wall by Gronk.
Courtesy of the artist.

signage. In 1984, she converted the "minus" signs dividing the main street of Santiago—the Alameda, which passes in front of the main government building—into large "plus" signs (Fig. 4.29). In elections in Chile, putting a vertical through a horizontal line next to the name of a candidate indicates that you have voted for him or her. The work was an explicit call for democratic elections—which were far from the intentions of the dictators—and a dangerous act at the time.

## Mexico

In the wake of the Muralist Movement which dominated the revolutionary years of 1910–40, certain Mexican artists, most notably the abstractionist Rufino Tamayo, espoused "pure painting" in contrast to the confrontational realism that had previously prevailed. During the 1960s, a younger generation emerged. Initially known as "Los Interioristas" ("The Insiders"), they later became known, after the title of a broadsheet published by them, as "Nueva Presencia" ("New Image").[20] Led by José Luis Cuevas, Arnold Belkin, and Francisco Icaza, these artists took a more Existentialist approach, emphasizing the alienating impact of social change upon individuals. Continuing but refining this tradition, artists such as Nahum B. Zenil and Julio Galán have combined images appropriated from popular culture (including the *retablos*, or ex-votos, much used by Frida Kahlo) with those suggested in dream states to create subtle, fantastical arrays evocative of, in their particular cases, the displaced situation of homosexuals in Mexican society.

Since the 1960s, the concerns of the increasing numbers of Mexican-Americans living in the U.S. have been given artistic voice by members of the Chicano art movement.[21] Mural collectives led by artists such as Judith Baca became active in Californian cities, and cultural centers were established that reflected the interests of local communities—for example, the Centro Cultural de la Raza fostered the "border art" of San Diego. Some Chicano artists dissented from the nationalist identity politics of these groups: in East Los Angeles in 1971, a group of multimedia performance artists formed the collective ASCO (meaning "disgust" or "nausea" in Spanish). Members staged "walking murals" on the streets of the city, and "instant murals" in which some members would pose in classic or unorthodox poses against walls to which others would tape them (Fig. 4.30).

## CUBA

In 1898, Cuba became the last Spanish colony to gain independence. Although it remained very much within the economic and political sphere of the United States until 1959, aspirations for untrammeled self-rule were common, including among artists. La Vanguardia, the first generation of modern Cuban artists, was active from 1927 to 1938. Unlike their predecessors—who had studied in Madrid and Rome—artists such as Eduardo Abela, Victor Manuel, Marcello Pogolotti, Antonio Gattorno, Carlos Enríquez, and Fidelio Ponce applied the new techniques learnt from the Parisian avant-garde to local subject matter. During the 1940s and 1950s, these artists, along with Amelia Peláez and Wifredo Lam, brought their work to higher levels of complexity: Peláez drew on the rich traditions of ornamentation that were a vital element of Havana's outstanding apartment architecture, while Lam applied the lessons he learnt directly from Picasso to intense depictions of Afro-Cuban religious beliefs, imagery, and historical experience, including slavery and racial intolerance.[22]

From 1959, many intellectuals and artists supported the Communist revolution led by Fidel Castro, but objected to the hardline application of its Socialist Realist principles. In 1961, Castro intervened in

4.31 Ana Mendieta
*Untitled (Guanaroca
[First Woman])*, 1981.
Estate Print: 1994.
Box-mounted black and
white photograph, 53½ x
39¼in (135.8 x 99.6cm).
Courtesy of Galerie
Lelong, New York.

the dispute by proclaiming: "With the Revolution, everything; outside the Revolution, nothing." The expectation that economic and social progress would be depicted in a sanitized manner was resisted by most. Instead, a highly graphic Pop Art style that created an iconography of revolutionary leaders such as Che Guevara and nationalist heroes such as José Martí was developed by Raúl Martínez and others. It became internationally prominent when applied to posters by designers such as Alfredo Gónzales Rostgaard to advertise the films of Tomás Gutiérrez Alea and Humberto Solas. Meanwhile, abstractionists such as Antonia Eiriz and Umberto Peña devised semi-figurative formats to treat political subjects. The May Salon, a famous annual contemporary art survey exhibition that was organized from Paris but held in different countries, was staged in Havana in 1967. Directly inspired by Wifredo Lam, artists from around the world painted a 66-square-yard mural that became known as *Cuba colectiva, el mural* (*Cuba Collective, The Mural*).[23]

Performance Art and feminist critique were rare in Cuba at this time, yet these elements were crucial to the practice of Ana Mendieta, the daughter of a political family who was sent to the United States as an adolescent. A student of multimedia and video art there, she began in 1972 to use her own body as the primary medium of her works, showing it marked by wounds or implied rape, blending it into natural environments that left outlines of its shape (the *Silueta*, or *Silhouette*, series, Mexico, 1973–78), or profiling it using gunpowder, flames, or blood. She returned to Cuba in 1980, visiting the gorges and caves of the Almendares River, and later the Jaruco region, where she carved shapes that evoked fertility goddesses (Fig. 4.31).

The exhibition *Volumen 1* at the Centro de Arte Internacional, Havana, in 1981 announced the arrival of a new generation of Cuban artists. Alert to widely circulating theories of Postmodern appropriation and pastiche, a number of the exhibiting artists expanded the scope and character of their earlier paintings and sculptures, turning them into striking installations. Commercial kitsch, popular imagery, and folk-art forms were vividly mixed in ways that echoed Postmodern painting in Europe and the United States. Yet the content and point of the works were specifically local. Flavio Garciandía de Oraá created flamboyant installations using kitsch decorative elements (he dubbed them "bad forms"): his *Tropicalia I* series of 1989 (Fig. 4.32) consisted of garish, wallpaperlike murals that repeated the Soviet hammer-and-sickle motif within an explosive cacophony of palm trees, flamingos, genitalia, and stick figures. Mixing Keith Haring-style graphics with signifiers of Cuban tropical lushness, he appropriated the great symbol of international socialism, and presented it as if it were dancing in a public festival, specifically a Latin American carnival. This gesture evokes, with amusing irony, the energy then being released by *perestroika* in the Soviet Union, the liberating "restructuring" policies not favored at the time by his own government.

While on cultural levels Cuba remained closely connected with Spain until the revolution, the island was and remains home to a number of religious cultures of African origin: Santería (Yoruba), Palo Monte (Kongo), Regla Arará (Ewe-Fon), and the secret society Abukuá (the Calabar). José Bedia draws on Palo Monte and Amerindian traditions and imagery for his installations, Ricardo Rodríguez Brey on Santería ritual, while Juan Francisco Elso Padilla absorbed much from these sources and more in his quest to give visual form to what he called "a Latin American spirituality."[24] In the last years of his life (he died in 1988), Elso Padilla worked in Mexico City on an installation entitled *The Transparency of God* (*La transparencia de Dios*) (Fig. 4.33). He completed three parts: a 7-foot-high skull shaped out

4.33 Juan Francisco
Elso Padilla
*Heart of America*, from
the *The Transparency
of God* series, 1986–88.
Branches, wax,
volcanic sand, iron
and fabric, 90½ x 67in
(230 x 170cm).

of bark paper with twigs articulating the features (*The Face of God*), a 6-foot-high heart made from intertwined branches (*The Heart of America*), and a hand of similar size (*The Creating Hand*). These sculptures evoke an ancient Mayan ritual relating to the different stages of adulthood, but they also posit a profound questioning of the nature of religious belief in the Americas.

The energy of artists such as these, the endorsement of Fidel Castro, and support from the widow of artist Wifredo Lam led to the creation of a center in Havana devoted to promoting contemporary art which subsequently undertook the organization of the Bienal de La Habana. This series of exhibitions was conceived in contrast to the other biennial exhibition in the region, that of São Paulo, which had been founded in 1951 with the intention of connecting local artists to international, especially European and U.S., styles and markets. Since 1984, in the staunchly anti-imperialist spirit of *tercomundismo* ("Third Worldism"), the Bienal has brought together artists who have shared the experience of colonization and have contributed to decolonization. Its early successes led certain Cuban intellectuals to believe that the conditions were ripe for the artists of the Third World to take global leadership in the creation of contemporary art. Critic Gerardo Mosquera proclaimed that it was possible for the artists of the South to "make Western culture" by infusing it with the critical spirit of previously colonized, now independent peoples. This, he hoped, would create a worldly art in which the dice were no longer loaded against non-Western cultural producers.[25]

While dictatorships of various kinds prevailed throughout much of South America during the 1980s, Cuba remained a socialist outpost, economically dependent on an increasingly fragile U.S.S.R. When the Soviet system collapsed in 1989, resulting in the withdrawal of support to Cuba, many Cubans sought to join their exiled countrypeople in the U.S. and elsewhere. A vital expatriate art scene developed in Miami, Florida, 90 miles from the island.[26] Social collapse, increasing authoritarianism, and the desire to emigrate became prominent themes in Cuban art, most subtly in the installations of Kcho (Alexis Leyva Machado), whose random-seeming accumulations of handcrafted, crude, and leaky boats are elegant metaphors of escape (Fig. 4.34). The group of sculptors Los Carpinteros (The Carpenters) carefully craft elaborate architectural or furniturelike structures, the shapes of which imply contrary meanings: in *Jewelry Case* (*Estuche*) (1999) (Fig. 4.35), an Art Deco wooden cabinet shaped like a hand grenade is topped with a firing pin.

Inspired by the work of Ana Mendiata (whose Cuban works she restaged during the 2000 Bienal), Tania Bruguera presented a series of performances in the late 1990s entitled *The Burden of Guilt*. In one, she wore a costume made from a headless sheep's carcass, the animal's body opened as if the interior of her own body was being exposed (Fig. 4.36). Of her work at this time, Bruguera has said: "Power has its own means of expression. Mass media is one of its most attractive

4.35 Los Carpinteros
(Marco Castillo Valdés,
Alexandre Arrechea
Zambrano, Dagoberto
Rodriquez Sanchez)
*Jewelry Case (Estuche)*,
1999. Wood, 88½ x
51⅛in (225 x 130cm).
Collection of Frankie
Diago, New York.

4.36 Tania Bruguera
*The Burden of Guilt*,
re-enactment of a
historical event,
1997–99. Decapitated
lamb, rope, water, salt,
Cuban soil, dimensions
variable. Courtesy of
Tania Bruguera.

4.37 Tania Bruguera
*Untitled (Havana 2000)*, 2000.
Video performance-installation, milled sugar cane, black and white monitor, Cubans, DVD, DVD player, 13 x 39⅓ x 164ft (4 x 12 x 50m). Courtesy of Tania Bruguera.

channels for adding, projecting or imposing ideology. The individual, recipient of the effects of the mechanisms set off by power (be it political, governmental, sexual, ideological, or economic, among many others), enters into an interrelationship in which, in the end, she can only count on her body as the most sincere means of expression or resistance. My body is my instrument. It is the place where I can give voice to my opinion. It is the space where I have certain power, even if it's only the power of locating my thoughts and emotions."[27] For the 2000 Havana Bienal, the floor of one of the cavernous basement rooms of the Castillo del Morro was covered with milled sugar cane, while near-naked performers lived in the space, listening to recorded propaganda and watching black and white television broadcasts (Fig. 4.37). At a time of extreme economic hardship, Bruguera evoked Cuba's dependence on one industry, itself at the mercy of global capital movements, while the prison-like setting hinted at the growing authoritarianism of the government. This theme became explicit in her exhibit at the Museo Nacional de Bellas Artes, Havana, in 2003. Entitled *Autobiograf* (*Autobiography*), it consisted of a large room with speakers at its perimeters and, at its center, rough partitions covered with exhortatory posters. These formed walls around a stage onto which the spectator was invited to step and talk into a microphone. Speakers at the edges of the room mixed one's voice with broadcasts of official slogans about revolutionary freedom. The gap between ideals and reality was directly experienced. At the 2009 Bienal, Bruguera set up a lectern before a red curtain and invited participants to talk about whatever they wished for two minutes. On either side of the speakers stood two young actors dressed in military uniform. They did not intervene;

instead they assisted a white dove to return to the lectern, alluding to the moment when, during Fidel Castro's victory speech in January 1959, a dove alighted on his shoulder. All speakers called for freedom.

Younger Cuban artists continue to explore similar concerns but do so in muted, low-key, and often humorous fashion.[28] During the 2003 Bienal, Wilfredo Prieto installed a row of flagpoles along the ramparts of the Castillo del Morro overlooking Havana harbor. Each was hung with a modified national flag, still recognizable due to its familiar symbols but transformed by limiting the colors to black, white, and gray (Fig. 4.38). Entitled *Apolitical* (*Apolitico*), it made a quiet yet pointed statement about the banalities of unreflective nationalism.

## ELSEWHERE IN THE CARIBBEAN

Saladoid pottery, Carib weavings, and Taino ritual objects are the best-known Pre-Columbian artifacts of the region. In the past two centuries, however, economic dependence on superpowers both near and distant, struggles against colonialism, governments swinging wildly between democracy and dictatorship, volatile conjunctions of indigenous and immigrant cultures, and valiant efforts to build national and sometimes regional sentiment have shaped artistic practices throughout the Caribbean. In countries such as the Dominican Republic, colonial academies were formed in the early nineteenth century, national exhibitions promoted competitive development, and independent professionals soon appeared, to be succeeded in the early to mid-twentieth century by modernizers (linked with a revival of nationalist sentiment), then by avant-garde

4.38 Wilfredo Prieto
*Apolitical (Apolítico)*,
2001. Flags from every
country designated by
the United Nations in
a scale of black, gray,
and white, with official
designs, dimensions,
and fabric. Installation
view, VIII Havana
Biennal, Havana, 2003.
Daros-Latinamerica
Collection, Zurich.
Courtesy of the artist.

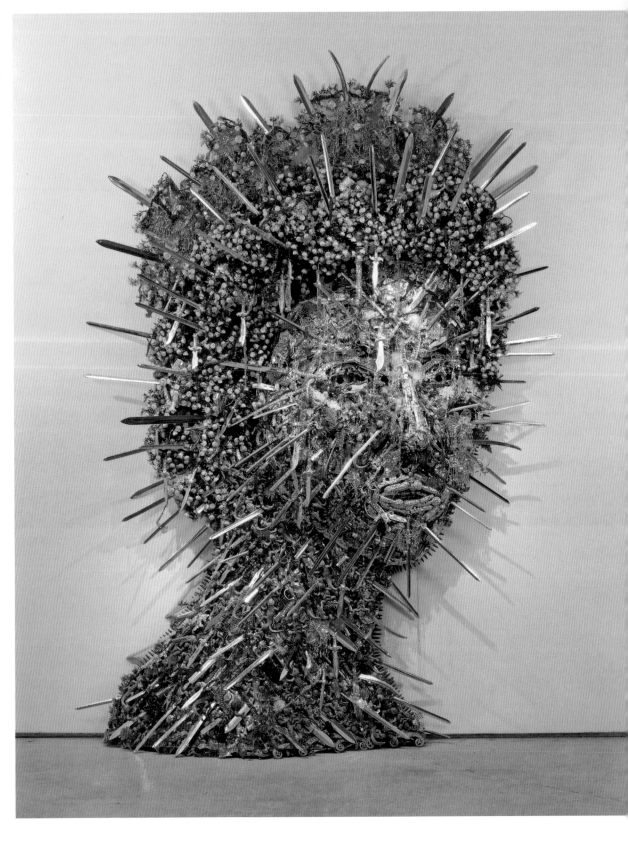

4.40 Arnaldo Roche-Rabell *Like a Thief in the Night*, 1990. Oil on canvas, 96⅛ x 96¼in (244.1 x 244.3cm). Hirshhorn Museum and Sculpture Garden, Washington, D.C.

groups, until in recent years various kinds of engagement with the international contemporary art world have become more frequent. While this general pattern is typical of the art of nations moving from colonial to postcolonial conditions, the changes occurred, as always, in ways quite specific to the history of each place. The French colonists of Haiti created few cultural institutions compared to those established by the Spanish elsewhere in the region. Few resources were available in the decades following the slave revolt of 1791. Subsequently, self-taught Afro-Caribbean artists such as the painters Hector Hyppolite and Philomé Obin depicted significant local events, decorated churches, or supplied imagery for Vodou (Voodoo) ritual. Sculptor Georges Liataud cut and welded pieces of iron into Vodou imagery, initiating a trend that persists today in the work of artists such as Serge Jolimeau. With the exception of such as Edna Manley, an accomplished Modernist sculptor active in Jamaica during the 1930s, professional artistic practice was rare in the region until the 1950s. Where it did exist, it was often enabled by the example and teaching of artists from other countries—Argentina and Mexico especially—and encouraged by the establishment of regular international exhibitions of art from the region: in São Paulo since 1951, Carifesta (roving) since 1976, in Havana since 1984, and, since 1992, the Bienal del Caribe held in San Domingo, Puerto Rico. Meeting the interests of tourists remains the main spur to art production, promoting the development of hybrid forms, such as the "Vodou Flags" of Haiti.

Contemporary artists from the Caribbean also respond creatively to their mobile positions as members of the diaspora. Belize-based artist Hew Locke vividly encapsulates this condition in his assemblage *El Dorado* (2005) (Fig. 4.39). The turned profile of Queen Elizabeth II, familiar from coins used in the British colonies, is evoked in a manner reminiscent of the famous portraits of people and seasons created in the seventeenth century by Giuseppe Arcimboldo. Yet the latter's fantastical fruit- and vegetable-based concoctions seem positively restrained in comparison with Locke's *El Dorado*. Not only is this bust nearly 10 feet high, it is composed entirely of glittery decorative items, fake jewelry, souvenirs, toys (lizards, daggers), and artificial flowers, each element wittily suggesting a part of the royal body, face, hair, and crown; a hedge takes the shape of a heavily fortified castle. The items are piled up, as if ready to be torched at the climax of a popular celebration. Yet the limits of possible protest are also indicated: most evidently in the swords that project from everywhere, but also in pickets around the queen's profile, in the unrelenting persistence of her golden glare, and, perhaps, in the wheel-like positioning of the curlicues around the base. The British Empire was, after all, one of the most successful war machines in history. It was an empire based on the gold and other precious produce of its colonies, and was seen by its subjects as the center of the universe, its streets paved with that gold. Now, however, this kind of El Dorado (meaning literally "Gilded Place"; the name originally referred to a fabled South American city containing unimaginable treasures) exists merely as a memory, its potency fading, its icons coming alive again only when appropriated by local cultures—those of the colonized, who are setting out to consume the old imagery via a brazen, over-the-top aesthetic.

Locke's work recalls that of perhaps the most famous Puerto Rican artist, Arnaldo Roche-Rabell. Active during the 1980s and 1990s, Roche-Rabell's paintings were made by literally covering his subject (himself or a model) with canvas or prepared paper, which he next rubbed with his paint-covered hands or other implements until an impression was made. He then added further elements, such as the leaves of local tropical plants. In *Like a Thief in the Night* (1990) (Fig. 4.40),

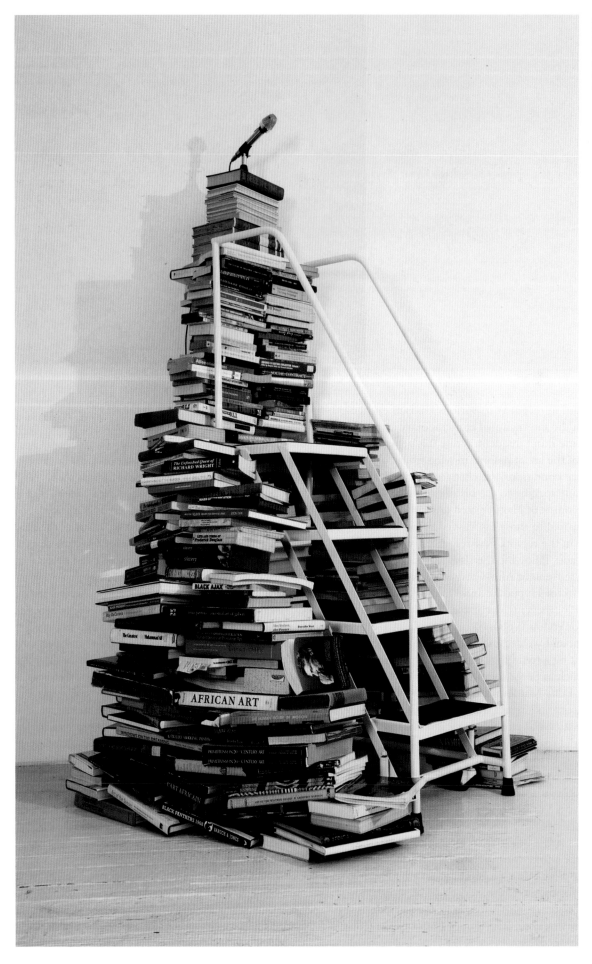

4.41 Satch Hoyt
*Say It Loud!*, 2004–07.
Books, staircase,
microphone, and 4
speakers, dimensions
variable. Courtesy of
the artist.

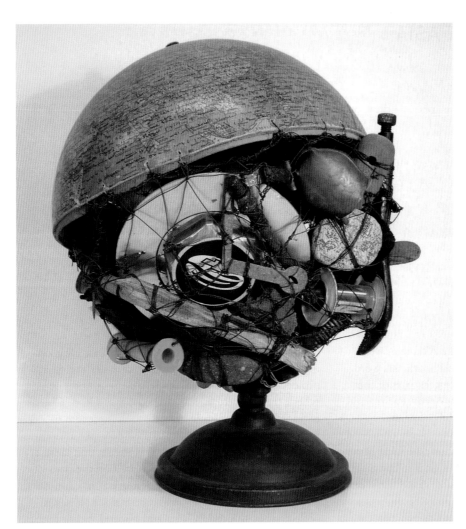

4.42 Arthur Simms
and Peter Orner
*Globe, The Veld*, 2004.
Globe, artists' nails,
metal, wood, plastic,
wire, tools, objects,
17 x 14 x 14in (43.1
x 35.5 x 35.5cm).
Text by Peter Orner.
Courtesy of the artist.

Roche-Rabell's own face appears as a godlike apparition, hovering within a hut, or a forest, at once intensely present and otherworldly. When we compare this work to Locke's *El Dorado*, we can see that both artists are adept at showing us what it feels like, in these very particular circumstances, to look from the inside outward, and the outside inward.

How might we approach each other's difference? As we shall see in Part III, this question exercises contemporary artists around the world. Jamaican artist Satch Hoyt's *Say It Loud!* (2004–07) (Fig. 4.41) quite literally embodies the idea that contemplation should lead to action, however demanding the initial study and however difficult the eventual action. A pile of 500 books surrounds the steps leading to a lectern. Stepping toward it, ones sees at its base large volumes on indigenous art from all over the world, interleaved with histories of slavery, interpretive texts by Edward Said and Paul Gilroy, the novels of Richard Wright, as well as inspiring biographies—of Muhammad Ali, for example. The James Brown song that gives the piece its title booms out from loudspeakers. A microphone sits on a thick volume: Bobby Seale's account of the rise of the Black Panther Party in the United States in the late 1960s. Its title, *Seize the Time*, faces any participant who chooses to pick it up as he or she stands to speak, squeezed up against the wall of the gallery, facing its blank expanse.

## Seeing the World's Currents

In 2004, Arthur Simms, a Jamaican artist living in the United States, and San Francisco-based writer Peter Orner made *Globe, The Veld* (Fig. 4.42), an assemblage of found objects. The top half of a free-standing globe shows the northern hemisphere as a totally mapped and smoothly ordered domain. But the bottom half has been cut away to reveal the insides of the world, the parts that usually escape mapping and that burst out here: manufactured materials such as hubcaps, plastic spools, and faucets are rendered useless when discarded as the waste of industrialization and overconsumption, scattered across the arid and poor regions of the world, where they are gathered and reused ingeniously. But natural materials such as wood and river-smoothed stones are also caught up in this world web, and some are made into decorative and even sacred items. North and South are thoroughly implicated in each other, wired together, albeit in a mismatching, fragile way. With this work, we have returned to the wish for global equity expressed in Joaquín Torres-García's 1935 diagram *The North Is the South*—but without, perhaps, the optimism that was possible at that time.

# 5. CHINA AND EAST ASIA

The region known as Asia (from the Akkadian word for the direction of sunrise and the Phoenician word *asa*, meaning "east") occupies the eastern part of the Eurasian landmass. Bounded by the Arctic, Pacific, and Indian Oceans, it has a border with Europe that has historically proved fluid, and remains deeply contested, but is generally held to run south from the Ural Mountains through the Caspian and Black Seas to the Suez Canal. Occupying a third of the Earth's land surface, it is also its most diverse region geographically, and its most densely populated (with 4 billion people, 60 percent of the world's humans); it contains the widest range of languages, and is the place of origin of all of the world's major religions. Although still primarily agriculture-based, its cultures have been formed by constant contact with other regions through extensive trade and wide-ranging warfare, leading to the creation of great civilizations whose achievements in writing, horsemanship, and urbanism far eclipsed those of Europe until the fifteenth century. Certain of the resulting empires, such as the Ottoman and the Chinese, were maintained into the early twentieth century. Since then, many Asian nations have undertaken industrialization programs that draw on abundant cheap labor, enabling some, such as Japan and more recently China, to compete with the economies of North America and Europe. During the twentieth century, East Asian countries also embraced social modernity, including those modes of visual communication, notably in advertising and art, that are commonly taken as definitive of Western life. Accordingly, we will treat the history of modern and contemporary art in this part of Asia before turning to developments in South and Southeast Asia.

## CHINA

Contemporary Chinese art began to attract worldwide attention during the 1990s, becoming prominent in major biennales, touring exhibitions, and scholarly publications. During the first decade of the twenty-first century, it started to receive the support of a burgeoning specialist market. Along with major architectural projects in Guangzhou, Shanghai, Beijing, and elsewhere, these developments are taken as a sign of China's extraordinary economic growth: the fastest rate of increase in the world (around 10 percent per annum since 1978), so that by 2009 it was the second largest economy in the world when calculated on the basis of purchasing power parity. As a phenomenon, Chinese contemporary art has fascinated critics, scholars, and collectors, both inside China and beyond its borders, who have examined it in detail while the explosion has been taking place. A sense of history pervades all aspects of the making and reception of this art. Both the distant and the more recent internal history of China, and the unprecedented ways in which China is changing, are inescapable factors for artists working today. So, too, is the achievement of Chinese artists over the centuries, a legacy that is still widely held in high esteem, and remains a model of practice for many. These factors shape even the most spontaneous actions, the most tradition-challenging gestures, and the most contemporary concerns of artists in China today.

Painting in China was for centuries practiced by craftsmen who produced great murals in tombs and temples, particularly Buddhist temples, and smaller-scale pictures in other settings, for instance, as part of a scheme of interior furnishings. In contrast, "Literati Painting" was the pursuit of independently wealthy gentlemen-scholars, or Confucian scholar–officials. Its aim was to unite poetry, calligraphy, and painting as a means of achieving true understanding of existence in both the natural and the supernatural world. Literati artists favored watercolors mounted on hanging scrolls or in albums, and developed rendering techniques tied to given subjects such as flowers, landscapes, and portraits. After the Opium Wars of the mid-nineteenth century—which accelerated trade with Western powers, especially Great Britain—variations in traditional practices were encouraged by new merchant elites with international connections, especially in such treaty ports as Shanghai.

5.1 Shi Lu
*Fighting in Northern Shaanxi*, 1959.
Originally ink and color on paper, 93⅝ x 85in (238 x 216cm). Museum of the Chinese Revolution, Beijing.

## Modern Chinese Art

These kinds of innovation accelerated after the overthrow of the Qing Dynasty and the establishment of a republic in 1911, above all in Shanghai, the fastest-growing, most rapidly modernizing metropolis in China. A fierce debate occurred between the intellectuals of the National Essence School (*Guo cui pai*) and those of the New Culture Movement, the former advocating the reinforcement of traditional beliefs and practices while the latter advocated their erasure and the wholesale adoption of Western attitudes and methods. Writers more than visual artists exemplified this pro-Western approach. Known from 1919 as the May Fourth Movement, their example remained influential, notably among the group of modern woodcut makers, inspired by the poet Lu Xun, who flourished in Shanghai during the 1930s. In many cities, reformist artists, educated in Europe, returned to institute a new art education system based on French models. Framed pictures in oils became known as "Western-style painting," in contrast to traditional ink on paper and silk scrolls and albums, which were now labeled "national painting" (*guohua*). In practice, most artists used Western techniques and artistic ideas to revitalize conservative approaches. Nor was this simply a two-way exchange between China and Europe. Interaction with Japanese artists continued to be important, as Chinese artists learnt from their Asian colleagues ways of modernizing what in Japan was known as *nihonga* (traditional as distinct from Western-style) painting. After war broke out between the countries in 1937, this kind of interaction ceased.

In his "Talks at the Yan'an Forum on Literature and Art" in May 1942, the Communist political leader Mao Zedong summed up his message: "through the creative labor of revolutionary writers and artists, the raw materials found in the life of the people are shaped into the ideological forms of literature and art serving the masses of the people."[1] This approach reflected the need to turn intellectuals, workers, and peasants into soldiers during the war against Japanese occupation. Following the victory of Communist Party-led forces in 1949, Mao's values became the core of official attitudes. In art, they led to a new form of *guohua* painting, as in Shi Lu's *Fighting in Northern Shaanxi* (1959) (Fig. 5.1), which shows Mao standing on a red-wash-bathed ridge, looking out across the seemingly impassable ranges before him, now shrouded in a white mist that is soon, the artists implies, to clear and allow the great leader through.

The Communist Party, under the influence of its Soviet counterpart, introduced Socialist Realism as

5.2 Dong Xiwen
*The Founding of
the Nation*, 1953.
Poster; original oil
on canvas, 90½ x
157½in (230 x 400cm).
Museum of the Chinese
Revolution, Beijing.

the desired form for oil painting and sculpture. This gave rise to a "revolutionary romantic" imagery of heroic peasants, workers, soldiers, and leaders which celebrated the Party, the Chinese people, and the advance of socialism within the nation, usually under the leadership of Chairman Mao. The most famous example is Dong Xiwen's monumental canvas *The Founding of the Nation*, which shows Mao on the balcony of the Tiananmen gate-tower of the Forbidden City, with fellow Party leaders behind him, proudly reading to the assembled multitudes the proclamation of the People's Republic of China. Painted in 1952 and approved by Mao on its first showing in 1953, the following year it was made into a poster that was reproduced over 56,000 times—soon, this image hung in countless Chinese homes (Fig. 5.2). Although the painting purports to record an event that took place in 1949, it has been repainted three times subsequently due to changes in the leadership in the intervening years. A number of the figures originally present in the painting were removed by the artist, and others inserted in their place; some that were removed have subsequently been restored as their reputations were rehabilitated. A more subtle and affecting work in this manner was *The Rent Collection Courtyard* (1965) (Fig. 5.3), consisting of 114 life-size clay figures made by Ye Yushan and a team of sculptors from the Sichuan Academy. In a series of tableaux approximately 100 yards long, it enacts scenes in a landlord's palace prior to the revolution. In the section illustrated here, a peasant is protesting against the exploitative requirement that he hand over—as in-kind rent—so much corn that he will be unable to feed himself or his family.

Chinese artists were organized into city and regional artists' associations supported and administered by the state. These bodies supervised local training of artists, exhibits in galleries, admission to the association, and thus the possibility and the continuation of each artist's livelihood. During the Cultural Revolution (1966–76)—a violent mass movement, launched by Mao and carried out largely by China's youth, aimed at purifying the Party and society at large of what were perceived as "liberal bourgeois elements"—galleries did not collect or exhibit art, or stage exhibitions with the intention of educating the public about the history of art, or its current forms. Rather, their main goal at this time was to publicize the policies of the Communist Party and to inspire political enthusiasm among the people, which they did through exhibitions devoted to key days in the state calendar. The "peasant painters" of Huxian County, Shanxi Province, devoted their work to precisely these purposes. Deploying aesthetic modes familiar to the broad masses—such as bright colors and "New Year" formats—their works were, for the most part, exercises in graphic propaganda, initially directed by visiting professionals but with the local artists eventually becoming quite skilled in their own right (Fig. 5.4).

## Contemporary Chinese Art

It has become customary to divide developments in contemporary Chinese art into four phases: 1976–84, the post-Cultural Revolution period, marked by uncertainty; 1985–89, the New Wave or avant-garde moment; 1990–99, a period of repression, exile, and protest through performance; and 2000–the present, when internationalist attitudes, large-scale exhibitions in China and overseas, and a burgeoning market have been prominent features. Some writers regard these as constituting phases in a broad experimental art movement. In the last few years it is possible to discern a growing convergence between nationalist and internationalist attitudes.

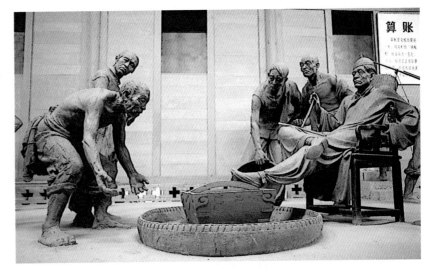

5.3 Ye Yushan and a team of sculptors from the Sichuan Academy *The Rent Collection Courtyard*, 1965. Over 100 life-size clay figures, dimensions variable. Sichuan Academy of Art.

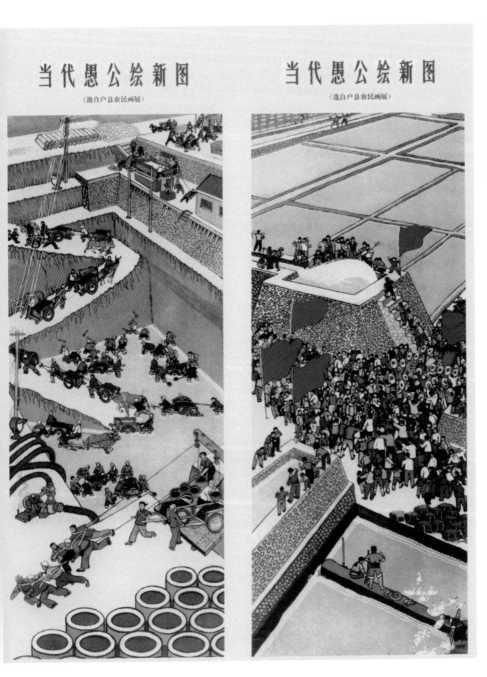

5.4 Chen Minsheng and Zhang Lin *Contemporary Yu Gongs draw a new picture*. Selection from the Huxian peasant painting exhibition (*Dangdai Yu Gong hui xintu – Xuan zo Huxian nongmin huazhan*). Two sheets, published by Shanghai renmin chubanshe, January 1975, set no. 8171.89.

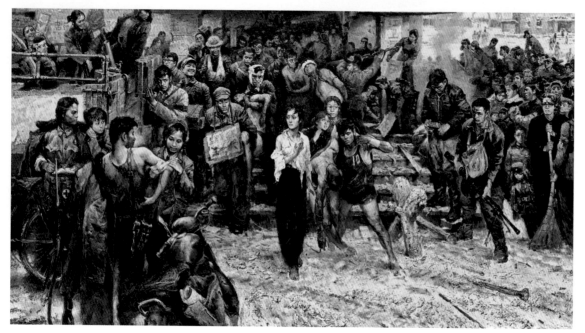

5.5 Cheng Conglin
*Snow, an Unknown Day from an Unknown Month in the Year of 1968*, 1979. Oil on canvas, 79½ x 118¹/₁₆in (202 x 300cm). Chinese National Art Gallery, Beijing.

### 1976–84: Post-Cultural Revolution

The Cultural Revolution ended abruptly in 1976, with the deaths of Mao Zedong and his deputy Zhou Enlai, and the arrest of key leaders known as the "Gang of Four." In the subsequent period of uncertainty, many artists reverted to traditional, pre-Revolutionary subjects and to the exploration of purely aesthetic challenges under the rubric of "abstract beauty." Others, notably writers and artists of the "Scar" or "Wounded" group, broached social criticism, manifesting their doubts about the Cultural Revolution. An outstanding example is Cheng Conglin's *Snow, an Unknown Day from an Unknown Month in the Year of 1968* (1979) [Fig. 5.5]. Built around the evident fears of a young woman, this finely calibrated panorama, painted in a consummately Realist style, demonstrates that the way a group of intellectuals, athletes, and other doubters were treated at the hands of rampant Red Guards at the beginning of the Cultural Revolution was not admirable political action but an expression of callous ignorance. An even more intense naturalism is evident in the work of the Rustic Painting group, notably Luo Zhongli's *Father* (1980) [Fig. 5.6], a close up view of the head and hands of an old peasant shown drinking from a bowl, eyes sightless, teeth broken, a ballpoint pen behind his ear, with sweat dripping from his brow, as if he has paused in the midst of back-breaking work. Far from being a traditional piece of propagandistic peasant painting, this work shocked audiences—not only because of its hyper-realism but also because of its size: at over 8 feet by 5, it matched the scale usually thought appropriate only for images of the leadership.

Members of the Star Group were more direct in their confrontation with official aesthetics. Mostly amateur artists, they presented satires of the regime in the form of cartoons and sculptures, associating themselves closely with the short-lived Xidan Democracy Wall movement of 1979–80. Meanwhile, abstraction of the kind favored in early twentieth-century European Modernism—itself regarded with official disfavor—provided an aesthetic framework for members of the No-Name Painting Society. During this period, artists took time to explore freshly revealed details of the history of art from elsewhere, and to respond to the sudden plethora of ideas flooding in from the West, not least the critical constellations of Postmodernism and Poststructuralism.

### 1985–89: The New Wave or Avant-Garde Moment

*The Sixth National Art Exhibition*—held in 1984 in nine major cities simultaneously, each venue emphasizing a different medium—was the last large-scale exhibition that fully reflected Communist Party artistic policy. Artists continued to form independent mutual support and exhibiting groups, such as the Hunan Zero Art Group, the Southwest Art Group, and the Northern Art Group from Harbin. The latter stated in their manifesto: "We must remove ourselves from the clutches of Eastern traditionalism, distance ourselves from the influence of Western consciousness and establish a unique Northern [Chinese]… cultural system," based on exercising restraint in both technique and choice of subject. They called this approach "rationalistic painting."[2] Others staged one-off happenings, such as Huang Yong Ping's *Xiamen Dada* event in 1986. So many artists' collectives were formed—echoing the young artists' training as idealistic cadres—that an avant-garde impetus swept through the art schools in both major and provincial cities. It was quickly named, in an echo of the May Fourth Movement, "'85 New Wave Art."

Huang Yong Ping launched a critique of the idea of Art through methods made familiar by Western Conceptual artists, such as burning all his paintings or dumping them as trash, during the *Xiamen Dada* event

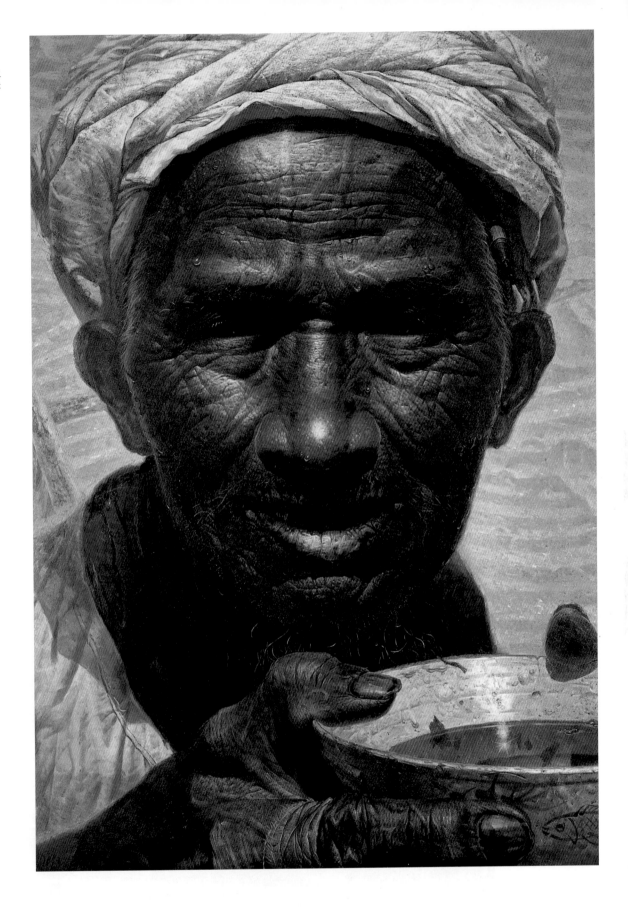

5.6 Luo Zhongli
*Father*, 1980.
Oil on canvas, 89⅓ x
60½in (227 x 154cm).
Chinese National Art
Gallery, Beijing.

5.7 Huang Yong Ping
*The History of Chinese Painting and The History of Modern Western Art Washed in the Washing Machine for Two Minutes*, 1987–93. Chinese teabox, paper pulp, glass, 30¼ x 19 x 27½in (76.8 x 48.2 x 69.8cm). Walker Art Center, Minneapolis. T.B. Walker Acquisition Fund, 2001.

5.8 Wu Shanzhuan
*Red Humor Series: Big Character Posters*, 1986. Installation, dimensions variable. Courtesy of the artist and Asia Art Archive.

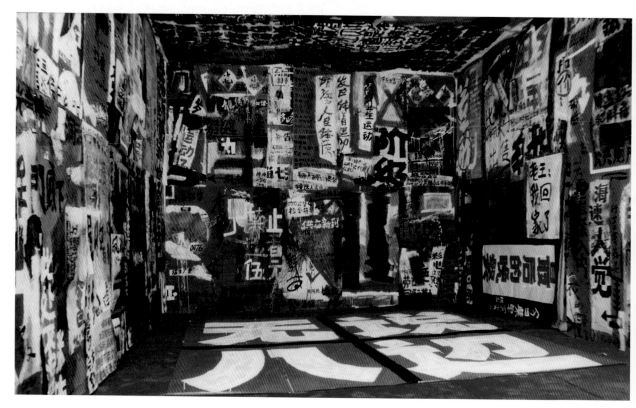

5.9 Xiao Lu
*Dialogue*, 1989.
Installation and
performance,
dimensions variable.
Courtesy of the artist.

mentioned above. In 1987, he laundered Wang Bomin's authoritative *A History of Chinese Painting* and a widely read translation of Herbert Read's *A Concise History of Modern Art* to generate an unsightly pile of pulp (Fig. 5.7). This gesture echoes that of English artist John Latham who, in 1966, chewed up and then distilled a copy of influential U.S. critic Clement Greenberg's *Art and Culture*, returning it to his art-school library in a phial (*Still and Chew/Art and Culture*, 1966–67). Huang had a parallel purpose: to use humor to draw attention to a serious example of the unequal distribution of cultural power, and to show how simple it can be to act against this inequity. He commented: "In China, regarding the two cultures of East and West, traditional and modern, it is constantly being discussed as to which is right, which is wrong, and how to blend the two. In my opinion, placing the two texts in a washing machine for two minutes symbolizes this situation, and solves the problem much more effectively and appropriately than debates lasting a hundred years."[3] Other Conceptualist works include the small-scale, unrealizable architectural projects of the "Apartment Artists," and the installations of Wu Shanzhuan, such as his 1986 *Red Humor Series: Big Character Posters* (Fig. 5.8)—total environments filled with advertising exhortations painted in political slogan style.

After four years' planning, and repeated attempts to gain permission to stage a survey of controversial contemporary work, the *China/Avant-Garde* exhibition finally opened at the National Art Museum of China in Beijing in February 1989. Organized by a committee directed by Gao Minglu and including the critics Li Xianting, Zhou Yan, Fan Di'an, Fei Dawei, and Wang Mingxia, it was jointly sponsored by six visual arts organizations, among them the magazines *Zhongguo meishu bao* (*Fine Arts in China*) and *Meishu* (*Fine Arts*). While the Chinese title of the exhibition translates as "Chinese Modern Art," the exhibition poster featured (along with a "no U-turn" logo) the English words "China/Avant-Garde"—the organizers felt that the eyes of the world were upon them. Their "Preparation Notice for the China Modern Art Show, No. 1," issued in October 1988, stated that it would: "for the first time exhibit art works with modern artistic concept and spirit to artists in China and the world as well as to the general public. The show will also reflect the art trends and experimental explorations in the past few years that are being debated and evaluated by the art circle, and the value and significance of modern art in the development of Chinese culture. As a high-powered exchanges and research event in the field of modern art, the show will boost the development of art pluralism in the Chinese art world."[4] Three hundred works made between 1985 and 1987 were arranged over three floors, with experimental versions of traditional painting on the third, "rational, religious and metaphysical art" on the second, but with the most confrontational—installations, happenings, and performances—on the first. In the volatile atmosphere leading up to the demonstrations in Tiananmen Square in June 1989, the exhibition lasted two weeks. It was closed down twice, once because one of the artists, Xiao Lu, "completed" the installation *Dialogue* (Fig. 5.9)—which consisted of life-size photographs of a man and a woman

5.10 Fang Lijun
*Series Two No. 1*, 1991–92.
Oil on canvas, 78¾ x
78¾in (200 x 200cm).
Courtesy of the artist.

installed in separate telephone booths, seemingly unable to communicate—by firing two shots from a revolver at it. She was among a number of artists who were arrested, and soon after left the country for Australia.

### 1990–99: Repression, Exile, Protest

The violent response of the Chinese government to the protesters in Tiananmen Square on June 4, 1989 ushered in a period of internal repression and fear. Reactions among artists, critics, and curators varied. Some left for exile abroad, most for a decade or more. A conservative turn was apparent in "New Literati Painting," which received its inaugural exhibition at the National Art Gallery in Beijing in 1989. Exhibitions focusing on traditional imagery and techniques continued to be held. A more contemporary emphasis was apparent in the work of brush and ink painters who used abstract and Expressionist modes inspired by post–World War II Western painting, including the modes of artists such as Frank Stella and Agnes Martin. Gao Minglu has noted that such Minimalist techniques are often used to record the process of daily meditation, but are pursued with a paradoxical intensity that comes to fill the artist's entire life and artistic output. He thus identifies it as "Maximalism."[5] New Generation painting appeared first in an exhibition of work by young art teachers in Beijing in 1991. With an eye on the German Neue Wilden and U.S. Postmodern artists, painters such as Liu Xiadong and Yu Hong applied a vigorous naturalism of style to scenes from their lives, highlighting the strangeness inherent in the everyday.

Yet the most pervasive reaction on the part of artists who remained in China was to retreat into a mood of despairing irony, by means of which they sought to parody the central government's efforts to embrace market capitalism while still maintaining control over social order and ideological expression. As we have seen, emotional distancing and pastiche are Postmodern strategies, but in China they took Late Modernist forms. Two movements quickly emerged. "Cynical Realism" is exemplified by Fang Lijun's deadpan paintings of groups of figures, dressed in drab quasi-uniforms and wearing inane, uncannily similar facial expressions (Fig. 5.10). "Political Pop" was instituted by Wang Guangyi's *Great Criticism* series (Fig. 5.11), in which propaganda posters from the Cultural Revolution are scattered with the logos and brand names of the international companies then entering China as it gave itself over to consumerism. A number of artists—including Yu Youhan, Liu Wei, Li Shan, Wang Jinsong, Zhang Xiaogang, and the Luo Brothers—produced parodies of the image of Mao and of policies such as one child per family using a variant of the silkscreen style made internationally popular by artists such as Andy Warhol. This combination of a smart look and a local story, with its sly critique of state totalitarianism, made their work attractive to audiences outside of China who, since the collapse of Communism in the Soviet Empire in 1989, have been fascinated by the Chinese government's sociopolitical balancing act. More direct criticisms of government policy were rare: Yue Minjun's *Execution* (1995) (Fig. 5.12), a chilling reworking of Francisco de Goya's *The Third of May 1808* and Édouard Manet's *Execution of Maxmilian* made in the artist's characteristic schematic style, shows victims

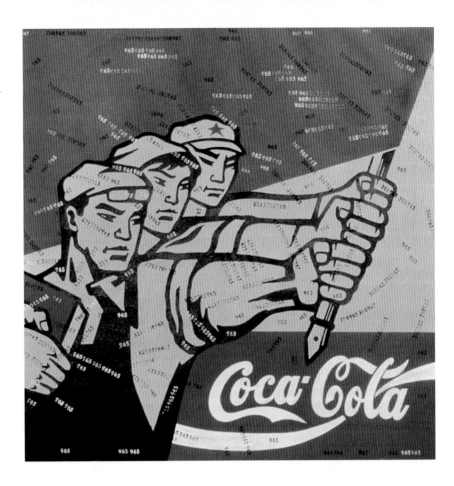

5.11 Wang Guangyi
*Great Criticism—
Coca-Cola*, 1993.
Oil on canvas, 59 x
39⅓in (150 x 100cm).
Courtesy of the artist.

5.12 Yue Minjun
*Execution*, 1995.
Oil on canvas, 59 x
118⅒in (150 x 300cm).
Courtesy of the artist.

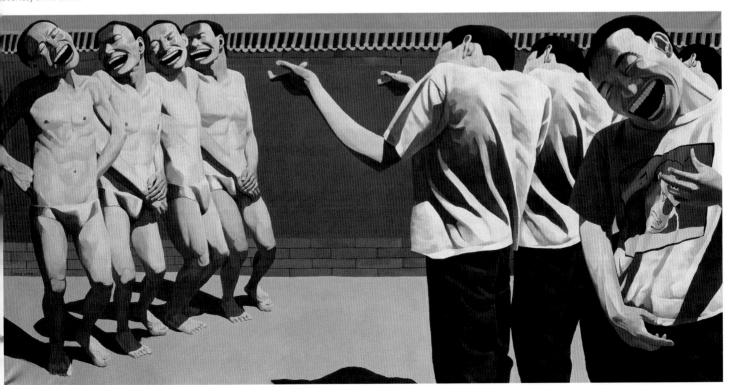

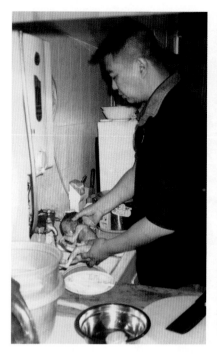
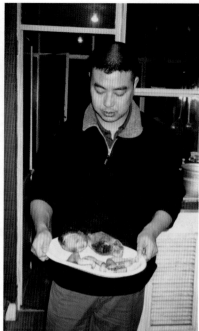

5.13 Zhu Yu
*Cannibalism*, 2000.
Images of performance
Courtesy of the artist.

in underwear and executioners in T-shirts, assembled as if for a rock and roll performance, all wearing fixed, false smiles—all are actually self-portraits of the artist. This belated response to the 1989 Tiananmen Square crackdown was acquired by a Hong Kong gallery in 1999 on condition that it not be displayed for at least five years, as it was too dangerous at the time to refer to the events in a way that implied criticism of the government's actions. This remains the case today. In October 2007, Sotheby's sold it in London for $6 million, then a record price for a living Chinese artist.

Of all the forms of contemporary art developed in China during this period, most challenging to the authorities and broader public were performances involving live participants, often the artist him- or herself. This sense of provocation or danger was true of the reception of Performance Art through the world, yet in China there were fewer precedents in the theater, and rather more in public demonstrations, a subject of deep concern to the state. Artists committed to transgressive practice were magnetically drawn to imagine actions that would test the limits of permissible protest. During the mid-1980s, the Southern Artists Salon staged genre-mixing, boundary-breaking "environmental art" installations/events in Guangzhou. In 1987, Wei Guangqing laid his shrouded body across railway tracks in his *Suicide Series* performance. Zhang Huan, Ma Liuming, and others positioned their naked bodies within landscapes: in *To Add One Meter to an Unknown Mountain* (1995), they piled on top of each other to create a mini-peak. The nude is a category unique to Western art: it is absent from premodern Chinese art, and thus retains strong shock value in China today.[6]

Beijing-based artist Zhu Yu has performed the most extreme actions: in *Cannibalism* (2000) (Fig. 5.13), he appeared to eat a cooked human fetus. The preferred Chinese term for this category is *xingwei yishu* ("behavioral art"), rather than the more literal word for performance: *biaoyan*. Exploring the limits of

possible human behavior toward other humans seems in part to be designed to test the state's willingness to tolerate dissent. In May 2001, the Chinese Ministry of Culture issued a proclamation against artists who stage "bloody, violent or erotic performances by abusing themselves or animals and exhibiting human corpses in public places in the name of art."[7]

Other performance artists made their points with more subtlety. Song Dong carried out his two-part work *Breathing* (Fig. 5.14). On New Year's Eve 1996, he lay motionless, face down in Tiananmen Square, breathing onto the pavement for 40 minutes. A thin layer of ice formed on the concrete block before him, giving this small area, briefly, a character quite different from the vast space surrounding it. Tiananmen Square can hold 60,000 people; this huge capacity has been exploited in the past for stagings of official history. The artist then moved to a frozen pond in the old quarter of Beijing known as the Back Sea and repeated his action. This time, the place absorbed his breath without observable change. Song Dong's performance embodies the ecological principle of touching the Earth lightly, and the Conceptualist idea of making a significant artistic statement with the most minimal and, in this case, poetic of means.

Feminist Art first appeared in China at this time.[8] Women artists were active within the avant-garde artists' cooperatives in the 1990s. They pursued themes of interest to feminist artists elsewhere, such as how identities are shaped by the materials of domestic life—as in Yin Xiuzhen's installation *Suitcase* (1995)—and the inequitable positioning of women, especially during times of rapid social change—as in Cui Xiuwen's video *Ladies* (2000), in which call girls prepare themselves for their work. Lin Tianmiao's installation *Braiding* (1998) (Fig. 5.15) subjects these themes to a more symbolic treatment, showing that identity is shaped in such tasks as weaving cotton and attending to one's hair.

5.14 Song Dong
*Breathing, Part 1 and
Part 2*, 1996. Color
transparencies and
compact disc. Courtesy
of the artist and
Chambers Fine Art.

5.15 Lin Tianmiao
*Braiding*, 1998.
Installation, mixed
media, dimensions
variable. Courtesy of the
artist and Long March
Space Gallery, Beijing.

5.16 Wenda Gu
*Wisdom Comes from Tranquility*, 1986. Mixed media ink and woven installation. Silk, cotton, wool, hemp, bamboo, ink, rice paper, lacquer, weaving, traditional mounting, splashing ink, 197 x 315 x 31½in (500 x 800 x 80cm). Installation view, 13th International Biennale of Tapestry, Lausanne, 1987. Commissioned by Zhejiang Academy of Arts, Hangzhou.

During this period, a number of contemporary artists lived for long periods abroad, many basing themselves in the United States, Europe, or Australia—countries that welcomed those alienated by the events of 1989. Most of these artists saw themselves as both Chinese *and* as internationalists. In common with artists who remained in China during the modern period, the issue of the individual versus the state is prominent in their work. They tend, however, to seek supranational values that go beyond the limits of this theme. Paradoxically, many find these values by revisiting the universalist beliefs of the religions that have evolved in China since ancient times. Awareness of the coexistence and present relevance of multiple, distinct temporalities is characteristic of contemporary art everywhere.

In 1984–86, Wenda Gu, a brilliant calligrapher in the traditional Chinese style, produced his series *The Pseudo-Characters* by splashing ink onto rice paper so as to write "big characters" (the large, boldly painted letters often used in propaganda, protests, and other forms of public communication, most recently advertising) incorrectly, or in the wrong position, then crossed them out, thus voiding them of their expected meaning. A turning point in his art was reached in *Wisdom comes from Tranquility* (*Jing Ze Sheng Ling*) (1986) (Fig. 5.16), a temple-like installation consisting of *Pseudo-Character* paintings, as well as beaded hangings which also erased key symbols by repeating and overlaying them. The net effect is of a kind of anti-temple, one that removes expected markers of authority and invites the viewer to arrive at belief in his or her own terms. Since 1987, Wenda Gu has lived abroad, mainly in New York. His definitive recent work is an ongoing series of installations (25 are planned) in which these nonsense letters are produced on a large scale, using human hair as their main material, to form hanging screens, walls, entire environments. Entitled the *United Nations Project*, these works do not suggest the pointlessness of human existence; rather, they show the vacuity of systems of order imposed by states through the control of language in contrast to the efforts of people in particular places to create meaningful lives for themselves and those around them. Manufactured through a collective, cooperative process, each includes

reference to local political and social issues. These factors, along with the literal blending of human materials from peoples everywhere, manifest a profound idealism. The artist has the universalizing goal of making similar works throughout the world.[9]

It was also in 1986 that printmaker Xu Bing began producing the 2,000 woodblocks of nonsensical, unreadable, impossible-to-pronounce characters that, laboriously handprinted onto 500-foot-long scrolls, onto wall hangings, and into album books, constitute his monumental work that was, at first, entitled *The Mirror for Analyzing the World* (Fig. 5.17). Its title draws attention to the paradox that, while the huge sheets seem to replicate an unfolded encyclopedia, and the installation suggests that we are in a library, we will find knowledge less in the printed pages before us, and more in opening ourselves out to the realization that truth lies beyond what can be said, printed, and even shown. Xu Bing is here drawing on ideas, central to Zen Buddhism and Daoism, about the enlightenment to be found in surrendering oneself to emptiness (*xu*) and nothingness (*wu*), as he affirmed by retitling the work *Book from the Sky*. After moving to New York in 1993, he developed an "art alphabet," highly calligraphic in style yet consisting entirely of roman letters, used to spell out many of the world's languages. In 2000, he used his "New English Calligraphy B" version to translate Mao Zedong's famous talks at Yan'an, the canonical text referred to above. He has also made many works that poke fun at stereotypes of China, such as *A Case Study of Transference* (1994), in which he lined the floor of an animal pen with books to provide a setting in which two pigs—one stenciled with English text, the other with Chinese characters—went about their lives, to the amusement of the audience. He continues to create significant works of contemporary art, such as his *Where Does the Dust Collect Itself?* (2004) (Fig. 5.18). Suspended from a crane above the floor of a gallery, the artist blew dust collected from downtown Manhattan immediately after 9/11 across the stenciled lettering of an ancient Chinese poem: "As there is nothing from the first/ Where does the dust collect itself?" In 2007, he returned to Beijing to take up a senior post at the Central Academy of Fine Arts.

5.19 Cai Guo-Qiang
*Nine Dragon Wall
(Drawing for Dragon or
Rainbow Serpent: A Myth
Gloried or Feared: Project
for Extraterrestrials No.
28)*, 1996. Gunpowder on
paper, 118¹⁄₁₀ x 708½in
(300 x 1,800cm); nine
drawings, each 118¹⁄₁₀
x 78¾in (300 x 200cm).
Queensland Art Gallery,
Brisbane.

5.20 Zhang Dali
*Demolition: Forbidden
City, Beijing*, 1998.
Chromogenic print,
35½ x 23½in (90 x 60cm).
Collection Andrew
Lewin. Courtesy
of Eli Klein Fine Art,
New York and Beijing.

Cai Guo-Qiang likewise left China, going to Japan in 1986 and then to New York in 1995. His main medium is gunpowder, one of the "four great inventions" (*si da fa ming*) for which China has long been famed. With this explosive substance, he draws on extended canvases, and creates dramatic light and sound happenings, earthworks, and spectacles in the sky. Each of these takes the form of an imaginary "Project for Mankind": a pyramid on the Moon, a 32,800-foot extension of the Great Wall, a Chinese dragon accompanying the spirit of the Brisbane River (itself seen by Aboriginal people as a rainbow serpent) (Fig. 5.19). Like Wenda Gu and Xu Bing, Cai Guo-Qiang is motivated by a deep-seated Chinese attitude, and activates an identifiable Chinese aesthetic, to highlight the dangers posed by the contemporaneous presence of seemingly incompatible viewpoints in the world today, and to show ways in which they might be imagined as joining together. His effort to do so in 1999 by exhibiting a re-creation of *The Rent Collection Courtyard* (see Fig. 5.3) at the Venice Biennale met with a positive reaction in Europe (he won a major Biennale award) but was criticized in China as opportunistic plagiarism of what had become a national art icon. He has, however, turned this characteristic Chinese attitude outward, exemplifying a freewheeling cosmopolitanism in his work much sought after by many artists, critics, and curators today.

Curator Hou Hanru argued in 2001 that the artists discussed in this section "not only provide information and other materials for other artists in China, they stimulate their imaginative powers, and they themselves in Western society open up a space for a multi-ethnic site in truly globalizing artistic creation."[10] This complex interaction is evident in current Chinese art and its worldwide impact. It is not, of course, confined to China vis-à-vis "the West." As we will see throughout these chapters, it is a major global phenomenon, one that develops in distinctive ways in each region and locality.

## 2000–the Present: Internationalism, Infrastructure, Remodernization

Since the late 1990s, contemporary Chinese art has been circulated throughout the world in a series of probing exhibitions curated by scholars such as Wu Hung, Gao Minglu, and Hou Hanru. This culminated in exhibitions in public museums and purpose-built private spaces of outstanding private collections, such as that of Uli Sigg, previously a Swiss ambassador to China, and Guy and Myriam Ullens from Belgium.[11] Private support for the visual arts in China was almost nonexistent until the 1980s, when it began to be promoted through Hong Kong galleries, notably by the traveling exhibition *China's New Art, Post-1989*. The market grew haphazardly in the 1990s and only really became substantial in the later 2000s, when Chinese artists outnumbered other nationalities in the top ten highest earners globally. Newly rich Chinese collectors have become major supporters of contemporary

Chinese art, and are beginning to buy in other market sectors, such as Impressionist and early Modern Art. Visual arts infrastructure has burgeoned: in 2010, Beijing boasted 400 recently opened art galleries, thriving "art zones" such as 798, and "art districts" such as Chaoyang. Shanghai has the Pudong district and an art supermarket at Zendai, and the thriving commercial center of Shenzhen, near Hong Kong, is taking up contemporary art with the zeal that made its Dafen Art Village famous as a factory town full of artists willing to make copies, to order, of any art from anywhere. There are now 1,600 auction houses in China and countless Internet outlets. Over 400 contemporary art museums are under construction across the country as local authorities rush to cash in on the boom.[12]

Infrastructure for independent exhibitions and critical interpretation remains under construction. The first two Shanghai Biennales, of 1996 and 1998, exhibited the work of local and some overseas Chinese artists. In 2000, a number of provocative experimental exhibitions were organized during the time of the Biennale, including *Usual and Unusual*, *Fuck-Off*, and *Useful Life*. The 2002 edition featured a wide range of international artists and guest curators, and centered on the hot topic "urban construction." The first Beijing Biennale occurred in 2003, and in the same year the first Guangzhou Triennial offered a detailed historical overview of the decade 1990–2000.[13] State-run galleries now accept the whole range of contemporary Chinese art—with the exception of Performance Art, due to its history of provocation, excess, and unpredictability. In general, however, the state has backed off from censorial regulation, acknowledging art's role in an expanding global economy.

The rapid transformation of Chinese cities into modern cosmopolitan centers, the destruction of the countryside to service the expanding manufacturing sector, the rise of an entrepreneurial class, and the increase in the numbers of the rural and urban poor—all of these distinctive features of the new China are themes in contemporary art. Since 1992, Zhang Dali has been spraypainting a spectral head on walls in ancient Beijing as they are slated for demolition and photographing the settings (Fig. 5.20). "I document the demolished homes and the new life established among the ruins. My camera is not only my eye, but also a tool for my thinking. The fortress of reinforced concrete that has been erected within the stink of money and red slogans has impaired the vision of good people… Is the emperor wearing new clothes?"[14] Other photographers, such as Rong Rong, explore the "aesthetic of ruins," while Sze Tsung Leong displays wide-angled vistas of the demolished ancient urban fabric and of the bleak architectural conformity arising in its place. In his 1995 video *Safely Crossing Linhe Road*, Lin Yilin records himself stacking and restacking a pile of bricks during the hour and a half that it took to move his "wall" across one of the busiest streets in Guangzhou. The films of Yang Fudong alternate between parodies of middle-class fantasies and the yearnings of intellectuals for the metaphysical quests of times past, notably in his suite of

5.21 Zhou Xiaohu
*Utopian Theatre*,
2006. Installation,
dimensions variable.
Gallery of Modern
Art, Brisbane.

five films *Seven Intellectuals in a Bamboo Forest*, released between 2003 and 2007. Yet he, too, has been drawn to the imagery of hopeless erasure, most poignantly in his six-channel video installation *East of Que Village* (2007). Shot in black and white, and in an understated style, scenes from the daily lives of peasants as they struggle for survival in a drought-prone area are juxtaposed with scenes of a pack of dogs whose own struggle is so desperate that they resort to cannibalism.

For his videos, such as *Utopia Machine* (2002), sculptor Zhou Xiaohu builds elaborate settings that show the spaces of the new China to be staged fictions, spectacles created by "socialism with Chinese characteristics." Row upon row of clay figurines line up for mock Party congresses, or perform Revolutionary operas. Heroes of the People are shown as attention-seeking giants. Mock trials are held, people sink into quicksand, and heavenly temples seem deserted. Zhou elaborated these themes in his *Utopian Theatre* (2006) (Fig. 5.21). A diorama over 3 feet high and 13 feet across is divided into ten dovetailed tableaux, in which wax figurines are shown in architectural and natural settings that alternate between precisely observed authoritarian spectacles, overbuilt natural settings, and scenes of unbridled pandemonium. Zhou observes: "When we take pleasure in the theatricality of political events, viewing them as entertainment, we are blinded."[15] An 11-channel video pans over the diorama, demonstrating that this blindness has saturated contemporary life.

Many Chinese artists are disturbed by their colleagues' eager and apparently uncritical embrace of the values of international art. Beginning in 2002, curator Lu Jie and his team launched their *Long March Project*. A loose grouping of over 100 artists set out to retrace the route of the famous forced march of the Communists undertaken in 1934–35. (The route has

been a major passageway for the informal dissemination of ideas into and out of the country for centuries. The Han peoples also took this path as they colonized China; military supplies were likewise transported along it to Indochina during World War II.) The *Long March* artists aimed to introduce aspects of contemporary art to local communities, and to learn from the craftspeople in these places. This was a return to the ideals that were expressed at the Yan'an Forum on Literature and Art, but self-consciously revisited, 60 years later, in the light of that earlier project's conspicuous failure. As he traveled, artist Qin Ga recorded the progress of the project by making additions to the map of China tattooed on his back (Fig. 5.22). During their three-year journey, the artists added another goal: to promote local art cultures, in their own localities and further afield, nationally and internationally. This they have done, by creating a center in Beijing and by exhibiting folk art in biennales, notably *The Great Survey of Paper-Cuttings in Yanchuan County* at the 2004 Shanghai Biennale.

China's rapid, indeed rapacious, modernization, allied with its strenuous efforts to maintain a one-party, centralized state, has provoked many artists to question both the country's "progress" and "stasis." Some do this with delicate indirection, others (most outspokenly Ai Weiwei—see Fig. 10.17) through all-out confrontation. This mix, and the context itself, reminds art historians of the conditions that—in France in the 1850s—generated Realism, and then Modernism more generally, in European art.[16] A central paradox is that, after the advent of Western Postmodernism, so many artists have reacted by embracing the core values of individualistic humanism, but in a "Chinese" manner—a mix that they will be obliged to keep on stirring as the complexities and contradictions of China's engagement with globalization, itself embattled, pile up around them.

5.22 Qin Ga
*The Miniature Long March – Site 23 Nanniwan*, 2002–05. C-print, 65 x 47¼in (165 x 120cm). Part of *Long March: A Walking Visual Display*, 2002–ongoing, a project curated by Lu Jie. Courtesy of the artist and Long March Space Gallery, Beijing.

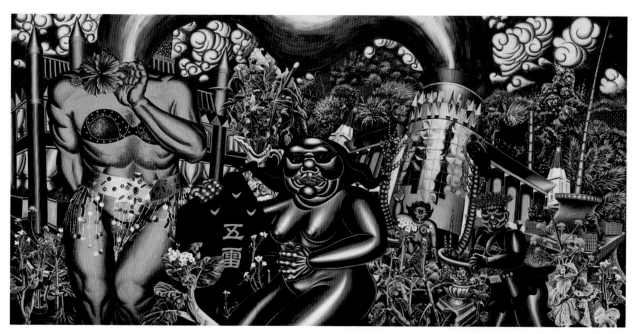

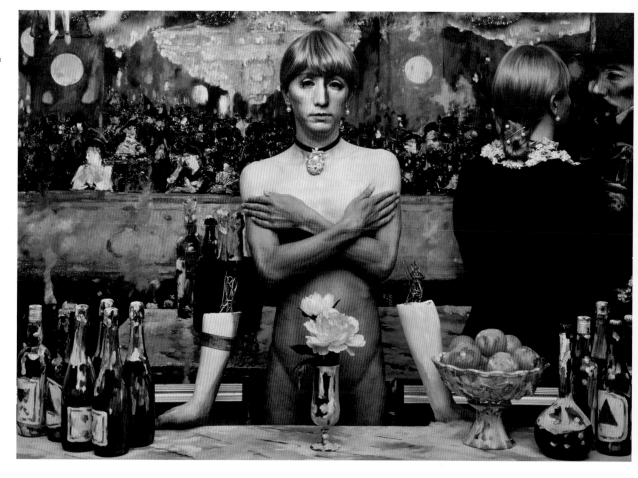

## TAIWAN

The culture of the small island country of Taiwan has been shaped by successive waves of colonization carried out, since the sixteenth century, by European, then mainland Chinese forces, culminating in the martial law rule of the Kuomintang regime from 1945 to 1987. Since then, a society-wide debate as to the nature of Taiwanese national identity has raged, accompanied by the sort of spectacular economic growth seen in many Asian countries. Because Taiwan remains subject to the territorial claims of the People's Republic of China—which demonstrated its willingness to reabsorb its previous territories as recently as 1997, when it began to resume control of Hong Kong—nation-building remains provisional.

These tensions form a central current in the work of many Taiwanese artists. Fragility in the performance of public identities is a theme in Wu Tien-Chang's series *Dreams of a Past Era* (1997), which combines a found photograph with kitsch objects such as sunglasses and flashing lights, suggesting the degradation of taste in consumption-driven cultures.[17] It is at the core of what is perhaps the major achievement of contemporary Taiwanese art, Huang Chin-Ho's massive mural *Fire* (1992) (Fig. 5.23). Corpulent hermaphrodites, bursting out of their silicone-saturated bodies, frozen in attitudes of frenzied self-display, loom like abandoned garden furniture in a pseudo-paradise that, in its luminescent confusion, looks like Las Vegas as imagined in a karaoke club in a provincial Taiwanese city (the buildings in the background are indeed such a club from Taichung, a postindustrial town on the island). Similar themes are explored by the current generation of new-media and installation artists, such as Wang Jun-Jieh in his multimedia series *Neon Urlaub* (1997).

## JAPAN

For centuries, Japanese art was deeply influenced by models from China, then, after the importation of illustrated books from Holland in 1792, by the West. Yet adaptation occurred in distinctive ways, creating a tradition of transformation most evident in the style and subject matter of *ukiyo-e* woodblock prints that, from the seventeenth to the nineteenth century, captured the "floating worlds" of a modernizing society, especially that of Edo, subsequently renamed Tokyo, "Capital of the East." Important styles of painting persisted across centuries and remain relevant today: for example, the schematic abstraction of the Rimpa School, originated in the early seventeenth century by the masters Sōtatsu and Ogata Kōrin. *Yōga*, or Western-style Japanese painting, evolved during the twentieth century in close but distinct parallel with European Modernism in the work of innovators such as Yorozu Tetsugorō, Onchi Kōshirō, Yoshihara Jirō, Saitō Yoshishige, Murai Masanari, and others. These developments provoked a reaction, on the part of some painters and patrons,

back toward traditional techniques. Known as *nihonga* painting, this was not simply antiquarianism: rather, in the work of masters such as Yokoyama Taikan, the tradition continued to renew itself by means of oblique allusions to modern life and through discrete technical refinements. Developments of this kind are known as "Neotraditionalism."

### Experimental Art in the 1950s to 1970s

While there was extensive experimentation on the part of painters during the 1920s, there was little precedent for the revolutionary eruption onto the scene of the Gutai artists in the mid-1950s (discussed in Chapter 1). It should be noted, however, that many of the participating artists subsequently returned to their lifelong practice as abstract painters, albeit of spare, gestural forms. Sculptors such as Isamu Noguchi sought to inflect biomorphic stone carvings with Zen concepts, while Lee U Fan, a Korean-born artist and chief theorist of *Mono-ha* ("School of Objects"), evoked such ideas through exquisite placements of natural and manufactured objects. The irrationalities generated by obsessive repetition and freewheeling analyses of rigid systems are the subject of influential paintings by Conceptualists On Kawara and Shusaku Arakawa. Since the 1970s, performance and installation artists such as Yayoi Kusama and Yoko Ono have invited exploration of sexual fantasies and other flights of the imagination. These initiatives were seen as part of Japanese artists' achievement of "international contemporaneity."

### Contemporary Art

Contemporary Japanese art continues many of these currents. Since the 1980s, Yasumasa Morimura has produced a series of works that draw attention to and exaggerate the resonances of *ukiyo-e* (Fig. 5.24). The artist inserts himself as the chief actor in elaborate restagings of famous works by Brueghel, Goya, Manet, Van Gogh, and Picasso, presenting them as museum-size photographs in elaborate frames. Morimura's flamboyant cross-dressing (and undressing) highlights the ambiguities in the ways sexuality is signaled in such representations; his outrageous self-foregrounding enacts a Western nightmare of the arrival of the ethnic "Other." In his *Daughter of Art History (Theater B)* (1990), he created an elaborate tableau, using makeup, props, and digital simulation, to present himself in place of the barmaid in Édouard Manet's famous 1882 painting *A Bar at the Folies-Bergère*. By showing himself naked, he renders literal the implied narrative of Manet's painting, and inserts himself as the imagined object of desire.

Japan reached a pinnacle of economic success in the 1980s. That this was a "bubble economy" became apparent in the following decade, yet certain artists persisted in imagining this consumerist wonderland as a world of far-reaching fantasy. In large cibrachrome

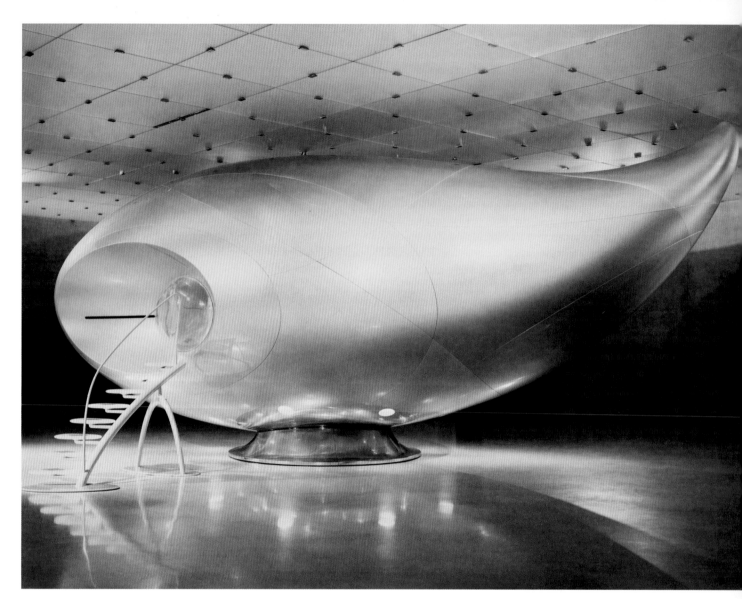

5.25 Mariko Mori
*Wave UFO*, 1999–2002.
Brainwave interface,
vision dome, projector,
computer system,
fiberglass, Technogel®,
acrylic carbon fiber,
aluminum, magnesium,
194 x 446½ x 207⅞in
(493 x 1,134 x 528cm).
Courtesy of Pinchuk Art
Center, Kiev.

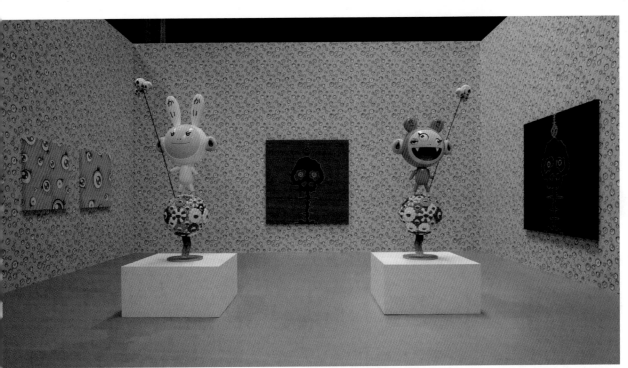

5.26 Takashi Murakami
*Kaikai, Kiki, Jellyfish
Eyes, Time Bokan—Black,
and Time Bokan—Red*,
2007. Installation
view of exhibition ©
*Murakami*, Museum of
Contemporary Art,
Los Angeles.

photographs, Mariko Mori presented herself as a typical Postmodern girl: stylish, beautiful, wide-eyed, open to adoration, a model of the future. Mixing these values with those of a generalized spiritualism, she created, in installations such as *Dream Temple* (1999), *Pure Land* (2002), and *Wave UFO* (1999–2002) (Fig. 5.25), spaceshiplike settings in which viewers might dream themselves into states of universal transcendence, suggested by slowly changing imagery of celestial vaults or a paradise peopled by Buddhist gods.

While the economic boom generated no overall aesthetic, it did spawn a number of subcultures, each with an intense style of its own. Takashi Murakami, by far the best-known Japanese artist of the global era, emerged from the *otaku*, a subculture interested in new technologies and *anime*, the enormously popular post-World War II cartoon and animated film genre. One line of his work revolved around his brand character "Mr. DOB," a Mickey Mouse-like creature seen variously in a Warhol-like close-up of parts of its face, as a surfer on a Hokusai wave, and as a designer children's toys. Another of the artist's lines picks up on the Japanese subculture interested in sex toys. In his activities as a curator, Murakami argues that art such as this, created by himself and disciples such as Chiho Aoshima and Mr., and fellow artists such as Yoshitomo Nara, represents a distinctively Japanese "Superflat" style that is equally evident in Rinoa screens, *ukiyo-e* woodblock prints, and early modern *nihonga* painting as it is in contemporary commercial graphics. The Superflat style is identifiable above all by its preference for shallow spaces animated by schematic characters that together conjure a supernatural realm, a world veering between apocalypse and paradise, peopled by monsters and innocents. Through a series of exhibitions between 2000 and 2005, Murakami argued that this Superflat quality distinguished Japanese art from that

of the West in crucial ways: it was not naturalistic, and it made no distinction between high art and low populism—indeed, it extended the refinements and practices of art to the entirety of popular visual culture.[18] Against charges that this aesthetic privileged the puerility of adolescent desires and the childish cuteness of commercial trademarks, Murakami countered that Japan's dependence on the U.S., not only during the 1945–51 occupation of the country but since too, had led to a pervasive impotence reflected in a widespread taste for infantilizing imagery. By combining Neo-Pop Art and the *otaku* subculture of those obsessively interested in *anime*, *manga*, and video games, Superflat created a Poku style that proved to be not only the future of Japanese art but also enormously influential on visual cultures everywhere. In this sense, Murakami represents a group of Japanese artists who, like the German artists of a generation before, propose the possibility of a national art, one that attempts to face the evasions of their predecessors and their own belated trauma. In recent years, Murakami has sought to project his style as an international "brand" aimed at absorbing popular commodity culture into art and art into commerce (Fig. 5.26).[19]

## KOREA

The modern history of Korea is dominated by two factors: colonial rule by Japan from 1910 to 1945, and the division of the peninsula since the Korean War of 1950 between a Communist regime in the north (the Democratic People's Republic of Korea) and an open, market society in the south (the Republic of Korea). There is no official modern or contemporary art in North Korea, but there is a considerable output from the art education system, centered on the Pyongyang University of Fine Art, and the art studio system, among

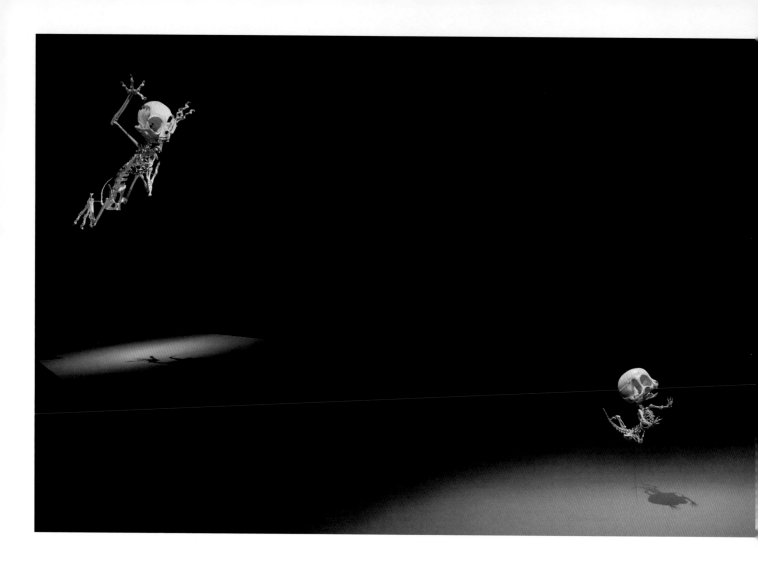

which the Mansudae, Paekho, Minye, and Central studios are the best known.[20] In the absence of consumerism cultivated through virtual spectacle—impossible in a highly militarized, defense-minded society subject to economic scarcity—social consensus is built through widespread participation in collective events created for nationwide spectatorship. Known as "mass games," these rallies combine parades, dances, and athletic and gymnastic performances with vast displays in which thousands of participants—48,000 at the Arirang Mass Games, Pyongyang, 2002—hold up colored flash cards that configure into national landscapes, inspirational slogans, familiar images, and portraits of the leadership.[21]

In South Korea, despite the fact that the military dictatorship only ended in 1993, artists followed developments in international art, such as abstract painting during the 1970s, and other forms of experimental art during the 1980s, notably in the Dada-Conceptualist video installations of Naum June Paik. Others reacted by forming a *Minjung* ("people's art") movement, emphasizing the role of the artist as social witness. Since then, efforts have been made to build a mixture of government-funded artists' cooperatives and private infrastructure for contemporary art similar to that common in contemporary art scenes elsewhere. For example, the Kwangju Biennale was established in 1995 with a budget and scope that eclipsed those of the Venice Biennale and Documenta exhibitions, and in

2004 a private foundation established the Leeum, Samsung Museum of Art, a conjunction of three buildings by "starchitects" Jean Nouvel, Rem Koolhaas, and Mario Botta. A number of artists have been active internationally. Performance artist Lee Bul (Yi Bul) created monstrous figures that parodied social fears of femininity, leading to ingenious cyborg sculptures, an interest pursued by Hyungkoo Lee in his series *The Objectuals*, which played mockingly on ideas about the ways in which human personality could be altered by science, and *Animatus*, a paleontology of impossible creatures such as duck-billed humanoids (Fig. 5.27). In his sculptures and installations, Do-Ho Suh (now resident in New York) makes subtle critiques of militarization in contrast to the fragile values of domesticity. In one strand of his work, he presents actual-size mock-ups of his living spaces in delicate, transparent cotton; in *Floor* (1997–2001) (Fig. 5.28), by contrast, we find ourselves walking across a thick glass floor that is supported by thousands of tiny figurines, their mottled uniforms looking like grass, their arms raised as if to worship a leader—or to escape their crushing confinement.

5.27 Hyungkoo Lee
*Felis Catus Animatus*
(left) and *Mus Animatus*
(right), 2006–07. Resin,
aluminum sticks,
stainless-steel wires,
springs, oil paint, 30¾
x 39 x 21¼in (78 x 99 x
54cm) and 6½ x 8 x 3¹⁄₁₀in
(17 x 18 x 8cm). Courtesy
of Hyungkoo Lee.

5.28 Do-Ho Suh
*Floor*, 1997–2001
(view above plus detail
right). Glass plates,
phenolic sheets,
polyurethane resin,
dimensions variable.
Installation view, 49th
Venice Biennale, Korean
Pavilion, Venice, 2001.

# 6. INDIA, SOUTH AND SOUTHEAST ASIA

South and Southeast Asia are distinguished from East Asia by their relative independence from Chinese and Japanese economic, political, and cultural influence, from West Asia by their geographic and cultural distance from the Mediterranean basin, and from Central Asia by their bordering upon oceans in the case of the Indian subcontinent and being isthmus or island countries in the case of the southeastern nations. All have been subject to varying degrees of colonization by empires originating elsewhere in Asia or, in recent centuries, Europe. Since the 1940s, wars of independence have led to the formation of new nation states, some of them returning to kingdoms (Thailand, Cambodia), others becoming socialist republics (Vietnam, Sri Lanka), and others still becoming democratic republics, albeit often with strong rulers (Indonesia, Singapore, the Philippines, Malaysia), including the military for long periods (Pakistan, Myanmar). A few have continued as dependencies (East Timor). While a number of artists currently active in these regions are closely connected with international art circuits, and most are respectful of their recent predecessors' efforts to establish modern art movements, all remain acutely aware of a deeper local inheritance from the great civilizations that originated in the area, often centuries ago, and which continue to flourish today.

## INDIA

The Indian subcontinent extends from the Himalayas to the Indian Ocean, and is traversed by major rivers, notably the Sindhu (Indus) and the Ganges. Today it consists of a number of nation states: India, Pakistan, Bangladesh, Nepal, Bhutan, and Sri Lanka. Indigenous peoples, interacting with waves of conquerors and travelers, have shaped the cultures of the region. Many world religions originated here: notably, Hinduism, Buddhism, and Jainism. Islam was also well established in the area by the thirteenth century. While few of these religions encouraged figurative representation in the arts during the early years of their development, all erected elaborate symbolic centers and smaller sites of worship, and, with the partial exception of Islam, invited artists to represent their spiritual cycles in sculptures, murals, and ritual objects. Secular rulers likewise required artists to record their reigns in these modes and others, such as manuscripts and miniatures. After the subcontinent came under British rule in the nineteenth century, its arts began to reflect Western tastes and employ Western methods, yet always with considerable modifications, introduced from what was by then a broad South Asian Muslim visual tradition which included the cosmopolitan, Indo-Persian cultural milieu of the Mughal Empire and a variety of reformist movements within Muslim culture in India. Since the formation of the independent nation states following the British withdrawal after 1947, this process of interaction has accelerated and deepened.

Modern Indian art began during the colonial period, notably with the highly sentimental, Victorian naturalist works of court painter Raja Ravi Varma, who circulated his images as oleographic prints (chromolithographs printed with oil paint on canvas in imitation of oil painting). Widely popular, his imagery still resonates in the visual languages used in Bollywood movie posters. In the early decades of the twentieth century, the artists of the Bengal School, such as Gaganendranath Tagore, sought a style that would have a distinctly self-sufficient (*swadeshi*) character through its depiction of local subjects, and evoke a broad Asian heritage by deploying *morotai*, a Japanese watercolor technique notable for its lack of outlines, while at the same time embracing modernity through the selective use of European innovations such as those of Art Nouveau, Cubism, and Expressionism. A related school emerged at Lahore but with a more consciously Muslim aesthetic based on illustrations of Urdu poetry by, for example, Abdur Rahman Chughtai. Bombay artist Amrita Sher-Gil (whose mother was Hungarian) absorbed much from her studies of the avant-garde painters in Paris, and applied their

approaches to Indian subjects when she returned in 1935. Santiniketan artists such as Nandalal Bose drew on local pottery decoration for their genre scenes, while Jamini Roy schematized Kalighat folk painting to produce a "radical primitivism" that has continued as a strand in avant-garde Indian art. The Progressive Artists' Group, formed in Bombay in 1946, undertook sustained applications of Western-influenced expressive figuration (M.F. Husain and Tyeb Mehta) and symbolic abstraction (Sayed Haider Raza) to traditional Indian themes. Very few of the predominant international art styles of the 1960s and 1970s—Pop Art, Minimalism, and Conceptual Art—were taken up by Indian artists. Perhaps the strongest direct external influence during the 1980s was the School of London, a group of Neo-figurative Symbolist painters led by R.B. Kitaj, whose influence on a number of Indian artists was reinforced by periods of study in London.

An outstanding exception to these general tendencies was Nasreen Mohamedi, who, uniquely, used precision instruments to draw delicate, magical geometries (Fig. 6.1): grids that did not repeat, planes that shifted irrespective of perspective, shapes that hinted at oblique details of modern architectural forms but did not depict them: glances at the invisible, the edge of

nothingness as it might begin to appear, before drifting off, out of sight. In these fragile drawings, the commitment to grid structures—painstakingly drawn in muted colors—found in the work of artists such as U.S. painter Agnes Martin was taken in another, transcendental direction. As Mohamedi states in her diary, itself a work of ascetic Minimalism: "One creates dimensions out of solitude."[1]

In contrast, most artists—such as K.G. Subramanyan, in terracotta murals and mural-sized paintings that teem with amused, engaging imagery drawn from everyday life—continued to depict local subjects using modern media and styles, all the while treating their local predecessors as rich resources, and drawing on aesthetic modes and artistic techniques from across Asia. Scholar Partha Mitter suggests that this mixture of content and approach typifies Indian art's development: it is parallel to, but distinct from, the history of modern European art. Mitter says that it is an element of global modernity to activate a "cosmopolitan primitivism" for nationalist ends.[2]

Women artists came to the fore during the 1980s, and have maintained their preeminence since. Anita Dube explores the fetishization of female body parts in her 1997 installation *Silence (Blood Wedding)*

6.2 Anita Dube
*Face*, from *Silence
(Blood Wedding)—
A Suite of 13 Fragments*,
1997 (detail). Installation,
human bone, velvet,
beads, gemstones,
glass, thread, glue,
dimensions variable.
Courtesy of the artist.

6.3 Nalini Malani
*Remembering Toba
Tek Singh*, 1998. Four-
channel and 12-monitor
video installation, 12 tin
trunks, sun control film,
20 mins. Installation
view, Prince of Wales
Museum, Bombay, 1999.
Courtesy of the artist.

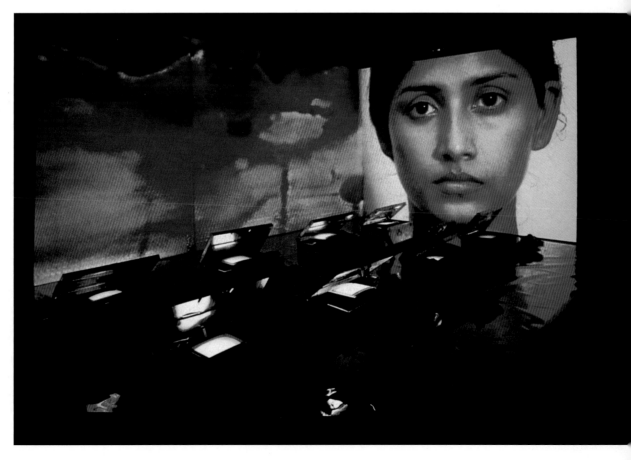

6.4 Navjot Altaf
*Naplar Project*, 2001.
Hand-pump, site-
specific project at
Kondagaon, Bastar
Province (ongoing
collaboration with
indigenous artists and
community members).
Dimensions variable.
Courtesy of the artist
and Talwar Gallery,
New York.

6.5 Swarna Chitrakar
and Manu Chitrakar
*The Titanic*, 2003. Poster
paint on paper scrolls,
94½ x 29½in (240 x
75cm). Courtesy of the
artists and Asia Society
Museum, New York.

(Fig. 6.2): 13 bones are wrapped in red velvet and deco-
rated with beads to become macabre items of feminine
adornment. Sangeeta Sandrasegar's delicate papercuts
expose tough stories, such as that of Phoolan Devi, the
"Bandit Queen" of India. Nalini Malani extended her
prints and paintings of the traumatic experiences of
women into performance, video, and installation modes.
In *Remembering Toba Tek Singh* (1998) (Fig. 6.3), she protests
against nuclear testing in the context of the volatile
relationship between India and Pakistan. Video monitors
show images of smoke, and of women coming together
to fold a sari, an act that their geographic separation
makes impossible. Meanwhile, the voice-over tells of
the futile efforts of the partitioned states to exchange
insane-asylum inmates.

Navjot Altaf draws on craft traditions to carve
raw images of female power in multimedia installations
such as *Modes of Parallel Practice: Ways of World Making*
(1998–99). In the *Naplar Project* (Fig. 6.4), she worked with
seven Adivasi women artists, beginning in 2001, to build
a set of sculptural structures around water sources in
villages near Kondagaon, Bastar Province. These elegant,
spare, yet visually legible cement and iron forms also
serve a variety of practical purposes, such as containing
water wastage, offering props for the lifting of heavy
jugs, and providing places of rest and conviviality.

Some artists who work primarily within rural
or neighborhood communities have, in recent years,
moved beyond time-honored subjects by adapting tra-
ditional means to more current concerns and presenting
these using techniques being developed by contempo-
rary artists. G. Ravinder Reddy is well known for his
renditions of iconic temple figures at unusually large
scale and in the isolated setting of an art gallery. In the
Midnapur district of West Bengal, Swarna Chitrakar and
her brother Manu continue the practice of *pat* painting
(elaborate narrative scrolls made using poster paint on
paper). In recent years they have chronicled subjects
ranging from the first television set in the community
to the Afghanistan War and the Hollywood film *Titanic*
(Fig. 6.5), as well as assisting the local authorities in public

health education campaigns. Similarly, Santosh Kumar Das has devoted a series of ink drawings (Fig. 6.6), executed in an intricate Islamic style, to the violence between Muslim and Hindu mobs in Gujarat in 2002, symptomatic of deep political divisions within the nation.

The poisoning of the postindependence ideal of a liberal, secular state by the rise of religious fundamentalism is a matter of deep concern to many contemporary artists, including the documentary film-makers Anand Patwardhan (*Father, Son, and Holy War*, 1994) and Amar Kanwar (*Night of Prophecy*, 2002). Vivan Sundaram's installations take us close to the physical and psychic sensations of historically momentous events. *History Project* (1998) (Fig. 6.7) turned the Victoria Memorial, Calcutta—a massive building erected in 1921 as a monument to British rule, conceived by Lord Curzon, then viceroy of India—into a house of memory charting India's emergence from its colonial past as a modernizing project. Jute bags symbolize Bengal's laborers and their political struggles, banks of box files the intellectuals of the region, while an Indian Railways car evokes transportation, refugees at the time of partition, and murdered victims of recent religious riots. Jitish Kallat's installation *Public Notice* (2003) (Fig. 6.8) presents the text of Jawaharlal Nehru's famous 1947 speech declaring India's independence burnt into a mirror of memory; the work's distorted surfaces show how shaky his words seem today while simultaneously reflecting viewers as themselves distended and unstable.

In recent years, India has been subject to the paradoxes thrown up as a secular national ideology and governmental structure seek to accommodate resurgent fundamentalism and perceived external threats while opening itself—or, at least, enclaves of its territory—to the demands of global capitalism. As a home to information-technology innovation and service-industry outsourcing, India has become, after China, the second fastest-growing and second largest economy in the region. This has led to the emergence of a lively local market for Indian Modernist Art, and for more spec-tacular art such as the large-scale assemblages of Subodh Gupta. The latter's *Line of Control* (2008) (Fig. 6.9) dramati-cally evokes the consequences for everyday life in the region if the uneasy nuclear standoff between India and Pakistan were to develop into actual conflict: stainless-steel, brass, and copper implements such as pots and pans, incense burners, goblets, and eating utensils are gathered up into a 16-foot-high mushroom-shaped cloud. Each item is stained, bent by use, and patinated by time. A tiny bell hangs from the overarching form, as if even within this horror the sounds of the temple may still be heard.

This new India—and the effects of globa-lization in general—have attracted critical questioning by contemporary artists. Foremost among these is the Raqs Media Collective, a Delhi-based cooperative founded in 1992 by Jeebesh Bagchi, Monica Narula, and Shuddhabrata Sengupta, who include architecture, design, critical theory, and new technology among their skill sets. Their 2005 installation *The Imposter in the Waiting Room* (Fig. 6.10) explores what the group characterizes

6.6 Santosh Kumar Das *Chief Minister Modi Rises as a Hero for the Hindu Fanatics While Gujarat Burns and Gandhi Is Forgotten*, 2003. Ink on paper, 15 x 22in (38.1 x 55.9cm). Collection of the artist.

6.8 Jitish Kallat
*Public Notice*, 2003.
Burnt adhesive on
acrylic mirror, wood, and
stainless-steel frames,
78 x 54 x 6in (198.1 x
137.1 x 15.2cm) (five
parts). Courtesy of Jitish
Kallat Studio.

6.9 Subodh Gupta
*Line of Control*, 2008.
Stainless-steel and steel
structure, stainless-
steel utensils, 393¾
x 393¾ x 393¾in
(1,000 x 1,000 x
1,000cm). Installation
view, *Altermodern*,
Tate Triennial 2009,
Tate Britain, London.
Courtesy of the artist,
Hauser & Wirth and
Arario Gallery, New York.

6.7 Vivan Sundaram
*History Project*, 1998.
Site-specific installation,
The Victoria Memorial,
Calcutta. Entrance view.
Approx. 100 x 60 x 50ft
(30.5 x 18.2 x 15.2m).
Courtesy of the artist
and Walsh Gallery,
Chicago.

6.10 Raqs Media Collective *They Called It the XXth Century*, from *The Imposter in the Waiting Room*, 2005. Three screens, soundscape, and site-specific print material, dimensions variable. Installation view, Künstlerhaus, Theater der Welt, Stuttgart, 2005. Courtesy of Raqs Media Collective.

as the encounter between modernity and its shadow. A video projection on one wall tracks the movements of a figure in a liminal space: seen from behind, he is a bowler hat-wearing everyman, but seen from the front he is a partly dressed, masked threat. Other projections show newspaper advertisements for missing persons, transport timetables, and opaque walls of various kinds. Architectural drawings and photographs of incomplete city-planning projects are displayed on one panel while photographs of "nonplaces" are pinned to another. The artists' own commentary demonstrates the subtlety (and black humor) of their analysis:

> Navigating routes in and out of modernity, its past, present and future, on a daily basis, we have come to realize that the world is densely encrusted with "waiting rooms"—spaces for transients to catch their breath as they prepare for the arduous ascent to the high promontory of modernity. The image of the "waiting room" gestures towards the sense of incompleteness and elsewhereness that fills those spaces of the world about which the overriding judgment is that they are insufficiently modern—that they are merely patchy, inadequate copies of "somewhere else." Such waiting rooms exist in the very heart of that "somewhere else"—in New York and Los Angeles, in London and Singapore—but it is outside these islands that they have their truest extent. Most of the world, in fact, inhabits such antechambers of modernity. We know such antechambers well; we are at home in them, everywhere. Waiting Rooms everywhere are full of Impostors waiting to be auditioned, waiting to be verified, waiting to know and to see whether or not their "act" passes muster, and whether they can cross the threshold and arrive on to the plane where "history is truly made."[3]

Awareness of the inequities—and the absurdities—of a world bent on globalization at whatever cost is increasing among artists, as we will see in greater detail in Part III.

## PAKISTAN

On partition in 1947, the newly established Pakistani state was divided into West and East Pakistan, the latter becoming—after a bloody civil war—the independent state of Bangladesh in 1971. Indigenous cultures that practiced a regional Sufi version of Islam continued to produce artifacts. Rapid urbanization and the sudden inrush of consumer goods led to a transformation of many kinds of popular decorations, themselves already inclined to richly textured surfaces. Buses, trucks, rickshaws, bicycles, carts, food stalls, shops, cinemas, and houses are embellished with mixtures of crafted and popular ornaments, a rich and distinctive profusion much enjoyed by passersby of every taste, class, caste, or clan. Little official effort was made to incorporate culture into nation-building, an activity that was itself divided between secular and Islamic ideologies. Nevertheless, certain artists were active as both producers and institution-builders, notably Zainul Abedin in East Pakistan and, in the west, Islamabad-based painter Zubeida Agha, pioneer of a decorative yet dynamic abstractionism, and Shakir Ali, who became principal of the National College of Art in Lahore in 1962. During the following decades, artist and muralist Sadequain developed a distinctive style of Modernist calligraphy, while others such as Zahoor ul Akhlaq drew on a wide range of international styles, from Pop to Minimalism, to imagine and evoke the striving for spiritual knowledge. In 1996, a group of young artists from Karachi worked with a number of traditional urban artisans to create the installation *Heart Mahal* [Fig. 6.11]: a shipping container decorated by the artists and artisans with painted panels, decorated bulbs, and neon lighting and similar associated imagery yet also lined with stainless-steel sheets beaten by the artisans into shapes used to decorate vehicles.

6.11 Durriya Kazi, David
Alesworth, Elizabeth
Dadi, Iftikhar Dadi
*Heart Mahal*, 1996–99.
Installation inside
shipping container;
beaten stainless-steel
sheets, painted MDF
panels, 1,000 light
bulbs, 94½ x 94½ x
236¼ in (240 x 240 x
600cm). Produced in
collaboration with Ustad
Yusuf, Ustad Mairaj and
Sarfaraz, craftsmen
(truck, market and
wedding decorators),
Karachi. Courtesy of
the artists and Fukuoka
Asian Art Museum.

6.12 Shahzia Sikander
*What Is under the
Blouse? What Is under
the Dress? (Cholee Kay
Pechay Kya? Chunree
Kay Nichay Kya?)*, 1997.
Vegetable color, dry
pigment, watercolor, tea
on hand-prepared wasli
paper, 9¼ x 5⅛in (23.4
x 13cm). Courtesy of
the artist and Sikkema
Jenkins & Co., New York.

6.13 Rashid Rana
*Veil VI*, 2007 (full view
and detail). C-print +
DIASEC, 70 x 51⅓in
(177.8 x 130.5cm).
Edition of 5. Courtesy
of the artist and
Gallery Cemould and
Gallery Chatterjee
& Lal, Mumbai.

These artists laid the foundation for the emergence of a bright younger generation of artists who are active both in Pakistan and abroad. Trained in miniature watercolor painting, Aisha Khalid, Imran Qureshi, and Shahzia Sikander apply the medium's exacting techniques to contemporary purposes. Sikander explores the constraints on the lives of women and their subtle registrations of selfhood through dress and dreaming (Fig. 6.12). Lahore artist Rashid Rana has developed a distinctive manner of displaying the contradictions of contemporary life, both in his native country and globally. Vast seascapes seem, at first, to be Romantic vistas punctuated with images of sailing ships, but, close up, turn out to be composed of thousands of pixel-like photographs of degraded rubbish dumps. He explains the relationship between his technique and his subject matter in this way: "Today, every image and idea (whether ancient or contemporary and media generated) encompasses its opposite within itself. Thus we live in a state of duality. The perpetual paradox, which reins in the outside world, is a feature for the internal self also. Thus all our moves are made not in one upward direction, but in two opposite ones—simultaneously. This internal conflict, which translates formally into my work through mirror images, symmetry, and the grid/matrix, underlies and pervades nearly every topic I choose to explore."[4]

*Veil VI* (2007) (Fig. 6.13) presents a highly pixelated, color magazine-type image of a group of veiled women and associated text. When inspected closely, the work turns out to be made up of thousands of tiny images of naked women taken from online pornographic sites. Critic Kavita Singh explains the context:

> The justification for the veil traditionally has been the protection of women from the lustful gazes of men but what is controlled is the sight of women not the vision of men. The veiled woman is one of the most common tropes of art from the Islamic world… Rana's work adds a new and discordant note to this chorus. His close-ups of the heavily shrouded, dehumanized faceless faces are, amazingly, composed of hard-core pornography downloaded from the Internet. In the encounter, the images are both shocking and beautiful… And when one recognizes the pixels, one thinks of the unlikely juxtaposition first as opposites, and then, numbingly as the same. The thousands of naked women are as depersonalized as the woman behind the veil.[5]

The complexity of the situation on the subcontinent inspires artists such as Bani Abidi and Huma Mulji, who deploy a variety of media—from video to performance to Conceptual objects—to evoke it in their work. Abidi has commented: "The South Asia I know is one where North Indians and Pakistanis have more in common than North and South Indians, where teenagers from the Maldives or Nepal can speak fluent Hindi gleaned entirely from Bollywood films, where Muslims, Hindus, Sikhs and Buddhists, to this day, cross borders in hordes

6.14 Watchara
Prayoonkum
*Return to the Oriental
Life and Spirit 3 – Pablo
Picasso*, 2005. Mixed-
media installation,
103½ x 86⅝ x 66⅞in
(263 x 220 x 170cm).
Courtesy of the artist
and Ardel Gallery of
Modern Art, Bangkok.

6.15 Montien Boonma
*Lotus Sound*, 1992.
Terracotta, gilded wood,
approx. 118¹/₁₀ x 137¾
x 118¹/₁₀in (300 x 350 x
300cm). Queensland Art
Gallery, Brisbane. The
Kenneth and Yasuko
Myer Collection of
Contemporary Asian Art.
Purchased in 1993 with
funds from The Myer
Foundation and Michael
Simcha Baevski through
the Queensland Art
Gallery Foundation.

to their pilgrimage sites which, it turns out, are not part of their own country anymore, and where families and friends cross borders to discuss the monsoon rains and mangoes during tapped telephone conversations."[6] These comments illustrate what artist and historian Iftikhar Dadi describes as the region's "impossible national predicaments."[7] These continue to dominate art practice, as they do everyday life in the region.

## THAILAND

*Return to the Oriental Life and Spirit* is the ironic title of a series of installations made in 2005 by Thai artist Watchara Prayoonkum. Images of Rodin, Van Gogh, Picasso, and Dalí in the act of creation appear, uncannily, as life-size, hyperreal sculptures. Yet each artist is shown doing something he never did: Rodin models a classical Buddha figure, Van Gogh paints Thai pagodas into his *Starry Night* landscape, Picasso draws a sacred face of the Buddha with a torch pencil (Fig. 6.14), while Dalí sits ready to paint the portrait of any viewer who stands so that his or her face appears in the mirror on Dalí's easel. These sculptures comment, with gentle ironic humor, on the worldwide commercialization of these artists' reputations, less warmly on the irrelevance of Thai culture to their art, and uncomfortably on the profound influence of artists such as these on art in Thailand since the 1920s, when Italian sculptor Corrado Feroci, known as Silpa Bhirasri, was employed by the government to introduce Western art and aesthetics. His greatest influence was felt from 1943 when he founded Silpa-korn University, which remained until the late 1960s a university of the fine arts. He promoted artists working in a wide range of Western twentieth-century art

styles—notably Impressionism, Post-Impressionism, and Cubism. Across the following three decades, other artists took up Surrealism and then abstraction.

Political unrest in the early 1970s—much of it directed against the military juntas that have frequently ruled Thailand—led to a focus on social themes, especially by artists forming the Dharma Group, the United Artists' Front, and the Thai Independent Artists Group. Others emphasized Buddhist themes, using local materials and inherited techniques, while Silpakorn University established a department of Thai art. During the 1980s, a strong current of "New Traditionalism" held sway, officially and in some private galleries, as artists returned to painting. The term *samai mai* ("modern art") refers to the concurrence of these various streams, and to their regional mixtures. These attracted strong local support during the economic boom period of the 1980s, up to the bursting of the "Asian Bubble" in 1997. In recent decades, Installation and Performance Art have become the modes most favored by innovative artists, including newly prominent women artists (not least the Womanifesto group), who have been active in the international artworld.

Montien Boonma was outstanding among installation artists. Rather late in life, he undertook post-graduate training in France, where Christian Boltanski (see Fig. 2.7) was a contemporary. He applied the measured repetitions of the most refined Minimalism and the clarity of word image interplay that typifies the best Conceptual Art to the composition of installations consisting of items in common use in both ritual and everyday settings in Thailand. *Lotus Sound* (1992) (Fig. 6.15) is an arrangement of terracotta bells, stacked to form a curved wall, above which falls a cluster of wooden shapes, gilded with paint in a manner much used in

6.16 Araya
Rasdjarmrearnsook
Still from *Reading for
Female Corpse*, 2001.
Single-channel video,
5 mins. 54 secs.
Carnegie Museum of
Art, Pittsburgh. Courtesy
of the artist and 100
Tonson Gallery.

6.17 the land
Founded in 1998 as an ongoing collaborative activity, initiated by Rirkrit Tiravanija and Kamin Lertchaiprasert, with contributions by artists, writers, farmers, and many people. Cultural precinct, Chang Mai. Courtesy of The Land Foundation, Thailand.

Buddhist temples, suggesting a pod releasing its seeds, but also, perhaps, evoking the souls lost during the massacre of protestors by soldiers that occurred in Bangkok that year. Reflecting her training in Germany and the impact of Joseph Beuys (see Fig. 11.6) on her practice, throughout the 1990s Araya Rasdjarmrearnsook created installations using the motif of a spare steel bed isolated in a room, the floor of which was covered with scattered materials such as husks, leaves, sump oil, or wires. Her personal response to her father's death is intensely evoked in *The Dinner with Cancer* (1993). Since 1997, Rasdjarmrearnsook has pursued this theme in deeply affecting ways. Her video *Reading for Female Corpse* (2001) (Fig. 6.16) records the practice of volunteers who visit morgues to recite scriptures, poetry, or, in this case, a play written by the Thai king Rama II in the early nineteenth century about Prince Inao, over the bodies of those who will not receive a formal burial.

Rirkrit Tiravanija takes Allan Kaprow's famous injunction to "blur the gap between art and life" to the point where the distinction disappears entirely. Convivial interaction, a heightened sense of getting on with life, a valuing of the everyday—these are the core materials of the "situations" that he stages. The best known of these is *Untitled (Free)* (1992), in which he brought everything in the backroom of the 303 Gallery, New York, including its owner, into the front area, then set about cooking Thai dishes as a gift to visitors for the duration of the show. For *Apartment 21 (Tomorrow Can Shut Up and Go Away)* (2002), he re-created

his apartment as a living environment in the galleries housing the Liverpool Biennial. *Untitled 2005 (The Air between the Chain-link Fence and the Broken Bicycle Wheel)* was a do-it-yourself installation at the Guggenheim Museum, New York, that functioned as a community television station. None of these is a replica of a "real-life" situation: all contain slight, nonconfrontational displacements, mostly suggested by their unconventional settings. Tiravanija's work is a key example of the influential concept of "relational aesthetics," as developed by French curator Nicolas Bourriaud during the 1990s.[8]

While his work is mostly shown in international exhibitions and in galleries in the U.S. and Europe, in 1998 Tiravanija (along with fellow artist Kamin Lertchaiprasert and academic Uthit Athiman) established an artists' community in an area near Chang Mai, fast becoming Thailand's second city of the visual arts. "The Land" is a rural commune that practices eco-Buddhism, sustainable nondevelopment, and positive engagement with the local community. It is dotted with structures designed by Thai and international artists (Fig. 6.17). It has inspired similar initiatives in Chang Mai itself, such as "ComPeung," a rural artists' residency program, and the "Invisible Academy," a nomadic art school without walls set up by artist Surasi Kusolwong. In the absence of elaborate official institutions, Thai artists are creating their own informal infrastructure.[9]

6.18 I Wayan Bendi
*Reformasi*, 1986.
Acrylic on paper, 21
x 30¾in (53 x 78cm).
Private collection.
Courtesy of Ms Joyce
Soen and Sunjin
Galleries, Singapore.

## INDONESIA

In 1949, newly independent Indonesia consisted of 17,000 islands, some uninhabited but many home to cultures of great historical and religious significance. By 2000, its population was 200 million, of whom 87 percent were Muslim, making it the largest Islamic nation in the world. Leading artists of the early nationalist period, such as Hendra Guanwan, Sudjojono, and Affandi, painted subjects from everyday life in straightforwardly realist or highly expressive styles. As *Pelukis Rayat* ("People's Painters"), they contrasted their work with the exotic landscapes of the *Mooi Indie* ("Beautiful Indies") painters which were popular with the economic elite. (The use of the word "Indies" in this expression is a legacy of the 350-year period of Dutch colonization, when the area was known as the Dutch East Indies.) Aesthetic choices often reflected political tensions. Choices narrowed during the New Order regime led by General (then President) Suharto from 1965 to 1988. Throughout, artists used techniques and approaches to subject matter derived from Western art, although always adapting them to local purposes. Artist and critic Jim Supangkat has labeled this "multimodernism," arguing that the mix specific to Indonesia is "modernism seen through pluralist principles."[10]

Muslim artists such as A.D. Pirous, Amad Sadali, and Made Wianta have deployed the rich, inflected surfaces of painterly abstraction to imply spiritual immanence without recourse to figuration. The pressures of urbanization are acutely observed in the Neorealism of painters such as Dede Eri Supria. Distinctive regional styles are sustained in great population centers such as Yogyakarta, Bandung, Jakarta, and Surabaya, as well as in popular tourist centers such as Bali. In his 1986 painting *Reformasi* (Fig. 6.18), Balinese artist I Wayan Bendi used the shadowy, *horror vacui* (fear of empty space) intricacy typical of the earlier Batuan School to represent how deeply the desire for freedom was embedded in the everyday lives of the Indonesian people. The agitation for change expressed in the banners calling for "*reformasi*" ("reform") seems to consume the whole island. These hopes began to achieve realization after 1998.

Sculptors such as Anusapati use ancient techniques of wood carving, and modern ones of iron welding, to create enigmatic objects; others, such as Nindityo Adipurnomo, adapt traditional imagery as a means of questioning the efficacy of modern modes of identity formation. Adipurnomo's *Hiding Rituals and the Mass Production II* (1997–98) (Fig. 6.19) shapes rattan into a *konde*—a distinctively Javanese type of hairpiece, originally used by the nobility, but more recently adopted by women to signify their acceptance of conservative, officially sanctioned social roles. Against this perspective, Adipurnomo presents the hairpiece as if it were a female body part, damaged and unraveling. His partner, Dutch-born Mella Jaarsma, creates clothing from items collected from local farmers, such as the skins of frogs, squirrels, bats, snakes, and chickens, as well as moth cocoons, water buffalo horns, and the bark of banana trees. These serve as wearable skins, evoking the sense of exchange between animals and humans, or between humans and nature—*The Healer* (2003) is woven of Javanese *jamu* (traditional homeopathic medicinal roots and leaves). Jaarsma sometimes cuts them into the shape of military uniforms (*The Warrior*, 2003), or a burka (*Shameless Gold*, 2002 (Fig. 6.20)).

6.19 Nindityo
Adipurnomo
*Hiding Rituals and
the Mass Production II*,
1997–98. Rattan, human
hair, plastic bag, paper,
string, 98½ x 118¹/₁₀
x 35½in (250 x 300
x 90cm). Singapore
Art Museum.

6.20 Mella Jaarsma
*Shameless Gold*,
2002. Mixed media,
four costumes made
from naturally gold-
colored cocoons from
caterpillars (*cricula
trifenestrata helf*),
approx. 59 x 15¾ x
23½in (150 x 40 x 60cm).
Courtesy of the artist.

6.21 Heri Dono
*Gamelan of Rumor*,
1992–93 (view and
detail). Wood, gamelan,
motor, cart-bell, wheel,
iron, cable, approx. 157½
x 157½in (400 x 400cm)
(each piece 10 x 6 x
13in; 25 x 15 x 33cm),
35 figures. Fukuoka
Asian Art Museum.

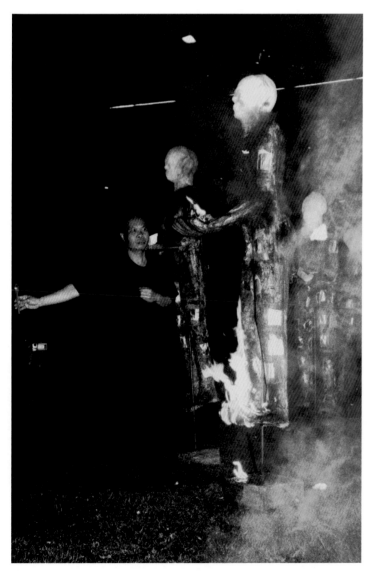

6.21 Heri Dono
*Gamelan* of *Rumor*,
1992–93 (view and
detail). Wood, gamelan,
motor, cart-bell, wheel,
iron, cable, approx. 157½
x 157½in (400 x 400cm)
(each piece 10 x 6 x
13in; 25 x 15 x 33cm),
35 figures. Fukuoka
Asian Art Museum.

6.22 Dadang Christanto
*Fire in May 1998 (Api di
bulan Mei 1998)*, 1998–99.
Performed for the Third
Asia-Pacific Triennial
of Contemporary Art,
Brisbane. Collection
of the artist.

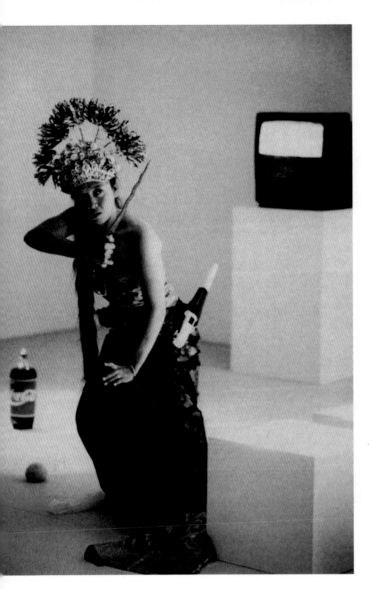

6.23 Arahmaiani
*Handle without Care*,
1996. Mixed media
and performance,
11 mins. Second
Asia-Pacific Triennial
of Contemporary
Art, Brisbane.

A number of Indonesian artists move between media, testing new modes as they become available, often with striking directness. During the 1980s, Heri Dono became known for his bold, colorful, roughly drawn paintings of aggressive interactions between men and women, and people and the state, shown through references to ancient legends and popular stories from the puppet theater, an important Indonesian cultural tradition, notably in Java, where shadow plays accompany performances by gamelan orchestras. In the following decade, Dono began producing installations and then performances. *Gamelan of Rumor* (1992–93) (Fig. 6.21) attaches to each of the instruments of this uniquely Javanese type of orchestra a machine that is electronically programmed to play these percussive units in a way that gives out, in sum, a monotonous tone. Dono sought to evoke the drone of whispering and rumor-mongering that resulted from the suppression of free speech during the Suharto era.

Other important installation and performance artists include Hedi Hariyanto, especially his *Terror Products* (1992), in which he covered his house with cardboard boxes, posters, brochures, and stickers ranging in subject matter from government propaganda to commercial advertisements; Dadang Christanto, especially his *Fire in May 1998* (*Api di bulan Mei 1998*) (1998–99) (Fig. 6.22), in which the artist moved among burning effigies, the latter evoking those who died in the political violence attending the end of the Suharto regime, thus creating a monument to mourning that affected both onlookers and those who subsequently came and left mementoes to their dead. In *Coke Circle, Nation for Sale*, and *Handle without Care* (Fig. 6.23), all performed in 1996, Arahmaiani shook Indonesian and imported elements into a critical cocktail.

The paradoxes that continue to shape art making in Indonesia are thrown into high relief if we juxtapose the viewpoints of sympathetic Australia-based curator Caroline Turner, instigator of the Asia Pacific Triennales at the Queensland Art Gallery, and those of long-time Yogyakarta-based critic and artist Jim Supangkat. Turner argues that *merdeka* (freedom), "combined with the ideal of transforming society for the better through artistic action," is the driving idea of contemporary Indonesian art.[11] For his part, Supangkat laments the insistence with which non-Indonesian commentators, especially those from the West, dwell on the overt political engagement of Indonesian artists at the expense of their continuing commitment to the continuity of ordinary local values.[12] Both are right: it is the coexistence of these currents that makes art in Indonesia contemporary.

## THE PHILIPPINES

Contemporary culture in the Philippines is pervaded by the persistent resonance of indigenous spirituality and craft practice, the fading legacy of four centuries of Spanish rule, the occupation of the country by the

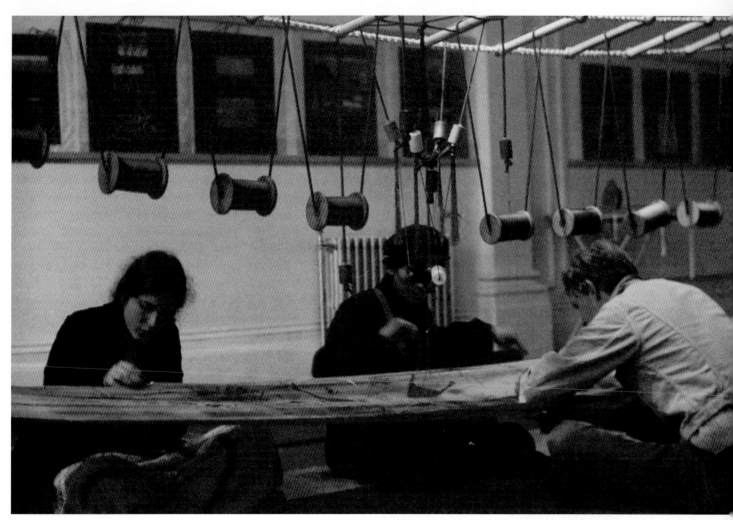

6.24 David Medalla
*A Stitch in Time*,
1968–72. Participatory
work, mixed media,
dimensions variable.
Arts Council of Great
Britain. Installation
view, Gallery House,
London, 1972.

6.25 Yasmin Almonte
*One*, 1996. Oil on
canvas, 48 x 48in
(122 x 122cm).
Courtesy of the artist.

United States from 1898 to 1941, then by Japan until 1946, and by the country's subsequent struggle toward nationhood in an increasingly globalized world order. Major changes in art have echoed these historical currents. The Amorsolo School of figurative painting dominated during the early decades of the twentieth century. At the same time, a distinctive kind of textbook illustration and newspaper cartooning emerged, notably in the work of Jose V. Pereira. During the 1930s, Victor Edades introduced Modernist styles as well as a focus on Filipino themes and the issue of national identity. Both realist and abstract artists, such as the brothers Galo B. and Hernando R. Ocampo, took up these concerns in the post-World War II period. This type of inventiveness received an extreme formulation in the work of David Medalla, the Manila-born organizer of the short-lived but important Signals gallery in London, which promoted Op Art and kinetic art. Medalla's ongoing series *Cloud Canyons* began in 1964 as a set of roughly assembled wooden boxes that frothed soap foam, amusingly embodying the idea of self-creating sculpture. In 1968, Medalla began his continuing *A Stitch in Time* project (Fig. 6.24) with the simple suggestion that friends who were about to travel should stitch their names into a handkerchief provided by him, which they would then take with them, further stitching whatever they wished to the item in the course of their journey. He has since elaborated this idea in many exhibitions, to which visitors are invited to bring items and stitch them onto whatever is already there. Open-ended participation in a trusting gift exchange is very much an idea of its time—the 1960s—as a younger generation in many parts of the world sought to change the parameters of social communication.

In the Philippines itself, state sponsorship of the arts increased under the Marcos regime during the 1970s, which was determined to promote the country as a tourist destination. Printmaking flourished, and regional styles were supported, as they were during the 1980s under the Aquino government. Realist imagery attacked the hypocrisy and violence of the political elite, as in the paintings of the Sanggawa Group. Feminist impulses emerged in the 1970s and 1980s. Yasmin Almonte paints images of the female body as an interiorizing form. In *One* (1996) (Fig. 6.25), a painter/sculptor/surgeon—her back to the viewer—is depicted as so immersed in her analysis of a woman's potentialities that she risks destroying herself and her subject. Emotional intensity is conveyed in this painting by the contrasts between the red coloration, the precision of the drawing, and the morphing of the central figure between womb, vagina, hip, and skull shapes.

As elsewhere in the region, installation has recently become the most flexible mode for condensing the complex currents coursing through Philippine society. Santiago Bose and Roberto Villanueva were

6.26 Santiago Bose
*Passion and Revolution*
(*Pasyon at Rebolusyon*),
1989. Installation,
dimensions variable.
Collection of the artist.

.27 Imelda
ajipe-Endaya
ilipina: DH, 1995.
nstallation with found
bjects, plaster-bonded
extiles, projected
nages, text, and sound,
imensions variable.
ourtesy of the artist.

members of the large Baguio art community in the Cordillera highlands of Northern Luzon. In his 1989 installation *Passion and Revolution (Pasyon at Rebolusyon)* (Fig. 6.26), Bose used local materials such as hay and volcanic ash, indigenous symbols such as *bulu* (wooden carvings made to propitiate rice gods), relics of struggle such as flags, and found objects to create an indigenous altar to the prospect of revolution. Printmaker Imelda Cajipe-Endaya accumulates cultural artifacts typifying the splintered existence of migrant workers (Fig. 6.27), who are increasingly common in a country where considerable numbers of poor people depend on income from relatives working in First World countries.

# 7. OCEANIA

The Pacific region encompasses a vast ocean between the continents of Asia, the Americas, and Australia dotted with many small and some large islands. While extraordinarily varied peoples and cultures live on these islands, their continuities of occupation and contact across great distances are equally remarkable. General differences of emphasis are also evident in the visual arts of each of these regions, as Anne D'Avella notes: "Melanesian art employs a variety of materials, often presenting within one piece a dazzling array of organic materials, including leaves, flowers, feathers, and shells. Performance is an essential aspect of many pieces, both aesthetically and symbolically. In Polynesia, the emphasis is on fine work, finish, and polish, whether in a plaited mat, bark cloth, or wood or stone figure. The art of Micronesia is characterized by simple, elegant forms and complex surface decoration. The materials—coral, wood, fiber, shark teeth—reflect the special nature of the coral-atoll environment."[1] The main purpose of these carefully crafted, intensely wrought, and highly decorative objects and performances is to bring into the human world the spiritual power of the gods and of the participants' divine ancestors. This power is known in the region as *mana*. These social structures and aesthetic styles have evolved over centuries: settlement in the region by the ancestors of Papuan language-speakers occurred over 40,000 years ago, whereas the artistic record is 8,000 years old for the Austronesian peoples whose Lapita pottery spread across the region, most actively between 3,000 and 4,000 years ago. Continuous interaction has led to subtle blending of local styles.

Just as important has been contact with peoples from outside the region, particularly colonizers from Europe. All of the Pacific islands have endured Western colonial rule, economic development, and exploitation, as well as conversion campaigns conducted by Christian and other missionaries, and have felt the economic impact of globalization. In recent years, some Pacific nations have been drawn into the political and economic agendas of rising Asian powers.

Others have been rent with internal divisions along racial or religious lines. Given the massive disparities of power and resources between external and local forces, concern has often been expressed that these developments might deplete or even destroy long-surviving cultures. Yet it has become obvious in recent years that many communities remain committed to the processes of selective, gradual renewal that have kept traditional practices alive for centuries. At the same time, it is evident that a number of individuals and groups in the region have become adept at taking off from this base to engage with the complexities of the wider world. Their work is a vital element in the second main current of contemporary art.

## PAPUA NEW GUINEA

Interest on the part of early twentieth-century artists such as Picasso and Braque, followed by the activity of collectors who gave generously to metropolitan museums, has led to the widespread presumption that the typical forms of New Guinean art are the spectacular carved and painted figures made by male ritual leaders in the Korwaar, Asmat, and Lake Sentani regions of West Irian, and in the Sepik region, Huon Gulf, Admiralty Islands, New Britain, New Ireland, Massim, and Papuan Gulf in Papua New Guinea. Certainly, ancestor figures, masks, spirit-house carvings, canoe parts, and musical and other instruments have been central to spiritual and communal connectedness (*mur*), and remain so. But equally significant have been performances involving self-adornment (*bilas*) (Fig. 7.1)—often presented at inter-tribal ceremonies involving thousands of participants—and more domestic crafts such as the weaving of mats, dresses, and bags (*bilum*) by women. While all of these forms continue to be made or performed, they now often incorporate new and sometimes surprising symbols, materials, and techniques, including items from Western cultures. This mix of traditional and modern symbols provided a rich source of imagery

7.1 Abiara Orere singing group from Bereina Village, Central Province, performing "Kairuku." Goroka Show, Goroka, Papua New Guinea, 1994.

7.2 Oscar Towa
*This Man Was Thrown into the Sea. It Made the B.R.A. Angry, so the Fighting Continues (Dispela em long bogenville island...)*, 1992–95. Gouache and marker-pen, 43 x 31¹⁄₁₀in (109 x 79cm). National Gallery of Australia, Canberra. Purchased in 1997.

for the decoration of government and other official buildings in Port Moresby during the 1970s, when Papua New Guinea achieved independence and actively sought to build an inclusive national identity.

The first examples of what was immediately recognized as "contemporary art" were made at this time by local artists who took up settler techniques such as printmaking, acrylic painting on canvas, and welded metal sculpture. In Port Moresby in the early 1970s, educators Ulli and Georgina Beier followed up their successful efforts in Africa by encouraging interested but untrained locals to develop a distinctive aesthetic using these imported techniques. Outstanding among those to emerge were the graphic artist Akis, the painter Kauage Mathias, and the sculptor Ruki Fame. These initiatives spread as more and more artists began to chronicle contemporary life in Papua New Guinea and the wider world. Using distinctively local imagery in a clear cartoon style, John Siune and Oscar Towa **(Fig. 7.2)** conveyed their dismay at the conflicts dividing their country in the mid-1990s as the Bougainville region attempted to secede politically.

7.3 Simon Gende
*On 11-9-2001 (Long 11-9-2001)*, 2003.
Acrylic on canvas, 61 x 40⅓in (155 x 102.3cm). Courtesy of Pasifik Nau Gallery.

Simon Gende did the same for the 9/11 attacks on the World Trade Center, New York, in a painting of 2003 (Fig. 7.3). Actively engaging with issues of pressing political moment is just as important to these artists as is maintaining and augmenting tribal values to those other artists who continue with more traditional practices.

## AOTEAROA/NEW ZEALAND

The intricate, elaborate carvings of the Maori people of Aotearoa (the term for New Zealand in the Maori language) have long provided a rich repertoire of imagery for the depiction of their ancestral lineage and the presencing of *mana*. Highly stylized, curvilinear forms interweave figure and ground and animal, human, and natural phenomena with an intensity that has parallels with Celtic art from the prehistoric through medieval periods as well as with Art Nouveau in Europe at the end of the nineteenth century. These forms are applied as tattoos to the body, including the face, to the wooden structural supports and decorative elements of sacred buildings, and as intricate figureheads to the prow and stern of war canoes. Another striking feature is the cross-referencing between media: a meetinghouse post, for example, might depict a fully tattooed warrior ancestor. During the wars with the British colonizers and under their subsequent rule, these skills were less widely practiced in Maori communities. Instead, they

were concentrated around the meetinghouse, the central structure of the *marae* (a sacred compound), where their proliferation served as visual testimony to the vitality of ancestral beliefs and a declaration of power intended to intimidate enemies. In recent decades, these designs have been revived and updated by a new generation of carvers, notably Clifford Whiting (Fig. 7.4) and Lionel Grant.

"Why not make art that really moves?" This question posed itself to Len Lye as a young man in Wellington. Born in 1901, Lye devoted much of the rest of his life to painting, scratching, cutting into, and otherwise manipulating film stock to produce a range of experimental films matched by few others. His earliest film-based works drew inspiration from the tapa cloths (painted paper bark) of the South Pacific. The work he did for the General Post Office in London during the 1930s established him as the most innovative practitioner of the genre. *Free Radicals* (Fig. 7.5), a four-minute film made in 1958 and revised in 1979, matches free-form jazz music to handmade visual cuts that have white slashlike markings dancing against shimmering black backgrounds. Leading U.S. experimental filmmaker Stan Brakhage describes it as an "almost unbelievably immense masterpiece (a brief epic)."[2] The idea of "figures in motion" released in cinematic space led Lye to create a number of sculptures during subsequent decades that are pivotal to the development of kinetic art.[3]

Aspects of Maori designs have resonated in the work of *pakeha* (white) New Zealanders, including the

7.4 Clifford Whiting
*The Sun Shines (Whiti-te-rau)*, 1969. Carved hardboard, 984⅛ x 472⅜in (2,500 x 1,200cm). Massey University College of Education Arts Trust Collection.

7.5 Len Lye
Film stills from *Free Radicals*, 1958 (revised 1979). Four mins., 16mm, black and white, sound. Courtesy of Len Lye Foundation, Govett-Brewster Art Gallery, New Plymouth, and the New Zealand Film Archive.

7.8 Jacqueline Fraser
*The Demure Artist Is Spying You (with Gleam) Now Chew This Foul Kawakawa Leaf Nineteen Times Clearly. Spit It and Clench*, from the series *A Demure Portrait of the Artist Strip Searched "with 11 Details of Bi-polar Disorder" (under closer scrutiny)*, 2001. Mixed media, 104⅓ x 35½in (265 x 90cm). Installation, Venice Biennale, Venice. Courtesy of the artist and Roslyn Oxley9 Gallery, Sydney.

country's premier Late Modernist, Colin McCahon, and its leading abstract painter, Gordon Walters (Fig. 7.6). Although clearly intended to give a national inflection to a visual language—Op Art—that carried heavy connotations of EuroAmerica, Walters's works attracted controversy, and were criticized by Maori and other activists as inappropriate, disrespectful borrowings. During the 1990s, however, when Postmodern notions of "appropriation" held sway, younger Maori artists such as Michael Parekowhai (Ngati Whakarongo) reversed the flow of influence by making work that quoted key images by McCahon and Walters, underscoring the mutuality of this exchange between white and Maori artists in Aotearoa/New Zealand (Fig. 7.7). Parallels may be drawn to the project of artists such as Gordon Bennett in Australia (see Fig. 7.18).

Women had important, although somewhat subordinate roles in Maori culture: relations between the sexes are a prominent theme in Maori imagery, including that which adorns meetinghouses. Inside these sacred compounds or *marae*, textiles woven by women constitute the main wall decorations. In recent years, Maori women artists such as Jacqueline Fraser have developed imagery involving spectral figures—their outlines suggested by synthetic fibers, with collaged costume details—that evoke actual and imagined Maori women. Fraser includes them in narrative sequences that parody the experiences of Maori women—as in her 2001 Venice Biennale installation *A Demure Portrait of the Artist Strip Searched "with 11 Details of Bi-polar Disorder" (under closer scrutiny)* (Fig. 7.8) —and in environmental installations that, in their proportions and schematics, suggest her people's sacred houses. This is a feminist reading of tradition, one that works through spatial suggestion rather than overt statement. In contrast, Lisa Reihana, in her 2001 DVD

7.9 Lisa Reihana
*Marakihau*, still from
*Digital Marae*, 2001.
DVD film. Courtesy
of the artist.

7.10 et al.
*restricted access*, 2003
(detail). Mixed media,
dimensions variable.
Courtesy of Auckland Art
Gallery Toi o Tamaki.

*Digital Marae* (Fig. 7.9), adopts an assured public persona that evokes both powerful Maori goddesses and the star of the popular television series *Wonder Woman*, which, as it happens, is set in Aotearoa/New Zealand.

The long exchange between visual cultures within the islands of Aotearoa/New Zealand have drawn local artists to an interest in distinctive kinds of word–image interplay, often involving the use of figure–ground reversals (Walters, Ralph Hotere) and a preference for assembling motifs, usually offcuts of craft processes, or rootless-seeming symbols, across a surface (John Pule, Richard Killeen, many women artists). Others engage with issues preoccupying artists elsewhere, such as the international spread of surveillance networks, fear-mongering, and social conformity as acts of terror increase and as governments seek to combat them. These circumstances are effectively evoked in the installations of et al. (Fig. 7.10), a group of artists (including Lionel Budd, Lillian Budd, Meriot Groting, and P. Mule) that has been active since the mid-1980s.

## AUSTRALIA

Aboriginal peoples living on the island continent of Australia represent the oldest continuing civilization on the planet: they maintain beliefs and ceremonial practices that have evolved over a 40,000-year span, yet also produce one of the most vibrant and various kinds of contemporary art—one that has, since the 1970s, cohered into a fully developed art movement. No other Indigenous people draws upon such a range of cultural reference, or maintains such an improbable yet potent mix of the most ancient and the most recent forms of art. Since the late eighteenth century, this has been achieved despite settlement of the continent by British colonizers, who brought with them their own highly developed visual cultures and subsequently established modern

and, recently, contemporary art institutions on a par with those common in Europe and the United States. Indigenous peoples (including Torres Strait Islanders) constitute only approximately 2.5 percent (517,200) of the overall Australian population of 20.5 million, yet their art has become its most prominent and, in many ways, representative form of visual expression.

Prior to colonial settlement, Australian Aboriginal art was devoted exclusively to sacred ceremonial purposes—to manifesting the presence of Originary Beings, who created the elements of the universe, including the Ancestors from whom all living beings are said to be descended. The many Aboriginal peoples living across the continent have distinct although related narratives (known as *jurkapa* or "Dreaming stories") of generation and continuity, all involving the integration of natural and human phenomena. These narratives are ritually repeated in song cycles and dance performances, and indicated through visual signs and arrangements of form marked on the body, carved into rocks or tree trunks, painted onto rocks or bark, or marked in the desert sands using natural ochers and other materials. "Galleries" of rock paintings, far more extensive than those that survive in Europe, Asia, Africa, or the Americas, may be found throughout northern Australia, for example, in the Mitchell Plateau, the Kakadu region, and the Atherton Tablelands.

Modern and contemporary Aboriginal art is not made for secret ceremonial purposes, although it may occasionally be used in them. In these contexts, it is not considered "art." Rather, it is made for circulation beyond its community of origin, with the aim of spreading sacred spiritual information into secular contexts, and of bringing income into communities that, usually, suffer conditions of extreme hardship and scarcity. The oldest surviving examples of such works are images of animals painted in the 1870s by the Tiwi people onto pieces of bark at the behest of British

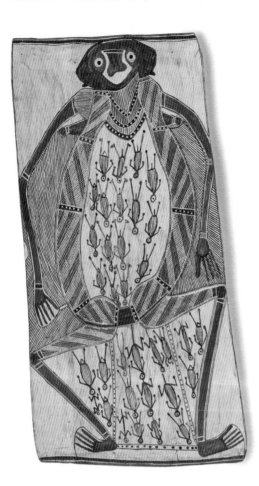

7.11 Yirawala
(Eastern Kuninjku people), *Maralaitj, the Earth Mother*, ca. 1973. Natural earth pigments on eucalyptus bark, 33½ x 17in (85.3 x 43cm). National Gallery of Australia, Canberra. Collected by Sandra Le Brun Holmes, Sydney. Purchased in 1976.

7.12 John Mawurndjul *Mardayin*, 2001. Natural pigments on eucalyptus bark, 84½ x 32in (215 x 81cm). Art Gallery of New South Wales, Sydney. Purchased in 2002.

soldiers stationed on Bathurst and Melville Islands, near Darwin. This portable form proved popular with early settlers and travelers, and was encouraged by missionaries. Beginning in the 1950s, masters such as the Kuninjku artist Yirawala painted entire cycles (in his case, the Mardayin Dreaming) on hundreds of pieces of bark: for example, *Maralaitj, the Earth Mother* (ca. 1973) (Fig. 7.11). Marwalan Marika painted scenes of the creation of the coastal region of northeast Arnhem Land by the Originary Being known as Barama, and of the generation of peoples and plant forms by the Djankawu Sisters, onto large single barks. His son Wanjuk elaborated these themes, and has been followed in this by his own children. A similar narrative, perhaps more recent in origin, concerns the travels of the Wagilag Sisters across central Arnhem Land, a subject painted often by the master Dawidi of Ramingining. In all these cases, generalized figures suggest the ancestral beings, abstract shapes indicate the settings, and cross-hatched brushstrokes laid down in overlapping patches of parallel lines (known as *rarrk*) with thin reeds create a vibrant effect across the entire field. Each of these elements is painted in a style specific to the moiety, or kinship group, to which the artist belongs—in this region, either Dhuwa or Yirritja. To the artists, it is the accumulation of signs that indicates the presence of their spirit being in the painting.

In the late 1980s, certain artists from northwest Arnhem Land, led by Peter Marralwanga, Jimmy Njiminjuma, and John Mawurndjul, began to remove overt figurative representation from their barks, and took to suggesting significant themes and places by eccentric division of the field and intricate cross-hatching of each

section. The resultant kaleidoscopic dazzle led to bark paintings as powerful as the canvases being produced by painters from the Central Desert region, whose work will be discussed shortly. On the one hand, this was a direct response to the preference for abstract painting among the *balanda* (a Kuninjku term for white people), who collected their works through the art center at Maningrida. On the other, it amounted to a determined effort to present spiritual presence without figural depiction. John Mawurndjul's *Mardayin* (2001) (Fig. 7.12), for example, evokes the actual features and the sacred resonance of a site for the Mardayin ceremony located on a large billabong (a tributary isolated from a river) covered in waterlilies.

Abstraction and indirect reference have become increasingly important in contemporary Australian Aboriginal art. When the techniques of ceremonial sand painting were first transposed to portable formats at Papunya in the Central Desert during the early 1970s, works often included secret sacred imagery. But objections from neighboring tribes led the artists to a more generalized use of visual codes, and to a greater emphasis on lesser elements. Backgrounds came to fill foregrounds with rich fields of color. Signs indicating place, travel, movement, and sacred beings became simplified. Artists such as Clifford Possum Tjapaltjarri, Michael Nelson Jagamara, and Uta Uta Tjangala were soon creating complex works that combined key elements from multiple Dreamings in one large canvas. Others, such as Johnny Warangkula Tjupurrula, presented their sacred stories—in his case, the Water Dreaming—through layering and allusion (Fig. 7.13).

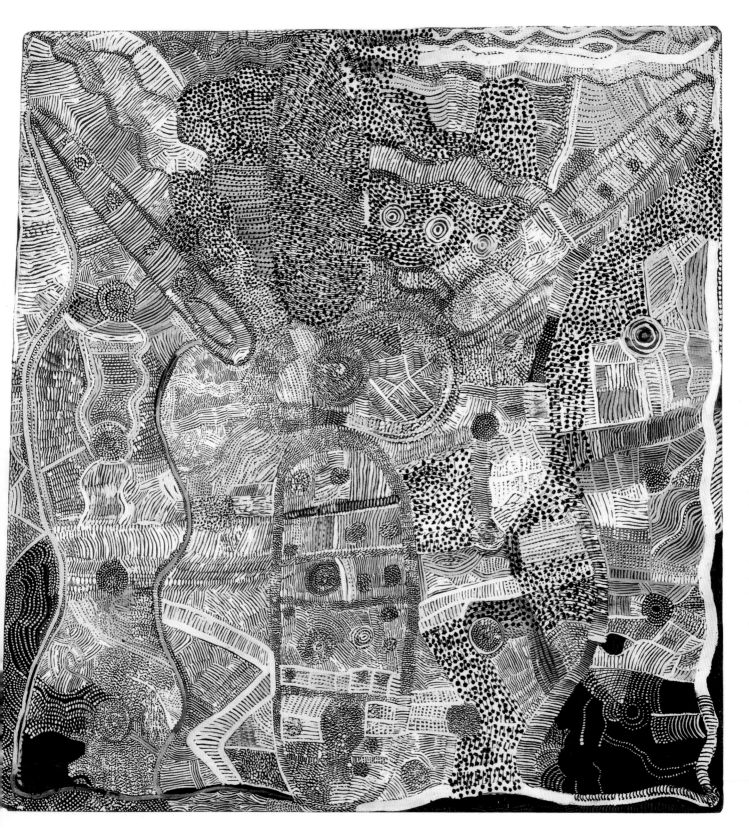

7.13 Johnny
Warangkula Tjupurrula
*Water Dreaming at
Kalipinypa*, 1972.
Synthetic polymer paint
on composition board.
Collection of John and
Barbara Wilkerson.

7.14 Warlukurlangu
Artists
*Karrku*, 1996.
Synthetic polymer
paint on canvas, 110¼ x
267¾in (280 x 680cm).
Kluge-Ruhe Aboriginal
Art Collection of the
University of Virginia,
Charlottesville.

7.15 Emily
Kame Kngwarreye
*Untitled (Winter Painting)*,
1993. Synthetic polymer
on canvas, 54 x 39¾in
(137 x 101cm). Private
collection, Sydney.

7.16 Turkey
Tolson Tjupurrula
(Luritja/Warlpiri
peoples), *Straightening
Spears at Ilyingaungau*,
2000. Synthetic polymer
paint on canvas, 72 x
96¼in (183.1 x 244.6cm).
National Gallery of
Australia, Canberra.
Purchased with funds
from Mrs Ann Lewis.

By 1984, James Mollison, director of the National Gallery of Australia, Canberra, declared that Papunya acrylic paintings were "possibly the finest abstract art achievements to date in Australia."[4] At nearby Yuendumu, men and women worked together to create mural-sized canvases that traced the main Dreaming stories of their region (Fig. 7.14). Women artists led painting activity among the Anmatyerre people at the Utopia bore northeast of Alice Springs. Emily Kame Kngwarreye was, in the years around 1990, widely acknowledged as the leading abstract painter in Australia. Her vigorous dotting with wet splotches of acrylic paint led to the creation of vibrant fields of densely variegated color that matched in subtlety the best abstract painting then being made anywhere in the world. She began each painting by drawing in outline the shapes that symbolized her spiritual responsibilities to the land from which she, like all Indigenous people, believed she was born, and of which she remained a living part. Asked to reveal the meaning of her painting *State of My Country* (1990), she replied: "Whole lot, that's whole lot. Awelye (my Dreaming), Arlatyeye (pencil yam), Arkerrthe (mountain devil lizard), Ntange (grass seed), Tingu (a Dreamtime pup), Ankerre (emu), Intekwe (a favourite food of emus, a small plant), Atnwerle (green bean), and Kame (yam seed). That's what I paint; Whole lot."[5] She is listing all of the natural phenomena for the continuing existence of which she had spiritual (and thus, to her, earthly) responsibility. The vivid surfaces of her paintings resulted partly from her desire to obscure what she felt might be too explicit a representation of this sacred knowledge if its symbols were presented in the direct manner used in secret ceremonies. Yet something of the power of this knowledge, and the intensity of her feeling for it, comes through in many of her paintings. *Untitled*

*(Winter Painting)* (1993) (Fig. 7.15) evokes the pink desert sand's eager welcoming of sudden, drenching rain—the run of water through low-lying scrub, the furrowing of new channels, the bursting forth of delicate flowers—as if it were a human body, or a sacred being, taking shape from inside the Earth itself.

Recent paintings and sculptures by a number of Aboriginal elders approach maximal intensity by seemingly the most minimal of means: severely limited ranges of color, repetitive dotting, unstable lines, all often loosely applied. This reflects the example of mesmeric calm set by the later paintings of Turkey Tolson Tjupurrula, who died in 2001 after spending a dozen years developing ways of telling, in a few horizontal lines, his core Dreaming story: the straightening of spears by a group of Pintupi men who sensed a threat from the north, a ritual carried out so carefully that no battle occurred (Fig. 7.16). Parallels appear in Willy Tjungurrayi's reflections on the death in ancient times of a large group of Tingari men by hailstorm, and in Dorothy Napangardi Robinson's black and white lattices that evoke the tracks of ancestral women across the Mina Mina saltpans near Lake Mackay. It is as if, for Australian Aboriginal artists from remote communities, abstract painting on canvas is a continually surprising way of bringing into visibility the spiritual aura of the Dreaming beings themselves.

Racial conflict and the possibilities for reconciliation are the main concerns of Aboriginal artists from the big cities and country towns. In her public art installations, Fiona Foley uses an imagery of natural phenomena to indicate sites of past massacres. Judy Watson integrates Performance Art techniques to leave traces of her body in the earth of her people's lands, which she then records by pressing paper or canvas to

7.17 Judy Watson
(Waanyi people), *Sacred Ground Beating Heart*, 1989. Natural pigments and pastel on canvas, 84½ x 75in (215 x 190cm). Queensland Art Gallery, Brisbane. Purchased in 1990. The 1990 Moët & Chandon Art Acquisition Fund.

them (Fig. 7.17). In Destiny Deacon's photographs, black dolls and other kitsch paraphernalia enact race relationships in urban interior settings. Gordon Bennett angrily confronts the deadening effects of visual stereotypes of Aborigines, reversing the appropriation techniques applied to the art of his people by white artists. Since the late 1990s, he has addressed larger questions of political division, such as those that erupted on September 11, 2001, through his series of painterly dialogues with the deceased U.S. artist Jean-Michel Basquiat (Fig. 7.18).

During the early years of European settlement in the late eighteenth century, artists joined surveyors, scientists, and agriculturalists in attempting to match their frames of reference to the strange realities of the newly conquered continent. Landscape quickly became the main subject of artists in the Australian colonies during the nineteenth century, and continued to be so, as the symbolic domain of the national imaginary, after their federation into the Commonwealth of Australia in 1901. European Modernism offered wave after wave of fresh stylistic options through the twentieth century, many of which were adopted or adapted to local needs,

sometimes with transformatory results, as in the paintings of Grace Cossington Smith, Sidney Nolan, Arthur Boyd, John Brack, Fred Williams, and John Olsen, or the assemblage sculptures of Robert Klippel. Australian artists abroad participated in the shifts from modern to contemporary art during the 1960s and 1970s, notably Ian Burn as a member of the Art & Language group in New York. Mike Parr has charted an extremely challenging but consistent course of performance work since that time, many examples of which involve processes of psychological purgation that are exacting for both artist and audience. In recent years his performances have highlighted the racist excesses of official policies toward local ethnic groups, immigrants escaping persecution, and Aborigines. For *Aussie Aussie Aussie Oi Oi Oi (Democratic Torture)* (Fig. 7.19), he had his face cut and stitched in the manner of those illegal immigrants who, after interminable and seemingly endless detention, resort to self-mutilation. The work drew attention to the attitudes of Australians who object to further immigration, which are often expressed by shouting the slogan used in the title of this work (these slang words

7.18 Gordon Bennett
*Notes to Basquiat
(Jackson Pollock and
His Other)*, 2001. Acrylic
on canvas, 60 x 119½in
(152 x 304cm). Private
collection, Adelaide.

7.19 Mike Parr
*Aussie Aussie Aussie
Oi Oi Oi (Democratic
Torture)*, 2003. Thirty-
hour performance,
Artspace, Sydney.

7.20 Juan Davila
*Fable of Australian Painting*, 1982–83.
Oil on canvas, 108 x
431½in (274 x 1,096cm).
Courtesy of Kalli Rolfe
Contemporary Art,
Melbourne.

7.21 Susan Norrie
Still from *Black Wind*,
2005. DVD. David
Mackenzie, editing
and camera (Aboriginal
Tent Embassy,
lawns of Parliament
House, Canberra).
Commissioned for
a performance with
the Amsterdam
Sinfonietta, Amsterdam,
and subsequently
performed at the
Adelaide Festival, 2006.
Courtesy of the artist.

7.22 Imants Tillers
*The Nine Shots*, 1985.
Synthetic polymer paint
and oilstick on 91 canvas
boards, overall 130 x
104¾in (330 x 266cm).
National Gallery of
Australia, Canberra.
Gift of the artist 2008.

translate as "Australians, Australians, Australians, Yes, Yes, Yes"). Chilean-born exile Juan Davila creates contemporary history pictures by combining imagery from Australian and European and U.S. Modernist art history with scenes of torture and homoerotic desire drawn from South American films and history (Fig. 7.20). Susan Norrie pursues similar issues, especially concerning environmental threat, in her haunting video installations. *Enola* (2004) evokes the nuclear bombing of Japan, *Havoc* (2007) the impact on Javanese villages of a flood of mud released by reckless clearing of forestland by developers. *Black Wind* (2005) (Fig. 7.21), in collaboration with musician Kim Bowman, explored the pollution of sacred Aboriginal land by the fallout from atomic bomb tests in Central Australia.

Art by Aborigines was mostly ignored, or used as a source of exotic, "primitive," imagery, but some Modernists—such as Margaret Preston in the 1940s and Tony Tuckson in the 1960s—understood that such work offered the possibility of radically different modes of representation. During the Postmodern 1980s, appropriation artists such as Latvian-born Imants Tillers absorbed Aboriginal imagery into his work to signify the alienation felt by the artist in Australia, isolated from U.S. and European power centers of innovatory art, condemned forever to repeat the bondage of his or her

provincialism (Fig. 7.22). His exchanges with artists such as Gordon Bennett, himself practicing a (largely successful) strategy of reverse appropriation, gradually changed the terms of this equation. Working together against the abiding conservatism of officialdom, Indigenous and non-Indigenous artists have, in recent years, sought careful ways of imagining a genuinely multicultural society. The shortcomings of official attitudes toward Indigenous peoples in the Pacific region are charted in works by Patricia Hoffie, some made in collaboration with women workers in the Philippines. Immigrants from elsewhere—Hoorshien Valamesh from Iran, Guan Wei from China—as well as artists with immigrant backgrounds—such as John Young—offer works that are subtly wrought cultural hybrids as their contributions to this quest.

The great racial divide in Australia remains an unresolved matter, but there are grounds for hope. As Indigenous activist Marcia Langton notes, "Aboriginality" is not properly understood as a quality possessed by Indigenous peoples alone as some kind of racial essence. In social terms it is, rather, the general name for a cluster of cultural concepts that Indigenous and nonIndigenous peoples use as they seek to negotiate ways of living together in the same, contested space, while keeping essential differences

7.23 Rod Moss
*Reconciliation Walk
(Todd River Bridge)*, 2003.
Graphite and synthetic
polymers on paper,
55¹⁄₁₀ x 120½in (140 x
306cm). Courtesy of
the artist. Represented
by Anna Pappas Gallery,
Fireworks Gallery,
Peta Appleyard Gallery.

intact and sharable values (such as the sense of belonging to a place) in play.[6]

Although they rarely study non-Indigenous Modernism or contemporary art closely, Aboriginal artists are well aware of the preferred aesthetic codes and broad tastes of those who are interested in their art, and have clearly gone some way toward meeting them, while pursuing their primary purpose of putting the sacred signs of their cultural heritage in front of those who would destroy the continuity of that heritage. Conversely, non-Indigenous artists such as Imants Tillers have come to recognize that Aboriginal art "unexpectedly and incredibly became the mainstream of Australian contemporary art," and to acknowledge that "many of us have been looking at, thinking about and consciously or unconsciously absorbing new forms of this art for at least twenty years," leading to the positive prospect of a new "cultural tradition in Australia as the consequence of the sweeping triumph of Aboriginal art and the concomitant opening of the non-Indigenous mind to Aboriginal culture."[7] This has been slow in coming, but coming it is.

One artist showing the way in both his life and his art is Rod Moss. Resident of the Central Australian city Alice Springs since the mid-1980s, he has painted, with unsparing realism, the fraught interactions between white settlers and the various Aboriginal peoples of the area, which is Arrernte country. He depicts ordinary, recurrent incidents, and scenes of everyday desolation, yet conveys their deep symbolic resonance by arranging the figures in poses drawn from Classical art, paintings by Gustave Courbet and nineteenth-century photographic panoramas, underscoring this disjunction by a Pointillist technique that uses for its dots the exact colors that pervade this desert town. *Reconciliation Walk (Todd River Bridge)* (2003) (Fig. 7.23) shows the white people of Alice Springs willing to march to show their solidarity with Aboriginal people on a day when Australians across the country did the same, in defiance of their (then) conservative government's refusal to offer an apology to the Aboriginal people. One of the men holds a poster painted with the Aboriginal flag and the words "Can we walk together?" in the Arrernte language. The artist strips himself naked in his effort to reach out to his fellow man.[8]

The process includes negotiation by confrontation. Murri artist Richard Bell's painting *Scientia E Metaphysica (Bell's Theorem)* (Fig. 7.24) won the 2003 Telstra National Aboriginal and Torres Strait Islander Art Award. Across its patchwork surface the artist scrawled the proposition "Aboriginal Art—It's a White Thing," attacking non-Indigenous control of the marketing, collecting, and interpretation of contemporary Aboriginal art.[9] His protest was, however, launched from a position of relative strength: 30 years into the unfolding of the Contemporary Aboriginal Art movement, its artists dominate art production in Australia, and a relatively large number of Indigenous people hold key positions in its dissemination, public collecting, and interpretation—though not, as yet, in its marketing. The way forward was shown by the response of 43 male artists from Ramingining to the 1988 celebrations of 200 years of colonization. Their *Aboriginal Memorial* (Fig. 7.25), consisting of 200 burial poles (hollow logs, known as *dupun*) painted with family and clan images of the lands around the mouth of the Blyth River, becomes a forest of sculptures arranged on either side of an imagined river and serves both to create a site of mourning and to welcome visitors to the site. Its aesthetic richness, its open sharing of sacred imagery, and its suggestion of persistence after death make it an extraordinary yet entirely accessible template for reconciliation.

While the connection made here is symbolic, art by Aboriginal people has had an extraordinary impact in engaging the sympathy of non-Indigenous Australians. A moving instance occurred in 2007, when the Federal Court sat at Pirnini, south of Fitzroy Crossing in Western Australia, to determine a land rights claim by the Ngurrara peoples for ownership of a 29,000 square mile area of the Great Sandy Desert. The local Aborigines were contesting 30 permits held by companies and individuals to explore for petroleum and minerals. Pivotal to demonstrating their case were two large paintings—*Ngurrara I* and *Ngurrara II*, painted in 1996 and 1997 respectively—that depicted their "country" as a patchwork of adjacent spiritual domains.[10] In a rare exception to the tendency in such cases, the court's determination was made in their favor. For Indigenous people, land is essential to their very existence.

7.24 Richard Bell
*Scientia E Metaphysica
(Bell's Theorem)*, 2003.
Acrylic on canvas, 94½
x 212½in (240 x 540cm).
Museum and Art
Gallery of the Northern
Territory, Darwin.

7.25 Ramingining Artists
*The Aboriginal Memorial*,
1987–88. Installation
of 200 hollow log
bone coffins, natural
pigments on wood,
height (irregular)
of 128¾in (327cm).
National Gallery of
Australia, Canberra.
Purchased with the
assistance of funds
from National Gallery
admission charges and
commissioned in 1987.

# 8. AFRICA

African art appears in all histories of Modernist Art, along with art from Oceania, as an important inspiration of the avant-garde breakthroughs in European art, especially Cubism, Expressionism, and Surrealism. When artists encountered African masks, ritual objects, pottery, costumes, weapons, tools, and other artifacts in ethnographic museums in Paris, Berlin, and elsewhere, they understood them as authored by peoples who, because they lived a more "primitive" form of life, were closer to the sources of human creativity. Centuries of academic rules, official legitimation, and exclusive service to the powerful and the rich in Europe had, they believed, obscured the original wellsprings of art. To Pablo Picasso, Georges Braque, Constantin Brancusi, Julio Gonzáles, and Wifredo Lam, to the German artists of Die Brücke, and to writers and cultural activists such as André Breton, these objects contained more than hints about how to make striking formal innovations within European painting and sculpture: they also suggested concentrated, effective, and above all *essential* ways to focus powerful ideas and to convey profound emotional effects. The European artists consciously subjected their inherited, learnt ways of picture making to these "strange," "magical," and "barbaric" practices, thus deliberately rendering their own art unfamiliar to themselves and their viewers. Undergoing this cleansing ritual (a reverse exorcism) was fundamental to the achievement of Modernist Art. It resonated through subsequent decades—not only in Europe and the United States but also throughout the rest of the world, including, eventually, Africa itself. In this sense, art from Africa and Oceania may be understood as one of the main *causes* of the avant-garde transformation of modern art in the world as a whole, rather than simply as a *means* to this end.

Within the continent of Africa itself, the interplay between tradition and modernization varied greatly from area to area and from place to place, depending on the nature of local art practice and the degree and kind of European colonization. In South Africa, for example, professional artists among early foreign settlers and subsequent generations adapted European styles and attitudes to the depiction of local scenery, unfamiliar light effects, and expansive spaces, generating imagery that underwrote the creation of a colonial narrative for the British and then a national one for the Dutch Afrikaners. Like the majority of artists in other settler colonies around the world, they ignored or disdained the visual cultures of the indigenous peoples around them. Already in a state of provincial dependence in relation to the art of their home countries, they were prevented from fully embracing innovatory Modernism by this double blindness. Again as elsewhere (in Australia and Canada, for example), this situation did not change until artists sensed the possibilities inherent in the internationalization of art after World War II, specifically Abstract Expressionist styles. At this time, African artists were also deeply affected by the explosive decolonization occurring throughout the continent. As art historian Esmé Berman observed in relation to South Africa in particular, by 1960 these winds of change "introduced a row of question marks into the scramble to identify with North Atlantic trends: Was the cultural spirit of South Africa indeed a mere extension of the European-American ethos; or was it indivisible from the ancient spirit of Africa itself? Could white descendants of three, four, five and more generations of South African residence continue to define themselves as Europeans; or were they not the issue of a dual heritage? And what of black South Africa and, more specifically, its emergent urban culture?"[1]

What, indeed, of black Africa? It is an effect of colonization that this question comes last in Berman's list, and is posed in narrow terms. Across the continent during colonization, indigenous artists and craftspeople had continued to develop their traditional practices, particularly sculpture, crafts, bodily decoration, and performance. The striking decorative designs making up murals on the sides of houses and public buildings and on the walls of compounds by the Nzundza Ndebele and Tsonga peoples of South Africa (not least prodigious practitioners such as Esther Mahlangu and Francina Ndimande) are often cited, as are the inventive

8.1 Yinka Shonibare MBE
*Victorian Philanthropist's
Parlour*, 1996–97.
Reproduction furniture,
fire screen, carpet,
props, Dutch wax printed
cotton textile, approx.
103 x 192 x 209in (2.60
x 4.88 x 5.30m). Overall
size according to
installation SHO 12.
Courtesy of the artist,
Stephen Friedman
Gallery, London, and
James Cohan Gallery,
New York.

costumes created for dances and other rituals throughout the continent. In general, indigenous artists adapted to the demands of colonization, and to the availability of new materials, including those imported from the West, as well as to the possibilities for the mass reproduction, and thus wider circulation, of iconic images. Colonial exchange itself generated some new art forms and crafts, notably the printed cotton textiles that were soon recognized all over the world as generically "African." Widely worn throughout the continent, and featuring distinctively local design styles, these actually used imagery derived from Dutch Javanese wax batik prints that were manufactured in Manchester, England, and then exported to markets throughout Africa. In his 1996–97 installation *Victorian Philanthropist's Parlour* (Fig. 8.1), British-Nigerian artist Yinka Shonibare MBE demonstrates that even the most morally scrupulous of Englishmen depended for his comfortable circumstances on an economy founded upon unequal, in fact iniquitous, exchange. Shonibare brings us to this realization by creating a life-size replica of a room in a large house in a nineteenth-century English city, but decorates it not in

one of the styles, such as High Victorian or Arts & Crafts, favored by wealthy patrons of the time, but with wallpaper and upholstery fabric made from the "African" textiles just described. In 2004, Shonibare was awarded the decoration Member of the Most Excellent Order of the British Empire. He then added this title, "MBE," to his professional name to highlight his status as, in his own words, "truly bicultural," a "post-colonial hybrid."[2]

## MODERN ART IN AFRICA

In the early years of the twentieth century, a small number of indigenous makers committed themselves to self-expression through professional practice as artists as distinct from offering craft-based services to their communities. They advocated the teaching of studio-based art in schools, the first of which were founded in Egypt. Independent artists were rare until the emergence of nationalist movements after World War II, however. In South Africa under apartheid, black artists were obliged to migrate to Europe if they wished to become fully

professional. Gerard Sekoto painted life in the townships of Johannesburg and Cape Town both before and after he left for exile in Paris in 1948. While in Europe, fellow South African artist Ernest Mancoba was an important member of the COBRA group, a loose association of experimental artists from Copenhagen, Brussels and Amsterdam who worked together in Paris and their native cities. Mancoba introduced Asger Jorn (see Fig. 1.5) and others to African art in the Trocadéro Museum, Paris, and himself developed a powerful, expressive form of abstract painting that mobilized, within fields of shaped color, emblematic yet elusive figures drawn from his heritage. Nigerian artist Ben Enwonwu became quite famous in England, not least for painting Queen Elizabeth II in 1957. Côte d'Ivoire sculptor Christian Lattier achieved recognition in France for his woven wire and fiber works. During the 1960s, Chicago-based Sudanese sculptor Amir Nour used the newly forged language of Minimalism to evoke the movement of animals—in his metal sculpture *Grazing at Shendi* (1969) (Fig. 8.2), a flock of goats roam the hills around his hometown. Nour commented: "There is nothing wrong with using technology; we need it. But the forms have to come from within the society itself—from the tradition and background we have… You can't have a culture isolated from the rest of the world. Cultures have always developed by being fertilized by new elements from other cultures. I mean the whole modern art movement came about because some artists saw African art. And yet Moore, Picasso, Modigliani are never labeled Africanist, as I am labeled Western."[3]

In Africa itself, great changes were underway. In 1960, no fewer than 17 countries gained independence and were admitted en masse to the United Nations. They were preceded by Ghana in 1957; it took the Portuguese-speaking colonies until the 1970s and South Africa (although formally independent in 1910) until 1994 to throw off the political legacies of colonial rule. These changes were, partly, precipitated by the spread of powerful ideas across the continent: Negritude, pan-Africanism, and pan-Arabism. Developed first by artists and intellectuals exiled in Europe during the 1930s, these ideologies sought to combine certain essential qualities of blackness with African or Arabic identity—often evoking aspects of precolonial periods—with the desire for independence and self-reliance in the present. Léopold Sédar Senghor, for example, insisted that "we could not go back to our former condition… to be really ourselves, we had to embody Negro African culture in twentieth century realities… to enable our negritude to be, instead of a museum piece, the efficient instrument of liberation."[4]

In this new situation, many black artists devoted themselves to the creation of national styles, often amalgamating indigenous imagery, local materials, and traditional practices with inherited forms, including Islamic and European ones. Unlike their white counterparts, they did not shy away from incorporating many of the "primitivist" modes of the leading European Modernists. It is the optimistic expectation that these many and various elements could be brought together in an ever more productive tension—one that could be resolved within individual works of art, each resolution contributing toward the next—that enables us to speak of a modern movement within indigenous African art. The Zaria Art Society, led by Uche Okeke and Demas Nwoko, undertook the task of building this movement for Nigeria in the name of their theory of "Natural Synthesis." This, in turn, led to a refinement along the same lines by artists at the University of Nigera (Nsukka) known as the *Uli* style, and a similar effort at the Obafemi Awolowo University at Ife known as the *Ona* style. Ibrahim El-Salahi and Osman Waqialla pursued these synthesizing goals in the Sudan, activating Arabic calligraphy within abstract painterly formats, inspiring a movement known as the Khartoum School. Skunder Bohossian and Gebre Kristos Desta led the modernizing movement in Ethiopia, and Ahmed Cherkaoui and Farid Belkahia attempted to do the same in Morocco.

While these artists were vital inspirations in their own countries, they also worked to create a pan-African style that could bring together imagery from all over the continent within formats derived from European experimental art. As president of Senegal, Léopold Sédar Senghor actively promoted the arts as a means to establish a sense of "Negritude," devoting 25 percent of the national budget to the Ministry of Culture in order to build museums, art schools, theaters, printing presses, and archives for what became known, after the first World Festival of Pan-African Arts held at Dakar in 1966, as the École de Dakar (School of Dakar). Elsewhere, informal workshops—such as those set up by Pierre Lods in the Poto-Poto neighborhood of Brazzaville, Congo, in 1951, and by Georgina Beier in Oshogbu, Nigeria, in 1964—were important, the latter especially in the spread of traditional "legends" via modern graphic media in the work of artists such as Twins Seven Seven (Fig. 8.3).[5] In South Africa under apartheid, workshops were crucial both for the training of indigenous artists and as centers within the townships (exclusively black urban settlements) for artistic resistance to the regime. Political opposition grew, during the 1970s and 1980s, to become the most prominent theme in contemporary art in that country.

## SOUTH AFRICA UNDER APARTHEID

Under apartheid, black South Africans were largely confined to separated townships proximate to cities such as Johannesburg and worksites such as the diamond mines. Resistance to the political system burst out in the 1976 Soweto uprising and continued until the regime's demise in 1994. Activism could take the form variously of posters, performances, and works of art. In 1983, Rastafarian artist M.K. Malefane painted an oil portrait, *Nelson Mandela*, picturing the resistance leader breaking out of his Robben Island prison and swimming to shore, to be greeted by his patient followers. It hung in the house to which Mandela's wife, Winnie, was confined,

8.2 Amir Nour
*Grazing at Shendi*,
1969. Stainless steel
(202 pieces), 119¾ x
161¾in (304 x 411cm),
variable. Collection
of Amna E. Nour.

8.3 Twins Seven Seven
*Healing of Abiku Children*,
1973. Pigment on
wood, carved, 51⅓ x
51½in (130.5 x 131cm).
Indianapolis Museum
of Art, Indianapolis.
Gift of Mr and Mrs
Harrison Eiteljorg.

8.4 Sam Nhlengethwa
*It Left Him Cold—The
Death of Steve Biko*,
1990. Collage, pencil
and charcoal on paper,
27¹⁄₁₀ x 36½in (69 x
93cm). Standard Bank
Collection housed
at the University of
Witwatersrand Art
Galleries, Johannesburg.

until both house and painting were destroyed by fire in 1985. Sam Nhlengethwa's *It Left Him Cold—The Death of Steve Biko* (1990) (Fig. 8.4) uses the collage technique of African-American artist Romare Bearden to poignantly evoke the death in detention of the leader of the Black Consciousness Movement. Billy Mandidi's 1986 construction *Necklace of Death* (Fig. 8.5) shows the grisly fate of informers against the anti-apartheid struggle: a charred corpse, the wire residue of a burnt tire encircling its neck, stares out sightlessly from a tower camouflaged like a police vehicle.

Other township artists manifested the degradations of their situation through more personal forms of expression. VhaVenda artist Nelson Mukhuba used the woodcarving skills he had developed while working on ceremonial drums to transform tree branches and trunks into highly idiosyncratic variants on the themes typical of tourist art: dancing couples, biblical subjects, members of the various professions, movie stars, and caricatures. In a self-portrait of ca. 1987 (Fig. 8.6), he depicted himself on his knees facing the viewer, his upper body sliced open to display his innards. He comments: "I am an artist who can see inside the wood… I am the doctor of wood because I can see inside."[6] Transvaal artist Johannes Segogela arranges his painted carvings into groups that portray the clash of Christian and traditional notions concerning good and evil. His *Burial of Apartheid* (1993) (Fig. 8.7) treats this subject as both a local village and a world-media event. A mechanical coffin is lowered into a grave, recorded by movie and still cameras, while mourners of all races and in a variety of costumes grieve, except for the main figure, a black priest who stands unmoved at the head of the coffin.

8.5 Billy Mandidi
*Necklace of Death*,
1986. Construction.

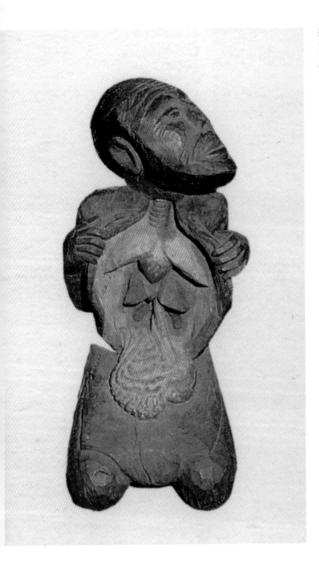

8.7 Johannes Segogela
*Burial of Apartheid*,
1993. Carved and
painted wood, 72 x
41¾ x 26in (183 x
106 x 66cm). Courtesy
of CAAC—The Pigozzi
Collection, Geneva.

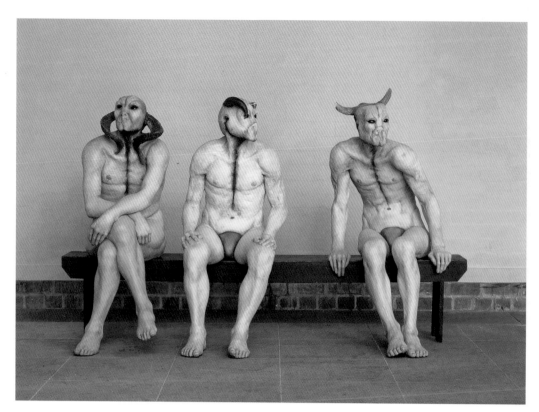

8.8 Jane Alexander
*Butcher Boys*, 1985–86. Reinforced plaster, oil paint, animal bone, horns, wood, 50½ x 84 x 35in (128.5 x 213.5 x 88.5cm). South African National Gallery Collection, Cape Town. Courtesy of the artist.

8.9 William Kentridge
Drawing for the film *Sobriety, Obesity, & Growing Old (Soho and Mrs. Eckstein in Pool)*, 1991. Charcoal and pastel on paper, 47¼ x 59in (120 x 150cm). Courtesy of the artist and Marian Goodman Gallery, New York.

8.10 Middle Art
(Augustine Okoye),
*Middle Art's Suffering
Stages of Life from
the War Until Now I am
in Ile-Ife*, 1970s. Oil on
board, 35½ x 23½in
(90.3 x 60cm).

South African artists living in the white communities also addressed such topics. Conceptualists Willem Boshoff and Sue Williamson used the device of repetition within grid structures to display the procedures used by the state to erase the individuality of indigenous peoples, who were obliged to carry identity cards that tracked their daily movement from the townships to workplaces in the capital cities. Photographer David Goldblatt recorded the racial divide evident in the urban planning that separated off white South Africans behind blank façades, elaborate walls, and guarded gates. Sculptor Jane Alexander confronted viewers with shockingly realistic embodiments of the institutionalized brutality that characterized the apartheid years. *Butcher Boys* (1985–86) (Fig. 8.8) consists of three young men casually seated on a bench, their naked, well-muscled bodies contorted into postures of fitful anticipation of violence, while their heads suggest those of different animals. That the figures are life-size, and presented with extraordinary verisimilitude, draws viewers into disturbing proximity with them.

In theater pieces, sculptures, drawings, and, above all, animated projections, William Kentridge, whose family were settlers from England, subtly tracks the inner traumas of apartheid as experienced by ordinary men and women, characters whom he has richly imagined, such as the businessman Soho Eckstein, his wife (whose name is never given), her lover, Felix, and the black woman Nadia. By filming constant adjustments to his charcoal drawings, he generates a medium that seems itself in a state of incessant agitation, of perpetual uncertainty. In *Johannesburg, 2nd Greatest City after Paris* (1989), swarming masses of miners become a protesting crowd, to be violently cut down, only then to merge with the body of a woman, herself imagined by a lonely lover. In *Stereoscope* (1988–89), Soho's life at the office and at home is connected by blue lines that switch between bar charts, electricity cable, and flowing water, emphasizing his befuddled, alienated immersion in all of the forces around him. In *Sobriety, Obesity, & Growing Old* (1991), the characters play out their highly personal dramas as the apartheid system collapses under the weight of insurrection against it. This disjunctive mood is captured in a drawing for the film of this name that is subtitled *Soho and Mrs. Eckstein in Pool* (Fig. 8.9). In *History of the Main Complaint* (1996), the failure of the hospital's treatment of Soho's heart attack morphs into his driving through the bare landscapes of industrial Johannesburg as he sets out to heal himself.

## POPULAR PAINTING AND SCULPTURE IN CENTRAL AFRICA

Elsewhere in Africa, indigenous artists have addressed similar themes through local styles of popular painting and sculpture. During the 1970s, Nigerian artist Augustine Okoye, known as Middle Art, chronicled his country's recent travails through cartoonlike panels in works such as *Middle Art's Suffering Stages of Life from the War Until Now I Am in Ile-Ife* (Fig. 8.10). Early in that decade, Lubumbashi artist Tshibumba Kanda Mutulu painted 102 panels recording, in poignant detail, his understanding of key events in the history of what was then Zaïre (since 1997, the Democratic Republic of the Congo).[7] Burlap sacks used to transport flour became a favored support on which to paint, as these were readily available, as well as being cheap and easy to transport. "Flour-sack painting" thus flourished in the main cities, and was sold through the shops of active artists, mainly

8.11 Moké
*Express Taxi Populaire
Kinshasa*, 1990. Acrylic
on canvas, 45¼ x 61½in
(115 x 156cm). Courtesy
of CAAC—The Pigozzi
Collection, Geneva.

8.12 Chéri Samba
*Après le 11 SEP 2001*,
May–September 2002.
Acrylic on canvas and
glitter, 78¾ x 137¾in
(200 x 350cm). Courtesy
of CAAC—The Pigozzi
Collection, Geneva.

8.13 Bodys Isek Kingelez
*Kimbembele thunga
(Kimbeville)*, 1993–94.
Installation, dimensions
variable. Courtesy of
CAAC—The Pigozzi
Collection, Geneva.

to a rising middle class. In *Express Taxi Populaire Kinshasa* (1990) (Fig. 8.11) by Monsengwo Kejwamfi (known as Moké), a louche fruit vendor, with jaguar-jaw shoes, plies his wares in a cart custom-built in the manner of a Mercedes taxi, to the admiration of local residents, while provoking the anger of a competitor in the modernization stakes: a shopkeeper who sells radios. Apparently guileless and upbeat, paintings such as these are actually quite subtle expressions of what it takes to survive poverty, inequality, and violence. In the early 1980s, billboard and sign painter Chéri Samba began signing his paintings "Chéri Samba: Artiste Populaire." With Moké, Bodo, Chéri Cherin, and others, Samba is a member of the self-named "Popular Painters" of Kinshasa. They supply paintings in either local or "Western" styles, on request.

In recent years, these artists have specialized in large contemporary history paintings: Samba's *Après le 11 SEP 2001* (Fig. 8.12), painted between May and September of 2002, presents a complex symbolic cluster concerning the roots and effects of terrorism today, in a manner reminiscent of Mexican artist Diego Rivera's Rockefeller Center mural (destroyed in 1933). At its center, a Gandhi-like figure of mixed race wanders the world seeking truth with the aid of a small candle. At the same time—in self-defense or because humans (and gods) are as war-prone as they are peace-seeking—he sows havoc of huge dimensions, particularly among those living in the southern hemisphere, while shooting at the airplanes—both fighters and commercial jets—that fill the skies around him. As they turn to golden dust, the dying figures at the left murmur: "When diplomacy is mocked, innocent people die. I am here because of terrorism," and "It's because of reprisals." Those on the right say: "We are not the dead. We are

the living image of diplomacy rejected. The future will judge." Samba comments: "Everyone can understand that painting, with or without the text. You might find it shocking, but that tragedy is meaningful to all of us. We don't know where we are headed in Africa or the Congo, and I've noticed the same thing all over the world… [These] are paintings with topics that are meaningful to everyone. Although they are inspired by Kinshasa, the subjects are nonetheless international."[8] The Kinshasa painters continue to advance from their populist starting point, learning fresh ways of conveying their growing awareness of the complexities in which they are embedded, while remaining loyal to their roots and to local perspectives.

Hopes for African renewal are perhaps nowhere more insistently expressed than in the fantasy cities of Congolese artist Bodys Isek Kingelez. Since 1985, pursuing what he labels "Architectural Modelism," he has created vibrant model urban environments using found materials, cardboard, foil, and colored papers. *Kimbembele thunga (Kimbeville)* (1993–94) (Fig. 8.13) honored his native village, while *Kinshasa: Project for the Third Millennium* (1997) dreamt up an ideal future for his adopted city, capital of his war-torn country. In the aftermath of 9/11, his installation *New Manhattan City 3021* (2001–02) imagined Manhattan as an upbeat Las Vegas. "I wanted my art to serve the community that is being reborn to create a new world, because the pleasures of our earthly world depend on the people who live in it. I created these cities so there would be lasting peace, justice and universal freedom. They will function like small secular states with their own political structure, and will not need policemen or any army."[9] A similarly positive outlook inspires the resplendent hanging curtains of Ghanaian sculptor El Anatsui, their

8.14 El Anatsui
*Fresh and Fading
Memories, Part I–IV*,
2007. Aluminum and
copper wire, 354⅓ x
236⅛in (900 x 600cm).
Courtesy of the artist
and Jack Shainman
Gallery, New York.

colorific splendor and rich tactility being achieved by the accumulation of thousands of crushed bottletops and soft-drink cans. His *Fresh and Fading Memories, Part I–IV* (2007) (Fig. 8.14) was a highlight of the 2007 Venice Biennale when it was hung across the façade of the Palazzo Fortuny.

Benin artist Romuald Hazoumé evokes the Fon masks of his people, using the battered water cans that are a necessity in this region as his nontraditional material. Between 1997 and 2005, Hazoumé created *The King's Mouth* (*La Bouche du Roi*) (Fig. 8.15), a collection of over 300 cans, each one shaped into a mask, the whole assembled into a well-known image from an eighteenth-century print showing slaves lying side by side in the hold of a ship, the *Brookes*. At one end, items essential to the slave trade are set out: a rifle, cowrie shells, liquor bottles, and beads. The shells, beads, and liquor were items of exchange, payments for the slaves. The rifle reinforced the power of the traders. Two large "masks"—one black, the other yellow, but with white hairpieces attached—are emblematic of the power and position of the traders, who were both African kings and businessmen from Asia and the Americas. The title refers to a place in Benin from which hundreds of thousands of slaves were exported to the Americas and the Caribbean. Their experience (and that of many who have been displaced from their homeland since) is evoked in a wall text: "They didn't know where they were going, but they knew where they had come from. Today they still don't know where they are going, and

they have forgotten where they came from." The installation also includes film of motorcyclists who transport petrol illegally between Nigeria and the Republic of Benin using the same kinds of can that Hazoumé uses for his masks and installation. The cans are expanded over fire to make them as large as possible, weakening them and rendering them subject to explosion. To the artist, this dangerous but necessary trafficking is a contemporary version of slavery.

There is a vital energy in the exchanges between popular and professional artists throughout the continent. *Sét Sétal* is a kind of mural painting that began in the towns and villages of Senegal in the early 1980s, initiated by artists including Issa Samb and El Hadji Sy. During the early 1990s, it was revived thanks to the activities of the collective Laboratoire Agit-Art (Fig. 8.16), whose members combined elements of performance and installation with wall paintings, hangings, sculptures, and assemblages.[10] Georges Adéagbo tracks the great historical changes affecting Africa in their most specifically local manifestations. Walking around his neighborhood in Contonou, Benin, he collects tribal artifacts, discarded clothing, decorations, utensils, signs, advertisements, posters, newspapers, magazines, and books, then assembles them across the courtyard of his home, in the street outside, or in halls or galleries, taking the viewer/reader through journeys such as *History of France* (1992), *The 11th Arrondissement of Paris and the Life of Voltaire: The Legacy* (1996), *The History of the Country: Writing* (1966), *From Colonialization to*

8.15 Romuald Hazoumé
*The King's Mouth*
*(La Bouche du Roi)*,
1997–2005. Sound and
mixed media installation,
plastic, glass, pearls,
tobacco, fabrics,
mirrors, cauris,
calabashes, dimensions
variable. The British
Museum, London.

8.16 Laboratoire Agit-Art
*Objects of Performance*,
1992. Courtyard of Issa
Samb, Dakar.

8.17 Georges Adéagbo
*African Socialism*,
2001. Mixed media,
dimensions variable.
Created for Okwui
Enwezor show *The Short
Century*, which toured
Munich, Berlin, Chicago,
and New York. Courtesy
of the artist and
Jointadventures.org.

8.19 Malick Sidibé
Photographs,
1962–72, and Siaka
Paul, sculptures, 1999
*The Clubs of Bamako*.
Installation. Museum
of Fine Arts, Houston.
Gift of Nina and
Michael Zilkha.

8.18 Seydou Keïta
*Untitled, #453*, 1950–60.
Silver gelatin print,
63 x 45in (160 x
114.3cm). Edition of 3.
CAAC—The Pigozzi
Collection, Geneva.

*Independence* (1999), and *African Socialism* (2001) (Fig. 8.17). He says of his working method: "I walk, I think, I see, I pass, I come back, I pick up the objects that attract me, I go home, I read things, I make notes, I learn… Artist? That means nothing to me. I didn't learn things in an art school, I am only a witness of history… I go for walks as befits a philosopher, who does so in order to relate to what is happening in nature and the world."[11]

## COMMERCIAL TO ART PHOTOGRAPHY

Everyday life throughout the continent has caught the attention of photographers working as part of small commercial studios and, more recently, as independent artist-photographers. During the 1990s, the archives of certain photographers were widely published through the agency, among others, of Swiss collector Jean Pigozzi. In 1948, Seydou Keïta opened a studio in Bamako, Mali (then French Sudan), specializing in portraits that matched formal poses with extraordinary backdrops ranging from luxury cars to resplendent fabrics (Fig. 8.18). During the 1960s, Malick Sidibé recorded the vital hopefulness that infused the dance-club scene of newly independent Mali, as well as youthful defiance of the rules constraining public behavior that the new regime

sought to impose. Since the 1970s he has concentrated on studio photography. Aged 72, he was awarded the Golden Lion for Lifetime Achievement at the 2007 Venice Biennale. The 2000 exhibition *The Clubs of Bamako* (Fig. 8.19) brought together Sidibé's photographs of the Mali club scene with life-size painted wood sculptures by Côte d'Ivoire carvers Siaka Paul, Nicholas Damas, Émile Guibéhi, and Koffi Kouakou, each of which vibrantly realized, in three dimensions, one of the scenes that Sidibé had photographed 30 years before. This cross-cultural mix attracted some criticism for its overt hybridity, and for the key role played in the project by a non-African curator, André Magnin. But it can also be seen as a subtle defiance of the passage of time, calling attention to a moment of vitality in the past that, the artists are saying, embodied a spirit that should animate the present in their country and else-where. Not least, the exhibition deftly unveiled a rare artistic genre: the photo-sculpture.

Photography has also become a vehicle for women artists in North Africa to explore issues relating to their social position within predominantly religious regimes. Moroccan artist and now U.S. resident Lalla Essaydi pictures Arabic women in chadors or in private settings in various states of undress, showing—in her ongoing series *Converging Territories*, for example

8.20 Lalla Essaydi
*Converging Territories
#30*, 2004. Chromogenic
print mounted on
Plexiglas®, 30 x 40in
(76.2 x 101.6cm).
Courtesy of Edwynn
Houk Gallery, New York.

(Fig. 8.20)—white clothing against white sheets and walls, with calligraphy written in henna over all surfaces.[12] These images have much in common with the work of women artists from the Arabian Peninsula, such as Shirin Neshat (see Figs. 9.9 and 9.10)

## SOUTH AFRICA AFTER APARTHEID

With the official end of apartheid and the institution of full parliamentary representation in 1994, artists contributed to the public debate about the shape of the democracy to come. Kagiso Pat Mautloa's assemblage *Reconstruction* (1994) (Fig. 8.21) is a succinct visual statement of this epochal change. From a black rod affixed to the wall, three much-used mailbags hang equidistant from each other. They are stamped with the name of the state, in Afrikaans and English, in the practice used in the apartheid era. (In 1994, nine African languages were recognized as official languages alongside Afrikaans and English.) Attached to the first bag is a photograph of a village devastated by war, to the second a collage of a newly built house, while the third carries the new South African flag—itself drawn from a Ndebele mural design, its colors signifying the people, the land, skies, precious metals, and spilt blood—and a bar inscribed with elementary African iconography. Reading the images from left to right takes the viewer through the great phases of recent history, acknowledging the abuses of the past (not least in that these bags were cleaned and repaired by prisoners), yet pointing toward reconciliation rooted in tradition.

Reflecting on this work ten years later, Andries Walter Oliphant summarizes the broad changes in South African art a decade after the end of apartheid:

> In the past, the arts in the hands of practitioners who opposed minority rule posed challenges to the society and contributed to the attainment of democracy. With the accomplishment of this objective the arts were freed to explore a much wider range of themes and visual modalities than before on international platforms not previously accessible. In this process the main shift has been a de-accentuation of overt political themes in favour of personalised, inward explorations of intimacy, identity and re-examinations of repressed aspects of the past. As the first decade of democracy unfolded, however, new social problems such as violent crime, rampant abuse of women and children, unemployment, xenophobia and the devastation of the AIDS pandemic have engulfed society. The arts once again, now under democratic conditions, are beginning to focus in a context where the state is either reluctant or unable to provide leadership.[13]

In the immediate aftermath of the formal cessation of apartheid as a legal system in 1994, a Truth and Reconciliation Commission was established to enable public confession, recognition, understanding, and forgiveness of the crimes and suffering of the foregoing period.

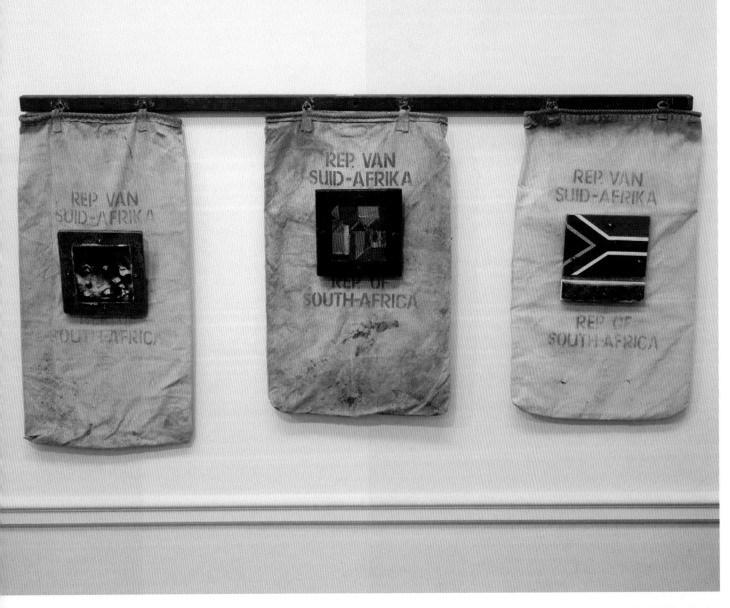

8.21 Kagiso Pat Mautloa
*Reconstruction*, 1994.
Canvas, wood, acrylic,
96 x 50in (245 x 127cm).
Courtesy of Iziko, South
African National Gallery,
Cape Town.

8.22 Sue Williamson
*Messages from the Moat*,
1997. Installation view
and detail, mixed media,
dimensions variable.
Collection of Iziko, South
African National Gallery,
Cape Town.

8.23 Churchill Madikida
*Blood on My Hands*,
2004. Video. Courtesy
of the artist and Michael
Stevenson Gallery,
Cape Town.

8.24 Kendell Geers
*My Traitor's Heart*,
2000. Scaffolding,
12 television monitors,
12 DVD players,
dimensions variable.
Courtesy of the artist.

Extraordinary tensions between public and private experience surfaced in much of the testimony. William Kentridge made his views explicit in his role as director and set designer of Jane Taylor's puppet play *Ubu and the Truth Commission* (1997), in which the monarch from Alfred Jarry's famous earlier play *Ubu Roi* enacts absurd and violent abuses typical of absolute power. Yet the complexities of such situations have since led Kentridge to a less ideological understanding of the political: "I am interested in a political art, that is to say an art of ambiguity, contradiction, uncompleted gestures, and uncertain endings. An art (and a politics) in which optimism is kept in check and nihilism at bay."[14]

Repressed aspects of the past are brought to light in works such as Sue Williamson's *Messages from the Moat* (1997) [Fig. 8.22], an installation consisting of a sweeping net suspended above a long trench, both filled with bottles—1,500 in all—engraved with the name of a slave, his or her birthplace and price, and the name of the seller and buyer. On a visit to Holland, the artist came to understand that Dutch glassware, china, and other items had been trafficked in the same ships that carried slaves, themselves human commodities. She expressed this idea by placing inside each bottle a cut-out piece of a stencil of an Old Master painting. The seemingly unbridgeable gulfs between cultures and sexualities in contemporary South Africa were dramatically brought out by Steven Cohen's 2001–02 performance series *Chandelier*. The extremely tall, very white, Jewish South African donned a skimpy costume,

hung an elaborate but evidently fake chandelier around his body, then, on exaggeratedly high heels, staggered into the garbage dump of a township in the early dawn, seeking community with the workers there, and finding a puzzled tolerance. The painful realities of contemporary South Africa listed by Oliphant have also caught the attention of black artists. Churchill Madikida's installations are compelling evocations of the impact of AIDS [Fig. 8.23]. Interiors of bodies ravaged by the disease, often projected through kaleidoscopic filters and always using intense color, serve as confrontational surrounds to floor-pieces that are staged as elaborate memorials to the absent dead.

Controversial performance artist Kendell Geers confronts both racism and what he sees as too-easy accommodations with its ongoing degradations. His 1996 performance piece *Mandela's Mask* featured the artist as a trader in African artifacts, wearing a mask with the features of his country's recently elected president.[15] In 2000, Geers created a video installation, *My Traitor's Heart*, that evoked Joseph Conrad's famous novella *Heart of Darkness*, in words spoken and projected ("the horror, the horror" and "pride/humility," "I was wrong/I was right," "terrifying simplicity") and images (videos showing the final scenes of the films *Heart of Darkness* and *Apocalypse Now*) [Fig. 8.24]. It also evoked journalist Rian Malan's newly published novel *My Traitor's Heart: A South African Exile Returns to Face His Tribe, His Country, and His Conscience*. Geers states: "I am an abandoned product of a failed experiment, a hybrid of cultures

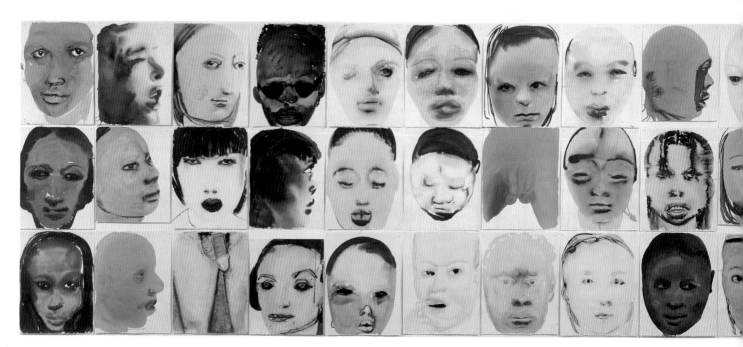

8.25 Marlene Dumas
*The Next Generation*,
1994–95. Mixed media
on paper, 45 parts,
each approx. 26 x 20in
(66 x 50.5cm). Courtesy
of Marlene Dumas
and Iziko South African
National Gallery,
Cape Town.

8.26 Tracey Rose
*The Kiss*, 2001.
Lambda photograph,
50 x 49in (127 x
124.5cm). South African
National Gallery,
Cape Town.

8.27 Nkosinathi Khanyile
*Wathinta' Bafazi Wathinta'
Imbokodo*, 1999–2002.
Red and white clay, cow
dung, wire, and grass.
Courtesy of the artist.

and identities, a contradiction in terms. Born into an upside-down world at the tail end of the millennium, my only responsibility is to this time and place."[16]

Is reconciliation possible? Marlene Dumas's *The Next Generation* (1994–95) (Fig. 8.25) is a suite of watercolor portraits displaying images of anonymous young people amidst those of well-known personalities, suggesting that shaping one's identity is a challenge as socially dispersed as it is individually focused, and that it will be faced and answered by those depicted, not external authorities or abstract categories. In a poem of the same title, Dumas articulates her hopes for change:

> When Black and White are colours
> and not races, people will still fall in
> love and discriminate between
> partners and feel sad and bad
> and need art that breaks your heart
> and takes you to those places
> where pain becomes beauty.[17]

This much-desired condition is playfully yet powerfully embodied in the performance works of Tracey Rose, above all in *The Kiss* (2001) (Fig. 8.26). Obviously referencing Rodin's famous sculpture, the image has qualities of that work's sense of a marble pedestal come to life, its call to ecstatic surrender, its enveloping eroticism. But the juxtaposition of white and black skin charges Rose's version with all the associations that attend any coming together of the races, especially at the most fundamental of levels, that of one individual passionately giving him- or herself to another. The specifically South African nuance here is that Rose, who is herself the woman in the photograph and whose ancestry includes German and Khoisan forebears, was, under apartheid, classified as "colored" and thus regarded as a second-class citizen. The international contemporary art nuance is that the man is her art dealer, an African-American. These aspects are important parts of this performance: they are, precisely, particularities that enable us to see through generalized, stereotypical, and racist markers of identity. Tentative tenderness, careful consideration of another person, a desire to show that love is possible, a demonstration of what at least one kind of reconciliation looks like—these are the implications of this admirable work.

*Ubuntu*, a Nguni and Sotho expression usually translated as "I am because you are," is widely used in South Africa to express the spirit of reconciliation. This idea is the explicit content of a series of installations made since 1994 by Nkosinathi Khanyile and a group of local craftsmen and women. In one installation (Fig. 8.27), a number of woven grass forms, shaped to evoke both generalized human figures and ceremonial totems, cluster as if into a spiritual community. Behind them, busts of black and white men and women are suspended as if awaiting bodies, ones that can only be supplied by the woven grass forms and by the spirit of *ubuntu* explicitly spelt out in the banners hanging between them. The viewer walking among these shapes sees him- or herself in the suspended mirrors. A similar desire for the

8.28 Sandile Zulu
*Involution 2*, 2002.
Fire, water, air, earth,
metal, barbed wire, and
canvas, 94½ x 35½ x 9in
(240 x 90 x 23cm).

8.29 Meschac Gaba
*The Museum of African
Art*, 1997. Ongoing
installations, dimensions
variable. Installation,
Witte de With,
Rotterdam. Courtesy
of the artist.

8.30 Frédéric Bruly Bouabré *Relevé sur noix de cola*, 1991. One drawing from a series of 70. Colored pencil and ballpoint pen on carton, 7½ x 5⅓in (19 x 13.5cm); *Musée du Visage Africain, Scarifications*. One drawing from a series of 162. Colored pencil and ballpoint pen on card, 5⅓ x 7½in (13.5 x 19cm). Courtesy of CAAC—The Pigozzi Collection, Geneva.

fusion of differences is manifest in the works of Sandile Zulu—something he attempts to do, by contrast, almost entirely on the level of form. *Involution 2* (2002) (Fig. 8.28), for example, is a triptych wallpiece that repeats its parts. In each, a checkered cloth that evokes traditional patterns and the body markings of a leopard is stretched across a curved sculptural element—mechanical in shape yet made of compacted straw—stitched, then stapled in ways reminiscent of ritual scarification. The colors are also traditional, and many of the markings are made in a traditional way: by subjecting the materials to fire. The overall implication is that we are looking at three quasi-human, quasi-animal presences, tied together, replete in their finery yet with their chests torn open, bursting with energy yet subject to the rule of law. This is a striking fusion of major differences, but it is an unstable one. There is evidently still a long way to go on the road to reconciliation.

## AFRICAN ART ENTERS THE INTERNATIONAL CIRCUIT

As the power of these works demonstrates, the recent prominence of contemporary African art is not simply a result of growing interest among collectors and the educative efforts of curators such as Nigerian-born Okwui Enwezor, who made it the centerpiece of his pivotal Documenta 11 exhibition in 2002. Despite political turmoil, economic struggles, and the ravages of disease, artists throughout Africa have, since the 1960s, highlighted the evils of colonization, contributed definitively to the imagining of a national consciousness in a number of states, and gone on to achieve international prominence as contemporary artists. None of them has been, or is, a mere mirror to his or her immediate community. Whatever the genre, or mix of genres, in which they work, each is alert to the complexities of life in changing times, not just locally but globally. It is this that decides the "authenticity" of the work, not an external judgment as to whether it appears to embody an essentially "African" spirit or to be made from distinctively African materials. Many artists reject the use of images or techniques that would look, from

the outside, "African," or, if they use them, do so in a self-conscious, critical way. For example, since 1997, Meschac Gaba, born in Benin but now based in the Netherlands, has pursued a roving project entitled *The Museum of African Art* (Fig. 8.29), installing 12 rooms of this imaginary institution in museums and galleries in Europe and the U.S. The first was a "Draft Room," the latest a "Humanist Space." None fits expectations about stereotypes.

More and more, in Africa as elsewhere, the leading artists are making large statements about big-picture issues of vital importance to peoples everywhere. Many do so by drawing on the inspiration of their traditional cultures, notably Frédéric Bruly Bouabré, a seer from Abidjan, Côte d'Ivoire. Born in about 1923, Bouabré never trained as an artist. In 1948, he experienced a revelation that led him to seek ways to revive the oral culture of the Bété people. He created a 448-letter alphabet that included phonetic symbols from many languages in order to transcribe Bété songs and stories. During the 1970s, he began to make a series of ballpoint pen and crayon drawings on postcards depicting Bété subjects. Since then, these drawings have expanded to include topics from all over the world, many seen by him in visions. To him, they are entries in a "universal" encyclopedia. Collectively, they are entitled *World Knowledge* (Fig. 8.30).[18] Other African-born artists, or artists of the African diaspora, engage directly with the differentiating currents that swirl between contemporaneous worlds. Painters such as Julie Mehretu from Ethiopia, collagists such as Wangechi Mutu from Kenya, both of whom live in New York, and digital installation/performance artists such as Jean-Michel Bruyère from Senegal, who lives in France, are just some of the many African-born artists, or artists of the African diaspora, whose work is shaped by the differentiating currents that swirl between contemporaneous worlds, and who continue to teach us much about them.[19]

# 9. WEST ASIA

During the twentieth century, culture in the eastern Mediterranean and the Arabian Peninsula was shaped by the decline of the Ottoman Empire and the rise to political, economic, and cultural dominance of certain European powers, especially after World War I. Great Britain controlled Iraq and Palestine, and created Transjordan within its Palestinian Mandate, while France occupied Syria and Lebanon. European cultural models —including Orientalist perspectives on the "Middle East" as an exotic domain—were introduced into the region, but with varying impact. Baghdad and Beirut became vital centers of modern art and literature, whereas Damascus proved largely resistant. During the 1930s and 1940s, Arab nationalism swept through the region, leading to the independence of Syria, Lebanon, Jordan (as it was now known), and Iraq, followed by Egypt in 1956, all of which sought to develop quasi-representative forms of secular government. Other states, such as Saudi Arabia, were formed by unifying local fiefdoms under absolute monarchies, or as confederations of kingdoms or principalities, for example, the United Arab Emirates. The oil fields controlled by many of these entities have led to great wealth, and to continuing political interest in them on the part of oil importers in Europe and the United States. Some states are seeking to shift their wealth base toward cultural tourism, often importing Western museum models as part of this effort. Others face escalating population growth, diminishing resources, ethnic conflict, and deepening division between secularist and religious conceptions of governance.

The region is the historical cradle of Islam, which has undergone a resurgence in recent decades, as many Muslims have challenged the modernizing paths taken by the countries in which they live and have sought—in varying forms, from negotiated co-existence to revolutionary fundamentalism—to bring about Islamic states that are ruled by Muslims, adopt the Qur'an as their constitution, and follow Sharia as a code of law. The region was also the birthplace of many other religions that remain vital, not least Christianity and Judaism. All of these religions, and the cultures that have emerged from them, take specific sites—often, as is the case with Jerusalem, the same ones—as their holiest places. All have had to make their accommodations with secular modernity as introduced by the European powers. For much of the twentieth century, elites in most countries embraced Western models. In the visual arts, this meant favoring easel painting, the graphic arts, and carved and cast sculpture, and European frameworks for such ancient genres as the portrait, landscape, and still life, over the applied Islamic arts and indigenous handicrafts. By mid-century, modern art movements had emerged in most countries: artists sought to depict local scenes, mobilize traditional imagery, and revitalize inherited techniques while matching the stylistic innovations of prominent European artists. Most of these efforts were tied to nationalist aspirations, yet some artists were loyal to pan-Arabic and, more broadly, Islamic visions. By the 1980s, certain artists and critics had begun to discern the emergence—first in Iraq, then throughout the region and the diaspora—of *Hurufiyah*, or a calligraphic school of art.[1]

The widespread use of words, letters, or sentences as core compositional elements in the fine arts, architecture, decorative arts, and crafts of the region reflects the pervasive vitality of Arabic calligraphy, but is rooted above all in the sacred texts of Islam, the Word of God (Allah) as revealed to the Prophet Muhammad in the early seventh century and inscribed in the Qur'an. *Huruf* translates from Arabic as "letter," *iyah* as "ism." *Hurufiyah* was first employed in the late thirteenth century as the name of a heterodox movement within the Sufi stream of Islam. Hurufis believed, among other things, that the spirit of Allah was embodied in words formed by the letters of the Arabic and Persian alphabets. As we shall see, a deep sense of the power of these sacred letters infused the work of many modern artists in Arab and other Muslim countries, serving as a means of uniting Western abstraction with the revival of a revered traditional practice, while also marking off their art as distinct within international

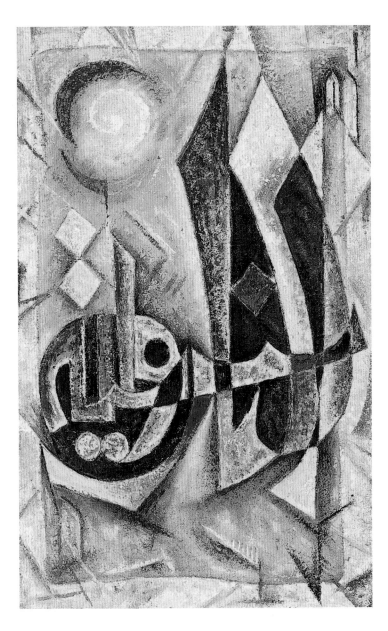

9.1 Jamil Hamoudi *People Are Equal (Al-nas Swaiya ka al-musht)*, 1976. Oil on canvas, 57 x 39⅓in (145 x 100cm). The permanent collection of the Jordan National Gallery of Fine Arts, Amman.

Modernism. At the same time, it clearly asserted a sense of Arab, or more generally Islamic, identity.[2] Its continuing relevance within contemporary art has, however, come under question, as artists—especially women artists who have directly experienced the diversity of recent and current international art—increasingly prefer to work in new media, and to seek less identarian, more individual pathways through the complexities of the present. In this chapter, I will trace these developments in some countries, taking them as representative of tendencies across the region.

## IRAQ

Madiha Omar and Jamil Hamoudi were the first artists from the region to use Arabic letters in their paintings. For a 1949 exhibition in Washington, D.C., Omar wrote a statement entitled "Arabic Calligraphy: An Element of Inspiration in Abstract Art," noting that "Each letter as an abstract image fulfills a specific meaning, and through their differences in expression these letters become a source of inspiration."[3] The

letters often refer to concepts, such as love or truth, or phenomena, such as water or light, that are immediately recognizable to Arabic-speakers as central to Islam, or as words from key phrases in the Qur'an. Often the words are assembled into a phrase, as in Hamoudi's *People Are Equal (Al-nas Swaiya ka al-musht)* (1976) (Fig. 9.1), which situates an ethical statement by the Prophet— "People are equal like the teeth of a comb"—in a refracted landscape complete with crescent moon, suggesting a space of retrospect, from which the injunction emerges like a series of sword slashes.

The most comprehensive and thoroughly theorized use of such imagery may be found in the work of Shakir Hassan al-Said. A student of Jawad Salim, pioneer of modern painting in Baghdad, he was also influenced by the work of Jean Fautrier and Jean Dubuffet which he saw while studying in Paris in the 1950s. Al-Said developed an approach to art practice that combined the central tenets of Sufism with those of *art informel*, in which the gradual obliteration of self-hood necessary to arrive at a higher truth occurs in the process of saturating the canvas with ambiguous marks, signs that, in effect, erase themselves. In *The Envious*

9.2 Shakir Hassan al-Said *The Envious Shall Not Prevail (Al-Hasud la yasud)*, 1979. Acrylic on wood, 33¼ x 48½in (84.5 x 123cm). Private Collection.

*Shall Not Prevail (Al-Hasud la yasud)* (1979) (Fig. 9.2), for example, he evokes a street wall in a city such as Baghdad: its rough plaster, random paint smears, crude scratches, and, above all, the graffiti sprayed upon its raw surface. The phrase used for its title is an Arabic proverb. While everything about the painting, including its title, evokes the transient, fading, and erasable, one also senses that this is a wall that has been marked for centuries, one that will continue to weather and to receive the traces of passing humans. To the artist, "The letter is not just a linguistic symbol. It is the only isthmus to penetrate from the world of existence to the world of thought."[4] Drawing on French philosopher Maurice Merleau-Ponty's phenomenological theories of the necessary relationships between the visible and the invisible, he proposes the concept of *al-Bu 'd al-Wahid* ("One Dimension")—that is, an art that draws the spectator through the actual surface of a painting (two dimensions), or wall (three dimensions), toward *al-abad* (the "eternal" void).[5]

Modern art in Iraq is a story of hopeful initiatives and brilliant experimentation disrupted by external intervention, internal social conflict, and war. The Ba'athist coup (1968), the Iran–Iraq War (1980–88), the first Gulf War (1991), the subsequent imposition of economic sanctions, followed in 2003 by occupation by the United States and other forces—accompanied throughout by sectarian violence—had debilitating effects on local artists, and drove many into exile. These disruptions continue, severely restricting contemporary art practice. The Baghdad Group of Modern Art, founded by Jawad Salim in 1951 with the intention of developing a modern art based on Babylonian and Assyrian precedents and medieval miniatures, contributed to the spirit of independence manifested in the 1958 revolution against British rule. Salim's bronze relief mural *Monument to Freedom*

was the outstanding artistic outcome of that moment. Since then, innovation has occurred mainly in the *Hurufiyah* paintings just discussed, and in printmaking.[6] *Dark Interludes*, a 1988 book by Kanaan Makia, attacks what the author sees as the "fictitious national and religious goals of the 1980s," over which Iran and Iraq had fought a mutually destructive war during the previous eight years. It is illustrated by Walid Siti's emphatic woodcuts, drawn while in exile in London. None contains imagery of the human figure, yet all show symbolic forms tortured by blinding light or swirling chaos. The central image in *Moonlight* (Fig. 9.3) is a tortured monument, perhaps a comment on the Victory Arch, a pair of huge sword-wielding arms erected in 1988 by Saddam Hussein at the entrance to a parade ground in central Baghdad. In Siti's print, it becomes a flailing figure, part text, part flag. Between its feet lies a gargantuan head, lopped off and fallen to the ground, while a crescent moon hovers above.[7]

## JORDAN

Master calligraphers continue to astound in finding new ways to convey the most complex thoughts and profound beliefs with striking visual economy. Jordanian artist Nassar Mansour inscribes the word *kun* ("be") in Kufic script on fine paper, highlighting its dot (used to distinguish it from similar letters) in gold (Fig. 9.4). The bold authority of the figure, its definitive shape within the flecked, imprecise white of the paper, is a powerful evocation of a phrase from the Qur'an (2:117): "and the day He says 'Be,' and it is." Kufic script (developed in Kufa, Iraq, in the seventh century and widely used until the twelfth) is also used by Paris-based Iraqi calligrapher Hassan Massoudy in an untitled work of

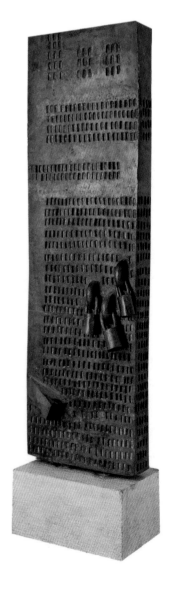

1995 (Fig. 9.5) that illustrates a line from the poetry of Waliba ibn al-Hubab, resident of Kufa in the late eighth century: "A gesture from one man to another is more noble than pearls or coral." Massoudy cites this line in red script along the lower reaches of the image, while boldly shaping in black ink the word *insan* ("man" or "person") in the main field. Quickly scraped onto the surface using ink-laden cardboard, the resultant word-image evokes both the violence of human interaction and tentative gestures of reconciliation.

The Jordan National Gallery, established at Amman in 1980 by the Royal Society of Fine Arts, was the first in the region to collect and exhibit a wide spectrum of historical and contemporary Islamic art. It has promoted artistic contact throughout the region and abroad ever since.

## IRAN

On his return from Paris in 1948, Jalil Ziapour was the first artist to introduce avant-garde attitudes to Iran. Abstract painter Marcus Grigorian, who had studied in Rome, added to this impetus, before moving to the U.S. in the 1970s and creating earthworks. From the mid-1950s, modern painting and sculpture received substantial official support, notably for the five Tehran Biennales held between 1958 and 1966. During this period a group of Neotraditionalist artists was dubbed *Saqqah–Khaneh*, the name of the water fountains ubiquitous in towns in the region and a formulation also associated with the martyrdom of Imam Husayn ibn Ali

ibn Abi Talib, grandson of the Prophet, a holy figure for Shi'ite Muslims. Outstanding among them was Charles Hossein Zenderoudi, whose vigorous deployment of sacred Shi'ite calligraphy using traditional colors within vibrantly optical settings often evoke such associations. Living in France since 1961, Zenderoudi has also made a series of etchings illustrating the Qur'an that revive ancient images and motifs, as well as paintings of texts so vivid that they parallel the innovations of Op Art.[8] Sculptor Parviz Tanavoli studied at the College of Fine Arts at Tehran University and with Mario Marini at the Brera Academy, Milan, yet his approach has more in common with the parodic aspects of Pop Art. His bronze sculptures evoke sacred words and statements but are assembled from the elements of popular and artisanal culture: machine parts, tools, and pieces of furniture found in bazaars. *Heech Tablet* (1973) (Fig. 9.6) has surface markings that recall cuneiform inscriptions from sacred texts, yet the word *heech* means "nothing" in Persian. The blocky shape evokes the heavy doors that often protect water fountains and religious structures, yet the embedded locks and flying wedge seem exaggerated.

Drawing much international attention, the Tehran Museum of Contemporary Art opened in 1977 as part of Shah Mohammad Reza Pahlavi's short-lived efforts to modernize Iranian culture. Following the 1979 revolution, politically exhortatory murals and posters became the preferred media of the visual arts. The revolutionary ferment also attracted major photographers, notably Abbas, whose *Young Woman at Anti-Shah Demonstration, Tehran* (1978) (Fig. 9.7) captures one of the period's ordinary yet archetypal moments.[9]

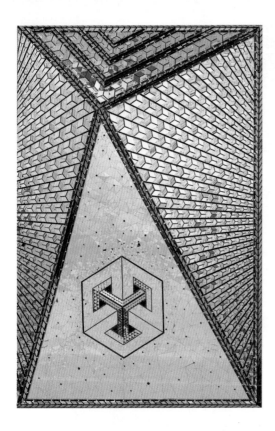

9.8 Monir Shahroudy Farmanfarmaian *Lightning for Neda*, 2009. Mirror mosaic, reverse glass painting, plaster on wood, six panels, each 118¹⁄₁₀ x 78¾in (300 x 200cm). Commissioned for APT6 and the Queensland Art Gallery Collection. The artist dedicates this work to the loving memory of her late husband Dr Abolbashar Farmanfarmaian. Queensland Art Gallery, Brisbane. Purchased 2009. Queensland Art Gallery Foundation.

The impact of this volatile legacy continues to resonate today in the work of Iranian artists both at home, such as Farhad Moshiri, and in exile, especially (as elsewhere in the region) among women artists. Born in 1924, Monir Shahroudy Farmanfarmaian studied in Tehran and then New York in the 1950s and 1960s, returning in 1957 to create works that drew on traditional forms and procedures. Exiled again after the 1979 revolution, she returned again in 2003. Her multipanel work *Lightning for Neda* (2009) (Fig. 9.8) is dedicated to a female student who was killed during the pro-democracy riots of June 12, 2009: it employs *aineh-kari*, an Iranian mirror mosaic technique, arranging thousands of cut-glass fragments into hexagonal shapes. The dazzling surfaces attract the viewer, who cannot make out a complete reflection.

Best known of the exiled artists, Shirin Neshat poignantly observes: "As an artist who has spent many years apart from her country, my art began, and has developed ever since, firstly as an excuse to reconnect to my place of origin, to keep alive that dissipating yet meaningful relationship, but most of all to face my own personal anxieties and obsessions in life."[10] She left Iran in 1974 to study in the U.S., returning in 1990 for the first of a number of visits. Neshat has since produced short films, usually presented as double- or multi-screen installations, that constitute an extraordinarily affecting evocation of the inscriptions of power, tradition, and institutionalized religion on the bodies, behaviors, and psyches of women and men in patriarchal cultures.

*Fervor* (2000) (Fig. 9.9) dramatizes three occasions on which the eyes of a man and a woman meet. After a chance encounter in the street, the pair see each other again in a hall where a sheet divides the sexes, yet the woman can look up to meet the gaze of the man who, standing on a podium, narrates the Qur'anic tale of Zuleikha and Yusuf (Potiphar's wife and Joseph in the Hebrew Bible). A famous and much-loved story of seduction, it is accompanied by warnings against temptation. The woman flees in confusion, the man follows, they meet in an open space but do not speak or touch. The film ends with them turning away from each other.

Neshat's most fully realized project to date, *Passage* (2001), is a dramatically compelling yet subtle meditation on the interplay between life and death. Beginning calmly, the camera pans over a rocky seashore. Gradually, from over a far horizon, a phalanx of black-clad men comes into focus; they hurry forward yet their purpose is unclear until we glimpse a shrouded corpse. Cut to a group of chador-clad women who, wailing, dig a hole in the stony desert with their bare hands. The music of U.S. Minimalist composer Philip Glass accumulates onrushing sounds, driving the action ever faster, until the men deliver the body to the women. At this point, fire sparks and spreads around a stone arc. In the final scene—illustrated as one of a series of photographs based on stills from the film—a small girl, her back to the camera, watches from the cairn that she has, playfully, just built. *Passage* allows us to act as witnesses to the most elemental of burial rituals. It acknowledges that, from time immemorial, men and women have taken (or been assigned) different roles in such rituals, but suggests that both have their importance in them—one that, in the end, is equal. It shows us that the trauma of mourning is, perhaps, best undergone collectively, and publicly—no matter where in the world it occurs. In the video *Passage*—Neshat also created a series of photographs entitled *Passage Series* drawn from scenes in the video (Fig. 9.10)—these truths are placed before us, not as closed statements or soft platitudes, but as self-evident performances of elemental actions, becoming thereby an open-ended offering.[11]

9.9 Shirin Neshat
*Fervor*, 2000. Gelatin
silver print, 66 x 47in
(167.6 x 119.4cm).
Courtesy of Gladstone
Gallery, New York.

9.10 Shirin Neshat
*Passage Series*, 2001.
Cibachrome print,
42 x 63⅛in (106.7 x
160.3cm) framed.
Courtesy of Gladstone
Gallery, New York.

9.11 Afshan Ketabchi
*Self-Portrait*, 2004.
Digital print on canvas,
2 of 7 editions, 59 x
47¼in (150 x 120cm).
Courtesy of the artist.

*j'ai toujours mal a me trouver
un endroit pour me concentrer*

it's always difficult for me to find
a place where I can concentrate

9.12 Ghazel
*Toilet*, still from video
installation from
the ongoing series
*Me*, 1997–2000.
Courtesy of the artist.

9.13 Shirazeh Houshiary
*Fine Frenzy*, 2004.
White and black
aquacryl, white pencil
and ink, 75 x 75in
(190 x 190cm). Courtesy
of the artist and Lisson
Gallery, London.

Other Iranian artists have explored these issues, and continue to do so, some while remaining in Tehran, others while living abroad. These include Shadi Ghadirian, who shows herself posing in photographer's studio settings, clad in a qajar (the traditional costume of the earlier dynasty of the same name) yet holding modern objects such as a ghetto-blaster, and Afshan Ketabchi, whose four-stage *Self-Portrait* (2004) [Fig. 9.11] shows her transformation from wearing the veil to Andy Warhol-style glamor queen. Cartoonist and filmmaker Marjane Satrapi chronicles her own life in comic strips, collected into books, notably *Persepolis*, which covers her adolescence in Tehran and her coming to maturity in Europe; it was made into an animated film, co-directed by Satrapi, in 2007.[12] In her video series *Me* [Fig. 9.12], 1997–2000, part of an ongoing series and now comprising over 700 scenes, performance artist Ghazel parodies both Islamic dress codes and the typical tropes of Conceptual Art by performing a number of actions based on commonsense sentiments while dressed in her chador.[13]

Shirazeh Houshiary has lived and worked in London since 1979. The densely packed surfaces of her paintings are major contributions to the wide stream of Late Modernist Minimalism, yet they also draw on the vibrant calligraphies of her countryman Hossein Zendouroudi, and the Sufic ambiguities of Iraqi abstractionist Shakir Hassan al-Said. Her procedure in paintings such as *Fine Frenzy* (2004) [Fig. 9.13] is to write one undisclosed word again and again—in black and then white ink, spiraling its dark shape toward the light center of the canvas—then over and over until it obscures itself. The artist then sands the surface, further erasing the words yet all the while building up richer layers of implied meaning. This repetitive, cumulative approach is akin to chanting sacred texts, to the process of evoking the presence of the sacred within the secular or, more deeply, the spiritual within the material. And vice versa, because Houshiary is by no means concerned with a one-way traffic out of this world. In remarks very relevant to *Fine Frenzy*, she cites the great Persian poet Rumi: "We come spinning out of nothingness, scattering stars like dust," and says of her methods: "The word 'reveal,' understood in its fullest sense, means at the same time to remove and to veil, that is, it designates a double, and contrary movement," and "The word loses its meaning and form is born from this."[14]

## PALESTINE

Art in Palestine may be regarded as evolving through three phases during the past century. During the first, traditional practices (Christian icon painting, Armenian pottery, *fellahin* embroidery) were pursued alongside studio arts taught, since 1906, at the Bezalel School of Arts and Crafts, Jerusalem, mostly to Jewish settlers.[15] In 1948, the State of Israel was founded, an event that precipitated what Palestinians call the *Nakba* ("catastrophe") because it was accompanied by the destruction of hundreds of Palestinian villages, the disintegration of traditional society, and the dispersal and exile of hundreds of thousands of Palestinians from many urban

9.14 Tina
Malhi Sherwell
*Map of Palestine*, 1990.
Mixed media and fabrics.
Courtesy of the artist.

9.15 Kamal Boullata
*Light upon Light*
(*Nur 'ala nur*), 1982.
Screenprint on paper,
30 x 22in (76.5 x 56cm).
The British Museum,
London, 1997 7-16
03. Brooke Sewell
Permanent Fund.

9.16 Mona Hatoum
*Measures of Distance*,
1988. Color video, sound,
15 mins. A Western
Front Video Production,
Vancouver. Courtesy of
Alexander and Bonin,
New York.

neighborhoods in historic cities to camps and cities in nearby countries and further abroad. These exiles included many artists, whose work engaged with modern themes and techniques in order to update traditional Arabic imagery or suggest states of embattled nationality. Since then, local and regional warfare has erupted constantly, Israeli settlements have honeycombed Palestine, walls have been built between territories (then been decorated with murals, some obfuscating, others critical), internal differences within both Israel and Palestine have generated inconsistency and conflict, while international efforts to establish peaceful relationships have failed again and again. This situation is portrayed in the confused, multilayered patchwork of Tina Malhi Sherwell's *Map of Palestine* (1990) (Fig. 9.14). In recent years, certain artists, notably Mona Hatoum, have emerged as major figures within international contemporary art circles, indicating a broader engagement with global conditions of contemporaneity.[16]

Post-*Nakba* artists were deeply affected by the experience of displacement (*ghurba*) and the challenges of creating a national culture in conditions of extreme adversity. Ismail Shammout's oil paintings chronicled the enforced exile (*manfa*) of ordinary Palestinians through empathetic narrations, while Sliman Mansour created compelling symbols of endangered heritage in a variety of styles and media. Palestinian artists such as Paul Guiragossian, Juliana Seraphim, and Ibrahim Ghannam (Ibrahim Hassan Kheite) contributed significantly to the emergence of a vibrant art scene in Beirut. Meanwhile, in the contested territories, efforts to create an inclusive, democratic society within Israel took many forms, including the artists' colony established by Romanian Dadaist Marcel Janco in the village of Ein Hod.[17]

Kamal Boullata is perhaps the outstanding artist of the subsequent generation of Modernists-in-exile. His paintings of the 1960s owe much to Italian abstract painting, notably the heavy textures of Alberto Burri. Frequently in Beirut—then the center of Modernist innovation in the Arab world—Boullata found himself cut off from Palestine when the 1967 war broke out. He subsequently went to the United States, where he

worked for 30 years, then moved to Paris, Morocco, and Medon, in the South of France, where he still lives. During those years, he worked primarily in portable media, especially silkscreens and artist's books. He developed a distinctive style, merging the high-contrast colors and visual dazzle of European Op Art with the compositional geometries of Islamic calligraphy and decorative design. *Light upon Light* (*Nur 'ala nur*) (Fig. 9.15), for example, a silkscreen of 1982, succinctly embodies a core concept from the Qur'an: "Light upon light, God guides whom He will to this light" (24:35). The artist comments: "Throughout the 1980s, I have been alternately using verses from Christian as well as Muslim sources where the word 'light' occurs. Having been raised in a Jerusalem Christian Arab family I felt free to borrow words from the Holy Qur'an and from the Sufis as well as from the Gospel of St. John and from Church liturgy where the word appears. Light has been central to my work and still is."[18]

Dreams of harmony, even on a symbolic level, seem to have all but vanished from contemporary Palestinian art. This reflects the long years of war, successive *intifadas* ("revolts"), and the experience of seemingly endless exile. Two generations of Palestinians remain suspended in states of dislocation. Mona Hatoum has explored the inner conflicts of displacement since the mid-1980s. Daughter of Palestinian exiles to Beirut, she found herself in London when the Lebanese civil war of 1975 broke out. Art historian Gannit Ankori describes her situation: "Negotiating between three countries (Palestine, Lebanon, England), none of them her 'real' home, and between three languages (Arabic, French, English), Hatoum struggled to find her place, to find her voice. Her vehicle for self-expression was a self-created 'dialect' composed of an amalgam of body language and the language of art. In this language she became masterfully fluent."[19]

Her major work from this period is *Measures of Distance* (1988) (Fig. 9.16), a 15-minute video in which photographs of the artist's mother taking a shower are glimpsed through a veil made up of lines from letters written to her daughter in Arabic. The sound

9.17 Yazan Khalili
from the *Camp* series,
2007. Color correction
#2, 2010. Digital
photographic print,
39⅓ x 24in (100 x 61cm).
Courtesy of the artist.

9.18 Emily Jacir
*Ramallah/New York*,
2004–05. Two-channel
video installation.
Courtesy of Alexander
and Bonin, New York.

component is similarly doubled: lively, happy-sounding chatter in Arabic between the two women is interrupted by the artist reading, in a sober manner, an English translation of her mother's letters. A typical passage is as follows:

> You say you can't remember that I was around when you were a child. Yes, things were different for your sisters, because before we ended up in Lebanon we were living in our own land… with our family and friends around us always ready to lend us a hand. We felt happy and secure and it was paradise compared to where we are now. So if I seemed to be always irritable and impatient, it was because life was very hard when we first left Palestine. Can you imagine us having to separate from all our loved ones, leaving everything behind and starting from scratch, our family scattered all over the world, some of our relatives we never saw again to this day? I personally feel as if I have been stripped naked of my very soul. I'm not just talking about the land and the property we left behind, but with that, our identity and sense of pride in who we were went out the window. Yes, of course, I suppose this must have affected you as well, because being born in exile, in a country that does not want you, is not fun at all. And now that you and your sisters have left Lebanon, you are again living in another exile in another culture that is totally different from your own. So, when you talk about a feeling of fragmentation and not knowing where you really belong, well, that has been the painful reality for all our people.[20]

The interplay of voices and visual/written imagery is deeply affecting. A strong sense of intimacy is established by the mother's nakedness—so rare in Arabic cultural contexts, and hardly less exceptional in the West, where images of aging bodies are seldom seen. Intimacy is reinforced by our uncomfortable awareness that we are witnessing the working out of a fraught family relationship. For all of its specificity to the lives of these two individuals, both of them know (and we learn) that their sufferings, and their occasional joys, are part of a larger story.[21]

Other Palestinian artists have returned from exile. These include Khalil Rabah, whose performances and installations reflect his Christian Druze inheritance, and imply that contemporary experience is a kind of perpetual martyrdom. Large numbers of Arabs—including artists such as collagist Asad Azi and painter Asim Abu Shaqra, whose brief career focused on reclaiming the *sabra* (a local cactus plant) as a symbol of Palestinian dispossession and resistance—live within the territory of Israel.[22] Women artists are increasingly drawn to symbolic imagery of sexual difference.[23] Some artists from

elsewhere in the region have moved to Ramallah, the capital of Palestine: these include photographer Yazan Khalili, whose *Camp* series (2007) (Fig. 9.17) acutely registers the hybrid architectural forms—densely stacked dwellings, TV satellite dishes, solar panels—generated in these supposedly temporary yet actually long-term settings. The artist notes: "Here I'm dealing with the Al-Amari Refugee camp, located inside/beside/outside Ramallah city… Changing the camp's colors is a symbolic act to fill the loss—like a child filling a coloring book—and produce the possibility of hope."[24]

Emily Jacir, a third-generation exile and U.S. resident, created a double-video installation, *Ramallah/New York* (2004–05) (Fig. 9.18), that juxtaposes fixed-camera recordings of shops, public places, and domestic spaces in the two cities, each carefully chosen so that any indications of locality are scarcely distinguishable. She says of this work:

> *Ramallah/New York* was shot in 2004 and is informed by my experience of living in between Ramallah and New York for the last six years. The video, a kind of experimental documentary, interweaves travel agencies, hairdressers, delis, shwarma shops, and arghile bars, while recording the movements of people to and from both sites. It records the spaces in between war, exile and destruction, and preserves another history—the resistance of everyday life. It is a record of local, public and daily exchange in both sites and between them. It is a document of a specific time that begins with personal exchanges from daily life as opposed to the official representations and narratives of history, CNN or Al-Jazeera. It examines both the safety and familiarity of interiors as well as their entrapment and claustrophobia. It is my homage to the transcendence of spaces beyond official or recognized borders or actual sites.[25]

As Edward Said acutely remarked: "Her compositions slip through the nets of bureaucracies and nonnegotiable borders, time and space, in search not of grandiose dreams or clotted fantasies but rather humdrum objects and simple gestures like visits, hugs, watering a tree, eating a meal—the kinds of thing that maybe all Palestinians will be able to do someday, when they can trace their way home, peacefully and without restriction."[26]

## ISRAEL

Prior to 1948, Jewish artists living in Palestine (known by them as *Eretz Yisrael*, "Land of Israel," a homeland to come) applied Realist, Expressionist, and Modernist styles and techniques to the depiction of local landscapes and themes from the Hebrew Bible, then, in an effort to demonstrate a historical link to the land, sought inspiration in ancient Canaanite mythology

and culture. By the late 1940s, groups such as New Horizons had turned to the abstract modes emerging in Europe, seeking in them ways of creating a modern artistic identity for the new state, especially in new cities such as Tel Aviv. Others settled abroad, some returning often: Yaacov Agam (Yaacov Gipstein), based since 1951 in Paris, became a leading figure in kinetic art. Constant war and social fragility led most Israelis to seek solace from disturbing realities in art. In the 1970s, however, certain individual artists expressed their dissent from aggressive nationalism through their art, while others, such as Joshua Neustein and Zvi Goldstein, embraced the political possibilities of Conceptualism.[27] Israel remains internally riven by antithetical national imaginaries ranging from socialist collectivism (*kibbutzim*) to ultra-orthodox religious exclusivism (*Haredim* or *Chareidim*), and by political differences about how to respond to its embattled situation within a region in which it is surrounded by hostile neighbors. These conflicts are especially acute in its relationships with Palestine and, to a lesser extent, Syria, certain historic territories of which it occupies. Israeli artists, like their fellow citizens, are acutely aware of the volatility of this situation. Its characteristic tensions inspire a number of photographers, notably Pavel Woldberg, Rina Castelnuovo, Leora Laor, and Barry Frydlender, but are perhaps being most vividly explored by artists, especially women, who use both the documentary and symbolic potentialities of video.[28]

Tel Aviv-born Michal Rovner studied photography at the local university and at the Bezalel Academy of Art and Design, then moved to New York in 1983. In the Israeli Pavilion at the 2003 Venice Biennale, she showed a two-part installation, under the general title *Against Order? Against Disorder?* In the first, laboratory-like space, *Data-Zone*, Petri dishes were placed on rows of tables. Each dish was actually a video screen showing humanoid figures as if they were nano-organisms seen through a microscope. The tiny figures frantically attached and divided in the manner of X and Y chromosomes: it seemed as if one were seeing male and female cells coming into being. Then, in a second, darkened room, *Time Left* (Fig. 9.19), large wall screens featured row upon row of dark figures marching resolutely toward… ever more meaningless yet seemingly inevitable, self-obliterating conformity. Since then, Rovner has worked on a series of constructions entitled *Makom* (*Place*) that employ cast-aside or war-destroyed stones from both Palestinian and Israeli houses. Each item is carefully documented according to archeological procedures. A building is then erected, using traditional techniques of nonmortar assembly but designed according to random principles intuitively imagined by the artist. These dwellings are impenetrable and, as yet, uninhabitable.[29]

This current generation of Israeli artists tackles these themes of dislocation and multiple identities straight on. Sigalit Landau states: "I explore displacement in sculpture and installation; in the way that I use materials, ready-mades, places and stories, in the way I perform with and towards them. I attempt to personally understand social and psychological sub and meta structures, physically (via architecture and my body) and politically (via true narratives)."[30] Her performance for the video *Barbed Hula* (2000) (Fig. 9.20) takes place at sunrise on a Mediterranean beach. Shot in a vacation-movie style, it tracks the scarring of her naked body by a barbed-wire Hula-Hoop. A bather walks by, indifferent. Like many of her generation, Landau studied abroad, in her case at Cooper Union, New York, before returning to Israel. "When you are always at the center, you live in a valley… When you live on the periphery, you're on a mountain. It gives you perspective."[31]

Yael Bartana left a country she found consumed by a siege mentality to live in New York's East Village in the 1990s, before studying at the Rijksakademie, Amsterdam. Since 2000, she has made return visits to Israel. *Summer Camp* (2007) splices footage from Helmar Lerski's 1935 film *Avodah*, which celebrated the building of villages in Palestine by Zionist pioneers, with documentation of the current actions of the Israeli Committee Against House Demolitions (ICAHD), an organization dedicated to rebuilding Palestinian homes destroyed by Israeli forces in the West Bank. Her implication (in common with Rovner) is that it is the young Israelis who are seeking to share the land with Palestinians, and to create an equitable society for all the region's inhabitants, who most truly carry on the progressive spirit of those who, in the early twentieth century, arrived in Palestine believing that "We came to build and to be built." In *Dreams and Nightmares* (*Mary Koszmary*) (2007) (Fig. 9.21), a film commissioned by the Foksal Gallery Foundation, Poland, a young man (played by leftist author, editor, and politician Slawomir Sierakowski) passionately declaims: "Let the 3,000,000 Jews that Poland has missed… return to Poland, to your country." As the camera pans around him in a style deliberately evocative of Leni Riefenstahl's famous Nazi propaganda film *Triumph of the Will*, the dilapidated stadium in which he is speaking appears. It is nearly empty, except for some Boy and Girl Scouts, who use chalk to stencil the slogan "3,000,000 Jews can change the lives of 40,000,000 Poles" on the sparse grass. It is one of the tragedies of our time that the speaker's diagnosis—"With one language, we cannot speak; with one religion, we cannot listen; with one color, we cannot feel"—applies as acutely to Israel and Palestine today as it did to Europe in the middle of the twentieth century, and that it does so to many parts of Europe and elsewhere in the world as well.

These artists, along with many others in Israel today (such as installation artist Irit Batsry), have much in common with other artists from the region, and expatriates living elsewhere in the world. Ghada Amer—born in Cairo, raised in France, studied in England, and now resident in New York—is committed to feminizing the practice of painting by sewing repeated motifs into blank canvas before beginning to apply paint. Motifs have included dictionary definitions of the words "love" and "pain," illustrations of women at work, the texts of

9.19 Michal Rovner
*Time Left*, 2002.
Video installation,
26¼ x 26¼ft (8 x 8m).
Installation view, 50th
Venice Biennale, Venice,
Israeli Pavilion, 2003.

9.20 Sigalit Landau
*Barbed Hula*, 2000. DVD,
1 min. 52 secs. Courtesy
of the artist.

9.21 Yael Bartana
Stills from *Dreams
and Nightmares
(Mary Koszmary)*, 2007.
16mm film transferred
to video, 10 mins.
50 secs. Courtesy of
Annet Gelink Gallery,
Amsterdam, and
Foksal Gallery
Foundation, Warsaw.

9.22 Ghada Amer
*The Line (La Ligne)*, 1996.
Embroidery and gel
medium on canvas, 70
x 64in (177.7 x 162.5cm).
Courtesy of the artist
and Cheim & Read,
New York.

9.23 Walid Raad
*Notebook Volume 38:*
*Already Been in a Lake*
*of Fire Plates 55/56*, 1991.
Color photograph, 11¾
x 15¾in (30 x 40cm).
Attributed to Dr. Fadl
Fakhouri. Courtesy of
Paula Cooper Gallery,
New York.

9.24 Youssef Nabil
*Big, Bright Shining Star,
Self-Portrait, Madrid,*
2002. Handcolored
gelatin print, 10¼ x
15⅓in (26 x 39cm).
Courtesy of the artist.

Arabic love poems, and pornographic images of women (Fig. 9.22). From 1994 to 2004, New York-based artist Walid Raad produced works under the name "The Atlas Group" which purported to document, through photographs, handwritten and printed texts, and videos, the conflicts that have engulfed his native land, Lebanon (Fig. 9.23). In fact, his fictive photo albums, altered photographs, misleading records, and absurd lists (colors of all the cars used as bombs between given dates) showed the limits of all attempts to write accurate and coherent histories of such complex and contested events. Young Egyptian artist Youssef Nabil photographs himself standing forlorn against what seem to be glimpses of famous cities, expressing his longing to be immersed within them, and to be a famous international artist (Fig. 9.24). Cairo, in fact, is his constant backdrop.

## FROM *HURUFIYAH* TO CONTEMPORARY COSMOPOLITANISM

This survey has suggested that, for much of the twentieth century, artists in the region (especially in those parts with a colonial presence) embraced many of the modernizing values, practices, and technologies that had been developed in European countries and, later, also looked to the United States. Within this framework, they sought ways of reanimating ancient imagery, traditional techniques, and local materials, sometimes producing awkward hybrids, at others distinctive and persistent Modernisms—for example, the *Saqqah–Khaneh* tendency in Iran since the 1960s, or *Hurufiyah* among the Iraqi, Lebanese, and Palestinian diaspora and in Jordan since the late 1970s. Contemporary work by artists from the region shares some of these characteristics, but is also the product of their geographic mobility (often exile due to political, religious, or economic considerations), their openness to a wide range and greater mix of art media, and their responsiveness to the accelerating complexities of global contemporary life. Like contemporary artists everywhere, they appropriate visual imagery already in use in the cultures of interest to them, but do so in critical, often subversive ways, asking us to question stereotypes, to resist conformity. This often brings them into conflict with their places

of origin. It is striking that the majority, and the most inventive, of these artists are women. This suggests the emergence of a distinct feminism in the region, and among its peoples' diasporas.

Glenn D. Lowry, director of the Museum of Modern Art, New York, and an Islamic art expert, argues: "In a fluid and global environment where technology collapses borders and physical distances are moot, these artists can, in theory, practice anywhere they want. In reality, given the conservative nature of many Islamic countries—with their restrictive policies concerning freedom of expression, political activism, nudity, sex, religious debate, and homosexuality, among other social and political issues—they offer difficult, even impossible environments for artists who make challenging art." He goes on to observe: "Their work operates in a unique psychological and metaphorical space, fraught with the tensions and contradictions that characterize Islam today. By neither confining themselves to making art that addresses only Islamic issues nor denying the importance of Islam in their work, these artists resist definition."[32] Singular definition, that is. It is a marker of their contemporaneity that their art is alert to the simultaneous presence of not just two but a multiplicity of different, often incompatible beliefs, attitudes, and cultures. These artists are not simply angry, alienated exiles, nor are they émigrés who have assimilated elsewhere. On the contrary, they are constantly drawn back to their countries of origin, and to their early religious beliefs, yet see them now as elements within a larger, cosmopolitan—even planetary—circulation that must confront complexity everywhere. Muslim communities living in Europe, the United States, and throughout Asia are very much part of this connectedness, yet, since the attacks on the U.S. in 2001 and subsequently on London and Madrid, majority suspicion of them has increased. To counter such attitudes, resources are flowing to support infrastructural development aimed at promoting a more positive image, and a higher degree of cultural exchange: these range from an Islamic Art wing at the Louvre Museum, Paris, to an I.M. Pei-designed Museum of Islamic Art in Doha, Qatar.[33] On the less formal, but ultimately more vital, level of artist-to-artist exchange, there are some signs that the work of the cosmopolitan exiles is influencing artists and others within their countries of origin.

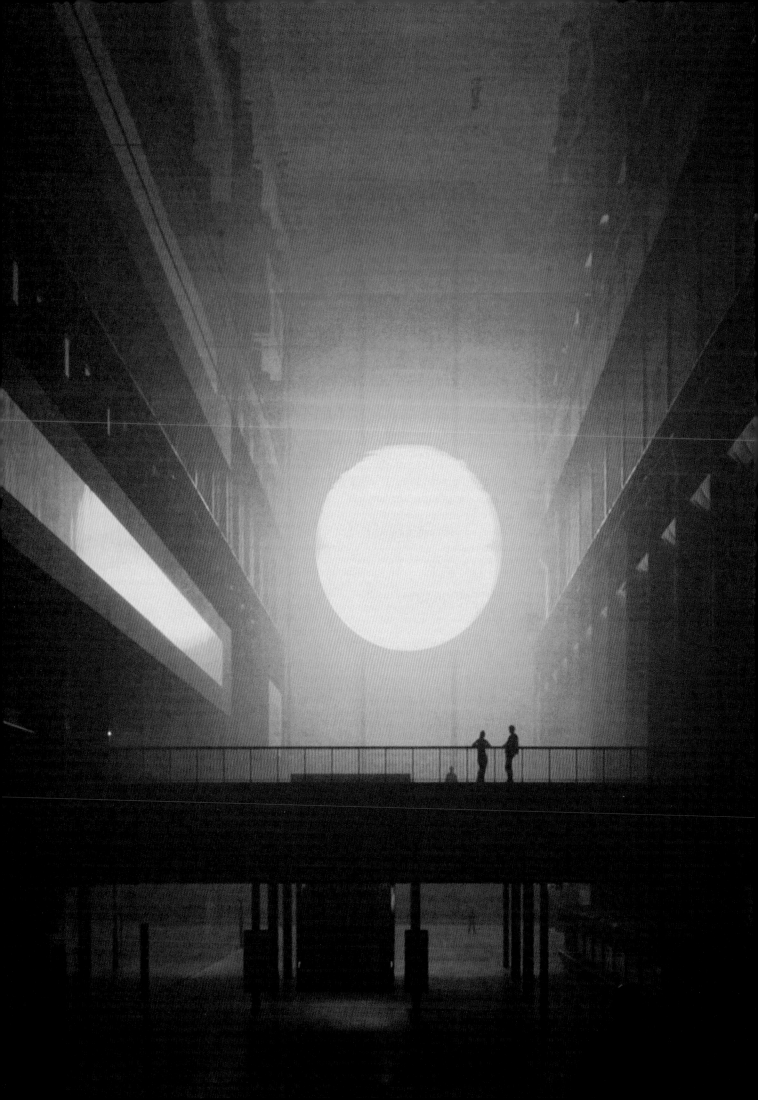

# CONTEMPORARY CONCERNS

# PART III: CONTEMPORARY CONCERNS
## INTRODUCTION

In the first two parts of this book we traced the evolution of art within the various regions of the world, noting that modern art often had a key role in the cultural construction of national narratives—themselves usually devoted to the expurgation of tradition in the name of modernization, or, more recently, to the revival of selected traditional practices in the name of a modified, local modernization. Contemporaneity entered the picture when local practitioners became aware that art in the relevant metropolitan center had accelerated its innovative thrust, especially when the implications of the great changes in EuroAmerican art of the 1960s and 1970s began to sink in. Struggles for liberation and subsequent processes of decolonization made African artists, for example, more aware of the potentialities and limits of this relationship. The abrupt opening of closed societies in Central and Eastern Europe around 1980 made other models of Modernism available, but also exposed artists to the repressed and forgotten innovations of their local avant-garde predecessors. In recent years, it is the contemporaneity of international contemporary art that is having the strongest effect: artists everywhere are much more aware of what their contemporaries elsewhere are doing, learn of it much more quickly, and seem much more interested in and open to it, than ever before.

On the level of artistic form, everything has changed from the craft- and studio-based practices that underlay modern art, although of course these persist in the wider communities beyond those associated with the leading edges of professional contemporary art—in many art schools, art societies, clubs, and community associations. The transformational changes precipitated during the 1950s and 1960s, especially those that made late modern art contemporary (see Chapter 1), have themselves been transformed by the broad currents we have been tracing: by Postmodernism, Retro-Sensationalism, and Remodernism during the 1980s and since in Euro-America (see Chapter 2), and by the transnational turn emergent from the rest of the world (see Part II).

These changes have meant that the most recent current in contemporary art is in the process of becoming different in kind from those so far discussed in Parts I and II. This is the outcome, largely, of a generational change and the sheer quantity of people attracted to active participation in the image economy. We had glimpses of it toward the end of each chapter in the previous section, when we discussed the work of the youngest artists, especially those who live internationally, as artistic cosmopolitans, with all the conflicts and challenges that we have noted. Looking at their work from a broader perspective, we can see that it is developing features that distinguish it from that of their predecessors, who are, simultaneously, their older contemporaries. In marked contrast to the generality of statement and monumentality of scale that has increasingly come to characterize Remodernizing, Retro-Sensationalist, and Spectacular Art, and the conflicted witnessing via symbolic form that continues to be the goal of most art consequent on the transnational turn, this newest work usually takes the form of quite personal, small-scale, and modest offerings of materials or processes marked with the traces of suprapersonal forces, these being presented, mostly, as tokens of subjective feeling ("affect").

Younger artists certainly continue to draw on elements of the first two currents, but with less and less regard for their fading power structures and styles of struggle, and with more concern for the affective and interactive potentialities of various material media, virtual communicative networks, and open-ended modes of tangible connectivity. Their radar of operations—their politics, in a word—is, for the most part, lower and more lateral yet also more networked than the global perspectives that exercise transnational artists, and is indifferent to the generalizations about art itself that remain important for the Remodernists. Working collectively, in small groups or loose associations, or individually, these artists present works that seek to arrest the immediate, to grasp the changing nature of time, place, media, and mood today. They make visible our sense that these fundamental, familiar constituents of being are becoming, each day, steadily stranger. They raise questions as to the nature of

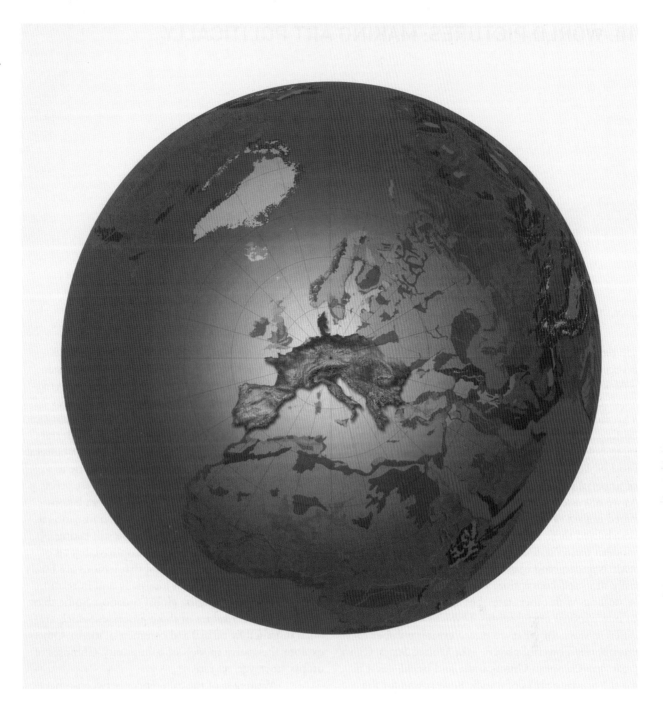

temporality these days, the possibilities of place-making vis-à-vis dislocation, about what it is to be immersed in mediated interactivity, and about the fraught exchanges between affect and effect. Within the world's turnings, and life's frictions, they seek sustainable flows of survival, cooperation, and growth.

We will explore these developments in the remaining chapters, concentrating on three tendencies or perspectives.

*Chapter 10: World Pictures: Making Art Politically*, in which we will examine the work of artists living in EuroAmerica who have responded to the transnational turn, and the work of artists—many from previously colonized societies—who live and work internationally, in a worldly fashion.

*Chapter 11: Climate Change: Art and Ecology*, in which we will trace the evolution of art from Land Art through a rising awareness of threats to the natural world to the current state of concern about the viability of interactions between nature, industrial and urban societies, and virtual domains—that is, planetary consciousness.

*Chapter 12: Social Media: Affects of Time*, in which we will explore the changes in the sense of selfhood being experienced by all of us as our lives become more thoroughly mediated by new technologies, competing models of desirable forms of life, and changed relationships to time.

# 10. WORLD PICTURES: MAKING ART POLITICALLY

*"All the lives we could live, all the people we will never know, never will be, they are everywhere. That is what the world is."*
—Aleksandar Hermon, *The Lazarus Project* (2008)[1]

This chapter will focus on the role of geopolitical critique in the work of a number of artists based in the metropolitan cities of Europe and the United States, most of which were, some for centuries, the capitals of imperial networks, the centers of economic empires. As we discussed in the General Introduction, the combined impact of decolonization and globalization has destabilized these patterns of geopolitical power. The modern nation state has been obliged to understand itself as undergoing massive transformation, both internally, in its self-conception, and externally, not only in its dealings with other states, but also in its relationships to international organizations. This is as true, albeit in different ways, for what are now a greater number of enormously powerful players—the United States, China, Japan, the European Union, India, and Brazil—as it is for the growing ranks of middle powers, and for the also expanding congeries of poor countries. What each nation does becomes quickly known around the world, and can have global consequences. Equally, no nation, however large or small, can shield itself from global economic, political, technological, and cultural currents. The very idea of what a "nation" is is changing, too fast for us to imagine what forms it will take in the years to come. We can, however, be certain that it will be an idea about an entity deeply entangled within a larger world picture.

As is the case with other citizens, each artist's relationship to nationality, and to the affiliations open within emergent international networks, becomes an important aspect of his or her sense of identity and his or her art's purpose. While some are descendants of long-established families, many have parents or grandparents who were migrants. An increasing number are themselves recent immigrants to these centers. Some live in involuntary exile, others maintain a more voluntary separation. Most maintain various degrees

of contact with their "home" cultures. These artists are often referred to as members of an African, Asian, Latino, or other diaspora. Yet as global interconnectedness increases, and the trafficking between cultures becomes more complex, more a union of mutuality and dependence, this model—with its associations of the random dispersal and continual weakening of a cultural (or often racial) essence—becomes less accurate as a description of the state of affairs. Instead, these artists enjoin us to envisage a world after the degradations of colonialism, a world that has become transnational. These artists are aware that changes are still taking place, that the legacies of colonization have left all of us in a postcolonial situation, and that nations are busily reinventing themselves both internally and in relation to the constantly changing global situation. Some draw attention to the realities of these processes, which are often disguised by official and commercial media. Others explore alternative models of community. Glimpses of utopia, however, are rare.

Awareness of the differences between others and ourselves, diverse observable variants within what we all seem to share, is arguably more of a factor in contemporary life than at any time before. Certainly, due to the unprecedented spread of communication systems, to their accelerated speed and intensity of image, it is a key element in the lives of many more of us. In this sense, we are all contemporaries, more so than ever before. This can increase divisions among us, yet it also has the potential to deepen mutual respect. The economic, political, and ideological fragmentation explored in the previous chapters is just part of the evidence that building respect has, in contemporary conditions, become increasingly difficult. It requires, at minimum, a better understanding of contemporaneity —the ability to think and act, simultaneously, in three registers: across the global sweep of the world picture, within the place-specific domain of the local, and through the subtle skeins of connectivity between these two. We have seen already how many contemporary artists, those located in national and regional cultures

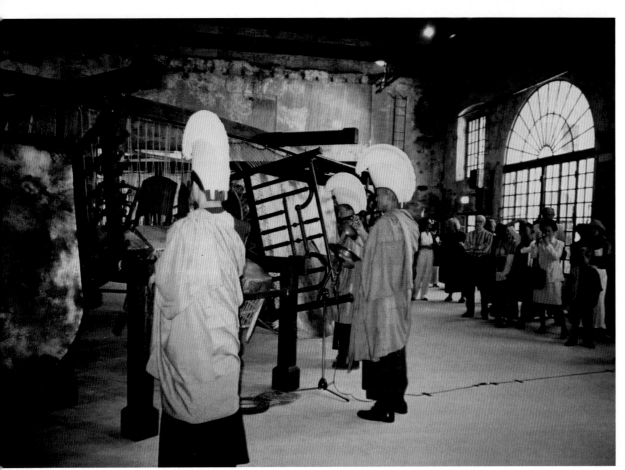

10.1 Chen Zhen
*Jue Chang, Fifty Strokes to Each*, 1999. Installation, wood, iron, chairs, beds, leather, ropes, nails, various objects, 96 x 386 x 393¾in (244 x 980 x 1,000cm). The 48th Venice Biennale, Venice, 1999. Courtesy of Annie Wong Art Foundation, Hong Kong.

that are in transition, have responded to this need. They offer a variety of ways of imagining these registers, and many kinds of suggestion as to how we might act within them. In this chapter we explore contributions to this effort by certain exemplary artists who are currently based in the older metropolitan centers, and those who work actively between these and emerging centers.

## ONE WORLD

In the 1990s, Chen Zhen, a Chinese artist resident in Paris, made a number of works that recycled the wastes of the Western world—its garbage and its instantly redundant information systems. The pulped remains of the *New York Times* and *Le Monde* became preserved ruins. Other installations consisted of ordinary household settings saturated with mud: the implication is that rampant developmentalism in China reduces its past to frozen archeological sites. Concerned about the health of the planet, and realizing that imagined solutions needed to transcend national boundaries and the limits of ideologies, Chen Zhen articulated in 1998 a condition that he shares with many of his generation: "transexperience" (*rong chao jing yan*): "Transexperience also represents a concept of art. This is not a purely conceptual notion: rather, it is an impure experiential concept, a mode of thinking and method of artistic creation that is capable of connecting the preceding with the following, adapting itself to changing circumstances, accumulating experiences year-in and year-out, and

being triggered at any instant. Furthermore, this type of experiential concept relates to an extremely important matter—becoming immersed in life, to blend and identify oneself with others." This is a condition open to everybody in the world today, as the artist went on to note that it is "a type of 'cultural homelessness,' namely, you do not belong to anybody, yet you are in possession of everything. This type of experience itself constitutes a world of its own."[2]

Chen Zhen's most effective artistic realization of this idea was the installation *Jue Chang, Fifty Strokes to Each* (Fig. 10.1), in which chairs and beds were hung from a solid wooden frame, covered with hide, and thus transformed into drums on which viewers were invited to beat. Created for the Tel Aviv Museum of Art in 1998, when the peace process in the region had stalled, it was then installed at the Venice Biennale in 1999. *Jue chang* means "the peak of poetic perfection"; 50 strokes on the buttocks of all parties to a dispute is a Buddhist way of settling conflict. In *Jue Chang, Fifty Strokes to Each*, Chen Zhen combines the two ideas: drummers are not beaten, nor do they do violence to others. Rather, viewers become participants who enact a spiritual cleansing (the artist calls it "drumming an awakening into the mind") *together*. By making music side by side—a collection of different percussion instruments invites the creation of shared sound—conviviality is brought into being as a voice unscripted, and more resonant than its individual parts. "Hopefully… *Jue Chang* will travel around the world, beaten, struck and drummed by all people," the artist has said.[3]

Not all visions of the outcomes of globalization are as optimistic as Chen Zhen's. Some artists emphasize the continuing negative legacies of colonization, especially in regions of the world where states and societies have been unable to negotiate economic independence. At Documenta 12, German artist Dierk Schmidt presented a suite of 21 acrylic paintings entitled *The Division of the Earth: Tableaux on the Legal Synopses of the Berlin Africa Conference* (Fig. 10.2). Three colors—orange, black, and white—were rendered with the sheen of office supply materials to evoke the look of official documents. Yet the density of the painted surfaces, their size and weight, implied earth being raked over, and bodies being marked (as indeed happened to slave laborers in the Congo). Employing a sparse visual repertoire—single-color grounds and reiterated shapes (lozenges, triangles, random words, and jagged, irregular lines)—the paintings suggested official pronouncements, diagrams that chart economic outputs, or track populations, and the maps of security or military forces. Attended by 14 European states with the United States as observer, the 1884–85 conference referred to in the work's title divided those Africans who at that time were not subject to direct control by a European power into "nation states"—the borders of which were drawn according to the economic interests of the colonizers. The paramount goal of the conference's organizer, German chancellor Otto von Bismarck, was to secure advantages for his country to rival Belgium's lucrative dominance of the Congo region. Schmidt's paintings follow recent scholarly reconstructions of the debates, including the effective exclusion, by means of timetabling and seating arrangements, of the voices of the few African attendees. Using visual languages familiar from early twentieth-century Modernist abstraction, the artist revisits, critically, a key moment in his country's empire-building, one that has direct relevance to present-day claims for compensation based on these events.[4]

## GLOBAL NETWORKS

In October 2001, a few weeks after the terrorist attacks on the World Trade Center, New York, and the Pentagon building in Washington, D.C., a Federal Bureau of Investigation agent found herself at the Whitney Museum of American Art in New York inspecting a large wall drawing entitled *BCCI - ICIC & FAB, 1972–91 (4th version)* (Fig. 10.3), made by Mark Lombardi between 1996 and 2000. The agent was investigating the financial links of the person suspected of masterminding the attacks, Osama bin Laden, specifically any ties that might exist to his brother-in-law, Khalid bin Mahfouz, a Saudi Arabian banker and former director of the Bank of Credit and Commerce International, which had offices in Karachi, Luxembourg, and London, but was controlled from Abu Dhabi. The agent had come to the right place for inspiration: few analysts in any professional sphere have been able to visualize the globalized world of multinational capital, including its legal and illegal entanglements in international politics, with the graphic precision, informational accuracy, and aesthetic elegance of this artist.

Mark Lombardi worked as an art curator, researcher, librarian, and archivist in the United States during the politically volatile decades of the 1970s and 1980s. Like many other artists, he was deeply influenced by French theorists such as Michel Foucault (especially his idea that the present should be understood as if from an archeologist's perspective) and Gilles Deleuze and Félix Guttari (especially their conceptions of the rhizomatic connectedness between events, actions, and phenomena, and of the random drivenness—the schizophrenic pathology—of capitalism). He applied their ideas to the information that he was gathering to support political activism against the "war on drugs" conducted by the Reagan administration, and the same government's lax financial regulation which led to the Savings & Loan Association crisis of the early 1990s. He realized that at the heart of these billion-dollar operations was money laundering—the transferring of illegally generated money through quasi-legitimate banks and businesses, and the sequestration of illegal income in offshore tax havens. That at least some of these exchanges were subject to official reporting, however cursory, meant that records existed and could be found by assiduous investigators. Just before his death in 2000, Lombardi recalled the moment in 1994 when he understood that he had worked his way toward an art practice that might meet his activist goals: "I originally intended to use the sketches solely as a guide to my writing and research but soon decided that this method of combined text and image in a single field (called a drawing, diagram or flow chart, whichever you prefer) really worked for me in other ways as well. It provided a new focus to my work; tended to support the same goals as the writing—to convey socially and politically useful information; and conformed 100% to my aesthetic inclinations—minimal, understated and somewhat iconoclastic."[5]

In his *Narrative Structures* series, Lombardi tracked the activities of, among others: Saudi Arabian arms broker Adnan Khashoggi; the shell companies set up by Lt. Oliver North, a National Security advisor to President Reagan, in order to sell arms to Iran (then engaged in a war with Iraq, which was officially supported by the U.S.) so as to provide financial support to the Contras, who were conducting a guerrilla war against the leftist Sandinista government of Nicaragua; the Mafia-related bankers who also acted corruptly for the Vatican; the World Financial Corporation, a major illegal player in relations between Cuba and the U.S.; the Nugan Hand Bank, implicated in financial scandals aimed at bringing down a Labor Party government in Australia; and a family of Indonesian bankers who illegally financed Bill Clinton when he was governor of Arkansas and subsequently president.

*BCCI - ICIC & FAB* is the culminating work of Lombardi's brief career. Bank of Credit and Commerce International assets grew from $5 million in 1973 to $23 billion by 1991, when it had offices

10.2 Dierk Schmidt
*The Division of the Earth:
Tableaux on the Legal
Synopses of the Berlin
Africa Conference*,
2006–07 (detail). Acrylic
and silicone on canvas,
oil on PVC film, five
paintings. Installation
view, Kunstraum der
University of Lüneburg,
2008–09. (Left) 102⅓
x 25⅔in (260 x 65cm),
(middle) 102⅓ x 51½in
(260 x 130cm),
(right) 102⅓ x 51⅓in
(260 x 130cm).

10.3 Mark Lombardi
*BCCI - ICIC & FAB, 1972–
91 (4th version)*,
1996–2000 (full view
and detail). Graphite
and red colored pencil
on paper, 51⅛ x 137¾in
(129.9 x 349.9cm).
Whitney Museum of
American Art, New
York. Purchase,
with funds from the
Drawing Committee
and the Contemporary
Painting and Sculpture
Committee 2000.250.1.

10.4 Zoe Leonard
*Analogue*, detail of
cast-off clothing, stored
in Brooklyn ready for
shipping, 1998–2009.
412 C-prints + gelatin
silver prints, each print
11 x 11in (28 x 28cm).
Courtesy of Galerie
Gisela Capitain, Cologne.

10.5 Zoe Leonard
*Analogue*, detail of shop
in Kampala, 1998–2009.
412 C-prints + gelatin
silver prints, each print
11 x 11in (28 x 28cm).
Courtesy of Galerie
Gisela Capitain, Cologne.

doing "normal" business in 78 countries. Yet it was, until its activities were exposed during the early 1990s, also the world's largest money-laundering organization, servicing drug cartels, illicit diplomatic traffic, and secret intelligence agencies in many countries. The horizontal lines on Lombardi's chart are datelines reading left to right around which are plotted the activities of the main organizations (BCCI, its Cayman Island offshoot, the International Credit and Investment Corporation, and its secretly controlled Washington, D.C. branch, First America Bank). Each circle represents an organization, the names of individuals are inscribed, and all are linked through lines that calibrate the degree of association—from direct through indirect to weak—as well as broken-off or aborted relationships. The initial impression is one of unfathomable complexity, of legitimacy and criminality densely interwoven into a cozy embrace, creating thereby an impregnable edifice of human greed. But steady looking reveals that these networks were created and maintained by relatively few individuals who, for all the power that they wielded over financial systems, historic institutions, and national governments, maintained that influence for relatively short periods of time. The morbid beauty of Lombardi's drawings arises from the fact that these webs of predation were destined to consume themselves. The unsettling affect we experience flows from our sense that the concrete connections depicted in the drawings subsist in seas of dangerous uncertainty, and that there were (and are) many more such shadowy schemers out there.

Globalization is a world-historical process that matches in scope and scale its much-publicized, well-known name. But its effects are always particular, and often occur in ways unnoticed until attention is drawn to them. Many artists become aware of such effects while working on projects that were initiated with quite other intentions and expectations. Zoe Leonard is known for the reflective, feminist critique evident in her photographs and installations. Her major work to date is the *Analogue* project, a collection of nearly 500 photographs culled from over 15,000 taken by her between 1998 and 2009, using Rolleiflex cameras and analogue film (Figs. 10.4 and 10.5). She is fascinated by modern technologies that become outdated (in this case, by the introduction of digitization), and how certain technologies of seeing and reproducing, even though they seem objective and mechanical, become for many of us embodiments of nostalgia. The images constituting *Analogue* are presented uncropped, as if they were enlargements from a contact sheet, and displayed on a grid structure that is organized into five parts, as if chapters in a historical record. Leonard began by photographing the façades of small shops in working neighborhoods of Manhattan, mostly her own area (the Lower East Side), that were closing down due to gentrification. The second part is filled with shops that remained open: modest businesses, places of exchange and barter that served newly arrived immigrants. Leonard then began to notice that some of these shops

served as feeders for the cast-off clothing donated to charities. Learning that most of these items were in fact sold on to merchants in Africa and other places, where they were cleaned and then sold as Western import items, she tracked this network from the clearing house in Brooklyn to the used-clothing markets of Kampala as well as to rural towns in Uganda. The close-up, front-on, resplendently colorful photographs of bundled clothes, stores, and stands have a portrait-like intensity. *Analogue* ends with a grid of images of closed shops, as if implying that even this low-key kind of globalization might be destined to disappear. As she says: "I am interested in making a record of an urban landscape as a way of looking at who we are as a people, who we are as a culture, understanding the city as a social space… as an economic space."[6] "We" here means the residents of Brooklyn, Kampala, and every city on the global circuitry that connects them.

The *Geography Lessons* cycle by Los Angeles-based photographer Allan Sekula manifests the more overtly political edge of postcolonial critique. The first work dealt with the border region in Germany, between East and West, at a time when Cold War tensions had been heightened by the stationing of Cruise Missiles on the NATO side and SS-20 missiles on the Warsaw Pact side. The second focused on the border between the U.S. and Canada as evinced through the wilderness imagery on Canadian money. Both works are ruminations on the relationships between historical aesthetic categories, especially landscape, and renderings of nature as symbolic instruments of institutional power.[7]

The third work in the cycle, *Fish Story* (1995), goes an important step further. "It struck me that port cities, which I knew from my own experience of growing up in the harbor of Los Angeles, were paradigmatic of extension and variability of connection as such—I mean, it's naive to think that any one port is the center of the world. What each port poses is the necessity of other ports, and they presume the possibility of yet other ports, of equally important but also variable connections."[8] Armed with this insight, Sekula went on a six-year journey that followed shipbuilding from its historical base in the Industrial Revolution in northeast England and southwest Scotland, on Clydeside and Tyneside, through the postwar Soviet Bloc concentration of shipbuilding at Gdansk, off the coast of Poland, and then to the migration of that industry to East Asia. This trajectory also traces the historical geography of radical political protest during the nineteenth century, of the subsequent instantiation, then erosion of Cold War oppositions, and then the emergence of economies, especially in Asia, based on delayed yet accelerated modernization. Each of the resulting 105 color photographs of *Fish Story* shows a particular kind and place of work, a type of equipment, a panoramic view out to sea, or a private refuge from both work and waiting—a proud self-advertisement for maritime industry or evidence of its failures. Subjects are repeated, registering the ways in which time unfolds in such settings, showing for example how certain

kinds of skill become outmoded as others come to the fore. *"Pancake," a Former Shipyard Sandblaster, Scavenging Copper from a Waterfront Scrapyard. Los Angeles Harbor, Terminal Island, California, November 1992* (Fig. 10.6) might be contrasted to *Seventy in Seven: The LNG Carrier Hyundai Utopia, Designed to Transport Liquefied Natural Gas from Indonesia to South Korea, Nearing Completion. Hyundai Heavy Industries Shipyard, Ulsan, 1993* (Fig. 10.7). Such a contrast illustrates Sekula's continuing commitment to a critical realist approach to photography. While acknowledging that workers-versus-bosses power struggles remain fundamental, he nuances the account (and makes it more real) by frequently interposing imagery with ambiguous signification, such as *Middle Passage: Filling Lifeboat with Water Equivalent to Weight of Crew to Test the Movement of the Boat before Departure. Port Elizabeth, New Jersey, 1993* (Fig. 10.8). We stand, unsteadily, inside a corridor of the container ship *M/V Sea-Land Quality*, between pipes leading to the outer deck, looking at a mop in the corner and some dirty worker's overalls on the wet floor. It is as if a ghost has just discarded them. But the ghost of whom or what? No single category can encompass what we witness: like those who labor in such settings, we feel ourselves subject to unseen forces that are at once arbitrary, implacable, and ordinary.

The images constituting *Fish Story* are organized into seven chapters broken up by intermittent wall texts that give voice to the workers in the images and to the artist's own lengthy ruminations, which are often expressed in the manner of Captain Ahab, anti-hero of Herman Melville's novel *Moby Dick*. There is no continuous narrative, no didacticism, no moralizing. In the artist's words: "If you look at postmodern displays of archival control, very often they never get beyond the sheer seriality of the archival system. Lost in this, I feel, is the possibility of another kind of ensemble, which is narrative, in a complex way, essayistic, which can flow in a way that a novel flows, or a set of prose poems, really creating a kind of internal heterotrophic tension. It's only in a complex dialogical structure, in the Bakhtinian sense, where you can weave in and out of paraphrase, quotation, restatement, new statement, that you can actually create a sense of variable logical type within images and within an image ensemble. That's the model I aspire to in *Fish Story*."[9]

## INTERVENING CRITICALLY

"Becoming an artist was a political choice. This does not mean that I make 'political art,' or even 'political graphic art.' My choice was to refuse to make political art. I make art politically."[10] This statement by contemporary Swiss artist Thomas Hirschhorn introduces an important distinction between the ways in which artists engaged with politics during the modern era, and how the artists we are discussing in this chapter engage with it in changed circumstances. In drawing his distinction, Hirschhorn is resisting two models of art and politics that dominated during the modern era: artists who used traditional media to make symbolic statements about political events or beliefs ("political art"), and those who used the techniques of mass-reproductive media to illustrate the viewpoints of parties, groups, or governments ("political graphic art"). The first approach has become, in the present circumstances, constrained by the anachronism of its medium, the second by its lack of independence. Hirschhorn has no doubt that his art must be devoted to matters of wide political significance, and that his creative process must embody the values he seeks to promote. All of his works are made from easily available, simple-to-use materials that are entirely familiar and instantly readable: in a word,

10.7 Allan Sekula
*Seventy in Seven: The LNG Carrier Hyundai Utopia, Designed to Transport Liquefied Natural Gas from Indonesia to South Korea, Nearing Completion. Hyundai Heavy Industries Shipyard, Ulsan, 1993*, from the *Fish Story* series, 1995. Photograph. Courtesy of the artist and Christopher Grimes Gallery, Santa Monica.

10.8 Allan Sekula
*Middle Passage: Filling Lifeboat with Water Equivalent to Weight of Crew to Test the Movement of the Boat before Departure. Port Elizabeth, New Jersey, 1993*, from the *Fish Story* series, 1995. Photograph. Courtesy of the artist and Christopher Grimes Gallery, Santa Monica.

10.9 Thomas Hirschhorn *Cavemanman*, 2002. Installation, wood, cardboard, tape, aluminum foil, books, posters, videos of Lascaux II, dolls, cans, shelves, fluorescent light fixtures. Courtesy of Gladstone Gallery, New York.

contemporary to their users. The artist sees them as "materials that don't require any explanation of what they are. I wanted to make 'poor' art, but not Arte Povera… quite simply, materials that make you think of poverty. To make poor art means to work against a certain idea of richness… Quality, no! Energy, yes!"[11] These materials are collaged together by a team of volunteers who form a small community for the occasion. Although much is improvised, the projects take shape under the artist's direction. They are shown in museums, galleries, in alternative spaces, in apartments, in illegally occupied buildings, in the streets, and, at times, as a trafficking between two or three of these places. Hirschhorn does not presume the either/or confrontations of traditional political struggle, nor the mediation preferred by liberalism, but rather the both/and complexity of contemporaneity.

Since the 1990s, Hirschhorn's installations have tended to take two somewhat distinct but nonetheless closely related forms: subversive art installations and public anti-monuments. The gallery and museum installations immerse viewers in environments as cobbled-together and random-seeming as were Allan Kaprow's in the early 1960s (see Fig. 1.9). Forty years later, however, the typical viewer is subject to a much greater saturation of commercial imagery and official ideology. First shown at the Barbara Gladstone Gallery, New York, in 2002, *Cavemanman* (Fig. 10.9) takes the visitor into a labyrinth whose imaginary inhabitants have retreated from the seductions of spectacle society and the banal standardizations required by officialdom, in order to read the texts of critical philosophers (books as symbolic bombs) and thus prepare for their rebirth as political activists.

The other major stream of Hirschhorn's work is a series of public pavilions devoted to the ideas of critical philosophers, poets, writers, artists, and political theorists. Temporary displays, they resemble the makeshift altars put up by families mourning accidental deaths in that they include photographs, decorations, and roughly written statements of heartfelt loss. But they also serve as libraries of the dead author's works, and as repositories of information about him or her. To the artist, they celebrate the revolutionary energy of these individuals. The *Bataille Monument* (Figs. 10.10 and 10.11), situated in a Turkish guest-worker neighborhood in Kassel, Germany, during Documenta 11 in 2002, consisted of eight related elements, all constructed by the artist, his collaborators, visiting volunteers, and local residents. These were: a 10-foot-tall wood, cardboard tape, and plastic sculpture that evoked the accidental discovery, in 1940, of the caves of Lascaux by children who fell into a hole beneath an uprooted tree (an event regarded by the work's subject, Georges Bataille, as miraculous); a library of books by Bataille arranged into categories (word, art, sport, sex); an exhibition about the writer; workshop discussions; a television studio broadcasting each day from the *Monument* on a local public-access channel; a food-and-drinks stall; a car shuttle to bring both visitors from the main exhibition venues to the *Monument* and back, and local residents to the main venues and back; and a website posting photographs from web cameras at the site all day, all week. Very much part of the mix was the intense activity of the artist as he negotiated with local authorities and residents during the planning stage, and his continuous presence through the four months of the exhibition where he interacted with residents and with other artists and intellectuals. His own statement, distributed at the site, makes his wishes clear: "The project is to make a Bataille Monument in the Kassel suburbs, with the local people living in Kassel. A precarious monument in the public space, accessible 24 hours a day, 7 days a week, free for everyone. I want to make a mental plan of and about the work of Georges Bataille. I want to make a mental plan of the city of Kassel. I want to

10.10 Thomas Hirschhorn
*Bataille Monument*, 2002.
Installation, Documenta
11, Kassel, 2002.
Courtesy of Gladstone
Gallery, New York.

10.11 Thomas Hirschhorn
*Bataille Monument (Bibliothek)*, 2002.
Installation, Documenta
11, Kassel, 2002.
Courtesy of Gladstone
Gallery, New York.

10.12 Paul Chan
*1st Light*, 2005.
Digital video projection,
14 mins. Courtesy of
Greene Naftali Gallery,
New York.

superimpose these two plans and choose the intersections, crossings between these two plans, where I can work out links. The links are artistic links. Links that come from the artist's decisions. These links can create space for ideas, reflections, for positions, for questions."[12] By insisting on the ongoing pivotal role of the artist, Hirschhorn both risks seeming elitist and maintains a potentially game-changing presence within a situation devoted to creating a community based on self-governing consensus. This parallels, in reverse, his insistence that poor materials and anti-aesthetic modes prevail in his museum installations. To him, such apparent contradictions are at the core of his responsibility as an artist and as a person: to insist on the disturbing complexity of critical thought while at the same time embracing it with infectious enthusiasm so as to activate collective work on the questions it raises. This is precisely what makes such important ideas and energies accessible and inspiring. And they are what bring responsible community into being. This, then, is what it means for an artist in one of the power centers to make art politically in a world that has taken the transnational turn.

## PROFILES IN SHADOWLAND

"After 9/11, after globalization, in the midst of that kind of radical and fundamental transformation of geo-political power and geo-political space, how do you visualize it? What is the new language to describe this new world?"[13] This question, posed by digital artist and political activist Paul Chan, is a succinct expression of the core challenge facing those artists of his generation who seek to engage with geopolitics, and with connectivity expressed through chains of power. For Chan, born in Hong Kong in 1973, raised in Omaha, Nebraska, and now working in New York, the starting point was to find ways for art to counter what he saw as the constraints on legitimate dissent imposed by official and commercial media. A number of videos may be found on his website www.nationalphilistine.com, dealing with subjects such as everyday life in Baghdad during the weeks prior to the 2003 invasion, or political posturing in his home state of Nebraska during the 2004 U.S. presidential campaign.

Chan's major work to date is *The 7 Lights* project, carried out from 2005 to 2007. The first six parts are digital animations projected onto various surfaces—floors, walls, ceilings, furniture—and each unfolding over 14 minutes, then repeating in an endless loop. In *1ˢᵗ Light* (2005) (Fig. 10.12), we enter a room empty except for a digital projector aimed at the floor, where a twisted rectangular field of light appears. Against the fixed profile of an electric light pole, the pale shadows of small, then larger objects, animals, and, finally, people rise steadily upward until only the pole is left, its wires straining aloft until they break. The bodies that fell from the World Trade Center towers on September 11, 2001, are unmistakably evoked, but so is a quite different event: the taking of souls to Heaven, known as the Rapture, something devoutly wished by certain Evangelical Christian

believers. What are we to make of the fact that quite contrary scenarios of an utterly changed world can, at any moment, erupt into our reality?

*2ⁿᵈ Light* (2005) anchors a similarly fearful set of occurrences around the relative comfort of a large tree. Red and blue suffuse *3ʳᵈ Light* (2006), within which the rising/falling figures are projected across simple furniture, including a table with the dimensions of that pictured by Leonardo da Vinci in his *The Last Supper*. Here, however, there are no holy figures and no visible savior. *4ᵗʰ Light* (2007) suggests a small window set into the upper wall of a well-lit room, perhaps a prison cell, or that of a monk. We see shadows of collapsing buildings, floating furniture, and office equipment; then a spider appears to commence industriously weaving its web. In *5ᵗʰ Light* (2007), the projected field has a triangular format, and appears on the wall as a shimmering, ghostly reflection. Weapons float and come apart. *6ᵗʰ Light* (2007) projects on floor and wall, both areas becoming large windows outside of which scarcely identifiable objects float. *7th Light* (2007) is not a projection but a musical composition, played from a score consisting of notations made by collages of pieces of ink-saturated torn paper randomly arrayed across stave lines.

The *Lights* "hallucinate" the seven days of Creation, but in reverse (thus the erasure of light in the title). If a utopian future no longer seems possible and yet apocalypse, however likely, must be resisted at all costs, how might the future be imagined? Chan seems to suggest that it is continuously coming into being as the aftermath of the present, of the familiar transforming itself, right before our eyes, into flat, enervated shadows of its separating constituents. Our world, he suggests, is haunted by an expanding, entropic universe, a world of pale forms at once outside and parallel to it, but also—like anti-matter—palpably yet invisibly inside us as well.[14]

How might these abstract speculations inform active responses to actual events in the world? The inadequate governmental response to the hurricane that struck New Orleans in 2005 made many Americans aware that while their nation was inflicting devastation abroad it was unable to manage crisis at home. Chan was among those artists who reacted in constructive ways. In November 2007, using actors from the Classical Theatre of Harlem, he worked with the Creative Time organization to stage Samuel Beckett's play *Waiting for Godot* on a street intersection in the Lower Ninth Ward and in front of an abandoned house in Gentilly, a suburb devastated by the hurricane and still awaiting effective assistance. Chan explained his intentions: "The longing for the new is a reminder of what is worth renewing. Seeing Godot embedded in the very fabric of the landscape of New Orleans was my way of re-imagining the empty roads, the debris, and, above all, the bleak silence as more than the expression of mere collapse. There is a terrible symmetry between the reality of New Orleans post-Katrina and the essence of this play, which expresses in stark eloquence the cruel and funny things people do while they wait: for help, for food, for tomorrow."[15]

10.13 Mark Bradford
*Mithra (Ark Sculpture)*,
2008. Found materials.
Installation, Prospect.1,
New Orleans, November
2008. Courtesy of the
artist and Sikkema
Jenkins & Co, New York.

10.14 Daniel
Joseph Martinez
*Call Me Ishmael:
The Fully Enlightened
Earth Radiates Disaster
Triumphant*. Project for
the 2006 International
Cairo Biennale, United
States Pavilion,
December 2006, Cairo.

10.15 Santiago Sierra
*Workers Who Cannot
Be Paid, Remunerated
to Remain Inside
Cardboard Boxes*,
2002. Performance,
sculptures, photographic
documentation, Berlin.
Courtesy of Lisson
Gallery, London.

Others have sought ways to make a more
sustained contribution. Dan Cameron, a long-serving
curator at the New Museum of Contemporary Art,
New York, left the city in 2006 to establish U.S. Biennial,
Inc., a nonprofit organization devoted to staging survey
exhibitions in New Orleans. The first iteration, *Prospect.
1 New Orleans*, opened in November 2008 to consider-
able acclaim both locally and in the wider artworld. It
included site-specific works by artists from many parts
of the world. Los Angeles artist Mark Bradford's *Mithra
(Ark Sculpture)* (Fig. 10.13), a 22-foot-high, 64-foot-long
boat standing precariously in a vacant lot, made from
semi-destroyed and abandoned signage, quickly became
an iconic image.[16]

If the U.S. government responded tardily to
the devastation of New Orleans, official representa-
tion in at least one other place showed more decisive
courage. Daniel Joseph Martinez was chosen for the
U.S. Pavilion at the 10th International Cairo Bien-
nale, 2006, where he showed *Call Me Ishmael: The Fully
Enlightened Earth Radiates Disaster Triumphant* (Fig. 10.14),
a prosthetic humanoid, modeled on the artist himself,
that lies prone on the floor of a pristine white room
yet is programmed to make severe jerking movements,
as if in paroxysm. A fake diamond-studded bling belt
of the kind worn by gangsta rappers flashes "his" name:
Ishmael, a figure recognized by a number of religions.
Visitors sense that their presence may be the cause
of the movements, or that they have stumbled across a
victim of prolonged torture and isolation. In the context
of the U.S. Pavilion, this feeling evokes the military
detention centers at Guantanamo and Abu Ghraib,
places that the U.S. government declared beyond the
reach of both U.S. and international law. Martinez's
convulsing figure makes the actuality of these places
unavoidably vivid.[17]

## BARE LABOR

Santiago Sierra is a Spanish artist living in Mexico City.
Initially a sculptor, in the 1990s he employed a reduced,
heavily industrial, highly formal vocabulary, familiar due
to the pervasiveness of the Minimalist aesthetic, along
with elements from Performance Art and Conceptual-
ism. Since 1999, he has used these elements to make
time-based works that draw attention to the inequities
of working conditions and the extreme disparities of
income in all parts of world. Sierra explained his moti-
vation for *Workers Who Cannot Be Paid, Remunerated to
Remain Inside Cardboard Boxes* (Fig. 10.15), first staged at the
Kunst Werke gallery, Berlin:

> I first experienced Germany as a foreign
> student at the Hamburg Art Academy and
> therefore knew firsthand how the country
> treated its immigrants. In the summer of 2000,
> there was much heated discussion about German
> policy with respect to political refugees, a
> debate that reached its climax when neo-Nazis
> from nearby Leipzig killed an African asylum
> seeker. At KW our project—*Workers Who
> Cannot Be Paid, Remunerated to Remain Inside
> Cardboard Boxes*, 2000—involved Chechen
> refugees who were not permitted to work,
> under threat of repatriation (which would,
> in most cases, lead to jail time or worse back
> home). Consequently, we could not openly
> state that we were paying the refugees, and
> in a sense the institution had become an ally,
> both to me as the artist and to the refugees.[18]

The German government gave 80 marks (US$40) per
month to such asylum seekers, and accommodation
in shared housing. The dimensions of the boxes were
those of the estimated average space thus provided. The
men stayed inside the boxes four hours a day for six

10.16 Wang Jin
*100%*, 1999.
Performance,
photographic
documentation,
Beijing. Courtesy
of the artist and Pékin
Fine Arts, Beijing.

weeks. Variations of this work were staged in Guatemala and New York City, with the payments adjusted to the minimum social wage in each case.

Many of Sierra's works highlight inequitable situations outside the artworld, often in controversial ways. For *250 cm Line Tattooed on 6 Paid People* (2000), six unemployed young men from Old Havana were paid $30 each to stand in a row and permit a horizontal line to be tattooed on their backs. At the Havana Biennial that year, he paid three people $30 each to remain inside wooden boxes as the opening party raged around them, the celebrants unaware of their presence. For *160 cm Line Tattooed on 4 People* (2000), four female prostitutes addicted to heroin were given the price of a hit in return for consenting to being tattooed. At San Juan, Puerto Rico in 2000, two junkies were each given a shot of heroin as payment for agreeing to have a 10-inch line shaved across their heads. Such works certainly spotlight exploitation, and underscore its existence to gallery-goers who may rarely encounter it in their daily lives. Yet these works also share in the process that they reveal; they are exploitative, unequivocally and unapologetically. Sierra says: "The tattoo is not the problem. The problem is the existence of social conditions that allow me to make this work. You could make this tattooed line a kilometer long, using thousands and thousands of willing people."[19] Free will

is something that, in contemporary conditions, is not available to all—as Sierra shows, it can be bought for the price of a hit, or much less. The freedom of the artist, the autonomy of art itself, the free movement of the spectator through the spaces of art—these liberties come at real costs to many others. These are facts about contemporary life: there is a vast, elaborate infrastructure devoted to maintaining secure barriers between those who live utterly different lives in extremely close proximity to each other. Sierra seeks constantly to open a fissure in these walls.

Some commentators object that the artist remains distant from the experience of the exploited, and that this makes his art inauthentic. Should Sierra subject himself to these degradations? The Australian artist Mike Parr did just this in his performance work *Aussie Aussie Aussie Oi Oi Oi (Democratic Torture)* (2003) (see Fig. 7.19), during which he sewed up his own face to draw attention to the indeterminate detention of illegal immigrants to Australia (known as "boat people") in isolated camps, a situation that drove some of them to self-inflicted damage. Would a similar procedure place Sierra in a more morally defensible, less exploitative relationship to his subjects? By making clear that he is paying the participants, Sierra argues that nothing now mediates the spectator's encounter with the economic realities of the poor, the exploited, the homeless, the

10.17 Ai Weiwei
*World Map*, 2006.
Fabric, cotton, nylon,
woodbase, 39⅓ x 315
x 236¼in (100 x 800 x
600cm). Installation
view, the 16th Biennale
of Sydney (2006) at the
Art Gallery of New South
Wales, Sydney. Courtesy
of the artist and the
Biennale of Sydney.

refugee—the countless millions who are living what Italian philosopher Giorgio Agamben has poignantly described as "bare life."[20]

The actuality of enactment—that it is done by real, visible, fellow humans who are unable to reject payment, however small and humiliating in sum—is crucial. Sierra could represent this kind of exploitation through, say, photography in the manner of Sebastião Salgardo, but he rejects this as offering the spectator an outlet via the mediation of an artistic medium. There is a regional precedent for his approach: in 1968, Argentine artist Oscar Bony paid a working-class family to pose on a pedestal for the duration of an exhibition. The family was carefully dressed in clean and respectable clothing, and posed as if for a visit to a city photographer's studio.[21] In context, this use of the idea of "living sculpture" to make a political point about class difference was a radical gesture. Forty years later, despite a global increase in the percentage of those living above the poverty line, the actual numbers of the desperately poor are astronomically high and growing—not only in "failed states," such as those in Central Africa, but also in the fastest-growing economies. It is anticipated that by 2020 the number of people leaving the Chinese countryside to work in its cities will exceed 300 million. If present conditions continue, most of them will live for years in very trying conditions. For his work *100%* (1999) [Fig. 10.16], Chinese artist Wang Jin asked a group of migrant workers in Beijing to stand on each other's shoulders to form a column that appears to be supporting one of the newly constructed roadways through cities such as Beijing and Shanghai. While the

symbolism of such a work is obvious, artists such as Sierra feel obliged to strip away even representation itself in order to reveal what they see as the elaborately shielded reality of systemic exploitation.

The works discussed in this section demonstrate that politically engaged artists have, in a few short years, moved away from the optimism about globalization embodied in Chen Zhen's concept of "transexperience." This change of mood is captured in Ai Weiwei's sculptural installation *World Map* (2006) [Fig. 10.17]: 2,000 pieces of cloth are cut into the shapes of the continents, then laboriously laid on top of each other to form fragile piles. This map is both unstable but also labor-intensive: as a vision of world unity built on unseen exploitation, it is unsustainable. Ai Weiwei is also commenting obliquely on his country's slogan for the 2008 Beijing Olympics, "One World, One Dream," and more overtly on the human cost of China's unregulated rush to modernization, not least through the exploitation of workers in its textile industries. Other works by him are more directly activist, evoking hot-button topics such as the corruption of officials whose behavior contributed to the high death toll in the 2008 Sichuan earthquake.[22] As we have seen in this chapter, Ai Weiwei is only one among many artists who are asking all whom they can reach first to see the world clearly, then to see it differently.

# 11. CLIMATE CHANGE: ART AND ECOLOGY

*"Humanity is sitting on a ticking time bomb. If the vast majority of the world's scientists are right, we have just ten years to avert a major catastrophe that could send our entire planet into a tail-spin of epic destruction involving extreme weather, floods, droughts, epidemics and killer heat waves beyond anything we have ever experienced."*—Al Gore, speaking in the film *An Inconvenient Truth* (2006).

If contemporary geopolitics are everywhere marked by dissensus, a quite other kind of message is being sent out by the planet itself, and is being articulated through publicity campaigns such as Al Gore's *An Inconvenient Truth*: life on Earth can no longer be sustained by economies based on the exploitation of fossil fuels such as oil, coal, and gas; a unified approach is urgently needed if catastrophe is to be avoided.[1] A potent mixture of natural events and the seemingly unstoppable overuse of these resources is changing climates throughout the world, to such an extent that some scientists believe that we have entered an Anthropocene era: a period in the Earth's history in which human impact will override all other forces. To mitigate global warming, the universal adoption of renewable sources of energy is an urgent necessity, along with other measures such as the shared management of water and the control of population growth. It is widely acknowledged that these solutions need to be local in application but global in scale, international in their organization, and inspired by a shared sense of responsibility toward the planet as home to all who live and die on it—that is, a planetary consciousness. As the inconclusive outcome of the 2009 Copenhagen conference on climate change demonstrated, international agreements capable of managing this change remain largely ineffective, despite recognition of the problem at the highest levels in most countries since many of them—though not some of the most powerful—signed the Kyoto Protocol in 1997.[2]

Are our political institutions ready to meet the urgent need for planetary solutions? During the nineteenth and twentieth centuries, as nation states proliferated, they competed—often violently—for territory and resources. They also modernized at different rates, but on such wildly different scales that while standards of living have nearly everywhere increased from the low levels of previous centuries, massive disparities remain within states, in each region of the world, and between regions. An uneven spread of economic and political influence results, leading to conflict that could increase as resources diminish. These tendencies remain powerful today, making international cooperation subject to national interests, and global governance a weak ideal. It may well be that the modern world system is not well suited to the challenges now facing it. A planetary system based on cooperation between contemporaries needs to evolve: some signs that it may be coming into being can be seen in the responses of artists to the crisis situation.

The interventions into natural settings characteristic of Land Art during the 1960s and 1970s were modified but not—in the United States in particular—blunted by concern for the environment and the emergence of an ecological consciousness during the latter decade. During the 1980s and 1990s, most—but not all—artists retreated from such concerns in favor of the populist, spectacle, and market orientations discussed in Chapter 2. Toward the century's end, however, planetary matters became of vital interest to many. Although their contribution to date has been relatively modest, artists are increasingly to be numbered among those who actively raise awareness of the issues, and do so often through specifically artistic means. Like the debate over "political art" and "making art politically" reviewed in the previous chapter, this involvement has led to lively discussions. To some critics, immersion in any kind of activism diminishes the aesthetic value of an artist's work. In contrast, some activists feel that too much emphasis on aesthetics can blunt real-world effectiveness. Artworld and public opinion swing between these two poles.[3] Nevertheless, it is beginning to become clear that this is a false dichotomy: the art called for by contemporary

conditions must forge fertile pathways between these options in order to render them redundant. How have artists responsive to environmental crisis so far sought to resolve this dilemma?

## ART AND ENVIRONMENTALISM

In a 1972 essay entitled "Art and Ecological Consciousness," designer and theorist Gyorgy Kepes noted: "The forces of nature that man has brought under a measure of his control have again become alien: they now approach us menacingly by avenues opened up by science and technology… Without an ecological consciousness, we have very little hope for change… Clearly, the artist's sensibility has entered a new phase in which its prime goal is to provide a format for the emerging ecological consciousness."[4] Kepes drew attention to three kinds of response: "The artist now has the opportunity to contribute to the creative shaping of the earth's surface on a grand scale… [Second,] Nature has become an artistic challenge once again. Artists, instead of representing nature's appearances, have explored ways to present nature's processes in their phenomenological aspects… Third, some artists, finding it hopeless to formulate their experiences of the expanding new world in sensuous objects or images, have attempted to capture the expanding space-time parameters in conceptual presentations that catch these experiences only partially."[5] As we saw in Chapter 1, Robert Smithson's work exemplifies all of these options. Following the positive public reaction to his work *Broken Circle/Spiral Hill* (1971), sited in an abandoned quarry near Emmen, the Netherlands, he made a number of proposals to mining companies that would reclaim abandoned open-cut pits by controlling water run-off and encouraging plant growth, to little response. In 1973, Smithson died in a plane crash in Texas while surveying the site of his projected work *Amarillo Ramp*, a reclamation "sculpture" on a private property, a local ranch. His wife, the artist Nancy Holt, sculptor Richard Serra, and others completed it.

The continuing practice of James Turrell echoes this transformatory spirit of the early Land artists. Turrell was a leading member of a loose association of Californian Minimalist painters and sculptors— including Robert Irwin, Larry Bell, Maria Nordman, and Eric Orr—known as the "Light and Space" movement.[6] He became known in the 1960s for his elegant projections of geometric fields of pure color that seemed to be suspended in space, or to be openings into infinite depth.[7] Since 1974, he has worked tirelessly on *Roden Crater*, a project that would encourage this conjuncture on a massive—indeed, planetary— scale, in the midst of a vast natural landscape rather than a gallery or museum setting. An experienced pilot, he has said that "the sky is not limitless and has definable shape and a sense of enclosure, often referred to as celestial vaulting." This may be experienced standing on an open plain, and differently when lying down in

the same place. Fascinated by "the difference in this sense of space," Turrell searched for a place that might house, and hone, a variety of experiences of this type.[8] A 2-mile-wide volcano was found on the edge of the Painted Desert in Arizona and the land acquired. Since then, Turrell has transformed *Roden Crater* into an elaborate sequence of sites and devices for observing sky events that occur daily, semi-annually, or more infrequently: openings that capture ancient light, enframed skyspaces, funnels aimed at particular phenomena, long dark tunnels that open out into lightwells. The observer's experience culminates in ascension to the rim of the actual crater, to a view of the heavens and of the uninhabited landscape all around. Turrell does not approve photographic illustrations of the site, believing that it must be experienced directly.

Although none has realized such sites at this scale, other artists have also sought ways to connect observers to the planet's rhythms, and to connect contemporary observers with the kinds of awareness of those rhythms possessed by premodern peoples.[9] In 1971, Charles Ross set out to create an observatory that would make visible the relationship between the Earth and the Pole Star. Four years later, construction began on *Star Axis* (Fig. 11.1), an inverted cone structure built into a mesa at the edge of the Sangre de Cristo mountain range near Santa Fe, New Mexico. Within the stone-lined cone rises a steel tunnel that is aligned exactly with the Earth's axis. Inside the tunnel are spiral stairs, each one of which is marked by a date going back 26,000 years and forward 13,000. Standing on a particular stair, one can look up and see, framed by the circular opening, the sky as it appeared on that date, or as it will appear. To the artist, "*Star Axis* distils the geometry of time into a physical environment."[10]

The rise of environmental consciousness meant that such monumental projects attracted criticism: writer Joseph Mashek protested that Michael Heizer's huge earthwork *Double Negative* (see page 32) "proceeds by marring the very land, which is what we have just learned to stop doing."[11] Such views made their way slowly into the broader public consciousness, but remained muted in the artworld, as gigantism came to hold sway. Exceptions in Europe included Hans Haacke, who made a number of works in the late 1960s that exemplified, then parodied cybernetics and systems theory. An installation of 1972, *Rhine Water Purification Plant*, pumped water from the highly polluted river through a set of filters to a tank in the Museum Haus Lange, Krefeld, where it was now found to be pure enough to sustain goldfish.[12]

English artists led their U.S. counterparts in developing ways of art making that would "touch the Earth lightly." Andy Goldsworthy shares many of the attitudes of his predecessor Richard Long (see Fig. 1.17), but depends less on abstract forms and has developed ways of encouraging natural materials and processes to generate each work. In 1980, he said: "I want an intimate, physical involvement with the earth. I must touch… I take nothing out with me in the way

11.1 Charles Ross
*Star Axis: Looking North
out of the Hour Chamber,
One Hour of Star Trails.*
1971–ongoing (interior
and exterior views).

11.2 Andy Goldsworthy
*Reconstructed icicles /
around a tree / finished
late afternoon / catching
the sunlight / Glen Marlin
Falls, Dumfriesshire, 28
December 1995*, 1995.

11.3 Andy Goldsworthy
*Storm King Wall*,
1997–98. Fieldstone,
approx. 5ft x 2½ x
2,278½ft (1.5 x 0.75 x
695m) (overall).
Storm King Art Center,
Mountainville, New York.

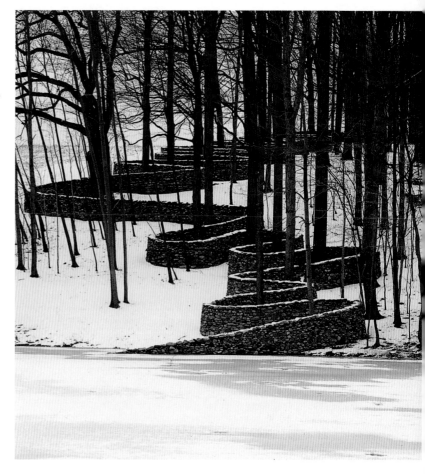

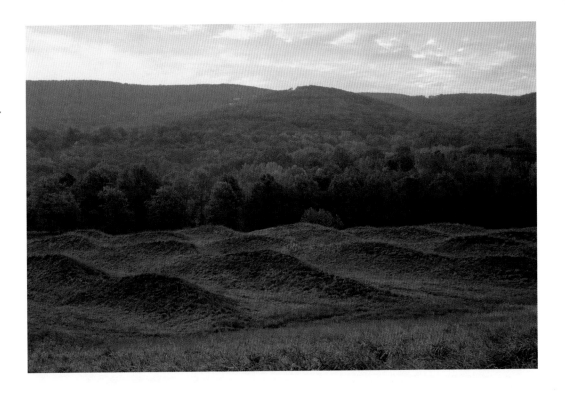

11.4 Maya Lin
*Storm King Wavefield*, 2007–08. Earth and grass, 240,000 sq ft (22,300 sq m) (11-acre site). Storm King Art Center, Mountainville, New York.

of tools, glue or rope, preferring to explore the natural bonds and tensions that exist within the earth… Each work is a discovery."[13] To create *Reconstructed icicles / around a tree / finished late afternoon / catching the sunlight / Glen Marlin Falls, Dumfriesshire, 28 December 1995* (1995) (Fig. 11.2), he spent a night in below-freezing temperatures affixing icicles to each other so that they would form a serpentine figure that, for a few hours after sunrise, seemed to penetrate a pinnacle-shaped rock. This compositional principle underlies all of his works, including those that echo human structures, such as dry-stone walls used in farming communities. His largest project of this kind is located at the most distant corner of the Storm King Art Center in upstate New York. *Storm King Wall* (1997–98) (Fig. 11.3), a dry-stone wall 5 feet high, 2,278½ feet long and 2½ feet thick, weaves like an ancient serpent between a small forest of beech and elm trees until it enters, then emerges from, a lake.

A number of artists continue to work in an environmentalist spirit. These include groups such as the loose association of Italian, German, and Scandinavian artists who, since 1989, have worked under the rubric "Art in Nature," as well as individuals such as Janet Laurence, whose site-specific installations explore the interactions between animate and inanimate matter, such as plants and toxic chemicals, in ways that point to the dangers but also suggest the poetic possibilities of fusion between humanity and the natural world; Mel Chin, whose *Revival Field* has, since 1990, used hyperaccumulator plants—those that process harmful chemicals into harmless gases at accelerated rates—to subject part of the Pig's Head Landfill near St. Paul Minnesota that was filled with toxin-laden weeds to an ongoing process of green remediation; and process/performance artist Jeremy Deller, whose project *Speak to the Earth and It Will Tell You* invited attendees at the 2007 *Sculpture Project* exhibition in Münster, Germany,

to visit an area on the edge of the town where vegetable allotments were maintained, and to follow exhibitions of the diaries he had invited the allotment holders to keep over the subsequent decade.[14] Maya Lin, designer of the *Vietnam Veterans Memorial* (see Fig. 2.28), has devoted herself increasingly to these issues, especially those involving the reduction of biodiversity. *Storm King Wavefield* (2007–08) (Fig. 11.4) echoes many of the characteristics of Land Art: huge size (240,000 square feet), repetition, Minimalist statement (echoing Donald Judd's injunction: "one thing after another"), and manicured look. But it did recycle a disused gravel pit, turning it into a domain of fertile earth. Symbolically, it invites us to remember the watery prehistory of this region, and to imagine the land breathing like an organic being. The urge to be at one with the Earth, to submerge oneself within its processes, inspired some of the pioneering virtual artworks, notably Charlotte Davies's *Osmose* (1995), an immersive, interactive environment that takes its participant, whom the artist calls "the immersant," through "a boundless oceanic abyss, shimmering swathes of opaque clouds, passing softly glowing dewdrops and translucent swarms of computer-generated insects, into the dense undergrowth of a dark forest," to a virtual tree made of visible code.[15]

## CRISIS AND CATASTROPHE

In the early 1980s, artists were among those who were becoming alarmed at the signs that environmental degradation was progressing at a rapid, potentially disastrous rate. Invited by the U.S. Public Art Fund to create an outdoor sculpture, Agnes Denes chose to plant a wheatfield in a section of Battery Park that was then landfill awaiting the office and apartment buildings that now constitute a mini-city in downtown Manhattan.

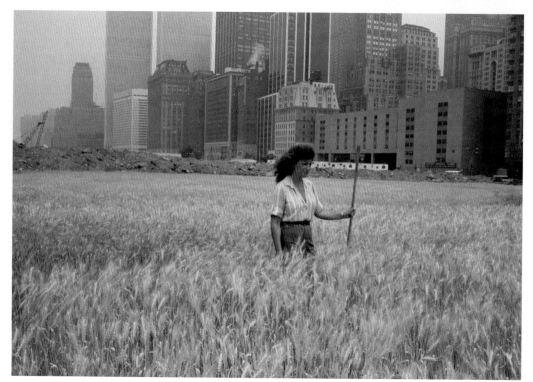

11.5 Agnes Denes
*Wheatfield—A Confrontation: Battery Park Landfill, Downtown Manhattan—With Agnes Denes Standing in the Field*, 1982. Two acres (0.8 hectares) of wheat planted and harvested by the artist on a landfill in Manhattan's financial district, a block from Wall Street and the World Trade Center, summer 1982. Commissioned by Public Art Fund, New York City.

Over a four-month period, Denes and others planted, cultivated, and harvested a field of golden wheat on a 2-acre side adjacent to Wall Street and the World Trade Center (Fig. 11.5). The artist explained her range of motivations: "*Wheatfield* was a symbol, a universal concept. It represented food, energy, commerce, world trade, economics. It referred to mismanagement, waste, world hunger and ecological concerns. It was an intrusion into the Citadel, a confrontation of High Civilization. Then again, it was also Shangri-La, a small paradise, one's childhood, a hot summer afternoon in the country, peace, forgotten values, simple pleasures."[16] Arguing that the values of an agrarian America had been forgotten in its capitalist heartland—the crop, harvested on land valued at $4.5 billion, realized less than $200—she wished to make them visible in the direct way that is typical of all the works discussed in this chapter.

Believing that all works of art should effect some kind of transformation ("social sculpture"), and that every act was potentially a work of art, Joseph Beuys helped found the German Green Party, and in 1980 was nominated as one of its candidates for election to the European Parliament. His contribution to Documenta 7 in 1982 was *7,000 Oaks* (Fig. 11.6), a project to plant that number of young trees in Kassel, beginning from the park in front of the main exhibition building and radiating outward through the primarily industrial city, effectively "greening" it. By these means he sought to recalibrate the meaning of the oak, which had been used as a symbol by the Nazis. Each tree was coupled with a basalt column placed vertically, implying the pairing of organic and inorganic, ancient and new, stasis and growth. Citizens were invited to sponsor a tree or a column. The project was completed in 1987. Under the auspices of the Dia Foundation, after Beuys's death, in 1988 and again in 1996, the project was repeated on

a small scale in the Chelsea art district in Manhattan. In both cities, it has come to blend into the still predominantly urban environment over time. In 2007, two Italian artists, Eva and Franco Mattes, relaunched Beuys's campaign on the Internet virtual world site Second Life, reconceiving it as a "conceptual virus."[17]

Working within the framework of eco-feminism, a small number of artists created works that sought to bring qualities understood as archetypally feminine to bear on environmental issues. For her *Touch Sanitation* performance piece (1977–80) (Fig. 11.7), Mierle Laderman Ukeles visited every facility of the New York Department of Sanitation, and shook the hands of all 8,500 employees, saying to each: "Thank you for keeping New York alive." Recorded by photographs and video, the work was presented through monitors stacked to resemble television towers. In her *Flow City* (1983), a garbage-recycling unit became a site at which the public could view the process of disposing of garbage that was taking place, as well as follow other parts of the process on video screens. Key elements of the installation were designed using recycled materials.

Responding to scientists' warnings about the impact of global warming on the marine environment, sisters Margaret and Christine Wertheim (respectively, a science writer and an artist), who grew up in Queensland, Australia, adjacent to the Great Barrier Reef, created the Institute for Figuring in 2005. Since then, its major activity has been *The Coral Reef Project*, which the sisters describe as "a woolly celebration of the intersection of higher geometry and feminine handicraft, and a testimony to the disappearing wonders of the marine world."[18] Vast sections of the reef have recently died, signified by a loss of color. *The Coral Reef Project* seeks to draw attention to this devastation by using the insights of mathematician Daina Taimina, who demonstrated that

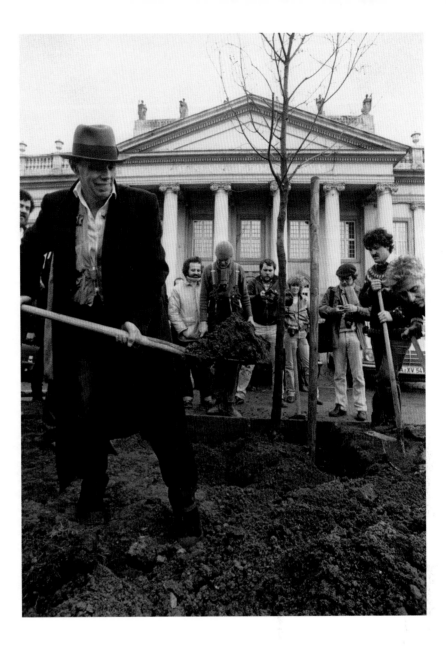

11.6 Joseph Beuys
*7,000 Oaks*, 1982–87.
Kassel.

11.7 Mierle
Laderman Ukeles
*Touch Sanitation
Performance: Fresh
Kills Landfill*, 1977–80.
"Handshake Ritual"
with workers of New
York City Department
of Sanitation. Color
photograph, 60 x 90in
(152.4 x 228.6cm).
Courtesy of Ronald
Feldman Fine Arts,
New York.

crocheting offered the best way of modeling hyperbolic geometry, also the structure of coral itself. *The Coral Reef Project* creates a symbolic substitute for the natural wonder, made (mostly) by women who use a traditional female craft to mourn its loss. Thousands have joined the Wertheims in this enterprise, which has expanded to include "sub-reefs" such as *Bleached Reef, Beaded Reef, The Ladies' Silurian Atoll,* a ring-shaped installation of nearly 1,000 individual crochet pieces, and *Crochet Coral and Anemone Garden* (Fig. 11.8), a woolen landscape that evokes something of the beauty of the reef itself. *Toxic Reef,* crocheted from yarn and plastic trash, responds to the escalating problem caused by the latter as it inundates oceans and chokes marine life.

   With projects such as these, we have moved from artworks that raise alarm about the environmental crisis to those that involve numbers of people in concerted actions. Most occur at symbolic levels, and are aimed at sending a message of concern to those with political and economic power. The crisis, however, is not only global, it is also local. What have artists contributed toward realizable solutions to real problems at this level? Have they done so in ways that are identifiably artistic?

## COLLECTIVE ACTIONS, SUSTAINABLE SOLUTIONS

Pioneers since 1969 in seeking direct and usable solutions to actual problems in particular environments, San Diego-based artists Newton and Helen Mayer Harrison continue to pursue "ecosystemic well-being." They develop each of their projects in a totally cooperative manner, conceiving them as triggers to the imagination of the residents of each place, the only people actually able to bring projects to realization. Typically, the artists are invited to an area by an arts organization, identify an environmental problem, consult with local experts, then present a display in a public venue that visualizes the circumstances that led to the problem, proposes what the artists call a visual "metaphor" that suggests a viable solution, and provokes discussion of how that might be brought about literally. Projects have ranged from sewage filtration ponds in parks in rustbelt cities in the United States (for example, Braddock, Pennsylvania) through lagoon reclamation in Thailand to some that are continental in scale. Presented at various venues in Europe between 2000 and 2003, *Peninsula Europe I: Bringing Forth a New State of Mind* (Fig. 11.9) envisaged

11.8 The Institute for Figuring and Companions *Crochet Coral and Anemone Garden*, 2005–ongoing. Created and curated by Margaret and Christine Wertheim.

11.9 Newton Harrison and Helen Mayer Harrison *Peninsula Europe I: Bringing Forth a New State of Mind*, 4/12–5/10 2003. Installation view, South Gallery. Courtesy of Ronald Feldman Fine Arts, New York.

11.10 Marjetica Potrč
*A Hippo Roller for Our
Rural Times*, 2005.
Utilitarian object
and printed drawing,
dimensions variable.
Courtesy of the artist
and Max Protetch
Gallery, New York.

11.11 Lucy Orta
*Nexus Architecture—2nd
Johannesburg Biennale*,
1997. Original Lambda
color photographs, 23½
x 35½in (60 x 90cm).
Collection of the artist.

the landmass as a single, coherent environmental whole, oblivious of national borders and organized according to the best use of its waterways, mountains, and other natural resources. Through reconfigurations of maps, and displays of information about water flows, land use, and nonpolluting industries such as green farming, the Harrisons showed that an idea of Europe as something greater than an aggregation of distinct nation states could be envisaged—indeed, that the region was once, and could be again, integrated by "biodiversity ribbons." To the Harrisons, these metaphorical ribbons become icons: lynxlike configurations, as if the land were a living creature, like one of the ancient animals it used to support. While their grand vision for Europe as a whole remains an ideal, smaller-scale projects based on the same values have been pursued, notably in Holland, where their *Green Heart* concept—which proposes the removal of housing from central Holland and its concentration in the areas close to the nation's borders—has influenced national planning since 1994.[19]

The example of the Harrisons echoes in the work of many others. In Chapter 6, we noted the transformations of the environs around water sources in a village in Central India made by Navjot Altaf. Marjetica Potrč assists poor communities living in the informal cities surrounding many of the world's cosmopoli to build "urgent architecture." She also designs useful objects, under the general title *Power Tools*, such as *A Hippo Roller for Our Rural Times* (2005) (Fig. 11.10), a cylindrical plastic container with a long handle that enables people living far from limited supplies of water to transport it over long distances.[20] Other artists who work closely with communities include: the Ala Plástica group, who since 2004 have been assisting in building structures to help indigenous people affected by floods, oil spills, and other disasters consequent on large engineering projects in the Río de la Plata river basin; the Wochenklauser collective, who are devoted to small but significant, consensual interventions aimed at improving the quality of life of suburban communities in Austria; the Hamburg-based urban activist group Park Fiction; and the Dakar-based group Huit Facettes-Interaction, who from 1996 to 2002 used their skills as artists to encourage villagers in remote parts of Senegal to develop their craft traditions as an income source.[21] Some artists have devoted time and energy to creating enclaves in which artistic imagination and ecological principles might meet. Among these is "The Land," a project being developed at Changmai, Thailand, under the leadership of artist Rirkrit Tiravanija (see Fig. 6.17). He makes modest claims for it:

> Yes, we started first as a place for the community, meaning ourselves and whoever is around. We never did think of it as an art project… But the platform itself is like an empty tabletop, that people bring different projects to… The idea is that this table somehow finds a way to sustain all these conditions, to provide people with a place

to do things. We struggled with the idea that it's becoming so embedded in the art world. Part of the distance is to stay away from that, partly because we want to find a way to interact with the real world, to actually survive in a real condition. Of course, it's done by a lot of artists so it always gets back to art.[22]

The long career of the Harrisons, and the incremental inroads made by the others discussed here, demonstrates that the role of artists in such circumstances must necessarily be modest, and that desirable change takes much more time than is usually offered by art or given to it.

## DESIGNS FOR LIVING

Disillusioned with the consumerist focus of the fashion industry, London designer and teacher Lucy Orta has, since 1992, been creating costumes for urban refugees, those who wish to live in the public spaces of cities without owning or renting property, and those, such as political protesters, who require temporary accommodation in distant, often inhospitable settings. Her *Refuge Wear* series (1992–98) consists of costumes that combine elements of weatherproof clothing, sleeping bags, and inbuilt supports that expand into or connect with tents. They become a form of body architecture, especially when a number of people are involved: then, they have the capacity to facilitate the formation of communities, ones that come together for a common purpose, then disperse once it is fulfilled. Walking through cities in these costumes becomes a collective enterprise, taking on symbolic resonance depending on the circumstances, as in the 1997 *Nexus Architecture* march from the shanty towns of Johannesburg to its cultural center in costumes made by women from the Usindiso hostel (Fig. 11.11). Some of these costumes are symbolic rather than practical (the fabric tubes, for example); as the artist says, they "act as a metaphor for creating a social alliance," an artistic image that both signals the desirability of an actual social relationship, and assists in making it happen.[23]

The same could be said of Ralph Borland's *Suited for Subversion* (2002) (Fig. 11.12). In a spirit of rather desperate fun, it is designed to outfit a civil disobedience protester: this padded plastic suit creates bulging shapes around the protester's body to protect the wearer from police batons. A wireless video camera in the hood records any attacks, transmitting the signal direct to a control station, thus obviating the need for tapes that could be destroyed. A speaker in the wearer's midriff amplifies his or her heartbeat, creating a sense of increased vulnerability that might deter attacks. It could also be used as a loudspeaker. Confronted by a crowd of such fantastic figures, a fully equipped police squad is matched—at least on the level of costuming.

These projects demonstrate that ecological issues arise not only in wilderness areas but also in cities as well as in agricultural regions—these are now understood as forms of man-made "second nature."

11.12 Ralph Borland
*Suited for Subversion*,
2002. Nylon-reinforced
PVS, padding, speaker,
and pulse reader, 47¼
x 31½ x 23⅝in (120 x
80 x 60cm). Museum of
Modern Art, New York.
Fund for the Twenty-
First Century.

11.13 Michael Rakowitz
*paraSITE Shelter for
Michael McGee*, 2000.
Plastic bags, polythene
tubing, hooks, tape.
Various sites, Cambridge,
Boston, New York, and
Baltimore, MD, and
Ljubljana. Courtesy of
the artist and Lombard-
Freid Projects, New York.

11.14 Center for Land
Use Interpretation
*Toyon Canyon Landfill*,
2008. Exhibition poster.

Social breakdown within them parallels the degradation of natural processes. The *Homeless Vehicle Project*, carried out by Krzysztof Wodiczko with David Lurie in New York in 1988–89, and Martha Rosler's 1991 project *If You Lived Here: The City in Art, Theory, and Social Activism*, are important precedents for works such as Michael Rakowitz's *paraSITEs* (Fig. 11.13). Since 1998, Rakowitz has designed inflatable vinyl and nylon structures as temporary, portable housing for homeless people in Cambridge, Massachusetts, and elsewhere. Rakowitz's core concept was that they could be inflated using the heat expelled from existing buildings, so he designed attachments to external exhaust vents. Beyond that detail, all other aspects of the design are developed in collaboration with each user, resulting in a variety of forms. Initially preferring a black color, he was persuaded by the occupants, conscious of their security, to use clear or translucent plastic bags, so that they could be seen and could see out. Made in readily available and cheap materials (tape and plastic), and easy to fold up after use and transport, they have also been used in New York and Baltimore. In 2004, Rakowitz augmented this idea with his project *(P)LOT*: a collapsible, easily portable framework that fits conventional car covers, turning them into tents that occupy the space normally filled by a car. They could become disguised housing for the homeless, or temporary accommodation for those able to afford to rent only a parking space.[24]

## EXPERIMENTAL GEOGRAPHY

Consciousness of the fragility of the natural environment has led to concern about the health of those tracts of land not subject to urbanization but nevertheless marked by human use. Retreating icepacks, rising sea levels, constant temperature increases, and transformations of animal habitats are matters of daily report. Less visible is information about the ownership and control of intermediate zones. At a time when information seems to

flow at unprecedented densities and be freely available as never before, it can be surprising to discover the depth of secrecy pertaining to the management of prohibited sites. The Center for Land Use Interpretation (CLUI), a group of geographers, artists, and scientists working in the United States, has dedicated itself to mapping such spaces, many of which are controlled by governmental agencies, working away from public scrutiny. Other places have become monuments to redundant industries, past conflicts, and outdated attitudes, as CLUI member Matthew Coolidge notes: "The entire landscape is an inscription of our culture on the ground, a mix of intentional and incidental markings, and that inscription can be read in many different ways… The whole world is scripted in many different languages. Sometimes it is literary, using text; sometimes it uses postmodern ideas in the form of architecture, and sometimes it employs aqueducts, open-pit mines and dumping grounds; all of these are scripts, and these are the hieroglyphs we interpret by means of the CLUI's programming."[25] Pursuing what it calls "anthropogeomorphology" (the ways in which human use has changed the Earth), the group has documented many obscure practices that amount to abuse of natural environments—such as abandoned areas within cities, nuclear waste dumps in desert areas in the U.S. southwest, uranium tailings all over, even earthworks by artists—mounted exhibitions about them, and published them online as a "Land Use Database" (Fig. 11.14).[26]

In his photographs, "experimental geographer" and artist Trevor Paglen turns the surveillance mechanisms of security agencies back upon their own sources. Having published studies of the extensive Californian private prison system, he turned to documentation of the secret military zones scattered across the country.[27] His images of secret missile bases show obscure shapes at great distances; those of extralegal surveillance satellites show blurred lines that might be star tracks. Part of his point is that the visual "evidence" is unreliable, no matter who presents it. More poetic but equally chilling is his

11.15 Trevor Paglen
*Code Names: Classified Military Programs Active between 2001 and 2007,*
2008 (detail). Print on paper. Courtesy of the artist and Altman Siegel Gallery, San Francisco.

*Code Names: Classified Military Programs Active between 2001 and 2007* (2008) (Fig. 11.15). CLUI and Paglen are among the growing number of interventionist artists who adopt what the Critical Art Ensemble (CAE) term "tactical media" strategies: "Tactical media is situational, ephemeral and self-terminating. It encourages the use of any media that will engage a particular sociopolitical context in order to create molecular interventions and semiotic shocks that contribute to the negation of the rising intensity of authoritarian culture." [28]

Founded in 1987, the CAE collective works in a variety of media, from web art to performance, focusing in recent years on the social and political implications of biotechnology. Its *Free Range Grain* performance at Frankfurt in 2004, for example, involved members acting as amateur scientists, testing foods for the presence of genetically modified organisms that were then banned in Europe. *Marching Plague* (2005–07) explored the historic failure of germ warfare, and questioned the continuing commitment to it by militaries in many countries. In May 2004, the Joint Terrorism Task Force of the FBI detained CAE member Steve Kurtz and seized materials relating to these projects. While bioterrorism charges were soon dropped, Kurtz and a scientist who sent him samples were charged with mail fraud. The Department of Justice finally dropped the case in June 2008. [29] (Fig. 11.16)

Many interventions have localized and temporary impacts: often, this is entirely appropriate, as the accumulation of small steps can lead to significant change. It is rare, however, for an artist to succeed in introducing a critical concept to the centers of political power, and to do so in a way that may have a lasting effect. A case in point is Hans Haacke's *DER BEVÖLKERUNG (To The Population)* (1999–2000) (Fig. 11.17). In German, the title means "the population," a neutral term preferred by many politicians because it does not carry the connotations of pure Aryan blood that *das Volk* ("the people") acquired during the Nazi period. Across the entrance to the Reichstag, the home of the German parliament in Berlin, is an inscription that reads *Dem Deutschen Volke* ("To the German People"). When the parliament returned to the building in 2000, a number of artists were invited to install works that might promote reflection on the building's history, its present circumstances, and its possible futures. Assigned an interior courtyard, Haacke chose to install a large rectangular plot in which the phrase *Der Bevölkerung*—written in a typeface similar to that on the building's façade, with the letters opaque by day but neon-lit at night—is the centerpiece. Deputies and visitors are thus constantly reminded of the tensions between the two phrases, their symbolic histories, and—as the German population increasingly includes migrant workers from poor countries and from elsewhere in Europe—the contemporaneity of their changing meanings. But it is another element of the work that definitively connects it with the concerns of this chapter, and which proved most controversial. The artist invited deputies to bring in a pound of soil from the district they represented and deposit it in the space around the letters. He stipulated that the plot not be treated as a garden, that whatever growth might occur be left unattended. After fierce debate about each aspect of the proposal as deputies divided along ideological lines, it was passed by a few votes. In September 2000, the Speaker, aided by the artist, brought soil from the Jewish Cemetery in Berlin. Since, over half of the deputies have brought soil from their districts. The work remains a subject of debate, and continues to grow—as does representation of the Green Party in the parliament. [30]

Artistic interventions can, of course, take a variety of forms, depending on the circumstances. While

11.16. Critical Art Ensemble *Evidence*, 2004. Still from video showing television broadcast material documenting the Federal Bureau of Investigation raid on CAE member's home. Courtesy of Steve Kurtz, University of Buffalo.

11.17 Hans Haacke *DER BEVÖLKERUNG (To The Population)*, 1999–2000. Northern interior courtyard, Reichstag, Berlin.

11.18 Jennifer Allora
and Guillermo Calzadilla
*Land Mark (Footprints)*,
2001–02. Twenty-four
color photographs, each
20 x 24in (50.8 x 61cm).
Courtesy of Gladstone
Gallery, New York.

Haacke acted at the heart of Germany's political system and under intense media scrutiny, Puerto Rican artists Jennifer Allora and Guillermo Calzadilla exemplify those who adopt strategies that operate indirectly, quietly, at the edges of visibility. Seeking to contribute to local protest against U.S. military bases on their island—particularly Vieques, for many years a site for bombing exercises that were degrading their beaches—they carved the soles of sneakers with images and statements objecting to this practice (Fig. 11.18). Anyone in these shoes who walked along the beaches linking the site to the city made a silent but unmistakable protest. Bombing was stopped in 2003.

## IMAGING THE FUTURE DYSTOPIA

Changes in natural environments ("first nature") and in the human settings embedded in them ("second nature") are becoming increasing intertwined with information that is accumulated and exchanged within virtual domains ("third nature").[31] The mixing of these worlds has caused widespread concern. Eduardo Kac and Patricia Piccinini stand out among artists concerned with bio-ethics and the social impact of cloning.

Kac uses simple, striking imagery and outlandish, attention-grabbing strategies to "instill in the public a sense of wonder about this most amazing of phenomena we call 'life.'" As part of his *Natural History of the Enigma* series, developed 2003–08, Kac had the genome sequence extracted from his own body's immune system (taking it to be his most singular expression) and inserted into a growing petunia that, when it flowered, expressed his DNA in its red veins. Naming it "Edunia," Kac regards it as hybrid life form, a "plantimal."[32] He wondered whether genetic adaptation might be signaled by changing the color of an organism, so he asked a laboratory in France to introduce green fluorescent protein (GFP) into a rabbit, thus producing a *GFP Bunny* named Alba ("white" in Latin), later adopted by his family as a pet. Images of the glowing green bunny achieved worldwide publicity (Fig. 11.19).

What are the broader social and psychological implications of the fear that contemporary stem-cell research, genetic engineering, cloning, bio-electronics, and technologically mediated ecological restoration and kin formation might lead to the creation of "monsters"? Piccinini imagines a world populated by technocreatures of all kinds, among whom humans dwell. Uncannily, the mutants seem to behave like humans, to have humanlike needs and desires—thus her series of mutants and human figures going about what seem quite ordinary lives: their shared childhoods in *We Are Family* (2003), their mutual fascination in *Still Life with Stem Cells* (2002) (Fig. 11.20), and, when merged, as a gently maternal pig–fish hybrid in *The Long-Awaited* (2008). Too accurately mimetic to be seen as "sculptures," they are experienced as actual life forms that are, temporarily, still.[33] Piccinini does not confine her work to uncanny human/animal clones. In projects made with designer Peter Hennessey, trucks and motorbikes might take amoebic shape, and seek to reproduce each other as such life forms do. Theorist Donna Haraway notes that Piccinini's work invites us to realize that "the important question is not found in the false opposition of nature and technology. Rather what matters is who and what lives and dies, where, when, and how? What is wild, and what quiet? What is the heritage for which technocultural beings are both accountable and indebted? What must the practices of love look like in this tangled wild/ quiet country?"[34] The artist's answer, evident in her work, is this: "I am particularly fascinated by the unexpected consequences, the stuff we don't want but must somehow accommodate. There is no question as to whether there will be undesired outcomes; my interest is in whether we will be able to love them."[35]

11.19 Eduardo Kac
*"Free Alba!"* (*Folha de São Paulo*) (left) and (*New York Times*) (right), 2001. Color photographs mounted on aluminum with Plexiglas®, 36 x 46½in (91.5 x 118cm). Edition of 5. Collections of Richard Sandor and Alfredo Hertzog da Silva.

11.20 Patricia Piccinini *Still Life with Stem Cells*, 2002. Silicone, polyurethane, human hair, clothing, carpet, life-size, dimensions variable. Courtesy of the artist.

# ECO-CHIC, GREENWASHING, SPECTACLE

In recent years, some artists have questioned whether the increasingly frequent endorsement of ecological principles matches the reality on the ground. It surprised many, for example, when the 8th Sharjar Biennial, held in 2007 in the United Arab Emirates—a region famous for using its revenues from oil to build whatever seems likely to generate more revenue—announced as its theme "Art, Ecology, and the Politics of Change." Biennial director Hoor Al Qasimi explained: "The theme of this year's Biennial stems out of a need to re-negotiate and re-locate the issues of both art and ecology to a touchable realm… Let us form an ecology of choice, [create] a space and means for contemplation, reconsideration, and reluctant interventions."[36] Exhibiting artist Tea Mäkipää put these ideas in a more concrete form in her *10 Commandments for the 21st Century* (2006) (Fig. 11.21). Printed on posters, T-shirts, and postcards, these injunctions floated in the sky, as if seen from an airplane flying high above the cloud line:

1. Do not fly.
2. Recyle.
3. Use a bicycle or public transportation instead of a car.
4. Avoid any products with plastic packages.
5. Avoid heating and air conditioning, if possible.
6. Avoid any products that come from far away.
7. If you are not really sure you need it, don't buy it.
8. Do not produce more than 2 children.
9. Do not cultivate, build on or otherwise consume virgin land and water.
10. Make all these steps easy and cheap for yourself and others to achieve.

On her website, the artist makes these messages available in a number of languages. She is aware of their time-bound character, commenting:

> Put into action, the simple rules displayed in "10 Commandments for the 21st Century" could slow down and gradually restore some parts of the ecological disaster caused by the human population. If humanity succeeds in steering itself clear of the crash course with its environment, "10 Commandments for the 21st Century" will have a different meaning. In the best-case scenario, the future viewers of the artwork will find our current problem, and these 10 ideas to solve it, as laughable signs of a rudimentary point of history around year 2000. The aim of the project is to evoke discussion, and to appeal to the viewer's personal feeling of responsibility on the level of daily life and choices. The second aim is to relieve the confusion and frustration of facing ecological issues, by making the choices very simple. The project refers to current technical solutions, instead of better ideas and practices of the future. The artwork is non-commercial, trying to be accessible to people of any culture, age, religion or social status.[37]

This is a succinct summary of the attitudes shared by many of her generation, not only about how we might best relate to the world around us but also about how an artwork should address a viewer.

Awareness that we all must try to live according to these principles is rapidly increasing. Our persisting failure to do so, and the self-deluding pathways that we often take in our attempts to be "ecologically sound," are the subject of Melbourne-based artist Emily Floyd's installation *The Fertile Void* (2009), in particular its centerpiece *Our Community Garden* (Fig. 11.22). Mixing graphic styles as diverse as those of Minimal sculpture and Montessori learning aids, Floyd targets the community gardens created by well-to-do suburbanites, the privileged enclaves of nontraditional schools, and the retailing of organic foods at inflated prices by chain stores catering to the upper middle classes. Contemporary art, she hints, is a parallel niche market. While every element of her sculptures is painstakingly and expertly crafted, she uses both natural woods and pulpboard, while the colors and shapes are those of the handyman store, the primary classroom, and the do-it-yourself workshop. Strewn among the towers made from toylike puzzle blocks are learning sticks: each has carved into it the URL of a "creative commons" Internet site (Fig. 11.23). The whole installation seems like a random accumulation of artifacts from the premodern era, while at the same time it prefigures a "greenwashed" environment in the near future. Neither scenario is comforting. As we navigate the implied meanings of this installation, and ruminate on its broader implications, we sense that everything we can see and feel has already been mediated by some external force (habit, fear, convention, commercial interests, distant ideologies, aliens?); that our sense of ourselves, our connections with others, and our relationships to the natural, man-made, and virtual worlds—even when

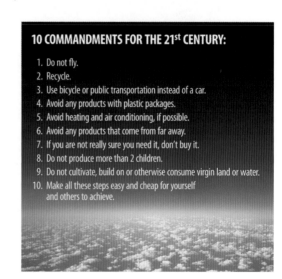

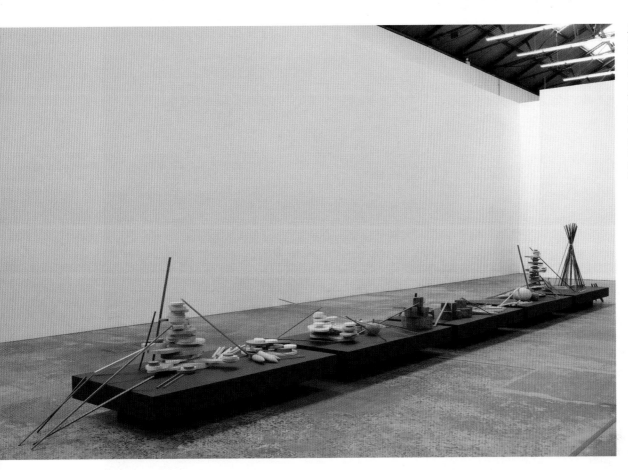

11.23 Emily Floyd
*Our Community Garden*,
2009 (detail) (see
fig. 11.22).

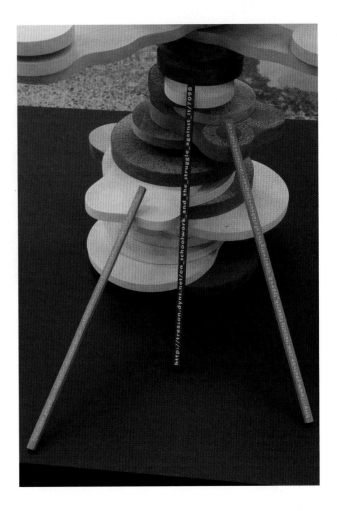

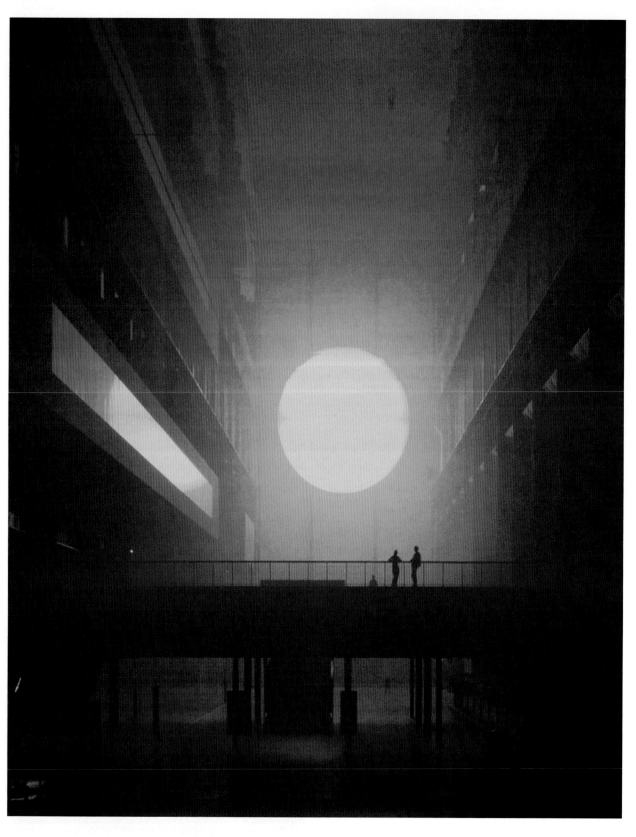

11.24 Olafur Eliasson
*The Weather Project*,
2003. Monofrequency
lights, projection foil,
haze machine, mirror
foil, aluminum, and
scaffolding, 87½ x
73⅒ x 509¾ft (26.7
x 22.3 x 155.4m).
Installation view,
Turbine Hall, Tate
Modern, London.
Courtesy of the artist
and Tanya Bonakdar
Gallery, New York, and
neugerriemschneider,
Berlin.

these relationships are open-hearted, respectful, and conducted one on one—are already prescribed.

In recent art, this sense—a very contemporary one—has nowhere been more evident than in Olafur Eliasson's *The Weather Project* (Fig. 11.24), installed during the winter of 2003 at Tate Modern, London. Joking that the English love talking about the weather, the Danish artist worked with museum publicists to place posters all over the city carrying statements such as "47% believe that the idea of weather in our society is based on culture; 53% believe that it is based on nature" and "Does talking about the weather lead to friendship?" Over 2 million visitors came. Entering the Turbine Hall, they sensed a mist—and could hear and see the cloud machines pumping it out. At the far end, 500 feet away, a giant yellow orb glowed. Walking forward, visitors became aware that the already gigantic hall was doubled in size and spun off into space by a ceiling of mirrors suspended above them, reflecting their presence, their movements, and those of everyone around them. Approaching the golden sun, they could see that it was an illusion produced by a semicircular steel frame, 50 feet in diameter and fitted with 200 sodium streetlamps. Suspended immediately in front was a semicircular projection screen of the same size, which diffused the lamp light into a yellowish aureole, ringed with dark shadows. Hung at the top of the wall, these two semicircles appeared round when reflected in the ceiling mirrors, but were not perfectly aligned, making the orb a shimmering, miragelike, even cinematic figure. Visitors stood entranced, sat in groups, conversed, and, sometimes, formed visible shapes, symbols, or even phrases—a popular one being "Stop War."

Professing "great faith in the spectator and in the self-reflective experience," Eliasson confessed to fellow artist Robert Irwin his hope that, in contrast to the physical, emotional, and cognitive distancing required by modern art, "my work can return criticality to the viewer as a tool for negotiating and reevaluating the environment—and that this can pave the way for a more causal relationship with our surroundings."[38] Although this particular project was entitled *The Weather Project*, and evocative of natural effects, the "surroundings" of which Eliasson speaks are not simply those of pristine natural environments, nor is he asking us to take such domains as the ideal. Like the other artists discussed in the second half of this chapter, he is aware that even the most apparently remote parts of the planet are connected with every other part, and that "first," "second," and "third" natures have interpenetrated thoroughly, each mediating the others in sometimes obvious, sometimes oblique ways. As part of his 2010 exhibition *Innen Stadt Aussen* (*Inner City Out*), Eliasson showed a film of a truck roaming the streets of Berlin with two large mirrors mounted back to back on its tray. Its progress through the city was, in turn, filmed from another truck. Many takes consisted entirely of reflected images, others tracked the truck's progress, while still others showed both.[39] At the core of the exhibition itself, in the central hall of the Martin Gropius Bau, Eliasson arranged a set of mirrors that surrounded the viewer. At both lateral perspectives, one's image was repeated to infinity (or, more accurately, toward a cloudy, white blurring caused by reflected fluorescent lights). On the other two sides and above, layered sequences of mirrors reflected the light monitor in the roof of the hall: this had the effect of disturbing one's sense of above and below, inside and out. In projects such as these, we are, like it or not, immersed in these surroundings, and in this mediation, with no other place to be—except, for a time, when immersed in works of art, such as his, that enable us, and our companions, to "see ourselves seeing."[40]

Is this where art concerned with the environment has arrived in the early decades of the twenty-first century? Does it offer a pathway between the aesthetic-versus-activist dichotomy that we declared false at the beginning of this chapter? Are works such as Eliasson's successful in enabling the "criticality" of which he speaks, or are they eco-chic fodder for the museum branch of the "experience industry"—a core component of spectacle society—and thus a kind of aesthetic greenwashing? They might, perhaps, be both (how contemporary can you get?). These questions are becoming urgent in art discourse, and the subject of a growing number of exhibitions.[41]

# 12. SOCIAL MEDIA: AFFECTS OF TIME

Self-making is the central concern of the now-maturing generation of contemporary artists. It leads them to ask: What is it to live, to exist, to *be* in contemporary conditions? The descriptive question "How do we live now?," when answered in the ways we have noted in previous chapters, quickly becomes an ethical one: "How might we live better?" While many artists take for granted, or by and large accept, the perspectives promoted by the world's nations, ideologies, religions, corporations, and communicative media, others feel obliged to question these narratives, and to contest the kinds of power that they enable. In Chapter 10, we traced strong challenges to prevailing economic and political accounts of how societies evolve historically, and, in Chapter 11, we saw artists questioning the belief that human progress was inevitably based on the continuous exploitation of nonrenewable natural resources, and noted their growing awareness that the interaction between first, second, and third "natures" has come to shape reality. In this chapter, we will examine the response of artists to two other definitive aspects of the current situation. The unprecedented proliferation of new communicative technologies throughout the daily lives and inner imaginations of most of the world's inhabitants has led to our immersion in what has been named a "media-scape."[1] How does all-pervasive mediation affect our efforts at self-fashioning, at being-with-others? This leads directly to the second concern of the chapter: time within contemporary art. Many artists sense that spaces outside media saturation—potential zones of freedom—exist as much within the realms of inner experience and imaginative projection as they may in actual, physical reality; perhaps more so. They sense, further, that grasping the changing nature of time is key to understanding these realms: the multiplicity of ways of being in time exhibited by the world's peoples (itself nowhere more evident than in what is shown by the new technologies), and the variety of temporalities experienced by each of us every day (not least in our use of these new technologies). As artists, they explore the traces that these factors leave upon the objects,

images, events, spaces, durations, and situations that they create. Their works invite us to join them in asking the key question: what is it to be "with time" these days—to be, in a word, contemporary?

Influential interpretations of contemporary art have recognized some but not all aspects of these changes. Most commentators are pessimistic about the prospects for wide-scale change, timid about tactics, and thus pragmatic in outlook. "Relational aesthetics," defined by Nicolas Bourriaud as "A set of artistic practices which take as their theoretical and practical point of departure the whole of human relations and their social context, rather than an independent and private space," is an example.[2] Summing up a mood emergent in the 1990s, Bourriaud comments: "Nobody nowadays has ideas about ushering in the golden age on Earth, and we are readily prepared just to create various forms of *modus vivendi* permitting fairer social relations, more compact ways of living, and many different combinations of fertile existence. Art, likewise, is no longer seeking to represent utopias; rather, it is attempting to construct concrete spaces."[3] This point may be broadened to encompass the art discussed in this chapter: the "concrete spaces" it prefers to create are interactive settings of immediate experience and direct exchange. Impermanent, unrepeatable, transitional, they reflect the occasional character of contemporary life. Because negotiated relationships rather than timeless, symbolic objects are their intended outcome, they tend to be temporary installations, provisional in form. They involve the emotions, minds, and bodies of all concerned, and are, therefore, *affective* in character.[4] Because these affects—while deeply felt by each individual (and thus subjective to the core)—occur in the context of relationships with others who are sharing in the experience, they are, as well, *participatory*. If the disinterested, consciously distanced yet nonetheless engaged viewer of Modernist Art was joined, during the 1970s and 1980s, by the fascinated spectator (or, as some would say, the spectacularized subject) of Postmodern Art, since the 1990s we have increasingly found ourselves participant

observers, active *within* works of art, cooperative makers of their presence in the world.[5] At the same time, many of our daily activities—especially those involving communication among friends, or within activist groups, even occasions of transient affiliation—resemble participatory artworks. In this sense, both art and everyday life are becoming more contemporary than ever before.[6] Let us see how these observations play out in the work of artists who take them as their primary subject matter, especially those concerned with the effects of immersion in media and the impact of multiple temporalities.

## MEDIATION, IMMERSION, INTERVENTION, AGENCY

The global spread of communicative media has been a major factor in enabling more of us to be more aware of those immediately around us (our families, friends, neighbors), of those nearby (in our city, country, and region), and of the actual and virtual presence of multitudes of more distant others—our contemporaries all over the world. Everywhere, different kinds of social cooperation are coming into being, along with new kinds of personal connection. Although 74 percent of

the world's population were still without Internet access in 2009, social media such as YouTube, MySpace, Flickr, Second Life, Facebook, and Twitter have become the preferred channel of communication for many of the nearly 2 billion who do enjoy such access—by 2010, Facebook alone had over 400 million users worldwide.[7] For these people, the technical potential of universal networking has converged with the basic human desire for community to generate constant, instant connectivity, a compulsion to broadcast the details of one's everyday life *as it is happening*, to participate in an out-there, transparent, eventful contemporaneity of shared self-formation.

*T_Visionarium II* (2008) (Fig. 12.1) is an extraordinary immersive, interactive environment produced by artists from the iCinema Centre, Sydney, and ZKM, Center for Art and Media, Karlsruhe.[8] On entering the space created by the 360-degree cylindrical screen (11½ feet high and 33 feet in diameter), entranced by the presence of 300 floating "windows" that hover in what seems to be an infinite blackness, one immediately loses any sense of spatial dimension. Each window is showing a clip from a television show broadcast on one day in 2006: taken from all programs broadcast that day, each screen plays the clip as originally edited and presented. The isolated, single screen to which our viewing habits

12.2 Pierre Huyghe
*The Third Memory*, 1999.
Installation, double
projection film, Beta
digital color, sound,
9 mins. 46 secs. Detail:
photographs of the
shooting. Images
showing a clip from
*Dog Day Afternoon*
(Pacino with rifle), and
Wojtowicz explaining
to camera. Courtesy
of Marian Goodman
Gallery, New York.

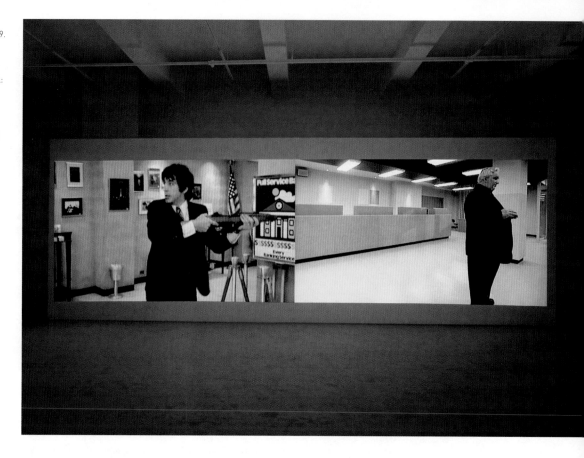

12.3 Candice Breitz
*King (A Portrait of
Michael Jackson)*, 2005.
516-channel installation
16 hard drives, 42 mins.
20 secs. Shot at UFO
Sound Studios, Berlin.
Courtesy of White
Cube, London.

usually confine us is strangely and pleasantly dispersed. As if visiting a panorama, a planetarium, or a wraparound aquarium, we feel that we are inside the monitor. We have entered a purely televisual world, populated by recognizable faces and familiar actions, sounds, and places. Soon, however, we notice repetitions, especially of gestures and expressions. They occur at unsettling speed (the average time between edits on television is 4.55 seconds). Where is the story? Why is there so much anxiety in the room, so much violence, so many similar gestures by so many similar-looking people? Why does every mood seem to spread like wildfire?

We are learning something about television, about its affective structures. Without the framework provided by unfolding narratives, normal programming, and advertisements, these affects are exposed to our gaze. The iCinema and ZKM artists, and their computer scientists, tagged every segment of the database footage (22,636 in total) according to its location within a range of emotions (anger, fear, grief, joy, and love), expressive relationships, physical movements, and structural elements (dense versus empty, slow versus frenetic, male versus female). It is these that are competing for our attention. We are supplied with a remote-control device that enables us to click on an image of our choice, which, we quickly learn, not only brings that window forward but also calls up all similar clips to cluster around it, like eager siblings. We may also double-click the chosen screen, with the effect that the full program from which the clip has been taken will play, and all other windows will freeze into silent accomplices. This is the only way to calm the agitated mood. Our urge to montage clips into our own movie is perpetually frustrated. Allowing only a choice between two banalities is tough on viewers of *T_Visionarium II*, but is honest about its subject matter, and about the relationship to television that most of us have as thoroughly mediated consumers. Yet this work contains within it a technology and an imaginative idea that have the potential to turn immersed viewers into active users. We will return to this point in conclusion.

Pierre Huyghe's 1999 installation *The Third Memory* (Fig. 12.2) offers an intriguing insight into how media saturation can drastically transform the life of one individual, with consequences for others. On August 22, 1972, New York resident John Wojtowicz robbed a bank in Brooklyn, wanting money to finance his partner's sex-change operation. When police surrounded the bank, he held the employees hostage, then negotiated a bus to the airport, where Wojtowicz's accomplice was shot, and Wojtowicz himself was arrested and subsequently jailed. Three years later, director Sidney Lumet made a successful film, *Dog Day Afternoon*, based on a *Life* magazine report of the incident, itself written as a film script. Huyghe's installation invites viewers to enter through a room in which they may peruse press reports, see the movie poster, and watch a daytime television show on the story. We then enter a space in which we see two screens that weave between scenes from *Dog Day Afternoon* and a film by Huyghe in which he follows

the bank robber, now 25 years older, as he tours a re-creation of the movie set, explains to camera how the film and the news reports varied from his memory of what actually happened, and directs a group of re-enactors. While Lumet's film claimed to be "based on a true story," Huyghe's installation aims to enable Wojtowicz —for the artist, "the real author"—to "reoccupy his place within the very apparatus that had dispossessed him of his own memory."[9] *The Third Memory* is the third memorializing of the event (following the magazine story and film). As a virtual projection, it is part of third nature. As we move through the installation space, it becomes obvious that no account of the events is more reliable, or "authentic," than the other. Each creates its own delusions, yet each has its unique authenticity. We also sense that the original event—the bank robbery— was itself already mediated by previous robberies, news reports, photographs, and movies. Our mediated selves subsist, like the bewildered bank robber, in the shifting worlds between these partial possibilities.

Noting that "No work of art can compete with the sheer drama, diversity and interest of everyday life," yet fascinated by the interactions between daily life and mediated representations of it, Candice Breitz devotes one stream of her work to a practice of "re-animation," of "seizing on a piece of inanimate footage and trying to revive it, along with the disastrous and unpredictable consequences that this may entail."[10] In her 1999 video *Babel*, tapes of performances were edited so that pop stars spouted endless baby talk. For the installation *Mother + Father* (2005), she edited shots of Hollywood actresses and actors playing parenting roles, displaying them on two facing, horizontal screens, six channels on each. The other stream of Breitz's work focuses on the nature of fandom. Taking Madonna and Michael Jackson to be the "queen" and "king" of popular music, in 2005 Breitz invited 30 Italian fans of the former to individually perform, right through, her album *Immaculate Conception* and 16 German and Austrian fans of the latter to perform his album *Thriller*. In the resultant works, *Queen (A Portrait of Madonna)* and *King (A Portrait of Michael Jackson)* (Fig. 12.3), film of each fan's performance, as designed and presented by the fan, is projected, floor to ceiling, in a darkened space. Breitz found that "few fans want to emulate their idols in the studio. They prefer to translate the material into their own terms."[11] It seems that independent selfhood—or, at least, inflections of it—remains possible within spectacle culture.

While the mass media in consumer societies prioritizes the shaping of subjectivity, it is also much concerned with fashioning multiple, actual, and conflicting temporalities into persuasive narratives, often quasi-historical in character, and with obliterating from memory inconvenient or threatening occurrences (deliberately creating what cultural theorists call "social amnesia").[12] Worried that the Miners' Strike of 1984–85 was fading from public memory, English artist Jeremy Deller organized the re-enactment in 2002 of a key event from that struggle: a violent clash between police

and miners in Orgreave, a Yorkshire town (Fig. 12.4). Eight hundred people took part, including many from both sides of the original battle. They were joined by members of battle re-enactment societies from many parts of Great Britain. The artist stated: "Of course I would never have undertaken the project if people locally felt it was unnecessary or in poor taste. As it was, we encountered a lot of support from the outset because there seemed to be an instinctive understanding of what the re-enactment was about." What, then, were the motivations, on both sides? Deller wanted "the re-enactment of the Battle of Orgreave to become part of the lineage of decisive battles in English history." A moment in the long history of struggle between classes on the island is thus joined to the even longer history of bloody clashes between tribes, peoples, princes and queens, religions, and ideologies that make up the pageant of British history. This is a constructive social purpose, one that many of the participants seemed to share. The artist was also interested in creating an opportunity for original participants and seasoned re-enactors to work together on a shared task: both, in this instance, re-enacting the same event. This is a participatory goal, of a kind now common to contemporary art. Finally, the artist wanted to test a technical limit: "I was interested in how far an idea could be taken, especially an idea that is on the face of it a contradiction in terms, [an orderly] recreation of something that was essentially chaos."[13] This is an affective goal, effectively realized, it seems, for those who participated, and readily imagined by those of us who did not.

After decades of "the Troubles" in their country, it is no surprise to find Irish artists Willie Doherty, James Coleman, and Gerard Byrne especially concerned with the processes of social amnesia. Byrne's *1984 and Beyond* (Fig. 12.5), made between 2005 and 2007, is an installation consisting of a wall text, three flat-screen digital monitors, and 20 black and white photographs. The date *1984* in the title is a reference to the famous 1949 novel by English writer George Orwell which conjures a totalitarian dystopia in which everyone is subject to constant surveillance that tests loyalty to "the Party." The main character works for the Ministry of Truth: his job is to falsify newspaper records, aligning them with what Big Brother decides is the truth required that particular day. "He who controls the past, controls the future," is one of Big Brother's slogans. In July 1963, the U.S. magazine *Playboy* published a discussion—entitled "The Playboy Panel: 1984 and Beyond"—between 12 famous science-fiction writers, including Ray Bradbury, Arthur C. Clarke, and Isaac Asimov, who were asked to imagine life in the year 1984. In Byrne's video, actors re-enact this discussion in the galleries, public rooms, and grounds of the Sonsbeek Pavilion, designed by the Modernist architect Gerrit Rietveld in 1965 for the Kröller-Müller Art Museum, Krefeld, Germany, and in the Provinciehuis of 's-Hertogenbosch, the Netherlands, designed by Hugh Maaskant. Along the walls of the installation space, photographs depict scenes of American life—house fronts, a space rocket, a bar sign, a long-bodied car, the entrance

to the Lever Building in New York, the globe insignia of the 1967 New York World's Fair—in the casual, snapshot style then coming into vogue. Even the introductory wall text—a lengthy quotation from eighteenth-century theologian Jonathan Edwards on how to see things in the world truly—evokes this period: it was used by formalist critic Michael Fried in his famous 1967 attack on Minimal sculpture.[14]

Yet nothing is exactly what it seems to be. Or rather, it is, but it is also something else, somewhere else, and from another time. Byrne achieves this effect by subtly undermining the exactitude of his re-creations. The actors are not dressed in the casual gear of writers, but as business executives from the 1960s ("Organization Men" in the jargon of the time). Being Dutch, they lack American accents, so give their speech the inflexions of EuroEnglish. While their gestures are natural, they utter slabs of words straight from the published (and thus already mediated) text. The camera pans around them, as if overhearing, in the style made famous in the 1960s by French-Swiss film director Jean-Luc Godard. The settings, while "modern" in a general sense, are slightly out of temporal alignment with the moment of the *Playboy* conversation: the Rietveld pavilion is a throwback to his famous International Style work of the 1920s and 1930s, while the Maaskant government building was completed in 1971 in a New Brutalist, corporatist style, thus postdating the conversation. The three videos do not present parts of a sequential piece of coverage: instead, they overlap, creating a discontinuous narrative. The viewer is encouraged to move between them, and between them and the photographs that look as if they were taken in the U.S. in the 1930s to the 1960s but that were in fact shot in 2005.

Thus we arrive at the third time zone evoked by *1984 and Beyond*: the now of the work's making, its present time, the moment from which it looks at other times, and from which we look at it—our present. We began with the year 1984, a date decided upon by Orwell because it inverts the year 1948, when he was writing the book. To Orwell, it was a terminal date, that of the end of the world: it has been widely accepted since as symbolic of global disaster. In contrast, the *Playboy* panel of 1963, in its optimism about the inevitable beneficial effects of technological progress, looked toward that year as just one in a future of unlimited economic, social, and sexual ("lifestyle") liberation. The 2005 photographs remind the viewer that these dreams were not realized, that they exist now only as nostalgia for a past in which such dreams were possible. *1984 and Beyond* offers an archeological view of the present: an excavated layering of the multiple temporalities that exist in the contemporary moment. As we view it, we experience all of them, contemporaneously, as pasts that echo in our present time—some as part of it, others as it might have been. We also sense that our time and place of viewing will itself "date," that is, become further layered with signs of time passing, and of beliefs changing.[15]

The agenda-setting powers of commercial mass and official media have enormous impact on the

12.6 Alfredo Jaar
*A Logo for America*,
1987. Public intervention
at Times Square,
New York.

world-picturing capabilities of all of us. In 1987, as one of a series of Public Art Fund projections onto LED screens in Times Square, New York, Chilean-born Alfredo Jaar presented *A Logo for America* (Fig. 12.6). A sequence of images including the outline of a map of the United States and of the American flag were shown, with the legend "This is not America" inscribed over them. These were followed by an image of the North and South American continents superimposed over the word "AMERICA." This simple juxtaposition reminded viewers of the history, and the continuing international resonance of the term, both of which are elided if one takes the word "America" to refer only to the United States. *A Logo for America* has been widely used in textbooks of many kinds to illustrate the unconscious presumptions underlying seemingly neutral public perceptions, and to trigger critical reflection about them.

Trained as an architect, Jaar considers himself "an architect making art."[16] His installations in interior spaces are carefully crafted to shape the spatial experience of the spectator. They are focused mainly on the role of the single image within the plethora of visual imagery that saturates both personal and public space in spectacle societies. How might an image become iconic when it must appear within a culture that is replete with images that are crafted to look already iconic? How might it compete with images generated by highly skilled professionals, pretested for their effectiveness, aimed at audiences that have been nurtured for decades to associate such images with positive feelings and strongly felt desires? To create similar images with the aim of conveying a countermessage is, Jaar believes, a strategy doomed to defeat. Instead, he builds environments that show us this system at work—its behind-the-scenes mechanics, as it were.

Outstanding among these is *The Sound of Silence* (2006) (Fig. 12.7). We enter a space that is dominated by a blinding array of fluorescent lights mounted on one side of a large cubic structure sheathed in aluminum. Walking around it, we discover an entrance with a signal that when red asks us to wait, when green invites us inside. The room is a single space set up for viewing a screen with two large photographer's lights, unlit, at either side. During the next eight minutes, a digital slide show unfolds that tells, in terse typewritten entries, the life story of South African photographer Kevin Carter. Drawn into photojournalism after suffering shattering experiences as a conscript in the army, Carter soon became a highly regarded professional photojournalist, employed by the major agencies. His photograph taken during the 1993 famine in Sudan of a starving young girl watched by a vulture caused a sensation when published on March 26, 1993 by the *New York Times* and other publications throughout the world (Fig. 12.8). Much of the resulting anger was directed at the photographer, especially when it emerged that he had waited 20 minutes for the vulture to open its wings. When it failed to do so, he took the picture anyway and shooed the bird away. At no point did he assist the girl, who was making her way to a feeding station.

In April 1994, Carter received the Pulitzer Prize for photography. Three months later, he killed himself, his suicide note stating that he had seen too much death and suffering. At this point in the slide sequence the photograph of the scene in Sudan appears, only to be instantly obliterated by the lights flashing on either side of the screen. Our surprise and perhaps anger at being taunted with, then deprived of, this image mixes with the uncomfortable sense that the installation has just taken our picture, as we have been

12.7 Alfredo Jaar
*The Sound of Silence*,
2006. Installation,
wood, aluminum,
fluorescent lights,
strobe lights, and video
projection, dimensions
variable. Software
design by Ravi Rajan.
Installation views,
Musée Cantonal
des Beaux-Arts,
Lausanne, 2007.

12.8 Kevin Carter
*Famine in Sudan*, 1993.
Photograph.

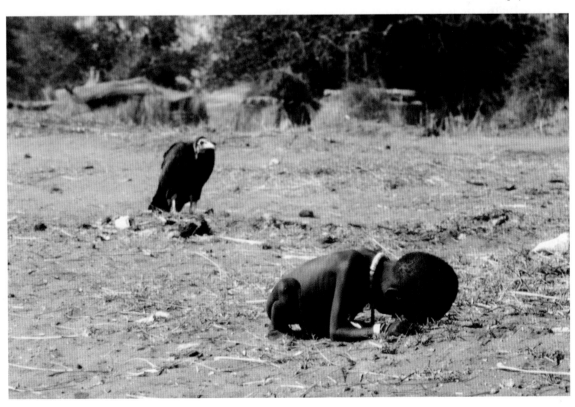

12.9 The Yes Men
*Bhopal Apology*, BBC TV,
December 3, 2003.

sitting there, entranced by this story, ready to relive our arm's-length horror at yet another instance of Africa's seemingly hopeless slide into natural and man-made disaster. The slide sequence then resumes its narrative of Carter's short life and offers some details about the status of the image itself, the rights to which are held by Carter's own young daughter. It is also one among millions managed by the Corbis Agency, owned by multimillionaire Bill Gates, founder of Microsoft and philanthropist of worthy causes, especially in Africa.

After complaining of being "moved yet irked, feeling raw yet manipulated," *New York Times* reviewer Roberta Smith concluded with a speculation about the title: "One implication is that silence is impossible; thought is its own kind of noise. Another is that the real silence is passivity, humanity's acquiescence to inhumanity. And a third is that the silence is the little girl, the absence at the center of the tale. She is gone forever, yet to focus on her and her image is to miss Mr. Jaar's point, and Mr. Carter's too."[17] The causes of famine are both natural and social: in Sudan, systemic racism and a corrupt government mean that suffering is spread unevenly, and is neither anticipated nor well managed—indeed, induced starvation is just one weapon among others in the arsenal of those who would control populations for their own benefit.[18] Jaar is fully aware of all of these factors. He admires photojournalists as "the conscience of our humanity," and acknowledges the physical risk and psychological ravages of their profession. He describes Carter's photograph as "one of the most extraordinary images I've ever seen as a human being and an artist… it is too easy to blame Carter for being the vulture, where in fact we are the vultures… I've never seen an image translate so much and so well the guilt of what is called Western civilization… it really reveals our real relationship with the African continent, which is continued indifference."[19] *The Sound of Silence* is a memorial to the child, to Carter, and to innocence within indifference in a globalized world.

So far, we have confined ourselves to artworks that reflect on the shaping of selfhood by the contemporary mass media. We encounter these works in art galleries, museums, and other cultural spaces. Some artists, however, are of a more activist disposition. They tackle the media in its own, very public domains. The

New York-based group known as the Yes Men (Andy Bichlbaum and Mike Bonnano) specialize in "Impersonating big-time criminals in order to publicly humiliate them. Targets are leaders and big corporations who put profits ahead of everything else."[20] Most of their interventions take the form of outrageous pranks. On December 3, 2003, posing as a representative of the Dow Chemical Company, one of them offered an apology for the leak, in 1984, of 27 tons of gases from a pesticide factory in Bhopal, India, which immediately killed 8,000 people and poisoned thousands of others (Fig. 12.9). The site was run at the time by Union Carbide India, a subsidiary of the U.S.-based company. A settlement was reached in 1990, but is regarded as inadequate by many residents. Union Carbide U.S.A. sold its shares in the Indian company in 1994, and was acquired by Dow in 2000. The Yes Men will not give up: on the twenty-fifth anniversary of the event, in 2009, they staged a lie-down protest in New York. They also market water purporting to be from the still-poisonous site in a designer plastic bottle under the label "B'eau Pal."[21]

Graffiti artists contest the shaping powers of official and advertising media in the most public spaces of cities and towns throughout the world. While much graffiti is so personal, obscene, or occasional that it has limited relevance, sustained campaigns are often the visual voice of marginal groups who wish to manifest their identities, demonstrate their resilience, and highlight alternative values. "Tagging" emerged during the 1970s in the U.S., often in African-American and Puerto Rican neighborhoods, as rival gangs competed for inner-city territory. Subsequently, individual graffitists vividly elaborated their tags (nicknames) on frequently observed sites throughout the country, some of them gaining artworld recognition for a time.[22] We have noted that artists such as Keith Haring and Jean-Michel Basquiat began their careers as graffiti artists at this time (see Chapter 2).

The attitudes of a later generation of graffiti artists are exemplified by the Bristol-based artist Banksy, known for the acute graphic economy of the images that he has stenciled on walls throughout Britain, such as the life-size profiles of two policemen kissing (Fig. 12.10), of rats behaving like urban anarchists, and of soldiers spraying peace symbols. He dreams of a public sphere

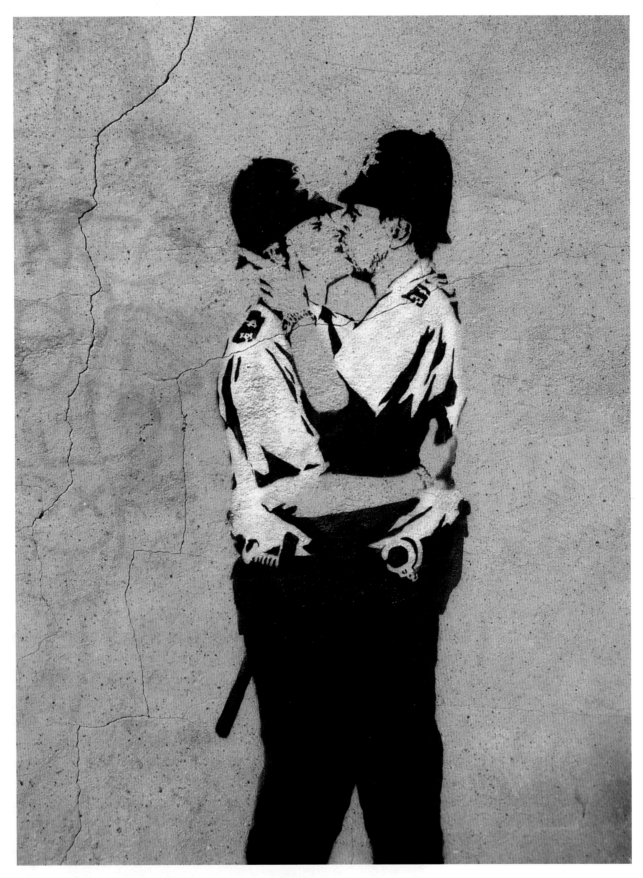

<u>12.10 Banksy</u>
*Kissing Coppers*, ca.
2005. Spraypaint on wall,
various sites, Brighton
and London.

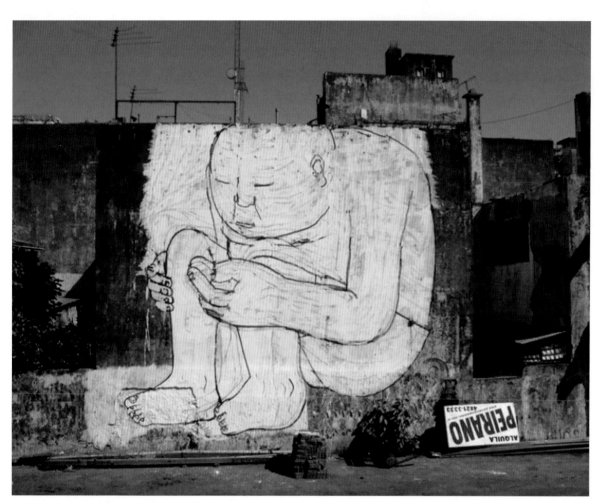

in which the voices of everyone are constantly heard, a genuinely democratic space: "Imagine a city where graffiti wasn't illegal, a city where everybody could draw wherever they liked. Where every street was awash with a million colours and little phrases. Where standing at a bus stop was never boring. A city that felt like a living breathing thing which belonged to everybody, not just the real estate agents and barons of big business. Imagine a city like that and stop leaning against the wall—it's wet."[23] Although each of Banksy's interventions takes the form of an amusing if pointed visual joke, there is anger against authority in these works, and encouragement to keep struggling against it because the very act of visual vandalism shows that such authority is not all-powerful.

Argentine artist group Blu, known since 2001 for its lively graphic animations about the alienation of life in rapidly modernizing societies, has recently—in an unexpected reversal—applied digital animation to mural paintings. In *MUTO* (Fig. 12.11), a seven-minute video made in Buenos Aires and Baden in 2007 and 2008, self-transforming humanoids shape-shift across one surface to another. Beginning as aliens who dig themselves out from a brick street-wall, the mutating figures then go through doorways and over fences and detritus, cover buildings of all kinds (consuming preexisting graffiti as they go), pass down alleyways, cross pavements, enter tunnels (here the figures become a Kafkaesque insect), and spread over interior walls, furniture, desktops, and sheets of paper (which a quasi-office-worker gobbles up). Sounds appropriate to each gesture are added, along with ambient street noises and upbeat circus music. A Surrealist fascination with the contingency of the incongruous echoes through Argentine art, as we saw earlier (see pages 121–25). *MUTO* ends on the side wall of a house, where a profiled head is swarmed over by a bevy of insects that eat it up, exposing its deformed skull.[24]

In a world increasingly subject to surveillance, it is no surprise that artists create works that not only alert us to these covert intrusions into our lives, but also enable us to practice the skills of alternative networking.

In a series of public art projects that he sees as a form of "relational architecture," Mexican new-media artist Rafael Lozano-Hemmer creates environments in which multiple participants can interact with others through a negotiated exchange of each other's visual image. Individuals walking across a town square are filmed, and their stilled images projected a few seconds later. By anticipating this, participants can act out a gesture. Others might respond to this gesture, and add one of their own. Soon, a small narrative of cooperation becomes visible. During 2005 and 2006, the *Under Scan* project (Fig. 12.12) enabled 1,000 people at a time to respond to digital footage of each other's portraits, simultaneously, in public squares in the English towns and cities of Derby, Leicester, Lincoln, Northampton, and Nottingham.[25] *Day of the Figurines* (2005–06) (Fig. 12.13), a game for mobile phones devised by the British artists' group Blast Theory, who specialize in interactive media, may be played by hundreds of people at the same time. Using the phone's text-messaging functionality, the game is woven into the player's daily life for 24 days, requiring each participant to send and receive just a few messages each day. The 24 days correspond to 24 hours in the life of a fictional English town undergoing changes (social breakdown, invasion, climate-change events) that render it dystopian. Participants have to find their own way to work against these pressures. Most soon begin to call on other players for assistance. The town is manifested as a large game board that registers the general decline and the players' moves. Housed in a public venue, it becomes a stage set, subject to remote change. Matt Adams of Blast Theory explains: "One of the motivations for this work is to create a morally ambiguous universe. We're making a case here for how games—which tend to be morally dry and lifeless—might be made to work… Can art exist on your mobile phone? Can it exist in your pocket, rather than in a gallery or a museum or a theatre?"[26] In *Day of the Figurines* and other new media-based, participatory works, Blast Theory is showing that it can.

12.14 Felix Gonzalez-Torres *"Untitled" (Perfect Lovers)*, 1987–90. Wall clocks, overall 35½ x 27 x 1¼in (90.1 x 68.5 x 3.1cm), two parts, 13½in (34.2cm) diameter each. Edition of 3, 1 of artist's print. Courtesy of Andrea Rosen Gallery, New York.

12.15 Tehching Hsieh and Linda Montano *Art/Life One Year Performance*, 1983–84, Courtesy of the artists and Sean Kelly Gallery, New York.

# TO BE WITH TIME IS ALL WE ASK

In artworlds everywhere in recent years, attention to time has transformed the nature of artistic media, led to the emergence of new modes of presentation, and radically altered the relationships between artists, artworks, and audiences. Each of these changes is an exchange between contemporaries: more insistently than before, artworks take up each participant's time, and invite a commitment of emotional, mental, and physical (and thus affective) effort, in exchange for an anticipated benefit, either directly to oneself or another—or, less directly, to a group, a set of others, elsewhere in time and space. This section will survey responses by artists and participants to the three major relationships to time that coexist in contemporary conditions: time as an objective fact of existence; time as a condition that may, in certain circumstances, be fully embraced and, in that moment, transcended; and time itself as a medium of affective experience.[27]

Two simple clocks, mounted on a pale blue wall, high in a spare space, their outer casings touching each other: we stand before *"Untitled" (Perfect Lovers)* (1987–90) (Fig. 12.14), a work by Cuban-born, Puerto Rican-educated, New York resident Felix Gonzalez-Torres. *Untitled* was a title much favored by Minimalist sculptors such as Donald Judd, Carl Andre, and Robert Morris during the 1960s: by using it, they wished to remove any sense that their works represented something else in the world, to clear the spectator's mind of all associations, and to open him or her up to the direct, unmediated experience of a "specific object." Reusing it in 1991, Gonzalez-Torres carefully placed it in quotation marks, so as to allude to his debt to Minimalism's economy of means, the aesthetic restraint with which his predecessors used industrial materials, and their employment of skilled workmen to manufacture works to their specifications. All of these qualities are present in Gonzalez-Torres's work, but in a quiet, gentle manner, one that invites shared reflection, rather than confrontational encounter. Quotation marks can also render a term equivocal, hinting that we are in the presence of something that cannot be named in public discourse. By adding the words "Perfect Lovers" to the title, and placing them in parentheses, Gonzalez-Torres evokes those who cannot be named, perhaps because they are of the same sex. Many of his works were acts of mourning for a partner, friend, or lover lost during the AIDS epidemic, which erupted during the 1980s. Yet he deliberately avoided using imagery that would reduce the meanings of his works to a single category, or make them representative of only one perspective. As the artist commented: "Two clocks side by side are more of a threat to power than the images of two guys giving each other a blow job, because it cannot use me as a rallying point in its struggle to obliterate meaning."[28]

As we look at the two electrically powered clocks, we become aware that, while one clock would simply represent standard, objective timekeeping, two clocks side by side reveal the fact that, however much each may have been designed and manufactured as a replica of every other, the passage of time will reveal that each becomes subtly different, that—due to batteries running down at different rates, material degradation, entropy—each will soon, again and forever, register a unique time. Both clocks will eventually stop, at close to (perhaps)—but not at *exactly*—the same time. With elegant economy, *"Untitled" (Perfect Lovers)* moves us to feel the human need to couple. The two clocks, suddenly anthropomorphic, embody the metaphor that love seeks total unity in the face of the loved one's absolute otherness, while knowing at the same time that bodies and psyches—love's carriers—inevitably run down. *"Untitled" (Perfect Lovers)* comes in two versions: in one, an edition of three plus artist's proof, the casings are black and may be mounted on a wall of any color; in the other, the casings are white and the clocks are mounted on a piece of wall painted pale blue. The colors of purity and death are exchangeable between cultures. Both versions possess qualities of hope and of mourning. Gonzalez-Torres died in Miami in 1996 at the age of 38.

As well as being indebted to the spare aesthetic of Minimalism, Gonzalez-Torres's work follows that of Conceptual Art, notably works such as Joseph Kosuth's *One and Three Chairs* (1965) (see Fig. 1.18). Conceptualism was deeply concerned with questioning the orthodoxies and regulations imposed upon us through systems of measurement. Many artists parodied the ways such systems turned "subjects" into "objects": thus On Kawara's *Today Series* of "date paintings," begun in 1966, Roman Opałka's *1965/1-∞* series (see Fig. 3.7), Douglas Heubler's documentations of everyday processes, and Vito Acconci's *Following* performances. In addition, all artists working with time as a medium are indebted to Andy Warhol's films of the 1960s and later.[29] The time-based projects undertaken by Taiwanese artist Tehching Hsieh in New York between 1978 and 1999 were an important bridge to present practice. For *Art/Life One Year Performance,* 1983–84, informally called *Time Clock Piece,* he punched a time clock in his studio every hour on the hour for one year. Subsequently, Hsieh lived for exactly a year out of doors; then for another year in a prisonlike environment in his studio, depending on a friend to supply him with food and to take away his waste. In July 1983, Hsieh and performance artist Linda Montano issued this statement: "We, LINDA MONTANO and TEHCHING HSIEH, plan to do a one-year performance. We will stay together for one year and never be alone. We will be in the same room at the same time, when we are inside. We will be tied together at the waist with an 8-foot rope. We will never touch each other during the year. The performance will begin on July 4, 1983, at 6 p.m., and continue until July 4, 1984, at 6 p.m."[30]

These performances were documented through photographs, sound, and witness records, which are displayed as films and installations (Fig. 12.15). While on one level the One Year performances demonstrate the absurdity of living according to the

**12.16 Bill Viola**
*Five Angels for the
Millennium*, 2001.
Video/sound installation,
five channels of color
video projection on
walls in large, dark
room; stereo sound
for each projection.
Installation view,
showing *Departing Angel*,
*Fire Angel*, and *Birth
Angel*. Courtesy of
the artist.

12.17 Tacita Dean
*Merce Cunningham
Performs STILLNESS
(in Three Movements)
to John Cage's
Composition 4'33" with
Trevor Carlson, New
York City, 28 April 2007
(six performances,
six films), 2008.* Six
16mm color films,
optical sound, projected
simultaneously,
continuous loops.
Edition of 4. Courtesy
of the artist and Frith
Street Gallery, London.

dictates of objective time, they also have a deeply affective dimension: each highlights an aspect of Hsieh's experience as an illegal immigrant.

It is no surprise that the complexities of contemporary life have led many to seek pathways toward unmediated, simpler, more natural relationships to the world and time. In the previous chapter we noted artists, such as James Turrell and Charles Ross (see Fig. 11.1), who provide elaborate settings in which we might align ourselves with the movements of the Earth within the universe. Others, such as Richard Long (see Fig. 1.17) and Andy Goldsworthy (see Figs. 11.2 and 11.3), do so in more modest ways. Surrendering the materiality of a work of art to inevitable erasure is a quiet but growing undercurrent. For millennia it has been the practice of those living in conditions of scarcity, such as Australian Aboriginal artists living in the desert regions.

Some artists concerned with the exploration of fundamental processes of making and of seeing have been drawn to religious, or more generally spiritual, conceptions of time. Prominent among these is pioneering video artist Bill Viola, in recent years the creator of spectacular multiscreen projections such as *Five Angels for the Millennium* (2001) (Fig. 12.16), in which generalized narratives of submersion and rebirth are dramatically staged, the five elements evoked, and the enchantment of the world is shown to be natural to it. He also produces smaller-scale animations of relationships within groups, for example, enacting a scene from the Bible, or between individuals, who appear to be experiencing a state of intense emotion. All are strongly affective, moving viewers to deep emotion. Against the seductions of present pleasures, Viola seeks immersion in eternal rhythms—bodily, natural, and spiritual. "I have for a long time been consciously aware that I've been reaching beyond this present period we're in for inspiration and ideas and even images in some cases. There's an attempt to link with something greater than the last few decades, which is what so much of the culture around us seems to be concerned with... I see that it all [i.e. his recent

work] just keeps expanding out from the center, farther and farther, with no end in sight."[31]

In contrast, works such as *1984 and Beyond* bring us back to the realities of time as a material fact of experience, as a reservoir of memory that is also the bearer of dreams of futurity. Artists have long been aware that their modes of representation (media, supports, techniques, procedures) change over time and thus have inherent historical resonance. This is also true of modes employed in wider communicative media such as film and television.[32] In 2006, English artist Tacita Dean filmed, in real time and through long, mostly unedited tracking shots, the machinery and the stock at the Kodak factory, Chalon-sur-Saône, France, just as it was ceasing to manufacture and process analogue film. In the era of digital imaging, 16mm film, Dean's own preferred medium, has become anachronistic. Yet she insists on continuing to use it. That contemporary artists—super-aware of the implicated relativity of distinct temporalities—feel no compulsion to be up-to-date is a positive paradox. Elements of nostalgia for a medium was part of Zoe Leonard's *Analogue* project (see Figs. 10.4 and 10.5), where it added to the mood of inexorable social transformation.

In Chapter 1, we noted that, in John Cage's composition *4'33"*, first performed in 1952, the absolute contemporaneity of the experience of listening to music was laid bare, in the paradoxical form of precisely demarcated periods in which music was *not* presented, thus inviting listeners to attempt to hear silence (but in fact to find themselves listening to the noises made by the world at those moments). This work, re-echoing through contemporary art ever since, has been especially important to those artists concerned with the changing nature of the experience of time. Choreographer Merce Cunningham was a lifelong partner and close collaborator of Cage, not least at Black Mountain College, North Carolina, in 1952. Eighty-eight years old in 2008, Cunningham was invited by Dean to choreograph Cage's famous "silent" composition, a piece he entitled *Stillness* (Fig. 12.17). This consisted of Cunningham sitting on a chair

12.18 Rivane
Neuenschwander
*I Wish Your Wish*, 2003
(full view and detail).
Screenprinted textile
ribbons, drilled holes
in wall, dimensions
variable. Installation
view, *Life on Mars: 55th
Carnegie International*,
Carnegie Museum
of Art, Pittsburgh,
2008. Collection of
Juan and Patricia
Vergez, Argentina;
Thyssen-Bornemisza
Contemporary Art
Foundation, Vienna.

before a practice mirror and barre in his New York dance studio, changing position slightly when Trevor Carlson, the director of Cunningham's dance company, consulting a stopwatch, signaled each of the three movements dividing time within *4′33″*. Using 16mm film, Dean recorded what took place in six takes. Only ambient sounds are heard. For the installation at the Dia:Beacon, New York, in 2008, the films were projected simultaneously on six hanging screens in the basement galleries. The whirring of the projectors and the sounds occurring while watching add to the near-silence. But the focus is on a dancer who confines himself as closely as possible to stillness—a state as unachievable as absolute silence. Instead, stasis results, and is what we see.

Or, at least, so it seems. We are, after all, watching a performer enact "stillness." And we are watching six distinct films of what may or may not be the same "performance." Ambiguities such as these are at the heart of Dean's work, as they were at that of Cage and Cunningham. *New York Times* critic Holland Cotter summed it up: "Mr. Cunningham's choreography has always had an existential dimension. 'Stillness' is about duration and change, which are the same, and are also the substance of life and history. Ms. Dean's film of Mr. Cunningham's performance is about the sound and motion of history in action: the personal history of one man's fidelity to the memory of another; the cultural history of a living artist transmitting and rejuvenating the creative essence of one who has died; the contemporary history of a younger artist preserving and honoring all this, and the two men (the piece is above all a portrait of Mr. Cunningham) in her art."[33] Merce Cunningham died in July 2009.

Connectivity across time and space, but above all between people, is a preoccupation of the current generation of emerging artists. Brazilian artist Rivane Neuenschwander's participatory installation *I Wish Your Wish* (Fig. 12.18) was suggested by pilgrimage practice at the church of Nosso Senhor do Bonfirm, Salvador, where visitors are offered ribbons that they tie to their wrists and knot when they make a wish. Tradition has it that the wish will come true when the band falls off. Neuenschwander began with a group of friends writing short statements expressing their fondest wishes, which she then silkscreened onto brightly colored ribbons, creating a mural-length array of ribbons hanging in dense rows from small holes drilled into the gallery wall. At each installation, visitors are invited to take the ribbon that comes closest to expressing a wish of their own, attach it to their wrist, and wear it until the ribbon disintegrates. They may also write a wish on a blank strip of paper, to be passed on to the artist, screened onto a ribbon, and added to the next installation. First shown at the Museu de Arte Moderna Aluisio Magalhaes, Recife, Brazil, in 2003, the installations have proven popular elsewhere, including at the Carnegie International, Pittsburgh (2008).

There is a desire here to share personal experiences—even deeply affecting ones—with many others, not only friends and acquaintances, but also strangers, as if the spreading of feeling might lighten the original bearer's burden, and the stresses of contemporary life might be more readily faced. Organizing time, inventing a "ritual," however temporarily, is a common strategy in this process. Australian artist Barbara Campbell's *1001 Nights Cast* (Fig. 12.19), a "durational performance" undertaken between 2005 and 2008, was inspired by the classic Arabian tale *The 1001 Nights,* in which the virgin bride Scheherazade staves off execution by telling a vengeful king a series of stories both beguiling and unfinished. As is well known, Scheherazade eventually succeeds in wearing down his homicidal rage at being wronged by an unfaithful wife, thereby saving herself—and, by implication, 1,000 others. Triggered by the accidental death of her husband, sculptor and performance artist Neil Roberts, Campbell's *1001 Nights Cast* enacts a process of mourning on the part of Campbell herself and, in ways specific to them, the 1,000 other participants. Both Scheherazade and Campbell use storytelling to stave off death: in Campbell's case, the all-consuming memory of death's arbitrariness, and the death that threatens within endless, unconsummated mourning. The following poem sets the tone of the project:

> In a faraway land a gentle man dies.
> His bride is bereft. She travels across continents
> looking for a reason to keep living.
> Every night at sunset she is greeted by
> a stranger who gives her a story to
> heal her heart and continue with her journey.
> She does so for 1001 nights.

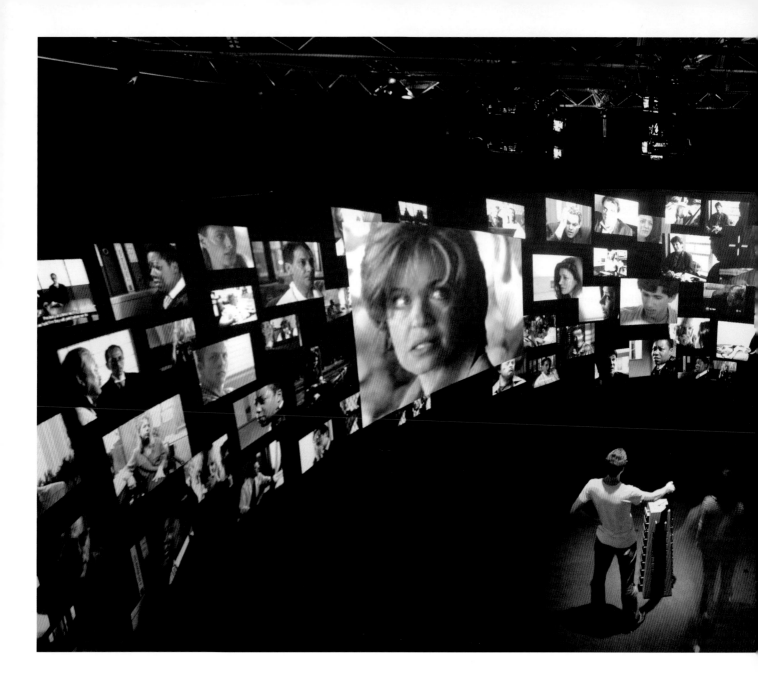

*1001 Nights Cast* has dimensions that reach beyond one person's grief. It uses a clear temporal framework derived from early Conceptualism to connect the mutually unknowable subjectivity that we all share. It also uses the Internet, contemporary medium *par excellence* for connecting widely dispersed, isolated subjectivities. Each day from June 21, 2005 to March 17, 2008, Campbell read newspaper accounts of events in the Middle East, from which she then chose a short phrase that she painted in watercolor and, at sunset, posted on a website devoted to the project.[34] Viewers were invited to respond by writing, during the subsequent 24 hours, a story of no more than 1,000 words that could take any form and address any subject that the quotation suggested to the author. These were then posted on the site.

More than mere occasional participation in the currents of everyday life, artists working in these ways seek a profound integration with them, an immersion in duration that, by slow yet irreversible paradox, becomes atemporal. It is as if absolute contemporaneity with life as it is being lived all around us becomes a gateway to the suddenly capacious, perhaps infinite, spatiality of time. This is not a spiritual quest, as no delivery from the world is expected. We are going nowhere: it is coming here. We have arrived at the ground zero of the ways in which many contemporary artists are responding to the disjunctive strangeness that seems to typify our experience of the present.

Yet this state of being is also, paradoxically, an imagining of the future. In 1952, Guy Debord, leader of the Situationists, predicted: "The art of the future will entail the shattering of situations, or nothing."[35] To this avant-garde absolutist, there were only two, quite antithetical options: total transformation of reality, or utter oblivion for all. This is a belated, cultural version of modernity's early credo: "Revolution or death!" Recent futurism, however ironic about its actual prospects, is inspired by a more expansive yet inclusive sense of the world's flux—not least that our being is dispersed through time, space, and the lives of others, and that what used to be understood as nothingness is, in fact, a richly generative froth, full of wonders. In a spirit now gaining

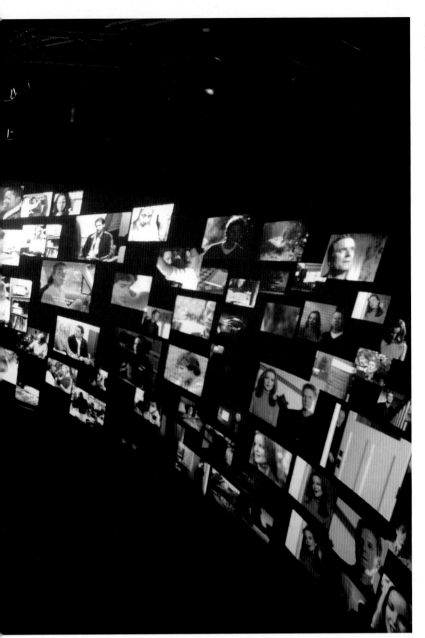

12.20 Neil Brown, Dennis Del Favero, Matt McGinity, Jeffrey Shaw, and Peter Weibel *T_Visionarium II*, 2008 (interior view). Biennale of Seville. Interactive environment. Courtesy of iCinema Center, Sydney, and ZKM, Center for Art and Media, Karlsruhe.

some ground against widespread fear and pessimism, new-media artist and theorist Ross Gibson invites us to develop "an art of TIME, an art other than any existing phenomenon. This art will take the form of some phenomenological routine that will offer each participant a compelling, fully conscious experience of perceptive intensification followed by alteration. People will partake of this new art in order to *be* differently in time, to be in time while also having time in them. If our occupancy of time gets altered with nuance and precision, as an artistic experience, then space will take care of itself, because the experience of time will be so strange and new, so compelling and *preoccupying* that the coordinates of consciousness will shift radically." [36] Imagine, therefore, an art form that encourages people to understand themselves *as* time, as "eventualities" always available in infinitely configurable ways as long as consciousness functions, as long as some kind of pulse marks the continuity of existence.

Many of the artworks that we have discussed in this chapter have offered elements of exactly this kind of experience. The *T_Visionarium* project with which we began does not, as yet, realize the art of time dreamt of by Ross Gibson and many others. But it makes a contribution—especially when we realize that its technology is a format that could carry any filmable content, all imaginable imagery, everything that may be digitized (Fig. 12.20). If the greatest challenge facing us at the moment is to devise ways of sharing our diversity, of picturing a world in which we, the Earth, and everything on it can peacefully and sustainably coexist, then these floating screens (along with many other equally imaginative artistic enterprises) might be of vital assistance. Working independently, yet with awareness of others, or, more and more frequently, in groups, artists everywhere are searching for fresh ways to bring into being an art of *this* time, adding to the stock of ideas, practices, and instincts that are moving us toward a connected contemporaneity. Their fusions of art and life might be a sign that we are becoming, at last, truly contemporary.

# 13. CODA: PERMANENT TRANSITION

Art everywhere today is contemporary in every sense: contemporary in and of itself—in spirit, in the media it deploys, and in its direct engagement of its highly participatory viewers. It is contemporary with other kinds of contemporary art elsewhere, about which artists and audiences know much more, and know it more quickly, than ever before. It is contemporary with art of the past, which is now present to us—via exhibitions, scholarly research, and virtual re-creations that bring its contexts to vivid life—in all of its original contemporaneity. It is also full of imagined intimations of art's future: one in which these contemporary characteristics seem set to expand throughout the cultures of most countries, and to become increasingly part of the everyday lives of more and more of us. In the deepest sense, art today is the product of a distinctively contemporary mix of cultural, technological, social, and geopolitical forces. By absorbing imaginable futures, and by contemporizing various competing visions of the past, this mix of forces has "thickened" the present, and created a state of permanent transition, of perpetual contemporaneity.

I hope to have demonstrated in this book a number of points that add historical depth to these general observations.[1] In Chapter 1, I argued that a fresh openness to the present, to immediacy, to direct contact between art and everyday life was essential to each of the avant-garde movements that shook modern art to its core during the 1950s and 1960s—among them Situationism, happenings and environments, Performance Art, Fluxus, Pop, Minimalism, and Conceptual, Political, and Feminist Art. Together, these experiments transformed modern art fundamentally, preparing it to become contemporary. Their success means that we can now regard them as constituting late modern art, the final phase of a two-century-long development. The worldwide shift from modern to contemporary art took definitive shape during the 1980s, and continues to unfold through the present, thus impacting upon art's imaginable futures. While artists all over the world participated in this shift, they did so in different and distinctive ways in each cultural region, and in each art-producing locality. The disseminative infrastructure (markets, museums, interpreters, publicists, administrators, funders) may have achieved its most concentrated forms in the cultural centers of Europe and the United States, but it was by no means confined to them. As we saw in Chapter 2, the tendency toward institutionalization and conformity that prevails in these centers, creating museum-focused, market-driven Contemporary Art in the process, was challenged as much as it was reinforced by artists resident within them, and has become fragile. The transnational turnings explored in detail in Part II add up to the second major transformatory force that has enabled art to become truly contemporary. Both currents have been taken up, evaded, or ignored by artists of a younger generation whose primary concern is to understand the nature of being in this utterly changed situation. In Part III, we saw that emergent artists deal with this bewildering multiplicity by looking within it for ways of world-picturing, place-making, and connecting. They do so by imaginative yet critical geopolitical mapping, by seeking genuinely constructive, sustainable ecologies within a scenario of growing environmental catastrophe, and, while acknowledging their immersion within media, attempt to forge selfhood in synchronicity with others.

How might we profile these currents at the beginning of the second decade of the twenty-first century? Retro-Sensationalism seems jaded: Jeff Koons continues to manufacture Postmodern Pop and shining baubles on an industrial scale, Damien Hirst repeats his signature imagery in a similar manner, while Takashi Murakami seeks to spread his brand across a widening product range (as © Murakami). As we have seen, it continues to resonate among artists in China, where it had such an impact when that country opened up to Western culture and art in the 1980s. Some artists elsewhere, such as Canadian performance and installation artist Terence Koh, give it continuing energy—in his case, as a spinoff from his encounters with queer youth culture in New York's downtown, where he sported the persona "asianpunkboy." Remodernism continues

13.1 Josephine
Meckseper
*The Complete History
of Postcontemporary
Art*, 2005. Mixed media
in display window,
63 x 98½ x 23½in
(160 x 250.2 x 60cm).
Courtesy of the artist
and Elizabeth Dee
Gallery, New York.

to resonate as its major practitioners (notably Richard Serra, Gerhard Richter, Jeff Wall, and Andreas Gursky) extend themselves late in their careers, and other, mid-career artists (Christian Marclay, Thomas Demand, Laura Owens, Angela Brennan, Tracey Moffatt, and many more) mine it for its remaining lode of inspiration. The market for work of this kind has survived the crisis of 2008 at its very top, but the upper reaches and its previously substantial middle zones have fallen away precipitously. Auction houses remain market leaders but in a more restrained manner. The collectors who set the agenda during the 1990s and 2000s are now building private museums. Commercial dealers strive to reassert themselves through art fairs, with modest results.

Perhaps the most interesting residue of this current is the taking up of some of its elements by younger artists, particularly those for whom sculpture, as a practice, remains at least a memory. Consumer societies have so successfully transformed objects into commodities, and so focused our response to them on flashy visual simulations, that a leap of the imagination is required for many of us to grasp the actual qualities of natural objects, material things, and manufactured items. Many artists—especially German sculptors such as Franz West, John Bock, Isa Genzken, and Urs Fischer, and the Swiss duo Peter Fischl and David Weiss, working after the transformatory example of Joseph Beuys and Viennese Actionism—use the installation format to provoke this perceptual shift. One of the most accessible and amusing examples of this tendency is a 1987 film by Fischl and Weiss, *Der Lauf der Dinge* (*The Way Things Go*).[22]

A younger, international generation working in this "unmonumental" mode—among them Josephine Meckseper, Alexandra Birken, Rachel Harrison, and Elliot Hundley—is also aware of the example of Los Angeles artists Mike Kelley and Paul McCartney, and of others such as Kiki Smith.[3] They are especially sensitive to the fact that commoditized objects can quickly lose their luster, becoming artifacts of what feels more and more like a culture declining into decadence. Meckseper's installation *The Complete History of Postcontemporary Art* (2005) (Fig. 13.1) appears, at first glance, a re-creation of a rather ordinary shop window display, a somewhat random collection of items that might be shown in a store in a poorer neighborhood in many cities of the world. The dark exterior lighting, the glare inside the window, and the relative sparseness of the objects contrast sharply with the impression of quantitative abundance that characterizes similar displays in malls, and with the exclusivist elegance that is sought in upmarket shopping streets. Global capitalism has touched this place, but seems to have left it behind too—are we being invited to look, as if from the future, at the residue left *after* the current triumph of globalization? An art student in Berlin, Meckseper saw the shops of East Germany exposed after 1989 as relics of a past era. The stuffed rabbit at left, mounted on a plinth that spins, holds a flag with "Oui" on one face and "Non" on the other: this is a witty parody of the division of opinion about the European Union constitution then being put to the vote. On another level of meaning, each of the items is chosen to evoke a well-known work by a famous artist: Joseph Beuys, Victor Vasarely, Georg Baselitz, and Jeff Koons among them. Will contemporary art fade as fast as the latest capitalist commodity?

13.2 Hany Armanious
*Wishful Thinking*, 2009.
Cast polyurethane,
pigment, 27½ x 22½ x
22½in (70 x 57 x 57cm).
Courtesy of the artist
and Roslyn Oxley9
Gallery, Sydney.

13.3 Steve McQueen
Images from *Gravesend*,
2007. 35mm film
transferred to HD for
installation. Courtesy
of Thomas Dane Gallery,
London and Marian
Goodman Gallery,
New York.

Other installation artists such as Hany Armanious, Mikala Dwyer, John Barbour, and Kathy Tremin (to list just some Australian artists active within this worldwide tendency) explore the low-key associative resonances of absolutely ordinary materials. The stranded consumables that fill the installations of their peers seem, in their work, more like wounded residues of modern sculpture's failed wish to be both independent as an art form and to merge with the things that fill up everyone's everyday life. We are a long way from the concerns of Anthony Caro and Richard Serra. Closer precedents are the psychologically resonant objects of Louise Bourgeois, and the example of the 1980s artists of abjection, such as Robert Gober and Felix Gonzalez-Torres (see Fig. 12.14).

Hany Armanious's *Wishful Thinking* (2009) (Fig. 13.2) sums up this spirit—and does so by means of a dispirited *jeu d'esprit*. A straw hat/basket sits, uselessly, on a rough, ready-made bench affixed to a wall, any wall. Two broken, taped cardboard tubes hover above. Is this a basket glimpsed in an Arabian bazaar? A corner of a suburban storage shed in Melbourne, or of a panhandler's hut? A rickshaw driver's hatstand? A homemade altar? An outtake from a Thomas Hirschhorn installation? None of the above: rather, it is a pathetic object that cannot become what it wishes to be, or what we might want from it. Yet it is made with loving care: every element is cast in polyurethane and carefully painted to look exactly as if it was the discarded thing we at first take it to be. Like much current work of this kind, *Wishful Thinking* is a visual joke with ambiguity as its punchline.[4]

The second current explored in the main body of this book continues to unfold in all of its complexity. National cultures are in continuing transition everywhere. By building out from the details of locality and place, artists elaborate their own society's sense of uniqueness. But they also see the importance of countering tendencies toward narrow chauvinism and nationalistic unfreedom, so they often highlight international and cosmopolitan perspectives. These frequently take the form of a kind of imaginative traveling through time, a display of the many pasts that persist in the present. A distinctive aesthetic is taking shape, one that mixes tastes, imagery, and textures from many times and places, creating unexpected conjunctures that override cultural borders, geographic boundaries, and semiotic stereotypes, and melt categorical distinctions such as those usually drawn between the human and the animal.

Two London-based artists, Steve McQueen and Isaac Julien, are outstanding exponents of this tendency. McQueen explores the unexpected beauties that might arise in situations that are confrontational, violent, and at times deadly. In a 1993 video, *Bear*, two naked black men, one of them the artist, wrestle vigorously while exchanging glances that shift between flirtatious and threatening. McQueen's 2007 film *Gravesend* is a widescreen, 17-minute meditation on the mining of coltan, a mineral used as a conductor in cell phones, computers, and other electronic devices (Fig. 13.3). The camera juxtaposes long takes of men in the Congo, deep in muddy trenches, using picks, shovels, and their bare hands to mine the precious metal, with scenes of its subsequent transformation in a high-tech laboratory. Against these, two other lengthy sequences interpose themselves: a stunning animation of a black crack opening, winding, then widening until it fills a white screen, and panoramas (at the opening and closing of the film) of Gravesend itself, a port city on the Thames, from which Joseph Conrad departed on the journeys that led to his novella *Heart of Darkness*, which is about a white European who loses his soul in Africa. A related work is *All That Is Solid Melts into Air* (2008), a two-screen video installation by Mark Boulos, which juxtaposes scenes from the Chicago Futures Exchange with records of the struggles of people in the Niger delta against their exploitation by local businessmen and oil companies.

Beginning as a radical documentarist in London during the 1970s, Isaac Julien went on to evoke the private worlds of gay poet Langston Hughes, and of the psychiatrist and revolutionary theorist Franz Fanon. His main focus since then has been the visual imagery of *créolité*—a term first used by writers from the Caribbean to emphasize the use of indigenous languages and cultures, alongside and in active, messy dialogue with those of colonizers such as the French. Mixed languages, hybrid mental states, and territorial transpositions are the *lingua franca* of cosmopolitan life. This ever-more-common mode of existence has it beauties, and its terrors. It is marked by all of the possibilities but also inequities of a world in full-scale transition. Julien's installation *Ten Thousand Waves* (2010) (Fig.13.4) was shot in China during the preceding four years. There is no coherent narrative; rather, fragments from a variety of events, stories, memories, and other films are projected in overlapping time sequences on nine screens that hang at oblique angles in the installation space. Grainy black and white footage shot from a helicopter records attempts to rescue a group of Chinese cockle-pickers stranded by incoming tides in Morecambe Bay, Cumbria, northwest England. Unable to communicate, 21 of the male and female illegal immigrants from Fujian Province drowned, one survived. Visiting the site afterwards, Julien learnt of a sixteenth-century tale of a goddess who led fishermen lost at sea to safety. Well-known actress Maggie Cheung plays this goddess in the film, while a ghostly protagonist, played by rising star Zhao Tao, leads us to the famous Shanghai Film Studio, via a restaging of the 1934 classic *The Goddess*. In other sequences, we hear a poem, *The Waves* by Wang Ping, which is also rendered using ink on glass in masterful calligraphy by Gong Fagen, and is then wiped away by young men in contemporary dress. Viewers are invited to sit for a time as one scene unfolds, to walk between screens, seeking associations, making connections, imagining narratives, or to acknowledge those moments when the world's chaos just is what it is.

The work of video artist Fiona Tan also exemplifies this development. Now based in Holland, she traces the diaspora of her family through Indonesia,

13.4 Isaac Julien
*Ten Thousand Waves*,
2010. Nine-screen
installation, 35mm
film, transferred to HD,
9.2 surround sound,
49 mins. 41 secs.
Installation view, 17th
Biennale of Sydney.

Hong Kong, Australia, and Europe. Her understanding of her own personality as dispersed back through time and across space, as shaped by broad historical forces and specific family memories—along with her ironic characterization of her artistic persona as that of "a professional foreigner"—is precisely what enables her to picture the multiplicities flowing through the present. In the late 1990s, she told an interviewer: "I look for something that's already present. I can't turn myself inside out. Distance, in time and space, is essential."[5] *Disorient* (2009) (Fig. 13.5) is a two-screen digital projection united by a single voiceover consisting of passages from Marco Polo's record of his journeys between Venice and Japan. On the larger screen, tracking shots roam languidly through a storage area replete with wondrous and ordinary objects, items, and artifacts from all over Asia. Glimpses of a yellow-robed figure, perhaps a monk, are afforded. The setting may be a European collector's cabinet of curiosities, a Chinese antique shop, a factory that furnishes such shops, or a gallery installation that evokes such places. The smaller screen shows news footage, travelers' tapes, and Internet imagery that reveal the places visited by Polo as they are today. When contrasted with the disorder, violence, and desperation shown on the smaller screen, the static, luxuriant, and exotic Orient pictured on the large screen becomes obscene. At different lengths, the two films are projected so as to coincide only rarely with each other, or with the voiceover. Uncannily, Polo's words nonetheless sometimes seem to fit the images on both screens.[6]

In the previous chapters we have looked at the work of other outstanding exponents of this tendency. They include Ilya Kabakov (see Fig. 3.2), Tania Bruguera (see Figs. 4.36 and 4.37), Xu Bing (see Figs. 5.17 and 5.18), the Raqs Media Collective (see Fig. 6.10), John Mawurndjul (see Fig. 7.12), Yinka Shonibare (see Fig. 8.1), William Kentridge (see Fig. 8.9), and Shirin Neshat (see Figs. 9.9 and 9.10). In each case, and in that of others such as Jean-Michel Bruyère, their body of work matches that of the most accomplished artists of the first current.[7] As they continue to add layers of meaning, complex subtleties, and delicate refinements to their cosmopolitan aesthetic, the challenge faced by these artists is to resist the temptation of slipping into a new kind of distracted exoticism, one that would permit viewers gently guided tours through signs of the Other rather than obliging them to undergo genuine encounters with its intractable difference. The artists discussed here resist this temptation, but not all artists whose work is inspired by the experience of decolonization do so.

Can the work of artists engaged with the transnational turn be linked to those of the first tendency, the Retro-Sensationalists and the Remodernists? A recent attempt to do so, at least in part, is curator Nicolas Bourriaud's coining of the term "altermodernism," which uses the Latin word *alter*, meaning "other," to evoke the linked ideas of a "Modernism of the others" (those from beyond EuroAmerica) and an "otherly" Modernism, one that is different in kind

from earlier versions. Conceiving it as "a leap that would give rise to a synthesis between modernism and post-colonialism," he proposes that: "Altermodernism can be defined as that moment when it became possible for us to produce something that made sense starting from an assumed heterochrony, that is, from a vision of human history as constituted by multiple temporalities, disdaining nostalgia for the avant-garde and indeed for any era—a positive vision of chaos and complexity. It is neither a petrified kind of time advancing in loops (postmodernism) nor a linear vision of history (modernism), but a positive experience of disorientation through an art form exploring all dimensions of the present, tracing lines in all directions of time and space."[8] It is not entirely clear from this definition whether the spirit identified here is a new kind of Modernism, a reversion to the Modernism first defined by Charles Baudelaire in Paris in the 1850s, or indeed whether it is Modernist at all. Nevertheless, it does point to a sense, widespread among artists and others today, that, for the reasons Bourriaud begins to identify, living in the present is a profoundly different experience from what it seems to have been before. It is what I have been describing throughout this book as the experience of contemporaneity.

The poetic approach to politics that has spun off as the most interesting outcome of the transnational turn also permeates the work of artists of the third current that I have identified. It inflects their total embrace of everyday life as the domain of affective experience. Immersion in everyday life is inevitable, especially as the practices of social media become more and more like those of contemporary art. But if the first tendency discussed in this book risks increasingly vacuous self-promotion or reversion to institutionalized Modernism, and the second courts a slippage into postcolonial aestheticism, for this tendency the concern is that the distinctive poetics of the visual arts, their fundamental nonconformity, will vanish into the excited normalities of instant communication—with everyone, everywhere, about everything—that have become typical of contemporary life. Describing these risks in such stark terms exaggerates their actual impact as artists currently experience it, and falsely suggests that they are equal in relation to each tendency. It is too soon to calibrate their force precisely. Nonetheless, they are real and present dangers. At the same time, they are unavoidable—necessarily so, because art, if it is to be significant, must be made close in to that which most threatens its distinctiveness. In contemporary circumstances, these risks are multiple, different in kind, and occur simultaneously. Therefore, they require from art different kinds of distinctiveness—many of them, and contemporaneously.

In the early months of 2010, visitors to the Guggenheim Museum, New York, found the famous rotunda empty, except for a couple lying on the floor who performed, as if it were a modern dance, slow-motion re-enactments of kisses from the history of art. This was not, however, the main event. Entering the ramped walkways, you were greeted by a lovely young

13.5 Fiona Tan
*Disorient*, 2009. HD
installation, color
film, 5.1 surround,
two screens, two HD
projectors. Courtesy
of the artist and Frith
Street Gallery, London.

child who announced: "This is a work by Tino Sehgal"
and asked you the question "What is progress?" As you
attempted an answer, you were led upward to a bright
teenager who then responded to a summary of your
words supplied by the child with a probing question.
While you struggled with this response, the teenager
passed you on to a middle-aged interlocutor who
elaborated your answer in a collaborative way, then
transferred you on to an elderly man or woman who
proposed his or her experience-based definition, and
also lamented the difficulties of finding a satisfactory,
universal answer. By this time, you had ascended five
floors, scarcely noticing your passage through space
and time. You had arrived, perhaps, at some degree of
enlightenment, or had sensed the limits of conceptu-
alization, even in such apparently ideal, untrammeled
circumstances. *This Progress*—the title of the work—
may be about the implosive circularity of the concept
these days, as well as a living demonstration of how
concern about such ideas is at once shared and par-
ticular to each of us.[9]

13.6 Francis Alÿs
*When Faith Moves
Mountains*, 2002.
In collaboration
with Cuauhtémoc
Medina and Rafael
Ortega. Photographic
documentation of
an event, Lima.
Collection of Museum
van Hedendaagse
Kunst, Antwerp.

Similar concerns inspire artists such as Francis Alÿs, a Belgian architect who has lived in Mexico City since 1986. Acutely aware of his own displacement, he responds deeply to the city's sprawling complexity, to its fractured yet persistent pre-Hispanic and colonial traditions, to its wary, partial embrace of change, above all, to the individual, often eccentric ways its inhabitants cope with these cultural and temporal layers. He comments: "Somehow it's a society that wants to stay in an indeterminate sphere of action as a way of defining itself against the imposition of modernity."[10] Alÿs's *When Faith Moves Mountains* (2002) [Fig. 13.6] was triggered by the proverbial phrase "Maximum effort, minimum result." In the South American context, these words are often spoken to reflect despair at the slow rate of progress despite the efforts of millions, and to express bitter resignation at yet another retreat to the status quo. Despite this, Alÿs conceived a way of turning demoralization into a surprising, paradoxical, yet resonant symbol of hope. During the last months of the Fujimori dictatorship, at Ventanilla, a *pueblos jóvenes* (new town) near Lima, Peru, he inspired 500 volunteers with shovels to shift a 1,600-foot-long sand dune about 4 inches from its original position. The town, a haven for poorer people unable to afford the cost of living in the center of the city, had been ignored by government, except in attempts to restrain its growth. Alÿs described his intentions: "Here, we have attempted to create a kind of Land art for the land-less, and, with the help of hundreds of people with shovels, we created a social allegory. The story is not validated by any physical trace or addition to the landscape. We shall now leave the care of our story to oral tradition… Indeed, in modern no less than premodern societies, art operates precisely in the space of myth. In this sense, myth is not about the veneration of ideals—of pagan gods and political ideology—but rather an active interpretative practice performed by the audience, who must give the work its meaning and its social value."[11]

This act of defiant, poetic possibility stands in sharp contrast to such icons of "Post-Studio" sculpture as Michael Heizer's *Double Negative*, a massive displacement of sections of a mesa in the Nevada desert carried out in 1969–70 (see page 32). *Faith Moves Mountains* has much more in common with the integrative character of Robert Smithson's *Spiral Jetty* (1970) (see Fig. 1.15), notably the spiral's hovering—according to environment conditions—above and below the threshold of visibility. To Alÿs, "poetics might have the potential to open up a political thought."[12] Anxious to avoid the appearance of exploitation, Alÿs bussed in engineering students from the universities of Lima who had volunteered to be the diggers. An opportunity for interaction was created, along with the chance to leave a symbolic trace. By inviting people to, as it were, "assist" a natural process, Alÿs makes visible the value of cooperation for community and planetary purposes, the poetry of conviviality when created by both humans and the earth.

We cannot know whether the recent acceleration of inequity and violence throughout the world will be further exacerbated by the new technologies, changing geopolitical alignments, and the threat of environmental catastrophe, or whether, as optimistic thinkers such as Jeremy Rifkin argue, the new technologies are themselves manifestations of the contemporary emergence of "empathy" as the central driver of world history, enabling us to see "the biosphere as an indivisible community and our fellow creatures as our extended evolutionary family."[13] But we can hope, as I put it in my General Introduction, that diversity continues to mark every aspect of the production and distribution of art, from the limitless range of materials used by artists, through the specificity, unpredictability, and relevance of the questions their art raises, to the fact that they are active all over the world and interested in rapidly circulating their art everywhere across the planet and into cyberspace. We can see, now, that since the 1980s contemporary art has shifted from somewhat distanced presumptions about art's universality to awareness that new kinds of art were coming *from* the world, connecting cultures all over the globe, thus creating, genuinely, an art *of* the world. Perhaps, ten years hence, we will be able to look back at the present and say that, in the first decades of the twenty-first century, contemporary art began to be an art *for* the world.

# NOTES

## GENERAL INTRODUCTION

1. My own definitions of "Modernism" and "Modernity," in Jane Turner, ed., *The Dictionary of Art* (New York: Grove, 1996), 777–78. Also in Oxford Art Online at www.oxfordartonline.com. See also Meaghan Morris and Naoki Sakai, "Modern," in Tony Bennett, Lawrence Grossberg, and Meaghan Morris, eds., *New Keywords: A Revised Vocabulary of Culture and Society* (Malden, MA: Blackwell, 2005), 219–24.

2. In influential writings such as his essay "Modernist Painting," Greenberg nominated a lineage of Modernist Art, a chain of formal innovations by artists, from Manet to the 1960s. See Clement Greenberg, "Modernist Painting," *Arts Yearbook* 4 (1961), in Clement Greenberg, *The Collected Essays and Criticism, Volume 4: Modernism with a Vengeance, 1957–1969* (Chicago: University of Chicago Press, 1993), 85–93.

3. For further discussion of the concepts "contemporary" and "contemporaneity," see my "Introduction: The Contemporaneity Question," in Terry Smith, Okwui Enwezor, and Nancy Condee, eds., *Antinomies of Art and Culture: Modernity, Postmodernity and Contemporaneity* (Durham, NC: Duke University Press, 2008), 1–19. For an earlier version of the ideas advanced in this book, see my *What Is Contemporary Art?* (Chicago: University of Chicago Press, 2009).

4. Martin W. Lewis and Kären E. Wigen, *The Myth of Continents: A Critique of Metageography* (Berkeley: University of California Press, 1997), 186. Note especially their diagram on page 187, *A Heuristic World Regionalization Scheme*, which I have followed, with modifications.

5. See www.un.org/Depts/Cartographic/english. Click on "Select a region or a country" under "Maps."

6. Useful definitions of "Postmodernity" and "Postmodernism" by John Storey may be found in Bennett, Grossberg, and Morris, *New Keywords*, 269–71. This concept will be discussed in more detail in Chapter 2.

7. A useful introduction, classic texts, and more recent contributions may be found in Bill Ashcroft, Gareth Griffiths, and Helen Tiffin, eds., *The Post-Colonial Studies Reader* (London and New York: Routledge, 2nd ed., 2006).

8. The best introduction to this concept remains Roland Robertson, *Globalization: Social Theory and Global Culture* (London: Sage, 1992).

## CHAPTER 1

1. Michael Fried, *Morris Louis* (New York: Abrams, n.d.), 32–33.

2. The key text is Guy Debord, *The Society of the Spectacle* (Paris: Éditions Buchet-Chastel, 1967, Detroit: Black & Red, 1970, and New York: Zone Books, 2nd ed. with preface by Debord, 1995). A virtual library of resources may be found at Situationist International Online, at www.cddc.vt.edu/sionline. The most useful book anthology is Tom McDonough, ed., *Guy Debord and the Situationist International* (Cambridge, MA.: MIT Press, 2004). A selection of statements by Debord may be found in Charles Harrison and Paul Wood, eds., *Art in Theory 1900–2000: An Anthology of Changing Ideas* (Malden, MA: Blackwell, 2003), 701–07. See also Simon Sadler, *The Situationist City* (Cambridge, MA: MIT Press, 1998).

3. Asger Jorn, "Détourned Painting," Rive Gauche Gallery, Paris, May 1959. At www.cddc.vt.edu/sionline/si/painting.html. Cited in Harrison and Wood, *Art in Theory*, 707–10.

4. See Pierre Restany, *Manifeste des Nouveaux Réalistes* (Paris: Éditions Dilecta, 2007).

5. McKenzie Wark, *50 Years of Recuperation of the Situationist International* (New York: Princeton Architectural Press, 2008).

6. Jirō Yoshihara, The "Gutai Manifesto," *Genitjutsu Shincho* (Dec. 1956); in Kristine Stiles and Peter Selz, eds., *Theories and Documents of Contemporary Art: A Sourcebook of Artists' Writings* (Berkeley: University of California Press, 1996), 695–98. See Charles Merewether and Rika Iezumi Hiro, eds., *Art, Anti-Art, Non-Art: Experimentations in the Public Sphere in Postwar Japan 1950–1970* (Los Angeles: Getty Research Institute, 2007).

7. John Cage, *Silence* (Middletown, CT: Wesleyan University Press, 1961), 10. See also Richard Kostelanz, ed., *John Cage: An Anthology* (New York: Da Capo, 1991). For a detailed study of *4' 33"*, see Kyle Gann, *No Such Thing as Silence* (New Haven: Yale University Press, 2010).

8. Rauschenberg's comments are made in his statement in Dorothy Miller, *Sixteen Americans* (New York: Museum of Modern Art, 1959). Cage's in his "On Robert Rauschenberg, Artist, and His Work," *Metro* (Milan), May 1961, reprinted in John Cage, *Silence*, 98–107, cited in Harrison and Wood, *Art in Theory*, 734, 736.

9. Thomas Kellein and Jon Hendriks, *Fluxus* (London: Thames & Hudson, 1995).

10. Allan Kaprow, "The Legacy of Jackson Pollock," *Art News* (Oct. 1958), 57.

11. See his collected *Essays on the Blurring of Art and Life* (Berkeley: University of California Press, 1993). The most thorough recent survey of art of this type worldwide is Paul Schimmel, ed., *Out of Actions: Between Performance and the Object 1949–1979* (New York: Thames & Hudson for the Museum of Contemporary Art, Los Angeles, 1998).

12. Allan Kaprow, *Assemblages, Environments, and Happenings* (New York: Abrams, 1966), 188–99, cited in Harrison and Wood, *Art in Theory*, 720–22.

13. Cited in Schimmel, *Out of Actions*, 61.

14. The script is published in Kaprow, *Assemblages, Environments, and Happenings*, 323–24, and is discussed in detail by Jeff Kelley, *Child's Play: The Art of Allan Kaprow* (Berkeley: University of California Press, 2004), 100–07. In 2008, the Museum of Contemporary Art, Los Angeles, created a site to promote the reenactment of a number of Kaprow's major happenings; see www.moca.org/kaprow.

15. Lawrence Alloway, "The Development of British Pop," in Lucy R. Lippard, *Pop Art* (New York: Praeger, 1966), 40.

16. Alloway is often credited with naming the Pop Art movement, an honor he declines, saying that his use of the phrase in the mid-1950s encompassed the whole of popular culture, including art that embraced it. See Alloway in Lippard, *Pop Art*, 27.

17. These attitudes are canvassed by Max Kozloff in "Pop Culture, Metaphysical Disgust, and the New Vulgarians," *Art International* 6:2 (1962), 34–36. See also Steven Madoff, ed., *Pop Art: A Critical History* (Berkeley: University of California Press, 1997).

18. This was the title Warhol wished to use for his first European exhibition at the Ileana Sonnabend gallery, Paris, in 1964. The owner agreed to show a suite of paintings of car crashes, electric chairs, and race riots, but refused the title.

19. Arthur C. Danto, *Andy Warhol* (New Haven & London: Yale University Press, 2009), 45, and the same author's *The Transfiguration of the Commonplace: A Philosophy of Art* (Cambridge, MA: Harvard University Press, 1981.

20. See Georg Frei and Neil Printz, eds., *The Andy Warhol Catalogue Raisonné Volume I: Painting and Sculpture 1961–1963* (New York: Phaidon, 2002), 286.

21. Cited in Bruce Glaser, "Questions to Stella and Judd," in Gregory Battcock, ed., *Minimal Art: A Critical Anthology* (New York: Dutton, 1968), 158.

22. Frank Stella, "Text of a Lecture, Followed by Illustrative Drawing, Given to Art Students by Frank Stella at the Pratt Institute, Winter 1959–60," in Robert Rosenblum, *Frank Stella* (Harmondsworth: Penguin Books, 1971), 57, cited in Harrison and Wood, *Art in Theory*, 820–21.

23. Donald Judd, "Specific Objects," *Arts Yearbook* 8 (New York, 1965); in Donald Judd, *Complete Writings 1959–1975* (Halifax, NS, Canada: Nova Scotia College of Art and Design, 1975), 181–89.

24. Robert Morris, "Notes on Sculpture, Part II," *Artforum* 5:2 (Oct. 1966), 20–23, extracted in Harrison

and Wood, *Art in Theory*, 832. This description stands in sharp contrast to the attack on Minimalist sculpture as "theatrical" launched by critic Michael Fried in his essay "Art and Objecthood," *Artforum* 5:10 (summer 1967), 12–23.

25. See Rosalind Krauss, "Allusion and Illusion in Donald Judd," in her *Perpetual Inventory* (Cambridge, MA: MIT Press, 2010). See also James Meyer, *Minimalism: Art and Polemics in the Sixties* (New Haven: Yale University Press, 2001).

26. See Rosalind Krauss's influential interpretation "Sculpture in the Expanded Field," 1979, in her *The Originality of the Avant-Garde and Other Myths* (Cambridge, MA: MIT Press, 1985).

27. Kaprow, *Assemblages, Environments, and Happenings*, 151, 159; cited in Harrison and Wood, *Art in Theory*, 717, 719.

28. Nancy Holt, ed., *The Writings of Robert Smithson* (New York: New York University Press, 1979), 111, cited in Stiles and Selz, *Theories and Documents of Contemporary Art*, 533.

29. Holt, *The Writings of Robert Smithson*, 111, cited in Stiles and Selz, *Theories and Documents of Contemporary Art*, 532.

30. Holt, *The Writings of Robert Smithson*, 114–15. See also Robert Smithson, "A Cinematic Atopia," in Holt, *The Writings of Robert Smithson*, 94–103.

31. See Michael Heizer et al., *Double Negative* (New York: Rizzoli, 1991),

32. See my *What Is Contemporary Art?* (Chicago: University of Chicago Press, 2009), ch. 2.

32. See Smith, *What Is Contemporary Art?*, ch. 2.

33. Interview, 1988, cited in Nicholas Baume, *From Christo and Jean-Claude to Jeff Koons: John Kaldor Art Projects and Collection* (Sydney: Museum of Contemporary Art, 1995), 40. See also Burt Chernow, *Christo and Jeanne-Claude: A Biography* (New York: St. Martin's Press, 2002), 190–95.

34. Richard Long, interviewed by Geórgia Lobacheff, 1994, in Richard Long, *Mirage* (London: Phaidon, 1998), n.p.

35. R.H. Fuchs, *Richard Long* (New York: Thames & Hudson, 1986), 46.

36. Richard Long, interviewed by Mario Codognato, 1997, in Long, *Mirage*, n.p.

37. Henry Flynt, "Essay: Concept Art," 1961, in Stiles and Selz, *Theories and Documents of Contemporary Art*, 820–22.

38. Ferreira Gullar, "Teoria do não-objeto" [Theory of the Non-object], *Jornal do Brasil* (Rio de Janeiro), Sunday supplement, Nov. 21, 1960. See Chapter 4.

39. For an open-ended compilation of works from the period, see Lucy R. Lippard, *Six Years: The Dematerialization of the Art Object from 1966 to 1972* (New York: Praeger, 1973).

40. For a more detailed description, see Charles Harrison, *Essays on Art and Language* (Oxford: Blackwell, 1991), 63–81.

41. Mel Ramsden and Michael Corris, eds., *Blurting in A&L: An Index of Blurts and Their Concatenation (The Handbook)* (New York: Art & Language Press, and Halifax, NS, Canada: Nova

Scotia College of Art and Design Press, 1973). See also Michael Corris, ed., *Conceptual Art: Theory, Myth, and Practice* (Cambridge: Cambridge University Press, 2004), introduction and ch. 15. Disclosure: I was a member of this group between 1972 and 1976.

42. Joseph Beuys, "I Am Searching for Field Character," from Caroline Tisdall, ed., *Art into Society, Society into Art* (London: Institute of Contemporary Art, 1974), 48. Cited in Harrison and Wood, *Art in Theory*, 929–30.

43. "Joseph Beuys: Entretien avec Bernard Lemarche-Vadel" [Joseph Beuys: Interview with Bernard Lemarche-Vadel], *Canal* 58–59 (winter 1984–85), 7.

44. For a useful, suitably ironic summary of the Beuys legend, see Alain Borer, *The Essential Joseph Beuys* (London: Thames & Hudson, 1996), 13. For a classic questioning of it, see Benjamin H.D. Buchloh, "Beuys: The Twilight of the Idol, Preliminary Notes for a Critique," 1980, in Buchloh, *Neo-Avantgarde and Culture Industry* (Cambridge, MA: MIT Press, 2000), 41–64. See also Claudia Mesch and Viola Michely, eds., *Joseph Beuys: The Reader* (Cambridge, MA: MIT Press, 2007).

45. See Jack Burnham, *Beyond Modern Sculpture: The Effects of Science and Technology on the Sculpture of this Century* (New York: Braziller, and London: Allen Lane the Penguin Press, 1968), and the same author's *The Structure of Art* (New York: Braziller, 1971).

46. For details about these and other works, see Kasper Koenig, ed., *Framing and Being Framed: 7 Works, 1970–1975* (Halifax, NS, Canada: Nova Scotia College of Art and Design, 1975); Walter Grasskamp, Molly Nesbit, and Jon Bird, *Hans Haacke* (London and New York: Phaidon, 2004); and Matthias Flügge and Robert Fleck, *Hans Haacke: For Real: Works 1959–2006* (Düsseldorf: Richter Verlag, 2006).

47. Linda Nochlin, "Why Have There Been No Great Women Artists?" *Art News* 69 (Jan. 1971), in Linda Nochlin, *Women, Art, and Power: And Other Essays* (New York: Harper & Row, 1988); Germaine Greer, *The Obstacle Race* (London: Secker & Warburg, 1979).

48. Lucy R. Lippard, "Sexual Politics: Art Style," *Art in America* 59:5 (Sept. 1971), in Lucy R. Lippard, *From the Center: Feminist Essays on Women's Art* (New York: Dutton, 1976), 29.

49. See womanhouse.refugia.net.

50. Lippard, *From the Center*, 7.

51. Judy Chicago, *The Dinner Party* (New York: Penguin, 1996), 3. An earlier volume is closer to the process: Judy Chicago, *The Dinner Party: A Symbol of Our Heritage* (Garden City, NY: Anchor/Doubleday, 1979).

52. For the text on the scroll, see Hilary Robinson, ed., *Feminism-Art-Theory: An Anthology 1968–2000* (Oxford: Blackwell, 2001), 33. It was long assumed that the male figure was the filmmaker Anthony McCall, Schneemann's lover at the time, but in 1988 the artist revealed that the text is a secret letter to the American critic and art historian Annette Michelson, who, Schneemann claimed, did not understand her films. See Bruce R. McPherson, ed., *Carolee Schneemann: More Than Meat Joy: Complete

Performance Works and Selected Writings* (New York: Documentext, 1979, 2nd ed., New York: McPherson & Co., 1997), 319.

53. "No Essential Femininity: A Conversation between Mary Kelly and Paul Smith," in Mary Kelly, *Imaging Desire* (Cambridge, MA: MIT Press, 1996), 63–76. A detailed profile of the work is provided in Mary Kelly, *Post-Partum Document* (London and Boston: Routledge & Kegan Paul, 1983). *Imaging Desire* profiles subsequent works by Kelly.

54. Kelly, *Imaging Desire*, xxiii.

55. For example: Robinson, *Feminism-Art-Theory*; Cornelia Butler and Lisa Gabrielle Mark, eds., *WACK! Art and the Feminist Revolution* (Cambridge, MA: MIT Press for Museum of Contemporary Art, Los Angeles, 2007); and Maura Reilly and Linda Nochlin, eds., *Global Feminisms: New Directions in Contemporary Art* (London and New York: Merrell for Brooklyn Museum, Brooklyn, 2007).

## CHAPTER 2

1. Jean-François Lyotard, *The Postmodern Condition: A Report on Knowledge* (Manchester: Manchester University Press, and Minneapolis: University of Minnesota Press, 1984).

2. Fredric Jameson, "Postmodernism, or, The Cultural Logic of Late Capitalism," *New Left Review* 146 (July–Aug 1984), 59–92, in Jameson, *Postmodernism, or, The Cultural Logic of Late Capitalism* (Durham, NC: Duke University Press, 1991).

3. Charles Jencks, *The Language of Post-Modern Architecture* (London: Academy, and New York: Rizzoli, 1977, 6th ed., 1991).

4. A history of these developments may be found in chs. 7 and 8 of my *What Is Contemporary Art?* (Chicago: University of Chicago Press, 2009).

5. The responses of museums including the Museum of Modern Art, New York, Dia:Beacon, Tate Modern, the Saatchi Gallery, and the Guggenheim Museum, Bilbao are discussed in the first five chapters of my *What Is Contemporary Art?*

6. Cited in Karin Thomas, *Zweimal deutsche Kunst nach 1945* (Cologne: DuMont Buchverlag, 1985), 137–39.

7. See Gregor Jansen, "'Words Are Swingling Swine': The Unfinished Work of Eugen Schöenbeck," in Eckhart Gillen, ed., *German Art: From Beckmann to Richter: Images of a Divided Country* (Cologne: Dumont Buchverlag, 1997), 139–49.

8. For example, the Berlinische Galerie in Berlin holds *Modern Painter (Remix)* (2007), a work that recalls *A Modern Painter* (1969). See also Klaus Kertess, *Georg Baselitz: Watercolors* (New York: David Nolan Gallery, 2008).

9. Gerhard Richter, Letter to Benjamin H.D. Buchloh, May 23, 1977, in Gerhard Richter, *The Daily Practice of Painting: Writings 1962–1993* (London: Thames & Hudson, and Cambridge, MA: MIT Press, 1995), 86–87.

10. Tamar Garb, "In Conversation with Christian Boltanski," in Phaidon editors, *pressPLAY: Contemporary Artists in Conversation* (London: Phaidon, 2005), 42.

11. Conversation with Georgia March, cited in Lynn Gumpert, *Christian Boltanski* (Paris: Flammarion, 1992), 133.

12. Achille Bonito Oliva, *Transavantgarde International* (Milan: Giancarlo Politi Editore, 1982), 8.

13. *Ibid.*, 13–14.

14. Cited in Tony Godfrey, *The New Image: Painting in the 1980s* (Oxford: Phaidon, and New York: Abbeville Press, 1986), 141.

15. Thomas Lawson, "Last Exit: Painting," *Artforum* 20:2 (Oct. 1981), 40–47.

16. See Kellie Jones, Thelma Golden, and Chrissie Iles, *Lorna Simpson* (London and New York: Phaidon, 2002) for prior works, and Okwui Enwezor et al., *Lorna Simpson* (New York: Abrams, 2006) for other relevant works.

17. Deutsche Bank, ed., *Wangechi Mutu: My Dirty Little Heaven* (Ostfildern, Germany: Hatje Cantz, 2010).

18. Quoted in Alexander Alberro, "Kara Walker," *Index 1* 1 (Feb. 1996), 25–26.

19. See Philippe Vergne et al., *Kara Walker: My Complement, My Enemy, My Oppressor, My Love* (Minneapolis: Walker Art Center, 2007).

20. Jeff Koons, *The Jeff Koons Handbook* (London: Thames & Hudson for the Anthony d'Offay Gallery, and New York: Rizzoli, 1992), 31–32.

21. Charles Saatchi, introduction to Patricia Ellis and Charles Saatchi, *100: The Work That Changed British Art* (London: Jonathan Cape, 2003), 11.

22. See Julian Stallabrass, *High Art Lite: British Art in the 1990s* (London and New York: Verso, 1999, 3rd ed. 2006).

23. Damien Hirst, *I Want to Spend the Rest of My Life Everywhere, with Everyone, One to One, Always, Forever, Now* (New York: Monacelli Press, 1997), 132, 285.

24. See Kirk Savage, *Monument Wars: Washington, D.C., the National Mall, and the Transformation of the Memorial Landscape* (Berkeley: University of California Press, 2009), 261–84.

25. Wall caption, Boston Museum of Fine Arts, transcribed 2008.

26. Bernd Becher and Hilla Becher, *Kunst-Zeitung No. 2* (Düsseldorf: Michelpresse, 1969), cited in Enno Kaufhold, "The Mask of Opticality," *Between Past and Future: New German Photography, Aperture* 123 (spring 1991), 64.

27. Jeff Wall, in conversation with Els Barents, in Jean-Christophe Ammann, *Jeff Wall: Transparencies* (Munich: Schirmer/Mosel, 1986, and New York: Rizzoli, 1987), 99–100.

28. Jeff Wall, cited in Theodora Vischer and Heidi Naef, eds., *Jeff Wall: Catalogue Raisonné 1978–2004* (Basel: Schaulager, 2005), 333.

29. "Arielle Pelenc in Correspondence with Jeff Wall," in Thierry de Duve, Arielle Pelenc, and Boris Groys, *Jeff Wall* (London: Phaidon, 1996), 21.

30. Jeff Wall, cited in Craig Burnett, *Jeff Wall* (London: Tate, 2005), 59. Trained as an art historian, the artist has long been an articulate interpreter of his and other artists' work: see Jeff Wall, *Jeff Wall: Selected Essays and Interviews* (New York: Museum of Modern Art, 2007).

31. The pairing of these two images is made in Peter Osborne, "Interview with Jeff Wall: Art after Photography,

after Conceptual Art," *Radical Philosophy* 150 (July–Aug. 2008), 36–51. In her *Regarding the Pain of Others* (London: Macmillan, 2004), 123–26, Susan Sontag offers a rich reading of *Dead Troops Talk*.

32. The social context and the design of the museum are treated in detail in my *The Architecture of Aftermath* (Chicago: University of Chicago Press, 2006), ch. 1, and in ch. 5 of my *What Is Contemporary Art?*

33. An extended discussion may be found in ch. 6 of my *What Is Contemporary Art?*

## CHAPTER 3

1. Milan Kundera, "The Tragedy of Central Europe," *New York Review of Books* 26 (April 1984), 33–38. Initially published as "Un Occident kidnappé, ou la tragédie de l'Europe centrale," *Le Débat* 27 (Nov. 1983).

2. Marina Gržinić, *Situated Contemporary Art Practices: Art, Theory, and Activism from East Europe* (Frankfurt: Revolver, 2004)

3. See IRWIN, ed., *East Art Map: Contemporary Art and Eastern Europe* (London: Afterall, 2006). A useful update and critique of this enterprise is Marina Gržinić, Günter Heeg, and Veronika Darian, *Mind the Map! History Is Not Given* (Frankfurt: Revolver, 2006).

4. Camilla Grey, *The Great Experiment: Russian Art 1863–1922* (London: Thames & Hudson, 1962). See also Deborah Wye and Margit Rowell, eds., *The Russian Avant-Garde Book, 1910–1934* (New York: Museum of Modern Art, 2002).

5. As argued by Boris Groys, *The Total Art of Stalinism: Avant-Garde, Aesthetic Dictatorship, and Beyond* (Princeton: Princeton University Press, 1992).

6. "A Case Study: Repression," in Laura Hoptman and Tomáš Pospiszyl, eds., *Primary Documents: A Sourcebook for Eastern and Central European Art since the 1950s* (New York: Museum of Modern Art, 2002), 65–77.

7. Ilya Kabakov, foreword to Hoptman and Pospiszyl, *Primary Documents*, 8.

8. Ilya Kabakov, *Ten Characters* (New York: Ronald Feldman Fine Arts Gallery, 1989). See also Amei Wallach, *Ilya Kabakov: The Man Who Never Threw Anything Away* (New York: Abrams, 1996).

9. See Carter Ratcliff, *Komar and Melamid* (New York: Abbeville Press, 1988).

10. Interview by Vladimir Bulat, Moscow, 2003, www.saatchi-gallery. co.uk/artists/boris_mikhilov_articles.htm.

11. Oleg Kulik, "Why Have I Bitten a Man?" in Hoptman and Pospiszyl, *Primary Documents*, 349–51.

12. Seeing himself as a shaman-artist, Beuys evoked a lyrical parallel (in his phrase "social sculpture") between the communality shared between animals in conditions of survival and the need for humans to cooperate in the reshaping of societies. Kulik's 1996 action, and his *I Bite America and America Bites Me*, performed at Dietch Projects, New York, 1997, ridiculed these lofty ambitions.

13. Eda Čufer, ed., *Transnacionala: Highway Collisions between East and West at the Crossroads of Art* (Ljubljana,

Slovenia: KODA, 1999).

14. See www.chtodelat.org.

15. Roman Opałka, cited at en.wikipedia.org/wiki/Roman_Opałka.

16. Cited in IRWIN, *East Art Map*, 290.

17. "Interview with Wodiczko," in Ine Gevers and Jeanne van Heeswijk, eds., *Beyond Ethics and Aesthetics* (Nijmegan: Sun, 1997), 450–52. Cited in Krzysztof Wodiczko, *Critical Vehicles: Writings, Projects, Interviews* (Cambridge, MA: MIT Press, 1999), 102–03.

18. Krzysztof Wodiczko, "Memorial Projection," *October* 38 (winter 1986), 10. Cited in Wodiczko, *Critical Vehicles*, 51–52. The text of the Kraków projection is in "Voices of the Tower (1996)," in *ibid.*, 69–73.

19. Mladen Stilinović, in Darko Šimičić, "Interview: Mladen Stilinović," in Mladen Stilinović, *Exploitation of the Dead, 1984–1989* (Zagreb: Edicija Šimičić, 1989), 1.

20. Zofia Kulik, "Autokomentarz" [Self-Commentary], *Magazyn Sztuki* 15–16 (1997), 224. Cited in Piotr Piotrowski, *Zofia Kulik: From Siberia to Cyberia* (Poznań, Poland: Muzeum Narodowe, 1999), 11.

21. Cited in Zdenka Badovinac, ed., *Body and the East from the 1960s to the Present* (Cambridge, MA: MIT Press, 1999), 68.

22. "Laibach: 10 Items of the Covenant," 1982, and text from the invitation to the *Ausstellung Laibach Kunst* exhibition, April 28, 1982, at the ŠKUC Gallery-Student Cultural Center, Ljubljana. Cited in Hoptman and Pospiszyl, *Primary Documents*, 294–96. See also Aleš Erjavec, *Ljubljana, Ljubljana: The Eighties in Slovene Art and Culture* (Ljubljana, Slovenia: Mladinska Kniga, 1991).

23. Eda Čufer and IRWIN, "NSK in Time," in Eda Čufer, ed., *NSK Embassy Moscow* (Koper, Slovenia: Gallery Loža, 1993).

24. Cited in Hoptman and Pospiszyl, *Primary Documents*, 277–80.

25. See www.georgkargl.com/en/box/exhibition/miklos-erdely-and-the-indigo-group-fotoworks-from-the-70ies-and-80ies. Some other works by Erdély may be found at www.artpool.hu/art73_74/erdely3.html.

26. Sirje Helme, "Nationalism and Dissent: Art and Politics in Estonia, Latvia, and Lithuania under the Soviets," in Alla Rosenfeld and Norton T. Dodge, eds., *Art of the Baltics: The Struggle for Freedom of Artistic Expression under the Soviets, 1945–1990* (New Brunswick, NJ: Rutgers University Press, 2002), 13.

27. See *Artists of Estonia* (Tallinn: Soros Center for Contemporary Art, 1998); *Myth and Abstraction: Actual Art from Estonia*, exh. cat. (Karlsruhe: Badischer Kunstverein Karlsruhe, 1992).

28. Kai Kaljo, cited in Bojana Pejic, David Elliot, eds., *After the Wall: Art and Culture in Post-Communist Europe*, (Stockholm: Moderna Museet, 1999), vol. 2, 63.

29. Cited in Helēna Demakova, "The Apple Harvest, or Art in Latvia 1945–1995: Personal and Ideological Time," in Anda Rottenberg, ed., *Personal Time: Art of Estonia, Latvia, and Lithuania, 1945–1996* (Warsaw: Galeria Sztuki Współczesnej Zacheta, 1996), 10.

30. Lionginas Šepetys, "Kommunistinai idealai ir modernizmo kaukė" [Ideals of Communism and the Mask of Modernism], *Literatura ir menas*, Jan. 30, 1982, cited in Vicktoras Luitkas, "Breaking the Barriers: Art under the Pressure of Soviet Ideology from World War II to Glasnost," in Rosenfeld and Dodge, *Art of the Baltics*, 333–34.

31. See Barbara Vanderlinden and Elena Filipovic, eds., *The Manifesta Decade: Debates on Contemporary Art Exhibitions and Biennials in Post-Wall Europe* (Cambridge, MA: MIT Press, 2006).

32. Călin Dan, "Untitled Celebration," *Imago: Another Europska Photography*, Bratislava (winter 1995–96), 31.

33. László Beke, "East Central Europe from the Perspective of a Hungarian Curator," in Laura Hoptman and László Beke, eds., *Beyond Belief: Contemporary Art from East Central Europe* (Chicago: Museum of Contemporary Art, 1995), 87–93, at pp. 87–89.

34. János Sturcz, "Europe?," in Katalin Keserü, ed., *Crossroads in Central Europe: Ideas, Themes, Methods, and Problems of Contemporary Art and Criticism* (Budapest: Association of Hungarian Creative Artists, 1996).

35. Robert Fleck, "Art after Communism?," in Robert Fleck, Maria Lind, and Barbara Vanderlinden, *Manifesta 2, European Biennial of Contemporary Art* (Luxembourg: Casino Luxembourg—Forum d'Art Contemporain, 1998), 194.

36. Cited in Zdenka Badovinac, ed., *Body and the East* (Cambridge, MA: MIT Press, 1999), 10.

37. Comment on Fleck's 1988 essay, cited in Maria Hlavajova and Jill Winder, eds., *Who if Not We Should at Least Try to Imagine the Future of All This?: 7 Episodes on (Ex)changing Europe* (Amsterdam: Artimo, 2004), 261.

38. Cited in the *Los Angeles Times*, May 19, 1997, 1.

39. Cited by Bojana Pejic, in Hlavajova and Winder, *Who if Not We?*, 250.

40. Étienne Balibar, *We, The People of Europe?: Reflections on Transnational Citizenship* (Princeton: Princeton University Press, 2003), 234.

## CHAPTER 4

1. See Walter D. Mignolo, *The Idea of Latin America* (Oxford: Blackwell, 2005), and various authors, "Caribbean Islands," in Jane Turner, ed., *The Dictionary of Art* (New York: Grove, 1996), vol. 5, 745–55.

2. Oswald de Andrade, "Anthropophagite Manifesto," *Revista de Antropofagia* (São Paulo) 1 (May 1928), 3, 7. Cited in Dawn Ades et al., *Art in Latin America: The Modern Era, 1820–1980* (New Haven: Yale University Press, 1989), 312–13.

3. Joaquín Torres-García, "The Southern School," Uruguay, Feb. 1935, cited in Ades et al., *Art in Latin America*, 320–22.

4. Gabriel García Márquez, in conversation with Plinio Apuleyo Mendoza, *The Fragrance of Guava* (London: Verso, 1983), 35.

5. This theme is explored in Holliday T. Day and Hollister Sturges,

*Art of the Fantastic: Latin America, 1920–1987* (Indianapolis: Indianapolis Museum of Art, 1987).

6. Max Bill, quoted in Nelly Perrazzo, *El Arte Concreto en la Argentina en la Década del 40* (Buenos Aires: Ediciones de Arte Gaglianone, 1983), 24–25.

7. These developments are surveyed in Ades et al., *Art in Latin America*, and in Mari Carmen Ramirez and Héctor Olea, *Inverted Utopias: Avant-Garde Art in Latin America* (New Haven: Yale University Press, 2004).

8. Ades et al., *Art in Latin America*, 256.

9. In this survey I have not, for various practical reasons, been able to encompass the contemporary art of some important countries within South America—Ecuador, Peru, Bolivia, Paraguay—and the small nations Guatemala, Honduras, El Salvador, Nicaragua, Costa Rica, and Panama that are usually known collectively as Central America. Countries of the Caribbean beyond Cuba require fuller treatment. I hope to remedy these defects in future editions. Introductions to modern art in these countries may be found in Edward J. Sullivan, ed., *Latin American Art in the Twentieth Century* (London: Phaidon, 1996), but no survey of their contemporary art is yet available.

10. Andrea Giunta, *Avant-Garde, Internationalism, and Politics: Argentine Art in the 1960s* (Durham, NC: Duke University Press, 2007), 9.

11. Rubén Sanantonin, manuscript notes, Nov. 8, 1961. Rubén Sanantonin Archives, BA, cited in Giunta, *Avant-Garde, Internationalism, and Politics*, 134.

12. Statement in the catalogue for the exhibition *Art and Cybernetics*, CAYC, Aug. 1969, cited in Jorge Glusberg, *Art in Argentina* (Milan: Giancarlo Politi Editore, 1986), 20.

13. Ferreira Gullar, "Teoria do não-objeto" [Theory of the Nonobject], *Jornal do Brasil* (Rio de Janeiro), Sunday supplement, Nov. 21, 1960.

14. Lygia Clark, "Writings," *Signals Newsletter* (London) (April–May 1965), 2–3, in Patrick Frank, ed., *Readings in Latin American Modern Art* (New Haven: Yale University Press, 2004), 176.

15. See Carlos Basualdo, ed., *Tropicália: A Revolution in Brazilian Culture 1967–1972* (São Paulo: Cosac Naify, 2005). The lyrics of the song "Tropicália" may be found in Patrick Frank, *Readings in Latin American Modern Art*, 180–81.

16. "4 de Março de 1968," in Hélio Oiticica, *Aspiro ao Grande Labirinto* (Rio de Janeiro: Rocco, 1986), 106, cited in Basualdo, *Tropicália*, 16.

17. Werner Spies, ed., *Fernando Botero: Paintings and Drawings* (Munich: Prestel, 1992), 11, 10.

18. Cited in Elizabeth Nash, "The Art of Abu Ghraib," *Independent* (London), April 13, 2005.

19. Doris Salcedo, "Interview with Charles Merewether 1998," in Doris Salcedo et al., *Doris Salcedo* (London: Phaidon, 2000), 140–45. Emmanuel Levinas (1906–95) was a French philosopher and Talmudic commentator best known for his advocacy of face-to-face ethics. See Adriaan T. Peperzak et al., eds., *Emmanuel Levinas: Basic Philosophical Writings* (Bloomington, IN:

Indiana University Press, 2008).

20. Shifra M. Goldman, *Contemporary Mexican Painting in a Time of Change* (Austin: University of Texas Press, 1981).

21. Amalia Mesa-Bains, Tomás Ybarra-Frausto, and Shifra M. Goldman, *Signs from the Heart: California Chicano Murals* (Venice, CA: Social and Public Art Resource Center, 1990), and Griswold del Castillo and Carlos Francisco Jackson, *Chicana and Chicano Art: ProtestArte* (Tucson, AZ: University of Arizona Press, 2009).

22. Juan A. Martínez, *Cuban Art and National Identity: The Vanguardia Painters, 1927–1950* (Gainesville, FL: University Press of Florida, 1994).

23. Discussed in Nathalie Bondil, ed., *Cuba: Art and History, From 1868 to Today* (Montreal: Montreal Museum of Fine Arts, 2008).

24. Cited in Luis Camnitzer, *New Art of Cuba* (Austin: University of Texas Press, 1994, 2nd ed., 2003), 52.

25. Gerardo Mosquera, "El Tercer Mundo hará la cultura occidental" [The Third World Makes Western Culture], *Revolución y Cultura* (July–Sept. 1986), 39–47. This was a special number in association with the second Havana Biennial, 1986. See also Gerardo Mosquera, "The New Cuban Art," in Aleš Erjavec, ed., *Postmodernism and the Postsocialist Condition: Politicized Art under Late Socialism* (Berkeley: University of California Press, 2003), 208–46, and Rachel Weiss, "Visions, Values, and Vestiges: The Curdled Victories of the Bienal de La Habana," *Art Journal* 66:1 (March 2007), 10–26.

26. A survey of work by Cuban artists in exile is provided by Ilena Fuentes-Perez, Graciella Cruz-Taura, and Ricardo Pau-Llosa, eds., *Outside Cuba: Contemporary Cuban Visual Artists* (New Brunswick, NJ: Rutgers University, 1988).

27. Cited at www.universes-in-universe.de/woven-maze/bruguera, which includes an animation of *Destierro: Obsesiones* (1998).

28. For a discussion of some recent Cuban art, see my *What Is Contemporary Art?* (Chicago: University of Chicago Press, 2009), ch. 9.

## CHAPTER 5

1. Mao Zedong, *Mao Tse-tung on Literature and Art* (Beijing: Foreign Languages Press, 1967), 22.

2. Shu Qun, "Beifang yishu qunti de jingshen" [The Spirit of the Northern Art Group], *Zhongguo meishu bao* [Fine Arts in China] 18 (1985), 1, cited in Xu Hong, "Chinese Art," in Caroline Turner, ed., *Art and Social Change, Contemporary Art in Asia and the Pacific* (Canberra: Pandanus Books, Research School of Pacific and Asian Studies, Australian National University, 2004), 334.

3. Cited in Gao Minglu, *The Wall: Reshaping Contemporary Chinese Art* (Buffalo and Beijing: Albright Knox Art Gallery and China Millennium Museum of Art, 2005), 129.

4. "Zhongguo xiandai yishuzhan chouzhan tonggao, diyihao" [Announcement of the Organization of China Avant-Garde], *Zhongguo meishu bao* [Fine Arts in China], 171 (1988), 1.

5. Gao Minglu, *Chinese Maximalism* (Chongqing: Chongqing chu ban she, 2003).

6. See François Jullien, *The Impossible Nude: Chinese Art and Western Aesthetics* (Chicago: University of Chicago Press, 2007).

7. Cited Charles Merewether, "The Spectre of Being Human," in Turner, *Art and Social Change*, 101.

8. See Liao Wen, *Feminism as a Method—Feminist Art* (Changchun: Jilin Fine Arts, 1998); Xu Hong, *Female: Thoughts on Fine Arts* (Nanjing: Jiangsu People's Publishing House, 2003); Liao Wen, "'Women's Art' as Part of Contemporary Chinese Art since 1990," in Wu Hung with Wang Huangsheng and Feng Boyi, *Reinterpretation: A Decade of Experimental Chinese Art 1990–2000* (Guangzhou: Guangdong Museum of Art, 2002), 60–66.

9. The artist's account of this project is under "A Divine Comedy of Our Times" at www.wendagu.com/home.html. Click "Publications," then "Wenda Gu's Writings."

10. Cited in *Dian Zang jin yishu* 104 (May 2001), 40.

11. Bernhard Fibicher, ed., *Mahjong: Contemporary Chinese Art from the Sigg Collection* (Ostfildern, Germany: Hatje Cantz, 2005).

12. Barbara Pollack, *The Wild, Wild East: An American Art Critic's Adventures in China* (Beijing: Timezone 8, 2010).

13. Wu Hung with Wang Huangsheng and Feng Boyi, *Reinterpretation: A Decade of Experimental Chinese Art 1990–2000* (Guangzhou: Guangdong Museum of Art, 2003).

14. Cited in Wu Hung, ed., *Chinese Art at the Crossroads* (Honolulu: University of Hawaii Press, 2003), 217.

15. Zhou Xaiohu, interviewed by Zoe Butt, in Lynne Seear and Suhanya Raffel, eds., *The Fifth Asia-Pacific Triennial of Contemporary Art*, exh. cat. (Brisbane: Queensland Art Gallery, 2006), 142.

16. Overviews include essays by Britta Erikson and Zhu Qi, in Wu Hung, *Chinese Art at the Crossroads* and John Clark, ed., *Chinese Art at the End of the Millennium* (Hong Kong: New Art Media, 2000), and my "Background Story: Modern and Contemporary Art, World Currents, China," in Chinese Contemporary Art Foundation, ed., *What Is Contemporary Chinese Art? The Collection of Essays of the 2009 International Conference on Art Theory and Criticism* (Beijing: Wall Art Museum, 2010).

17. Collection Fukuoka Asian Art Museum, no. 950. See faam.city.fukuoka.lg.jp.

18. Takashi Murakami, ed., *Super Flat* (Tokyo: Madra Shuppan, 2000); Murakami, ed., *Little Boy: The Arts of Japan's Exploding Subculture*, exh. cat. (New York: Japan Society, 2005).

19. Takashi Murakami, *Geijutsu Kigyō-ron* [The Theory of Art Entrepreneurship] (Tokyo: Gentosa, 2006), 177–78. Peter Schimmel, ed., ©*Murakami* (Los Angeles: Museum of Contemporary Art, and New York: Rizzoli, 2007). Murakami's impact on younger artists is evident in publications such as Yumi Yamaguchi, *Warriors of Art: A Guide to Contemporary Japanese Artists*

(Tokyo and New York: Kodansha International, 2007).

20. See Nicholas Bonner, "Mansudae Art Studio and Art in North Korea (DPRK)," in Asia Pacific Triennial of Contemporary Art, *The 6th Asia Pacific Triennial of Contemporary Art*, exh. cat. (Brisbane: Queensland Art Gallery, 2009), 106–11.

21. Mark Edwards Harris, *Inside North Korea* (San Francisco: Chronicle Books, 2007), and Jane Portal, *Art Under Control in North Korea* (London: Reaktion Books, 2005).

## CHAPTER 6

1. "Diaries," Sept. 3, 1967, in Sasha Altaf, ed., *Nasreen in Retrospect* (Bombay: Ashraf Mohamedi Trust, 1995), 87.

2. Partha Mitter, "Decentering Modernism: Art History and Avant-Garde Art from the Periphery," *Art Bulletin* 90:4 (Dec. 2008), 531–48. See also his "Reflections on Modern Art and National Identity in Colonial India," in Kobena Mercer, ed., *Cosmopolitan Modernisms* (Cambridge, MA: MIT Press for Institute for International Visual Arts, London, 2005), and Rebecca M. Brown, *Art for a Modern India, 1947–1980* (Durham, NC: Duke University Press, 2009).

3. See the Raqs Media Collective online site at www.raqsmediacollective.net/impostor.html.

4. Rashid Rana, cited in Salima Mashmi, *Hanging Fire: Contemporary Art from Pakistan*, exh. cat. (New York: Asia Society, 2009), 118.

5. Kavita Singh et al., *Rashid Rana: Identical Views*, exh. cat. (New Delhi: Gallery Nature Morte, 2005), 24.

6. Cited in Fondazione Sandretto Re Rebaudengo, *Subcontingent: The Indian Subcontinent in Contemporary Art*, exh. cat. (Milan: Electa, 2006), 52.

7. Iftikhar Dadi, "Art in Pakistan: The First Decades," in Salima Mashmi, *Hanging Fire*, 45.

8. Nicolas Bourriaud, *Relational Aesthetics* (Dijon: Les Presses du Réel, 1998, English trans., 2002).

9. See David Tey, "Independent Means: An Overview of Contemporary Art in Thailand," *Art and Australia* 45:3 (autumn 2008), 450–57.

10. Jim Supangkat, introduction to *Indonesian Modern Art and Beyond* (Jakarta: The Indonesian Fine Arts Foundation, 1997).

11. Caroline Turner, "Indonesia: Art, Freedom, Human Rights, and Engagement with the West," in Turner, *Art and Social Change,* 197.

12. Jim Supangkat, "Multiculturalism/Multimodernism," in Apinan Poshyananda et al., *Contemporary Art in Asia: Traditions, Tensions* (New York: Abrams for the Asia Society Galleries, 1996), 70–81.

## CHAPTER 7

1. Anne D'Avella, *Art of the Pacific* (London: George Weidenfeld and Nicolson, 1998), 17.

2. Letter, Sept. 2, 1980, cited in Roger Horrocks, *Len Lye: A Biography* (Auckland: Auckland University Press, 2001), 381.

3. See Tyler Cann and Wynstan Curnow, eds., *Len Lye* (Melbourne: Australian Centre for the Moving Image, 2009).

4. James Mollison, Australia Day address, reported in the *Sydney Morning Herald*, Jan. 26, 1984, 2.

5. Cited in Michael Boulter, *The Art of Utopia* (Tortola, British Virgin Islands: Craftsman House, 1991), 61.

6. Marcia Langton, "Dreaming Art," in Nikos Papastergiadis, ed., *Complex Entanglements: Art, Globalisation and Cultural Difference* (London: Rivers Oram Press, 2003), 51.

7. Imants Tillers, "A Conversation with Ian North," *Artlink* 21:4 (2001), 37.

8. A companion painting, *Reconciliation Walk (Doubt)* (2004), shows a group of local Aboriginal men gathered on the bridge as the procession makes its way into the distance. They are halted by a crack that spreads across the road surface. One of them gestures in the manner of the figure in Caravaggio's *The Incredulity of St. Thomas* (ca. 1602). Moss gave a moving account of his years in Alice Springs in his book, *The Hard Light of Day: An Artist's Story of Friendships in Arrernte Country* (St Lucia, QLD, Australia: University of Queensland Press, 2010), which also includes a supplement illustrating his paintings since 1986.

9. Richard Bell, "Bell's Theorem: Aboriginal Art – It's a White Thing," 2003, at www.kooriweb.org/foley/great/art/bell.html.

10. See www.aboriginalartdirectory.com/news/feature/ngurrara-the-great-sandy-desert-canvas.php.

## CHAPTER 8

1. Esmé Berman, *Painting in South Africa* (Johannesburg: Southern Book Publishers, 1993), xxi.

2. See "Gordon's Turner Prize Artist Talk: Yinka Shonibare," Dec. 2004, Tate Channel, at channel.tate.org.uk/media/26608109001.

3. Cited in Jean Kennedy, *New Currents, Ancient Rivers: Contemporary African Artists in a Generation of Change* (Washington, DC: Smithsonian Institution Press, 1992), 113–14.

4. In Lilyan Kesteloot, ed., *Black Writers in French: A Literary History of Negritude* (Washington, DC: Howard University Press, 1991), 1002–03.

5. A firsthand account is Ulli Beier, *Contemporary Art in Africa* (New York: Praeger, 1968).

6. Nelson Mukhuba, cited in Gavin Younge, *Art of the South African Townships* (London: Thames & Hudson, 1998), 17.

7. The circumstances of the painting of this series, including the artist's comments on each work, may be found in Johannes Fabian, *Remembering the Present: Painting and Popular History in Zaire* (Berkeley: University of California Press, 1996). See also Paul Faber, *The Dramatic History of the Congo as Painted by Tshibumba Kanda Mutulu* (Amsterdam: KIT, 2005).

8. Chéri Samba, interview by André Magnin, in André Magnin, ed., *J'aime Chéri Samba* (Paris: Fondation Cartier pour l'Art Contemporain, 2004), 29.

9. Cited in André Magnin et al., *African Art Now: Masterpieces from the Jean Pigozzi Collection* (London: Merrell in Association with the Museum of Fine Arts, Houston, 2005), 116.

10. El Hadji Sy, "Objects of Performance," in Clémentine Deliss, ed., *Seven Stories about Modern Art in Africa* (Paris: Flammarion, 1995), 78–101.

11. Cited in Magnin et al., *African Art Now*, 58.

12. Amanda Carlson, *Lalla Essaydi: Converging Territories* (Brooklyn: power-House Books, 2005).

13. Andries Walter Oliphant, "Postcolonial South Africa: Three Canvas Bags on Art and Change," in Emma Bedford, ed., *A Decade of Democracy: South African Art 1994–2004* (Cape Town: Double Storey Books, 2004), 18.

14. William Kentridge, cited in Calvin Tompkins, "Lines of Resistance: William Kentridge's Rough Magic," *The New Yorker*, Jan. 18, 2010, 57. See Jane Taylor, *Ubu and the Truth Commission* (Cape Town: University of Cape Town Press, 1998) and www.handspringpuppet.co.za/html/ubu.html.

15. Illustrated and discussed in Sidney Littlefield Kasfir, *Contemporary African Art* (London: Thames & Hudson, 2000), 165.

16. Kendell Geers, "The Perversity of My Birth: The Birth of My Perversity," in Sue Williamson and Ashraf Jamal, *Art in South Africa: The Future Present* (Cape Town: David Philip, 1996).

17. Marlene Dumas, "The Next Generation," in Marlene Dumas, *Sweet Nothings: Notes and Texts* (Amsterdam: Uitgeverij De Balie, 1998), 93.

18. See www.caacart.com/pigozzi-artist.php?i=Bruly-Bouabre-Frederic&bio=en&m=14, and the film *L'Alphabet de Bruly Bouabré*, directed by Nurith Aviv (Swan Productions, ZDF/ARTE).

19. On Mehretu, see www.whitecube.com/artists/mehretu/. On Bruyère, see www.epidemic.net/en/art/bruyere/index.html, and the discussion of his work in my *What Is Contemporary Art?* (Chicago: University of Chicago Press, 2009), 173–81. Ch. 10 in that book, "Our Otherness: The Beauty of the Animal," discusses some themes raised in this chapter.

## CHAPTER 9

1. See Bernard Lewis, *Islam and the West* (New York: Oxford University Press, 1993) and Edward Said, *Orientalism* (New York: Vintage Books, 1979). The foundational, and ongoing, theorization of Islamic art has been led by Oleg Grabar, *Constructing the Study of Islamic Art, vol. 3: Islamic Art and Beyond* (Aldershot: Ashgate, 2006)

2. See Charbel Dagher, *Al-Hurufiyah al-Arabuyah: Fann wa Hawiyah* (*Arab Letterism: Art and Identity*) (Beirut: Sharikat al-Matbu 'at Lil Tawzi ' wa al-Nashir, 1990), and, on the calligraphic school, Wijdan Ali, *Modern Islamic Art: Development and Continuity* (Gainesville, FL: University Press of Florida, 1997). Incisive commentary on both formulations is offered, from an Arabist perspective, by Nada M.

Shabout, *Modern Arab Art: Formation of Arab Aesthetics* (Gainesville, FL: University Press of Florida, 2007). An enthusiastic external survey is Venetia Porter, *Word into Art: Artists of the Modern Middle East* (London: British Museum Press, 2006).

3. Cited in Dagher, *Al-Hurufiyah al-Arabuyah*, 141.

4. Cited in Porter, *Word into Art*, 71.

5. Shakir Hassan al-Said, *Studies in Spatial Time*, exh. cat. (Amman: Jordan National Gallery of Fine Arts, 1992), n.p.

6. See Maysaloun Faraj, ed., *Strokes of Genius: Contemporary Iraqi Art*, exh. cat. (London: Saqi Books, 2001).

7. On Saddam Hussein's monumentalizing ambitions, see Samir al-Khalil (Kanaan Makia), *The Monument: Art, Vulgarity, and Responsibility in Iraq* (London: André Deutsch, 1991).

8. See www.zenderoudi.com.

9. See Shiva Balaghi and Lynn Gumpert, *Picturing Iran: Art, Society and Revolution* (London: I.B. Taurus, 2002).

10. Cited in Fereshteh Daftari, ed., *Without Boundary: Seventeen Ways of Looking* (New York: Museum of Modern Art, 2006), 103.

11. Farzaneh Milani, *Shirin Neshat* (Milan: Edizioni Charta, 2001); Lisa Corrin, ed., *Shirin Neshat*, exh. cat. (London: Serpentine Gallery, and Vienna: Wien Kunsthalle, 2000).

12. See Marjane Satrapi, *Persepolis: The Story of a Childhood* (New York: Pantheon, 2003); *Persepolis 2: The Story of a Return* (New York: Pantheon, 2004).

13. See Ghazel, *All About Me*, exh. cat. (Tokyo: Musashino Art University AlphaM Project, 2005).

14. Cited in Daftari, *Without Boundary*, 97, 32, and Porter, *Word into Art*, 63. See also Benjamin Genocchio, "In the Heat of the Moment," *Art in America* 10 (Nov. 2009), 121–29.

15. See Elias Newman, *Art in Palestine* (New York: Siebel Company, 1939).

16. The historiography of Palestinian art has been established by Kamal Boullata in a number of articles and books written since the 1970s, notably "Art," in Philip Mattar, ed., *The Encyclopedia of the Palestinians* (New York: Facts on File, 2000), 69–73; online at virtualgallery.birzeit.edu/media/artical?item=11151. His *Istihdar al-Makan, Dirasah fi al-Fann al-Tashkili al-Filastini al-Mu'asir* (Tunis: Al-Munzammah al-'Arabiyyah lil-Tarbiyyah wa al-Thaqafah, wa al-'Ulum, 2000) is currently being translated as *Conjuring Up Space: A Study of Contemporary Palestinian Art*. A thorough, if controversial, parallel study is Gannit Ankori, *Palestinian Art* (London: Reaktion Books, 2006). See also Samia A. Halaby, *Liberation Art of Palestine: Palestinian Painting and Sculpture in the Second Half of the 20th Century* (New York: HTTB, 2001).

17. See Susan Slyomovics, *The Object of Memory: Arab and Jew Narrate the Palestinian Village* (Philadelphia: University of Pennsylvania Press, 1998).

18. Cited in Porter, *Word into Art*, 33. See also Kamal Boullata, "To Measure Jerusalem: Explorations of the Square," *Journal of Palestine Studies* 28:3 (spring 1999), 87–88.

19. Ankori, *Palestinian Art*, 125.

20. Cited in *ibid.*, 123.

21. Other important works by

Hatoum are illustrated and discussed in Michael Archer, Guy Brett, and Catherine de Zegher, *Mona Hatoum* (London: Phaidon, 1997); *Mona Hatoum: The Entire World as a Foreign Land*, exh. cat. (London: Tate Gallery, 2002); and Ankori, *Palestinian Art*, ch. 6.

22. On Asad Azi, see Ankori, *Palestinian Art*, ch. 8. On Abu Shaqra, see Kamal Boullata, "Asim Abu Shaqra: The Artist's Eye and the Cactus Tree," *Journal of Palestine Studies* 30:4 (summer 2001), 68–82.

23. See Tal Ben Zvi and Yael Lerer, eds., *Self-Portrait: Palestinian Women's Art*, exh. cat. (Tel Aviv: Andulus, 2001).

24. Personal communication from the artist, Feb. 22, 2010.

25. Personal communication from the artist, June 6, 2008. See also Daftari, *Without Boundary*, 391.

26. Edward Said, "Emily Jacir," *Grand Street* 72 (fall 2003), online at www.grandstreet.com/gsissues/gs72/gs72d.html.

27. See Susan Tumarkin Goodman, ed., *Artists of Israel, 1920–1980*, exh. cat. (Detroit: Wayne State University for the Jewish Museum, New York, 1981).

28. See Susan Tumarkin Goodman, *Dateline Israel: New Photography and Video Art* (New Haven: Yale University Press and the Jewish Museum, New York, 2007).

29. For example, *Makom II* (2007–08); see www.artcal.net/event/view/3/6358. Prior works are illustrated in Sylvia Wolf, *Michal Rovner: The Space Between* (New York: Whitney Museum of American Art, 2002).

30. Cited at www.videoartworld.com/beta/artist_1639.html.

31. Cited in Linda Yablonsky, "The Hebrew School," *New York Times*, travel magazine, Nov. 16, 2008, 80.

32. Glenn D. Lowry, "Gained in Translation," *Art News* 105:3 (March 2006), 120–25.

33. A survey of these may be found in Sarah H. Bayliss, "A Positive Understanding of Islam," *Art News* 107:5 (May 2008), 92–94, online at artnews.com/issues/article.asp?art_id=2494.

## CHAPTER 10

1. Aleksandar Hermon, *The Lazarus Project* (New York: Riverhead, 2008), 2.

2. Chen Zhen, "An Interview with Chen Zhen and Zhu Xian," *Transexperiences* (Kitakyushu: Korinsha Press for Center for Contemporary Art, 1998), in David Rosenberg and Xu Min, *Chen Zhen: Invocation of Washing Fire* (Prato, Italy: Gli Ori, 2003), 153. "Zhu Xian" is a name formed by separating the two Chinese characters that make up the given name "Zhen." See also Antoine Guerrero, *Chen Zhen: A Tribute*, exh. cat. (Long Island City, NY: P.S.1 Contemporary Art Center, 2003).

3. Cited in Rosenberg and Xu, *Chen Zhen*, 155.

4. See *Documenta Kassel 16/06–23/09: 12*, exh. cat. (Cologne: Taschen, 2007), 194–95.

5. Mark Lombardi, "Proposal for Over the Line," 2000, cited in Robert Hobbs, *Mark Lombardi: Global Networks* (New York: Independent Curators International, 2003), 16.

6. Leonard discusses the work as displayed at *Documenta 12*, 2007, at web.mac.com/rossner/dmovies/documenta12/Entries/2007/6/26_Zoe_Leonard.html. See also Zoe Leonard, *Analogue* (Ohio: Wexner Art Center, 2007).

7. Illustrated in Allan Sekula, *Geography Lesson: Canadian Notes* (Cambridge, MA: MIT Press for Vancouver Art Gallery, 1997). Sekula's important earlier works and critical essays may be found in Allan Sekula, *Photography Against the Grain: Essays and Photo Works, 1973–1983* (Halifax, NS, Canada: Nova Scotia College of Art and Design, 1984).

8. Unpublished interview with the artist, May 12, 1995.

9. *Ibid.* For the entire text-image work, see Allan Sekula, *Fish Story* (Düsseldorf: Richter Verlag for Witte de With, Rotterdam, 1995). Sekula developed this aspiration in subsequent series, such as *Titanic's Wake* (1998–99), on which see Allan Sekula, "Titanic's Wake," *Art Journal* 60:2 (summer 2001), 26–37. See also Sabine Breitwieser, ed., *Allan Sekula, Performance under Working Conditions* (Ostfildern, Germany: Hatje Cantz for the Generalii Foundation, Vienna, 2003).

10. Thomas Hirschhorn, interview with Okwui Enwezor, in *Thomas Hirschhorn: Jumbo Spoons and Big Cake* and *Flugplatz Welt/World Airport* (Chicago: The Art Institute and The Renaissance Society at the University of Chicago, exh. cat., 2000), 13–14. See also Benjamin H.D. Buchloh, "Thomas Hirschhorn: Lay Out Sculpture and Display Diagrams," in Benjamin H.D. Buchloh, Alison M. Gingeras, and Carlos Basualdo, *Thomas Hirschhorn* (London: Phaidon, 2004), 42–83.

11. "Interview: Alison M. Gingeras in Conversation with Thomas Hirschhorn," in Buchloh, Gingeras, and Basualdo, *Thomas Hirschhorn*, 15.

12. Thomas Hirschhorn, press release, Feb. 20, 2002, Kassel.

13. Paul Chan, cited in Scott Rothkopf, "Embedded in the Culture: The Art of Paul Chan," *Artforum* 44:10 (summer 2006), 304–12.

14. Illustrations and related information may be found in Paul Chan, *Paul Chan, The 7 Lights*, exh. cat. (London: Serpentine Gallery, and Cologne: Buchhandlung Walther König, 2007).

15. For a record of this project and of responses to it, see www.creative-time.org/programs/archive/2007/chan/welcome.html.

16. See www.prospectneworleans.org.

17. See Hakim Bey et al., *Daniel Joseph Martinez: A Life of Disobedience* (Ostfildern, Germany: Hatje Cantz, 2009).

18. Santiago Sierra, "A Thousand Words: Santiago Sierra—Interview," *Artforum* 41:2 (Oct. 2002), 131.

19. Cited in Pil Kollectiv and Galia Kollectiv, "The Spectre of Manual Labour," a paper presented at the conference *On Liberty and Art*, Tate Britain, 2006, at www.kollectiv.co.uk/Labour.html. Other works by Sierra may be found at www.santiago-sierra.com.

20. A concept developed in Giorgio Agamben, *Homo Sacer: Sovereign Power and Bare Life* (Stanford: Stanford University Press, 1998).

21. Oscar Bony, *La familia obrera* [The Working-Class Family], 1968, *tableau vivant* staged at *Experiencias 68*, at the Instituto Torcuato di Tella, Buenos Aires. See Mari Carmen Ramírez and Héctor Olea, eds., *Inverted Utopias: Avant-Garde Art in Latin America* (New Haven: Yale University Press, 2004), 378, 536. Similarly, Sierra's 2009 closure of the refurbished Lisson Gallery, London, on the occasion of its reopening echoes the action by Graciela Carnevale of locking in attendees at an art opening in Rosario, Brazil, also 1968 (see Ramírez and Olea, *Inverted Utopias*, 381).

22. In September 2009, Ai Weiwei's activism provoked a brutal reaction from the Chinese authorities. See the report in *Der Spiegel*, Sept. 16, 2009, online at www.spiegel.de/international/germany/0,1518,649346,00.html, and the profile by Evan Osnos, "It's Not Beautiful," *New Yorker* (May 24, 2010), 54–63.

## CHAPTER 11

1. *An Inconvenient Truth*, film and DVD, directed by Davis Guggenheim, Paramount Classics and Participant Productions, 2006; see www.climatecrisis.net. On Al Gore's investments in the renewable energy industries, see John M. Broder, "Gore's Dual Role in Spotlight: Advocate for Cause and Investor," *New York Times*, Nov. 3, 2009, A1, 15.

2. For further information, see the *Fourth Assessment Report*, issued in 2007, by the Intergovernmental Panel on Climate Change, at www.ipcc.ch.

3. For useful discussions of these opposing viewpoints, see Grant H. Kester, *Conversation Pieces: Community and Communication in Modern Art* (Berkeley: University of California Press, 2004), and Claire Bishop, "The Social Turn: Collaboration and Its Discontents," *Artforum* 45:6 (Feb. 2006), 178–83.

4. Gyorgy Kepes, "Art and Ecological Consciousness," in Gyorgy Kepes, ed., *Arts of the Environment* (New York: Braziller, 1972), 1, 8.

5. *Ibid.*, 10–11.

6. See Jan Butterfield, *The Art of Light and Space* (New York: Abbeville Press, 1993); Pamela M. Lee, *Chronophobia: On Time in the Art of the 1960's* (Cambridge, MA: MIT Press, 2004), 4–34.

7. See projects illustrated in Peter Noever, ed., *James Turrell: The Other Horizon* (Ostfildern, Germany: Hatje Cantz, 1998), 96.

8. Craig Adcock, *James Turrell: The Art of Light and Space* (Berkeley: University of California Press, 1990), 181. Detailed descriptions of *Roden Crater* and earlier Turrell works may be found in this volume.

9. Many examples are given in Lucy R. Lippard, *Overlay: Contemporary Art and the Art of Prehistory* (New York: Pantheon, 1983). See also Barbara C. Matilsky, *Fragile Ecologies: Contemporary Artists' Interpretations and Solutions* (New York: Rizzoli, 1992).

10. Cited in Baile Oakes, ed., *Sculpting with the Environment: A Natural Dialogue* (New York: Van Nostrand Reinhold, 1995), 53.

11. Joseph Mashek, "The Panama Canal and Some Other Works of Art," *Artforum* 9:9 (May 1971), 136–50.

12. See Walter Grasskamp, Molly Nesbit, and Jon Bird, *Hans Haacke* (London: Phaidon, 2004), 52–53.

13. Andy Goldsworthy, in A. Causey, *Nature as Material*, exh. cat. (Arts Council of Great Britain, 1980), n.p., cited in Terry Friedman and Andy Goldsworthy, eds., *Hand to Earth: Andy Goldsworthy Sculpture 1976–1990* (New York: Abrams, 1993), 1. See also Andy Goldsworthy, *Leaves* (London: Common Ground, 1989); Andy Goldsworthy, *Time: Andy Goldsworthy* (London: Thames & Hudson, 2000); and *Rivers and Tides: Andy Goldsworthy Working with Time*, DVD (New York: New Video Group, 2004).

14. See Ben Tufnell, *Land Art* (London: Tate, 2006), 83–87. On Laurence, see Drusilla Modjeska, *Janet Laurence: The Green in the Glass* (Sydney: Pesaro, 2006). On Chin's project, see collections.walkerart.org/item/object/7577. On Deller's, see www.saatchi-gallery.co.uk/blogon/art_news/jeremy_deller_in_conversation_with_matt_price/2719.

15. Oliver Grau, *Virtual Art: From Illusion to Immersion* (Cambridge, MA: MIT Press, 2003), 193. *Osmose* is accessible at www.medienkunstnetz.de/works/osmose. This interest has been pursued by many other new-media artists, such as Louis Bec, Thomas McIntosh, Christa Sommerer, and Laurent Mignonneau.

16. Robert Hobbs et al., *Agnes Denes* (Ithaca, NY: Herbert F. Johnson Museum of Art, 1992), 118.

17. Julia Gwendolyn Schneider, "Conzeptualle Viren: Joseph Beuys' '7000 Eichen' in einer synthetischen Welt," *Springerin—Hefte für Gegenwartskunst* 13:3 (summer 2007), 10.

18. For the Institute of Figuring, see www.theiff.org. For a presentation by Margaret Wertheim, see www.ted.com/talks/margaret_wertheim_crochets_the_coral_reef.html.

19. A full description of projects since 1970 may be found at www.theharrisonstudio.net. The *Peninsula Europe* project is described in detail by the artists at escholarship.org/uc/item/9hj3s753.

20. See www.potrc.org.

21. All of these projects, and others, are described in Grant H. Kester and Patrick Deegan, *Groundworks: Environmental Collaboration in Contemporary Art* (Pittsburgh: Carnegie Mellon University, 2005). See also Nato Thompson and Gregory Sholette, *The Interventionists: Users' Manual for the Creative Disruption of Everyday Life* (Cambridge, MA: MIT Press, 2004).

22. Rirkrit Tiravanija, interview with Paul Schmelzer, "The Land," in Max Andrews, ed., *Land, Art: A Cultural Ecology Handbook* (London: Royal Society for the Encouragement of Arts, Manufactures and Commerce, 2006), 53.

23. "Lucy Orta, Nicolas Bourriaud in Conversation, July 2002, Paris," in Phaidon editors, *pressPLAY: Contemporary Artists in Conversation* (London: Phaidon, 2005), 479. The Johannesburg project is described in *ibid.*, 481–82. For Orta's other projects, see www.studio-orta.com. See also Roberto Pinto, Nicolas Bourriaud, and Maia Damianovic, *Lucy Orta* (London:

Phaidon, 2003).

24. See Michael Rakowitz, "Interview," in Stephanie Smith and Victor Margolin, ed., *Beyond Green: Toward a Sustainable Art* (Chicago: University of Chicago Press for the Smart Museum of Art, 2005), 122–25.

25. Matthew Coolidge, press release for the exhibition *Britain Bombs America, America Bombs Britain* (London: Royal College of Art, 2003).

26. For further information see www.clui.org.

27. Trevor Paglen, *Black Spots on the Map: The Dark Geography of the Pentagon's Secret World* (New York: Dutton, 2009). See also Nato Thompson et al., *Experimental Geography: Approaches to Landscape, Cartography, and Urbanism* (Brooklyn: Melville House, 2009).

28. At www.critical-art.net/TacticalMedia.html.

29. On the legal case, see www.caedefensefund.org. For Critical Art Ensemble projects, see www.critical-art.net.

30. A website including images, a webcam of the site, lists of deputies who have contributed soil, and other information may be found at: www.bundestag.de/kulturundgeschichte/kunst/kuenstler/haacke/derbevoelkerung. See also Grasskamp, Nesbit, and Bird, *Hans Haacke*, 138–42, which includes the artist's statement.

31. As argued, for example, by McKenzie Wark, *The Virtual Republic* (Sydney: Allen & Unwin, 1997), and his *A Hacker Manifesto* (Cambridge, MA: Harvard University Press, 2004), 153–56.

32. See www.ekac.org/nat.hist.enig.html.

33. See www.patriciapiccinini.net. For the artist's comments on *Still Life with Stem Cells*, see www.patriciapiccinini.net/essay.php?id=24.

34. Donna Haraway, "Speculative Fabulations for Technoculture's Generations: Taking Care of Unexpected Country," in Patricia Piccinini, *(Tender) Creatures*, exh. cat. (Vitoria-Gasteiz, Spain: Artium, 2007), and online at www.patriciapiccinini.net.

35. Patricia Piccinini, *In Another Life* (Wellington, New Zealand: City Gallery, 2006), 13.

36. Hoor Al Qasimi and Jack Persekian, *8th Sharjah Biennial: Art, Ecology, and the Politics of Change*, exh. cat. (Sharjah, United Arab Emirates: Sharjah Biennial, 2007), 25.

37. See www.tea-makipaa.eu/ten_commands.htm.

38. Olafur Eliasson and Robert Irwin, "Take Your Time: A Conversation," in Madeleine Grynsztejn, ed., *Take Your Time: Olafur Eliasson* (London and New York: Thames & Hudson for the San Francisco Museum of Art, 2008), 52–53.

39. Daniel Birnbaum, ed., *Olafur Eliasson: Innen Stadt Aussen*, exh. cat. (Cologne: Buchhandlung Walther König, 2010).

40. Eliasson, in Grynsztejn, *Take Your Time*, 55.

41. Recent catalogues include: Smith and Margolin, *Beyond Green*; Andrews, *Land, Art*; Sabine Himmelsbach and Yvonne Volkart, eds., *Ökomedien/Ecomedia: Ecological Strategies in Today's Art* (Ostfildern, Germany: Hatje Cantz, 2007); Ilaria Bonacossa, ed.,

*Greenwashing. Environment: Perils, Promises and Perplexities*, exh. cat. (Milan: Fondazione Sandretto Re Rebaudengo, 2008), for which see also greenwashing.lttds.org; Francesco Manacorda, ed., *Radical Nature: Art and Architecture for a Changing Planet 1969–2009* (Cologne: Buchhandlung Walther König for Barbican Art Gallery, London, 2009); Stephanie Hanor, Lucía Sanromán, and Lucinda Barnes, eds., *Human/Nature: Artists Respond to a Changing Planet*, exh. cat. (Berkeley: Berkeley Art Museum, 2008), for which see artistsrespond.org/about, which asks "Can art inspire conservation? Can conservation inspire art?"; Rachel Kent, ed., *In the Balance: Art for a Changing World* (Sydney: Museum of Contemporary Art, 2010).

## CHAPTER 12

1. On "mediascapes," see Arjun Appardurai, "Disjuncture and Difference in the Global Cultural Economy," ch. 2 of his *Modernity at Large: Cultural Dimensions of Globalization* (Minneapolis: University of Minnesota Press, 1996).

2. Nicolas Bourriaud, *Relational Aesthetics* (Paris: Les Presses du Réel, 1998, English trans., 2002), 46, 113.

3. *Ibid.*, 45–46.

4. Affective responses or relationships entail the simultaneous, interpenetrative activation of emotional, mental, and physical faculties, in contrast to those that are primarily and predominantly emotive, cognitive, *or* physiological. A narrower definition of affect isolates the "basic" emotions (anger, fear, joy) that are automatic and innate from those that are more social (love, grief). See Silvan S. Tomkins, *Affect, Imagery, Consciousness*, 3 vols. (New York: Springer, 1962–91). For influential views on affect in contemporary art, see Hal Foster, *The Return of the Real: The Avant-Garde at the End of the Century* (Cambridge, MA: MIT Press, 1996), and Ernst van Alphen, *Caught by History: Holocaust Effects in Contemporary Art, Literature, and Theory* (Stanford: Stanford University Press, 1997). A useful review of recent art from this perspective is Jill Bennett, *Empathic Vision: Affect, Trauma, and Contemporary Art* (Stanford: Stanford University Press, 2005).

5. There is as yet no satisfactory single text on participatory art. Useful beginnings may be found in Claire Doherty, ed., *Contemporary Art: From Studio to Situation* (London: Black Dog, 2004), and Clare Bishop, ed., *Participation* (London: Whitechapel, 2006). Precedents include Suzanne Lacy, ed., *Mapping the Terrain: New Genre Public Art* (Seattle: Bay Press, 1995).

6. See Boris Groys, "Comrades of Time," *e-flux* (journal) 11 (Dec. 2009), online at www.e-flux.com/journal/view/99.

7. On Internet access, see www.internetworldstats.com/stats.htm. On Facebook usage, see www.crunchbase.com/company/facebook.

8. For technical specifications and a detailed analysis, see Jill Bennett, *T_Visionarium: A User's Guide* (Sydney: University of New South Wales Press, 2008). The first iteration, *T_Visionarium*

*I*, was developed in 2003 and shown in Jeffrey Shaw's EVE (Extended Virtual Environment). *T_Visionarium II* is regularly shown in iCinema's AVIE (Advanced Visualisation and Interaction Environment). See also my "Interaktion in dem Zeitgenössischen Kunst" [Interaction in Contemporary Art], in Richard Castelli et al., eds., *Vom Funken zum Pixel: Kunst + Neue Medien* (Berlin: Nicolaische Verlagsbuchhandlung, 2007), 23–31.

9. Pierre Huyghe, "The Third Memory," in Jeffrey Shaw and Peter Weibel, eds., *Future Cinema: The Cinematic Imaginary after Film* (Cambridge, MA: MIT Press for ZKM, Karlsruhe, 2003), 242.

10. "Candice Breitz and Louise Neri: Eternal Returns," in Breitz, *Candice Breitz*, exh. cat. (London: White Cube, and New York: Sonnabend, 2005), 6.

11. *Ibid.*, 19.

12. See Russell Jacoby, *Social Amnesia: A Critique of Contemporary Psychology from Adler to Laing* (Boston: Beacon Press, 1975), 2nd ed., *Social Amnesia: A Critique of Contemporary Psychology* (New Brunswick, NJ: Traction Publishers, 1997).

13. All citations from Jeremy Deller, "The Battle of Orgreave, 2002," in Claire Bishop, *Participation*, 146–47. *The Battle of Orgreave* is also the name of a film of the event, directed by Mike Figgis, and first screened in 2002.

14. Michael Fried, "Art and Objecthood," *Artforum* 5:10 (June 1967); reprinted in Fried, *Art and Objecthood: Essays and Reviews* (Chicago: University of Chicago Press, 1998).

15. See Sarah Pierce and Claire Coombes, eds., *The Present Tense Through the Ages: On the Recent Work of Gerard Byrne* (London: Buchhandlung Walther König, 2007), with excellent essays by Mark Godfrey and Lytle Shaw on this and related works by Byrne.

16. "In Conversation: Alfredo Jaar with Dore Ashton, Phong Bui, and David Levi Strauss," *Brooklyn Rail* (April 2009), 15–19, quotation at 18.

17. Roberta Smith, "One Image of Agony Resonates in Two Lives," *New York Times*, April 19, 2009, 1, 7.

18. Discussion of the politics of poverty and aid in Africa may be found in, for example, James Ferguson, *Global Shadows: Africa in the Neoliberal World Order* (Durham, NC: Duke University Press, 2006).

19. Jaar, *Brooklyn Rail*, 17.

20. Text on the Yes Men website, at theyesmen.org.

21. See theyesmen.org/hijinks, their film *The Yes Men Fix the World* (New York: New Video Group, 2009), and the book of the same title (New York: Disinformation Press, 2009).

22. See Markus Mai and Arthur Remke, *Writing: Urban Calligraphy and Beyond* (Berlin: Gestalten Verlag, 2003), and Jon Naar, *The Birth of Graffiti* (Munich: Prestel, 2007). More specific compilations include Sacha Jenkins and David Villorente, *Piecebook: The Secret Drawings of Graffiti Writers* (New York: Prestel, 2008), and Eleanor Mathieson, ed., *Street Art and the War on Terror* (London: Rebellion Books, 2007).

23. Cited in Banksy, *Banksy: Wall and Piece* (London: Century, 2005), 85, and at www.banksy.co.uk.

24. See www.blublu.org/sito/video/muto.htm.

25. Rafael Lozano-Hemmer and David Hill, eds., *Under Scan* (Nottingham, England: emda & Antimodular, 2007).

26. Matt Adams of Blast Theory, cited in Nick Coleman, "How Tiny Phyllis Took Over My Life," *The Times* (London), May 19–25, 2007, magazine supplement *The Knowledge*, 16–17.

27. For a wider survey of this topic, see my *What Is Contemporary Art?* (Chicago: University of Chicago Press, 2009), ch. 11.

28. Cited in Nancy Spector, *Felix Gonzalez-Torres* (New York: Guggenheim Museum, 1995), 73. Bourriaud offers a sensitive account of the coupling theme in Gonzalez-Torres's art; see his *Relational Aesthetics*, 49–57.

29. On time in 1960s art, see Pamela M. Lee, *Chronophobia: On Time in the Art of the 1960s* (Cambridge, MA: MIT Press, 2004). On Warhol's films, see Peter Gidal, *Andy Warhol: Films and Paintings* (New York: Dutton, 1971, 2nd ed., Da Capo, 1991), and Stephen Koch, *Stargazer: The Life, World, and Films of Andy Warhol* (New York: Boyars, 3rd ed., 1991).

30. Cited in Adrian Heathfield and Tehching Hsieh, *Out of Now: The Lifeworks of Tehching Hsieh* (Cambridge, MA: MIT Press, 2009).

31. "Conversation: Lewis Hyde and Bill Viola," in David A. Ross and Peter Sellars, *Bill Viola*, exh. cat. (New York: Whitney Museum of American Art, 1997), 165.

32. See, for example, Maeve Connolly, *The Place of Artists' Cinema: Space, Site, and Screen* (Chicago: University of Chicago Press, 2009).

33. Holland Cotter, "Oh So Quiet," *New York Times*, Aug. 22, 2008. See also Jean-Christophe Royoux, Marina Warner, and Germaine Greer, *Tacita Dean* (London: Phaidon, 2006).

34. See 1001.net.au.

35. Guy Debord, "Prolegomena to All Future Cinema," *ION Centre de Création* 1 (April 1952). See www.cddc.vt.edu/sionline///si/situ.html.

36. Ross Gibson, 'The Time Will Come When…," in Shaw and Weibel, *Future Cinema*, 570.

## CHAPTER 13

1. Readers interested in the art-critical and art-historical methods that I have been using might wish to consult my *What Is Contemporary Art?* (Chicago: University of Chicago Press, 2009), ch. 13, and my essay "The State of Art History: Contemporary Art," *Art Bulletin* 92:4 (Dec. 2010), 366–83.

2. See the DVD and Jeremy Millar, *Fischl and Weiss: The Way Things Go* (London: Afterall Books, 2007).

3. Richard Flood, *Unmonumental: The Object in the 21st Century* (London: Phaidon for the New Museum of Contemporary Art, 2007).

4. Heather Galbraith and Robert Leonard, eds., *Hany Armanious: Morphic Resonance* (Brisbane: Institute of Modern Art, and Wellington, New Zealand: City Gallery, 2007).

5. Cited in Saskia Bos, "The Netherlands, Disorient," in David Birnbaum, ed., *Making Worlds: La Biennale di Venezia, 53rd International Art Exhibition, vol. 2, Participating Countries* (Venice: Marsilio Editori, 2009), 98.

6. See Fiona Tan, *Fiona Tan: Coming Home*, exh. cat. (Sydney: Sherman Contemporary Art Foundation, 2010).

7. See Part II of this book, and the argument proposed in my *What Is Contemporary Art?*, ch. 10, where the work of Jean-Michel Bruyère is discussed in detail.

8. Nicolas Bourriaud, "Altermodern," in Bourriaud, ed., *Altermodern: Tate Triennial 2009*, exh. cat. (London: Tate, 2009), 12–13. These formulations echo those of Okwui Enwezor, "The Postcolonial Constellation," in Terry Smith, Okwui Enwezor, and Nancy Condee, *Antinomies of Art and Culture: Modernity, Postmodernity, Contemporaneity* (Durham, NC: Duke University Press, 2008), 207–34, and my essays "Contemporary Art and Contemporaneity," *Critical Inquiry* 32: 4 (summer 2006), 681–707, and "Creating Dangerously: Then and Now," in Okwui Enwezor, ed., *The Unhomely: Phantom Scenes in Global Society* (Seville: Bienal Internacional de Arte Contemporáneo de Sevilla, 2006).

9. The artist prohibits images of these works, and the publication of catalogues, records, even invitations to his exhibitions. His intention is that the works should exist only as they are experienced, or as shared reports of them.

10. Cited in Cuauhtémoc Medina, Russell Ferguson, and Jean Fisher, *Francis Alÿs* (London: Phaidon, 2007), 21. He has a cartoon pinned to his wall in which an old man is depicted saying: "Of course, it was a long time ago, but at the time it seemed like the present."

11. Francis Alÿs, "A Thousand Words: Francis Alÿs Talks About *When Faith Moves Mountains*," *Artforum* 40:10 (summer, 2002), 146–47.

12. "Russell Ferguson in Conversation with Francis Alÿs," in Medina, Ferguson, and Fisher, *Francis Alÿs*, 40.

13. Jeremy Rifkin, *The Empathic Civilization: The Race to Global Consciousness of a World in Crisis* (New York: Tarcher/Penguin, 2009).

# SELECT BIBLIOGRAPHY

This bibliography lists publications designed to enable the reader to take the next steps beyond the account offered in this book. Organized on a chapter by chapter basis, it includes source books and general surveys of the main tendencies in late modern and contemporary art, studies of regional, national, and local developments in art throughout the world, as well as key theoretical and critical texts. English translations are noted where possible. Specific references to the work of individual artists discussed in this book are given in the endnotes to each chapter. Many artists have websites; the work of others may be accessed through their gallery representation. A list of key websites follows this bibliography.

## GENERAL, INTRODUCTORY

Michael Archer, *Art since 1960* (New York: Thames & Hudson, 2nd ed., 2002)

H.H. Arnason and Elizabeth C. Mansfield, *History of Modern Art: Painting, Sculpture, Architecture, Photography* (Upper Saddle River, NJ: Prentice Hall, 6th ed., 2009)

Patricia Bickers and Andrew Wilson, *Talking Art: Interviews with Artists since 1976* (London: Art Monthly and Ridinghouse, 2007)

Jonathan Fineberg, *Art since 1940: Strategies of Being* (London: Laurence King; and Upper Saddle River, NJ: Prentice Hall, 3rd ed., 2011)

Hal Foster, Rosalind Krauss, Yve-Alain Bois, and Benjamin H.D Buchloh, *Art since 1900: Modernism, Anti-Modernism, Postmodernism* (London: Thames & Hudson, 2004)

Charles Harrison and Paul Wood, eds., *Art in Theory, 1900–2000: An Anthology of Changing Ideas* (Malden, MA: Blackwell, 2003)

Eleanor Heartney, *Art and Today* (London; New York: Phaidon, 2008)

David Hopkins, *After Modern Art: 1945–2000* (Oxford and New York: Oxford University Press, 2000)

Sam Hunter, John Jacobus, and Daniel Wheeler, *Modern Art: Painting, Sculpture, Architecture* (Upper Saddle River, NJ: Prentice Hall, 3rd ed., 2004)

Zoya Kocur and Simon Leung, eds., *Theory in Contemporary Art since 1985* (Malden, MA: Blackwell, 2005)

Jean-Hubert Martin, *Magiciens de la Terre* (Paris: Centre Pompidou, 1989)

Kobena Mercer, ed., *Cosmopolitan Modernisms* (London: Institute of International Visual Arts, and Cambridge, MA: MIT Press, 2005)

Nicholas Mirzoeff, ed., *The Visual Culture Reader* (London and New York: Routledge, 2nd ed., 2002)

Gillian Perry and Paul Wood, eds., *Themes in Contemporary Art* (New Haven: Yale University Press for the Open University, 2004)

Phaidon editors, *pressPLAY: Contemporary Artists in Conversation* (London: Phaidon, 2005)

Richard J. Powell, *Black Art: A Cultural History* (London: Thames & Hudson, 2nd ed., 2002)

Terry Smith, *What is Contemporary Art?* (Chicago: University of Chicago Press, 2009)

Terry Smith, Okwui Enwezor, and Nancy Condee, eds., *Antinomies of Art and Culture: Modernity, Postmodernity, Contemporaneity* (Durham, NC: Duke University Press, 2008)

Julian Stallabrass, *Contemporary Art: A Very Short Introduction* (Oxford: Oxford University Press, 2006)

Kristine Stiles and Peter Selz, eds., *Theories and Documents of Contemporary Art; A Sourcebook of Artists' Writings* (Berkeley: University of California Press, 2nd ed., 1996)

Brandon Taylor, *Contemporary Art: Art Since 1970* (Upper Saddle River, NJ: Pearson/Prentice Hall, 2005)

## CHAPTER 1

Gregory Battcock, ed., *Minimal Art: A Critical Anthology* (New York: Dutton, 1968)

Benjamin H.D. Buchloh, *Neo-Avantgarde and Culture Industry: Essays on European and American Art from 1955 to 1975* (Cambridge, MA: MIT Press, 2000)

Marta Buskirk, *The Contingent Object of Contemporary Art* (Cambridge, MA: MIT Press, 2005)

Guy Debord, *The Society of the Spectacle* (Paris: Éditions Buchet-Chastel, 1967, Detroit: Black & Red, 1970, and New York: Zone Books, 2nd ed. with preface by Debord, 1995)

Jane Farver, Luis Camnitzer, and Rachel Weiss, eds., *Global Conceptualism: Points of Origin, 1950s–1980s* (New York: Queens Museum of Art, 1999)

Briony Fer, *The Infinite Line: Re-Making Art After Modernism* (New Haven: Yale University Press, 2004)

Michael Fried, *Art and Objecthood: Essays and Reviews* (Chicago: University of Chicago Press, 1998)

Allan Kaprow *Assemblages, Environments, and Happenings* (New York: Abrams, 1965)

Rosalind E. Krauss, *The Originality of the Avant-Garde and Other Modernist Myths* (Cambridge, MA: MIT Press, 1985)

Lucy R. Lippard, *Six Years: The Dematerialization of the Art Object from 1966 to 1972* (New York: Praeger, 1973)

Lucy R. Lippard, *Pop Art* (New York: Praeger, 1966)

James Meyer, ed., *Minimalism* (London and New York: Phaidon, 2005)

Linda Nochlin, *Women, Art, and Power and Other Essays* (New York: Harper & Row, 1988)

Alex Potts, *The Sculptural Imagination: Figurative, Modernist, Minimalist* (New Haven: Yale University Press, 2000)

Hilary Robinson, ed., *Feminism-Art-Theory: An Anthology 1968–2000* (Oxford: Blackwell, 2001)

Paul Schimmel, ed., *Out of Actions: Between Performance and the Object 1949–1979* (New York: Thames & Hudson for the Museum of Contemporary Art, Los Angeles, 1998)

## CHAPTER 2

Stephanie Barron, Sabine Eckmann, eds., *Art of Two Germanys: Cold War Cultures* (New York: Abrams for the Los Angeles Country Museum of Art, 2009)

Hans Belting, *Art History After Modernism* (Chicago: University of Chicago Press, 2003)

Claire Bishop, *Installation Art: A Critical History* (London: Tate, 2005)

Richard Bolton, ed., *The Contest of Meaning: Critical Histories of Photography* (Cambridge, MA: MIT Press, 1989)

Susan Bright, *Art Photography Now* (New York: Aperture, 2005)

Charlotte Cotton, *The Photograph as Contemporary Art* (London and New York: Thames & Hudson, 2009)

Arthur C. Danto, *After the End of Art: Contemporary Art and the Pale of History* (Princeton: Princeton University Press, 1997)

Patricia Ellis and Charles Saatchi, *100: The Work That Changed British Art* (London: Jonathan Cape, 2003)

Lisa E. Farrington, *Creating Their Own Image: The History of African-American Women Artists* (Oxford and New York: Oxford University Press, 2005)

Wolfgang Max Faust and Gerd de Vries, *Hunger Nach Bildern: Deutsche Malerei der Gegenwart* (Cologne: DuMont Buchverlag, 1982)

Hal Foster, *Design and Crime (and Other Diatribes)* (London and New York: Verso, 2003)

Hal Foster, ed., *The Anti-Aesthetic: Essays on Postmodern Culture* (Port Townsend, WA: Bay Press, 1983)

Kenneth Frampton, *Modern Architecture: A Critical History* (London and New York: Thames & Hudson, 4th ed., 2007)

Michael Fried, *Why Photography Matters As Art As Never Before* (New Haven: Yale University Press, 2008)

Eckhart Gillen, ed., *German Art: From Beckmann to Richter: Images of a Divided Country* (Cologne: DuMont Buchverlag, 1997)

Tony Godfrey, *The New Image: Painting in the 1980s* (Oxford: Phaidon, 1986)

David Harvey, *The Condition of Postmodernity: An Enquiry into the Origins of Cultural Change* (Oxford and Cambridge, MA: Blackwell, 1989)

Salah M. Hassan, ed., *Gendered Visions: The Art of Contemporary Africana Women Artists* (Trenton, NJ: Africa World Press, 1997)

Alistair Hicks, *The School of London: The Resurgence of Contemporary Painting* (Oxford: Phaidon, 1989)

Fredric Jameson, "Postmodernism, or, The Cultural Logic of Late Capitalism," *New Left Review* 146 (July–August 1984), 59–92, in Jameson, *Postmodernism, or, The Cultural Logic of Late Capitalism* (Durham, NC: Duke University Press, 1991)

Charles Jencks, *The Language of Post-Modern Architecture* (London: Academy, and New York: Rizzoli, 1977, 6th ed., 1991)

Sarah Kent, *Shark Infested Waters: The Saatchi Collection of British Art in the 90s* (London: Zwemmer, 1994)

Rosalind E. Krauss, *A Voyage on the North Sea: Art in the Age of the Post-Medium Condition* (London and New York: Thames & Hudson, 2000)

Adam Lindemann, *Collecting Contemporary Art* (Cologne and London: Taschen, 2006)

Jean-François Lyotard, *The Postmodern Condition: A Report on Knowledge* (Manchester: Manchester University Press, and Minneapolis: University of Minnesota Press, 1984).

Jean-François Lyotard, "Answering the Question: What is Postmodernism?" in Ihab Hassan and Sally Hassan, eds., *Innovation/Renovation: New Perspectives on the Humanities* (Madison, WI: University of Wisconsin Press, 1983), 329–341

Claudia Mesch, *Modern Art at the Berlin Wall: Demarcating Culture in the Cold War Germanys* (London and New York: Tauris, 2008)

Victoria Newhouse, *Towards a New Museum* (New York: Monacelli Press, 1998)

Achille Bonito Olivia, *Transavantgarde International* (Milan: Giancarlo Politi Editore, 1982)

Craig Owens, *Beyond Recognition: Representation, Power, and Culture* (Berkeley: University of California Press, 1992)

Sharon F. Patton, *African-American Art* (Oxford and New York: Oxford University Press, 1998)

Luigi Prestinenza Puglisi, *New Directions in Contemporary Architecture: Evolutions and Revolutions in Building Design since 1988* (Chichester: John Wiley & Sons, 2008)

Julie H. Reiss, *From Margin to Center: The Spaces of Installation Art* (Cambridge, MA: MIT Press, 1999)

Norman Rosenthal et al., *Sensation: Young British Artists from the Saatchi Collection* (London and New York: Thames & Hudson for the Royal Academy of Arts, 1998)

Terry Smith, *The Architecture of Aftermath* (Chicago: University of Chicago Press, 2006)

Julian Stallabrass, *High Art Lite: British Art in the 1990s* (London and New York: Verso, 1999, 3rd ed. 2006)

Don Thompson, *The $12 Million Dollar Stuffed Shark: The Curious Economics of Contemporary Art* (New York: Palgrave Macmillan, 2008)

Karin Thomas, *Zweimal deutsche Kunst nach 1945* (Cologne: DuMont Buchverlag, 1985)

Brian Wallis, ed., *Art After Modernism: Rethinking Representation* (New York: New Museum of Contemporary Art, and Boston: D.R. Godine, 1984)

John Welchman, *Art After Appropriation: Essays on Art in the 1990s* (Amsterdam: G+B Arts International, 2001)

## CHAPTER 3

Gábor Andrási, Gábor Pataki, György Szücs, and Andras Zwickl, *The History of Hungarian Art in the Twentieth Century* (Budapest: Corvina, 1999)

Ekaterina Andreeva, *Sots Art: Soviet Artists of the 1970s–1980s* (East Roseville, NSW, Australia: Craftsman House, and G+B Arts International, 1995)

James Aulich and Tim Wilcox, eds., *Europe Without Walls: Art, Posters and Revolution 1989–1993* (Manchester: Manchester City Art Galleries, 1993)

Zdenka Badovinac and Igor Zabel, *P.A.R.A.S.I.T.E.: Slovene Art of the Nineties* (Ljubljana, Slovenia: Moderna Galerija, 1995)

Zdenka Badovinac, ed., *Body and the East from the 1960s to the Present* (Cambridge, MA: MIT Press, 1999)

Matthew Baigell and Renee Baigell, *Soviet Dissident Artists: Interviews After Perestroika* (New Brunswick, NJ: Rutgers University Press, 1995)

Ruxandra Balaci and Raluca Velisar, eds., *The National Museum of Contemporary Art* (Bucharest: MNAC, 2004)

Barnabás Bencsik and Suzanne Mészöly, eds., *Polyphony: Social Commentary in Contemporary Hungarian Art* (Budapest: Soros Center for Contemporary Art, 1993)

Timothy O. Benson and Éva Forgács, eds., *Between Worlds: A Sourcebook of Central European Avant-Gardes, 1910–1930* (Cambridge, MA: MIT Press, 2002)

Barbara Borčić, ed., *Videodokument: Video Art in Slovenia, 1969–1998*, 3 vols. (Ljubljana: Open Society Institute and Soros Center for Contemporary Art, 1999)

Wieslaw Borowski, *Galeria Foksal 1966–1988*, exh. cat. (Warsaw: Galeria Foksal SBWA, 1994)

Iaroslava Boubnova and Haralampi G. Oroschakoff, eds., *Bulgaria Avant-Garde* (Cologne: Salon Verlag, 1998)

John E. Bowlt, *Russian Samizdat Art: Essays* (New York: Willis Locker & Owens, 1986)

Andris Breze, *Beyond Control: Critical Transition in the Baltic Republics* (Vancouver: Presentation House Cultural Society, 1991)

Matthew Cullerne Brown, *Contemporary Russian Art* (New York: Philosophical Library, 1989)

*Bulgarian Art: A Powerful, Creative Art that Reflects the Change in the Social and Political Life of Today's Reality* (Varna: PRAM, 1992)

Lenka Bydžovská, Vojtěch Lahoda, and Karel Srp, *Czech Modern Art 1900 1960: The National Gallery in Prague: Modern Art Collection, the Trade Fair Palace* (Prague: The National Gallery in Prague, 1995)

Magda Cârneci, *Art of the 1980s in Eastern Europe: Texts on Postmodernism* (Bucharest: Mediana Collection, 1999)

Roger Conover, Eda Čufer, and Peter Weibel, eds., *In Search of Balkania, A User's Manual* (Graz: Neue Galeries Graz, 2002)

*Contemporary Art in Czechoslovakia: Selections from the Jan and Meda Mladek Collection*, exh. cat. (Ithaca, NY: Herbert F. Johnson Museum of Art, 1988)

Andree Cooke and Susan Copping, *Distant Voices: Contemporary Art from the Czech Republic* (London: South London Gallery, 1994)

David Crowley and Susan E. Reid, eds., *Style and Socialism: Modernity and Material Culture in Post-War Eastern Europe* (Oxford and New York: Berg Publishers, 2000)

Eda Čufer, ed., *Transnacionala: Highway Collisions between East and West at the Crossroads of Art* (Ljubljana, Slovenia: KODA, 1999)

Călin Dan, Nina Czegledy, and YYZ Gallery, *In Sight: Media Art from the Middle of Europe* (Toronto: YYZ Artists' Outlet, 1995)

Marion F. Deshmukh, ed., *Cultures in Conflict: Visual Arts in Eastern Germany since 1990* (Baltimore: American Institute for Contemporary German Studies, John Hopkins University, 1998)

Sonja Abadzieva Dimitrova, *Radiations: Recent Macedonian Fine Art* (Skopje, Macedonia: Museum of Contemporary Art, 1998)

Dubravka Djurić and Misko Šuvaković, *Impossible Histories: Historical Avant-Gardes, Neo-Avant-Gardes, and Post-Avant-Gardes in Yugoslavia, 1918–1991* (Cambridge, MA: MIT Press, 2003)

Norton T. Dodge and Alla Rosenfeld, eds., *Nonconformist Art: The Soviet Experience, 1956–1986* (New York: Thames & Hudson, and New Brunswick, NJ: Jane Voorhees Zimmerli Art Museum, Rutgers University Press, 1995)

Alla Efimova and Lev Manovich, eds., *Tekstura: Russian Essays on Visual Culture* (Chicago: University of Chicago Press, 1993)

Ekaterina Dyogot, *Contemporary Painting in Russia* (East Roseville, NSW, Australia: Craftsman House, 1995)

David Elliott and Bojana Pejić, eds., *After the Wall: Art and Culture in the Post-Communist Europe* (Stockholm: Moderna Museet, 1999)

Aleš Erjavec, *Ljubljana, Ljubljana: The Eighties in Slovene Art and Culture* (Ljubljana, Slovenia: Mladinska Kniga, 1991)

Aleš Erjavec, ed., *Postmodernism and the Postsocialist Condition: Politicized Art under Late Socialism* (Berkeley: University of California Press, 2003)

Vasile Florea, *Romanian Art: Modern and Contemporary Ages* (Bucharest: Meridiane, 1984)

Rimma Gerlovina and Valeriy Gerlovin, *Russian Samizdat Art: 1960–1982* (Chappaqua: Chappaqua Library Gallery, and New York: Franklin Furnace, 1982)

Dan Grigorescu, *Idea and Sensitivity: Trends and Tendencies of Romanian Contemporary Art* (Bucharest: Meridiane, 1991)

Boris Groys, *The Total Art of Stalinism: Avant-Garde, Aesthetic Dictatorship, and Beyond* (Princeton: Princeton University Press, 1992)

Boris Groys, *Total Enlightenment: Conceptual Art in Moscow, 1960–1990* (Ostfildern, Germany: Hatje Cantz, 2008)

Marina Gržinić, *Situated Contemporary Art Practices: Art, Theory, and Activism from East Europe* (Frankfurt: Revolver, 2004)

Lóránd Hegyi, ed., *Aspects/Positions: 50 Years of Art in Central Europe, 1949–1999* (Vienna: Museum Moderner Kunst Stiftung Ludwig, 1999)

Maria Hlavajova and Jill Winder, eds., *Who if Not We Should at Least Try to Imagine the Future of All This?: 7 Episodes on (Ex)changing Europe* (Amsterdam: Artimo, 2004)

Laura Hoptman and László Beke, eds., *Beyond Belief: Contemporary Art from East Central Europe* (Chicago: Museum of Contemporary Art, 1995)

Laura Hoptman and Tomáš Pospiszyl, eds., *Primary Documents: A Sourcebook for Eastern and Central European Art since the 1950s* (New York: Museum of Modern Art, 2002)

Jeremy Howard, *East European Art, 1650–1950* (Oxford: Oxford University Press, 2006)

IRWIN, ed., *East Art Map: Contemporary Art and Eastern Europe* (London: Afterall, 2006)

Marie Judlová, ed., *Focal Points of Revival: Czech Art 1956–1963* (Prague: City Gallery of Prague and Institute for Art History, 1994)

Katalin Keserü, ed., *Crossroads in Central Europe: Ideas, Themes, Methods, and Problems of Contemporary Art and Art Criticism* (Budapest: Association of Hungarian Creative Artists, 1996)

Katalin Keserü, ed., *Variations on Pop Art: Chapters in the History of Hungarian Art between 1950 and 1990* (Budapest: Foundation of Art Today, 1993)

Aurora Király, ed., *Photography in Contemporary Arts. Trends in Romania, After 1989* (Bucharest: Asociația Galeria Nouă, 2006)

S.A. Mansbach, *Modern Art in Eastern Europe: From the Baltic to the Balkans, ca. 1890–1939* (Cambridge: Cambridge University Press, 1999)

Gianfranco Maraniello, *Art in Europe 1990–2000* (Milan: Skira, 2003)

Lidija Merenik and Dejan Sretenović, eds., *Art in Yugoslavia 1992–1995* (Belgrade: Radio B92, 1996)

Suzanne Mészöly, ed., *Modern and Contemporary Hungarian Art: Bulletin,*

*1985–1990* (Budapest: Soros Foundation Fine Arts Documentation Center, 1991)

Suzanne Mészöly, ed., *SVB Voce: Contemporary Hungarian Video Installation* (Budapest: Soros Foundation Fine Arts Documentation Center, 1991)

Boris Mikhaylov, *Unfinished Dissertation* (Zürich: Scalo, 1998)

*Myth and Abstraction: Actual Art from Estonia*, exh. cat. (Karlsruhe: Badischer Kunstverein Karlsruhe, 1992)

Diane Neumaier, *Beyond Memory: Soviet Nonconformist Photography and Photo-Related Works of Art* (New Brunswick, NJ: Rutgers University Press, 2004)

Sonia Petrovski, *Anthology of Macedonian Art 1894–1994* (Skopje, Macedonia: Museum of Contemporary Art, 1994)

Zoran Petrovski, *9 1/2: New Macedonian Art* (Skopje, Macedonia: Museum of Contemporary Art, 1995)

Piotr Piotrowski, *Meanings of Modernism: Towards a History of Polish Art After 1945* (Poznań, Poland: Rebis, 1999)

Donald Pirie, Jekaterina Young, and Christopher Carrell, eds., *Polish Realities: The Arts in Poland 1980–1989* (Glasgow: Third Eye Center, 1990)

Gregor Podnar, *Somewhere Else, Weimar 1999* (Ljubljana, Slovenia: Galerija Škuc, 1999)

Oskar Rabin, *L'artiste et les bulldozers: être peintre en URSS* (Paris: R. Laffont, 1981)

Nasgaard Roald and Clara Horgittay, *Free Worlds: Metaphors and Realities in Contemporary Hungarian Art* (Toronto: Art Gallery of Ontario, 1991)

Alla Rosenfeld and Norton T. Dodge, eds., *Art of the Baltics: The Struggle for Freedom of Artistic Expression under the Soviets, 1945–1990* (New Brunswick, NJ: Rutgers University Press, 2001)

David Ross, ed., *Between Spring and Summer: Soviet Conceptual Art in the Era of Late Communism* (Cambridge, MA: MIT Press, 1990)

Anda Rottenberg, *Art from Poland: 1945–1996* (Warsaw: Galeria Sztuki Współczesnej Zacheta, 1997)

Anda Rottenberg, ed., *Personal Time: Art of Estonia, Latvia, and Lithuania, 1945–1996* (Warsaw: Galeria Sztuki Współczesnej Zacheta, 1996)

Johannes Saar, ed., *Artists of Estonia* (Tallinn: Soros Center for Contemporary Art, 1998)

Valerie Smith and Kathy Rae Huffman, *Deconstruction, Quotation, and Subversion: Video from Yugoslavia (Metaphysical Visions / Middle Europe)* (New York: Artists Space, 1989)

Marta Smolíková, ed., *Orbis Fictus: New Media in Contemporary Arts* (Prague: Soros Center for Contemporary Art, 1996)

Ryszard Stanislawski and Christoph Brockhaus, *Europa, Europa: Das Jahrhundert der Avantgarde in Mittel und Osteuropa*, exh. cat. (Bonn: Kunst- und Ausstellungshalle der Bundesrepublik Deutschland, 1994)

Natalia Tamruchi, *Moscow Conceptualism, 1970–1990* (East Roseville, NSW, Australia: Craftsman House, 1995)

Barbara M. Theimann, *(Non)Conform: Russian and Soviet Art 1958–1995: The Ludwig Collection* (Munich and New York: Prestel, 2007)

Alexandra Titu, *Experiment in Romanian Art since 1960* (Bucharest: Soros Center for Contemporary Art, 1997)

Margarita Tupitsyn, *Margins of Soviet Art: Socialist Realism to the Present* (Milan: Giancarlo Politi Editore, 1989)

Margarita Tupitsyn, *Sots Art* (New York: New Museum of Contemporary Art, 1986)

Barbara Vanderlinden and Elena Filipovic, eds., *The Manifesta Decade: Debates on Contemporary Art Exhibitions and Biennials in Post-Wall Europe* (Cambridge, MA: MIT Press, 2005)

Nebojša Vilic, ed., *Few Candies for Venice: Art in Macedonia at the End of the Millennium* (Skopje, Macedonia: Laurens Coster, 1999)

Igor Zabel, *Aspects of the Minimal: Minimalism in Slovene Art, 1968–1980* (Ljubljana, Slovenia: Moderna Galerija, 1990)

Igor Zabel, *Disclosed Images: The Young Slovene Art of the Seventies and the Eighties* (Ljubljana, Slovenia: Moderna Galerija, 1989)

## CHAPTER 4

Dawn Ades et al., *Art in Latin America, The Modern Era, 1820–1980* (New Haven: Yale University Press, 1989)

Petrine Archer-Straw, *New World Imagery: Contemporary Jamaican Art*, exh. cat. (London: National Touring Exhibitions, 1995)

Jacqueline Barnitz, *Twentieth-Century Art of Latin America* (Austin: University of Texas Press, 2001)

Carlos Basualdo, ed., *Tropicália: A Revolution in Brazilian Culture 1967–1972* (São Paulo: Cosac Naify, 2005)

Holly Block, ed., *Art Cuba: The New Generation* (New York: Abrams, 2001)

Nathalie Bondil, ed., *Cuba: Art and History, From 1868 to Today* (Montreal: Montreal Museum of Fine Arts, 2008)

Luis Camnitzer, *New Art of Cuba* (Austin: University of Texas Press, 1994, 2nd ed. 2003)

Luis Camnitzer, *Conceptualism in Latin American Art: Dialectics of Liberation* (Austin: University of Texas Press, 2007)

Eleanor Ingalls Christensen, *The Art of Haiti* (Philadelphia: Art Alliance Press, 1975)

David Craven, *Art and Revolution in Latin America, 1910–1990* (New Haven: Yale University Press, 2002)

Holliday T. Day and Hollister Sturges, *Art of the Fantastic: Latin America, 1920–1987* (Indianapolis: Indianapolis Museum of Art, 1987)

David Elliott, ed., *Argentina 1920–1994: Art from Argentina* (Oxford: Museum of Modern Art, 1994)

Mary Lou Emery, *Modernism, the Visual, and Caribbean Literature* (Cambridge: Cambridge University Press, 2007)

Patrick Frank, ed., *Readings in Latin American Modern Art* (New Haven: Yale University Press, 2004)

Ilena Fuentes-Peréz, Graciella Cruz-Taura, and Ricardo Pau-Llosa, eds., *Outside Cuba: Contemporary Cuban Visual Artists* (New Brunswick, NJ: Rutgers University, 1988)

Ruben Gallo, *New Tendencies in Mexican Art: The 1990s* (New York: Palgrave Macmillan, 2004)

Andrea Giunta, *Avant-Garde, Internationalism, and Politics: Argentine Art in the Sixties* (Durham, NC: Duke University Press, 2007)

Jorge Glusberg, *Art in Argentina* (Milan: Giancarlo Politi Editore, 1986)

Shifra M. Goldman, *Contemporary Mexican Painting in a Time of Change* (Austin: University of Texas Press, 1981)

Julia P. Herzberg, *Recovering Histories: Aspects of Contemporary Art in since 1982* (New Brunswick, NJ: Rutgers University, 1993)

Carlos Francisco Jackson, *Chicana and Chicano Art: ProtestArte* (Tucson, AZ: University of Arizona Press, 2009)

Ines Katzenstein, ed., *Listen, Here, Now!: Argentine Art of the 1960s; Writings of the Avant-Garde* (New York: Museum of Modern Art, 2004)

Edward Lucie-Smith, *Latin American Art of the 20th Century* (London: Thames & Hudson, 1993)

Gerardo Mosquera, Cylena Simonds, and Mailyn Machado, *States of Exchange: Artists from Cuba* (London: Institute of International Visual Arts, 2008)

Gerardo Mosquera, ed., *Beyond the Fantastic: Contemporary Art Criticism from Latin America* (London: Institute of International Visual Arts, 1995)

Gerardo Mosquera, Carolina Ponce de León, and Rachel Weiss, *Ante América* (Bogotá: Biblioteca Luis-Angel Arango, 1992)

Tumelo Mosaka, ed., *Infinite Island: Contemporary Caribbean Art* (New York: Phillip Wilson for the Brooklyn Museum of Art, 2007)

Victoria Noorthorn, ed., *Beginning with a Bang!: From Confrontation to Intimacy; An Exhibition of Argentine Contemporary Artists 1960–2007*, exh. cat. (Cambridge, MA: Harvard University Press, 2008)

Héctor Olea and Mari Carmen Ramirez, eds., *Versions and Inversions: Perspectives on Avant-Garde Art in Latin America* (New Haven: Yale University Press for the Houston Museum of Fine Arts, 2006)

John P. O'Neill, ed., *Mexico: Splendors of Thirty Centuries* (New York: Metropolitan Museum of Art, 1990)

Veerle Poupeye, *Caribbean Art* (New York: Thames & Hudson, 1997)

Kevin Power, *While Cuba Waits: Art from the Nineties*, exh. cat (Santa Monica: Smart Art Press, 1999)

Mari Carmen Ramirez and Héctor Olea, *Inverted Utopias: Avant-Garde Art in Latin America* (New Haven: Yale University Press, 2004)

Waldo Rasmussen, ed., *Latin American Artists of the Twentieth Century* (New York: Museum of Modern Art, 1993)

Nelly Richard, ed., *Art from Latin America, La Cita Transcultural*, exh. cat. (Sydney: Museum of Contemporary Art, 1993)

Edward J. Sullivan, *Brazil: Body and Soul* (New York: Guggenheim Museum, 2001)

Edward J. Sullivan, *The Language of Objects in the Art of the Americas* (New Haven: Yale University Press, 2007)

Edward J. Sullivan, ed., *Latin American Art in the Twentieth Century* (London: Phaidon, 1996)

Marta Traba, *Art of Latin America, 1900–1980* (Baltimore: John Hopkins University Press for the Inter-American Development Bank, 1994)

Paul Vandenbroeck, ed, *America, Bride of the Sun: 500 Years Latin America and the Low Countries*, exh.cat. (Antwerp: Royal Museum of Fine Arts, 1992)

Rachel Weiss and Gerardo Mosquera, *The Nearest Edge of the World: Art and Cuba Now* (Brookline, MA: Polarities, 1990)

## CHAPTER 5

Claudia Albertini, *Avatars and Anti-Heroes: A Guide to Contemporary Chinese Artists* (Tokyo: Kodansha International, 2008)

Julia F. Andrews and Kuiyi Shen, *A Century in Crisis: Modernity and Tradition in the Art of Twentieth Century China* (New York: Guggenheim Museum, 1998)

Julia F. Andrews, *Painters and Politics in the People's Republic of China, 1949–1979* (Berkeley: University of California Press, 1994)

Thomas Berghuis, *Performance Art in China* (Hong Kong: Timezone 8, 2006)

JoAnne Birnie-Danzker, Kuiyi Shen, and Zheng Shengtian, eds., *Shanghai Modern 1919–1945* (Ostfildern, Germany: Hatje Cantz for the Museum Villa Stuck, Munich, 2004)

Waling Boers, Pi Li, and Brigitte Oetker, eds., *Touching the Stones: China Art Now* (Cologne: Buchhandlung Walther König , 2007)

Chinese Contemporary Art Foundation, ed., *What is Contemporary Chinese Art? The Collection of Essays of the 2009 International Conference on Art Theory and Criticism* (Beijing: Wall Art Museum, 2010)

Melissa Chiu and Zheng Shengtian, eds., *Art and China's Revolution* (New York: Asia Society, 2008)

John Clark, *Asian Modernities: Chinese and Thai Art Compared, 1980 to 1999* (Sydney: Power Publications, 2010)

John Clark, *Modern Asian Art* (Honolulu: University of Hawaii Press, 1998)

John Clark, *Modernities of Chinese Art* (Leiden, the Netherlands: Brill, 2010)

John Clark, Maurizio Peleggi, and T.K. Sabapathy, eds., *Eye of the Beholder: Reception, Audience, and the Practice of Modern Asian Art* (Sydney: Wild Peony Press, 2006)

Ellen P. Conant et al., *Nihonga, Transcending the Past: Japanese-Style Painting, 1868–1968* (New York: Weatherhill, 1995)

Daniell Cornell and Mark Dean Johnson, eds., *Asian / American / Modern Art: Shifting Currents, 1900–1970* (Berkeley: University of California Press, 2008)

Amanda Cruz et al., *Takashi Murakami: The Meaning of the Nonsense of the Meaning* (New York: Abrams, 1999)

Arif Dirlik and Xudong Zhang, eds., *Postmodernism and China* (Durham, NC: Duke University Press, 2000)

Bernhard Fibicher and Matthias Frehner, *Mahjong: Contemporary Chinese Art from the Sigg Collection* (Ostfildern, Germany: Hatje Cantz, 2005)

Fine Arts Collection, State Council of the People's Republic of China, *Peasant Paintings from Huhsien County* (Beijing: Foreign Languages Press, 1976)

Maria Galikowski, *Art and Politics in China 1949–1984* (Hong Kong: Chinese University Press, 1998)

Gao Minglu, *The Wall: Reshaping Contemporary Chinese Art* (Buffalo and Beijing: Albright Knox Art Gallery and China Millennium Museum of Art, 2005)

Gao Minglu, ed., *Inside Out: New Chinese Art* (Berkeley: University of California Press, 1999)

Mark Edwards Harris, *Inside North Korea* (San Francisco: Chronicle Books, 2007)

Cees Hendrikse, ed., *Writing on the Wall: Chinese New Realism and Avant-garde in the Eighties and Nineties* (Rotterdam: NAI, 2008)

Binghui Huangfu, ed., *Text and Subtext: Contemporary Art and Asian Women* (Singapore: Earl Lu Gallery, 2000)

Nicholas Jose and Yang Wen-I, *Art Taiwan: The Contemporary Art of Taiwan* (Sydney: Gordon and Breach, 1995)

Kataoka Mami et al., eds., *Roppongi Crossing: New Visions in Contemporary Japanese Art 2004* (Tokyo: Mori Art Museum, 2004)

Sheldon H. Lu, *China, Transnational Visuality, Global Postmodernity* (Stanford: Stanford University Press, 2001)

Mao Zedong, *Mao Tse-tung on Literature and Art* (Beijing: Foreign Languages Press, 1967)

Charles Merewether and Rika Iezumi Hiro, eds., *Art, Anti-Art, Non-Art: Experimentations in the Public Sphere in Postwar Japan 1950–1970* (Los Angeles: Getty Research Institute, 2007)

Alexandra Munroe, *Japanese Art After 1945: Scream Against the Sky* (New York: Abrams, 1994)

Takashi Murakami, ed., *Little Boy: The Arts of Japan's Exploding Subculture*, exh. cat. (New York: Japan Society, 2005)

Takashi Murakami, ed., *Super Flat* (Tokyo: Madora Shuppan, 2000)

Museum Moderner Kunst Stiftung Ludwig Wien, *China: Facing Reality* (Nurnberg: Verlag fur Moderne Kunst, 2007)

Jochen Noth, Wolfger Pohlmann, Kai Reschke, eds., *China Avant-Garde: Counter-Currents in Art and Culture* (Hong Kong: Oxford University Press, 1994)

Michel Nuridsany, *China Art Now* (Paris: Flammarion, 2004)

Pan Gongkai, ed., *Reflections: Chinese Modernities as Self-Conscious Cultural Ventures* (Hong Kong: Oxford University Press, 2007)

Jane Portal, *Art Under Control in North Korea* (London: Reaktion Books, 2005)

Apinan Poshyananda et al., *Contemporary Art in Asia: Traditions, Tensions* (New York: Abrams for the Asia Society Galleries, 1996)

Irmtraud Schaarschmidt-Richter, ed., *Japanese Modern Art: Painting from 1910 to 1970* (Zurich, New York: Edition Stemmle for the Japan Foundation, 1999)

Hugh Shaw, ed., *Peasant Paintings from Hu County, Shensi Province, China*, exh. cat. (London: Arts Council of Great Britain, 1977)

Michael Sullivan, *Art and Artists of Twentieth Century China* (Berkeley:

University of California Press, 1996)

Caroline Turner, ed., *Art and Social Change, Contemporary Art in Asia and the Pacific* (Canberra: Pandanus Books, Research School of Pacific and Asian studies, Australian National University, 2004)

Mark Wilson et al., *New World Order: Contemporary Installation Art and Photography from China* (Rotterdam: NAI, 2008)

Wu Hung, *Transience: Chinese Experimental Art at the End of the Twentieth Century* (Chicago: Smart Museum of Art, 1999)

Wu Hung and Christopher Phillips, *Between Past and Future: New Photography and Video from China* (Chicago: Smart Museum of Art, 2004)

Wu Hung with Wang Huangsheng and Feng Boyi, *Reinterpretation: A Decade of Experimental Chinese Art 1990–2000* (Guangzhou: Guangdong Museum of Art, 2002)

Wu Hung and Penny Wang, eds., *Contemporary Chinese Art: Primary Documents* (New York: Museum of Modern Art, 2010)

Yumi Yamaguchi, *Warriors of Art: A Guide to Contemporary Japanese Artists* (Tokyo and New York: Kodansha International, 2007)

Alice Yang, *Why Asia? Contemporary Asian and Asian American Art* (New York: New York University Press, 1998)

## CHAPTER 6

Wayne Baerwaldt, ed., *Memories of Overdevelopment: Philippine Diaspora in Contemporary Art* (Irvine, CA: University of California at Irvine Gallery, 1997)

John Clark, *Asian Modernities: Chinese and Thai Art Compared, 1980 to 1999* (Sydney: Power Publications, 2010)

John Clark, *Modern Asian Art* (Honolulu: University of Hawaii Press, 1998)

Ifitkhar Dadi, *Modernism and the Art of Muslim South Asia* (Chapel Hill, NC: University of North Carolina Press, 2010)

Yashodhara Dalmia, *The Making of Modern Indian Art: The Progressives* (New Delhi and New York: Oxford University Press, 2001)

Yashodhara Dalmia, ed., *Contemporary Indian Art: Other Realities* (Mumbai: Marg, 2002)

Yashodhara Dalmia et al., *Indian Contemporary Art: Post Independence* (New Delhi: Vedehra Art Gallery, 1997)

Vidya Dehejia, *Indian Art* (London: Phaidon, 1997)

Manuel D. Duldulao, *Contemporary Philippine Art: From the Fifties to the Seventies* (Manila: Vera-Reyes, 1972)

Joseph Fischer, ed., *Modern Indonesian Art: Three Generations of Tradition and Change, 1945–1990* (Jakarta and New York: Panitia Pameram KIAS and Festival of Indonesia, 1990)

Fondazione Sandretto Re Rebaudengo, *Subcontingent: The Indian Subcontinent in Contemporary Art*, exh. cat. (Milan: Electa, 2006), curated by Ilaria Bonacossa and Francesco Manacorda

Furuichi Yasuko, Nakamoto Kazumi, et al., *Asian Modernism: Diverse Development in Indonesia, the Philippines and Thailand*, exh. cat. (Tokyo: Japan Foundation Asia Center, 1995)

Alice G. Guillermo, *Protest/Revolutionary Art in the Philippines 1970–1990* (Quezon City: University of the Philippines Press, 2001)

Purita Kalaw-Ledesma and Amadis Ma. Guerrero, *The Struggle for Philippine Art* (Manila: Purita Kalaw-Ledesma, 1974)

Geeta Kapur, *When Was Modernism: Essays on Contemporary Cultural Practice in India* (New Delhi: Tulika, 2000)

Akiko Miki, Nanjo Fumio, and Karlheinz Essl, *Chalo! India: A New Era of Indian Art*, exh. cat. (Munich: Prestel for the Essl Museum, Vienna, 2009)

Partha Mitter, *Indian Art* (Oxford: Oxford University Press, 2001)

Partha Mitter, *The Triumph of Modernism: Indian Artists and the Avant-Garde, 1922–1947* (London: Reaktion Books, 2007)

Akbar Naqvi, *Image and Identity: Fifty Years of Painting and Sculpture in Pakistan* (New York: Oxford University Press, 1998)

Shivaji K. Panikkar et al., eds., *Towards a New Art History: Studies in Indian Art* (New Delhi: D.K. Printworld, 2003)

Steven Pettifor, *Flavours: Thai Contemporary Art* (Bangkok: Thavibu Gallery, 2003)

Christopher Pinney, *"Photos of the Gods": The Printed Image and Political Struggle in India* (London: Reaktion Books, 2004)

Apinan Poshyananda, *Modern Art in Thailand: Nineteenth and Twentieth Centuries* (Singapore and New York: Oxford University Press, 1992)

Amanda Katherine Rath, *Taboo and Transgression in Contemporary Indonesian Art*, exh. cat. (Ithaca, NY: Herbert F. Johnson Museum of Art, 2005)

Chaitanya Sambrani, *Edge of Desire: Recent Art in India* (London: Phillip Wilson, 2005)

Gayatri Sinha, *Indian Art: An Overview* (New Delhi: Rupa., 2003)

Helena Spanjaard, *Exploring Modern Indonesian Art: The Collection of Dr Oei Hong Djien* (Singapore: SNP, 2004)

Jim Supangkat, *Indonesian Modern Art and Beyond* (Jakarta: The Indonesian Fine Arts Foundation, 1997)

Jim Supangkat et al., *Outlet: Yogyakarta within the Contemporary Indonesian Art Scene* (Yogyakarta: Yayasan Seni Cemeti, 2001)

Caroline Turner, ed., *Art and Social Change, Contemporary Art in Asia and the Pacific* (Canberra: Pandanus Books, Research School of Pacific and Asian Studies, Australian National University, 2004)

Astri Wright, *Soul, Spirit and Mountain: Preoccupations of Contemporary Indonesian Painters* (Kuala Lumpur and New York: Oxford University Press, 1994)

## CHAPTER 7

Christopher Allen, *Art in Australia: From Colonization to Postmodernism* (London: Thames & Hudson, 1997)

Anne D'Avella, *Art of the Pacific* (London: George Weidenfeld and Nicolson, 1998)

Mary Barr, ed., *Headlands: Thinking Through New Zealand Art*, exh. cat. (Sydney: Museum of Contemporary Art, 1992)

Rex Butler, ed., *Radical Revisionism: An Anthology of Writings on Australian Art* (Brisbane: Institute of Modern Art, 2005)

Wally Caruana, *Aboriginal Art* (London: Thames & Hudson, 2nd ed., 2003)

Susan Cochrane, *Contemporary Art in Papua New Guinea* (East Roseville, NSW, Australia: Craftsman House, 1997)

Fiona Foley, ed., *The Art of Politics, The Politics of Art: The Place of Indigenous Contemporary Art* (Southport, QLD, Australia: Keeaira Press, 2006)

Charles Green, "Australian Contemporary Art, 1995–2010," *Oxford Art Online* at www.oxfordartonline.com, posted Nov. 9, 2009

Charles Green, *Peripheral Vision: Contemporary Australian Art 1970–1994* (East Roseville, NSW, Australia: Craftsman House, 1995)

Hamish Keith, *The Big Picture: A History of New Zealand Art from 1642* (Auckland: Godwit, 2007)

Ian McLean, *How Aborigines Invented the Idea of Contemporary Art: An Anthology of Writing on Aboriginal Art 1980–2006* (Sydney: Power Publications, 2009)

Sidney Moko Mead, ed., *Te Maori: Maori Art from New Zealand Collections* (New York: Abrams, 1984)

Howard Morphy, *Aboriginal Art* (London: Phaidon, 1998)

Francis Pound, *The Invention of New Zealand: Art and National Identity 1930–70* (Auckland: Auckland University Press, 2010)

Andrew Sayers, *Australian Art* (Oxford: Oxford University Press, 2001)

Bernard Smith with Terry Smith and Christopher Heathcote, *Australian Painting, 1788–2000* (South Melbourne: Oxford University Press, 2001)

Terry Smith, *Transformations in Australian Art, vol. 1: The Nineteenth Century: Landscape, Colony and Nation; vol. 2: The Twentieth Century: Modernism and Aboriginality* (Sydney: Craftsman House, 2002)

Nicholas Thomas, *Oceanic Art* (New York: Thames & Hudson, 1995)

Caroline Turner, ed., *Art and Social Change, Contemporary Art in Asia and the Pacific* (Canberra: Pandanus Books, Research School of Pacific and Asian Studies, Australian National University, 2004)

Ian Wedde and Gregory Burke, eds., *Now See Hear! Art, Language, and Translation* (Wellington, New Zealand: Victoria University Press, 1990)

## CHAPTER 8

Emma Bedford, ed., *A Decade of Democracy: South African Art 1994–2004* (Cape Town: Double Storey Books, 2004)

Ulli Beier, *Contemporary Art in Africa* (New York: Praeger, 1968)

Esmé Berman, *Painting in South Africa* (Johannesburg: Southern Book Publishers, 1993)

Clémentine Deliss, ed., *Seven Stories About Modern Art in Africa* (Paris: Flammarion, 1995)

Okwui Enwezor and Chika Okeke-Agulu, *Contemporary African Art since 1980* (Bologna: Damiani, 2009)

Okwui Enwezor and Olu Oguibe, eds., *Reading the Contemporary: African Art from Theory to Marketplace* (London: Institute for International Visual Arts, 1999)

Okwui Enwezor, ed., *The Short Century: Independence and Liberation Movements in Africa, 1945–1994* (Munich: Prestel, 2001)

N'Goné Fall and Jean Loup Pivin, *An Anthology of African Art: The Twentieth Century* (New York: Distributed Art Publishers, 2002)

Shannon Fitzgerald, Tumelo Mosaka, et al., *A Fiction of Authenticity: Contemporary Africa Abroad*, exh. cat. (St. Louis: Contemporary Art Museum of St. Louis, 2003)

Jack Flam with Miriam Deutch, eds., *Primitivism and Twentieth Century Art: A Documentary History* (Berkeley: University of California Press, 2003)

Sidney Littlefield Kasfir, *Contemporary African Art* (London: Thames & Hudson, 2000)

Yukiya Kawaguchi et al., eds., *An Inside Story: African Art of our Time*, exh. cat. (Tokyo: Japan Association of Art Museums, 1995)

Jean Kennedy, *New Currents, Ancient Rivers: Contemporary African Artists in a Generation of Change* (Washington, DC: Smithsonian Institution Press, 1992)

André Magnin et al., *African Art Now: Masterpieces from the Jean Pigozzi Collection* (London: Merrell in association with the Museum of Fine Arts, Houston, 2005)

André Magnin with Jacques Soulillou, *Contemporary Art of Africa* (London: Thames & Hudson, 1996)

Simon Njami, ed., *Africa Remix: Contemporary Art of a Continent* (Ostfildern, Germany: Hatje Cantz, and London: Hayward Gallery, 2005)

John Peffer, *Art and the End of Apartheid* (Minneapolis: University of Minnesota Press, 2009)

Sophie Perryer, ed., *10 Years 100 Artists, Art in a Democratic South Africa* (Cape Town: Bell-Roberts and Struik Publishers, 2004)

Christopher Spring, *Angaza Afrika: African Art Now* (London: Laurence King, 2008)

Gilane Tawadros, *Fault Lines: Contemporary African Art and Shifting Landscapes* (London: Institute for International Visual Arts with the Forum for African Art and the Prince Klaus Fund, 2003)

Susan Vogel, ed., *Africa Explores: 20th Century African Art* (New York: Center for African Art, 1991)

Sue Williamson, Ashraf Jamal, *Art in South Africa: The Future Present* (Cape Town: David Philip, 1996)

Gavin Younge, *Art of the South African Townships* (London: Thames & Hudson, 1988)

## CHAPTER 9

Wijdan Ali, *Modern Islamic Art: Development and Continuity* (Gainesville, FL: University Press of Florida, 1997)

Wijdan Ali, ed., *Contemporary Art from the Islamic World* (London: Scorpion, 1989)

Hossein Amirsadeghi, ed., *Different Sames: New Perspectives in Contemporary Iranian Art* (London: Thames & Hudson, 2009)

Hossein Amirsadeghi, ed., *Unleashed: Contemporary Art from Turkey* (London: Thames & Hudson, 2010)

Hossein Amirsadeghi, Salwa Mikdadi, Nada M. Shabout, eds., *New Vision: Arab Contemporary Art in the 21st Century* (London: Thames & Hudson, 2009)

Gannit Ankori, *Palestinian Art* (London: Reaktion Books, 2006)

David A. Bailey and Gilane Tawadros, eds., *Veil: Veiling, Representation, and Contemporary Art* (Cambridge, MA: MIT Press, 2003)

Shiva Balaghi and Lynn Gumpert, *Picturing Iran: Art, Society and Revolution* (London: I.B. Taurus, 2002)

Kamal Boullata, "Art," in Philip Mattar, ed., *The Encyclopedia of the Palestinians* (New York: Facts on File, 2000), 69–73, online at virtualgallery.birzeit.edu/media/artical?item=11151

Kamal Boullata, *Istihdar al-Makan, Dirasah fi al-Fann al-Tashkili al-Filastini al-Mu'asir* (Tunis: Al-Munzammah al-'Arabiyyah lil-Tarbiyyah wa al-Thaqafah, wa al-'Ulum, 2000), being translated as *Conjuring Up Space: A Study of Contemporary Palestinian Art*

Fereshten Daftari, ed., *Without Boundary: Seventeen Ways of Looking* (New York: Museum of Modern Art, 2006)

Sharbal Daghir, *Al-Hurufiyah al-Arabiyah: Fann wa Hawiyah* [Arab Letterism: Art and Identity] (Beirut: Sharikat al-Matbu 'at Lil Tawzi 'wa al-Nashir, 1990)

Saeb Eigner, *Art of the Middle East: Modern and Contemporary Art of the Arab World and Iran* (London: Merrell, 2010)

Maysaloun Faraj, ed., *Strokes of Genius, Contemporary Iraqi Art*, exh. cat. (London: Saqi Books, 2001)

Oleg Grabar, *Constructing the Study of Islamic Art, vol. 3: Islamic Art and Beyond* (Aldershot: Ashgate, 2006)

Brion Gysin et al., *Croisement de Signes* (Paris: Institut du Monde Arabe, 1989)

Samia A. Halaby, *Liberation Art of Palestine: Palestinian Painting and Sculpture in the Second Half of the 20th Century* (New York: HTTB, 2001)

Isabel Herda, Nicoletta Torcelli, *iran.com: Iranian Art Today* (Freiburg: Modo, 2006)

Rose Issa, Ruyin Pakbaz, and Daryush Shayegan, *Iranian Contemporary Art* (London: Booth-Clibborn Editions, 2001)

Bernard Lewis, *Islam and the West* (New York: Oxford University Press, 1993)

Fran Lloyd, ed., *Contemporary Arab Women's Art: Dialogues of the Present* (London: I.B. Taurus, 1999)

Amitai Mendelsohn, *Real Time: Art in Israel, 1998–2008* (Jerusalem: Israel Museum, 2008), online at www.imj.org.il/exhibitions/2008/realtime/Mendelsohn_e.html

Elias Newman, *Art in Palestine* (New York: Siebel Company, 1939)

Venetia Porter, *Word into Art: Artists of the Modern Middle East* (London: British Museum Press, 2006)

Edward Said, *Orientalism* (New York: Vintage Books, 1979)

Nada M. Shabout, *Modern Arab Art: Formation of Arab Aesthetics* (Gainesville, FL: University Press of Florida, 2007)

Paul Sloman, *Contemporary Art in the Middle East* (London: Black Dog, 2009)

Susan Tumarkin Goodman, ed., *Artists of Israel, 1920–1980*, exh. cat. (Detroit: Wayne State University for the Jewish Museum, New York, 1981)

Susan Tumarkin Goodman, ed., *Dateline Israel: New Photography and Video Art* (New Haven: Yale University Press and the Jewish Museum, New York, 2007)

## CHAPTER 10

Matthew Beaumont, Andrew Hemingway, Esther Leslie, and John Roberts, eds., *As Radical As Reality Itself: Essays on Marxism and Art for the 21st Century* (Bern: Peter Lang, 2007)

Carol Becker, *The Subversive Imagination: Artists, Society, and Social Responsibility* (New York: Routledge, 1994)

Charlotte Bydler, *The Global Artworld Inc.: On the Globalization of Contemporary Art* (Uppsala, Sweden: Uppsala University, 2004)

Elena Filipovoc, Marieke van Hal, and Solveig Øvestebø, *The Biennial Reader: An Anthology on Large-Scale Perennial Exhibitions of Contemporary Art* (Ostfildern, Germany: Hatje Cantz for Bergen Kunsthalle, 2010)

Jean Fisher, ed., *Global Visions: Towards a New Internationalism in the Visual Arts* (London: Kala Press in association with the Institute of International Visual Arts, 1994)

Jack Hirschman, ed., *Art on the Line: Essays by Artists about the Point where their Art and Activism Intersect* (Willimantic, CT: Curbstone Press, 2002)

bell hooks (Gloria Jean Watkins), *Art on my Mind: Visual Politics* (New York: New Press, 1995)

Grant H. Kester, *Art, Activism and Oppositionality: Essays from Afterimage* (Durham, NC: Duke University Press, 1998)

Suzanne Lacy, ed., *Mapping the Terrain: New Genre Public Art* (Seattle: Bay Press, 1995)

Marsha Meskimmon, *Contemporary Art and the Cosmopolitan Imagination* (Oxford: Routledge, 2011)

Irit Rogoff, *Terra Infirma: Geography's Visual Culture* (London and New York: Routledge, 2000)

Gregory Sholette and Blake Stimson, eds., *Collectivism After Modernism: The Art of Social Imagination after 1945* (Minneapolis: University of Minnesota Press, 2006)

Gregory Sholette and Nato Thompson, eds., *The Interventionists: Users' Manual for the Creative Disruption of Everyday Life* (Cambridge, MA: MIT Press, 2004)

Gilane Tawadros, ed., *Changing States: Contemporary Art and Ideas in an Era of Globalisation* (London: Institute for International Visual Arts, 2004)

## CHAPTER 11

Max Andrews, ed., *Land, Art: A Cultural Ecology Handbook* (London: Royal Society for the Encouragement of Arts, Manufactures and Commerce, 2006)

Ilaria Bonacossa, ed., *Greenwashing. Environment: Perils, Promises and Perplexities*, exh. cat. (Milan: Fondazione Sandretto Re Rebaudengo, 2008)

Stephanie Hanor, Lucía Sanromán, and Lucinda Barnes, eds., *Human/Nature: Artists Respond to a Changing Planet*, exh. cat. (Berkeley: Berkeley Art Museum, 2008)

Sabine Himmelsbach and Yvonne Volkart, eds., *Ökomedien/Ecomedia: Ecological Strategies in Today's Art* (Ostfildern, Germany: Hatje Cantz, 2007)

Jeffrey Kastner, ed., *Land and Environmental Art* (London: Phaidon, 1998)

Gyorgy Kepes, ed., *Arts of the Environment* (New York: Braziller, 1972)

Grant H. Kester and Patrick Deegan, *Groundworks: Environmental Collaboration in Contemporary Art*, exh. cat. (Pittsburgh: Carnegie Mellon University, 2005)

Miwon Kwon, *One Place After Another: Site-Specific Art and Locational Identity* (Cambridge, MA: MIT Press, 2004)

Pamela M. Lee, *Chronophobia: On Time in the Art of the 1960s* (Cambridge, MA: MIT Press, 2004)

Lucy R. Lippard, *Overlay: Contemporary Art and The Art of Prehistory* (New York: Pantheon, 1983)

Lucy R. Lippard, *The Lure of the Local: Sense of Place in a Multicentered Society* (New York: New Press, 1997)

Francesco Manacorda, ed., *Radical Nature: Art and Architecture for a Changing Planet 1969–2009* (Cologne: Buchhandlung Walther König for Barbican Art Gallery, London, 2009)

Barbara C. Matilsky, *Fragile Ecologies: Contemporary Artists' Interpretations and Solutions* (New York: Rizzoli, 1992)

Stephanie Smith and Victor Margolin, ed., *Beyond Green: Toward a Sustainable Art* (Chicago: University of Chicago Press for the Smart Museum of Art, 2005)

Heike Strelow, Herman Prigann, and Vera David, eds., *Ecological Aesthetics: Art in Environmental Design: Theory and Practice* (Basel: Birkhäuser Verlag für Arkitektur, 2004)

Erika Suderburg, ed., *Space, Site, Intervention: Situating Installation Art* (Minneapolis: University of Minnesota Press, 2000)

Nato Thompson and Gregory Sholette, eds., *The Interventionists: Users' Manual for the Creative Disruption of Everyday Life* (Cambridge, MA: MIT Press, 2004)

Nato Thompson et al., *Experimental Geography: Approaches to Landscape, Cartography, and Urbanism* (Brooklyn: Melville House, 2009)

Ben Tufnell, *Land Art* (London: Tate, 2006)

## CHAPTER 12

Ernst van Alphen, *Caught by History: Holocaust Effects in Contemporary Art, Literature, and Theory* (Stanford: Stanford University Press, 1997)

Jill Bennett, *Empathic Vision: Affect, Trauma, and Contemporary Art* (Stanford: Stanford University Press, 2005)

Claire Bishop, ed., *Participation* (London: Whitechapel, 2006)

Nicolas Bourriaud, *Relational Aesthetics* (Dijon: Les Presses du Réel, 1998, English trans., 2002)

Claire Doherty, ed., *Contemporary Art: From Studio to Situation* (London: Black Dog, 2004)

Hal Foster, *The Return of the Real: The Avant-Garde at the End of the Century* (Cambridge, MA: MIT Press, 1996)

Grant H. Kester, *Conversation Pieces: Community and Communication in Modern Art* (Berkeley: University of California Press, 2004)

Seth Price, "Dispersion," an online essay continually revised since 2002, at www.distributedhistory.com/Dispersion2008.pdf

Edward A. Shanken, *Art and Electronic Media* (London: Phaidon, 2009)

Jeffrey Shaw and Peter Weibel, eds., *Future Cinema: The Cinematic Imaginary After Film* (Cambridge, MA: MIT Press for ZKM, Karlsruhe, 2003)

Silvan S. Tomkins, *Affect, Imagery, Consciousness*, 3 vols. (New York: Springer, 1962–1991)

## CHAPTER 13

Hans Belting and Andrea Buddensieg, eds., *The Global Art World: Audiences, Markets, and Museums* (Ostfildern, Germany: Hatje Cantz, 2007)

Nicolas Bourriaud, ed., *Altermodern: Tate Triennial 2009*, exh. cat. (London: Tate, 2009)

Richard Flood, *Unmonumental: The Object in the 21st Century* (London: Phaidon for the New Museum of Contemporary Art, 2007)

Boris Groys, *Art Power* (Cambridge, MA: MIT Press, 2008)

Jacques Rancière, *The Politics of Aesthetics: The Distribution of the Sensible* (London: Continuum, 2004)

Terry Smith, Okwui Enwezor, and Nancy Condee, eds., *Antinomies of Art and Culture: Modernity, Postmodernity, Contemporaneity* (Durham, NC: Duke University Press, 2008)

# SELECTED CONTEMPORARY ART WEBSITES

This directory is designed to enable readers to call up further images and information to augment those provided by this book, and to undertake further study and research in the contemporary art of the world. It begins with a sampling of sites that take global perspectives, then offers some leads to interesting blogs, to important organizations, and to new media sites. Online journals are also major sources of information, and are key connective nodes: some general ones are cited, after which they are organized regionally, according to the chapter by chapter framework of this book. There follows a selection of sites of important mega-exhibitions, biennials, and triennials, and finally some key sites relating to the art market.

## GENERAL, INTRODUCTORY

*Art In Context*
www.artincontext.org
Directory of artists offering images, exhibitions, information, and international museum links

*art21*
beta.art21.org
The website of the fine television and book series

*Artnews.org*
www.artnews.org
Open registration site for information on contemporary art

*College Art Association*
www.caareviews.org
Reviews of books and exhibitions across art history, including contemporary

*Database of Virtual Art*
www.virtualart.at
Documents the rapidly evolving field of digital installation art

*East of Borneo*
www.eastofborneo.org
A non-profit website and imprint of books published by the School of Art at the California Institute of the Arts, devoted to Los Angeles art and culture

*Electronic Arts Intermix*
www.eai.org
Website for artists working in new media

*Fine Art Sites*
www.fineartsites.org/contemporary.php
Directory of arts and artists' sites

*International Contemporary Art Network Association*
www.c3.hu
After 1999 the Soros Contemporary Art Centers combined into this organization

*Modern Art Notes*
blogs.artinfo.com/modernartnotes
An example of the many blogs out there; this one is by Tyler Green

*Rhizome*
rhizome.org
Supporting the creation, presentation, and preservation of contemporary art that uses new technologies in significant ways

*Saatchi Online*
www.saatchionline.com
The world's interactive art gallery, with links to open-site postings of images of works, information about the international art scene, interviews with artists, an online market, etc.

*Society of Contemporary Art Historians*
scahweb.org

*Triple Canopy*
canopycanopycanopy.com
Online site for texts on art, art projects, and artists' statements

*Universes in Universe*
universes-in-universe.org
Visual arts from Africa, Asia, the Americas in the international art context

*Zeroland*
www.zeroland.co.nz/art_blogs.html
A directory of contemporary art blogs

## REGIONAL

*Archivos Virtuales*
www.aaa.si.edu/guides/site-archivos
Online access to the archive of the papers of Latino and Latin American artists at the Smithsonian Institution

*ArtAfrica*
www.artafrica.info
Website for the promotion of contemporary plastic artists from Portuguese-speaking African countries

*arthub*
arthubasia.org
A non-profit, multidisciplinary organization supporting contemporary art creation in China and the rest of Asia

*Asia Art Archive*
www.aaa.org.hk
A non-profit research center in Hong Kong dedicated to documenting contemporary visual art from Asia within an international context

*Central and Eastern Europe's Cultural Institutions*
www.cee-culture.info
A networking project initiated in 2000 by Kulturkontakt, Austria

*Centre for Contemporary Art, Lagos*
www.ccalagos.org
Independent, non-profit visual art organization dedicated to providing a platform for the development, presentation, and discussion of contemporary African visual art and culture

*Chinese Art*
www.Chinese-art.com
Commercial site for traditional and contemporary Chinese art

*Contemporary Art Centre*
www.cac.lt/en
The largest contemporary art center in the Baltic States

*Creative Time*
www.creativetime.org
New York-based innovative art-commissioning and public debate organization

*Dictionary of Australian Artists Online*
www.daao.org.au
Comprehensive historical and contemporary biography site

*East Art Map*
www.eastartmap.org
Group IRWIN's ongoing project to promote the art history of the region

*Information on Contemporary Art Network*
www.c3.hu/ican.artnet.org/ican
"The ultimate source on East and Central European Art"

*South African Resistance Art*
library.thinkquest.org/18799
Online resource covering resistance art

*Transitland*
www.transitland.eu
Video art from Central and Eastern Europe 1989–2009

## JOURNALS/ PUBLICATIONS

*Arts Online: A Portal*
www.zeroland.co.nz
Directory of art magazines and journals

*The Exhibitionist*
www.the-exhibitionist-journal.com
By curators, for curators; theory, practice, and history of curatorship

## EUROAMERICA

*A Prior*
www.aprior.org

*Afterall*
www.afterall.org/journal

*Art Aujourdhui*
www.artaujourdhui.info

*art, Das Kunstmagazin*
www.art-magazin.de

*Art in America*
www.artinamericamagazine.com

*Art Journal*
www.collegeart.org/artjournal

*Art Monthly*
www.artmonthly.co.uk

*ArtReview:*
www.artreview.com

*Artbitare*
www.abitare.it

*Artforum*
www.artforum.com

*Art-in-Berlin*
www.art-in-berlin.de

ARTnews
www.artnews.com

artpress
www.artpress.com

artUS
www.artext.org

Critical Inquiry
criticalinquiry.uchicago.edu

Critical Secret
www.criticalsecret.com

e-flux
www.e-flux.com/journal

Flash Art
www.flashartonline.com

Frieze
www.frieze.com

Fuse
www.fusemagazine.org

Journal of Contemporary Art
www.jca-online.com

Kaleidoscope
www.thekaleidoscope.eu

Leonardo
www.leonardo.info/leoinfo.html
International Society for the Arts,
Science and Technology

Modern Painters
www.modernpainters.co.uk

n.paradoxa
web.ukonline.co.uk/n.paradoxa
International feminist art journal

NU: The Nordic Art Review
www.nordicartreview.nu

October
www.mitpressjournals.org/loi/octo

Parkett
www.parkettart.com

Studio International
www.studio-international.co.uk

Tate Etc.
www.tate.org.uk/tateetc

Tate Papers
www.tate.org.uk/research/tateresearch/
tatepapers

Texte zur Kunst
www.textezurkunst.de

## CENTRAL AND EASTERN EUROPE

agora8
www.agora8.org
Research into Eastern European time-
based art

Artchronika
www.artchronika.ru
Leading Russian magazine

ARTMargins
www.artmargins.com
Contemporary Central and Eastern
European visual culture, since 1998

## LATIN AMERICA AND THE CARIBBEAN

ArtNexus
www.artnexus.com
Magazine for Latin American art and its
international presence

Arte al Día
www.artealdia.com.ar
Magazine for Latin American art

Arteamérica
www.arteamerica.cu
Magazine for the visual arts of Latin
America and the Caribbean

LatinArt
www.latinart.com
Online journal of Latin American art
and culture

## ASIA

ArtConcerns
www.artconcerns.com
Online publication for Indian
contemporary art

ART India
www.artindiamag.com
Magazine of contemporary Indian art

ArtAsiaPacific
www.aapmag.com
Magazine of contemporary visual
culture in Asia and the Pacific regions

artscape Japan
www.dnp.co.jp/artscape/eng
Web magazine on Japanese
contemporary art scene

ArtZine
new.artzinechina.com
A Chinese contemporary art portal

Asian Art
www.asianartnewspaper.com
Monthly online newspaper about Asian
contemporary art, and information on
the international art market

Beijing Commune
www.beijingcommune.com
Website for emerging Chinese
contemporary artists

Diatxt
www.bun.kyoto-u.ac.jp/~yoshioka/
Diatxt/index_e.html
Critical journal published by Kyoto
Art Center

Yishu
yishu-online.com
Journal of contemporary Chinese
art since 2007

## OCEANIA

Art & Australia
www.artaustralia.com
Long-standing journal of record
and criticism

Art Monthly Australia
www.artmonthly.org.au

Art New Zealand
www.art-newzealand.com

ArtAsiaPacific
www.aapmag.com
Magazine of contemporary visual
culture in Asia and the Pacific regions

Artlink
www.artlink.com.au
Contemporary art of Australia and
the Asia-Pacific region

Pasifik Nau
www.pasifiknau.com
Online gallery showcasing contemporary
art from Papua New Guinea

Reading Room
www.aucklandartgallery.com/library/
reading-room-journal
Journal of art and culture, from
Auckland Art Gallery

## AFRICA

Africa e Mediterraneo
www.africaemediterraneo.it
Italian-based journal on contemporary
African art

African Arts
www.international.ucla.edu/africa/
africanarts
Quarterly journal on African
architecture, arts of personal adornment,
contemporary fine and popular arts, and
the arts of the Africa diaspora, published
by UCLA

Africultures
www.africultures.com
Information on current African
culture and arts

ArtSMart
news.artsmart.co.za
Arts news from South Africa

ArtThrob
www.artthrob.co.za
Journal of contemporary art in
South Africa

de arte
www.unisa.ac.za/default.asp?Cmd=Vie
wContent&ContentID=935
Journal of the Department of Art
History and Fine Arts at the University
of South Africa

Nafas Art Magazine
universes-in-universe.org/eng/nafas
Journal of contemporary art from
Islamic-influenced regions

Nka
www.nkajournal.org
Leading journal of contemporary
African art

Revue Noire
www.revuenoire.com
Online version of the French
magazine on African culture

Virtual Museum of Contemporary
African Art
www.vmcaa.nl/vm
Online gallery of practicing
African artists

## WEST ASIA

Bidoun Magazine
bidoun.org
Art and culture from the Middle East

Contemporary Practices
www.contemporarypractices.net
Visual arts from the Middle East

Nafas Art Magazine
universes-in-universe.org/eng/nafas
Journal of contemporary art from
Islamic-influenced regions

## MEGA-EXHIBITIONS, BIENNIALS, AND TRIENNIALS

Berlin Biennale
www.berlinbiennale.de

Dak'Art Biennial of Contemporary African
Art (Senegal)
www.biennaledakar.org

Documenta (Germany)
www.documenta.de

Echigo-Tsumari Art Triennial (Japan)
www.echigo-tsumari.jp/english

Havana Biennial
www.bienalhabana.cult.cu

International Istanbul Biennial
www.iksv.org/bienal/english

Biennale de Lyon
www.biennale-de-lyon.org

Mercosul Biennial (Brazil)
www.bienalmercosul.art.br

Bienal de São Paulo
www.fbsp.org.br

Shanghai Biennial
www.shanghaibiennale.com

Sharjah Biennial (United Arab Emirates)
www.sharjahbiennial.org

Singapore Biennial
www.singaporebiennale.org

Biennale of Sydney
www.biennaleofsydney.com.au

Taipei Biennial
www.taipeibiennial.org

Biennial of the End of the World
(Argentina)
www.bienalfindelmundo.org

Venice Biennale
www.labiennale.org

Yokohama Triennale (Japan)
www.yokohamatriennale.jp

## MARKETS

Art Market Monitor
www.artmarketmonitor.com
Website following public reporting
on the art market

Artnet
www.artnet.com
Most comprehensive information and
price trends site, plus online magazine

Artprice
www.artprice.com
Art-market information, including
artist profiles, price indicators, market
confidence index, and images of works
at auction

Christie's
www.christies.com
International auction house specializing
in postwar, modern, and contemporary
fine art, jewelry, and watches

Sotheby's
www.sothebys.com
International fine-art auction house
based in London and New York

# INDEX